C000218936

COMPOSTELA and EUROPE

COMPOSTELA

and EUROPE *The Story of Diego Gelmírez*

SKIRA

Cover and page 8
Apostle Saint James
[*Platerías* Door]
Master of the Betrayal
c. 1101–1111
Cathedral of Santiago de Compostela

Page 10
Pope Urban II (1042–1099) confirms
the privileges and possessions of Cluny
Abbey at its altar, granting Abbot Hugh
the use of all Episcopal ornaments; 1088
[*Chroniques de Cluny*, Ms Latin 17716,
fol. 91; detail]
1189
BnF~Bibliothèque nationale de France,
Paris

Page 12
Capital [Cloister]
c. 1100
Abbey of Sainte-Foy de Conques, Aveyron

Design
Marcello Francone

Editing
Monica Maroni

Layout
Lorena Biffi

Translations
Interlingua Traduccións
Manuela Domínguez

Editorial Management
A&M

First published in Italy in 2010 by
Skira Editore S.p.A.
Palazzo Casati Stampa
via Torino 61
20123 Milano
Italy
www.skira.net

© 2010 by Skira editore, Milano
© 2010 S.A. de Xestión del Plan Xacobeo
© 2010 the authors for the texts

Printed and bound in Italy. First edition.

ISBN 978-88-572-0493-2 (Skira editore)
ISBN 978-84-453-4881-9 (S.A. de Xestión
do Plan Xacobeo)

Distributed in North America by Rizzoli
International Publications, Inc., 300 Park
Avenue South, New York, NY 10010, USA.
Distributed elsewhere in the world by
Thames and Hudson Ltd., 181A High
Holborn, London WC1V 7QX, United
Kingdom.

The Publication

Edited by
S.A. de Xestión do Plan Xacobeo
Avenida Fernando Casas Novoa 38
Pabellón de Galicia. San Lázaro
E–15707 Santiago de Compostela
Tel. +34 981 557 355
Fax. +34 981 557 373
www.xacobeo.es

Scientific Direction
Manuel Castiñeiras

Scientific Coordination
Victoriano Nodar
Rosa Vázquez

Documentation
Marta Oreiro

Essays
Manuel Castiñeiras
Quitterie Cazes
Annaig Chatain
José María Díaz Fernández
Klaus Herbers
Jean-Marc Hofman
Francisco Prado-Vilar
Arturo Carlo Quintavalle
Adeline Rucquoi
José Luis Senra Gabriel y Galán
Francisco Singul
Alison Stones
Miguel Taín Guzmán
Rosa Vázquez
Ramón Villares
John Williams

Texts of the Catalog Entries
Manuel Castiñeiras (M. C.)
Fátima Díez (F. D.)
Emmanuel Garland (E. G.)
Antonio Milone (A. M.)
Victoriano Nodar (V. N.)
Dulce Ocón (D. O.)
Marco Piccat (M. P.)
Mercedes Pintos Barreiro (M. P. B.)
Charlotte Riou (C. R.)
José María Sánchez (J. M. S.)
Rocío Sánchez (R. S.)
Alison Stones (A. S.)
Rosa Vázquez (R. V.)

COMPOSTELA and EUROPE
The Story of Diego Gelmírez

This book is published in conjunction with the exhibition *Compostela and Europe. The Story of Diego Gelmírez* organized by S.A. de Xestión do Plan Xacobeo.

Cité de l'architecture et du patrimoine–
musée des Monuments français, Paris
16 March–16 May 2010

Braccio di Carlo Magno, Vatican City
3 June–1 August 2010

Monasterio de San Martiño Pinario, Santiago de Compostela
15 August–15 October 2010

Xunta de Galicia

President
Alberto Núñez Feijóo

Culture and Tourism Council

Councilor
Roberto Varela Fariña

General Secretary
Antonio Fernández-Campa García-Bernardo

General Secretary for Tourism
María del Carmen Pardo López

General Secretary for Cultural Heritage
José Manuel Rey Pichel

General Secretary for Cultural Promotion
Francisco López Rodríguez

S.A. de Xestión do Plan Xacobeo

General Manager
Ignacio Santos Cidrás

Assistant Manager
María del Camino Triguero Salas

Program Coordinator
Silvia Álvarez Álvarez

Administration
Ana Piñeiro Fuentes
Basilio Fontenla Couceiro
Conchi Quintana López
Gloria Quintela Hernández
Lucía Rodríguez López

Communication and Press
Jesús Cao Rivas
Luisa Redondo Escaríz

Exhibitions and Publications Area
Francisco Singul Lorenzo
Elvira Fernández Piñeiro
Carla Fernández-Refoxo González
Rosa García Ameal
José Manuel Garrido Rivero
Ofelia Gómez Estalote
Francisco Gómez Souto
Carmo Iglesias Díaz
Pilar Ron Güimil

Legal Consultancy
Esmeralda Pazo Esparís
María Carnero Míguez
Rosa Cortizo Prieto

Secretariat
Pilar Garayzábal Pedrosa
Margarita García Cabanas
Natalia Fajundes Dorelle

Supporting Services
Darío Blanco Vázquez
Julio Costoya Valiño
Sergio Vázquez Domínguez

The Exhibition

Curator
Manuel Castiñeiras

Assistant Curator
Victoriano Nodar

Coordination
Rosa Vázquez

Documentation
Marta Oreiro

Design and Installation Management
Grop Exposicions i Museografia

Audiovisual Production
Infernos TV
Jaime Fernández Producción Audiovisual

3D Production
Guiarte
Magneto Studio

Interative Production
Pexego Sistemas Informáticos

Restoration
Lucia Morganti
Gianluca Tancioni

Scientific Council

Quitterie Cazes
Professor of Medieval Art History, L'Université Paris I Panthéon-Sorbonne, Paris

José María Díaz Fernández
Dean, Cathedral of Santiago de Compostela

Klaus Herbers
Chairman of Medieval History, Friedrich-Alexander-Universität, Erlangen-Nuremberg

Fernando López Alsina
Chairman of Medieval History, USC~Universidad de Santiago de Compostela

Arturo Carlo Quintavalle
Chairman of Medieval Art History, Universitá degli Studi di Parma

Adeline Rucquoi
Research Director, CRH-EHESS~Centre de Recherches Historiques de L'Ecole des hautes etudes en Sciences Sociales, Paris

Alison Stones
Professor of Medieval Art History, University of Pittsburgh

Ramón Villares
President, Consello da Cultura Galega

John Williams
Emeritus Professor of Medieval Art History, University of Pittsburgh

Xunta de Galicia, through the Culture and Tourism Council and S.A. de Xestión do Plan Xacobeo, and Manuel Castiñeiras, would like to acknowledge the trust, assistance, support and dedication of the following people, without whom this book and the exhibition would not have been possible.

Abbatiale Sainte-Foy de Conques
American Academy of Rome
Amigos del Románico
Archivio di Stato di Pistoia
Archivo de la Catedral de Santiago de Compostela
Archivo de la Catedral de Tui
Archivo Histórico Nacional
Artifex, S.R.L.
Basilica Metropolitana di Modena– i Musei del Duomo
Biblioteca Apostolica Vaticana
Biblioteca General Histórica de la Universidad de Salamanca
Biblioteca Universitaria de Santiago de Compostela
Bibliothèque Humaniste Sélestat
Bibliothèque Municipale de Tours
Bibliothèque de la Ville de Tournai
Cabildo Metropolitano de la Catedral de Santiago
Capitolo metropolitano del Duomo di Modena
Centro Italiano di Studi Compostellani
Centre des Monuments Nationaux
Cité de l'architecture e du patrimoine–musée des Monuments français
Diócesis de Huesca
Direction Régionale des Affaires Culturelles Alsalce
Direction Régionale des Affaires Culturelles Midi-Pyrénées
Direction Régionale des Affaires Culturelles Paris-Ille-de-France
Fondazione per i Beni e le Attività Artistiche della Chiesa
Historisches Institut beim Österreichischen Kulturforum Rom
Kunsthistorisches Institut in Florenz
Mairie de Conques
Mairie de Sélestat
Musée des Augustins
Musée Lapidaire de Conques
Musée de Saint-Raymond, museé des Antiques de Toulouse
Musei Nazionali di Lucca
Museo Catedral-Basílica de San Martiño de Ourense
Museo Civico d'Arte di Modena
Museo das Peregrinacións e de Santiago
Museo de la Catedral de Santiago de Compostela
Museo Diocesano de Jaca
Museo de Navarra
Museo e Pinacoteca Nazionale Palazzo Mansi
Office de tourisme Conques
Parrocchia San Carlo Frati Minori Conventuali a Cave
Pieux Établissements de la France à Rome et à Lorette, Iglesia de la Santissima Trinità dei Monti
Scala Group SpA
Soprintendenza Archivistica per la Toscana
Soprintendenza speciale per il patrimonio storico, artistico ed etnoantropologico e per il Polo Museale della Città di Roma
Soprintendenza per i beni architettonici, paesaggistici, storici, artistici ed etnoantropologici per le province di Lucca e Massa Carrara
Soprintendenza per i beni storici, artistici e etnoantropologici del Lazio
Soprintendenza per i beni storici, artistici e etnoantropologici per le province di Modena e Reggio Emilia
Tesouro-Museu da Sé de Braga
Trésor de Conques
Università degli Studi di Perugia
The Warburg Institute

Michele Abate
Esperanza Adrados
Cónego Doutor Pio Alves de Sousa
Elvira Allocati
Monsignore Rino Annovi
Simona Antellini
Marie-Paule Arnauld
Francesco Baragiola
Fernanda Barbosa
Marcel Bauer
Margarita Becedas González
Paolo Bedeschi
Massimo Bertolucci
Cardinale Tarcisio Bertone
Lorena Biffi
Sandrine Bousquet
Avelino Bouzón Gallego
Lourdes Blanco
Federica Brivio
Jean-François De Canchy
Maria Chiara Carboni
Isabel Casal Reyes
Belén Castro
Paolo Caucci
Renato Cavani
Emma Cavazzini
Daniel Cazes
Quitterie Cazes
Annaig Chatain
Danielle Ciuffardi
Régine Combal
Doriana Comerlati
Amalia Dalascio
Fr. Cyrille Deverre
José María Díaz Fernández
Felisa Díez Lobato
Fátima Díez
Manuela Domínguez
Joako Ezpeleta
Michel Escourbiac
Cardinale Raffaelle Farina
Natalia Fernández
Isabel Ferreira
Daniela Ferriani
Maria Teresa Filieri
Maurice H. Florens
Marcello Francone
Graciella Frezza
Denis Gabio
Antonio García Omedes
Emmanuel Garland
Jean-Paul Gheleyns
Patrick Godeau
Michael Golder
Miguel Ángel González García
Anne-Marie le Guevel
Axel Hémery
Klaus Herberts
Jean-Marc Hofman
Miguel Ángel Hurtado
Anna Imponente
Anna Justo
Hervé Lemoine
Rebecka Lindau
Jesús Lizalde Giménez
Fernándo López Alsina
Lorenzo Lorenzini
Denis Louche
Eloy Lozano †
Cónego António Macedo
Begoña Martínez
Rita Martínez
Tino Martínez
Sandra Marsini
Antonio Milone
Amanda del Monte
Giovanni Morello
Lucia Morganti
Suso Mourelo Gómez
Laurent Naas
Dulce Ocón
Juan Antonio Olañeta
Dominique Paillarse
Monsignor Cesare Pasini
Bieito Pérez Outeiriño
María Isabel Pesquera Vaquero
Stefano Piantini
Marco Piccat
Francesca Piccinini
Mercedes Pintos Barreiro
Olivier Poisson
Francisco Prado-Vilar
Michèle Prévost
Arturo Carlo Quintavalle
Silvia Riboldi
Charlotte Riou
Fátima Rodríguez Pinto
Adeline Rucquoi
Catherina Saavedra
Gloria Sallent
José María Sánchez
Rocio Sánchez
Mario Scalini
Peter Schmidtbauer
José Luis Senra Gabriel y Galán
Marino Sevilla Uhalte
Francisco Singul
Patrizia Spinelli
Cristina Stefani
Alison Stones
Miguel Taín Guzmán
Gianluca Tancioni
Diana Toccafondi
Francesco Trani
Philippe Varsi
Simón Vázquez
Ramón Villares
Carmela Vircillo Franklin
Rossella Vodret
Odile Welfelé
John Williams
Gerhard Wolf
Ramón Yzquierdo Peiró

The fathers of yore, in their concern for the instruction and education of future generations, were wont to leave a written record of the exploits of kings and captains and of the virtues and achievements of illustrious men, so that they should not fall into oblivion, erased from all memory by their very antiquity or the long passing of time.

Historia Compostellana I. "In the name of the Holy and Indivisible Trinity. Here begins the first book of the account of the venerable Diego II, Pontiff of the Church of Compostela. Here begins the prologue"

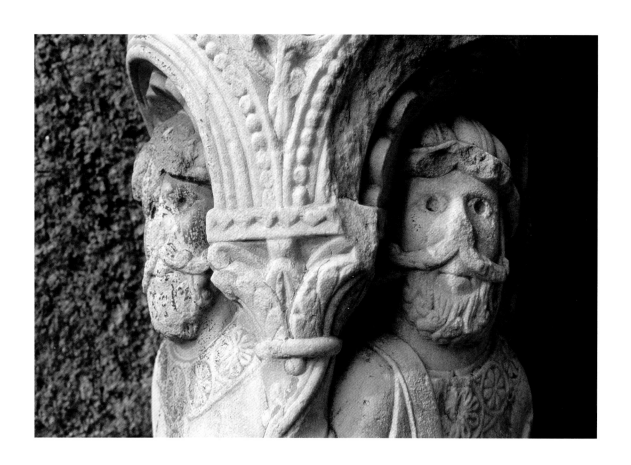

If the Compostelan Holy Year of 1993 represented a turning point in the revitalization of pilgrimages to Santiago, the following *jubileos* – when Saint James' Day falls on a Sunday – in 1999 and 2004 constituted the consolidation and expansion of an event which, today, in 2010, enjoys an international reputation that nobody could possibly have dared to imagine. Along the geographical tracts that this thousand-year-old migratory movement has drawn with its numerous routes, in the twentyfirst century pilgrims of more than 150 different nationalities now come together in the spontaneous and continuous proliferation of associations and brotherhoods which safeguard the collective memory of the phenomenon, which has expanded from Norway to Canada, from South Africa to Japan.

This context provides us with the perfect opportunity to talk of a character such as Archbishop Diego Gelmírez. Gelmírez made Compostela one of the most important centres of power among the various kingdoms of Spain and Portugal, exercising significant political and ecclesiastical power, as nobody had ever managed previously, making the Cathedral of Santiago the destination for one of the most important pilgrimages in Christendom.

With the exhibition *Compostela and Europe. The Story of Diego Gelmírez*, the Xunta de Galicia have underlined their existing commitment to the international character of the *Camino de Santiago*, assuming for the first time the challenge of taking a large exhibition to three European cities, Paris, Rome and Santiago de Compostela.

By thus honouring Gelmírez we seek to emulate his travel exploits, coming to better understand in the process that ours is not only the destination but also that of walking, as he once showed, the road that leads the way to Santiago.

Alberto Núñez Feijóo
President of Xunta de Galicia

bruno. eodem die in ipso monas tutelamq; commendauit. nisi
terio uibente papa tria untrib' deo et beato Petro eiusq; uica
pmis cancellis sacrauit alta rius. romanis scilicet pontificab'
ria. Tunc papa mt sacudo mis Quox numero uel ordini diuina
sasq; agendo. p' alia salutis hor me dignatio licet indignum as
tamta. cox epis & cardinalibus sociauit. me olim monachum
multoxq; psonis. huiccemodi priozemq; monasterii huuis. sub
 habuit ad ipsm. domno ac uenerabili hugone

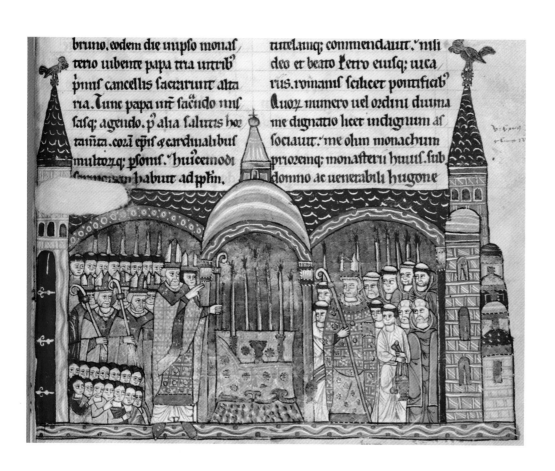

In these times in which we move ever closer towards the consolidation of European unity, the pilgrimage to Santiago takes on a key role – even more so if we take a journey through our collective memory in order to submerge ourselves in the historical roots of the human phenomenon, where the true essence of concepts such as "universality" and "multi-culturality" which had come about as a result of the intense commercial, cultural and artistic exchange existed on the roads which led to Compostela in the High Middle Ages.

In fact the international idiosyncrasy of Santiago de Compostela in the twelfth century cannot be truly understood without a figure such as Diego Gelmírez (1070?–1140). His career was orientated toward the elevation and consolidation of the then emerging Church of Santiago, which, since the ninth century had proudly held the Apostolic remains of Saint James the Greater. During his government, *Campus Stellae* – "Field of Stars," the origin of Compostela – went from being a peripheral *Finis Terrae* outpost to becoming the very point of reference within the cultural panorama of Romanesque Europe, situating the pilgrimage to Santiago at the same level as Rome and Jerusalem, and thus converting the City of Saint James into one of Christianity's main centres of pilgrimage.

The exhibition and this publication, *Compostela and Europe. The Story of Diego Gelmírez*, offer us the chance to comprehensively review the complex figure of Diego Gelmírez, under whose stewardship the city experienced an era of splendor. The Culture and Tourism Council of the Xunta de Galicia, and through the S.A. de Xestión do Plan Xacobeo, which seeks to promote the collective memory that helps us to understand the present, the protection and revitalisation of the heritage on which our identity is founded, are both fully aware that this is one of the most ancestral of all communication networks and fully committed to projects which, like this, continue to promote notions of cultural exchange, spreading the word beyond our borders. Guided by the memory of Diego Gelmírez, let us now "walk" through Compostela's momentous achievements around 1100, as well as the connections that the great Archbishop set in place for us, through the major creative centres of the Romanesque period.

Roberto Varela Fariña
Councilor for Culture and Tourism

The internationality of Compostela in the twelfth century cannot be properly understood without first understanding the character of Diego Gelmírez (1070?–1140). In fact his long life, which spanned the end of the eleventh and the start of the twelfth centuries, proved to be the great leap forward for the city of Santiago, making it one of the most important cities in Romanesque Europe from a number of perspectives. Politically speaking, Gelmírez made Compostela one of the key centres of power amongst the various Hispanic kingdoms of the time. He ensured that Galicia carried weight and enjoyed political independence which would see him crown the young Alfonso Raimúndez, born and raised in this region, crowned king of Galicia in Santiago Cathedral in 1111. From an ecclesiastic point of view, as administrator of the see, this would pass from Iria to Compostela in 1095, with Diego Gelmírez, later named Bishop, marking the start of the struggle for metropolitan status. This recognition was granted in 1120, making Gelmírez the first Archbishop of Santiago. During the same period, the *Camino de Santiago* – the Way of Saint James – flourished as never before, undoubtedly favouring the city's urban expansion and the progress of the local population.

Under Gelmírez, Compostela also experienced its golden age in terms of artistic and cultural output. With the Archbishop expressing his concern for the prestige that the Compostela see enjoyed, work on the cathedral received its greatest boost, creating the grand transept portals, the *Porta Francigena* and *Platerías*, two Episcopal Palaces were built, important urban infrastructure projects were undertaken, including aqueducts and hospitals, the position of the *Escuela de Gramática* or "Grammar School" was consolidated and a number of important historical, religious and literary texts were written, such as the *Codex Calixtinus* and the *Historia Compostellana*. There can be little doubt that Diego Gelmírez was one of Galicia's truly great architects with a reputation which was to extend far beyond our borders. For this reason, S.A. de Xestión do Plan Xacobeo is proud to honor the prestigious man through the *Compostela and Europe. The Story of Diego Gelmírez* project. As an untiring traveller who visited the western world's main centres of power at that time, such as Cluny and the eternal city of Rome, the exhibition will likewise travel first to the musée des Monuments français in Paris, and then to the Braccio di Carlo Magno in the Vatican City, before coming home to Santiago de Compostela. This journey will be completed, very much in the style of Gelmírez, with this publication, in keeping with that which was outlined in the *Historia Compostellana*, "The fathers of yore, in their concern for the instruction and education of future generations, were wont to leave a written record of the exploits of kings and captains and of the virtues and achievements of illustrious men, so that they should not fall into oblivion, erased from all memory by their very antiquity or the long passing of time."

Ignacio Santos Cidrás
S.A. de Xestión do Plan Xacobeo General Manager

Contents

Manuel Castiñeiras

The Reason for a Traveling Exhibition. Diego Gelmírez, Genius and Traveling Spirit of Romanesque

To Compostela, the magic lamp of Galicia

In an era when we have returned to history written in the first person, when past events tend to be narrated through a biographical profile, the figure of Diego Gelmírez (1070?–1140) emerges before us like a colossus. Few figures in the lengthy – and often mute – history of Galicia enjoy an artistic and textual memory that is so broad and conclusive. In fact, Gelmírez is part of our monumental landscape: from the breathtaking ruins of the Western Towers in Catoira (Pontevedra), where his father worked as *tenente* and in whose shadows he would play in his childhood, to the solid architecture of the Cathedral of Santiago, from whose windows he saw, at the height of his power, the population of Compostela rebel against him in 1117.

Gelmírez has further been a subject for history and literature: the *Historia Compostellana*, a thorough and lively record of his deeds, was drafted by his faithful canons Munio Alfonso, Giraldo of Beauvais and Pedro Marcio,[1] and centuries later, at the height of Romanesque, the journalist from Navarre, Francisco Navarro Villoslada (1818–1895) turned part of this epopee into a historical novel dedicated to the queen, *Doña Urraca* (1849), with the suggestive subtitle *Memoria de tres canónigos*.[2] Finally, Gelmírez, genius and figure, represents the spirit of Compostela and the Pilgrims' Road to Santiago like no-one else: to him we owe the erection of the giant stone cross at the Cathedral of Santiago, which still crowns the city sky and majestically opens its doors to the bustle of urban life, thus marking the deserved goal of the pilgrimage. There, at the early north door, pilgrims encountered the famous scallop shells, the universal insignia of the pilgrim to Santiago, which saw the light of day in the early years of Gelmírez's time in office, between 1099 and 1106.

We should not forget that Hegel, in his *Lectures on Aesthetics*, conceded art an inestimable value in the history of culture, since mankind has used it as "a means of gaining awareness of the most sublime ideas and interests of its spirit."[3] It would not be an exaggeration then to say that Bishop Gelmírez (1100–1140) deposited, like so many other great patrons of the arts in his time, like Desiderius of Montecassino, Bégon III of Conques, Hugh of Cluny or Sugerius of Sant-Denis himself, his loftiest conceptions in the commissioning of artistic and literary productions. The major accesses, covered with diverse reliefs that make up, or made up, the entries in the south of the church – the *Platerías* Door – and the north – the French Door, or *Porta Francigena* – are quite simply what Sigmund Freud called sublimation, or the symbolization of our deepest desires.

1 F. López Alsina, *La ciudad de Santiago de Compostela en la Alta Edad Media* (Santiago de Compostela: Ayuntamiento de Santiago, 1988), pp. 48–92.

2 F. Navarro Villoslada [1849], *Doña Urraca de Castilla* (Madrid: Círculo de Amigos de la Historia, 1976). Cf. M. Castiñeiras, "Tre miti storiografici sul romanico ispanico: Catalogna, il Cammino di Santiago e il fascino dell'Islam," in A. C. Quintavalle (ed.), *Medioevo: arte e storia. Atti del Convegno Internazionale di Studi di Parma (18-22 settembre 2007)* (Milan: Electa, 2008), pp. 86–107, esp. p. 86.

3 G. W. F. Hegel [*Vorlesungen über die Ästhetik*, Berlin: H. G. Hotho, 1835 & 1842], *Introducción a la estética* (Barcelona: Ediciones 62, 1979), p. 10.

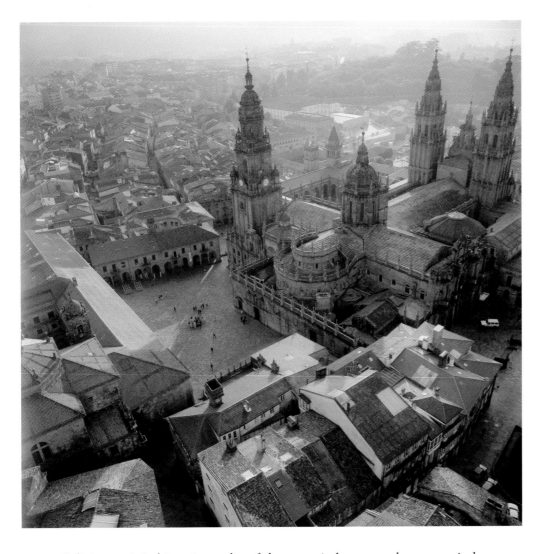

The Cathedral of Santiago
de Compostela [aerial view]

Galician artistic historiography of the twentieth century has very wisely
recognized and held, unanimously, the indivisible nature of the archbishop
of Compostela as a promoter of the arts; the *Historia Compostellana* even defines
him as *sapiens architectus*, a wise architect.[4] Filgueira Valverde did not hesitate
to introduce Gelmírez as a real "constructor," "with a desire for lasting results,"
the same way as Serafín Moralejo considered him a "patron of the arts," who
sought to project a new status for the see of Compostela through his church.[5]
His evaluation as *principle* in Anglo-Saxon historiography, where both sides of the
coin can be found, is, however, more diversified. From an original perspective,
Karen Rose Mathews believed that Gelmírez's excessive ambition for Compostela
to become a "second Rome," without the city's social consensus either in the
construction of the buildings or in the sharing of the profits derived from
pilgrimage, doomed his project to failure, seen by the people of Compostela as
the monument par excellence to his despotic secular authority.[6] Hence the two
attacks suffered by the basilica at the hands of the mob, whose aim was to put
an end to the personal safety of the prelate: in the fire of 1117, Gelmírez had
to escape from the crowds in disguise, wrapped in a pauper's cloak and covering
his face with a crucifix (*Historia Compostellana*, I, CXIV, 6), while in the breach
of the church in 1136, the aged archbishop had no choice but to take refuge

4 "*Historia Compostellana*, I, LXXVIII,"
 in H. Flórez, *España Sagrada. Teatro
 Geográfico-Histórico de la Iglesia de
 España*, vol. 20:56 (Madrid: 1765),
 p. 137.
5 J. Filgueira Valverde, "Gelmírez,
 constructor," in *Historias de Compostela*
 (Vigo: Edicións Xerais de Galicia, 1982),
 pp. 37–75, esp. p. 27. S. Moralejo,
 "El patronazgo artístico del arzobispo
 Gelmírez (1100–1140): su reflejo en la
 obra e imagen de Santiago," in *Pistoia e
 il Cammino di Santiago. Una dimensione
 europea della Toscana medioevale. Atti
 del Convegno internazionale di studi,
 Pistoia 28–29–30 settembre 1984*
 (Naples: Edizioni Scientifiche Italiane,
 1987), pp. 245–72.
6 K. R. Mathews, *They wished to destroy
 the Temple of God. Responses to Diego
 Gelmírez's Catedral Construction in
 Santiago de Compostela, 1100–1140*
 (Chicago: The University of Chicago
 Press, 1995), pp. 256–9.

Acroterion of the chapel of Saint
Faith
c. 1122
Cathedral of Santiago de Compostela

7 Ch. Watson, *The Romanesque
 Cathedral of Santiago de Compostela:
 A Reassessment* (Oxford: British
 Archaelogical Reports, 2009).
8 I am referring to the talk to be
 held at the University of Berne
 (Switzerland) on 25 and 27 March 2010,
 organized by Bernd Nicolai and Klaus
 Rheidt and entitled *Pilgerarchitektur
 und bildliche Repräsentation in neuer
 Perspektive / Pilgrimage Architecture and
 Pictorial Concepts in a New Perspective*.
 I am partially familiar with the results
 of the investigation carried out with
 a scanner by Nicolai-Rheidt in the
 Cathedral of Santiago concerning
 a possible western doorway in
 Gelmírez's time, but out of prudence
 and professional ethics, as this is
 unpublished material, I refer readers
 to the proceedings of the congress
 for any further debate.
9 H. Toubert, *Un art dirigé. Réforme
 grégorienne et Iconographie* (Paris: Cerf,
 1990).

at the altar of the Apostle, closing the iron doors of the building, only to suffer, under the roof of his silver canopy, a heavy rain of stones that the rebels threw down on him from the galleries (HC, III, 47–48). More dignified for the character, but perhaps equally daring, is the image given in the recent publication by Christabel Watson, in which the idea of a western enclosure in the cathedral in Gelmírez's time is recovered, preceding the work of Maestro Mateo,[7] and which seems to be currently gaining more and more support outside our country.[8]

In the eyes of our contemporaries, in an era when the historical novel has become fashionable, the Bishop of Compostela's epopee and the slow rise of his church, designed as a bastion for Jacobean pilgrimage, could have reached the rank of best-seller. In fact, Gelmírez's true story has nothing to envy Ken Follett's novel *The Pillars of the Earth* (New York: 1989), where not coincidentally the famed architect, Jack, travels along the Pilgrims' Road to Santiago to reach the goal, Compostela, and admire its cathedral. Nor was the archbishop of Compostela in his own time a minor character: if abbot Sugerius (1081–1151) was able to build in Saint-Denis (1137–1144) a leading construction in its time with the help of the most diverse workmen, giving rise to what we call the Gothic style, Gelmírez had promoted the erection of the most perfect pilgrimage church years before, on the western edge of Europe, with the help of architects and masons come from beyond the Pyrenees, joined by many other locals.

However, in our opinion, the fact that best defines "Gelmírez's" constructive gesture is the journey. The definition of the image of the cathedral was undoubtedly a difficult and contrasted task, probably planned down to the smallest detail and needing direct knowledge of other monuments. Most likely, as demonstrated by Hélène Toubert for the case of Rome and Montecassino,[9] Diego Gelmírez carried out a "directed" art, with the complicity of his closest canons who accompanied him on journeys with clear political overtones, in which the search for artistic models fell within his own interests to reach a new status for Compostela. The patient reconstruction of these long routes through Romanesque Europe and the Gregorian Reform in 1100, 1102, 1105, 1118 and 1122–1124 help us understand the progressive construction of an unprecedented figurative program in *Finis Terrae*. The visit by different members of the Compostela curia to Braga, Toulouse, Moissac, Cahors, probably Conques, Limoges, Cluny, to the cities of the Italian *via francigena* to Rome, the major early Christian basilicas of the Eternal City, the lands of Apulia and Sicily as well as to the newly conquered Jerusalem, help us to understand the attempt of a town on the edge of Europe to open up and become known; Compostela, which then was becoming a center. This internationalism is evident in the sumptuous, now lost, decoration of the High Altar of Saint James, in the construction of the large sculptured *Porta Francigena* and in *Platerías*, in the ornamentation of the height of the chapels of Saint John and Saint Faith with their acroteria, and in the creation of a fully domed basilica architecture with galleries. To this must be added the development of the first "Guide" to the Pilgrims' Road to Santiago, written around

Acroterion of the chapel of Saint John
c. 1122
Cathedral of Santiago de Compostela

1137 and included in Book V of the *Liber Sancti Jacobi* or *Codex Calixtinus*, which also contains the first detailed description of the city and its cathedral.

Art historians are still debating the true nature of Romanesque architecture and sculpture of this period. Today, many prefer to explain the similarities between monuments by simply resorting to the circulation of books of models as opposed to the old ideas of Arthur Kingsley Porter, who strongly believed in the fundamental transmition role of traveling artists, as argued in his monumental work *Romanesque Sculpture of the Pilgrimage Roads* (Boston: 1923). A series of texts in Compostela sources seem, however, to corroborate some of the American author's "dissemination" hypotheses. In the famous *Liber Sancti Jacobi* "Guide," the fifth chapter is dedicated to remembering "the names of some of those who repaired the Way of Saint James," known as *viatores* or walkers, who due to the diversity of their names – "Andreas Rotgerius, Alvitus, Fortus, Arnaldus y Petrus"[10] (also known as "*Peregrinus*") – might well have been of many different nationalities, as suggested by Serafín Moralejo. Therefore, without underestimating the role of books of models, a central part in any artistic work, we should not only recognize the significant role played by itinerant artists in building the so-called "Art of the Pilgrims' Road to Santiago," like the oft-quoted *Stephanus, magister operis sancti Jacobi*, who in 1101 started work on the Cathedral of Pamplona, but also admit that some "traveling" patrons, like Gelmírez, conditioned forever the bias of their artistic ventures. It is in this line, through the long route or journey to the great centers of Christianity, that we wish to explain certain peculiarities of the Cathedral of Santiago, in its desire to emulate or be compared to the monuments of its time. There is nothing more explicit in this sense than Diego's own words around 1124 concerning the need to build a cloister for the cathedral:

10 *Liber Sancti Iacobi Codex Calixtinus*, trans. A. Moralejo, C. Torres and J. Feo (Santiago de Compostela: Instituto Padre Sarmiento de Estudios Gallegos, 1951; reed. fac. Santiago de Compostela: CSIC~Centro Superior de Investigaciones Científicas, 1999), p. 509.

"Hermanos, nuestra iglesia no por nuestros méritos sino por la gracia de Dios y por nuestro santísimo patrono el apóstol Santiago es de nombre muy grande y célebre y a ambos lados de los Pirineos es tenida por muy noble y rica. Sin embargo, no tiene ningún claustro ni tiene todavía buenas dependencias; cualquier sede más allá de los Pirineos tiene edificios más hermosos y de más valor que los nuestros, como yo he visto con mis propios ojos antes de ser obispo y después cuando por exigirlo el provecho de nuestra iglesia viajé por muchos y diversos lugares. Y vosotros que habéis viajado al extranjero sabéis tan bien como yo que lo que digo es muy verdadero."[11]

The main role: Diego Gelmírez, his journeys and the birth of "Gelmirian art"

Since his birth around 1070, Diego Gelmírez was closely linked to the origins and vicissitudes of the cathedral project. In fact, his father, *miles* Gelmirio, served the Iria-Compostela Church under the bishopric of Diego Peláez (1070–1088) as governor of the lands of Iria, A Mahía and Postmarcos. It was here, on the Atlantic coast, near the mouth of the Ulla river, that the famous West Towers stood; Gelmirio was their *tenente*. This defensive bastion of the dominion of Compostela was of great strategic importance, because it was a bulwark against possible incursions by Normans and Muslim pirates.

Very likely, under these circumstances, which connected him to the defense of the Dominion of Santiago, the young Gelmírez made a brilliant career, as in 1090, at the age of twenty, he became chancellor and consultant to Raymond of Burgundy, Count of Galicia and husband of Alfonso VI's daughter, Urraca, the future Queen of Castilla and León. In this difficult but crucial decade of the 1090s, in which the see was virtually vacant, Gelmírez twice occupied the position of administrator-vicar of the dominion of the Church of Santiago, from 1093–1094 and 1096–1099.[12] Finally, once he was appointed subdeacon in 1100 at the Church of Saint Peter's in the Vatican, he was immediately elected Bishop of Compostela with the consent of King Alfonso VI and Count Raymond of Burgundy. He was not consecrated, however, until the Easter of the following year, on 22 April 1101. Then in 1105, he obtained the dignity of the pallium in Rome and finally, in 1120, he was elevated by Burgundian Pope Calixtus II, uncle of the future King Alfonso VII, to the rank of archbishop, thus obtaining the metropolitan dignity of the Church of Saint James at the expense of Mérida. Not without tension, Gelmírez held his responsibilities of great authority until his death in 1140, enjoying the friendship of popes, kings and great abbots and prelates of his time. His fame as a patron of the arts is beyond dispute, because although he was not the initiator of the Cathedral of Santiago, nobody knew better than him how to carry it out and promote it to one of the most significant churches in Romanesque Europe.

In the exhibition we have mainly tried to recover the impact of the two journeys made by Gelmírez, on his way to Rome, along the French pilgrimage routes in 1100 and 1105. Of the four main roads that crossed France according to the *Codex Calixtinus* – the *via tolosana*, the *via podiensis*, the *via lemosina* and the *via turonensis* – Gelmírez followed the southernmost road, the *tolosana*, on both occasions: the first time, in 1100, he went directly to Rome, while on the second journey, in 1105, he visited Cluny, which is why he had to travel various stretches

11 *Historia Compostelana*, trans. E. Falque Rey (Madrid: Akal, 1994), p. 494. Cf. J. Filgueira Valverde, *Historias de Compostela* (Vigo: Edicións Xerais de Galicia, 1982), pp. 45–7.

12 R. A. Fletcher [*Saint James's Catapult: The Life and Times of Diego Gelmírez of Santiago de Compostela*. Oxford: Oxford University Press, 1984], *A vida e o tempo de Diego Xelmírez* (Vigo: Editorial Galaxia, 1993), pp. 129–35. J. J. Cebrián Franco, *Obispos de Iria y Arzobispos de Santiago de Compostela* (Santiago de Compostela: Agencia Gráfica, 1997), pp. 87–8. Among other publications, there is also a beautiful fictionalized biography of the man, written by D. Ramón Otero Pedrayo, *Xelmírez, xenio do Románico* [1951] (Vigo: Editorial Galaxia, 1993).

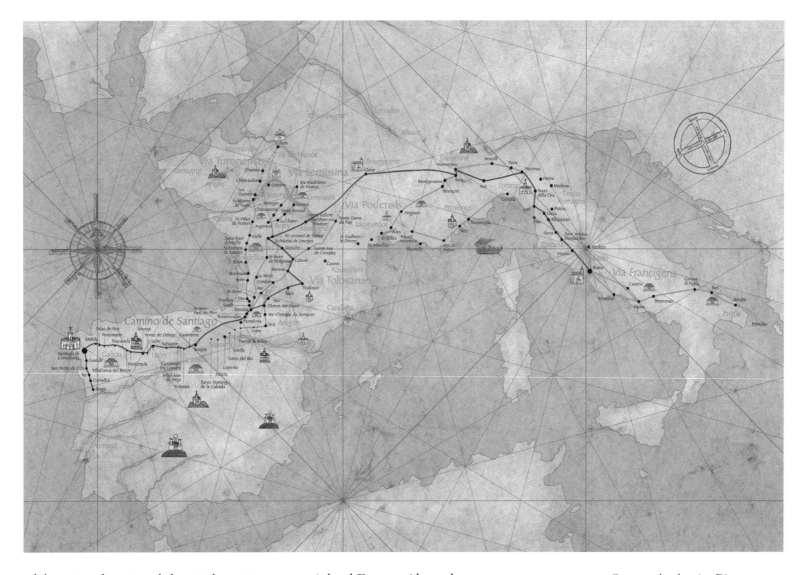

Cartography showing Diego
Gelmírez's travels

of the *via podiensis* and the *via lemosina* to cross inland France. Along these
roads Gelmírez and his entourage, perhaps accompanied by an artist, were able
to see first-hand the great creation centers of Romanesque art in France, like
Toulouse, Moissac, Conques and Cluny, which led to large artistic exchanges
with the workshops then busy in Compostela with the construction and decoration
of the Cathedral of Santiago. Similarly, the route along the Italian *via francigena*
to reach Rome and the visit to the Eternal City are essential for understanding
other peculiarities of the art of Compostela in the first decade of the twelfth
century.

In my opinion, the French and Roman lesson – learned over the course of
the two journeys – explain the birth of what could be called "Gelmírez art," whose
golden phase took place between 1100 and 1122. In fact, it would be incorrect
to speak of "Gelmírez art" previous to 1100–1101. Only when Diego Gelmírez
entered fully into the ecclesiastical career, first being appointed subdeacon and
consequently bishop, could he develop a perfectly coherent and avant-garde
figurative program in Compostela. His two journeys in 1100 and 1105 had
implications for the course of monumental sculpture, as they enabled him to
transform and renovate the traditions received up to that time in Compostela

– the art of Auvergne, Conques and Jaca – and become permanently incorporated in the new French fashions: the Toulouse of the *Porte Miègeville* (Cat. 7) and the Conques of Bégon III (Cat. 10–12). In parallel, as pointed out by Serafin Moralejo, Rome also became an ideological referent for his decorative program, as shown by the Solomonic columns on the original *Porta Francigena* (Cat. 21) and the systematization of the altar and silver canopy in 1105–1106, following the models of the liturgical items in Roman basilicas.[13] If the journey in 1100 led to the magnificent production of the "Master of the Twisted Columns" – the journey no doubt included visits to the repertoire of Solomonic columns produced by the Roman marble workers (Cat. 19, 20) – the visit in 1105 to San Lorenzo fuori le Mura to receive the pallium probably influenced the evolution of the "Master of the *Porta Francigena*," who conceived the slabs of the *Hombre cabalgando al gallo* and the *Sonador del Olifante sobre el León* after seeing a Dionysian directory on the second-century sarcophagus reused as the tomb of Pope Damasus (†1048) in the above-mentioned Roman basilica.[14]

During this special opening of Compostela to the roads of Europe, the final alignment of the ambulatory and huge transept of the cathedral saw the light of day, the main altar was consecrated – probably in 1106 and not in 1105 as was assumed up to now – the raising of the two large carved fronts, the *Porta Francigena* and *Platerías* (1101–1111) and the completion of the adjacent galleries, roofs and public spaces in this area around 1122, when the *Paradisus* fountain was installed[15] and altars in the transept galleries were dedicated.[16] In short, a great constructive epopee, which converted a town in the suburbs into an artistic center and true melting pot of the so-called "Art of the Pilgrims' Road to Santiago."

Other journeys were, to a greater or lesser extent, the driving force of this epopee. The so-called "Pious Robbery" committed in 1102 by Gelmírez and his entourage in Portugal, to acquire the most prestigious relics of the see of Braga, the holy bodies of Saint Fructuosus, Saint Cucufate, Saint Silvestre and Saint Susanna, is part of the annals of the *furta sacra* of the time. There is a precedent in the celebrated expedition of the sailors from Bari to acquire the relics of Saint Nicholas in Mira (Turkey) in 1087. By translating their relics to Santiago and placing them in the cathedral – Saint Cucufate in the chapel of Saint John, Saint Silvestre in the chapel of Saint Peter and Saint Fructuosus in the chapel of The Savior (later in that of Saint Martin) – the idea was to attract the flow of pilgrims to Compostela and block their interest in Braga, which in 1100 had recovered the metropolitan dignity Compostela craved and envied so greatly.

From his interest in the western lands of the old *Gallaecia*, over the years Gelmírez turned his interest to the distant ports in southern Italy and the Holy Land. We know, in fact, that he sent two canons from Compostela, Pedro Astruáriz and Pelayo Yánez, to Apulia and Sicily in search of donations for the completion of the church in Compostela from 1122 to 1124.[17] In my opinion, this southern connection would explain some of the "Apulian" references in the dedication of altars in Compostela – more specifically the altar of Saint Nicholas in the south transept gallery in 1122, for the bishop's private use[18] – and the external crowning

13 S. Moralejo, "Ars sacra et sculpture romane monumentale: Le trésor et le chentier de Compostelle," *Les Cahiers de St-Michel de Cuxa. Les origines de l'art roman. 11ème centenaire de la fondation de Cuxa*, 11 (Cuxa: 1980), pp. 189–238.

14 M. Castiñeiras, "El Concierto del Apocalipsis en el arte de los Caminos de Peregrinación," in C. Villanueva (ed.), *El Sonido de la Piedra. Actas del Encuentro sobre Instrumentos en el Camino de Santiago* (Santiago de Compostela: Xunta de Galicia, 2005), pp. 119–64.

15 *Liber Sancti Iacobi...* op. cit., p. 558. M. Castiñeiras "A poética das marxes no románico galego: bestiario, fábulas e mundo ó revés," in *Semata. Ciencias Sociais e Humanidades (Profano y Pagano en el Arte Gallego)*, 14 (Santiago de Compostela: 2003), pp. 313–4.

16 *Historia Compostelana...* op. cit., p. 402.

17 *España Sagrada...* op. cit., p. 401. Cf. *Historia Compostelana...* op. cit., p. 429.

18 *Historia Compostelana...* op. cit., p. 372. Cf. trans. cit. p. 402.

19 M. Castiñeiras, "La catedral románica: tipología arquitectónica y narración visual," in M. Núñez (ed.), *Santiago, la Catedral y la memoria del arte* (Santiago de Compostela: Consorcio de Santiago, 2000), pp. 39–96. Cf. M. Castiñeiras, *Semata. Ciencias Sociais e Humanidades*, 14... op. cit.

20 *Historia Compostelana...* op. cit., pp. 302–3.

21 Ibidem, p. 537. N. Jaspert, "*Pro nobis, qui pro vobis oramus, orate. Die Kathedralkapitel von Compostela und Jerusalem in der resten Hälfte des 12. Jahrhunderts*," in P. Caucci (ed.), *Santiago, Roma, Jerusalén. Actas del III Congreso Internacional de Estudio Jacobeos* (Santiago de Compostela: Xunta de Galicia, 1999), pp. 187–212.

of the chapels of Saint John and Saint Faith in the ambulatory, between 1117 and 1122, with acroteria that seem to be borrowed from the repertoire of "Apulian" Romanesque.[19] In fact, this familiarity of the Compostela curia with Apulia would be confirmed by the journey to Jerusalem made a few years earlier, in 1118, by canons Pedro Díaz and Pedro Anayaz, cardinal and treasurer respectively of the Church of Santiago.[20] In all probability, they embarked for the Holy Land in one of the Apulian ports. Some years later, in 1129, the Patriarch of Jerusalem sent Gelmírez a letter to thank him for the donations received, proposed the creation of a *confraternitas* between the two churches and requested that he would receive a certain Aymerico, canon of the Holy Sepulcher, and give him the Church of Santa María de Nogueira (Cambados, Pontevedra), which at the time belonged to the diocese of Compostela,[21] but which had been granted to the Holy Sepulchre in the papal privilege of 1128.[22] In all likelihood, as I have pointed out in previous studies, the incorrectly called *Lignum Crucis* "de Carboeiro" came to Galicia with this canon. It is kept nowadays in the chapel of Relics in the Cathedral of Santiago.[23]

I am aware that Diego Gelmírez also carried out significant work as aedile in Compostela and its diocese, beyond the work of the cathedral, but this is not covered by the current publication, which aims to extol his most direct links with the roads of Europe. We should note, however, his contribution to civil architecture and town planning in the city with the construction of two episcopal palaces, the first by the *Platerías* Door in 1101, and the second, on the north side, from 1120 on, a hospital for pilgrims. We could also mention an aqueduct and a beautiful fountain in the *Paradisus*, with four outlets to quench the thirst of the pilgrims who came to the basilica, built under the supervision of Treasurer Bernardus.[24] Similarly, the *Historia Compostellana* praises him as a builder of smaller churches within the city – like the Holy Sepulchre, which was soon to host the remains of Saint Susanna (HC, I, 19), and Santa Cruz on the Monte do Gozo (HC, I, 20), where he developed his own processional rites in the Roman liturgy[25] – as well as others scattered throughout his diocese and for which he was assisted by the munificence of priests and canons. We could highlight among these, for example, Santiago de Padrón (c. 1106), where under the altar lies the famous "boulder" with which the apostolic boat arrived, for which he had the support of the priest Pelagius (HC, I, 22, 36), and the numerous churches of the Nendos region – Piadela (in 1101), Abegondo, Barbeiros, Dexo, Mántaras and Morás – restored and consecrated thanks to the generosity of Archdeacon Juan Rodríguez (HC, I, 32).[26] Although many of them are still standing, later Romanesque transformations and interventions from the Baroque period have forever transformed their original appearance.

However, his undeniable action was immortalized in his diocese in an image, long after his death, around 1289, in a miniature in the daily record book at the monastery of San Justo y Pastor de Toxosoutos[27] (A Coruña). The bishop is depicted, with miter and the apostolic tau shaped staff – prescriptive for bishops of Compostela – blessing Fruela Alfonso and Pedro Muñíz, knights of the court of Alfonso VII, who in 1127 abandoned the world to retire to a remote oratory with the

22 G. Bresc-Bautier (ed.), *Le Cartulaire du Chapitre du Saint-Sépulcre de Jérusalem* (Paris: P. Geuthner, 1984), pp. 39–44, no. 6, esp. p. 43: "*in epsicopatu Sancti Jacobi [...] monasterium Sancte Marie de Nogaria cum pertinentiis suis.*" The town of Cambados, the property of Nogueira and the monastery of the same name, which belonged to the Order of the Holy Sepulchre in Jerusalem, were incorporated into the Militar Order of Saint John of Jerusalem under the Bull of Innocence in 1489, effective in Galicia in 1542, within the Encomienda of Pazos de Arenteiro. I. García Tato, *Las Encomiendas gallegas de la Orden Militar de S. Juan de Jerusalén. Estudio y edición documental. I. Época Medieval* (Santiago de Compostela: CSIC~Centro Superior de Investigaciones Científicas, 2004), pp. 74, 77, 357–8, 688.

23 I have developed this hypothesis in the following publications: "Lignum Crucis de Carboeiro," in J. M. Díaz Fernández and J. I. Cabano (eds.), *Los Rostros de Dios* (Santiago de Compostela: Consorcio de Santiago, 2000), p. 364. "Platerías: función y decoración de un 'lugar sagrado'," in *Santiago de Compostela: ciudad y peregrino. Actas del V Congreso Internacional de Estudios Jacobeos* (Santiago de Compostela: Xunta de Galicia), pp. 330–1. "Fragmento de fuste con *putti* vendimiadores," in *Luces de Peregrinación* (Santiago de Compostela: Xunta de Galicia, 2003), pp. 38–9, tab. 11. Concerning the piece itself, see also J. Filgueira Valverde, *El Tesoro de la Catedral Compostelana* (Santiago de Compostela: Bibliófilos Gallegos, 1959), p. 44, tab. 4. S. Alcolea, *Artes decorativas en la España Cristiana (siglos XI–XIX)*, Col. Ars Hispaniae, vol. 20 (Madrid: Plus Ultra, 1975), p. 123, tab. 121. H. Meuer, "Zu den Staurotheken der Kreuzfahre," *Zeitschrift für Kunstgeschichte*, 48 (Basle: 1985), pp. 65–76, esp. p. 69, tabs. 9–10. S. Moralejo, "Lignum Crucis de Carboeiro," in *Santiago, Camino de Europa. Culto y cultura en la peregrinación a Compostela* (Madrid: Xunta de Galicia, 1993), pp. 351–2, cat. 70. N. Jaspert, "Un vestigio desconocido de Tierra Santa: la Vera Creu d'Anglesola," *Anuario de Estudios Medievales*, 29 (Madrid: 1999), pp. 447–75, esp. pp. 458–9, tabs. 5–6.

24 *Historias de Compostela... op. cit.*, pp. 66–9.

25 M. Castiñeiras, *Os traballos e os días na Galicia medieval* (Santiago de Compostela: USC~Universidad de Santiago de Compostela, 1995), p. 55.

26 J. Filgueira Valverde, *Historias de Compostela... op. cit.*, pp. 58–65. M. Castiñeiras, "Arte románico y reforma eclesiástica," in *Semata. Ciencias Sociais e Humanidades (Las religiones en la historia de Galicia)*, 7–8 (Santiago de Compostela: 1996), pp. 307–32, esp. p. 310.

27 *Clero-Tumbo de Toxosoutos* (Madrid: AHN~Archivo Histórico Nacional), sg. 1302, f. 2v.

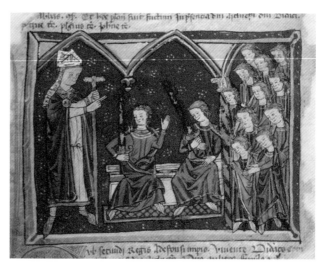

Pedrón
first century
Church of Santiago de Padrón,
A Coruña

Archbishop Diego Gelmírez
[Tumbo de Toxos Outos,
Cod. L1002, fol. 2v, detail]
1289
AHN~Archivo Histórico Nacional,
Ministerio de Cultura, Madrid

purpose of founding a new monastery.[28] As the text accompanying the illustration says, the event took place with the blessing of the abbot of San Paio de Antealtares, who, as owner, gave them the hermitage in the presence of archbishop Gelmírez. This is the only image of Gelmírez from medieval times and has acquired great relevance in both the work process and the exhibition, as well as in this publication.

The collective articulation of an exhibition discourse: the venues of itinerancy and the publication

The transmission of the idea of a Compostela present in Europe on the occasion of Holy Year 2010 was considered a fundamental goal in the preparation of the project. It was not, as in other previous exhibitions, a case of concentrating a large number of pieces in Santiago to explain the great adventure of the pilgrimage to Compostela, as happened in the magnificent exhibition *Santiago, Camino de Europa. Culto y cultura en la peregrinación a Compostela*, held in 1993 under the curatorship of Professor Serafín Moralejo. Moreover, the idea of several venues had been rehearsed in the years 2003 and 2004 by S.A. de Xestión do Plan Xacobeo, in an equally extensive exhibition on the phenomenon of pilgrimage, *Luces de Peregrinación*, under the curatorship of Francisco Singul. This exhibition opened at the National Archaeological Museum in Madrid and then went to the Diocesan Museum of Santiago of Compostela, located in the Monastery of San Martiño Pinario. Previous experiences thus required a renewed effort on our part: we could not return to a repetitive discourse on the pilgrimage to Compostela, we had to show the historical, artistic and cultural legacy of Santiago in Europe – not just within our own borders – and, ultimately, we needed an issue powerful enough to convey a forceful message.

From the beginning we knew that a traveling option, at venues in different countries, partly prevented a great grouping together of pieces due to the difficulty of maintaining long-term institutional loans, although this could be overcome with the use of new digital technologies. However, reducing the number of items exhibited allowed for a selection of quality and appropriate content to the idea of excellence that was desired. In the same vein, the theme chosen, *Compostela and*

28 A. Sicart, *Pintura medieval: la miniatura* (Santiago de Compostela: Arte Galega Sánchez Canton, 1981), pp. 111–2. F. J. Pérez Rodríguez, *Os documentos do Tombo de Toxos Outos* (Santiago de Compostela: Consello da Cultura Galega~Sección do Patrimonio Histórico, 2004), doc. no. 2, pp. 22–3.

Europe. The Story of Diego Gelmírez, met many of these expectations: Gelmírez was a worldly man, a tireless traveler through Europe, whose work turned the Cathedral of Santiago de Compostela into a unique referent of European Romanesque, raising the pilgrimage to Compostela to the heights of Jerusalem and Rome. It was a story that deserved to be told with a selection of the best pieces of the time.

Moreover, the election of venues in Paris and Rome sought to fit in with the character's own epopee. In fact, the first, the current musée des Monuments français, located in the Cité de l'architecture et du patrimoine in Paris, contains a monumental collection of casts of the landmarks of French Romanesque sculpture in the *Galerie des moulages*, some of which have been incorporated into the exhibition discourse – Moissac, Conques, Toulouse and Cluny – as they are intimately related to Gelmírez's travels. Therefore, in this venue, the selection of pieces and sections of the exhibition were reduced with respect to Rome and Santiago, in such a way that the first two were eliminated as they were considered more local – "Iria, the land of his parents" and "Galicia trembles under Diego Peláez" – as well as the one referring to France – "Gelmírez, the French roads and Cluny" – since these comments made on purpose, on site, in the gallery of casts, as a prelude to the exhibition, supplemented it a hundredfold. In any case, the Paris venue is in the eyes of the Compostela epopee a major milestone, as Gelmírez's memory now rides over one of the sanctuaries of French culture, whose origin lies in the Musée de Sculpture Comparée (1882), projected and conceived by the famous architect-restorer Eugène Viollet-le-Duc. Whoever said, recalling the fourth – "Pseudo-Turpin" with Charlemagne's deeds and his peers in Spain – and fifth – the "Guide" attributed to Aymeric Picaud of Parthenay – books, that Compostela is a French "invention," will find something to rejoice over in the exhibition, as Santiago and Gelmírez's Road are incorporated in perfect dialog in the great hall of Gallic Romanesque monuments.

The musée des Monuments français
Cité de l'architecture et du patrimoine au Palais de Chaillot, Paris

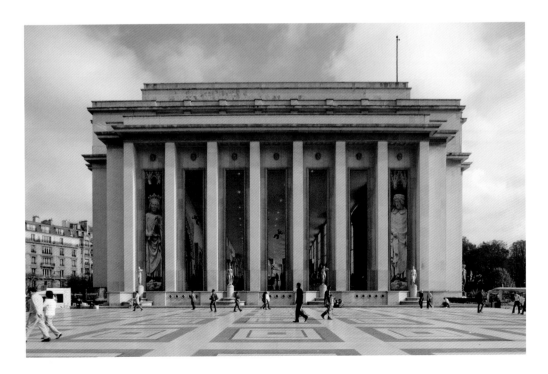

Braccio di Carlo Magno
Saint Peter's Square, Vatican City

With regards to Rome, the first venue in which the exhibition will be shown in its full extent of sections and pieces, the place could not be more appropriate: the so-called Braccio di Carlo Magno, an exhibition space located in the privileged left "arm" of Saint Peter's Square in the Vatican. Gelmírez and his history, making the pilgrimage to Rome twice to obtain papal privileges and dignities, become more explicit than ever, in a context that was not at all alien to him. In fact, a few meters from the place where the pieces are exhibited, the young Galician, prostrate on the ground and in front of the old pergola of Saint Peter, received the order of subdeacon in 1100, which enabled him to undertake his brilliant ecclesiastical career. Finally, the venue in Compostela – the Monastery of San Martiño Pinario – close to the bustle of the Jacobean pilgrims who, going down the *Rúa da Acibechería*, at the end of the French Road, entered through the north door of the cathedral, is full of echoes of Gelmírez.

Nine sections make up the route of the exhibition. In the first two, "Iria, the land of his parents" and "Galicia trembles under Diego Peláez," the early years of the character are discussed, either through a reconstruction of the West Tower (Catoira, Pontevedra), a bastion ruled by his father in his childhood years, or by copying the founding capitals of the chapel of The Savior (Cat. 1, 2), witness to the beginnings of the great cathedral he then would to a great extent complete. In the third section, "A brilliant career: from Galicia to Rome" Gelmírez's journeys around Europe are explained in an audiovisual, opening the way to four fundamental sections: "Santiago and the adventure of the Pilgrims' Road: Gelmírez, the French roads and Cluny," "Gelmírez in Italy" and "Gelmírez in Portugal." Through the selection of a number of extraordinary pieces, the privileged dialog that Compostela established with the major creative European centers at the beginning of the twelfth century is told. Together with items from Pamplona, Jaca, Toulouse, Conques, Altopascio and Modena there are a few

landmarks such as the *Liber Miraculorum Sanctae Fidis* of Sélestat (Cat. 13), which contains two hymns dedicated to the Apostle James, the Solomonic columns from Trinità dei Monti and San Carlo a Cave (Cat. 19, 20), shown for the first time in an event of this type, and the *Polycarpus*, a collection of canons of the Roman church dedicated to Gelmírez, and correspondence which he held in connection with the donation of a relic of Saint James to the Cathedral of Pistoia (Cat. 22, 23). In the eighth section, "The Golden Age of the Cathedral of Santiago," the result of this long pilgrimage through the three-dimensional reconstruction of monuments now lost like the *Porta Francigena* or the Main Altar is shown in Compostela, together with a further series of pieces. Finally, the last section, "The written memory of a genius," pays tribute to the character's willingness to remain beyond his time, either in the *Historia Compostellana* or the collection of texts in the *Codex Calixtinus* (Cat. 29, 30), or through his contemporary fortune, from Manuel Murguía to Richard A. Fletcher.

The decision to publish a book with scientific studies and a reasoned catalog was from the outset one of the main objectives of the project. The idea was for the book to be a monograph of a crucial period for the definitive growth of Compostela and the Jacobean pilgrimage. This is why a triple structure was conceived, in which an extensive reference essay about Diego Gelmírez's role as promoter of arts is combined with a series of complementary texts on different aspects related to the conformation of Santiago, its cathedral and the Pilgrims' Road related to Compostela and Europe and, finally, a catalog of the exhibition pieces on show at the three venues.

The introductory study on Diego Gelmírez's "artistic biography" takes up the idea of transforming Compostela from a periphery town to a center of Romanesque art through the evolution of the cathedral from 1075 to 1140. It focuses firstly on Gelmírez's pre-episcopacy phase, i.e. the beginnings of the cathedral under Diego Peláez (1075–1088) and its building under Master Esteban (1093/94–1101). Secondly, the definitive implementation, starting in 1100, of Gelmírez's program, visible in the symbolic and liturgical function of the monument, in the birth of the large decorated doorways, in the embellishment of the main altar with its wealth of Roman connotations, and the possible painted decoration of the building thanks to the recent pictorial findings in San Martiño de Mondoñedo. All this is done from a novel point of view, in which the perspective of the consequences of the prelate's journeys – Toulouse, Conques, Rome – takes pride of place, with the training of his stonemasons, sculptors and goldsmiths, the doubts and *pentimenti* in the implementation of some of his projects – *Platerías* –, the ideological weight of his adhesion to the Gregorian reform in its figurative programs, as well as the attempted emulation of Rome and Jerusalem as a major place of pilgrimage.

Many of these aspects are extended and complemented by a pleiad of scholars and renowned specialists. In the section related to Compostela, John Williams then masterfully analyzes the problem of defining the types of pilgrimage churches, the importance of the basilica as a *martyrium* and the cultic importance

of creating a *confessio*. Klaus Herbers and Alison Stones detail in their contributions the wealth of the *Codex Calixtinus* as both a legitimation and propaganda book for the see of Compostela, and as an excellent example of Anglo-Norman links in its artwork, which Stones brings forward to a date near the prelate's death. Meanwhile, Adeline Rucquoi sketches a magnificent panorama of the cosmopolitanism of the episcopal school in Compostela, while José María Díaz Fernández, *Deán* of the cathedral, delights us with the story of the "Pious Robbery", a genuine witness to the importance of the cult of relics in the Middle Ages. From a careful analysis of modern sources, Miguel Taín Guzmán reconstructs the fortune of Gelmírez's liturgical furnishing, providing new information about the fate of the marble table of Gelmírez's altar, reused by Antonio Lopez Ferreiro in the systematization of the crypt altar built in the late nineteenth century. Francisco Singul, meanwhile, raises for the first time the possible origin of the reused shaft in the stone cross of Santa María de Lamas (Boqueixón) from the lost *Porta Francigena*. Finally, Ramón Villares closes the Compostela chapter with a keen vision of Gelmírez's valuation in the *Galician* cultural tradition, in which he was described as a cacique and traitor, but also a visionary Prince of Christendom.

In the section dedicated to Europe a group of specialists analyze the problem of the upsurge of Romanesque art around the year 1100 from the privileged observation towers of their extensive experience in research. Arturo Carlo Quintavalle claims the existence of a genuine program of artistic action by the Gregorian Reform, giving meaning to the cultural unity of Romanesque; Quitterie Cazes presents us with an unavoidable monument for Compostela, Saint-Sernin de Toulouse, from a fresh perspective, in which he highlights the fruitful dialog of the magnificent sculptors of the basilica with Theodosian antiquity; José Luis Senra Gabriel y Galán rewrites the all-powerful influence of Cluny on the Pilgrims' Road, focusing it on the reception of the model of Cluny II and the rise of the massive western monasteries of Dueñas, Nájera and San Zoilo de Carrión, with an interesting reflection on Cluniac echoes in the Cathedral of Compostela; Francisco Prado-Vilar takes us to the world of the mythical image and the *mythopoeic* value of much of the Spanish sculpture from the late eleventh and early twelfth centuries, finding new readings for the decorated columns of the early *Porta Francigena*. Finally, Rosa Vazquez explores the origins of the cult of Saint James in Italy, with Rome and Pistoia as reference points, so closely linked to Gelmírez's deeds.

A result of this kind is the consequence of institutional support, more specifically from the S.A. De Xestión do Plan Xacobeo, part of the Culture and Tourism Council of the Xunta de Galicia, as well as a long-standing effort in teamwork. I am indebted to my closest collaborators, Victoriano Nodar, assistant curator, and Rosa Vázquez, coordinator of the exhibition, who have travelled several times most of the past and present routes of the exibition in search of pieces and precious data. In their company I have experienced and contrasted *in situ* some of the impressions that the monuments had on the retinue from Compostela in the past as they traveled along the roads of Spain, France and Italy

in search of a new status for Compostela, and by extension, for Galicia. Thanks to the recovery of some of these milestones related to Gelmírez and the construction of the cathedral, the S.A. de Xestión do Plan Xacobeo has contributed to the restoration and dissemination of a common European heritage which is now available to everyone, such as the cleaning of the molds of the foundational capitals of the chapel of The Savior in the Museum of the Cathedral of Santiago, the restoration of the columns of San Carlo a Cave (Lazio, Italy), the reproduction in plaster of the relief of Santiago de Altopascio in the Museo Nazionale di Villa Guinigi (Lucca), as well as the digitization of the *Liber Miraculorum Sanctae Fidis* at the Bibliothèque Humaniste de Sélestat and the Compostela epitolary from the Archivio di Stato di Pistoia. Finally, I would like to thank the Scientific Committee of the exhibition as well as the authors of this publication – we are in debt to their absolute dedication and generous wisdom in carrying out this project.

COMPOSTELA a

nd EUROPE

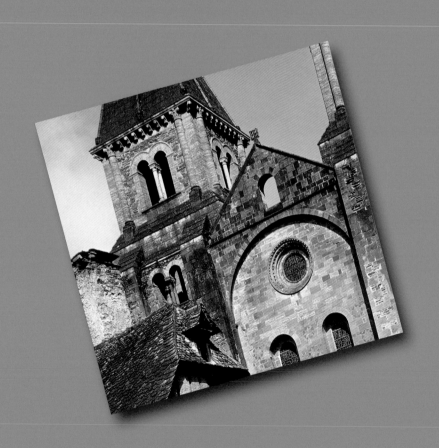

Didacus Gelmirius, Patron of the Arts. Compostela's Long Journey: from the Periphery to the Center of Romanesque Art

The international status of Santiago de Compostela in the twelfth century cannot be understood without reference to the figure of Diego Gelmírez (1070?–1140). His whole career was oriented towards elevating and consolidating the then up-and-coming see of Saint James, which from the ninth century onwards boasted of its possession of the remains of the apostle Saint James the Elder and which had received the unconditional support of the monarchs of Asturias and Leon since their discovery in or around the year 820. After his appointment as Bishop in 110, Gelmírez devoted all his efforts to obtaining metropolitan status for his cathedral, which was achieved in 1120 when the Burgundian Pope Callistus II finally granted him the title of Archbishop.

During his time in power Compostela went from being a place on the periphery, at the *Finis Terrae*, to become a center of reference within the artistic and cultural panorama of Romanesque Europe. Gelmírez wielded great political and ecclesiastical power in Hispanic realms and promoted Santiago Cathedral as the destination of one of Christendom's major pilgrimages like none other before him. Indeed, owing above all to the journeys made by Diego Gelmírez and his retinue of canons throughout Europe in the early years of the twelfth century, in a very short space of time Compostela positioned itself at the forefront of European art, attaining a place as a creative center of Romanesque art in full flower similar to those occupied by the Toulouse of the *Porte Miègeville*, the Conques of Abbot Bégon (1087–1107), Cluny, Modena or the Rome of the Popes.

Nevertheless, in reality this launching of Compostela on the race for Europe benefited from a previous stage that goes a long way to explaining many of the features of Gelmírez's era. I refer here to the episcopate of Diego Peláez (1070–1088), whom Gelmírez's father, the knight Gelmirio, served as *tenente* of the lands of Iria, A Mahía and Postmarcos; for this reason Fernando López Alsina had no reservations in stating that from his earliest days Diego Gelmírez was closely linked to the Church authorities in Compostela and their project for an "apostolic" see. We must remember that during Peláez's rule the diocese of Iria-Compostela underwent two fundamental changes: on the one hand, the introduction of the Roman Rite in the Galician Church (1080), and on the other the commencement in 1075 of the construction of a new Romanesque church in Compostela intended to replace the obsolete pre-Romanesque basilica, built under Alfonso III and consecrated in AD 899. To this end Peláez was able to count on two master builders, Roberto

and Bernard the Elder, who probably came from France. They designed an ambitious building, whose typology, analyzed in John Williams' article, belonged to the so-called "group of pilgrimage churches," characterized by the spacious dimensions of their ambulatory, radial chapels and transept, which favored the circulation of pilgrims and worship of relics. Other churches in this group are those of Sainte-Foy de Conques (the initial model for Santiago), Saint-Sernin de Toulouse, Saint-Martin de Tours and Saint-Martial de Limoges, all located along the French routes to Santiago described in the "Guide" of the *Codex Calixtinus*.

The precedents: Diego Peláez, from angelical promoter to impertinent exiled

Diego Peláez's apse (1075–1088): commemoration and myth, two
constant features of the Cathedral at Compostela

The majority of authors coincide in fixing 1075 as the year when work commenced on the new basilica. Three items of news would appear to provide irrefutable proof of this, the first being the holding in that same year of a *concilio magno* in Compostela on the return of Alfonso VI's expedition to Granada, during which the latter handed over part of the treasure he had obtained to finance the new architectural undertaking.[1] The second came in the form of what has become known as the *Concordia de Antealtares*, between Diego Peláez (Bishop of Santiago) and Saint Fagildo (Abbot of the Monastery of Antealtares), in which it is mentioned that in 1077, the year in which this agreement was drawn up, the three central chapels of the ambulatory were already under construction.[2] Finally, the third item, much more conclusive than the other two, is given both in the form of an epigraph and by the decoration of the interior of the chapel of The Savior. Indeed, on the right-hand wall of this chapel there is a mutilated inscription, published by Ángel del Castillo,[3] celebrating the laying of the foundations of the church in 1075, thirty years before the consecration of the altar in 1105: "ANNO [MILENO?] [SE]PTVAGENO QUI[N]TO [FUN]DATA IACOBI."[4]

In 1075 Diego Peláez was bishop of Iria, and it was during his prelacy that the first stage of construction work was undertaken, until he was deposed by the reigning monarch at the Council of Husillos in 1088. During this stage, which lasted from 1075 to 1088, only the three central chapels of the ambulatory and their immediate neighboring walls were built, although the latter were left incomplete and were only

1 S. Moralejo, "Santiago de Compostela: origini di un cantiere romanico," in R. Cassanelli (ed.), *Cantieri medievali* (Milan: Jaca Book, 1995), pp. 127–43.

2 J. Carro García, "La escritura de concordia entre Don Diego Peláez, Obispo de Santiago, y San Fagildo, abad del monasterio de Antealtares," *Cuadernos de Estudios Gallegos*, 12 (Santiago de Compostela: 1949), pp. 111–22.

3 A. del Castillo, "Inscripciones inéditas de la Catedral de Santiago," *Boletín de la Real Academia Gallega*, 15 (A Coruña: 1926), pp. 314–20.

4 For a full reading of the inscription, see M. Gómez Moreno, *El arte románico español. Esquema de un libro* (Madrid: Centro de Estudios Históricos, 1934), p. 113.

Topography showing the start of work on the chevet of Santiago de Compostela Cathedral, 1075–1088 [*hypothetical reconstruction*] *Victoriano Nodar*

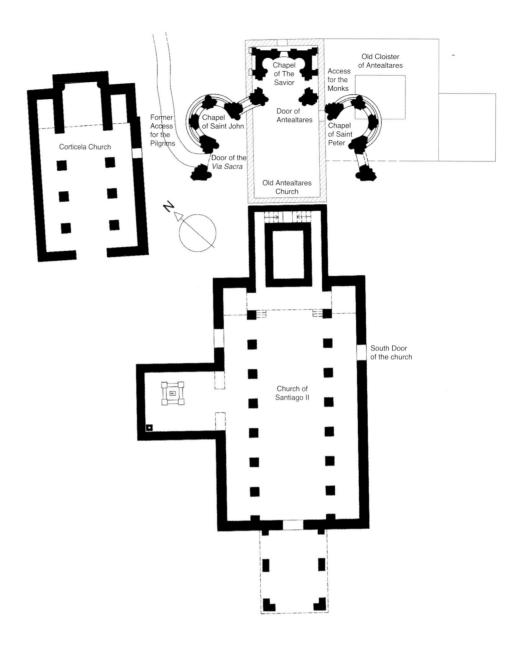

finished during the second stage, as can be deduced from some of their interior and exterior decorative elements,[5] where we can find, more specifically on the interior capitals of the windows of the chapel of The Savior, a typology of baskets and ornamental motifs in the artistic style developed in Jaca and its subsequent derivations. Further elements that would also refer to the foundational year of 1075 are the two commemorative capitals located at the entrance to the aforementioned chapel, bearing the effigies of its promoters, Alfonso VI and Bishop Diego Peláez, each accompanied by angels and cartouches bearing the respective epigraphs "REGNANTE PRINCIPE ADEFONSO CONSTRVCTVM OPUS [This work was built with Prince Alfonso on the throne]" and "TEMPORE PRESULIS DIDACI INCEPTVM HOC OPUS FVIT [This work was begun during the times of the prelate Diego]."

The trans-Pyrenean origins of the builders who took charge of this first campaign, and therefore by extension of the initial project for the building, would appear to be undisputed. Serafín Moralejo has stated the case for the participation of an *auvergnat* sculptor in the production of some of the capitals, such as the one with

5 S. Moralejo, "Notas para una revisión crítica de la obra de K. J. Conant," in J. K. Conant, *Arquitectura románica de la Catedral de Santiago de Compostela* (Santiago de Compostela: COAG~Colegio Oficial de Arquitectos de Galicia, 1983), p. 221–36. V. Nodar, *Los inicios de la catedral románica de Santiago: el ambicioso programa iconográfico de Diego Peláez* (Santiago de Compostela: Xunta de Galicia, 2004).

two gryphons framing a chalice, a common theme in the churches of the Auvergne in and about 1170, such as those at Volvic or Ennezat.[6] This privileged relationship with the French region of the Massif Central region, crossed by the *via podiensis*, would however probably have come about through the then mighty Abbey of Sainte-Foy de Conques (Aveyron), which not only shares very similar figurative repertories but also gave us the first architectural model of what became known as a "pilgrimage church," adopted in the same decade of the 1070s in both Toulouse and Compostela. For this reason I believe in the continued validity of Kenneth John Conant's affirmation that the names of the master masons who according to the *Codex Calixtinus*[7] commenced the construction of the Cathedral at Compostela, Bernard the Elder and Robert ("*dominus Bernardus senex mirabilis et Robertus*"), suggest a Gallic origin.[8]

In this regard, I stand by the old theory of the fundamental role played by the Abbey at Conques as a center of creation of its time, and in particular the peculiar influence (and fascination) it exercised on the mason's workshops in Compostela between 1075 and 1103. In corroboration of this theory, Victoriano Nodar[9] has recently pointed out that the name of one of the architects working at Compostela, Bernard, coincides with that of one of the masters who built the transept of Sainte-Foy de Conques, working during the time of Abbot Stephen in the 1070s. Indeed, he had even carved his name – "BERNARDUS ME FE[CIT]" – on a capital decorated with an angel carrying a phylactery, a typology very similar to that repeated several years on the two capitals from the earliest stage of construction in the chapel of The Savior. Whether or not this is mere coincidence, it must be recognized that it was precisely this type of composition, present in Conques and Compostela (two angels with widespread wings carrying their respective phylacteries), that had become a veritable seal or trademark of the dissemination of the style of the workshop that worked on the transept of the French abbey, as is shown by the presence of this subject in the gallery of the *clocher-porche* of the Church of Saint-Pierre de Besséjouls (Aveyron).[10] Nevertheless, John Williams, in an attempt to arbitrarily invert the order of the *Calixtinus*, states that Bernard the Elder and Robert were in fact Diego Gelmírez's architects, not those of Diego Peláez, attributing to the latter, on the other hand, the figure of Stephen,[11] whose activity is in fact well documented in Pamplona after his arrival there from Compostela in 1101, as we shall see below.

As Nodar has indicated, Peláez's project was also notable for its carefully thought out iconographic program, which can even be given an iconological reading, expressed through the series of figured capitals that constitute the decoration of the three chapels, their theme being suited to the use and ownership of each one. According to this alleged functional topography, the key to which is provided by the text of the *Concordia de Antealtares*, whereas building work was in progress the Bishop enjoyed ownership of the chapel of The Savior, where it can be no accident that we find a veritable *speculum principis*, whilst in the adjacent chapels, those of Saint John and Saint Peter (the former provisionally allocated to the Bishop and the latter being for the exclusive use of the old-established monastic community of Antealtares), we find a *speculum monachorum*.[12] However, once construction was completed, all three chapels became the property of the Monastery of Antealtares.

Capital *[Saint Michael's Gallery]*
c. 1070
Saint-Pierre de Besséjouls, Aveyron

6 "Notas para una revisión crítica de la obra de K. J. Conant"... op. cit.
7 *Liber Sancti Iacobi Codex Calixtinus*, trans. A. Moralejo, C. Torres and J. Feo (Santiago de Compostela: Instituto Padre Sarmiento de Estudios Gallegos, 1951; reed. fac. Santiago de Compostela: CSIC~Centro Superior de Investigaciones Científicas, 1999), V, 9.
8 K. J. Conant, *The Early Architectural History of the Cathedral of Santiago de Compostela* (Cambridge: Harvard University Press, 1926).
9 *Los inicios de la catedral románica de Santiago: el ambicioso programa iconográfico de Diego Peláez*... op. cit.
10 The capital can be found in the so-called chapel of Saint Michael Archangel. P. Gerson and A. Shaver-Crandell, *The Pilgrim's Guide to Santiago de Compostela. A Gazetteer* (London: Harvey Miller, 1995), p. 133.
11 J. Williams, "La arquitectura del Camino de Santiago," *Compostellanum*, vol. 29, 3–4 (Santiago de Compostela: 1984), pp. 267–90. Id., "¿Arquitectura del Camino del Santiago?," *Quintana*, 7 (Santiago de Compostela: 2008), pp. 157–77.
12 V. Nodar, "Obispo, Rey y monasterio, una nueva lectura del programa de la cabecera de la Catedral de Santiago de Compostela," in A. C. Quintavalle (ed.), *Il Medioevo. La Chiesa e il Palazzo. Atti del Convengo internazionale di studi di Parma* (Milan: Electa, 2007), pp. 484–90.

Capital [*Chapels of Saint John and The Savior*]
1075–1088
Cathedral of Santiago de Compostela

Capital [*Chapel of The Savior*]
1075–1088
Cathedral of Santiago de Compostela

13 Id., "Sus cabelleras brillaban como plumas de pavo real: los guerreros de Alejandro y las sirenas en un capitel de la Catedral de Santiago de Compostela," *Troianalexandrina*, 5 (Santiago de Compostela: 2005), pp. 29–61.

14 Id., "Alejandro, Alfonso VI y Diego Peláez: una nueva lectura del programa iconográfico de la Capilla del Salvador de la Catedral de Santiago," *Compostellanum*, vol. 45, 3–4 (Santiago de Compostela: 2000), pp. 617–48. Id., "De la Tierra Madre a la Lujuria, a propósito de un capitel de la girola de la Catedral de Santiago," *Semata. Profano y pagano en el arte gallego*, 14 (Santiago de Compostela: 2003), pp. 335–47.

15 M. J. Lacarra Ducay, *Pedro Alfonso* (Saragossa: Gobierno de Aragón, 1991), pp. 9–12.

16 F. Prado-Vilar, "*Saevum Fascinum*. Estilo, genealogía y sacrificio en el arte románico español," *Goya*, 324 (Madrid: 2008), pp. 173–99. For a discussion of the date of Frómista and whether or not it was earlier than Jaca, see M. Castiñeiras, "Verso Santiago?: la scultura romanica da Jaca a Compostela," in A. C. Quintavalle

In the first case, in the chapel of The Savior, we find an ambitious and clearly expressed program in which the patron, Diego Peláez, a strict follower of the principles of the Gregorian Reform, makes use of commemorative and mythological images to express a mythopeic image appropriate for a true magnate of the time. In it he warns the monarch of the dangers of pride and arrogance through a series of capitals that accompany those celebrating the founding of the cathedral, in which the story of Alexander is referred to by means of two themes: Alexander's ascent to heaven with the help of two birds, inspired by the oldest versions of the *Pseudo-Callisthenes*, and the seduction of the soldiers of Alexander's army by the "women of the waters" (the Sirens), according to the *Epistula Alexandri Magni ad Aristotelem*.[13] The counterpoint to this illustrated program is to be found in the side chapels and adjoining areas, through which the Benedictine monks of Antealtares, responsible for worship at the Altar of the Apostle, circulated. Here use is made of the more direct and incisive language of moral fables, such as the Punishment of Lust, the Horn Blower, the Fable of the Fox and the Crow or a varied bestiary,[14] all extremely suitable for criticizing vices and which were skilfully used in the *Disciplina Clericales* of Pedro Alfonso, a converted Jew from Huesca (c. 1070–1142), who worked in Aragon in the service of Alfonso I the Battler (1104–1134) and Henry I of England.[15] Furthermore, this entire universe of images in the side chapels of Saint John and Saint Peter and their adjoining walls is characteristic of the then incipient historiated cloisters, such as that of Saint Pierre de Moissac (1085–1100). It would therefore appear that in Compostela this imagery was perfectly suited to the particular idea of the apse as a passageway between the monastery and the Apostle's tomb.

I would like to highlight the value acquired by history, myth and fable in the structuring of this iconographic program of the central chapels in the ambulatory of the Cathedral in Compostela. Indeed, Francisco Prado-Vilar has recently proposed a suggestive reading of the relationships between history and myth in the interior

Messengers of William the Conqueror (1027–1087), King of Normandy, reporting that Harold, having come from the court of Edward the Confessor, England, has been taken prisoner by Count Guy de Ponthieu [Bayeux Tapestry, *detail*]
1077
Musée de la Tapisserie, Bayeux

William the Conqueror (1027–1087), Duke of Normandy, knights Harold, who swears an oath of allegiance to the relics [Bayeux Tapestry, *detail*]
1077
Musée de la Tapisserie, Bayeux

decoration of the famous Church of San Martín de Frómista in the province of Palencia, which in his opinion should be dated to between 1088 and 1090.[16] In the case that interests us in Compostela we are moving in a somewhat earlier time frame (1075–1088) in which myth and fable are also used to metaphorically narrate or comment on historical events, although in Santiago the common thread would appear to be the emulation of genres from the realm of literature as such, for example history (the capitals commemorating the King and the Bishop, or the allusion to episodes from the life of Alexander the Great) or the newly emerging epics of the *Chanson de Geste*, visible in the presence of animals that define the virtues and vices of their heroes and villains. It is no mere chance that in another contemporary work, albeit

(ed.), *Medioevo, l'Europa delle Cattedrali* (Parma: Electa, 2007), pp. 387–96. Id., "Tre miti sull'originalità del romanico ispanico: Catalogna, il Cammino di Santiago e la multiculturalità," in A. C. Quintavalle (ed.), *Medioevo: arte e storia* (Parma: Electa, 2008), pp. 86–107. J. L. Senra Gabriel y Galan, "Architecture et décor dans le contexte de la colonisation clunisienne des royaumes septentrionaux de la péninsule ibérique," in *Haut lieux romans dans le sud de l'Europe (XIᵉ-XIIᵉ siècles). Moissac, Saint-Jacques-De-Compostelle, Modène, Bari* (Cahors: La Louve, 2008), pp. 11–70.

Bréviaire de Montiéramey
[Ms lat. 796, fol. 235v]
c. 1150
BnF~Bibliothèque nationale
de France, Paris

17 C. R. Dodwell, *Artes pictóricas en Occidente, 800–1200* (Madrid: Ediciones Cátedra, 1995), pp. 36–41. Id., "The Bayeux Tapestry and the French Secular Epic," in R. Gameson (ed.), *The Study of the Bayeux Tapestry* (Rochester: Boydell Press, 1997), pp. 47–62.

18 F. R. Cordero Carrete, "Los esponsales de una hija de Guillermo el Conquistador con un 'Rey de Galicia,'" *Cuaderno de Estudios Gallegos*, 21 (Santiago de Compostela: 1952), pp. 57–8.

19 Ibidem, pp. 66–70.

20 This hypothesis, which I first put forward in Bari in 2002, has been partially published in "La meta del Camino: la Catedral de Santiago de Compostela en tiempos de Diego Gelmírez," in M. C. Lacarra Ducay (ed.), *Los caminos de Santiago. Arte, historia, literatura* (Saragossa: Institución Fernando el Católico, 2005), pp. 220–1, and in full as "Monks, Pilgrims, Bishops and Glory: the Topography of the Images in the Cathedral of Saint James," in J. D'Emilio (ed.), *Culture and Society in Medieval Galicia: a Cultural Crossroads at the Edge of Europe* (Leiden: Brill, 2010).

21 B. Respsher, *The Rite of Church Dedication in the Early Medieval Era* (New York: Edwin Mellen Press, 1998), pp. 53, 73, 74.

22 BnF~Bibliothèque nationale de France: *Bréviaire de Montiéramey* [Ms Lat 796], fol. 235v. On the manuscript, see W. Cahn, *Romanesque Manuscripts. The Twelfth Century* (London: Harvey Miller, 1996), vol. 1:2, fig. 173; vol. 2:2, pp. 90–91, cat. 73.

one that is very different in form and technique, namely the scroll of cloth commonly known as the *Bayeux Tapestry*, we can see the creation, between 1066 and 1082, of a program devoted to narrating a historical event, equally full of solemn ceremonies such as the oath sworn by Harold on the relics of Bayeux Cathedral before William, Duke of Normandy and future King of England, whilst fables are used in its borders to comment on the moral qualities of the characters depicted.[17]

This reference to the contemporary Anglo-Norman work is by no means gratuitous, since we should not forget that the biographer of William I himself, William of Poitiers (c. 1020–c. 1090) wrote in his *Gesta Guillelmi, duce Normannorum et regis angliae*, that two brothers, kings of Spain, vied for the hand of one of the former's daughters in marriage. The record would appear to be completed by Orderico Vital (1075–c. 1142), who in his *Historia Eclesiástica* talks of Águeda (Agatha), initially betrothed to Harold and then to the "*Rey de Galicia.*"[18] Although some sources identify this monarch with "Alfonso" (Alfonso VI), this attribution would not seem very likely. As Felipe Cordero Carrete has pointed out, the facts probably refer to the period in and around 1066, so the person in question would therefore be García II, brother to Alfonso VI and King of Galicia from 1065 to 1072.[19] Nor should we forget that according to Robert Wace (*Roman de Rou*), at the Battle of Hastings (1066) William the Conqueror rode into battle on the horse that the Norman Galtier Giffart had brought him from Spain on his return from a pilgrimage to Santiago. Thus, when the *Historia Compostellana* states that the reason why Diego Peláez was deposed in 1088 was because he had attempted to hand over the Kingdom of Galicia to the "rey de los ingleses y normandos" we cannot but think that circle surrounding King García, to which Diego Peláez and other Galician magnates belonged, enjoyed a fluid relationship with the Normans throughout this long period (1065–1088), and would therefore have had access to an emerging figurative culture that may well be the explanation for the original composition of the iconographic program of the three chapels in the apse of Santiago Cathedral, as Victoriano Nodar has indicated in such a masterly manner.

Leaving speculation aside, and returning to the indisputable historical facts, we should once again stop to consider the peculiar and extraordinary iconography of the earliest capitals. Each of the patrons, Diego Peláez and Alfonso VI, is flanked on either side by an angel to indicate that these personages, commemorated here, share in the glory of the Heavenly Jerusalem. Both scenes, located in the chapel with which construction of the cathedral commenced and where the first stone was laid, appear to allude to the liturgical formulae of the rite of dedication.[20] In fact, during the *dedicatio ecclessiae* a series of passages from the Bible were read that referred to the dedication of the Temple of Jerusalem by Solomon and to the Heavenly Jerusalem of the Apocalypse.[21] These texts, as in the case of the mid-twelfth century Burgundian breviary from Montiéramey,[22] were on occasions illustrated with the anachronistic figuration of the above-mentioned Biblical King and a Bishop, accompanied by the vision of Christ Pantocrator surrounded by a retinue of angels. This group was at times reduced to the motif of winged angels' heads (*angelots cravatés d'ailes*), as in an archivolt that was reused in the sacristy of Monopoli Cathedral in Apulia (1107–1117), where twelve of these heavenly faces on clouds

accompany an inscription bearing the name of the patrons: Bishop Romuald and the Norman Robert of Hauteville, third son of Robert Guiscard. This is a work whose style and iconography have led Arthur Kingsley Porter and Maria Stella Calò to relate it to the art of the Route of Pilgrimage; more specifically, the comparison with Conques is yet again the most eloquent, since its retinue of angels is very similar to that on the left-hand capital of the *enfeu* of Abbot Bégon III of Conques, who died in 1107.[23]

Thus both in Monopoli and Conques we come across the above-mentioned formula of the winged host announcing the glory of the person to whom homage is being paid, and which in the case of the Apulian cathedral, as in that of the chapel of The Savior, is accompanied by the rites of the dedication, or rather "foundation," of the building. This would explain the continuous appearance of the motif of winged angels' heads in the decoration of the chancels of some churches related to the art of the Way, such as a capital in the upper church at Loarre (c. 1094–1096),[24] where there is a decorated cyma moulding of a capital on the right-hand side of the apse, also in possible reference to the consecration of the building work done. It is no mere coincidence, as Antonio García Omedes has recently pointed out to me, that the existence of a capital in the same chancel depicting a host of angels accompanied by the figure of a bishop in the act of consecration could indeed be a reference, as it is in Santiago, to an event of some importance, perhaps the solemn consecration that can be inferred, as Marta Poza Yagüe suggests, from the presence in Loarre, in April 1094, of Sancho Ramírez, King of Aragon and Navarre, accompanied by Frotard, Abbot of Saint-Pons de Thomières; Aymerich, Abbot of San Juan de la Peña; Peter, Bishop of Pamplona; and Peter, Bishop of Jaca.[25]

Nevertheless, what is most striking about the stonework at Compostela is the genuine desire to narrate the history of the cathedral's construction, which at times becomes a veritable exercise in "self-citation," enabling us to witness the written record of its foundation, the dedication of its altar or the construction of its various fronts. This genre characterizes the major masons' workshops in Western Europe in the late eleventh century, the case of Compostela having a suggestive parallel with that of Modena, since at both sites the intention was to "renew, rebuild and raise" a new temple on an existing one that was now considered to be obsolete. Thus, in *Relatio de innovatione ecclesie sancti Geminiani mutinensis presulis*,[26] we can read how, faced with the ruinous condition of the old building, the decision was taken to renovate it with the support of the lay authorities, in this case Matilda of Tuscany, and the hiring of an admirable architect, the master builder Lanfranco. To this end excavation of the new foundations for the building commenced on 29 May 1099, the first stone being solemnly laid on 9 June of the same year. A few years later, in 1106, it was possible to undertake the *traslatio* of the relics, in the presence of Countess Matilda and Bishop Dodone, the altar being consecrated by none other than Pope Paschal II himself.[27]

Although it is true to say that in the case of Santiago we do not have such detailed information about the different rites pertaining to the foundation of the cathedral, it is no less true that it is equally possible to reconstruct the history of its construction through the epigraphs and the written testimonies contained in the *Codex Calixtinus* and the *Historia Compostellana*. The first action would have been

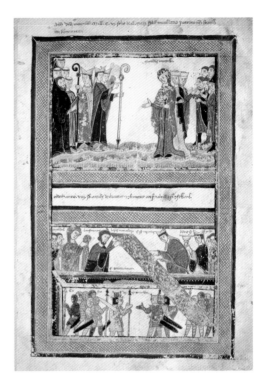

Matilda of Tuscany before the Bishop of Modena. Matilda of Tuscany attends the exhumation of Saint Geminianus [Relatio de innovatione ecclesie sancti Geminiani mutinensis presulis, O. II. 11, fol. 9r] eighth century Archivio Capitolare del Duomo di Modena, Modena

23 M. S. Calò Mariani, "Considerazioni sulla cultura artistica nel territorio sud-est di Bari tra XI e XV secolo," in V. L'Abbate (ed.), *Società, cultura, economia nella Puglia medievale* (Bari: Dedalo, 1983), pp. 392–6, fig. 6.

24 A. K. Porter, *Romanesque Sculpture of the Pilgrimage Roads*, 1:2 (Barcelona and Florence: Gustavo Gili and Pantheon, 1928), p. 84. M. Durliat, *La sculpture romane de la route de Saint-Jacques. De Conques à Compostelle* (Mont-de-Marsan: Comité d'études sur l'histoire et l'art de la Gascogne, 1990), p. 276, fig. 271.

25 M. Poza Yagüe, "Fortaleza militar y refugio de fe: proceso constructivo y relaciones estilísticas del conjunto de Loarre," in *Siete Maravillas del Románico Español, Aguilar de Campoo* (Palencia: Fundación Santa María la Real, 2009), pp. 53–81, esp. p. 72.

26 Archivio Capitolare del Duomo di Modena: *Relatio de innovatione ecclesie sancti Geminiani mutinensis presulis* [O. II. 11] (C. 13).

27 For an analysis of the *Relatio*, see A. C. Quintavalle, *Willigelmo e Matilde. L'officina romanica* (Milan: Electa, 1991), pp. 48–9.

Capital [*Apse of the High Church*]
c. 1094–1096
Loarre Castle, Huesca

Capital [*Chancel of the High Church*]
c. 1094–1096
Loarre Castle, Huesca

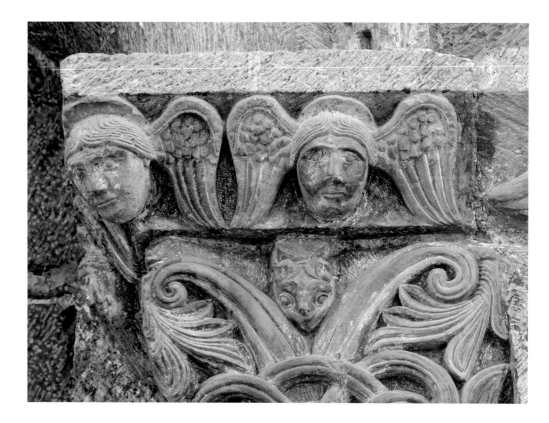

to demolish the old Antealtares Church and dig out the foundations of the new building, to whose first stone the ceremony of the commemorative capitals in the chapel of The Savior would refer. This very probably all took place in 1075, the date being confirmed by the inscription in the chapel of The Savior celebrating its consecration, thirty years after its foundation in 1075. Nevertheless, this date has often been called into question by the contradictory references in both the *Historia Compostellana* and the *Codex Calixtinus* to the beginning of work on the cathedral in 1078 (!). The explanation for this confusion lies in the French origin of the authors of both texts, who misread the inscription on the ingoing jambs on the right-hand side of the *Platerías* Door, and being unaware of the Hispanic paleographic custom of joining together the group XL, simply saw XV in the date. For Gómez Moreno, Bouza Brey, Moralejo and López Alsina the correct reading of this inscription is "ERA ICXLI / V IDVS I[V]LII [11 July 1103]" on the left-hand jamb, and "M[AGISTER] Q[VI] F[ECIT] O[PVS] [the master who did the work]" on the right-hand jamb.[28] We must therefore reject the reading "ERA ICXVI / IDVS I[V]LII [11 July 1078]," copied by the author of Chapter 78 of the *Historia Compostellana*, Master Gerald of Beauvais, as well as the even more contradictory reference given by another Frenchman, Aymeric Picaud, author of the "Guide" in the *Calixtinus* in or around 1137, who says that "*la iglesia se comenzó en la era MCXVI* [year 1078],"[29] in all probability echoing the previous reading made by Gerald. However, and from the same source, he then goes on to state, with no embarrassment whatsoever, that "*desde el año en que se comenzó hasta la muerte de Alfonso, famoso y muy esforzado rey aragonés, se cuentan cincuenta y nueve años*" (!):[30] Alfonso the Battler died in 1134, and thus the year in which construction commenced is being taken as 1075. Although James D'Emilio recently tried to defend the year 1078 for the *Platerías* inscription,[31] his arguments are unconvincing, since, as Bouza Brey pointed out in his day, the small "A" that appears over the XL group only makes sense if it is read as "*quadragesima*." Be that as it may, as we shall see below, this inscription in the *Platerías* Door speaks to us of a different moment in the construction of the cathedral, namely the work done on the transept, and not the commencement of the apse.

Between Jaca and Conques: the Cathedral of Master Stephen (1093/94–1101) and Diego Peláez's long exile in Aragon

In order to understand the new phase entered into by the cathedral after Diego Peláez's deposition and departure in 1088 we have to forget many of the ideas that historiography has insistently attempted to impose on us and try to remember others that have remained partially hidden or neglected. I refer to the opinion that Diego Gelmírez, future Bishop of Compostela from 1100 onwards, played a major role in the construction of the cathedral before he was elected Prelate.[32] The *Calixtinus* tells us that it was Don Segeredo, treasurer and prior of the Canóniga,[33] and the Abbot Don Gundesindo who were responsible from the outset for the administration of building work in Santiago. In all probability they continued to hold this responsibility after Peláez's dismissal, and as far as we know there is no mention of the name of any other treasurers until 1107, when those of the canons Munio Alfonso and Munio Gelmírez appear.[34] On the other hand, Diego Gelmírez was administrator of the manor of

28 *El arte románico español. Esquema de un libro...* op. cit., p. 115. F. Bouza Brey, "El epígrafe fundacional de la iglesia de Tomonde y el de la Puerta de las Platerías de la Catedral de Santiago," *Cuadernos de Estudios Gallegos*, 1 (Santiago de Compostela: 1944), p. 177. S. Moralejo, "¿Raimundo de Borgoña (†1107) o Fernando Alfonso (†1214)? Un episodio olvidado del Panteón Real compostelano," in *Galicia en la Edad Media* (Madrid: Sociedad Española de Estudios Medievales, 1992), p. 211. F. López Alsina, "Implantación urbana de la catedral románica de Santiago de Compostela (1070-1150)," in *La meta del Camino de Santiago. La transformación de la catedral a través de los tiempos* (Santiago de Compostela: Xunta de Galicia, 1995), pp. 50–1. Id., *La ciudad de Santiago de Compostela en la alta Edad Media* (Santiago de Compostela: Consorcio de Santiago, 1988), pp. 141, 143, 246–7. M. Castiñeiras, "Un adro para un bispo: modelos e intencións na fachada de Praterías," in A. Vigo Trasancos (ed.), *Cultura, poder y mecenazgo* (Santiago de Compostela: USC~Universidad de Santiago de Compostela, 1998), pp. 231–64. Id., "La catedral románica: tipología arquitectónica y narración visual," in M. Núñez (ed.), *Santiago, la Catedral y la memoria del arte* (Santiago de Compostela: Consorcio de Santiago, 2000), pp. 39–96. Id., "Platerías: función y decoración de un 'lugar sagrado,'" in *Santiago de Compostela: ciudad y peregrino* (Santiago de Compostela: Xunta de Galicia, 2000), pp. 289–331. "Roma e il programma riformatore di Gelmírez nella cattedrale di Santiago," in A. C. Quintavalle (ed.), *Medioevo: immagini e ideologie* (Milan: Electa, 2005), pp. 211–26. Id., "La Catedral de Santiago de Compostela (1075–1122): obra maestra del románico europeo," in *Siete Maravillas del Románico Español, Aguilar de Campoo...* op. cit., pp. 237–9.
29 "Prudencia del obispo," *Historia Compostelana*, trans. E. Falque (Madrid: Akal, 1994), I, 78, p. 189. For the attribution of this capital to Gerald, see *La ciudad de Santiago de Compostela en la alta Edad Media...* op. cit., pp. 64–6.
30 *Liber Sancti Iacobi Codex Calixtinus...* op. cit., V, 9, pp. 570–1.
31 J. D'Emilio, "Inscriptions and the Romanesque Church: Patrons, Prelates, and Craftsmen in Romanesque Galicia," in C. Hourihane (ed.), *Spanish Medieval Art: Recent Studies* (Princeton: Princeton University Press, 2007), pp. 17–8.
32 "¿Arquitectura del Camino del Santiago?"... op. cit., p. 160.
33 I follow the interpretation of the passage from the *Calixtinus* given in *La ciudad de Santiago de Compostela en la alta Edad Media...* op. cit., pp. 37–8, note 26.
34 Ibidem.

Santiago during two different periods (1093–1094 and 1096–1100), but not, as such, of the building work on the cathedral. Furthermore, it should not be forgotten that the deposed and exiled Diego Peláez never ceased to be "present" in some form or other amongst the Church authorities in Santiago, since as well as continuing to call himself Bishop of Compostela until his death, two people appointed by him, and therefore in whom he had absolute trust, namely Segeredo and Gundesindo, continued to run the cathedral building work during those difficult times.

It is highly likely that during the six troublesome years of court cases, struggles and vacuums of power in Compostela after Diego Peláez was deposed (1088–1093) work was suspended and the first workshop dissolved. The arrival from Cluny of Bishop Dalmatius saw the appearance of a new context for the cathedral that undoubtedly facilitated the continuation of the project, since in 1095 the episcopal see of Iria was definitively transferred to Compostela. Although we cannot be sure of the exact whereabouts of the deposed Diego Peláez during those first few years, we do know that until the moment of his death he never abandoned the desire to return to the see of Compostela. The documents indicate that he took refuge in Navarre or Aragon, in the company of other magnates who had taken part in the Lugo revolt in 1087–1088, where he formed a close relationship with King Pedro I (1094–1104). The latter not only welcomed him to his kingdom, but also recognized his title of *episcopus sancti Iacobi*, granting him as such the right to the usufruct of donations made to Santiago Cathedral in the districts of Huesca (1098) and Barbastro (1099) by the monarch himself.

There can also be no doubt that the Bishop may well have maintained close contact with Galicia during his time in exile. First of all, as we have already seen, two men in whom he had absolute trust continued to administer the building of the cathedral. Secondly, during his episcopate he had shown respect for the Benedictine community of Antealtares, allowing them to continue to worship at the apostolic altar and destining one of the chapels built in the apse for the monks. In fact ever since the times of Bishop Sisnandus I the monks of Antealtares had formed part of the cathedral community, known as the *magna congregatio beati Iacobi*, from which they would only be expelled by Gelmírez in 1102 when he created a chapter of seventy-two canons and seven senior canons, causing them to lose their rights over the apostolic altar.[35] Thirdly, Diego Peláez had been made Bishop of Santiago in 1071, at the same time that Gonzalo was appointed Bishop of Mondoñedo. There has been bitter debate about who was responsible for these appointments. Some have considered that they were imposed by the joint rule of the brothers Sancho II of Castile and Alfonso VI of León, following the imprisonment of their other brother, García II of Galicia.[36] However, it has become increasingly clear that both prelates had in fact previously been made bishops by King García of Galicia (1066–1071) himself.[37] Indeed, the complicated careers of both Diego Peláez and Gonzalo of Mondoñedo during the long reign of Alfonso VI would appear to demonstrate this hypothesis and also explain the existence of a certain complicity between the two during the former's years in exile.

To the possible existence of this good relationship with influential persons in Compostela (the administrators of the building work on the cathedral and the

35 F. López Alsina, "De la *magna congregatio* al cabildo de Santiago: reforas del clero catedralicio (810–1110)," in *IX Centenário da Dedicaçao da Sé de Braga*, vol. 1:3 (Braga: Universidade Católica Portuguesa, 1990), pp. 758, 762.

36 R. A. Fletcher [*Saint James's Catapult. The Life and Times of Diego Gelmírez of Santiago de Compostela*, Oxford: Claredon Press, 1984], *A vida e o tempo de Diego Xelmírez* (Vigo: Xerais, 1993), pp. 61–3.

37 E. Portela, *García II de Galicia. El rey y el reino (1065–1090)* (Burgos: Ediciones Trea, 2001), pp. 82–94.

community of Antealtares) and in Mondoñedo (Bishop Gonzalo) we can add a further element, often overlooked. Although Diego Peláez only had time to build three chapels and two doors in the perimeter of the apse, his project covered the design of the whole of the new building, in which many dedications had already been decided. It is indeed more than symptomatic that Saint Faith's chapel, built in a new style in the 1090s, should reveal a first-hand knowledge of the iconographic models of the masons' workshops at Conques, precisely those to which the first workshop at Santiago was linked, as we have already seen. We should therefore consider the possibility that the new masons employed to continue work on the apse followed, under the watchful gaze of Segeredo and Gundesindo, some of the lines of work or decisions taken during Peláez's time, such as the dedication of a chapel to Saint Faith of Conques, with iconographic models taken from the French abbey itself, as had been the custom during the first stage of construction.

It should also be noted that this is the only chapel in the Romanesque apse of the Cathedral at Santiago de Compostela whose dedication is explicitly expressed in images. This custom is documented precisely in Conques Abbey, where the lateral apses of Saint Mary and Saint Peter, on either side of the high altar, were decorated with reliefs alluding to their patron saints. In the case of Compostela, at the entrance to the chapel, in the ambulatory, there are two historiated capitals of a hagiographic nature. On the right-hand capital the characters are easily recognized in the central face: Saint Faith, her head veiled, is seized and led by an assistant to the executioner who is waiting to behead her with his sword. On the other hand, on the left-hand capital the martyr, occupying the central position, is speaking with two male figures, each holding a book, whilst a third holds his hands together in prayer on the shorter right-hand side. This is perhaps an unusual joint representation of the three Martyrs of Agen, Saint Faith, Saint Caprasius and his two brothers, Primus and Felician, all of whom were put to death by Dacian. The third martyr is placed on the shorter left-hand side since, in my opinion, the praying figure on the right would have acted as a visual mediator between the faithful in the church and the saints worshipped there.[38]

It is obvious that the composition in a narrative frieze of the scenes in Compostela was inspired by the famous capital with the theme of the martyrdom of Saint Faith of Agen in the nave of the Church at Conques Abbey, carved in the 1070s. Access to this figurative repertoire undoubtedly came through the masons' workshop in the first building campaign at Santiago, which must have had figurative models of the work at Conques. However, the style of the capitals at Compostela, clearly carved in the manner of Jaca, manifestly reveals that they were done by a different master. This is visible both in the volutes of the corners of the capitals and in the figures, their chubby round faces framed by a cap of hair and the plasticity of the folds in capes and tunics that reveal the shape of their anatomy. The scenes also simplify, with some variations, the iconographic model of the Gallic shrine in which the story of the saint's martyrdom is told.

Both the architecture of the chapel of Saint Faith in the Cathedral at Compostela and its decoration correspond to the period of building work between 1093/94 and 1101, under the direction of the controversial Master Stephen, who

38 See the commentary in M. Castiñeiras, "Los santos viajan: la circulación de objetos y modelos artísticos en el Camino," in P. Caucci (ed.), *Visitandum est... Santos y Cultos en el Codex Calixtinus* (Santiago de Compostela: Xunta de Galicia, 2005), pp. 63–89.

was very probable of French origin but, in my opinion, who came to Compostela after some time spent in the Kingdom of Navarre and Aragon. Until now the only information that had come down to us about the date when work on the cathedral recommenced was either Gelmírez's appointment as administrator of the manor of Santiago in 1093 or the arrival of Bishop Dalmatius in 1095. However, as early as 11 February 1093 one *Guillelmus Seniofredi*, desirous of making the journey to Rome – "*cupiens ire Romam*," – willed that he should be buried in the Church of Santa Maria de Vilabertran (Girona), leaving part of his possessions "*ad opera S. Iacobi de Gallicia.*"[39] The information is somewhat surprising, but it does allow for the possibility that building work recommenced in Santiago before Gelmírez's administration, as I have attempted to suggest above, and we must therefore consider the possibility that the treasurer and administrator of the building program had started to reactivate the mason's workshop in the cathedral as early as 1092.

There can be no doubt that Master Stephen's contribution supposed an innovation in architecture and style in comparison with the work done under Diego Peláez. In fact, as Moralejo has pointed out, Stephen introduced the polygonal model of chapel floor-plan in the chevet, imitated in the chancel of the Romanesque Cathedral at Pamplona, with which we are now familiar thanks to excavation work.[40] It is no mere coincidence that Stephen was the *magister operis sancti Iacobi* who in 1101 was working on the Cathedral at Pamplona, as José María Lacarra has indicated,[41] according to a document by Bishop Pedro of Rodez (1083–1115) and confirmed by Gelmírez himself (11 June 1101). In this record he appears as being married with children, and is granted various houses and vineyards in Pamplona, as well as sufficient resources to build himself a house. I do not think that Stephen returned to Santiago, because 1101 saw the commencement in Compostela of a new and ambitious program of construction in which he had no part: the foundations for the ground floor of Gelmírez's palace on the south side of the Cathedral and the resulting building of the *Platerías* front, which according to the inscription on the left-hand ingoing jamb began in 1103. Stephen would therefore have only been responsible for completing the perimeter walls of the ambulatory, with its polygonal chapels of Saint Faith and Saint Andrew, as well as a large proportion of the transept walls, between 1093–1994 and 1101.

Nevertheless, the possibility that both the dedication and the model for the hagiographic cycle of the chapel of Saint Faith had already been designed during the preceding period is an extremely suggestive one. The cult of the saint from Conques as a freer of captives has in fact been documented from the 1080s in the Kingdom of Navarre and Aragon, its promotion being to a large extent the work of the above-mentioned Bishop of Pamplona, Pedro of Rodez (1083–1115). Of French origin, he was the son of Didon d'Andouque and had been a monk at none other than the Abbey of Sainte-Foy de Conques. Indeed, this prelate not only surrounded himself in the cathedral curia and chapter by persons from the said abbey, but also showed his gratitude to the shrine at Conques through the donation of the tithes, whether monetary or in the form of produce and livestock, of the Navarrese churches of Garinoain (1086), Caparroso, Murillo el Cuende and Bartiaga (1092), where the churches are still dedicated to Saint Faith.[42] Finally, Pedro of Rodez himself took

39 J. M. Marquès, *Escriptures de Santa Maria de Vilabertran (968-1300)* (Figueres: Institut d'Estudis Empordanesos, 1995), p. 82, doc. 199

40 "Santiago de Compostela: origini di un cantiere romanico"... op. cit. C. Fernández-Ladrera, "El Camino de Santiago en Navarra: Pamplona, Sangüesa y Estella," in *Los caminos de Santiago. Arte, historia, literatura...* op. cit., pp. 29–62.

41 M. J. Lacarra, "La Catedral románica de Pamplona. Nuevos documentos," *Archivo Español de Arte y Arqueología*, 7 (Madrid: 1931), pp. 73–86.

42 A. Durán Gudiol, *La Iglesia en Aragón durante los reinados de Sancho Ramírez y Pedro I (1062-1104)* (Rome: Iglesia Nacional Española, 1962), p. 48. J. Goñi Gaztanbide, *Historia de los obispos de Pamplona. Siglos IV–XIII*, 1:10 (Pamplona: UNAV~Universidad de Navarra, 1979) pp. 255–99. A. Ubieto Arteta, *Colección diplomática de Pedro I de Aragón y Navarra* (Saragossa: CSIC~Centro Superior de Investigaciones Científicas, 1951), pp. 302, 342, 376. C. Laliena Corbera, *Pedro I de Aragón y de Navarra (1094–1104)* (Burgos: La Olmeda, 2000), pp. 174, 299, 333–4.

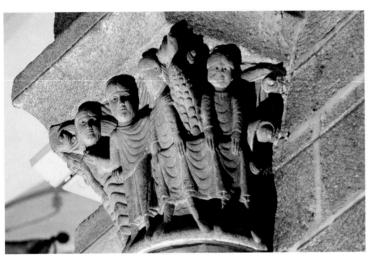

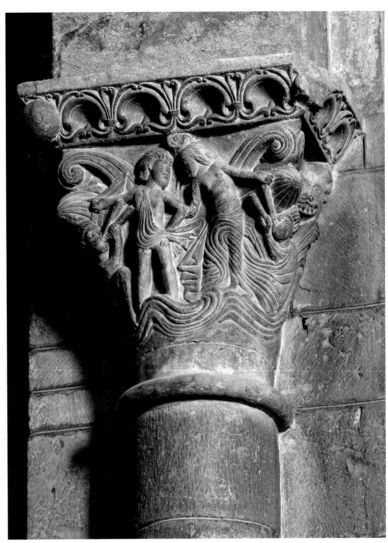

Capital [*Chapel of Saint Faith*]
1094–1101
Cathedral of Santiago de Compostela

Capital [*Southern wing
of the transept*]
1094–1101
Cathedral of Santiago de Compostela

Capital [*Central nave*]
1080–1096
Cathedral of Jaca, Huesca

part in 1105, after beseeching the favor from Diego Gelmírez, in the consecration of the chapel of Saint Faith in Santiago Cathedral on the occasion of the dedication of all the chapels in the ambulatory and transept (except for that of Saint Nicholas):

> "*Y puesto que tenía él [Gelmírez] sus miras puestas indisolublemente en la contemplación de la patria celestial y ardía siempre en la mutua caridad, accedió a los ruegos del obispo Pedro de Pamplona, que se lo pedía, y le autorizó a que consagrase con gran veneración el altar de la Santa Fe.*"[43]

This fact, repeatedly quoted in the historiography, has in my opinion not been sufficiently valued in its full artistic significance. In the first place, the Bishop of Pamplona was given the rare privilege of consecrating a chapel that had been built several years earlier (1093/94–1101) by a master mason who was now working on the construction of his cathedral. Secondly, the altar was dedicated to Saint Faith, to whose shrine the said prelate had made many donations in Navarre from 1086 onwards. Thirdly, the capitals decorating the chapel are the earliest testimony of the introduction of the hagiographic cycle of the saints of Agen outside their original places of worship in France. From the above we can draw the conclusion that the project of the chapel of Saint Faith in Compostela was from the very outset related

43 "Consagración de altares y ofrendas hechas al hospital. De la iglesia del Santo Sepulcro," *Historia Compostelana...* op. cit., I, 19, p. 109. Cf. *Historia de los obispos de Pamplona. Siglos IV–XIII...* op. cit., pp. 281–3. M. C. Lacarra Ducay, "El Arte y los Caminos," in M. A. Magallón (ed.), *Caminos y comunicaciones en Aragón* (Saragossa: Institución Fernando el Católico, 1999), pp. 135–50.

with the privileged milieu of the Bishop of Pamplona. It may even have been "conceived" during Diego Peláez's final years in Santiago, although as a result of the suspension of the cathedral building program its construction would not have recommenced until 1094, with a new team of masons who had come from the Kingdom of Navarre and Aragon.

Indeed, it is no coincidence that both the Jaca style and the cult of the Agen martyrs can be seen in a third capital, moved from its original location, to be found in the first section of the south arm of the transept of Santiago Cathedral. It uses the formula of various persons depicted in an aquatic milieu, and seemingly owes its origins to one of the interior capitals of Jaca Cathedral, in which several figures are engaged in dialog in a scene inspired, according to Moralejo, in a marine *thiasos*.[44] This composition of bodies that are partially submerged in sinuous waves was used in Aragon as a workshop standard on which other themes of obviously sacred content could be based, this being the case of a controversial capital in the Church of Santa María de Iguázel (1072) or the cut-off frieze of the gate of Loarre Castle, done in 1094–1096 by a workshop following the Jaca tradition.[45]

In Santiago the scene is presided over by a central character, richly clothed, who is accompanied by another four, submerged in the waves of the sea, which the artist confuses on the right-hand side with a pleated robe. It should be mentioned that the problems involved in interpreting the scene have produced the most unlikely readings, although in the light of what has been said above the capital could perfectly well be part of the hagiographic cycle of the Agen martyrs. The scene would refer to the story of Caprasius, who, fearful of persecution, took refuge on a rock. On the day of the saint's martyrdom the hermit had a vision in which the former appeared to him wearing the crown of a blessed martyr and richly dressed.[46] Caprasius in his surprise struck the rock with his right hand causing a spring of miraculous water to flow forth. The saint then miraculously appeared before Dacian at Saint Faith's execution and declared his faith, convincing his brothers Primus and Felician to suffer the martyrdom of beheading with him.

This hagiographic version would explain some of the peculiarities of the scene: the richly dressed and crowned central figure is none other than the vision of Saint Faith in glory, the waves represent the spring that gushed forth from Saint Caprasius' rock, and the other characters are the Agen martyrs, brought back to life by the water of salvation. Indeed in the *Passio* of Saint Faith and Saint Caprasius, dated in the tenth century, the hermit explains to Dacian his symbolic regeneration through baptism, in clear allusion to the miracle of the spring:

> "*Lo más importante y destacable de mí es que soy cristiano. Renací cuando fue bautizado por un sacerdote que me confirmó mi nombre: Caprasio.*"[47]

To my understanding, the theme of this capital confirms that a hagiographic cycle for Saint Faith and Saint Caprasius reached Compostela from Conques during the times of Diego Peláez that was intended to serve as a model for the decoration of a chapel that was never built. When work actually began, years later and at the hands of a different workshop, the scene concerning Saint Caprasius was not properly understood, and was

44 S. Moralejo, "La sculpture romane de la cathédrale de Jaca. État des questions," *Les Cahiers de Saint-Michel de Cuxa*, 10 (Cuxa: 1979), pp. 79–106.

45 On the subject of the frieze at Loarre, see the recent interpretations of the aquatic motifs as the sea of glass in the Book of Revelations 4:6: F. Español Bertran, "El castillo de Loarre y su portada románica," *Locus Amoenus*, 8 (Barcelona: 2005–2006), pp. 7–16. "Fortaleza militar y refugio de fe: proceso constructivo y relaciones estilísticas del conjunto de Loarre"... op. cit., pp. 72–4.

46 P. Sheingorn (ed.), *The Book of Sainte-Foy* (Philadelphia: University of Pennsylvania Press, 1995), p. 35.

47 "The principal and outstanding thing about me is that I am Christian. I was reborn when I was baptized by a priest who confirmed my name of Caprais": ibid., p. 36.

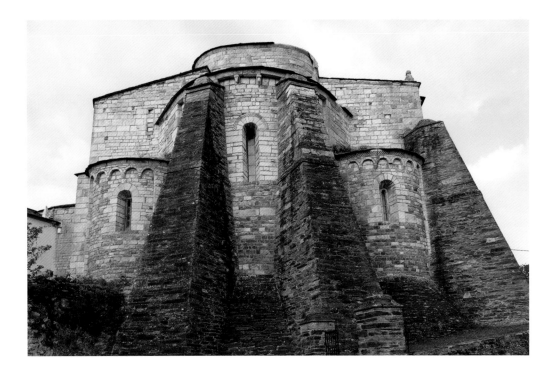

therefore used to decorate a capital outside the context of the chapel and errors of
reading were committed in its making, as witnessed by the water that becomes clothing.
We must not forget that from very early on there was a cult of Saint Caprasius in
Aragon, evidence of this being a parish church dedicated to him in Santa Cruz de la
Serós,[48] donated in 1083 (the year in which Pedro of Andouque was appointed Bishop)
by King Sancho Ramírez to the Benedictine Monastery of San Juan de la Peña, one of
the first to introduce monastic reform in the kingdoms of Spain. The elegance and
purity of its architecture, similar to that of Lombardy, has been related with the
Cathedral at Roda de Isábena (1050–1060), although it could just as well have been
built in the times of the King who donated, if we go by certain complications in both its
floor-plan and elevation. Furthermore, the flow of artistic objects between the prelates
of Navarre and Aragon and the Abbey of Conques in the late eleventh century is well
documented. Thus, Pedro of Pamplona gave the above-mentioned monastery the book
Moralia in Job, by Gregorio Magno, in 1092,[49] whilst for his part in 1100 Ebontius,
Bishop of Roda and Barbastro (1094–1104), consecrated the magnificent portable altar
of Abbot Bégon III, which bears the portrait busts of Saint Faith and Saint Caprasius.

It is therefore possible to conclude that around 1094–1095 a masons' workshop
from Navarre and Aragon, perfectly familiar with what was happening in Jaca, started
work on the cathedral. This workshop, possibly directed by Stephen, continued until
1101. It was very probably employed after Dalmatius had come from Cluny to take
charge of the see at Compostela and saw no problem in following the old figurative
program designed by Diego Peláez. The latter was then living in Aragon, at the court
of Pedro I, and enjoyed the friendship of Pedro of Rodez, a former Benedictine of
renowned prestige in the introduction of the Gregorian Reform. The basilica in
Compostela was in need of someone who could satisfactorily continue the work that
had already been done, and perhaps Peláez, who had an extensive knowledge of the
territory of the Kingdom of Aragon, then in full artistic bloom, did not hesitate to

48 "Los santos viajan: la circulación de
objetos y modelos artísticos en el
Camino"... op. cit., p. 71.
49 BnF~Bibliothèque nationale de France:
Gregorio Magno, *Moralia in Job* [Coll.
Doat., vol. 143].

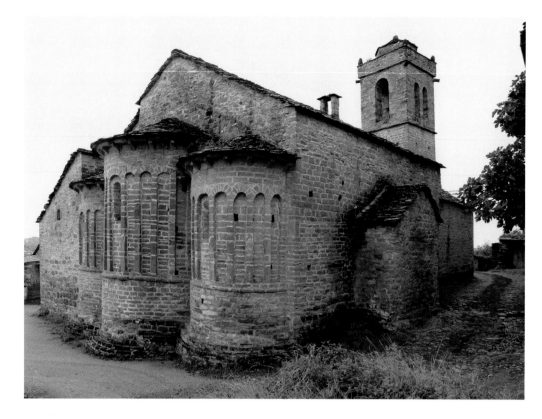

facilitate, in one way or another, the hiring of an outstanding Aragonese craftsman for his former cathedral. I am fully convinced that Peláez's presence in Aragon influenced this and other Pyrenean tendencies in late eleventh-century Galician Romanesque art. Indeed, I suspect that Bishop Gonzalo may also have had recourse to Peláez, a former colleague of his during the times of King García, when he commenced work on Mondoñedo Cathedral in or around 1096. The clearly "Lombard" look of the apse of the latter cathedral seems to derive from the churches of Sobrarbe, where Peláez acted as a judge in 1100. Similarly, the figuration of the south eaves of this same cathedral is the work of a workshop that can be linked to the sculpture of the stonemasons of Loarre and the less well-known church of the Monastery of Cristo de Catalain, near Pamplona, in the municipal district of Garinoain, or in other words, in the domains conceded to Sainte-Foy de Conques by Pedro of Andouque in 1086.[50]

The fact that Stephen's involvement with Santiago Cathedral was been silenced by twelfth century local sources and that his definitive leave-taking from the city coincided with Diego Gelmírez's rise to power is certainly disturbing. It is as if the latter, once he had been appointed Bishop of Compostela in April 1101, had wished to erase the memory of an uncomfortable decade. The fear that Diego Peláez and Pedro I still managed to inspire in the newly-appointed prelate is reflected in the *Historia Compostellana*, which tells us that after his election Gelmírez was not allowed to cross the Kingdom of Aragon so as to be consecrated Bishop in Rome in 1101:

> "*Pues el que había sido obispo, Diego Peláez, y sus parientes vivían con el rey de Aragón, don Pedro, por cuyo reino el electo debía atravesar, y por ello el glorioso Alfonso y la iglesia de Santiago de ninguna manera permitían que él fuera a Roma para su consagración, pues temían que fuera capturado por los referidos enemigos.*"[51]

50 M. Castiñeiras, "San Martiño de Mondoñedo (Foz) revisitado," in *Rudesindus. A terra e o templo* (Santiago de Compostela: Xunta de Galicia, 2007), pp. 119–37.

51 "Consagración de altares y ofrendas hechas al hospital. De la iglesia del Santo Sepulcro," *Historia Compostelana...* op. cit., I, 9, p. 86. Cf. *A vida e o tempo de Diego Xelmírez...* op. cit., p. 49.

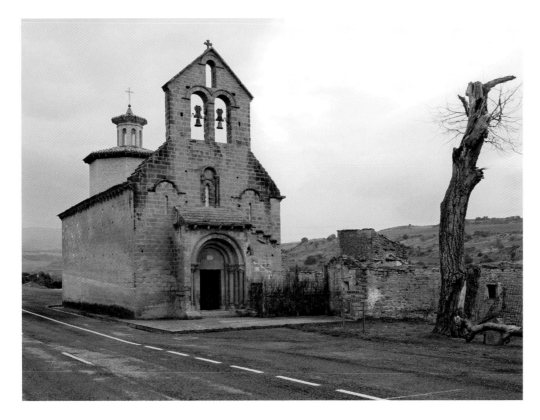

Monastery of Cristo de Catalain
c. 1100–1115
Navarra

The great artistic achievements of Diego Gelmírez (1100–1122): the great church of pilgrimage and the historiated doors

"En esta iglesia, en fin, no se encuentra ninguna grieta ni defecto; está admirablemente construida, es grande, espaciosa, clara, de conveniente tamaño, proporcionada en anchura, longitud y altura, de admirable e inefable fábrica, y está edificada doblemente, como un palacio real. Quien por arriba va a través de las naves del triforio, aunque suba triste se anima y alegra al ver la espléndida belleza de este templo."[52]

For Compostela, the change of century was an important moment in the city's history. Diego Gelmírez was probably the front runner to occupy a see that had lain vacant for several years, but the culminating moment of his brilliant career was still pending a series of journeys during which he made use of the then incipient network of pilgrim routes to Santiago, which would be described years later in the "Guide" of the *Codex Calixtinus*. In 1100 he set off for Saint Peter's in Rome, to be ordained sub-deacon. On that occasion he chose the southernmost route, the so-called *via tolosana*, and from there continued along the *via francigena* through Italy as far as Rome. The following year he finally obtained his consecration as Bishop, and shortly afterwards, in 1105, he once again traveled to Rome to receive from Pope Paschal II (1099-1118) the privilege of the Pallium in the Roman Basilica of San Lorenzo fuori le Mura. On this journey he followed various stretches of the principal French pilgrim routes (*via tolosana*, *via podiensis* and *via lemosina*) that brought him first of all to Cluny Abbey, from where he once again took the *via francigena* through Italy as far as Rome.

Meanwhile, the shape of the cathedral gradually rose up against the sky of Compostela, a small town that started to grow in the shadow of this new building,

52 *Liber Sancti Iacobi Codex Calixtinus...* op. cit., V, 9.

begun in 1075. If there is one single aspect of this edifice that stands out above all others it is its genuine interaction with its urban surroundings, as revealed by its considerable number of doors, ten according to the description in the *Calixtinus*,[53] as well as in that of two urban spaces on either side of the transept, around which the life of the city revolved. Hence the enormous nave of the transept could be seen, then as now, as the vaulted prolongation of an immense street or passageway that "crosses" the city, linking together two of its most emblematic sites: the Pilgrims' Paradise to the north and the Courtyard of Justice in the original palace to the south. It was common enough to find in large-scale Romanesque constructions the existence of large doors and adjoining squares with functions that were both penitential and civil. Similarly, in that architectural style access to the interior did not always correspond exactly with the axes of the building, but rather in relationship to the network of streets and squares into which they fitted. We only have to think of the *Porte Miègeville* in the Basilica of Saint-Sernin de Toulouse, opened in one of the sections of the south wall of the nave in order to connect with the thoroughfare that led "to the center of the town." Something similar happened with the location of the smaller doors of the Romanesque Cathedral in Santiago, although their number, seven, had no equal and almost suggests the gates of a city, the City of God, opening onto the streets and thoroughfares of the city of man.

The "Guide" of the *Calixtinus* in fact describes in minute detail these seven smaller doors of the basilica (most of which no longer exist) as well as the three main ones. In the former category we had the door of Santa María (which led into the church from the Corticela, between the chapels of Saint Nicholas and the Holy Cross): that of the *Via Sacra* (between the chapels dedicated to Saint John the Evangelist and Saint Faith, with its pentagonal lintel and clearly Auvergnian vocation); that of Saint Pelagius (between the chapels of The Savior and Saint Peter, which provided access for the monks of Anteataltares and corresponded to the present Puerta Santa);[54] that of the Canónica (between the chapels of Saint Martin and Saint John the Baptists, which gave on to the Canóniga or canons' residence in the Rúa da Conga); the two doors of the Pedrera (with arches on the south wall of the nave, leading to the stonemasons' workshop); and that of the Escuela de Gramáticos (on the north side of the nave). On the other hand, in its structure of three main doors sculpted according to a single iconographic discourse (the *Porta Francigena* in the north transept, the *Platerías* Door in the south transept and the West Door, designed at the time but not actually built until later, by Master Mateo) Santiago anticipated the three-door model that was to characterize the Gothic cathedrals of France from Chartres onwards.[55] The three constituted a summary of the history of mankind with their capitals dedicated to the Fall and the promise of Redemption (the North Door), its fulfilment (the South Door) and the Final Judgement and Glory (the West Door). It is also possible to make out in this structure a corresponding hierarchy of their function in the urban setting: the *Paradisus*, the point of entry for pilgrims, with its marketplace and use as a background for the rites of public penitence; *Platerías*, the Bishop's door, open to the city for the holding of trials and triumphant entries; and the West Front, possibly a liturgical and symbolical heir of the *westwerke* tradition.

53 Ibidem.
54 This has been defended with solid arguments by A. Fraguas, *La Puerta Santa* (A Coruña: Sada, 1993) and in *Los inicios de la catedral románica de Santiago: el ambicioso programa iconográfico de Diego Peláez... op. cit.*, plan 2. The latter author makes particular reference to the fact that the text of the *Concordia de Anteataltares* leaves no room for doubt as to its location between the chapels of The Savior and Saint Peter. On the other hand, J. Carro Otero, "En rectificación de un error común: la Puerta Santa no es una de las románicas (siglos XI–XII)," *Cuadernos de Estudios Gallegos*, 20 (Santiago de Compostela: 1965), pp. 257–9, defended the site of the Door of Saint Pelagius as being between the chapel of Saint Peter and the older chapel of Saint Andrew.
55 S. Moralejo, "Modelo, copia y originalidad en el marco de las relaciones artísticas hispano-francesas (siglos XI–XIII)," in *Una hipòtesi sobre el seu origen. Vè Congres Espanyol d'Història de l'Art*, vol. 1:2 (Barcelona: Generalitat de Catalunya, 1986), pp. 87–115.

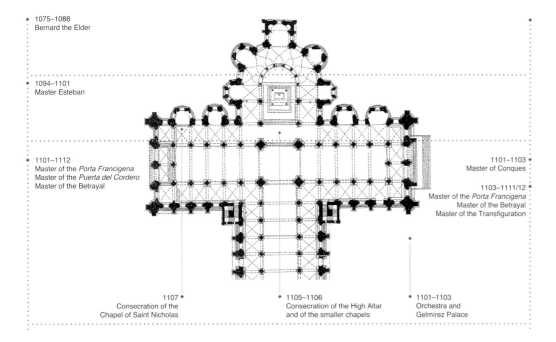

Building phases and master craftsmen of the chevet and transept of the Cathedral of Santiago de Compostela
Victoriano Nodar

1075–1088
Bernard the Elder

1094–1101
Master Esteban

1101–1112
Master of the *Porta Francigena*
Master of the *Puerta del Cordero*
Master of the Betrayal

1101–1103
Master of Conques

1103–1111/12
Master of the *Porta Francigena*
Master of the Betrayal
Master of the Transfiguration

1107
Consecration of the
Chapel of Saint Nicholas

1105–1106
Consecration of the High Altar
and of the smaller chapels

1101–1103
Orchestra and
Gelmírez Palace

The great church of pilgrimage

In the past, the Romanesque Cathedral of Saint James (1075–1211) was considered by many authors to be an example of the so-called great church of pilgrimage. The intention behind this denomination was to identify a school that also included an outstanding group of French monuments consisting of Saint-Martin de Tours, Saint-Martial de Limoges, Sainte-Foy de Conques and Saint-Sernin de Toulouse. The Cathedral at Compostela shares with these examples not only the characteristic grandeur of their size, but also the peculiarity of the elements that combine to make up the building: a long central nave flanked by two smaller side aisles with galleries that continue along a broad transept and round an ambulatory that surrounds a spacious chancel. A multiplicity of chapels (some transformed) provided the crowning touch to the cathedral structure: two on each arm of the transept, five radiating out from the apse, and a *confessio* located in the semi-circular space behind the altar.

Another characteristic common to the churches in this group is that they are fully vaulted: the central nave, with a cannon vault divided up by diaphragm arches that mark out the sections; the lateral aisles with cross-vaults; and the galleries with a corset-like frame formed by a barrel vault over which a second, higher quadrant vault has been placed, in the manner of an *arc-boutant*. The structure is an articulated one that transfers load to counter-forts, in which the wall framing in arcades creates on the outside a rhythmic play between full and empty enlivened by a double row of windows that throw an indirect light on the central nave. In the interior cruciform columns with square shafts and bases and attached half-columns alternate rhythmically with cruciform columns with circular shafts and bases, also with attached half-columns. This variation, a characteristic feature of Romanesque architecture, comes together in the transept, where we find four immense cruciform columns festooned with eight attached columns on a many-sided base (as in Conques), but does not appear in the chancel, where all the bases are square. The floor plan of the cathedral also reveals a

51

Chevet [*interior view*]
1075–1105
Cathedral of Santiago de Compostela

56 I am grateful to J. F. Esteban Llorente, from the University of Saragossa, for the valuable information he gave me in this regard after a lecture I gave on 25 March 2004 in Saragossa, titled "La meta del Camino: la Catedral de Santiago de Compostela en tiempos de Diego Gelmírez," as part of the course *Los Caminos de Santiago. Arte, Historia, Literatura...* op. cit., pp. 213–51. On the topic of the application of the ideas of Vitruvius and Boethius in medieval architecture, see N. Hiscock's monograph *The Wise Master Builder. Platonic Geometry in Plans of Medieval Abbeys and Cathedrals* (Singapore: Ashgate Publishing, 2000), and also the comments on this topic in my study "La catedral románica: tipología arquitectónica y narración visual"... op. cit., pp. 39–96, esp. pp. 39–41. Cf. J. F. Esteban Llorente, "La *ordinatio* y la *compositio* vitruviana en las columnas románicas. Metrología de ejemplos escogidos," in F. Español, M. L. Melero, A. Orriols and D. Rico (eds.), *Imágenes y promotores en el arte medieval. Miscelánea en Homenaje a Joaquín Yarza Luaces* (Barcelona: UAB~Universitat Autònoma de Barcelona, 2001), pp. 101–14.

subtle rhythmical modulation, based on the Romanesque principal of alternation, in which the width of the large central nave is equal to the sum of that of the two smaller side aisles. In Compostela this is combined with an anthropometric system of measurements, described in the "Guide" of the *Calixtinus*, with obvious echoes of Vitruvius.[56] Finally, the external silhouette of the cathedral was enhanced by a series of nine towers. To that of the dome, which was modified in the fifteenth century, we must add a further eight, all with a square cross-section: two larger ones over the West Front, built in the late twelfth century; two smaller ones above the intersection between nave and transept, the uppermost part having a polygonal cross-section; and four small stepped towers at the outer corners of the transept that culminated in a cylindrical body topped with a conical capital, like those of certain churches in Poitou (Montierneuf, Fenioux or Nôtre-Dame-la-Grande de Poitiers), although the only one still partially standing is that on the south-west corner.

The building was designed to be a large functional structure that would favor the circulation of pilgrims through its interior, enabling them to use the side aisles to walk right round the cathedral without disturbing the holy offices being said in the chancel, presbytery and central nave, which in the twelfth century were already partially occupied, and even more so in the thirteenth, by the canons' choir. In this

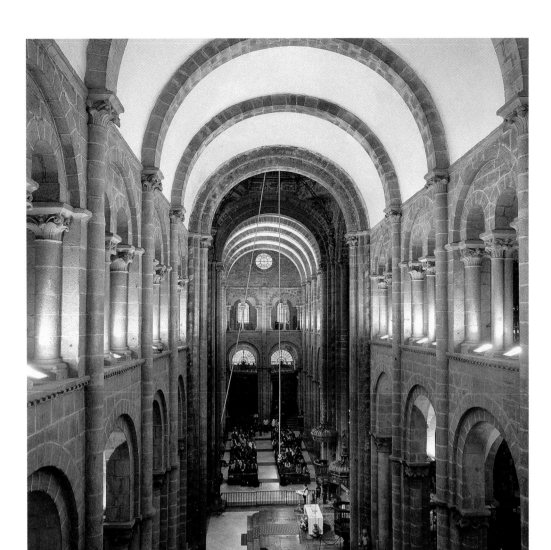

Transept
1101–1122
Cathedral of Santiago de Compostela

journey round the sides of the cathedral pilgrims could visit, as they can still do so today, the numerous chapels in the transept and ambulatory, where they could pray, hear mass and worship relics, and even enter, behind the altar, a *confessio* designed especially for them: the chapel of Saint Mary Magdalene, where they could pray next to the wall of the room where the body of Saint James was kept, following, as we shall see below, a typology that is typical of the basilicas in Rome.

Nevertheless, although the so-called great churches of pilgrimage share almost all these functional solutions to a greater or lesser extent, in recent decades the existence of a common "group" has been called into doubt. It is true, as Isidro Bango Torviso has pointed out,[57] that many of their features had been previously tried out in eleventh century European church architecture. The crypt (1008–1009) and church of Saint-Philibert de Tournus (1050–1075), Saint-Étienne de Vignory (1051–1057) and Saint-Jean de Montierneuf (1075) all have an ambulatory with radial chapels, complete in the case of Tournus and Montierneuf, with an incipient development of a transept with chapels. However, similarities of floor-plan apart, the spatial experience and the sight of the elevations of these buildings is to say the least disappointing when compared to the astonishing sensation of unity that we still feel today when seeing Conques, Santiago or Saint-Sernin, or simply contemplate the century-old drawings

57 I. Bango Torviso, "Las llamadas iglesias de peregrinación o el arquetipo de un estilo," in M. V. Carballo Calero, *El Camino de Santiago, Camino de Estrellas...* (A Coruña: Fundación Caixa Galicia, 1994), pp. 11–75.

published by Charles de Lasteyrie in his 1901 monograph on Saint-Martial de Limoges. The solid and heavy nature of Tournus, a church without galleries, or the narrowness of the transept at Montierneuf have nothing in common with the harmony and proportion of the spaces in the so-called group of churches of pilgrimage, nor with their soaring elevations of slender pillars with attached half-columns and spacious galleries with mullioned arches, nor with their broad and well-developed transepts.

Similarly, it can also be said with reference to the definition of the chevet of this group of churches it is necessary to take into account architectural models from before the Romanesque period, but which were very much in fashion in the second half of the eleventh century. Thus, the formula of a passageway around the altar-tomb or altar-reliquary corresponds to a specific function and intention: facilitate and intensify a cult of martyrdom that could be traced back to the early days of Christianity. For this reason its typology was certainly not alien to the prestigious formula of the fourth-century Rotunda of the Church of the Holy Sepulchre, the tomb of Christ, in which a broad ambulatory, with three absidal chapels and galleries, enclosed the Holy Place.[58] Even in the case of Santiago, and possibly that of Saint-Sernin also, these connections with paleo-Christian architecture may explain certain other peculiarities of the building and its liturgical furniture. It is sufficient to cite, for example, the peculiar shape of the *confessio* dedicated to Saint Mary Magdalene in the Basilica of Saint James, very possibly inspired by the models of the basilicas of Rome.

It is perfectly true that we are not in the presence of the interregional school of style, with shared architects, that has been suggested by Émile Mâle, Porter, Conant[59] or even Élie Lambert,[60] but rather in that of a particularly successful typological formula that arose from common elements in the context of the pilgrim routes to Santiago, as would appear to be the case if we go by the statements of Marcel Durliat, Moralejo[61] or Williams.[62] Be that as it may, what really brings together the above-mentioned five classic examples of Franco-Hispanic Romanesque is the fact that they shared, within a short time-span, a similar artistic language in projects so far apart. It is therefore impossible to deny the Western European role of a phenomenon like the pilgrimage to the tomb of Saint James, which so greatly defined the eleventh and twelfth centuries, in churches that owed their very existence to it, and which, furthermore, formed part of the network of pilgrim roads to Compostela. Each of them is located along one of the routes described in the "Guide" of the *Calixtinus*: *turonensis, lemosina, podiensis, tolosana*. What is more, each of these basilicas is the functional response to the cult of a saint or martyr, and were even singled out by their contemporaries as being ideal models to imitate. Indeed, Aymeric Picaud says that Saint Martin de Tours, in or around 1137, was being admirably constructed "*ad similitudinem ecclesie beati Jacobi miro opere fabricatur.*"[63]

In spite of its reservations, modern French historiography recognizes, to quote Anne Prache, the existence of the "group of Saint James,"[64] although the author is inclined, however, to define the model as a church of pilgrimage conceived for a community of regular canons, which would explain the similarities between Saint-Martial de Limoges, Saint-Martin de Tours, Saint-Sernin de Toulouse and Santiago itself. In my opinion we cannot exclude the Benedictine Church of Sainte-Foy de

58 For a status of the issue of the architecture of the Church of the Holy Sepulchre, see F. Galtier, "El Santo Sepulcro de Jerusalén: el *martyrium* emblemático para la ciudad irredenta," *Boletín del Museo e Instituto Camón Aznar,* 58 (Saragossa: 2001), pp. 73–104, esp. pp. 79, 91, fig. 1.

59 K. J. Conant [*The Early Architectural History of the Cathedral of Santiago de Compostela*, Cambridge: Harvard University Press, 1926], *Arquitectura románica de la Catedral de Santiago de Compostela* (Santiago de Compostela: COAG~Colegio Oficial de Arquitectos de Galicia, 1983).

60 É. Lambert, "La cathédrale de Saint-Jacques de Compostelle et l'école des grandes églises romanes de pèlerinage," in *Études medievales*, vol. 1:4 (Toulouse: Privat-Didier, 1956), pp. 245–59.

61 "Notas para una revisión crítica de la obra de K. J. Conant"... op. cit., pp. 221–36.

62 "La arquitectura del Camino de Santiago"... op. cit., pp. 267–90.

63 *Liber Sancti Iacobi Codex Calixtinus*... op. cit., V, 8.

64 A. Prache, "Les sources françaises de l'architecture de Saint-Jacques-de-Compostelle," in A. Rucquoi (ed.), *Saint-Jacques et la France* (Paris: Cerf, 2003), pp. 263–75.

Conques from this group, since it unquestionably predates all the others (having been started in the mid-eleventh century) and had an undoubted influence on the first campaign at Compostela, as Victoriano Nodar has recently demonstrated, as a result of the participation of one Bernard at both sites. This is by no means an obstacle to the most ambitious and refined projects of this typology having taken shape in the form of canonical churches, which at the time enjoyed a period of vigorous expansion. For this reason nobody questions the phrase used by Lambert when he defines the Cathedral at Compostela as "*la plus parfaite*," the most complete and rounded example of a group.

THE CATHEDRAL, A SYMBOLIC GEOGRAPHY

However, as Moralejo has pointed out, pilgrims arriving at Compostela were offered the opportunity of traversing, in the space of the chevet of the cathedral, a veritable symbolic geography of their pilgrimage, since the dedication of many of its chapels allowed them to pray to saints and recall places of worship that they would have visited along their journey.[65] If in the ambulatory they could pay homage to Saint Saint Faith of Conques, the Saint Mary Magdalene of Vézelay and Saint Peter of Rome, in the transept they would find Saint Nicholas of Bari and Saint Martin of Tours, both of them protectors of pilgrims and travelers. In fact a priest versed in foreign tongues was assigned to the ancient Romanesque chapel of Saint Nicholas, to hear the confession of foreigners and give them communion when the ambulatory was too crowded. When the passageway to the Corticela was opened, his altar was moved to an adjoining space, on the east side of the inner portico of the *Porta Francigena*, later dedicated to Saint Fructuosus.[66]

Even up on high Saint Michael Archangel watched over the chancel from his altar in the ambulatory gallery, thereby serving as a reminder of the function and fame of the well-known shrines of Saint Michael at Monte Gargano, Mont-Saint-Michel or Saint-Michel en Aiguilhe in Le Puy. In my view, Gelmírez designed this altar to be the place at which the Easter celebrations of the *Triduum Sacrum* would be held. Its unusual location in the ambulatory gallery would only have been provisional until the *westwerk* or galilee had been built, this being its customary position, as can be seen in the Church of Cluny III (1109–1122).

This sacred topography is by no means fortuitous, since it not only responds to the need to provide pilgrims with spiritual consolation (an obligation of any center of pilgrimage), but also served the propagandistic needs of the see of Compostela in the early twelfth century. All the chapels in the ambulatory and transept were solemnly consecrated at the same time as the high altar in 1105–1106 by Bishop Gelmírez (1100–1140), with the exception of that dedicated to Saint Nicholas, which was nevertheless completed shortly afterwards, in or around 1107. The desire to integrate French and Italian shrines in the symbolic interior journey around the basilica in Compostela was paralleled by the sermons read in the cathedral during that same period, in which the phenomenon of pilgrimage was addressed in a desire to point out the superiority of Saint James the Apostle and his shrine over any competition from abroad. Thus, in the *Veneranda dies* sermon there is repeated reference to these churches in a desire to warn pilgrims of the malice of

65 S. Moralejo, "La imagen arquitectónica de la Catedral de Santiago," in *Il Pellegrinaggio a Santiago de Compostela e la letteratura jacopea* (Perugia: Università degli Studi di Perugia, 1985), pp. 37–61, esp. pp. 42–4.

66 J. M. Zepedano y Carnero [Lugo: Soto Freire, 1870], *Historia y descripción arqueológica de la basílica compostelana*, ed. J. M. Díaz Fernández (Santiago de Compostela: Xunta de Galicia, 1999), p. 161.

their keepers and innkeepers, with the promise that their patron saints would accuse these evil-doers on Judgement Day:

> *"Los guardias que custodian los altares de las basílicas de Santiago, Saint-Gilles (Nîmes), San Leonardo (-de-Noblat), San Martín (de Tours), Santa María (del Puy-de-Dôme) y de San Pedro de Roma son también cómplices de las maldades de los hospederos [...] Los hay quienes procuran que sus siervos aprendan estos ardides, y los envían al Puy, a Saint-Gilles, a Tours, a Piacenza, a Lucca, a Roma, a Bari y a Barletta, pues en estas ciudades suele haber escuela de toda clase de engaños [...] Más si no os convertís de vuestros innumerables engaños a los mismos santos, a saber, Santiago, Pedro, Gil, Leonardo; a la misma Madre de Dios, Santa María del Puy; a Santa Magdalena (de Vézelay), a San Martín de Tours, a San Juan Bautista de Angély, a San Miguel Marino (del Monte Gargano), a San Bartolomé de Benevento, a San Nicolás de Bari, los tendréis como acusadores delante del Señor, pues habéis explotado a sus peregrinos."*[67]

There can be no doubt whatsoever that European pilgrimage was then being experienced as a present and growing phenomenon, and that in this regard the shrine of Saint James wished to emerge triumphant. Hence the author of the *Veneranda dies* places Saint James at the head of the saints that mediated before Our Lord and already distinguishes the shrine at Santiago for the excellence of its emblem, the scallop shell or *vieira*, created precisely during the same period (1099–1106), thereby comparing it with Jerusalem itself:

> *"Por lo mismo los peregrinos que vienen de Jerusalén traen las palmas, así los que regresan del santuario de Santiago trae las conchas. Pues bien, la palma significa triunfo, la concha significa las obras buenas."*[68]

According to Díaz y Díaz, the aim of the propaganda in this sermon was to place Santiago on an equal footing to Rome and Jerusalem, its fiercest competitors, or even, if possible, above them.[69] Hence the number of Italian cities to which negative reference is made, all of them on the pilgrim route to Rome and beyond as far as Jerusalem, following the *via francigena* and the *Via Appia Traiana*: Piacenza, Lucca, Rome, Benevento, Monte Gargano, Barletta and Bari. The route was well-known to the members of the Church at Compostela, since from the earliest years of the twelfth century onwards the cathedral canons had made frequent journeys to Rome to request prebends, on one occasion even traveling as far as Bari to ask for donations towards the cost of building the Cathedral of Saint James. As we have already seen, Gelmírez himself had visited Rome twice, the first time in 1100, on the occasion of his appointment as sub-dean in Saint Peter's in the Vatican, and the second in 1105, when he obtained the dignity of the Pallium in San Lorenzo fuori le Mura.

This intense desire for propaganda can also be seen in the "Book of Miracles" of the *Codex Calixtinus*, which was written during the same period. As Díaz y Díaz indicates, in its stories Saint James appears as the unrivalled protector of all pilgrims: he brought the young Gerald back to life at the doors of Saint Peter's in Rome; saved pilgrims on their return journey from the Holy Land; and used a scallop shell to cure a knight from Apulia,[70] the principal place of embarkation for crusaders. Needless to say, most of them then made the journey to Compostela as a sign of their gratitude.

67 Ibidem, pp. 221, 223. *Liber Sancti Iacobi Codex Calixtinus...* op. cit., I, 17: the feast day of 30 December.
68 Ibidem, p. 205. *Liber Sancti Iacobi Codex Calixtinus...* op. cit., I, 17.
69 M. C. Díaz y Díaz, "Las tres grandes peregrinaciones vistas desde Santiago," in P. Caucci (ed.), *Santiago, Roma, Jerusalén* (Santiago de Compostela: Xunta de Galicia, 1999), pp. 81–97.
70 *Liber Sancti Iacobi Codex Calixtinus...* op. cit., I, 17.

With these Italian miracles, Santiago entered into direct competition with the main centers of pilgrimage in Italy at that time, which were Rome and Bari. The miracle of the knight of Apulia, furthermore, occurred in 1106[71] and therefore coincides in time with the completion of the chapel dedicated to Saint Nicholas in the north arm of the transept of the Cathedral at Compostela. For this reason I do not believe that only explanation for its dedication is the existence of a chapel to the same saint and also located at the north end of the transept of the Church of Cluny III (1095–1100)[72] or by the earlier altars dedicated to Saint Nicholas in the Benedictine monasteries of Antealtares (1077) and Pinario (1102) in Santiago.[73] The cult of this saint underwent a veritable revolution when his relics were brought in 1087 from Myra in Asia Minor to Bari,[74] this event being one of the most famous *furta sacra* of the Middle Ages in Europe. Work started on the construction of his magnificent basilica very soon afterwards (1089), and the success of his cult and pilgrimage became unstoppable after the First Crusade (1095–1099). We must not forget that the Crusader knights had set sail for Jerusalem from the nearby port of Brindisi, nor that in 1098 Pope Urban II had held a council in the recently-built crypt of the Basilica of Saint Nicholas of Bari. As one of the focal centers of Christianity, the Basilica at Compostela was doing the right thing when it included Bari in its sacred topography by dedicating one of its chapels to Saint Nicholas.

It is possible, however, to delve deeper into the intentions of the Church at Compostela. The choice of the subject of the miracle of the knight of Apulia[75] is by no means fortuitous, since his ailment consisted of an inflammation in his throat, which "swelled up like a wineskin full of air." Since nobody could cure him, he asked a pilgrim who had been to Santiago to touch the afflicted area with the shell he had brought back from his pilgrimage, and was immediately made well. In gratitude, the Apulian knight journeyed to Compostela. This "appropriation" of the miracle by Saint James would of course have been an insult for any Apulian, because since time immemorial, in the vicinity of Brindisi, the foremost port of embarkation for crusaders and a waystage on the Italian *via francigena*, Saint Biagio or Saint Blaise had been curing ailments of the throat by a similar method in his grotto shrine of San Vito dei Normanni, the afflicted touching their throat with a candle from his shrine.[76]

We also have information about the cult of Saint James in Apulia. Thus, the present-day grotto Church of Sant'Angelo di Calarotto in Mottola, in the province of Taranto, was probably originally a funeral temple dedicated to Saint James, as can be deduced from the presence of the Apostle replacing that of Saint John in a Deesis in the right-hand apse dated to the end of the twelfth century. The saint is carrying two shells, one on his pouch and the other on his arm, and is accompanied by the epigraph "s. IACO/BVS." The Norman Riccardo Senescalco, Lord of Mottola, had donated these ancient grotto shrines that followed the Greek Rite to the Benedictine Abbey of Cava dei Tirreni (Campania) in 1081 in order to convert them to the Latin Rite. Their closeness to the *Via Appia* meant that they were transited by pilgrims and crusaders, and therefore there dedication to Saint James the Greater should not surprise us. Even less so when we learn that during the excavations of the twelfth- and thirteenth-century

71 "Corriendo el año mil ciento seis de la encarnación del Señor, a cierto caballero de tierras de Apulia [...]," "Las tres grandes peregrinaciones vistas desde Santiago"... op. cit.

72 "La imagen arquitectónica de la Catedral de Santiago"... op. cit. Cf. K. J. Conant, *Cluny. Les églises et la maison du chef d'ordre,* (Mâcon: Protat Frères, 1968), pp. 93–4. Id. [1959], *Arquitectura carolongia y románica (800–1200)* (Madrid: Cátedra, 1991), p. 216.

73 F. López Alsina, "Implantación urbana de la catedral románica de Santiago de Compostela (1070-1150)," in *La meta del Camino de Santiago. La transformación de la Catedral a través de los tiempos* (Santiago de Compostela: Xunta de Galicia, 1995), pp. 40, 46.

74 On the subject of this removal, see P. J. Geary [*Furta Sacra. Thefts of relics in the central Middle Ages.* Princeton: Princeton University Press, 1990], *Furta sacra. Le vol des reliques au Moyen Âge* (Paris: Aubier, 1993), p. 141.

75 *Liber Sancti Iacobi Codex Calixtinus...* op. cit., II, 12.

76 Saint Blaise was a fourth-century Armenian doctor who became Bishop of Sebaste in Asian Minor, although he continued to live in a cave. He is the healer *par excellence* of ailments related to the throat, since one of his most famous miracles was the healing of a child who was suffocating after choking on a fish bone that had got lodged in this throat. This sense persist in German in the verb *blasen*, to blow, where he is invoked against storms and hurricanes. His martyrdom is shown in the Benedictine priory of Berzé-la-Ville (c. 1120): G. Duchet-Suchaux and M. Pastoureau, *Las Biblia y los santos. Guía iconográfica* (Madrid: Alianza, 1996), pp. 68–9. The grotto shrine at San Vito dei Normanni also contains a cyle dedicated to the life of Saint Blaise under the *hegumen* Benedetto in 1196, N. Lavermicocca, *I sentieri delle grotte dipinte. Per le Scuole Superiore* (Bari: Laterza Edizioni Scolastiche, 2001), pp. 32–3.

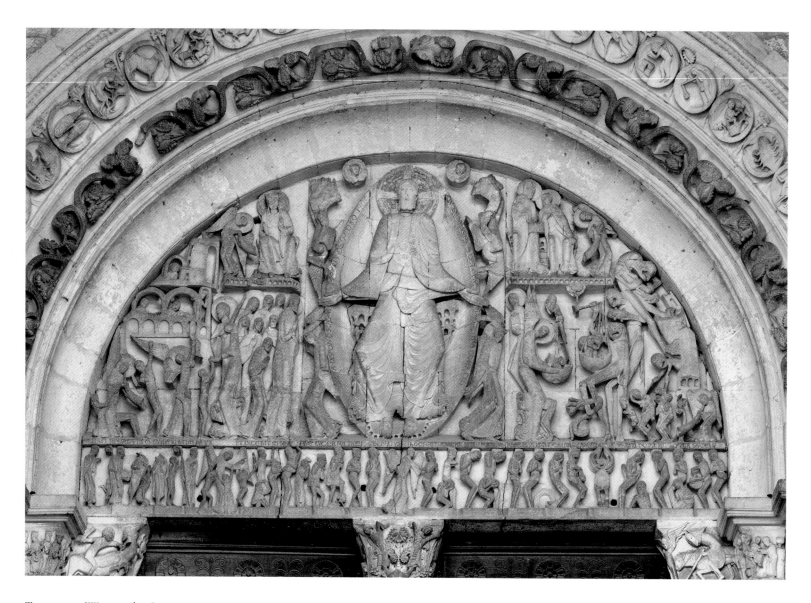

Tympanum *[Western door]*
Gislebertus
c. 1130–1135
Church of Saint-Lazare d'Autun,
Burgundy

77 R. Bianco, "Culto e iconografia di
 San Giacomo di Compostella lungo le
 vie di pellegrinaggio," in M. Stella Calò
 Mariani, *Il Cammino di Gerusalemme*
 (Bari: M. Adda, 2002), pp. 373–86,
 esp. pp. 375, 385, n. 20, fig. 1. Id.,
 "Circolazione di modelli iconografici
 lungo i percorsi di pellegrinaggio. San
 Giacomo di Compostella in Puglia,"
 ibid., pp. 201-10, esp. p. 203, fig. 7.
 S. Natale Maglio, *Mottola: the Cave of
 God. Between History, Art and Nature*
 (Mottola: Mottola City Hall, 2000),
 p. 24.
78 C. Frugoni, *Due Papi per un Giubileo.
 Celestino V, Bonifacio VIII e il primo
 Anno Santo* (Milan: Rizzoli, 2000),
 pp. 12–5.
79 *Liber Sancti Iacobi Codex Calixtinus...*
 op. cit., I, 17.

necropolis, in Sector I Tomb 47 they unearthed some bones together with a scallop shell (*pecten maximus*), the symbol of Saint James, with two holes pierced in it to enable it to be hung around the neck, and which undoubtedly belonged to a pilgrim.[77]

The symbolism of the scallop shell and the desire to be buried with it belong not only to the spiritual but also to the figurative culture of the twelfth century pilgrim: from the first shell found in a pilgrim's grave, today preserved in the Museo das Peregrinacións, which came from the excavations in the central nave of Santiago Cathedral, in the sixth section from the crossing, near the Tower of Cresconius, and therefore predating its demolition in 1120, to its representation in the Last Judgement of the West Door of the Cathédrale Saint-Lazare de Autun, located on an extension of the *via lemosina* to Compostela. This work, carved in or around 1135 by Gislebertus, includes two pilgrims amongst the chosen portrayed on its architrave, one of whom had been to Jerusalem and the other to Santiago, with their respective emblems (which would set them apart on Judgement Day), the Patriarchal Cross and the Scallop.[78] What an appropriate image for understanding a pilgrim's intention when he asked to be buried with his shell! The shell, as a symbol of his good works, as the *Calixtinus* reminds us,[79] would help to save him when the Day of Judgement arrived.

One of the least known aspects of the relationship between architectural spaces and liturgy is that concerning the use of the galleries. Widespread credence has been given to the aberrant belief that the galleries were was used as a sleeping area by pilgrims, a use that can certainly be considered inappropriate for a shrine that had so many *ex profeso* hostels within the city itself. In all probability this "legend" owes its origins to a ritual that was common in the great churches of pilgrimage, namely that on the eve of the patron saint's feast day the faithful would spend the night in prayer in the interior of the building. This custom is documented, for example, in the *Liber Miraculorum Sanctae Fidis*, written by Bernard d'Angers in the second quarter of the eleventh century. The book tells of how during the night the pilgrims would stay inside the church with candles and torches, accompanying the chanting of the clerics who intoned the psalms and holy offices during the vigil. It then goes on to say that prevent themselves from being overcome by sleep some of the pilgrims sang country songs (*lais*) and other frivolous ditties, which so enraged the abbot that he decided to henceforth close the church doors during the night to prevent the common people from entering. However, the devotion shown by these faithful pilgrims gathered together outside the church was such that Saint Faith herself opened the doors for them anew, to enable them to take part in the vigil.[80] This story may well help us to suppose that in Santiago, on the high feast days of the Apostle, in other words those of his Martyrdom (25 July), Miracles (3 October), and Translation (30 December), the basilica would also have remained open all night, the faithful occupying the galleries as well as the floor in order to be present during the celebrations. This is the sense in which we should interpret the sermon *Veneranda dies*, when it lists the different peoples of the earth who come to the Basilica of Saint James and the choirs of pilgrims who stay there "*en perpetua vigilancia*," some holding candles and others playing musical instruments, and who "*pasan la noche en vela*" since "*las puertas de esta basílica nunca se cierran, ni de día ni de noche.*"[81]

In my opinion this is nothing but an exaggeration of a rite that undoubtedly only took place during the vigils and octaves of the high feast days of Saint James, on which, as has been mentioned above, the galleries were possibly also exceptionally occupied to enable people to attend the liturgical celebrations. Nevertheless, the texts in the *Calixtinus* and the *Historia Compostellana* appear to attribute a use of the galleries that was more private than public, more of the palace than of the populace. Indeed, when describing the cathedral's architecture they are mentioned as if they were part of the rooms of a palace, since "*que etiam dupliciter velut regale palacium operatur* [this church is constructed on two levels, like a royal palace]."[82] And in fact the gallery of double arcades over a portico of columns, suggested by the appearance of the galleries over the side aisles, is characteristic of palace architecture in Late Antiquity and the Early Middle Ages.

This perception is by no means alien to twelfth-century Compostela, since we must remember that the galleries were adjacent to Diego Gelmírez's Bishop's palace, and in part reserved for his private use. In fact, on the occasion of the commencement of the construction of his second palace on the north side of the

80 "Livre des Miracles de Sainte Foy, II, 12," in A. Bouillet et L. Servières, *Sainte Foy. Verge et Martyre*, vol. 2:4 (Rodez: Carrère, 1900), pp. 522–3.
81 *Liber Sancti Iacobi Codex Calixtinus...* op. cit., I, 17, pp. 199–200.
82 Ibidem, V, 9, p. 556.

83 "Y puesto que el coro de la iglesia de Santiago estaba lejos de este palacio y era muy incómodo ir allí y volver bajando y subiendo continuamente, construyó arriba, sobre el pórtico, su capilla, ante la cual se acuña moneda, en frente de la iglesia de Santiago, a la derecha según se sale de la misma iglesia del Apóstol. Finalmente consagró esta capilla en honor del apóstol San Pablo, de San Gregorio, de San Benito y de San Antonino. Pues anteriormente, antes de que se hiciera la actual iglesia de Santiago, los altares de San Benito y de San Antonino había estado en las torres que había construido el obispo Cresconio para la defensa de la iglesia del Apóstol delante de la antigua y pequeña iglesia de Santiago. El mencionado arzobispo había destruido estas torres, cuando construyó esta insigne iglesia del Apóstol, por ello recompensó con un lugar de honor a San Benito y a San Antonino para que fuesen venerados en la referida capilla, ya que había destruido sus altares, y así se hizo": "Construyó un nuevo palacio," in Historia Compostelana... op. cit., II, 25, pp. 345–6.

84 K. R. Mathews, "They wished to destroy the temple of God": Responses to Diego Gelmírez's Cathedral Construction in Santiago de Compostela, 1100–1140 (Chicago: University of Chicago Press, 1995), pp. 127–30.

85 Saint Antoninus of Apamea, greatly worshipped in the Diocese of Toulouse, was the patron saint of some of the most emblematic constructions of the earliest Romanesque period in Western Spain: the Cripta de San Antolín de Palencia in 1034 (see M. Gómez Moreno, El arte románico español. Esquema de un libro... op. cit.); and the Monastery Church of San Antoniño de Toques (A Coruña) in 1067. Similarly, there is a record of devotion to Saint Benedict in Compostela from the end of the tenth century with the Church of San Benito do Campo, and particularly in the Monastery of San Antolín de Toques, which, in addition to being governed by the Rule of Saint Benedict, had as one of its patron saints Saint Benedict of Nursia: J. M. Andrade Cernadas, El monacato benedictino y la sociedad en la Galicia medieval (siglos X al XIII) (Sada: Edición do Castro, 1997), p. 36. Id., "En torno a la benedictización del Monacato gallego," Compostellanum, vol. 45, 3–4 (Santiago de Compostela: 2000), pp. 649–56, esp. p. 653, note 18 (AHN, Clero, 557/14). M. Lucas Álvarez, San Paio de Antealtares, Soandres y Toques: tres monasterios medievales gallegos (Sada: Edicións do Castro, 2001), pp. 275–7, esp. p. 276, doc. 1.

86 "Construyó un nuevo palacio," in Historia Compostelana... op. cit., II, 25, p. 345. It should be remembered that Saint Paul already appeared in 1067 in the list of patron saints of the Monastery of Toques: "En torno a la benedictización del Monacato gallego"... op. cit. San Paio de Antealtares, Soandres y Toques: tres monasterios medievales gallegos... op. cit.

cathedral, after his appointment as Archbishop and papal legate by Calixtus II in 1120, he was to install a personal chapel consecrated to Saints Paul, Gregory, Benedict and Antoninus in the gallery of the *Porta Francigena*.[83]

For Karen Mathews, the reason for the existence of this chapel can be explained by the arduous experience that Gelmírez had been obliged to undergo during the siege and attempted burning of the cathedral and his original palace in 1117.[84] The latter, which was located next to the south transept and the *Platerías* Door, was to be moved after the above-mentioned events to the north transept, less open to the city and therefore easier to defend from an attack. The construction of a private chapel there would also allow Gelmírez to follow the holy offices in the chancel from the galleries, without having to continuously frequent the annoying company of some canons or to be in full view of the crowds in the cathedral. Gerald of Beauvais, the author of this text, justifies the dedication of altars to Saint Benedict and Saint Antoninus as substituting others that had previously existed in the towers of the wall built by Cresconius to defend Alfonso III's basilica, and which were destroyed at that time. Furthermore, the cult of these two saints had been established in the Kingdom of Galicia and that of Castile and Leon in the eleventh century.[85] Nothing is said, however, about the reasons for the dedications to Saint Paul the Apostle or Saint Gregory the Great, uncommon in Spanish territory, as the same author was later to explain, in the case of the former, in a second text. The Roman nature of the cult of these two saints may perhaps explain why Gelmírez chose them, since his new palace had been built to provide him with a residence "*acorde con su nueva dignidad de legado romano.*"[86] López Alsina attributes another chapter of the *Historia Compostellana* (II, 55) to the same Gerald,[87] in which he also describes the construction in or around 1122 of a second space with altars, this time situated above the *Platerías* Door:

> "*Sobre el pórtico de la iglesia de Santiago, por el que se va a la Rúa del Villar, construyó un altar en honor de San Benito, también otro en honor de San Pablo, porque rara vez se le recordaba en las iglesias de España, y en honor de San Antonino y San Nicolás.*"[88]

There is also a partial reference to this second chapel in the list of the altars in the cathedral given by the "Guide" of the *Calixtinus*, in which it states that "*en el triforio de la iglesia se encuentran tres altares, el principal de los cuales es el de san Miguel arcángel, y hay otro en la parte derecha, el de san Benito, y otro en la izquierda, el de los santos Pablo, apóstol, y Nicolás, obispo, donde también solet esse* [used to be] *la capilla del arzobispo.*"[89] All the above would indicate the existence of two chapels in the galleries, one on each side of the transept, with dedications that were repeated except in the case of Saint Gregory, who only appears on the north side, and Saint Nicholas, who only appears on the south side. The reason for this may perhaps derive from the fact that Gelmírez's second palace was still being built when the two texts were written, namely in 1124 for that by Gerald and 1137 for that in the "Guide." From the expression "*solet esse*" used in the latter we take it that until the new building was finished the Archbishop continued to use the rooms of the original palace next to the south transept and the adjoining chapel pending his move to the

Gallery [Platerías *Door*]
c. 1122
Cathedral of Santiago de Compostela

north arm. The fact that this chapel included an altar dedicated to Saint Nicholas (to whom a chapel had already been consecrated on the ground floor of the transept) indicates Gelmírez's particular devotion to the other great patron saint of pilgrims, to whose lands in Apulia he had precisely sent two canons in or around 1122 to request a donation towards the cost of the building work on the Cathedral in Santiago.[90] This saint from Bari would also have enjoyed special devotion as a result of being the patron saint *par excellence* of scholars. We should not forget that one of Diego Gelmírez's most important cultural endeavours was to encourage the education of his clergy from childhood through the episcopal school attached to the cathedral.[91] As the *Calixtinus* indeed reminds us, there was a door with that name (*de Grammaticorum Scola*) located in the left-hand aisle of the basilica, which led to both the school and the palace.[92]

THE CATHEDRAL, A GIGANTIC LITURGICAL MACHINE

From all that has been said until now, we can see that the sacred topography of the cathedral included functioned on two levels, one horizontal, to which we are accustomed, and the other vertical, in an upwards direction. The building thus functioned as a perfect liturgical and ceremonial machine that had to adapt itself

87 *La ciudad de Santiago de Compostela en la alta Edad Media...* op. cit., pp. 64–77.
88 "Edificación de iglesias y palacios," in *Historia Compostelana...* op. cit., II, 55, p. 402.
89 *Liber Sancti Iacobi Codex Calixtinus...* op. cit., V, 9, pp. 564–5.
90 "*Estaban entonces (año 1124) en aquellas tierras (Pavía) dos canónigos de Santiago, Pedro Astruáriz y Pelayo Yánez, los cuales habían marchado ya hacía dos años a Apulia y Sicilia para pedir ayuda a los fieles para la obra de la iglesia de Santiago*": "Celebración de un concilio," in *Historia Compostelana...* op. cit., II, 64, p. 429.
91 M. Díaz y Díaz, "Problemas de la cultura en los siglos XI–XII. La escuela episcopal de Santiago," *Compostellanum*, 16 (Santiago de Compostela: 1971), pp. 187–200.
92 The door to the Grammar School was located in the fourth stretch of the side wall of the north aisle, i.e. in the place where Gelmírez decided to build his palace after 1120: *Liber Sancti Iacobi Codex Calixtinus...* op. cit., V, 9, p. 557, note 5.

to a wide range of celebrations and devotions, both public and private. One of the highlights of the ecclesiastical calendar in Romanesque cathedrals was Easter, for which the Basilica of Saint James also appears to have had an excellent systemization of altars and heights.

I suggested some time ago that some of the dedications of the cathedral altars seemed to have been suited to their use in the processions of the Easter liturgy of that time. The ritual, known as the *Triduum sacrum*, consists of the ceremonies of the *Adoratio Crucis*, the *Depositio*, the *Elevatio* and the *Visitatio Sepulchri*, celebrated between Good Friday and Resurrection Sunday.[93] Proof of the fact that it was celebrated in Compostela is the folio preserved in the Archive of the Cathedral from a twelfth-century Roman Gradual with the trope of the *Visitatio Sepulchri*, to be performed at Easter matins. The presence of this dialog not only supports the liturgical resonance of the cult of Saint Mary Magdalene in the chevet but also the intention to evoke the Holy Places through this dedication. In fact, the location of a Magdalene chapel next to the Apostle's tomb appears to be an allusion to the famous rotunda of the Church of the Holy Sepulchre in Jerusalem, in which the Edicule is also associated with the altar dedicated to Saint Mary Magdalene in the nearby chapel of the Apparition.

Furthermore, the layout of the cathedral undoubtedly corresponds to the celebration of the Carolingian seasonal liturgy of the *Triduum sacrum*, as contained in the *Liber Ordinarius* of the nunnery at Essen or the *Barking Abbey Ordinal* (Essex, fourteenth century). The dedications chosen by Gelmírez for the altars of the Holy Cross, Saint Michael Archangel and Saint Mary Magdalene could well reflect his intention to celebrate, between Good Friday and Easter Sunday an in accordance with the Roman Rite, the ceremonies of the *Adoratio Crucis, Depositio, Elevatio* and *Visitatio Sepulchri.* The Adoration of the Cross would have taken place on Good Friday in the chapel of the Holy Cross, in the north arm of the transept, next to the chancel, as is traditional in England or even in Saint-Sernin de Toulouse, where there is a pictorial paschal cycle on the north arm. After the *Adoratio,* the procession would leave the chapel of the Holy Cross and go up to the altar dedicated to Saint Michael, on the gallery above the ambulatory, where after climbing the stairs it would perform the *Depositio,* as is described in Essen.

This use of the different areas of a cathedral for purposes relating to worship and liturgy undoubtedly continued beyond the Romanesque period. José Manuel García Iglesias, by following the track of the figure of Saint Mary Magdalene in the Modern period, has recently concluded that there was a certain continuity of medieval practices. Although the original altars of the Holy Sacrament and Saint Mary Magdalene were dismantled in 1532, their cult and function lived on in the adjoining chapel of The Savior, where a statue of the saint formed part of a Renaissance retable. Similarly, in the double retable of the chapel of the Immaculate Conception, the penitent formed part of the group of the Descent, a highly appropriate theme for a space that had previously been occupied by the Romanesque chapel of the Holy Cross, where important rites of the Easter liturgy were performed.[94]

93 M. Castiñeiras, "Topographie sacrée, liturgie pascale et reliques dans les grands centers de pèlerinage: Saint-Jacques-de-Compostelle, Saint-Isidore-de-Léon et Saint-Étienne-de-Ribas-de-Sil," *Les Cahiers de Saint-Michel de Cuxa,* 34 (Cuxa: 2003), pp. 27–49. Id., "La persuasión como motivo central del discurso: la Boca del Infierno de Santiago de Barbadelo y el Cristo enseñando las llagas del Pórtico de la Gloria," in R. Sánchez y J. L. Senra y Galán (eds.), *El tímpano románico* (Santiago de Compostela: Xunta de Galicia, 2003), pp. 231–58.
94 J. M. García Iglesias, "Espacios y percepciones. María Magdalena en la Catedral de Santiago de Compostela," *Quintana,* 2 (Santiago de Compostela: 2003), pp. 41–56, esp. pp. 43–4, 46, figs. 3, 8.

To go by the ideal description given in the "Guide" of the *Codex Calixtinus*, Gelmírez's project for the cathedral included the construction of a *westwerk* at the end of the building, as in the other pilgrimage churches, but by the time of his death in 1140 work had gone no further than the seventh section of the nave. Thus, in the absence of this structure in 1105–1106 the solution of installing an altar on high to Saint Michael in the ambulatory gallery was taken, to provide a place for the rites of the *Depositio, Elevatio* and *Visitatio Sepulchri* until the West Front could be built. The towers of the transept thus fulfilled a liturgical function for many years, by facilitating the progress of the processions, firstly upstairs and then downstairs, since these would have ended on the ground floor in front of the altar of the Holy Cross and in the *confessio* of Saint Mary Magdalene, where the rite of the sundering of the *Portae Inferni* or the Descent into Limbo (*Barking Abbey Ordinal*) would have taken place. The construction of the west front by Master Mateo between 1168 and 1211 possibly provided the opportunity to celebrate the Carolingian-Ottonian ritual in all its pomp, since in this rite the *Depositio, Elevatio* and *Visitatio* always took place in the gallery of the *westwerk*. Indeed, only by taking into consideration this background of the Easter liturgy can some of the peculiarities of the composition of the central tympanum of the Portico of Glory be explained.

The era of the historiated portals: Gelmirian art and Gregorian Reform
On both his visits to Rome, in 1100 and in 1105, Gelmírez took the Italian *via francigena*, the route taken by pilgrims traveling to Rome and which connected, via the *via tolosana*, with the pilgrim road to Santiago. This gave him the opportunity to experience first hand the rebirth in Italy of monumental art promoted by the ideology of the Gregorian Reform which drew on paleo-Christian models in its quest to return to the origins of the Church and to teach the dogmas of the faith by means of images in a sort of "writing for the illiterate." It is important to remember that on both journeys, in order to reach Italy, Gelmírez and his retinue had to travel on French roads, where they came into direct contact with the great creative centers of Romanesque art of the day, such as Toulouse, Conques, Moissac, and Cluny, which led to important artistic exchanges with the masons' workshops engaged in work in Compostela on the construction and decoration of the Cathedral of Santiago.

The completion of the gigantic transept in 1122 and the erection, in 1101 and 1111, at its ends of two sculptured portals of unprecedented monumentality, the *Porta Francigena* and the *Platerías* Door, represented the apogee of Gelmirian art, which was directly indebted to the artistic experience of the Way of Saint James. There is no clearer proof of the building's symbolic intentions than these two grand entrances which, on the one hand, received the pilgrims (*Porta Francigena*), and, on the other, served as a backdrop for the political exploits of the Compostelan prelacy (*Platerías*). Thousands of pilgrims were able to contemplate these portals by carrying in their capes the scallop shell (*vieira*), which in around 1100 had been consecrated as the insignia *par excellence* of the pilgrimage to Compostela, and in whose interior was a magnificently decorated altar, including a silver canopy and front, in the manner of Saint Peter's of the Vatican, which extolled the Basilica of Santiago as an apostolic tomb.

Porta Francigena of the Cathedral of
Santiago de Compostela, 1101–1111
[hypothetical reconstruction]
Victoriano Nodar

Northern Door
c. 1125–1150
San Quirce de Burgos

95 A. Fernández González, "Un viejo plano
 olvidado en el Archivo de la Catedral
 de Santiago: la *Porta Francigena*, su
 atrio y la Corticela en el año 1739,"
 Compostellanum, vol. 48, 1–4 (Santiago
 de Compostela: 2003), pp. 701–42.
96 *Liber Sancti Iacobi Codex Calixtinus...*
 op. cit., V, 9.
97 D. Cazes and Q. Cazes, *Saint-Sernin de
 Toulouse. De Saturnin au chef-d'œuvre de
 l'art roman* (Graulhet: Odyssée, 2008).

THE PARADISE OF THE *PORTA FRANCIGENA*: GELMÍREZ'S FIRM ADHESION
TO THE ART OF THE GREGORIAN REFORM AND THE MASTER SCULPTORS

The French Door – *Porta Francigena* – or original north door, lay at the culmination of the *via francigena*, where the Azabachería portal stands today, therefore constituting the goal of the said route. Pilgrims entered the cathedral through it having traveled long distances from far-off lands. Although it is very likely that it was built at the same time as the *Platerías* Door – between 1101 and 1111 – there are certain differences between them. In the case of the former, the terrain was 1.5 m higher than on the southern side, so that the north facade must have presented a bulkier and more cluttered aspect. In fact, in contrast with the eleven columns of the modern-day *Platerías*, the north door had thirteen columns, allowing for a greater separation between the arches of the mullioned door, perhaps in similarity with the *Porte des Comtes* of Saint-Sernin in Toulouse, and the columns were shorter: approximately 2.4 m. Alberto Fernández has recently had access to a plan designed by the master builder Simón Rodríguez in 1735 that is kept in Santiago Cathedral Archive, which throws light on the original Romanesque layout. It shows a certain similarity with the *Porte des Comtes* of Saint-Sernin of Toulouse (c. 1080–1090), for we see that there was a mullioned door with a counterfort pillar in the central buttress that separated the two entrances. Each opening was arranged into two trumpet-shaped archivolts, one external and one internal, resting on paired columns, as occurs on the western portal of Conques. This reduction of the trumpet shape with respect to what we see in the present-day *Platerías* Door ensured that the entrances were not only similar in width but also presented a more harmonious aspect within the pure form of the mullioned door.[95]

Thanks to the description given in the *Codex Calixtinus*,[96] it is possible to roughly recreate the general structure of the facade and certain decorative details. In addition to its geminated door structure was a host of sculptured reliefs, most of which can be attributed to four main master masons. The first and most gifted was one whom we will henceforth refer to as the "Master of the *Porta Francigena*," already dubbed by Moralejo, in his day, as the "Master of *Platerías*" and all too often identified, totally erroneously, by conventional historiography as Master Stephen. The "Master of the *Porta Francigena*," with its figurines with jowly faces, stocky build and contrastingly sculpted robes (the *Creation of Adam*, *David*, *Woman with the Lion*, *Grape Woman*, *Man Riding a Rooster*, etc.), was undoubtedly a follower of the penchant for Antiquity favored by the Master of Jaca, who was directly familiar with the immense skill of the workshop behind the *Porte Miègeville* of Saint-Sernin in Toulouse, the reliefs of which had begun to be carved in perhaps around 1100, as the recent investigations by Daniel and Quitterie Cazes suggest.[97] It is quite possibly thanks to the journey, along the *via tolosana*, which Gelmírez made to Rome in 1100 with members of his curia to be ordained subdeacon that the incipient Compostelan workshop came into contact with the sculptors of Tolosa and, as we shall see, with Roman marblers. The second master, responsible for the magnificent twisted columns – the "Master of the Twisted Columns" – was also trained in the tradition of Jaca, but he distinguished himself for remaining more

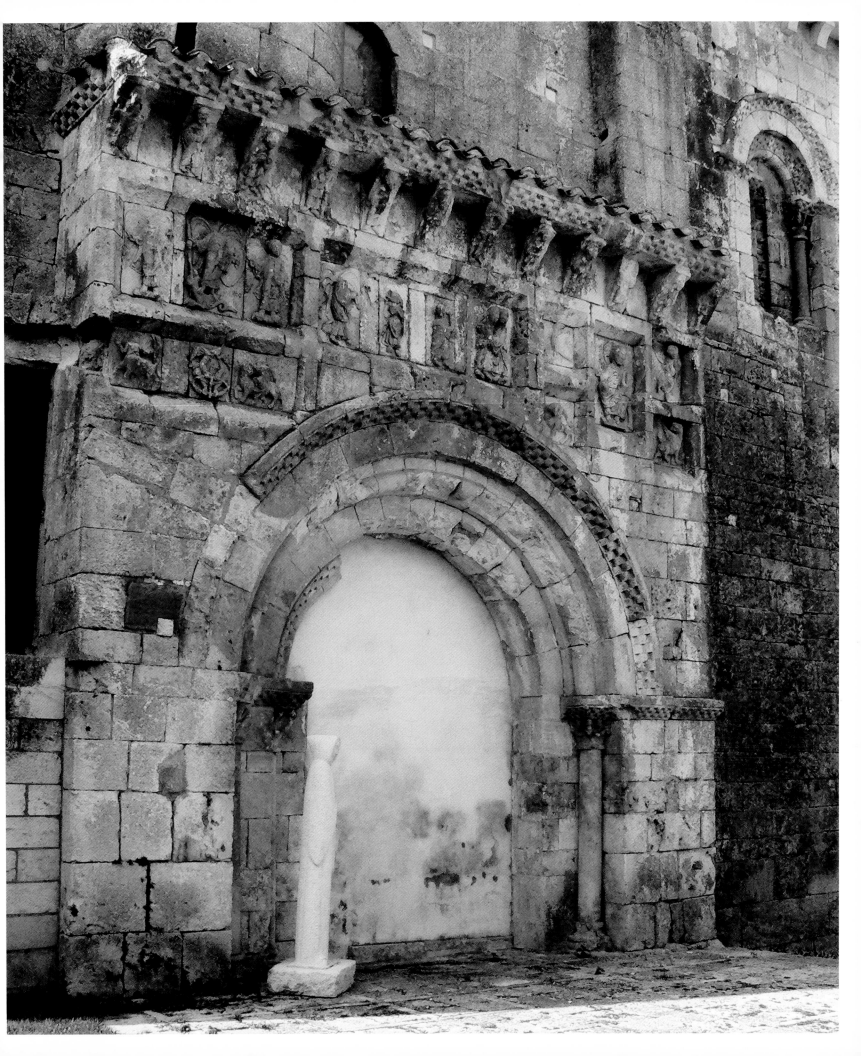

The Story of Adam and Eve
[Moutier-Grandval's Bible,
Add. 10546, fol. 5v]
840
BL~The British Library, London

The Expulsion of Adam and Eve
[Platerías *Door*]
Master of the Betrayal
1101–1111
Cathedral of Santiago de Compostela

faithful to the Classicism that characterized this workshop and enriching it with the novelties of the contemporary Roman experience. Added to these two is the epigonal "Master of the *Puerta del Cordero*" (Door of the Lamb), who favored geometrical volumes, smooth surfaces, timeless faces, bulging eyes, and a tendency to frontality (the Christ Pantocrator of the left-hand counterfort of *Platerías*, *Sign of Matthew*, *Creation of Eve*). He was a local sculptor, familiar with the Jaca tradition and the work of the "Master of the *Porta Francigena*," but incapable of articulating an artistic monumental language of sophistication. Lastly, also working on the *Porta Francigena* was a fourth artist, who came from a very different professional background: the Master of the Betrayal. He was a follower of the Master of the Temptations or of Conques – active only in *Platerías* – and was an expert in the art of narration, typically portraying figures in three-quarter profile, with naïve expressions, dug-out pupils filled with glass paste, large moustaches, thick folds around the lower half of their bodies and a marked bulkiness (*Reprimanding* and *The Expulsion of Adam and Eve*).

Extraordinarily for such dates, the reliefs executed by these four masters covered – as they did in *Platerías* – the entire surface of the facade: jambs with Apostles, ox-headed pilasters, lion-topped outer spandrels, the tympanum of the left-hand entrance showing the Annunciation, and the profusely decorated

frontispiece. Sitting directly over the portal's arches, the latter consisted of two friezes made of small stone panels showing, on the left, profane reliefs of the Months of the Year, and personifications of sin in the form of the *Centaur*, the *Siren*, the *Crossbowman*, and the *Man Riding a Rooster*. These last four reliefs, each similarly quadrangular in shape, were originally part of the series of images of "beasts, men, angels, women, flowers and other creatures"[98] that decorated the original portal and which, in the eighteenth century, were moved to *Platerías*. Although we do not know their exact location on the original facade, some indications suggest that they had occupied the frieze above the right-hand door, in perfect symmetry with that of the Months, situated, according to the "Guide," over the left-hand door. A possible echo of this arrangement of square reliefs on the frieze is found on the north door of San Quirce in Burgos, which dates from the second quarter of the twelfth century, where stone panels depicting a Centaur, a Crossbowman, and Samson and the Lion, decorate the frieze above the left entrance.[99]

Surprisingly, the Burgos portal presents further coincidences with the portals of the transept in Santiago, suggesting that the former was directly inspired by the original configuration of the latter. From a topological point of view, the frontispiece of the north door of San Quirce is totally covered in square and rectangular reliefs, as were the *Francigena* and *Platerías* doors, and the eaves are decorated with figured corbels, like the south door of the Compostelan Cathedral. Iconographically, many of the themes found decorating the facades of the transept in Compostela are also recreated in San Quirce: the Christ in Majesty surrounded by a Tetramorph and the Annunciation of the Burgalese facade occupied, on the *Porta Francigena,* the center and one of the tympanums, while the apostolate decorating the eaves was located on the *Platerías* frontispiece.

All the pieces of the profane repertory of the original north door in Santiago, believed to be the work of the Master of the *Porta Francigena*, alluded to the consequences of the Original Sin, the story of which was related on the contiguous upper frieze. The music of the Siren's voice, ever since the Odyssey was a sign of the enchantment of destructive seduction, is here synonymous of the deceit and bewitchment of worldly pleasures. The figure is wounded by the Centaur's arrows in an allegory of the fight against evil. The stone panels would have served as metaphorical references to Eve's greed and to the seductive power of the devil. The Crossbowman – an image of discord – magnifies the effects of the Original Sin, for one must not forget that the crossbow was not only execrated at that time for its capacity to kill but it was also considered to be a weapon of the devil, and its use was made punishable by the Second Lateran Council.[100]

The frontispiece was presided, just above the profane cycles, by a large historiated frieze depicting Biblical themes and made up of a great many pieces narrating the story of the Creation and the Fall of Adam and Eve, following the illustration models of the Carolingian Bibles. Above this was the figure of the Pantocrator with the four symbols of the Evangelists. Very probably, this great Biblical episode was flanked by rectangular stone panels depicting the promise

Man Riding a Rooster [Platerías Door]
Master of the Porta Francigena
1101–1111
Cathedral of Santiago de Compostela

98 *Liber Sancti Iacobi Codex Calixtinus...* op. cit., V, 9.
99 M. Castiñeiras, "A poética das marxes no románico galego: bestiario, fábulas e mundo ó revés," *Semata. Profano y pagano en el arte gallego...* op. cit., pp. 293–334. "La meta del Camino: la catedral de Santiago de Compostela en tiempos de Diego Gelmírez"... op. cit. Regarding the Cathedral of San Quirce in Burgos, see the thought-provoking study by D. Rico Camps, *Las voces del Románico. Arte y epigrafía en San Quirce de Burgos* (Murcia: Nausicaa, 2008), esp. p. 89.
100 "A poética das marxes no románico galego: bestiario, fábulas e mundo ó revés"... op. cit.

of Redemption: *David the Musician Defeating the Devil*, the *Sacrifice of Isaac*, the *Woman with the Lion*, the *Grape Woman*. The mysterious content of these two *imagenes feminarum*, referred to in the "Guide," should be interpreted Christologically, as an allegory of the two natures – divine and human – of Christ: the lion as vanquisher but also as the sacrificial victim.[101] From a formal perspective, the untidy hair, violent movements and enormous plasticity point to a synthesis of the traditions of Jaca and Toulouse on the part of the Master of the *Porta Francigena*. In conclusion, if the early monumental association between an episode from Genesis and the Months offered the possibility of redemption of sin through work, hope for the Second Advent of the Messiah was expressed through its prefiguration in David and Isaac, and in the feminine attributes of the Lion of Judah and of the Vine of the Eucharistic sacrifice. Lastly, the content of this message of redemption was rendered explicit in the relief of the Annunciation.

Like some grand stage decoration, the iconographic program of the primitive north door partook fully of the functional and symbolic character of the urban space it defined. The "plaza," denominated *Paradisus*, was not only an emulation of the Paradise of the Old Saint Peter's in Rome, but also an attempt to evoke the aspect of the Biblical Eden. This *locus amoenus* was signified by a fountain – the *fons vitae* – crowned by four lions that spouted water in the manner of the Rivers of Paradise, and by the presence, in the frontispiece of the facade, of finely carved stone panels showing vegetal decoration beside historiated reliefs of the Fall of Adam and Eve. All of this composed a perfect backdrop for the celebration of the penitential rites of Ash Wednesday befitting a pilgrim center.[102] Added to this was the novel reformist influence evident in the facade's iconography, which associated for the first time the friezes of Genesis and the Months in a truly optimistic vision of the history of mankind through the redemption of work.

Although unfortunately destroyed between 1757 and 1758, numerous pieces of the ornamentation of the original *Porta Francigena* have survived, some of which are kept in the Cathedral Museum: the *Twisted Columns*, *Month of February*, *Woman of the Bunch of Grapes*, *The Reprimanding of Adam and Eve*, and many others were reused in the frontispiece (*Annunciation*, *Sign of Matthew*, *Expulsion of Adam and Eve*, *Eve Suckling Cain*), jambs (*Crossbowman*, *Man Riding a Cockerel*, *Lion Woman*), and counterforts of *Platerías*[103] (*David*, *Creation of Adam*, *Creation of Eve*, *Sacrifice of Isaac*). Due to their exceptional quality, it is particularly worth noting the six twisted marble columns preserved in the Cathedral Museum in Santiago. They were originally part of the decoration of the mullioned door of the facade that gave onto the *plaza* called *paradisus*. Moralejo was right to see in the systematization of this urban space an evocation of Old Saint Peter's in Rome, where there was also a *paradisus* in front of the basilica as well as an apostolic pergola on the main altar with helical shafts decorated with wine harvesting *putti*.[104]

The motifs recreating these themes on the Compostelan shafts, however, refer more to the interpretations of Roman marblers working on the columns of Saint Peter's at the end of the eleventh century – such as those of Santa Trinità dei Monti

101 S. Moralejo, "La primitiva fachada norte de la Catedral de Santiago," *Compostellanum*, vol. 14, 4 (Santiago de Compostela: 1969), pp. 623–68.

102 "La imagen arquitectónica de la Catedral de Santiago"... op. cit.

103 "La primitiva fachada norte de la catedral de Santiago"... op. cit.

104 S. Moralejo, "Saint-Jacques de Compostelle. Les Portails retrouvés de la cathédrale romane," *Les dossiers de l'archéologie*, 20 (Paris: 1977), pp. 87–103. "La imagen arquitectónica de la Catedral de Santiago"... op. cit. Id., "El patronazgo artístico del arzobispo Diego Gelmírez (1110–1140): su reflejo en la orba e imagen de Santiago," in L. Gai (ed.), *Pistoia e il Cammino di Santiago. Una dimensione europea nella Toscana medioevale* (Perugia: Centro Italiano di Studi Compostellani, 1987).

and San Carlo in Cave (c. 1093) – than to the Vatican model.[105] Indeed, the columns in Santiago were made probably not long after 1100, following Gelmírez's first journey to Rome to receive the dignity of subdeacon, before the pergola of Saint Peter's in the Vatican. Four of the six fragments of shaft measure 1.85 m high and it is clear from looking at them that they had a fourth decorated bundle that is missing today. This suggests that originally the shafts would have reached 2 m in length, as do those of Cave and Trinità dei Monti in Rome, and in addition to this there would have been a base and a capital, so that they would have easily reached the 2.4 m cited in Roman medieval copies and not, of course, the 5 m that the columns of the Vatican's pergola measure. This particularity suggests the existence of a model that circulated around the workshops of Roman marblers at the end of the eleventh century[106] and which became known to Gelmírez's entourage during his two visits to Rome. In fact, there is an evident similarity between the compositional and ornamental designs of the Roman medieval columns and those of Santiago. Examples of this are the vintager Cupid beside a bird, the *putti* eating a bunch of grapes, the pests biting the vine, and the birds pecking at the grapes.

In either case, whether in Rome or in Compostela, it seems that these copies or serial imitations of the columns of the pergola of Saint Peter's all sought to highlight, in the choice and repetition of the motifs, an ecclesiological significance that reflected the ideals of the art of the Gregorian Reform. This message is perfectly clear in Santiago, for in the *Liber Sancti Jacobi*, in the Sermon of the Passion of the Apostle (25 July), mention is made of the *barbarae ferae* and the *vulpes hereticae*, represented in Cave, Trinità dei Monti and Santiago, as enemies of the apostolic vintager of the Church's vine. The same can be said of the representation of the birds on another shaft, which, as in the Roman examples, wickedly peck away at the vine. However, in the case of Compostela, on one of the shafts a Cupid grips a dove by its neck in an attempt to protect his hard work in a direct correspondence with the contents of the verses of a hymn by San Fortunato, contained in the same sermon of the *Codex Calixtinus*: "*La uva hinchada en el pámpano, que pasto / sería de los pájaros, con este / guardián el buen lagar no ha de perderla.*"[107] The original *Porta Francigena* thus adhered to the ideal of art propounded by the Gregorian Reform and which could be seen emerging in monumental sculpture beyond Rome, both in the *Porte Miègeville* as in the western front of the Cathedral of Modena.

This Roman lesson is crucial in understanding the art in Compostela during Gelmírez's time, particularly at its apogee, from 1100 to 1122. It is therefore wrong to talk of a "Gelmirian art" prior to 1100–1101. Only when Diego Gelmírez fully embarked on his ecclesiastical career, obtaining the dignity of subdeacon and later that of Bishop, was he able to develop in Compostela a perfectly coherent and avant-garde figurative program. As Moralejo observed, Rome became, as a result of the two journeys Gelmírez undertook in 1100 and 1105, an ideological point of reference in the ecclesiarch's decorative program, as is borne out by the twisted columns and the systematization, in 1105–1106, of the altar and silver baldachin echoing the style of the liturgical objects of Roman basilicas.[108] All this of course had

105 "Roma e il programma riformatore de Gelmírez nella catedrale de Santiago"… op. cit. "La meta del Camino: la catedral de Santiago de Compostela en tiempos de Diego Gelmírez"… op. cit.

106 P. C. Claussen, "Römische Skulptur aus der zweiten Hälfte des 11. Jahrhunderts," in A. Franco Mata (ed.), *Patrimonio artístico de Galicia y otros estudios. Homenaje al Prof. Serafín Moralejo Álvarez*, vol. 3:3 (Santiago de Compostela: Xunta de Galicia, 2004), pp. 71–80. Id., "Un nuovo campo della storia dell'arte. Il secolo XI a Roma," in J. Eckell and S. Romano (eds.), *Roma e la Riforma Gregoriana. Tradizione e innovazione artistiche (XI–XII secolo)* (Rome: Viella, 2007), pp. 61–71.

107 *Liber Sancti Iacobi Codex Calixtinus*… op. cit., I, 6, p. 41.

108 S. Moralejo, "Ars sacra et sculpture romane monumentale : le trésor et le chantier de Compostelle," *Les Cahiers de Saint-Michel de Cuxa*, 11 (Cuxa: 1980), pp. 189–238.

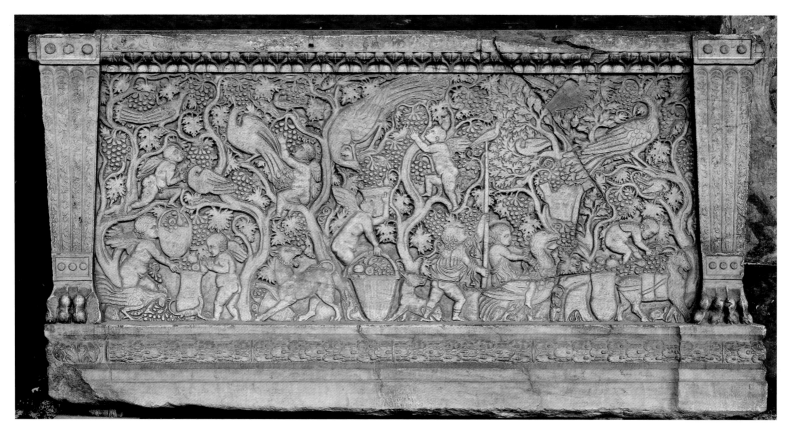

Sarcophagus of Pope Damasus II
(†1048)
third century
Church of San Lorenzo fuori
le Mura, Rome

repercussions on the development of monumental sculpture: if the journey of 1100 yielded the magnificent work by the Master of the Twisted Columns, the visit of 1105 to San Lorenzo fuori le Mura, to receive the Pallium, unquestionably influenced the evolution of the Master of the *Porta Francigena*, whose stone tablets showing the *Man Riding a Rooster* and the *Horn Blower on a Lion* were the result of having had recourse to a Dionysian repertory belonging to a late-Antiquity, third century, sarcophagus that was reused as a tomb for Pope Damasus (†1048) in the aforementioned Roman basilica.[109]

PLATERÍAS: THE BISHOP'S DOOR

THE ENIGMA OF A STONE PALIMPSEST: FROM THE FIRST PROJECT OF THE MASTER OF CONQUES (1101–1103) TO A SECOND PROJECT (1103–1111)

> "*Compre imaxina-lo nacer e crecer do pórtico das Praterías e o rumor de interpretacións que acompañou desde os primeiros días, as fermosas e expresivas esculturas nun tempo en que a cultura simbólica e imaxinativa non necesitaba de filtros críticos e non diferenciaba o imaxinado da súa representación.*"[110]

Access to Santiago Cathedral's south door is gained via *Platerías*, which communicates the southern arm of the Compostelan Basilica with the nowadays bustling *plaza* of the same name. Tradition says that it owes its name to the silversmiths' shops established around the square since at least the Modern age. Both the aspect of *Platerías* and its commercial activity have changed, however, with regard to the square's original, medieval organization. Although there remain many unanswered questions, in the absence of a systematic excavation of its urban setting it is possible

109 "Roma e il programma riformatore de Gelmírez nella catedrale de Santiago"... op. cit.
110 R. Otero Pedrayo, *Xelmírez xenio do Románico* (Vigo: Galaxia, 1993), p. 194.

to affirm that its *frontis* has undergone several alterations practically since its conception and that, as we shall see, it originally served as a smaller door of representation for the Compostelan bishopric and was more connected with the present-day *Rúa del Villar*.

As far as the actual facade is concerned, fortunately there survive two descriptions of its state from before the eighteenth century. The first and most notorious is given in the "Guide" of the *Codex Calixtinus*, a book written around 1137, that is, by someone living at the time of, or just after, the completion of the facade in 1111. The second description, less famous though more akin to the modern observer's perception, is given by Mauro Castellá y Ferrer in his *Historia del Apóstol de Jesús Christo Santiago Zebedeo*, published in 1610.[111] The latter likens the facade to a veritable lapidary museum that accumulated relics from other places. This is a fair comparison, since, as we shall presently see, from the earliest times, its walls were the destination for pieces removed from other facades, endured the consequences of two sieges, and underwent at least three medieval restorations. Hence its condition of stone palimpsest: its existence is like that of a parchment, whose letters have largely been erased due to the treachery of time and to the desire to "wash" it in order to rewrite its history.

Firstly, Castellá y Ferrer affirms, incorrectly, that "*muchas imagines, figuras y colunas de rico mármol perfectamente labradas, que estan en las pueras de Mediodía, Setentrión y principal de Occidente*" originally belonged to the Basilica of Alfonso III,[112] for in the extended version of the proceedings of its consecration reference is made to the transportation, from Portugal to southern Spain, of rich and sumptuous stone tablets and marble columns destined for the construction of the Alfonsine Basilica.

He arrived at this erroneous conclusion because of the very mise-en-scène of the three portals:

> "*Es gran argumento, que muchas destas figuras, y columnas no fueron hechas para los lugares adonde estan, sino que las hallaron en las ruynas deste templo, de que aquí se trata, que fue derribada gran parte del por le moro Almançor y las pusieron allí, cuando se hizo el que ahora vemos en el tiempo del Católico Rey don Alfonso Sexto.*"[113]

To support his theory he adduces the state of the right-hand tympanum of *Platerías*, dedicated to the Infancy and Passion of Christ:

> "*El ver que entre estas ay algunos passos de la pasion de nuestro Redentor, y que junto con ellos estan mezclados otras imágenes de santos, que novienen con aquellos passos, y otras de animales diversos; de suerte, que se vee que no fueron hechas para allí, ni en tamaño ni en traça, ni vienen con la de las portadas, sino que hallandolas en diferentes partes de la Iglesia, las pusieron allí engastadas, para hermosear las portadas, como pedrería en alguna pieça de oro o plata.*"[114]

Castellá was possibly wanting to refer to the chaotic arrangement, above the left-hand side of the said tympanum, of the bust of a saint holding a book, placed horizontally in the foreground of the tympanum, above a stone panel showing the healing of the

111 M. Castellá y Ferrer [Madrid: Oficina de Alonso Martín de Balboa, 1610], *Historia del Apóstol de Iesús Christo Sanctiago Zebedeo Patron y Capitan General de las Españas* (Santiago de Compostela. Xunta de Galicia, 2000), IV, 19, pp. 464v–465r.
112 Ibidem, p. 464v.
113 Ibidem.
114 Ibidem, p. 465r.

blind man, and to the inexplicable presence of a bear that appears in the second ground, behind the genuflecting Magi of the Epiphany scene.

Certainly, both figures – the saint and the bear – seem to be "add-ons" or "*pastiches*" of the original composition, for if we read the description of the south door given in the "Guide" of the *Calixtinus*, we find that there is no mention of these pieces but only of two "admirably sculpted" registers:

> "*En la entrada de la derecha, por la parte de afuera, en primer término sobre las puertas, está admirablemente esculpido el prendimiento del Señor. Allí por manos de los judíos es atados de las manos a la columna, allí es azotado con correas, allí está sentado en su silla Pilatos como juzgándole. Arriba en cambio en la otra línea está esculpida Santa María, madre del Señor, con su hijo en Belén, y los tres reyes que vienen a visitar al niño con su madre, ofreciéndole el triple regalo, y la estrella y el ángel que les advierte que no vuelvan junto a Herodes.*"[115]

Mauro Castellá y Ferrer's antiquarian vision of the Romanesque portals of the Compostelan cathedral's transept – as a sort of lapidary museum that accumulated relics brought from other parts of the building – precedes that which, centuries later, the great French art historian Henri Focillon would formulate in regard to *Platerías*.[116]

The puzzle-like impression we get of the facade's stone tablets, with their irregular breaks and variations of size and shape, is due in part to the successive alterations made to an original project which, perhaps from its very inception, presented a certain maladjustment between its architectural design and its decoration. Indeed, the three exterior archivolts of the double doors intersect in the central spandrel before reaching the base – an entirely novel formula for the epoch – causing both the monogram of Christ and the pair of lions intended to embellish the said place to lack sufficient space and to protrude from the wall. This was something entirely different to what could be seen on the northern arm of the transept, whose mullioned door had amply separated archivolts.

There was, therefore, in *Platerías*, a deliberate effort to potentialize the space of the tympanums, in sacrifice of the harmony of a mullioned door, which, instead of being differentiated, was built to intersect at its center. In fact, the most logical solution – as seen in the *Porte des Comtes*, or western portal, in Toulouse – would have been to keep a perfectly mullioned door and follow the layout of the thirteen columns of the north door, whose interior columns were paired – 1 + 2 / 2 + 1 / 1 [pilaster] / 1 + 2 / 2 + 1 – and allowed for much smaller tympanums. In *Platerías*, on the other hand, there are only eleven columns – with the exception of two on either side of the central buttress – which stand at regulated intervals – 3 / 2 + 1 + / 2 / 3 –.

In the case of the original *Porta Francigena*, the tympanums presented no difficulty in terms of design as their decoration was minimal, as the *Calixtinus* tell us. Only the left-hand tympanum had a plain marble tablet depicting the Annunciation – Gabriel and Mary – which was relocated to the *Platerías* facade in the eighteenth

115 *Liber Sancti Iacobi Codex Calixtinus...* op. cit., V, 9, pp. 360–1.
116 H. Focillon [*L'art des sculpteurs romans. Recherches sur l'histoire des formes*, Paris: E. Leroux, 1931], *La escultura románica. Investigaciones sobre la historia de las formas* (Madrid: Akal, 1986), p. 46.

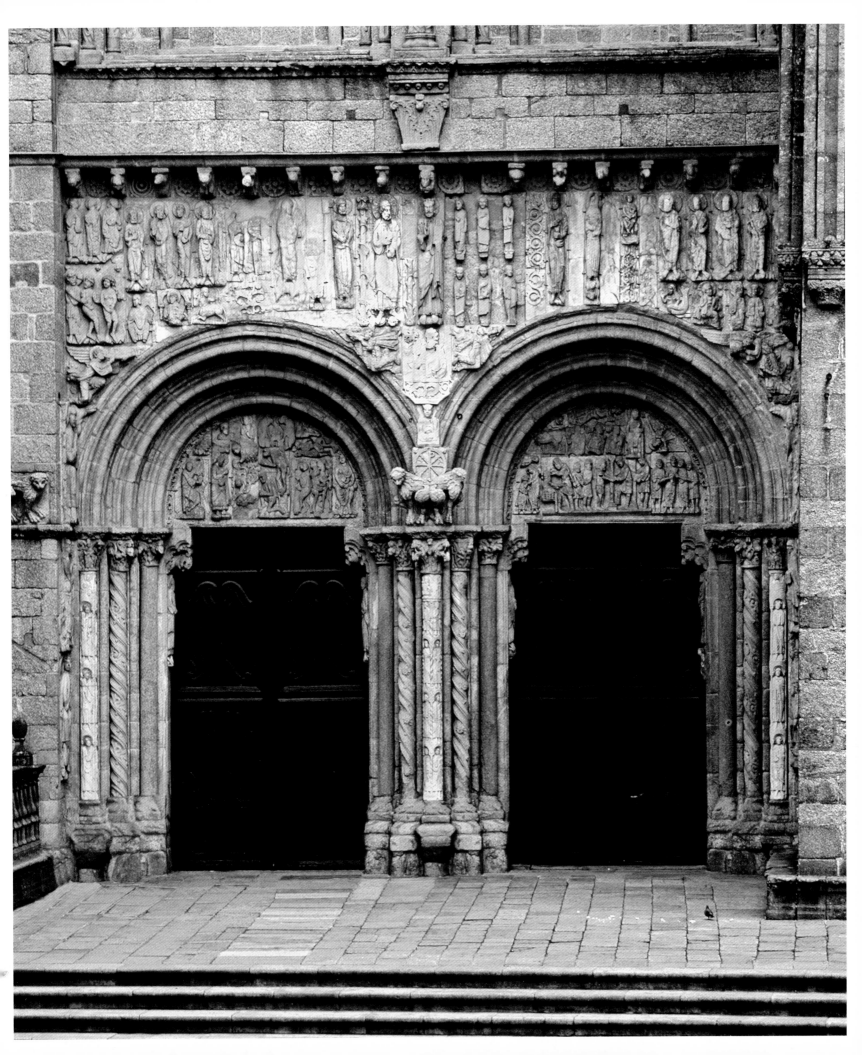

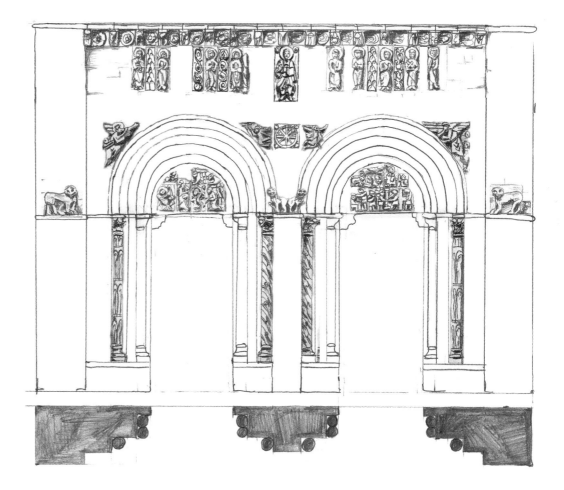

117 "La primitiva fachada norte de la
Catedral de Santiago"... op. cit., p. 648.
118 This hypothesis was first formulated
in "La catedral románica: tipología
arquitectónica y narración visual"...
op. cit., p. 56.
119 O. Næsgaard, *Saint-Jacques de
Compostelle et les débuts de la
grande sculpture vers 1100* (Aarhus:
Universitetsforlaget, 1962), p. 16.

century. It is very likely that this old tympanum dated from this primitive stage in which tympanums had no, or very little, figurative decoration (*Porte des Comtes*).[117] As with the western portal at Jaca, the stone panels are rectangular in shape and difficult to fit into a semicircular shape.

We do not know how or when, but we suspect that a heated discussion regarding the decoration of the tympanums of *Platerías* took place in those early years of the twelfth century, which resulted in the drawing up of two consecutive projects. The first sought to respect the widths of the door of *Platerías* and of the tympanums of the *Francigena*. In my view, the workshop responsible for this first decoration of the southern front was directed by the "Master of the Temptations" or "of Conques," and the reliefs it made were for a project that never saw the light of day. This project consisted of two smaller, less crowded tympanums, thirteen columns, and a perfectly separated mullioned door.[118] The reliefs were executed but not the architectural plan for which they had been conceived. Hence the irregularities we can see today in the left tympanum, where the upper contours of the four reliefs shaping the temptations of Christ suggest, as Ole Næsgaard[119] has observed, that they were originally conceived for a smaller arch and when mounted onto a structure affording the tympanum a larger space, necessitated that the tympanum be filled in with lots of stone panels, hence the rather chaotic aspect that characterizes it. The second project, which gave rise to the architectural plan we see today, gave greater protagonism to the tympanums, requiring the

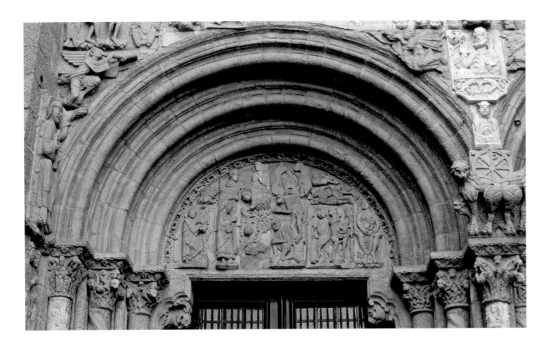

Left-hand tympanum [Platerías
Door]
1101–1111
Cathedral of Santiago de Compostela

Left-hand tympanum [Platerías
Door, detail]
Master of the Temptations
1101–1103
Cathedral of Santiago de Compostela

Right-hand tympanum [Platerías
Door]
1101–1111
Cathedral of Santiago de Compostela

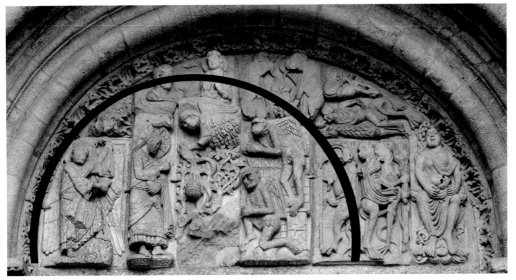

75

Platerías Door, Cathedral of Santiago de Compostela, 1111 *[hypothetical reconstruction]* Victoriano Nodar

120 S. Moralejo, "Artes figurativas y artes literarias en la España medieval: Románico, Romance y Roman," *Boletín de la Asociación Europea de Profesores de Español*, vol. 17, 32–33 (Santander: 1985), p. 66. Id., "Cluny et les débuts de la sculpture romane en Espagne," in *Le gouvernement d'Hugues de Semur à Cluny* (Mâcon: Buguet-Comptour, 1990), p. 42. M. Castiñeiras, "*Introitus pulcre refulget*: algunas reflexiones sobre el programa iconográfico de las portadas románicas del transepto de la Catedral," in *La meta del Camino de Santiago. La transformación de la catedral a través de los tiempos*... op. cit., pp. 85–103. J. Williams, "La Mujer del Cráneo y la simbología románica," *Quintana*, 2 (Santiago de Compostela: 2003), pp. 13–27.

121 "Artes figurativas y artes literarias en la España medieval: Románico, Romance y Roman"... op. cit., p. 68. S. Moralejo, "Artistas, patronos y público en el arte del Camino de Santiago," *Compostellanum*, 30 (Santiago de Compostela: 1985), pp. 418–21. "*Introitus pulcre refulget*: algunas reflexiones sobre el programa iconográfico de las portadas románicas del transepto de la catedral"... op. cit., pp. 94–5.

involvement of another master to fill them in. Whereas the reliefs depicting the temptations are ascribed to the so-called "Master of Conques," this chaotic infill must have been the work of the so-called "Master of the *Porta Francigena*," who, as his name suggests, was the great artifice of the decoration of the north door (the *Creation of Adam*, *David*, the *Lion Woman*, the *Woman of the Bunch of Grapes*, the *Month of February*) and who placed, on the right-hand side of the left entrance in *Platerías*, the following reliefs (among others): the *Three Cynocephalus Demons at the Doors of Hell*, the *Horn Blower on a Lion*, and a lone *Woman with a Skull*.

In all probability the statue of the mysterious woman with the skull[120] was originally conceived for the right-hand tympanum of the original North Door, for its profane and moralizing contents tie in with another story depicted on one of the twisted columns on the same facade: certain episodes of the ill-fated love of Tristan and Iseult. As Moralejo pointed out, this theme was treated a few decades prior to its written depiction in *Roman de Tristan*. In the lower section, the warrior who appears to be unconscious or slumbering in a small boat, his horse standing by, echoes the journey Tristan makes to Ireland in search of the ointment that can save his life after being wounded by Morholt's poisoned spear. The second and third sections seem to evoke the hero's second journey to Ireland, during which, following a fight with a dragon, is nursed and his wounds dressed by Iseult.[121] But nobody until now has noticed that, according to the version of Gottfried von Strassburg (1205–1210), Tristan, in the presence of his uncle, Mark of Cornwall, is moved by a Welsh harpist's rendering of a beautiful melody – the *Lai Guiron* – which tells the story of how a woman's husband murders her lover and forces her to eat his heart served to her at table:

"In due course it came about that on occasion Marke sat a little after dinnertime, when entertainment was the custom, listening attentively to the verses of a lay his harpist performed, a master of his craft, the finest anyone knew. The fellow was a Gaulois. Then came Tristan, the Parmenois, and sat down at the singer's feet. And listening with rapt attention to the verses and fluid melody, even had it been forbidden, he couldn't have concealed his feelings. His emotions got the best of him, flooding his heart with recollection. 'Master,' he said, 'you're a fine harpist. You do the melody very well, with just the intended sense of yearning. The Brituns composed it, you know, about my Lord Gurun, and about his beloved.'"[122]

In this early context of the *Porta Francigena*, the image acquires full meaning since it would have served as an *exemplum libidinis* of the consequences of wild love such as that of Tristan and Iseult, which always led to the tragic death of its protagonists. The figure, in its "exile" in *Platerías*, would not, however, have lost its tragic and moralizing force for in the words of the "Guide" in the *Calixtinus Codex*, there was always some comment made about it that was not far removed from the *lais* sung by Tristan:

> "*Y no ha de relegarse al olvido que junto a la tentación del Señor está una mujer sosteniendo entre sus manos la cabeza putrefacta de su amante, cortada por su propio marido, quien la obliga dos veces por día a besarla. ¡Oh cuán grande y admirable castigo de la mujer adúltera para contarlo a todos!*"[123]

Returning to the original project of *Platerías*, I would like to focus our attention on this Master of the Temptations or of Conques, unquestionably an inheritor of the style of Conques during the period of Abbot Bégon III (1087–1107) and who very probably also worked on the great western portal of the French abbey.[124] The latter is characterized by its figures, in profile and three-quarter view, that present round faces framed by a cap of hair, broad noses, a short and stocky build, "ironed" folds in their robes, a great variation in the position of the feet on the cornices, and a propensity for inscriptions and anachronistic clothing.

It is not by accident that this master was hired to decorate the two tympanums in the first project for *Platerías*. In fact, on the right-hand lunette the stone tablets that can be attributed to him – the Crown of thorns and Flagellation and the Epiphany – originally formed the lunette's composition. It consists of three rectangular panels, one slightly wider and higher and conceived for the lower section (Coronation-Flagellation) and the other, lower and narrower, which was designed to appear above them in the upper section. Both would have fit together perfectly so that the Virgin would have occupied the center of the semi-circumference, above the column of the flagellation, as the pedestal supporting her feet seems to indicate. But with the change of plan and the execution of wider tympanums, the tablet of the Epiphany was placed differently – to the right – so that the Virgin, intended to preside over the semi-circumference, could not fit into the space proposed for her – the start of the descent of the curve – making it necessary to sever her halo and shave the pedestal.

As with the former, for this tympanum depicting the infancy and passion of Christ it was necessary to enlist the help of a second master who had also been actively involved in the *Porta Francigena*: the Master of the Betrayal. This master

122 This is an old Breton song about the fate of Master Gurún and his beloved, known as the *Lai de Guiron*: Gottfried von Strassburg, *Tristán e Isolde*. L. Stavenhagen, *A Musical Translation* [online] 2001, 2004 <http//stavenhagen.net/GvS/Tris.html>.

123 *Liber Sancti Iacobi Codex Calixtinus…* op. cit., V, 9, p. 562.

124 J. Williams defends this connection with new arguments in "Arquitectura del Camino de Santiago?"… op. cit. See also P. Deschamps, "Études sur les sculptures de Sainte-Foy de Conques et Saint-Sernin de Toulouse et leurs relations avec celles de Saint-Isidore de Leon et de Saint-Jacques de Compostelle," *Bulletin Monumentale*, 100 (Paris: 1941), pp. 239–64, and G. Gaillard, "Une abbaye de Pélerinage: Sainte-Foy de Conques et ses rapports avec Saint-Jacques," *Compostellanum*, vol. 10, 4 (Santiago de Compostela: 1965), pp. 335–46. I have recently explored further the Conques-Platerías relationship: "Da Conques a Compostella: retorica e performance nell'era dei portali parlanti," in A. C. Quintavalle (ed.), *Medievo: Immagine e Memoria* (Milan: Electa, 2009), pp. 233–51.

ERA ICXLI / V IDVS I[V]LII *[Platerías Door]*
1103
Cathedral of Santiago de Compostela

was an expert in the art of narration, who favored three-quarter figures, with naïve expressions on their faces, dug-out pupils filled with glass paste, large moustaches, thick folds about the lower half of their bodies and a marked bulkiness. Responsible mainly for the more dramatic scenes of the Genesis episode on the north door (the Reprimanding and Expulsion of Adam and Eve), his task was to "fill in" the primitive project of the right-hand tympanum in *Platerías* (the episode of the Passion), with the following scenes: to the right the taking down of Christ and the angel with the nailed crown; above, in the middle, the angel in the *serpentinata* posture hovering above the Magi; and on the left, the curing of the blind man. All these reliefs present more elongated forms and are fixed to the wall by means of iron clasps, except the lower ones, which lack the solid cornice indicating the ground line used by the "Master of Conques." Castellá y Ferrer, at the start of the seventeenth century, saw these iron clasps as visible proof that they had not been made for that site:

> "[...] *porque no entran por las paredes de adentro, sino que en hierros que metieron entre ellas (porque son delgadas) encaxando los mismos hierros en la pared, las pusieron en ella, de suerte, que pudieron sustentarse como ahora se vee; y algunas descarnándolas las aguas se han caydo,quedándose allí los hierros como se vee donde estuvieron.*"[125]

Nevertheless, this systematization of reliefs supported by iron brackets that we see in *Platerías* was also used on the *Porte Miègeville* in Toulouse at the same time, and was peculiar to the Romanesque style.

Thus the final result of *Platerías* reflects the mismatch between a first project, based on smaller tympanums and decorated by the "Master of Conques," and a second project, which sought to create a wider entrance, making it necessary to broaden the space for the tympanums and fill it in with other panels made by the so-called "Masters of the *Porta Francigena*" and of "the Betrayal." This allows me to affirm that the "chaos" of *Platerías* was not intentional and that the failure of its systematization was due to a certain improvisation.

But when did the change of project occur? According to the *Historia Compostellana*, Gelmírez decided to build his first palace following his Episcopal consecration, on 21 April 1101.[126] The said palace occupied the space adjacent to what later became the *Platerías* Door, on a site referred to in the documents as the *platea*, as it occupied an elevated area designed to mark out the area of the palace and southern front of the cathedral, both of which overlooked the city. The inscription on the left jamb of the right hand entrance of *Platerías* – 11 July 1003 – tells us when the elevation was begun, which we know was a feature of the second project. This means that by 1103 the reliefs of the "Master of Conques" had been completed. Therefore, the tablets of the Temptations and the Passion of Christ, conceived for the first project, must have been executed between 1101 and 1103.

It is my view that the Master of the Temptations or of Conques arrived in Compostela in around 1101, perhaps to make the tympanums of *Platerías*, although

125 *Historia del Apóstol de Iesus Christo Sanctiago Zebedeo Patron y Capitan General de las Españas...* op. cit., IV, 19, p. 465r.
126 "Construcción y consagración de una iglesia en el monte del Gozo. Palacios pontificales. Regla y número de los canónigos," *Historia Compostelana...* op. cit., I, 20, p. 110.

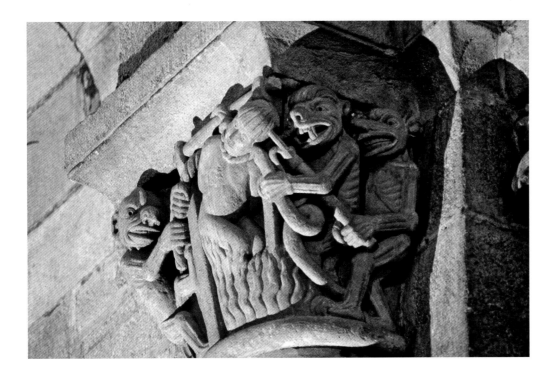

Capital [*Northern wing
of the transept*]
c. 1101–1103
Cathedral of Santiago de Compostela

we know he also made the famous capital depicting the Punishment of the Miser
on the southern arm of the transept. He would have been trained in the workshop
of the Abbott Bégon, responsible for realizing, in Conques, both the capitals
of the nave's tribune and the decoration of the cloister, the completion of which
around the year 1100 seems quite plausible. In Compostela he was faced with
a challenge: to go from making capitals to making panel-friezes destined for
tympanums. Following his stint in Compostela, he may have returned, with the
Master of the Betrayal, to Conques on the same journey that Gelmírez undertook
to Cluny, in France, in 1105.[127] There, both may have joined the workshop that
was then working on the magnificent western door and pass on what they had
learned from their frustrated experience in Compostela: that of executing a vast
tympanum covered in reliefs instead of dividing it into small lunettes and a
frontispiece.

Regarding the facade's frontispiece, it appears that it was originally conceived
for a frieze of the Apostolate, a typology that became very popular in Spain during
the Romanesque period, with examples in San Quirce de Burgos (the north door),
San Pedro de Tejada, Santiago de Carrión, Moarves and Santa Maria de Ripoll.[128]
Nine of these twelve primitive apostles survive, and can now be seen rearranged
into two groups in the frieze, which was conceived to sit comfortably under twelve
of the sixteen figured corbels framing the facade. The same possibly occurred with
the tympanums: when they were definitively systematized a central group showing
the Transfiguration was added which had been originally conceived for the Western
door. These tablets must have been added fairly early on, perhaps around 1111,
if, as Williams recommends, we take the inscription of the Saint James between
cypresses, "ANF[US] REX," as an allusion to the coronation of Alfonso Raimúndez
in the Compostelan Cathedral.[129] This would therefore have constituted an alteration
to the initial project, made either near the start or when work was well underway,

127 "Da Conques a Compostella: retorica
e performance nell'era dei portali
parlanti"... op. cit.
128 R. Otero Túñez, "Problemas de la
catedral románica de Santiago,"
Compostellanum, vol. 10, 4 (Santiago
de Compostela: 1965), pp. 609–10.
"Saint-Jacques de Compostelle. Les
Portails retrouvés de la cathédrale
romane"... op. cit., p. 103. "La catedral
románica: tipología arquitectónica y
narración visual"... op. cit., p. 56.
129 J. Williams, "Spain or Toulouse
a Half Century Later. Observations
on the Chronology of Santiago de
Compostela," in *Actas del XXIII
Congreso Internacional de Historia del
Arte*, 1:2 (Granada: ugr~Universidad
de Granada, 1976), p. 561.

Abbey Church of Sainte-Foy
de Conques
c. 1030–1110
Aveyron

ahead of the coronation ceremony and not as a result of its restoration following
a fire in 1116 as has been argued until now.

Furthermore, the door endured two attacks. The first, well known by art
historians, occurred when the cathedral was besieged in 1116–1117. According to
Historia Compostellana, the Jacobean complex was seriously damaged as a result,
since the wooden scaffolding and centrings used in the construction caught fire and
left the primitive Gelmírez Palace in such a state that the Bishop considered moving
his residence from the south to the north side.[130] As López Alsina has pointed out,
it is no surprise that during the uprising the citizens besieged, looted and set fire to
Platerías for it was the maximum expression of feudal power.[131] Did the facade of
the palace share in common any type of sculptural adornment with the south door
of the cathedral? We do not know, but perhaps one or other of the pieces that
decorate *Platerías* today were to be originally found on the walls of the Bishop's
residence. The memory of the site of the first palace still lingered in the second
half of the fifteenth century. In fact, in the *Coronica de Santa María de Iria*, which
narrates a second siege of the cathedral in 1466 in which *Platerías* burned,[132] a
reference is made to the early Gelmírez Palace "*aos quaes agora dicen os paaços
vellos.*"[133]

The three medieval restorations of the facade were carried out partly as a
result of the aforementioned events. The first, the scope of which has always been
exaggerated by art historians, took place immediately after the fire, in 1116.[134]
In view of the numerous broken pieces and the danger of their falling, the iron
clasps may have been fixed then (hence why some can be found supporting even
securely placed plaques such as those showing the Temptations of Christ) and
both tympanums rather shoddily filled in. The second restoration was carried
out perhaps in an effort to re-monumentalize the cathedral's exterior, coinciding
with the completion of the western body between 1188 (when the lintels of the
Portico of Glory were put in place) and the cathedral's consecration in 1211.[135]
A workshop associated with Master Mateo is believed to have executed the
additional elements of the first floor (vegetally decorated archivolts for windows,
capitals and columns), gable end (rose window), and replaced the Transfiguration
of Christ, that had possibly been left in a damaged state since the fire of 1117,
for another, new one in the style of Mateo.[136] In my view, this piece shares some
similarity with that of the recumbent royal in the Royal Pantheon, Alfonso IX,
identified by Moralejo as Fernando II and therefore dating from around 1211.[137]
Lastly, the third restoration to be carried out in the medieval period was
undertaken by Archbishop Alonso II de Fonseca to repair the damage caused
by the acts of war narrated in the *Crónica de Santa Maria de Iria*. Thus was erected
the "*fincapié dos Ourives*" (1468–1484), which would later be used to elevate
the Bell Tower of the King of France (1484–1494) or Clock Tower.[138] With this
structure, the idea was to create a porticoed access to *Platerías* in the style of the
Hispano-Flemish retable-facades found in Castile, but the project did not prosper
and only the bases of the arch on the western side of the Tower of the King of
France were made.[139]

130 "Construyó un nuevo palacio,"
Historia Compostelana... op. cit., II, 25,
pp. 345–6.

131 "Implantación urbana de la catedral
románica de Santiago de Compostela
(1070–1150)"... op. cit., p. 51.

132 "*Poseron fogo ena Prateria et en derredor
de todas a egllesia et ardeu todo:*"
J. Carro García (ed.), *Coronica de Santa
Maria de Iria (codice gallego del siglo XV)*
(Santiago de Compostela: Instituto
Padre Sarmiento de Estudios Gallegos,
1951), p. 46.

133 Ibidem, p. 86.

134 "Problemas de la catedral románica
de Santiago"... op. cit., pp. 609–10.
R. Izquierdo Perrín, *Arte medieval I.
Galicia Arte*, vol. 10:15 (A Coruña:
Hercules Edicións, 1995), pp. 13–25.

135 M. Castiñeiras, *El Pórtico de la Gloria*
(Madrid: Ediciones San Pablo, 1999).
"La catedral románica: tipología
arquitectónica y narración visual"...
op. cit. "Platerías: función y decoración
de una "lugar sagrado'"... op. cit.

136 J. M. Pita Andrade, "En torno al arte
del Maestro Mateo: el Cristo de la
Transfiguración en la Portada de
Platerías," *Archivo Español de Arte*,
23 (Madrid: 1950), pp. 13–25.

137 "Raimundo de Borgoña (†1107)
o Fernando Alonso (†1214)? Un
episodio olvidado del Panteón Real
compostelano"... op. cit., pp. 161–79.

138 J. Vázquez Castro, "La Berenguela
y la Torre del Reloj de la Catedral de
Santiago," *Cultura, poder y mecenazgo...*
op. cit., pp. 111–48.

139 J. M. Caamaño, "El Gótico," in
M. Chamoso Lamas, *La Catedral de
Santiago de Compostela* (Leon: Everest,
1976), p. 250.

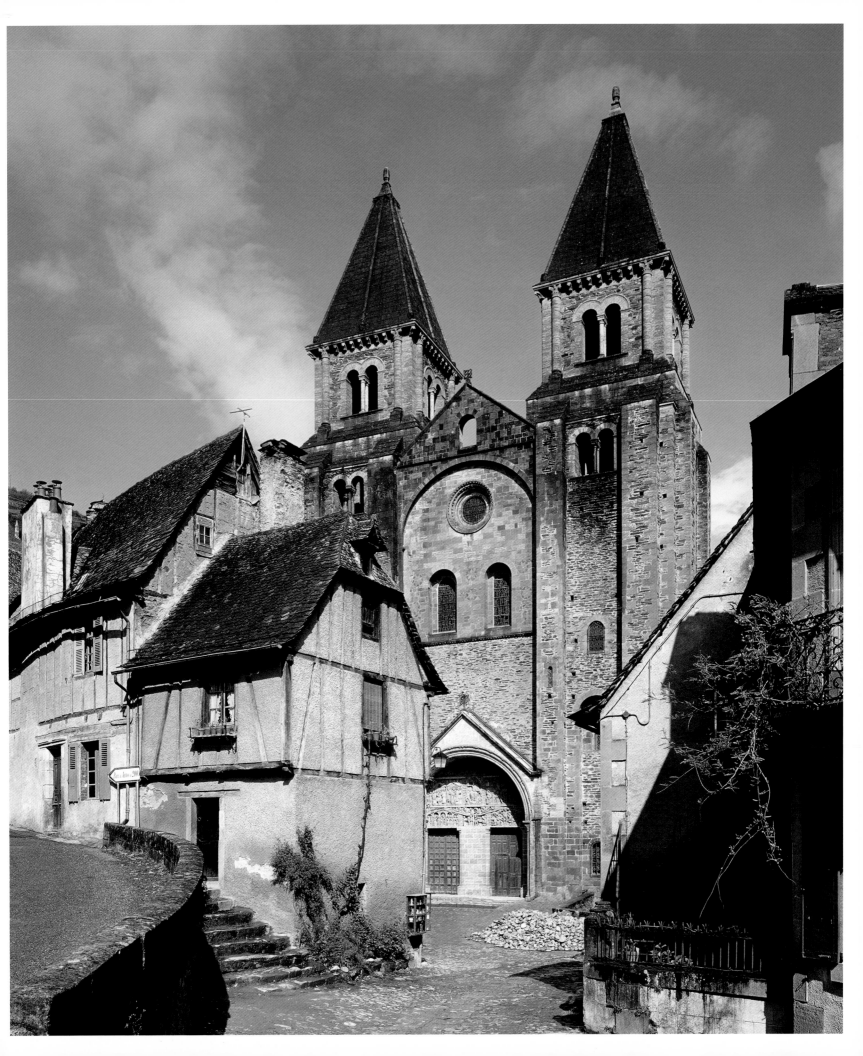

Castellá y Ferrer's antiquarian vision that Compostela Cathedral's portals were decorated with relics taken from other parts of the building is given credence in the destruction of the *Porta Francigena*, between 1757 and 1758, for it is then that many of its stone panels were removed and fitted into the buttresses and frieze of the southern facade, requiring certain pieces, in particular, the Apostolic College, to be rearranged.[140] The last intervention made to this palimpsest-front was by the hand of López Ferreiro who, in 1884, added six prophets of the choir of the workshop of Master Mateo, and the relief showing the *Expulsion of Adam and Eve*, taken from the *Rúa de Pitelos*.

THE "PUERTA DE LOS JUICIOS"

Despite all the changes and alterations, it is still possible today to discover in this jumbled and perplexing "stone palimpsest" some vestiges of Gelmírez's original design. Indeed, it is to him that we owe its urban role as facade of a public square, with an important symbolic function. The fact that it is called a "holy place" in Early Modern documents is proof of this, as is the fact that it was enclosed by iron chains (1537), and that within it people could claim sanctuary (1739). This was indoubtedly a right which was assigned to certain church entrances in the Middle Ages, which, by virtue of their exemption from civil jurisdiction, not only proffered the Peace of the Lord so desired by the Gregorian Reform, but which were also areas reserved for the judicial resolution of appeals against ecclesiastical authority. It is clear that the "sacred" status of the *Platerías* derived from the fact that the square was within the walls of the original Apostolic *locus sanctus* erected by Bishop Sisinand II (952–968).[141] This was a consecrated and enclosed space around a cathedral or church still known in rural Galicia as the "sagrado" or "adro."[142]

When Gelmírez decided to build his first palace in 1101, next to what would be the *Platerías* entrance (1103–1111), that space, or *platea*, would take on a special significance. The Archbishop's intention was to convert the area into a built-up zone in order to establish the facade of the south transept, begun as the inscription on the jamb of the east entrance tells us, on 11 June 1103: "ERA ICXLI / V IDVS I(V)LII M[AGISTER] Q[UI] F[ECIT] O[PUS]."[143] According to the *Historia Compostellana*, "*los viernes de cada semana, abiertas las puertas del palacio pontifical – 'Pontificali palatii januis referatis' – expónganse las querellas e injurias que hubiese, en presencia del pontífice, de los jueces y de los canónigos, y resuélvanse.*"[144] So in this *platea* of the original episcopal palace, Gelmírez used to hold public audiences in which he would hear a great variety of pleas. The Latin term *platea* originally meant a public way, but it was also used in the Middle Ages to designate a place where justice was done, especially when it was broad and elevated. Indeed, it was very common to hear pleas in the space in front of a door of a medieval cathedral, as is well known. It is for this reason that these entrances were decorated with lions, alluding to the throne of Solomon, the biblical judge *par excellence*, as we see in the *Porta dei Mesi* of the Cathedral of Ferrara or in the portico of the Cathedral at Sessa Aurunca (Campania). This is how we should interpret the presence of the three "fierce"

140 "La primitiva fachada norte de la catedral de Santiago"... op. cit., pp. 623–4.
141 *La ciudad de Santiago de Compostela en la alta Edad Media...* op. cit., pp. 246 (plan 4), 255–6, n. 371.
142 "Un adro para un bispo: modelos e intencións na fachada de Praterías"... op. cit., p. 232.
143 "Implantación urbana de la catedral románica de Santiago de Compostela (1070–1150)"... op. cit., pp. 50–1. Cf. *La ciudad de Santiago de Compostela en la alta Edad Media...* op. cit., pp. 141, 143, 246–7. "Un adro para un bispo: modelos e intencións na fachada de Praterías"... op. cit. "La catedral románica: tipología arquitéctonica y narración visual"... op. cit. "Platerías: función y decoración de un 'lugar sagrado'"... op. cit.
144 "Empiezan los decretos de Diego II, obispo de la iglesia de Santiago, para proteger a los pobres," *Historia Compostelana...* op. cit., I, 96, 14, p. 227.

lions that still flank the two entrances to the *Platerías* (originally four, according to the "Guide" in the *Codex Calixtinus*). These lions of earthly justice take on an eschatological significance juxtaposed with the apocalyptic trumpets of the four angels of the Last Judgement depicted on the spandrels of the arches.[145] The two in the center were also moved in 1111 to make room for the Resurrection of Abraham, which had been intended for the west door.

VISUAL PROPAGANDA FOR THE GREGORIAN REFORMS?

SACERDOTIUM OVER REGNUM

The clearly ecclesiological tone of the *Platerías* is not altered by the addition in 1111 of the reliefs of the Transfiguration, since it was done to mark the coronation of the infant Alfonso Raimúndez as King of Galicia, who was given his symbols of power by Bishop Gelmírez on the altar of the Apostle Saint James. The occasion would have been used to include an additional phrase, "ANF[US] REX," to the relief of the transfiguration of Saint James. This addition makes the relief a true "visual manifesto" of the Gregorian theory of the supremacy of the *sacerdotium* over the *regnum*, in which the Apostle Santiago – whose seat is governed by Gelmírez – is tutor to the monarch. Indeed, this link between Saint James and the crown forms the basic concept behind the Astur-Leonese Reconquest. It is Bishop Gelmírez who will carry out a sequence of ideas and actions to consolidate the link. He thus makes the king a canon of the cathedral (1127) with the idea of obliging him to choose the Apostle's Cathedral as the site of his tomb, and of turning him into an authentic priest-king.[146] The same program is evident in the cartulary known as the *Tumbo A*, put together almost immediately afterwards (1129–1133). The codex is illustrated, for the most part, with a succession of idealized portraits of monarchs who patronized the Cathedral of Santiago, and which opens with a miniature of the discovery of the tomb of the Apostle and ends with a portrait of the Emperor Alfonso VII. In almost all of the images at the head of documents of grants of land, the formula of the name of the monarch and his title is repeated over and over again, just as in the aforementioned *Platerías* relief. Two of these images are very significant for this very reason, for their symbolic connotation: that which heads the list of the sequence of kings, that of Alfonso II – "ADEFONSUS: REX" –, the King of the discovery of the apostolic tomb, and Alfonso VI – "ADEFONS[US]: REX: PATER: PATRIE" –, the King who remodelled the Romanesque cathedral.

The symbolic significance of the *Platerías* facade lies, therefore, in the representative role of that space during the first two decades of the twelfth century. On the one hand, it was an atrium which gave access to the Bishop's Palace, with the functions appropriate to an "architecture of power," since every Friday in this *platea Palatii* the Bishop together with a council of canon-judges held court, and, on the other, King Alfonso VII entered and emerged by that door at the ceremony of his coronation in the cathedral. That is, the *Platerías* facade would have been a true *visual representation* of the Gregorian Reform as applied to the promotion of the see of Compostela.

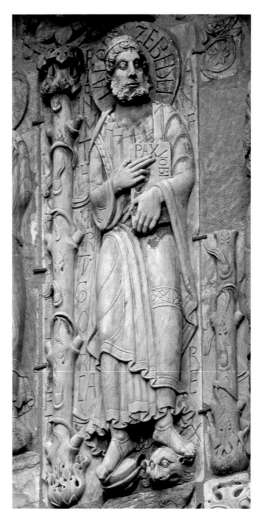

Saint James Between Cypress Trees
[Platerías *Door*]
Master of the Transfiguration
1103–1111
Cathedral of Santiago de Compostela

145 "Un adro para un bispo: modelos e intencións na fachada de Praterías"... op. cit. "La catedral románica: tipología arquitéctonica y narración visual"... op. cit. "Platerías: función y decoración de un 'lugar sagrado'"... op. cit. "La meta del Camino: la catedral de Santiago de Compostela en tiempos de Diego Gelmírez"... op. cit.
146 "La catedral románica: tipología arquitéctonica y narración visual"... op. cit. "Platerías: función y decoración de un 'lugar sagrado'"... op. cit. "Roma e il programma riformatore di Gelmírez nella catedrale di Santiago"... op. cit. "Rendición del Castillo de Burgos," *Historia Compostelana*... op. cit., I, 87, p. 478.

Emperor Alfonso VII [Tumbo A,
CF 34, fol. 26v; detail]
1129–1134
ACS~Archivo de la Catedral
de Santiago de Compostela

147 Biblioteca Apostolica Vaticana:
 Polycarpus [Vat. Lat. 1354], III, 7,
 fol. 53r.
148 "Cómo aspiró el Obispo a alcanzar el
 arzobispado," *Historia Compostelana...*
 op. cit., II, 3, pp. 300–1.
149 "Difamación del arzobispo de
 Compostela hecha por sus rivales,"
 Historia Compostelana... op. cit., III,
 10, p. 507.
150 I have developed this hypothesis in
 various previous studies in which
 abundant cited bibliographical
 references can be found relating to this
 topic: "Un adro para un bispo: modelos
 e intencións na fachada de Praterías"...
 op. cit. La catedral románica: tipología
 arquitéctonica y narración visual"...
 op. cit. "Platerías: función y decoración
 de un 'lugar sagrado'"... op. cit. "Roma
 e il programma riformatore de Gelmírez
 nella catedrale de Santiago"... op. cit.
151 *Polycarpus* [Vat. Lat. 1354]... op. cit.

Evoking Rome and Jerusalem

The Platerías *Door: between Rome and Jerusalem*

> "It is one thing to admire painting, and quite another to learn via the history of painting what should be admired. For painting is for the unwitting who contemplate it what writing is for those who know how to read, since the ignorant see in it what they should do, and those who are unlettered read through it."[147]

As I have said more than once, in the construction of the south face of the cathedral, Gelmírez was possibly attempting to imitate a prestigious Roman source, namely the *Patriarchium*, the Roman Episcopal see located exactly next to the north gate of the Basilica of Saint John Lateran, in front of which there was also a *platea* on which justice was administered. Gelmírez was inspired by Roman models, and copied and adapted them in his see so as to construct a huge complex as witness to the power befitting a place where reposed the body of an Apostle. For, according to the *Historia Compostellana*, such were the appurtenances befitting "either the Papacy, a Patriarchy or at least an Archbishopric, except in the case of the Church of Santiago."[148] Therefore, once the Archbishopric and the Papal Legacy had been obtained in 1120, Gelmírez did not conceal his pleasure at this achievement, which caused his rivals to accuse him of "*se comportaba imprudentemente como un Papa.*"[149]

It has become customary to interpret the construction of the Compostelan transept as an ordered biblical narrative: while on the North Door the Fall and the promise of Redemption were related, on the south the theme of the fulfilment of this promise was expounded in the life of Christ in the tympanums – Incarnation, Ministry and Passion – and in the "mission" of the Apostles in the frieze. However, the exposition of the *Platerías* scenes is complex indeed, since two projects were imposed upon it in the space of a decade, two projects that served the same end: Gelmírez's promotion of and adhesion to the Roman program of Gregorian Reform. I have previously noted[150] with delight the correspondence of the decoration of the marble columns of the *Platerías* with the return to "*Ecclesiae primitivae forma,*" popular in Rome at that time, and visible in the use of themes and motifs of Roman painting of around 1100–1120, such as angels with palm-leaves, birds drinking from chalices, the Chrismon, fleurons, twisted columns, and *velaria*. This imitation clearly reflects Gelmírez's two visits to Rome, in 1100 and 1105, but also the collection of canon law called *Polycarpus* which Cardinal Gregory of Saint Chrisogon (1109–1111) gave with a personal dedication to the Bishop of Compostela for the governance of his diocese, the artistic consequences of which I have dealt with elsewhere. A copy of this compilation of Canon Law, now in the Vatican Library[151] must have been done in the *scriptorium* of Santiago Cathedral in about 1160, for the hand and the historiated capitals appear to be done by the same scribes as those of the *Codex Calixtinus*.

Roman too is the focus on the *arma Christi* in the frieze of the Passion over the right-hand door of the *Platerías*. In particular, the representation of the column of flagellation is surprisingly detailed. If we discount the plinth, it is the same height

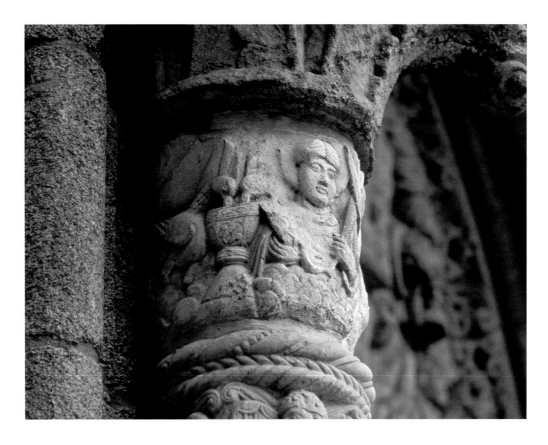

Peacocks Drinking from a Chalice
[Platerías *Door*]
Master of the Puerta del Cordero
1101–1111
Cathedral of Santiago de Compostela

as the figure of Jesus, attempting thereby to reproduce or evoke the relic with the "*mensura Christi*" preserved in Rome in the Middle Ages beside the south door of San Giovanni in Laterano.[152] We should not forget that the iconographic programs of the Church of the Gregorian Reforms aimed to revive the "*Ecclesiae primitivae forma.*" Indeed the scheme, composition and certain themes in the frieze of the *Platerías* Passion evoke, to a certain degree, the composition of the front of a paleo-Christian sarcophagus of the late fourth or beginning of the fifth centuries, such as that in the Necropolis of Toulouse. There we find examples of the scenes of the healing of the blind man, or the same arrangement of a person seated in the left corner holding his hand out to the front,[153] who, in the *Platerías* depiction is undoubtedly that of Christ at the moment of the imposition of the crown of thorns.[154] These same motifs – the Crown of Thorns or the Cyrenean – appear in other sarcophagi of the fourth century with the Resurrection as their theme; the *Domitilla Sarcophagus* in Rome is an example.[155] In any case, I am sure that the visit of Gelmírez and his Compostelan retinue to Rome in 1100 was key to these and the choice of other clearly paleo-Christian themes. One must not forget that the company would then have had to go down to the underground semicircle which enclosed the *confessio* of Saint Peter from where they would have been able to see the magnificent fourth-century *Sarcophagus of Junius Bassius*,[156] with its Christological reliefs at the front, and scenes of grape-harvesting *putti* on the sides; two themes which were omnipresent in the Compostelan workshops at the beginning of the twelfth century.

On the other hand, that reference to the relics underlies the whole lay-out of the right-hand lintel of the *Platerías* archway, being a faithful exposition of the *arma Christi* – Crown of Thorns, scourges, column, the cross borne by the Cyrenean –

152 "Un adro para un bispo: modelos e intencíns na fachada de Praterías"... op. cit.

153 D. Cazes, "Cara frontal de un sarcófago de la Necrópolis de Saint-Sernin," in J. Camps and M. Castiñeiras (eds.), *El románico y el Mediterráneo. Cataluña. Toulouse y Pisa (1120-1180)* (Barcelona: MNAC~Museo Nacional de Arte de Catalunya, 2008), pp. 332–3.

154 For my arguments supporting this associations, see "Un adro para un bispo: modelos e intencíns na fachada de Praterías"... op. cit., p. 264. "Platerías: función y decoración de un 'lugar sagrado'"... op. cit., p. 329.

155 A. Graber [*Les voies de la creation en iconographie chrétienne*, Paris: Flammarion, 1979], *Las vías de la creación en la iconografía cristiana* (Madrid: Alianza, 1991), p. 117, fig. 79.

156 Regarding the original emplacement of this tomb, see D. Casassayas, *Fedele Guida delle Sagre Grotte Vaticane cavata da una preziosa edizione del seccolo XVII* (Rome: British School at Rome, 1867), p. 36.

whereby the so-called "Master of Conques" anticipated by seventy years what would later be produced under the direction of Master Mateo on the west portal of the cathedral, in the famous Portico of Glory.[157] This reverence for relics was undoubtedly one of the defining features of what has become known as the "Art of the Pilgrim Routes," in which their acquisition and their representation as images became symbols of identity in many of these great places of worship. Debra Birch has studied the competition that arose in the twelfth century between the three great centers of Christianity – Santiago, Jerusalem and Rome – and the strategies used by each to increase its appeal. Faced with the attraction of the pilgrimage to Jerusalem, it was natural that the western sanctuaries should have sought to complement their treasures with Christ's relics.[158] Rome already had these in the early Christian period, but the same could not be said of Compostela, where there were practically none. Hence Gelmírez's desire to forge links with the Patriarchy of Jerusalem and procure relics from the Holy Land. Two such were donated by Queen Urraca to the Bishop of Compostela, according to the *Historia Compostellana*:[159] a piece of Christ's tomb and a relic of the Holy Cross set in silver. As I have explained elsewhere, one would have to add to these the so-called *Lignum Crucis de Carboeiro*, which was very possibly a gift to Gelmírez from the Patriarch of Jerusalem, brought in 1129 by Aymerich, canon of the Church of the Holy Sepulchre, as witness to the bond of confraternity between the two Chapters and as a token of gratitude for the grants of land made to the Patriarch in the diocese of Santiago.[160]

The depiction of images of the instruments of the Passion on a door opening on to the arm of the transept containing the baptistery is a normal feature of Christian art. It is found in the mosaic in the apse of the atrium of the fifth-century Lateran baptistery, in which the *lancea Domini*,[161] is depicted, or on the door of the so-called *Tomba di Rotari*, which is actually a baptistery dedicated to Saint John – *San Giovanni Battista del Sepulcro* –, on the crusader route to the Holy Land, reminiscent in its architecture of Jerusalem's Holy Sepulchre. In these reliefs the story of the Passion and Resurrection of Christ is narrated. According to the recent theory of Paolo Piva,[162] these stone reliefs would have been part of the doors of a tomb-monument inside the building whose intention was to copy in stone the mosaics which adorn the crusader aedicule of the Resurrection in the Basilica of the Resurrection in Jerusalem, the ante-chamber to which was possibly decorated with images of the taking of Christ, and the chamber itself with the deposition and visitation. So, in Monte Sant'Angelo, as in the *Platerías*, in the lower section, within a synthetic depiction of the taking of Christ, there are images of people bearing the *arma Christi* – scourge, lance, cross and nails. The whole is completed in the upper section by a series of depictions of the deposition, the burial and the visitation of the tomb, and another set of *arma Christi* carried by various characters – Stephaton, Longinus, Nicodemus and Joseph of Arimathea – and the image of Christ's tomb with three holes, typical of the crusader period.

It is worth noting the appropriacy of the representation of these instruments of the Passion on the door of a martyrial baptistry-sepulchre, as they all refer to the symbolism of the blood spilled by Christ that washes the sin of the world

157 *El Pórtico de la Gloria... op. cit.*, pp. 12, 44.

158 D. J. Birch, *Pilgrimage to Rome in the Middle Ages. Continuity and Change* (Woodbridge: Boydell Press, 1998), pp. 115, 150–86.

159 "De cuando la reina entregó la cabeza de Santiago al obispo," "Noticias sobre las vestiduras, libros y otros ornamentos de iglesia que adquirió el arzobispo," *Historia Compostelana... op. cit.*, I, 112, 2, p. 268; II, 57, p. 409.

160 "Prisión de arcediano llevada a cabo por el conde Rodrigo y enfado del arzobispo contra él hasta que dio satisfacción, sobre las vestiduras, libros y otros ornamentos de iglesia que adquirió el arzobispo," *Historia Compostelana... op. cit.*, III, 16, p. 537. Cf. M. Castiñeiras, "Topographie sacrée, liturgie pascale, reliques dans les grands centers de pèlerinage: Saint-Jacques de Compostelle, Saint-Isidore de Léon et Saint-Étienne de Ribas de Sil," *Les Cahiers de Saint-Michel de Cuxa*, 34 (Cuxa: 2003), pp. 38–40.

161 A. Iacobini, "Lancea domini. Nuove ipotesi sul mosaico absidale nell'atrio del Battistero Lateranense," in *Arte d'Occidente. Temi e metodi. Studi in onore di Angiola Maria Romanini*, 2 (Rome: Edizioni Sintesi Informazione, 1999), pp. 727–42.

162 P. Piva, "San Giovanni Battista del Sepolcro (a proposito di Civate e Monte Sant'Angelo)," *Arte Medievale*, 5/1 (Milan: Silvana, 2006), pp. 49–82.

like baptismal water. Very appropriate for the rites of Holy Saturday, which combine the Baptism with the celebration of the Resurrection. For this reason the emplacement in *Platerías* of these reliefs decorating the right-hand entrance does not seem fortuitous, as it is through there that access is gained, even today, to the cathedral baptistery, which was probably originally located in an adjacent place: the now destroyed chapel of Saint John the Baptist on the southern far side of the transept.[163]

Shrine, reliquary, and treasure: from the Roman basilicas to Celestial Jerusalem.
Was the Cathedral of Santiago painted?
The apse of a medieval church is the focal point of the building. It is the site of the altar; the place where the Divine Office is held, and where the sanctuary's most significant relics are worshipped. The author of the "Guide" of the *Codex Calixtinus*, written around 1137, following the discovery of this section of the Jacobean basilica, did not hesitate to employ a language lade with martyrial and eschatological metaphors to describe this singular part of its architecture. Thus the ambulatory surrounding it, with its radial chapels containing the relics of saints and martyrs, is called the *laurea* or *corona*, as the crown of laurels was the symbol of victory associated with martyrs on meeting their deaths; whereas the vault is called

Sarcophagus in the necropolis at Saint-Sernin de Toulouse
fourth-fifth century
MSR~Musée Saint-Raymond,
Musée des Antiques de Toulouse,
Haute-Garonne

Domitilla Sarcophagus in the Domitilla Catacomb
c. 350
Museo Pio Cristiano, Vatican City

163 "La imagen arquitectónica de la Catedral de Santiago"... op. cit., p. 47, n. 21. "Platerías: función y decoración de un 'lugar sagrado'"... op. cit., pp. 330–2.

164 *Liber Sancti Iacobi Codex Calixtinus...* op. cit., V, 9, p. 554.

165 *Rabani Mauri Allegoriae in Universam Sacram Scripturam*, PL, 112, Paris, s. d., cols. 849-1089. *Honorii Augustodunensis Elucidarium sive Dialogus de summa totius christianae theologiae*, I, 27 ("De mystico Christi corpore, hoc est Ecclesia"), PL 172, ed. J.-P. Migne, Paris: s. d., cols. 1128–1029 (reed. Turnhout: Brepols, s. d.). *Sicardi Cremonensi Episcopi Mitrale sivo De Officiis Ecclesiasticus Summa*, I, 4 ("De partibus ecclesiae"), PL, 213, ed. J.-P. Migne, Paris, 1885, cols. 19–26 (reed. Turnhout: Brepols, 1981).

166 *The Pilgrim's Guide to Santiago de Compostela. A Gazetteer...* op. cit., vol. 1:2, p. 152. See the text by Sugerio in J. von Schlosser [*Quellenbuch zur Kunstgeschichte des abendländischen Mittelalters. Ausgewählte Texte des vierten bis fünfzehnten Jahrhunderts, Quellenbuch*, Vienna: C. Graeser, 1896], *Repertorio di fonti per la Storia dell'Arte del Medioevo occidentale (secoli IV–XV)*, ed. J. Végh (Florence: Le Lettere, 1992), pp. 283–90.

167 *Liber Sancti Iacobi Codex Calixtinus...* op. cit., V, 9, p. 567. The parietal inscription of the chapel of The Savior also refers to 1105.

168 "De la restauración del altar de Santiago y de otras cosas," *Historia Compostelana...* op. cit., I, 17, pp. 107–8.

169 ACS~Archive of the Cathedral of Santiago: Tumbo B, fols. 225v–226r. L. Vones, *Die Historia Compostellana und die Kirchenpolitik des Nordwestspanischen Raumes 1070–1130* (Cologne: Böhlau, 1980), pp. 160–1.

170 "También de lo mismo," *Historia Compostelana...* op. cit., I, 17, pp. 103–5.

171 "De la restauración del altar de Santiago y de otras cosas," *Historia Compostelana...* op. cit., I, 18, pp. 107–8. During an excavation of the chancel in 1878 the original slab of the *confessio* was discovered one metre under the present-day chancel, A. López Ferreiro, *Historia de la Santa A. M. Iglesia de Santiago de Compostela*, vol. 3:11 (Santiago de Compostela: Seminario Conciliar de Santiago, 1898–1911), pp. 238–9. Id. [Santiago de Compostela: Seminario Conciliar de Santiago, 1893], *El Pórtico de la Gloria, Platerías y el primitivo altar mayor de la Catedral de Santiago* (Santiago de Compostela: Pico Sacro, 1975), pp. 115–37.

the *ecclesie celum*,[164] the "sky of the church," as here is where the just will find the reward of future life. This recourse to architectural metaphors was common in medieval exegetic literature, as is can be seen in *Allegoriae in Universam Sacram Scripturam,* by Rabano Mauro, *Elucidarium,* by Honorio Augustodunensis, and *Mitrale,* by Sicardo de Cremona,[165] and explains its recurring use by scholarly canons in the descriptions of buildings, as the cited passage of the *Calixitinus* or the no less famous *De consecratione* (1144–1147), by Sugerio of Saint-Denis, show.[166]

In the case of Santiago this symbolic interpretation of the shrine served to lend prestige and highlight certain architectural solutions that were unique to the Jacobean basilica. The building had been designed as a great functional complex to allow the internal circulation of its pilgrims, who, by means of the lateral naves, could go round the entire perimeter of the basilica without inconveniencing the celebration of the Office at the high altar, presbytery, and central nave, which were occupied, partly during the twelfth century and then more extensively in the thirteenth, by the canons' choir. In this lateral ambulation the faithful could visit, as they can today, the numerous absidal chapels along the transept and apse, where they would pray, attend masses, and worship the relics. Once there, they could reach the place closest to the *sancta sanctorum* – the Apostle's tomb – thanks to a *confessio*, situated behind the altar, especially conceived for them: the chapel of Mary Magdalene. Here they were permitted to pray next to the wall of the room that kept the hold body, following, as we shall see, a prestigious solution that was characteristic of Roman churches.

The first systematization of the apse probably took place in 1106 and not in 1105 as has been supposed until now. According to the verses the decorated the silver front of the high altar, this had been donated by Diego Gelmírez in the fifth year of his episcopacy: "*Diego segundo, prelado que fue de Santiago, esta tabla / Hizo cuando un quinquenio su episcopado cumplió.*"[167] Let us not forget that although Gelmírez was "elected" in 1100, his confirmation as a Bishop did not happen until Easter of 1101. In fact, a consecration of the high altar and of the chapels of the apse and transept in 1106, five years after his definitive confirmation, would be more logical if one we recall that the second journey to Rome was made in the autumn of 1105, and not in 1104 as stated in the *Historia Compostellana*.[168] Indeed, Ludwig Vones has demonstrated that the privilege of the Pallium was conferred by Pope Paschal II on 21 October 1105, as is stated in *Tumbo B* of the Santiago Cathedral Archive.[169] In all probability, the collocation of the silver front coincided with the consecration of the various surrounding altars, that is, those of Saint Mary Magdalene, Saint Savior, Saint Peter, Saint Andrew, Saint John the Baptist, Saint John the Apostle, Saint Faith and the Holy Cross.[170] With them, all the chapels of the cathedral's apse were consecrated, except that of Saint Nicholas on the far northern side of the transept.

The Compostelan *confessio* would involve a lower chamber, situated in the hemicycle behind the altar, "*por debajo de las dos columnas del baldaquino,*" and the remains of the aedicule dragged and buried there by Gelmírez in 1105:

"Y después de construir el altar según hemos referido anteriormente, puesto que estaba abierto a los ojos humanos por todas partes, no quedaba ningún sitio oculto en el que los fieles satisficieran los deseos de orar en privado. Así pues, era oportuno y claramente necesario para la santa meditación que las almas, iluminadas por el resplandor de la interna contemplación, lavasen las manchas de su conciencia con el abundante río de sus lágrimas en un lugar secreto y, restablecidas por medio de los favores de la santa oración con los alimentos del celestial banquete, salieran descargadas del pestífero peso de sus pecados. Por lo cual empezó el obispo a insistir en este pensamiento dentro del albergue de su mente y a desear ardientemente con una solicitud infatigable hacer una confesión en el altar. Y ciertamente se ve qué grande y de qué manera construyó esta confesión por debajo de las dos columnas del altar que sostienen el baldaquino, cuando ofrece feliz paso a los que entran."[171]

There the pilgrims could attend matins,[172] pray "before" the tomb, and even receive communion,[173] following a typology that was peculiar to Roman churches. Although it is not there today, due to the remodellings undertaken during the baroque period,[174] echoes of its structure can still be found in the main chapel of Santa María de Cambre (A Coruña) (c. 1200),[175] a building which is architecturally very close to the Cathedral of Santiago, and in which a series of columns in the ambulatory gives access to a space that lies adjacent to the altar in which it is still possible to see where it was drilled in its lower section. This type of architecture, with its rear access for pilgrims to an oratory-*confessio* beneath a canopy-altar, can be traced back to the straight section *ad corpus* annular crypts of Old Saint Peter's at the Vatican (590–604)[176] or to their imitation in the lower church, Saint Chrisogon in Rome (731–741).[177] In any case, the liturgical-ritual function of all the oratories beside the high altar was similar: to satisfy the pilgrims' need to pray in a space beside the tomb. Although sadly we do not know if the Compostelan *confessio* had any type of *fenestella* like that of the Roman crypts, it is very likely that at least a trap door in the paving existed, exclusively reserved, as in Saint Peter's in the Vatican, for access by illustrious travelers. We should not be surprised, however, by the encapsulated character of the room housing the holy body beneath the altar, as the idea was to emulate a veritable *sub altari* reliquary. Indeed, this layout is very similar to the underground chamber of the Church of San Giovanni in Laterano, built in 844 under Pope Sergius II, which was barely accessible, whose relics were not visitable, and which had but one small *fenestella*.[178]

How did the stonemasons of Santiago Cathedral decide on such a singular solution? Why does the text of the *Historia Compostellana* insist so much on Bishop Gelmírez's desire to create such a space of seclusion? It is not easy to answer these questions but there are some signs that suggest a satisfactory solution. In the first place, the Compostelan curia had gained first-hand experience of Roman monuments. In fact, Gelmírez himself had been ordained subdeacon in 1100 in Saint Peter's of the Vatican, according to the canonical rite. This consisted of postrating himself, clothed, before the *confessio* of Saint Peter's, where the imposition of hands is then performed.[179] Very probably, as Moralejo noted, it was then that Gelmírez conceived his artistic program of "Apostolic" evocation and exaltation for the Basilica of

172 "*Entre el altar de Santiago y el de san Salvador está el de santa María Magdalena, donde se cantan las misas tempranas par los peregrinos*": *Liber Sancti Iacobi Codex Calixtinus...* op. cit., V, 9, p. 564.

173 In 1532, the traveler Juan de Azcona bore testimony to this medieval use although the rite had been moved to the chapel of The Savior in modern times: "*Tras el altar mayor, el altar de la Magadalena, donde se solía dar los sacramentos a los peregrinos, y ahora se da en la dicha capilla del Rey del Francia o de El Salvador,*" J. Guerra Campos, *Exploraciones Arqueológicas en torno al sepulcro del Apóstol Santiago* (Burgos: Ediciones Aldecoa, 1982), p. 29. I owe my awareness of this information to M. Cotelo Felípez, *Culto e Iconografía da Madalena en Galicia* (Santiago de Compostela: USC~Universidad de Santiago de Compostela, 2001).

174 Under the supervision of the churchwarden-canon José Vega y Verdugo, in 1668 the Romanesque altar was replaced by a baroque one. See *El Pórtico de la Gloria, Platerías y el primitivo altar mayor de la Catedral de Santiago...* op. cit., pp. 115–37. Regarding the magnitude of the restructuring of the chancel undertaken in those years, see M. Taín Guzmán, "El viaje a Lisboa del canónigo fabriquero D. José Vega y Verdugo (1669)," *Quintana*, 1 (Santiago de Compostela: 2002), pp. 301–11.

175 For Michael Petri's dating of the chancel of Santa María de Cambre, see M. Vila da Vila, *La iglesia románica de Cambre* (A Coruña: Diputación Provincial de A Coruña, 1986), pp. 34–7, fig. I.

176 This corresponds to the reforms implemented by Gregorio Magno between 590 and 604, according to which the high altar of Saint Peter's at the Vatican presides over the tomb which is accessed by an annular crypt, R. Krautheimer, *Roma. Profilo di una città 312–1308* (Rome: Edizione dell'Elefante, 1981), p. 112. *Pilgrimage to Rome in the Middle Ages. Continuity and Change...* op. cit., p. 32.

177 M. Mesnard, *La basilique de Saint Chrysogone à Rome* (Paris: Les Belles-Lettres, 1935), pp. 61–74. R. Krautheimer, *Corpus Basilicarum Christianarum Romae*, vol. 1:2 (Vatican City: Pontificio Istituto di Archeologia Cristiana, 1937), pp. 156–9.

178 S. de Blaauw, *Cultus et decor. Liturgia e architettura nella Roma tardoantica e medievale* (Vatican City: Biblioteca Apostolica Vaticana, 1994), pp. 240–2.

179 Ibidem, p. 604.

Santiago, which he would then mature during his second visit to the Eternal City in 1105 to receive the Pallium. Indeed, the high altar at Santiago of 1105–1106 incorporates distinctively Roman elements: a *confessio*, baldachin, a silver front and even the institution of seven cardinals,[180] the only possible officiators, as in Saint Peter's.[181] There were, however, determining factors that the Prelacy could not alter. The initial project of the cathedral did not envisage a crypt and to execute it was impossible around 1100–1105, as building works had already reached the transept. Gelmírez decided to adapt the formula of the straight section *ad corpus* annular crypt to the cathedral's architectural plan, exploiting the ambulatory and incorporating the space behind the altar, which he excavated to imitate the *ad corpus* solutions he had seen in Rome.

As in Rome, the *confessio* in Santiago thus constituted the closest point of contact between pilgrims and the hidden and buried relics of the Apostle. It is important to stress this, for in the Romanesque period the high altar was not an enclosed space accessed only by the Compostelan curia to preserve the *sancta sanctorum* and its treasures. The composition of the altar's furniture during Gelmírez's time is known thanks to the descriptions given in the "Guide" of the *Calixtinus*[182] as well as certain passages of the *Historia Compostellana*.[183] The Bishop progressively enlarged the ensemble of objects over a period stretching from 1105 to about 1135, building up a rich and varied collection of liturgical objects, which have been irretrievably lost in modern times.

Moralejo studied the more outstanding pieces, all of them made of silver and elaborately decorated, in which the image of the Apostolate was recurrent: the baldachin and front, executed in 1105–1106,[184] and the retable in c. 1135.[185] It is not my intention to explore here these pieces, a study of which has been made by Miguel Taín, but it is worth mentioning that the silver *ciboria* were a recurrent element in the decoration of Roman basilicas intended to monumentalize the altar, exalt the liturgical celebration, and indicate the place of the holy relics.[186] Proof of this was the *ciborium* of the Church of Lateran, made in 810 over a subterranean crypt,[187] and that of Saint Peter's in the Vatican, work of Gregorio Magno y León III (795-816),[188] which loomed large over the site of Saint Peter's tomb. With this baldachin, Gelmírez sought to match his altar up to that of an apostolic tomb. Hence the inclusion, in 1105 or 1106, of a beautifully carved silver and gold front, the inspiration for which was taken from the chancel of Saint Peter's in Rome, remodelled by Pope Paschal I (817–824), in which the high altar was covered in gold and a golden *propitiatorium* (a Biblical term for the Ark of the Covenant, *Exodus* 25, 17–21) was made for the *confessio*.[189]

Unfortunately, we have no trace in Galicia of these medieval objects - front and baldachin – except for the description in the *Calixtinus*. The only baldachins that survive correspond to much later dates — from the end of the fifteenth century to the first half of the sixteenth – and they are made in stone. The latter do not, however, directly reproduce the structure of Gelmírez's baldachin; rather they are rural versions of the *ciborium*, in the *flamboyant* style, made of wood and cased in silver, which the Archbishop of Santiago, Alonso de Fonseca I, ordered to be placed

180 *Liber Sancti Iacobi Codex Calixtinus...* op. cit., V, 9, p. 569.
181 *Cultus et decor. Liturgia e architettura nella Roma tardoantica e medievale...* op. cit., p. 693.
182 *Liber Sancti Iacobi Codex Calixtinus...* op. cit., V, 7.
183 "Noticias sobre las vestiduras, libros y otros ornamentos de iglesia que adquirió el arzobispo," *Historia Compostelana...* op. cit., II, 57. "Adquisición de un cáliz de oro," ibid., III, 8. "Adquisición de un aguamanil," ibid., III, 9. "Retablo del altar," ibid., III, 44.
184 *Liber Sancti Iacobi Codex Calixtinus...* op. cit., V, 9, pp. 566–8.
185 "Ars sacra et sculpture romane monumentale : le trésor et le chantier de Compostelle"... op. cit.
186 "El patronazgo artístico del arzobispo Diego Gelmírez (1110–1140): su reflejo en la obra e imagen de Santiago"... op. cit.
187 *Cultus et decor. Liturgia e architettura nella Roma tardoantica e medievale...* op. cit., pp. 173–4.
188 Ibidem, pp. 534, 549.
189 Ibidem, p. 537.

on the high altar of the cathedral some time between 1462 and 1480 to replace the old Gelmirian baldachin and which we also only know from descriptions.[190] The stone baldachins that can be seen in Galicia's rural milieu respect the typology of the square plan but their localization and character experiment with other formulae that are alien to the Romanesque tradition. Thus sometimes they are seen occupying corners of walls, between the entrance to the main chapel and the nave, as in the case of Santo Tomé de Serantes in Ourense,[191] perhaps to mark the space of an altar dedicated to the Passion, and sometimes they stand separately and serve a funerary function, as is the case of the baldachin of San Salvador de Vilar de Donas, dating from 1492.[192]

For this reason, to recreate the true aspect of the Santiago's Romanesque altar, we must look to the furniture of the epoch used in rural churches in the Pyrenees of Catalonia, today preserved in the Museu Nacional d'Art de Catalunya. What we find here, however, is a "poor" version of those impressive altars of enamelled metal that decorated the shrines of the grander cathedrals and monasteries, emulations made of brightly painted wood, as is the case of the baldachins of Toses (c. 1220)[193] and Estimariu in Lleida (c. 1300), and the front from the first half of the thirteenth century of Sant Romà (Encamp, Andorra).

To further enhance the magnificence of the *sancta sanctorum* in the description of the altar given in the *Calixtinus*, allusion is also made to three silver lamps, one of them with seven incense stick holders representing the gifts of the Holy Spirit[194] and which constituted a Christianized allusion to the seven-armed *menorah* in the tabernacle of Moses, an Old Testament model of Christian altars.[195] Moreover, these crown-shaped lamps were very common in the Romanesque period and a few of them, made of forged iron, survive in Catalonia, some of them having up to three candlestick rings (Museu Episcopal de Vic, inv. # 10808, thirteenth century[196]). All this furniture was complemented by a sumptuous collection of robes, books, and other sacred ornaments used in liturgical celebration. The *Historia Compostellana*[197] includes a chapter that mentions the numerous acquisitions made by Gelmírez in this regard between 1105–1106, years of the main altar's consecration, and 1122, one of the most important moments of his career, since two years earlier he had been granted the dignity of Archbishop as well as the apostolic legacy for the provinces of Braga and Mérida. In the said collection of objects there were richly embroidered Dalmatian chasubles, a purple Gospel Book, two of silver and one of gold, a silver missal, a silver epistolary, two silver boxes – one for keeping the head of Saint James –, a marble box, a silver *Lignum Crucis* (a gift from Queen Urraca), three silver chalices and one gold one, a golden incense burner, three silver cruets and as many liturgical books. Unfortunately, none of these pieces have survived either, although echoes or reflections of them in the iconography of their day provide us with clues as to their appearance. Thus in the left-hand tympanum in *Platerías* we see Christ in the scene of the Temptations wearing a luxurious chasuble decorated with flowers in what seems to be a stone rendering of the four magnificent *citheras* made in the Greek style that Gelmírez donated to his church. It is quite possible that these *citheras* sought to imitate the

190 A. Rosende, "A mayor gloria del Señor Santiago: el baldaquino de la catedral compostelana," in M. V. García Quintela (ed.), *Las Religiones en la Historia de Galicia* (A Coruña: Universidad de A Coruña, 1996), pp. 485–534, esp. pp. 491–7.

191 C. Manso Porto, "El tablero del baldaquino de Santo Domingo de Ribadavia," *El Museo de Pontevedra*, 53 (Pontevedra: 1999), pp. 119–27. For a study of Galician baldachins generally, see X. R. Fernández Oxea and X. Filgueira Valverde, "O baldaquino en Galicia denantes do arte barroco," *Arquivos do Seminario de Estudos Galegos*, 5 (Santiago de Compostela: 1930), pp. 95–141. Id., *Baldaquinos gallegos* (A Coruña: Fundación Pedro Barrié de la Maza, 1987).

192 J. Vázquez Castro, "La capilla funeraria de los Piñeiro en el priorato santiaguista de San Salvador de Vilar de Donas," *Compostellanum*, vol. 36, 3–4 (Santiago de Compostela: 1991), pp. 427–66.

193 Example already cited in "Ars sacra et sculpture romane monumentale: le trésor et le chantier de Compostelle"... op. cit.

194 *Liber Sancti Iacobi Codex Calixtinus*... op. cit., V, 9, pp. 568–9.

195 J. Onians, *Beares of Meaning* (Princeton: Princeton University Press, 1990), pp. 78–9.

196 G. Ylla-Català, "Corona de llum 2 (MEV, 10808)," *Catalunya Romànica*, 22 (Barcelona: Fundació Enciclopèdia Catalana, 1986), p. 248.

197 "Noticias sobre las vestiduras, libros y otros ornamentos de iglesia que adquirió el arzobispo," *Historia Compostelana*... op. cit., II, 57, pp. 408–9.

Angel with Thurible [Platerías *Door, detail]*
Master of Conques
1101–1103
Cathedral of Santiago de Compostela

Christ of the Temptations [Platerías *Door, detail]*
Master of Conques
1101–1103
Cathedral of Santiago de Compostela

198 "Un adro para un bispo: modelos
 e intencións na fachada de Praterías"...
 op. cit., p. 246.
199 Ibidem, p. 251.
200 R. J. Payo, "Incensario," in *El
 scriptorium silense y los orígenes
 de la lengua castellana* (Valladolid:
 Junta de Castilla y León, 1995), p. 72.
 MNAC~Museo Nacional de Arte de
 Catalunya, inv # 4581.
201 G. Ylla-Català, "Encenser 7 (MEV, 1,
 332)," *Catalunya Romànica*, 22
 (Barcelona: Fundació Enciclopèdia
 Catalana, 1986), p. 221.
202 "Violación de la Iglesia," *Historia
 Compostelana*... op. cit., III, 47,
 pp. 578–81.
203 "Cuando el arzobispo escapó de la
 iglesia," *Historia Compostelana*...
 op. cit., III, 48, pp. 580-1.
204 "Violación de la Iglesia"... op. cit., III,
 47, p. 580.

embroidered fabrics decorated with pearls, arabesques, flowers and foliage that were in vogue since the eleventh century in the liturgical costumes of Byzantium.[198] Similarly, in the same tympanum, in a kind of echo of the liturgical ceremonial, an angel-thurifer carries a beautiful censer richly decorated with a face of vegetal motif. In this case it might be an echo of one of two golden censers Gelmírez donated to the cathedral, as the painstakingly executed reliefwork points to the technique of openwork and incisions applied in silversmithing that was characteristic of his period.[199] Two fine examples of censers are preserved in Catalonia. The first, in *champlevé* enamel on engraved copper with gold leaf, probably made in this region during the second half of the twelfth century, is composed of two semispheres and eight hinges, like the one in Santiago, and is decorated with embossed vegetal and animal motifs (birds facing each other).[200] The other, kept in the Episcopal Museum of Vic, is executed in cast bronze and somewhat plainer. It has the same structure and is decorated with openwork coiling vegetal motifs that recall the Compostelan relief.[201]

To protect its luxurious liturgical furniture, the high altar of Santiago Cathedral was a place sealed by iron bars. In fact, one passage of the *Historia Compostellana*,[202] which narrates a violation of the church in 1136, tells how Gelmírez takes refuge in the altar of the Apostle and orders that all the iron doors in the building be closed[203] to impede access to the traitors who sought to murder him. In their frustration, they decide to hurl stones at him from the tribunes:

> *"Llevaron al arzobispo hasta el venerable altar de Santiago donde está enterrado el cuerpo del Apóstol, glorioso y admirado en todas la tierras, y poniéndolo bajo el baldaquino del altar cerraron firmemente las puertas del altar."*[204]

*"Después que se reunieron con todas sus armas ante las puertas de hierro del altar y
como encontraron las puertas cerradas y clausuradas firmemente con sus cerrojos, de
ninguna manera pudieron entrar en el altar. Furiosos y rechinando los dientes, subieron
a la obra de la misma iglesia para matar desde arriba tirándole piedras al que desde
abajo no podía matar."*[205]

From the text we learn that there were bars all around the sanctuary, as was
normal in the Romanesque. This measure was taken to protect the ornaments
and sacred objects of worship from the crowds: the baldachin, the front, and
the silver retable,[206] the glasses and the liturgical cloths, as well as the precious
reliquaries.

Material evidence of the use of bars to seal off the high altar in the Galician
Romanesque is found in the Church of Santa María de Melide, in the province of
A Coruña, on the French pilgrim route. Its primitive high altar was enclosed by an
imposing wrought iron railing made of decorated bars and c-shaped metal plates
ending in a flower. Today, its remains are divided between the Church of Santa María
and the parish Church of Sancti Spiritus. In modern times, the church made a sacristy
door using a fragment of the railing, which was displayed at the Galician Exhibition
of 1909. Other remains of the railing were kept until as recently as 1933 in the
sacristy's mezzanine, making it possible to imagine an enclosure for a high altar that
measured 3 m wide by 2 m high:

*"No faiado que vai riba da sagristía, atopamos moitos máis anacos da mesma reixa
d'abondo para forma co que hai na porta un pecho de dous metor de altor por máis de
tres de ancho. Tendo en conta a pequena difrencia co ancho do arco trunfal doadament
espricabre pol-os anacos que teñan desaparecido nos arrombamentos, semella posibre
que todo sexa de unha reixa que pechase a capela maor."*[207]

A very approximate reconstruction has been made with these fragments which is
currently kept – in appalling conditions – in a chapel of the parish Church of Sancti
Spiritus de Melide.[208] The original function of the railing of the triumphant arc of
Santa María de Melide (1177–1191) was to seal off the presbytery to protect sacred
and valuable objects, as Gelmírez had done a few decades earlier in the Cathedral
of Santiago.

The main altar to the Apostle Saint James had no match in Spain. Over an
apostolic tomb and a Roman-style *confessio*, it rose up exultantly, displaying its rich
furnishings – front, baldachin, silver lamps – and appurtenances – chasubles, censers,
books – from behind the protective iron railing. Perhaps the only aspect in which
Compostela was not on a par with its European counterparts was in the absence of
a painted decoration of walls and vaults. Fortunately, the recent discovery of a large
painted cycle in the old Cathedral at San Martiño de Foz (Lugo) has triggered debate
about whether the Compostelan Basilica's interior was also ornamented with
paintings. The southern vault of the transept of San Martiño de Mondoñedo is
decorated in its central section with the Assumption of Mary, while the lateral vaults
depict the representation of the Glory of the Just, with their palm trees (Ap. 20, 4–6)
and a surprising Tree of Jesse. Very probably, the workshop that painted them would

205 Ibidem, p. 581.
206 "Ars sacra et sculpture romane
 monumentale: le trésor et le chantier
 de Compostelle"... op. cit., pp. 189–238,
 esp. pp. 231–6.
207 E. Camps, X. Carro and X. R. Fernández
 Oxea, "Arqueoloxia relixiosa de Melide,"
 Terra de Melide (Santiago de Compostela:
 Compostela, 1933), pp. 251–322, esp.
 p. 262.
208 M. P. Carrillo Lista, *El arte románico
 en Terra de Melide* (A Coruña: Diputación
 Provincial de A Coruña, 1997), pp. 72–3.

have been familiar with the great mural painting at Poitou through the experiences of Santiago Cathedral's *scriptorium*, in particular, that of the first miniaturist of the *Tumbo A* (1129–1134).[209]

This last association is explained in the arrival to the see of Mondoñedo of the Compostelan canon Munio Alfonso, who governed that diocese between 1112 and 1134–1136. This native of Galicia, who had been trained and educated in Cathedral of Santiago, had faithfully served Bishop Diego Gelmírez, occupying the post of cathedral treasurer and writing, between 1109 and 1110, part of the *Historia Compostellana*.[210] Although at the start of his episcopacy, in 1113, it had been decided that the seat of Foz should be moved to Villamaior do Val do Brea – modern-day Mondoñedo –, as ratified by Queen Urraca in 1117,[211] there are ample reasons to believe that it was he who was in charge of overseeing the conclusion of the works begun by his predecessors in San Martiño de Foz. This period would see the completion not only of the architectural work begun by Bishop Gonzalo around 1096 but also the decoration of the church's interior walls.

All the walls of the chancel at the moment of the completion of this part, were covered, under Don Gonzalo's supervision, and during the first decade of the twelfth century, with a single layer of plaster which imitated the decoration of ashlars, a popular practice in the early Romanesque period in Catalonia, as the examples of Sant Llorenç de Munt and Sant Jaume de Frontanyà show. This same decorative imitation of ashlars was revealed recently during the cleaning, carried out by Blanca Besteiro, of the southern wall of the southern arm of the transept, in areas where no mural paint is conserved. Later, once the entire building was completed, this layer of plaster was covered with another pictorial layer – the representation of which has been studied in the present text – using the fresco-secco technique. In fact, although the see had been established since 1117 in the new Mondoñedo, the building at Foz possibly continued for some time to act as a cathedral while the new church in Villamaior was not ready. One must not forget that, in addition to having a community of canons regular of Saint Augustine proper of a concathedral, as a bull issued by Pope Adrian IV in 1156 makes clear, San Martiño de Mondoñedo continued to act as a second seat, with bishops from Mondoñedo hearing pleas even as late as 1254.[212]

It is therefore plausible that during the bishopric of Nuño, who had worked closely with the treasury and *scriptorium* of Compostela, a team of painters from Santiago arrived, who knew not only the techniques and repertories of the painting of Poitou, but also the sources used by the first miniaturist of the *Tumbo A*. The years corresponding to the first phase of the manuscript's illumination (1129–1134) seem to have been the most auspicious for the realization of the task. In turn, the evidence of the cycles of Poitou that can be detected in the pictorial decoration of San Martiño leads one to contemplate the possibility that the said workshop may also have previously painted the interior of the Compostelan Cathedral or perhaps the palace itself of Bishop Gelmírez.[213] An entry in the *Historia Compostellana*, reflected in a chapter written by Munio Alfonso, allows us to posit this hypothesis, for in it mention is made of the existence in the environs of the original palace built by Gelmírez of a "*linda iglesia fabricada y pintada admirablemente.*"[214]

209 M. Castiñeiras, "San Martiño de Mondoñedo: un edificio singular del arte medieval gallego. A propósito del descubrimiento de un ciclo pictórico del siglo XII," *Rudesindus. San Rosendo. Su tiempo y su legado* (Santiago de Compostela: Xunta de Galicia, 2008), pp. 51–65. Id., "Cuando las catedrales románicas estaban pintadas: el ciclo pictórico de San Martiño de Mondoñedo (Foz, Lugo) al descubierto," *Revista de Amigos del Románico*, 8 (Barcelona: 2009), pp. 18–31.

210 *La ciudad de Santiago de Compostela en la alta Edad Media*... op. cit., pp. 48–51.

211 *Arte medieval I. Galicia*... op. cit., p. 18.

212 J. Villa-Amil y Castro, *Iglesias gallegas* (Madrid: San Francisco de Sales, 1904), p. 34.

213 I first put forward this hypothesis in: "A obra de arte: 'reconstrucción' e recreación,'" in C. Fontenla (ed.), *Os profesionais da historia ante o patrimonio cultural: liñas metodolóxicas*, (Santiago de Compostela: Xunta de Galicia, 1996), p. 164.

214 "Construcción y consagración de una iglesia en el monte del Gozo. Palacios pontificales. Regla y número de los canónigos," *Historia Compostelana*... op. cit., I, 20, p. 111. According to Fernando López Alsina ("A mayor gloria del Señor Santiago: el baldaquino de la catedral compostelana"... op. cit., p. 51), Munio Alfonso was directly responsible for the writing of chapters 1–14 and 16–45 of Book I of *Historia Compostelana* and therefore it is to him that we must attribute the description of the painted church of the cited chapter 20.

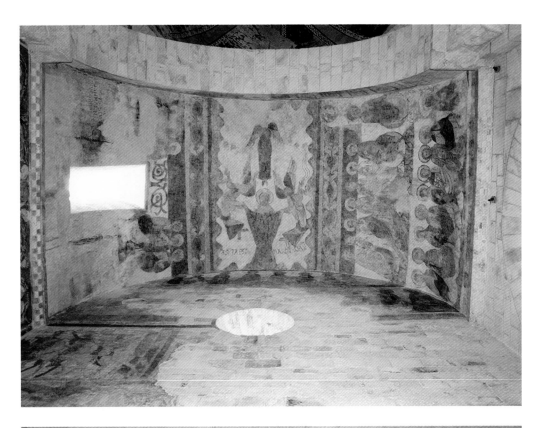

Vault [*Southern wing of the transept*]
c. 1133–1134
San Martiño de Mondoñedo, Lugo

Vault [*Southern wing of the transept, detail*]
c. 1133–1134
San Martiño de Mondoñedo, Lugo

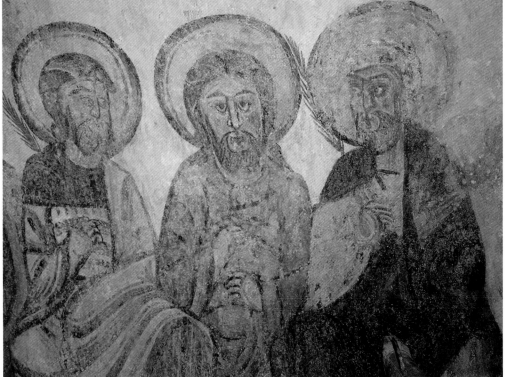

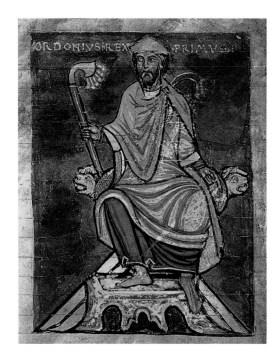

Ordoño I [Tumbo A, CF 34, fol. 1v; detail]
1129–1134
ACS~Archivo de la Catedral de Santiago de Compostela

Ordoño II [Tumbo A, CF 34, fol. 5v; detail]
1129–1134
ACS~Archivo de la Catedral de Santiago de Compostela

[BERNA]RDVS: SCVL / PSIT: INMAGIN[ES] *[Vault of the southern wing of the transept, detail]*
c. 1133–1134
San Martiño de Mondoñedo, Lugo

To this we must add a second reference from the *Codex Calixtinus*, which, in its description of the cathedral building, says that the stones are "*por dentro pintadas de distintas maneras.*"[215] Repairs and successive whitewashing and applications of paint have barely left any evidence in Compostela of these pictorial cycles, if we discount the occasional imitation of ashlar painted in the area of the organs in the nave's tribunes possibly dating from the Romanesque period.

At the risk of hypothesizing, one of the painted epigraphs which appeared during the recent restoration of the vault of the southern transept of San Martiño and which accompanies a statue of a priest in prayer, seems to feed some of these speculations. In the northern angle of the eastern section of the transept's vault, we can read: "[BERNA]RDVS : SCVL / PSIT : IMMAGIN[ES] [Bernard engraved[216] these images]." Was this the Bernard who worked as treasurer of the Compostelan Church and directed the project of the cartulary of the *Tumbo A* and of the Work of Santiago Church since 1129? The same that proudly engraved his name, one 11 April 1122, on the fountain of paradise beside the *Porta Francigena* of the Compostelan Cathedral?[217] Bernard, treasurer of the Compostelan Church since 1118 and royal chancellor since 1127 under Alfonso VII, fell into disgrace in 1133 and was removed from the chancellery and imprisoned in Galicia, his possessions confiscated by Gelmírez.[218] Shortly after, between 1133 and 1134, the year of his death, at the request of the papal legate, Cardinal Guido, he was transferred to Mondoñedo and placed in the custody of Munio Alfonso and his possessions were returned to him.[219] Perhaps with the arrival of Bernard to Mondoñedo this egregious promotor of the arts, a connoisseur like no-one else of the work of the Cathedral of Santiago and of the project of the *Tumbo A*, directed his last project: the decoration of the Church of San Martiño de Mondoñedo, with some of his former collaborators from Compostela.

215 *Liber Sancti Iacobi Codex Calixtinus...* op. cit., V, 9, p. 563.
216 The Latin verb "*sculpo*" is often employed in the description of Gelmírez's liturgical furniture given in the "Guide" of the *Codex Calixtinus* (V, 9), to talk of the execution of both the facade and the silver ciborium.
217 The inscription of the Fuente del Paraíso in Santiago, carved in two lines above the central bronze column, read: "*Yo, Bernardo, Tesorero de Santiago, traje aquí esta agua y realicé la presente obra para remedio de mi alma y la de mis padres en la era MCLX el tercero de los idus de abril* [11 April 1122]," *Liber Sancti Iacobi Codex Calixtinus...* op. cit., V, 9, p. 558.
218 *La ciudad de Santiago de Compostela en la alta Edad Media...* op. cit., pp. 34–5.
219 *A vida e o tempo de Diego Xelmírez...* op. cit., pp. 335–8.

And thus Mondoñedo became not only the oldest building containing Romanesque mural painting that survives in Galicia, but also an exceptional testimony of what may have been the painted decoration of the Romanesque Cathedral of Santiago, which perhaps now, with the restoration of the paintings in the main chapel carried out by the Fundación Barrié de la Maza under the direction of the restorer Concha Cirujano, might still have one or two surprises in store for us. The old theory put forward by Janine Wettstein claiming the existence of an "*iter picturae sancti Iacobi*" between western France and far-off Galicia would thus take on more meaning than ever,[220] since one would have to add to the cycles of San Juan de la Peña, Bagüés, Perazancas and León, that of Mondoñedo and the lost ensemble of Compostela.

Paradise Fountain *[Cloisters]*
1122
Cathedral of Santiago de Compostela

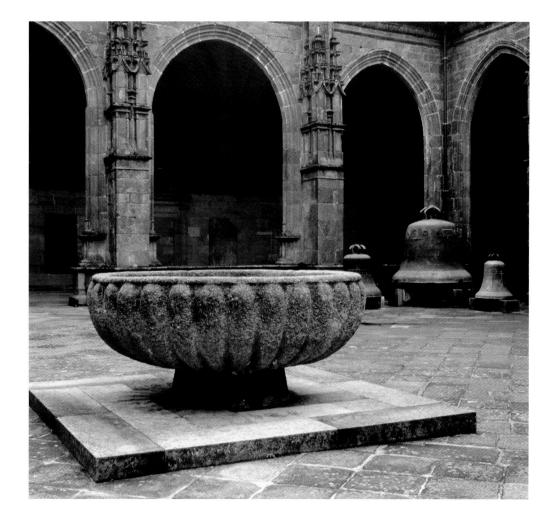

220 J. Wettstein, "La fresque romane. La route de Saint-Jacques, de Tours à Compostelle," in *Études comparatives*, vol. 2:2 (Geneva: Droz, 1978), pp. 125–37.

COMPOSTELA

Adeline Rucquoi

Culture and Learning in Compostela
and the Way of Saint James

The development of Compostela as an urban and cultural center from the tenth century onwards is intimately linked to the discovery of the body of Saint James the Apostle in approximately AD 820–830. A further decisive contribution to this development was the decision taken by the bishops of Iria to move to the city in the second half of the century, although at the beginning of that same century Bishop Sisnandus I had already ordered a hospital to be built for pilgrims, whose offerings enriched the "holy place." The sanctuary was at that time attracting pilgrims not only from the Iberian Peninsula but also from other countries, like Bretenaldo, a Frank who settled in the city some time during the first third of the century; the anonymous German cleric who in 930 said that he had been cured of his blindness in Santiago: Godescalc, Bishop of Le Puy, who made the pilgrimage during the winter of 950–951 accompanied by a great retinue; Hugues de Vermandois, Bishop of Rheims, who came to Compostela ten years later; or the Armenian monk Simeon, who reached the "Church of Saint James the Apostle" in 983 or 984.[1]

Throughout the eleventh century, growing numbers of pilgrims, laymen and clerics, rich and poor, directed their steps towards the city of the Apostle. Just like the good and the great, such as Peter II Bishop of Le Puy in 1063, an anonymous Greek pilgrim in 1064, the envoys from Liège the following year, Siegfried of Mainz in or around 1070, Count Baldwin of Guines in 1084 or Hugo de Die, Archbishop of Lyon in 1095, by then so many people were traveling to Santiago that King Alfonso VI, with the consent of his sister Urraca, in November 1072 suppressed the toll levied in the pass of Valcarce for "*todos aquellos que allí pasan, y sobre todo los* peregrini *y los pobres que van a Santiago para orar*," explaining that it affected "*no sólo de los de España, sino también de Italia, Francia y Alemania*," as well as merchants.[2] In 1109, when the revolt against the "black friars" broke out in Sahagún, one of the great staging points along the Way, the town was full of "*gascones, bretones, alemanes, yngleses, borgoñoñes, normandos, tolosanos, provinçiales, lombardos e otros muchos negoçiadores de diversas naçiones e estrañas lenguas*."[3] Shortly afterwards, the authors of Sermon XVII, *Veneranda dies*, included in Book I of the *Codex Calixtinus*, after listing the names of seventy-four peoples, amongst them the *Arabes* and the *Iudei*, thus demonstrating that the whole world came to Santiago, made particular mention of the Germans, French and Italians who congregated in places other than the basilica, and of the English and the Greeks, with their characteristic chants.[4]

The growth in the population of Europe and the attractiveness of the Iberian Peninsula at that time, a place where neither gold nor parchment were lacking, where war could be made on the infidels and access be had to ancient philosophy, where

1 F. López Alsina, *La ciudad de Santiago de Compostela en la alta Edad Media* (Santiago de Compostela: Ayuntamiento de Santiago, 1988), p. 171. K. Herbers, "El primer peregrino ultrapirenáico a Compostela a comienzos del siglo X y las relaciones de la monarquía asturiana con Alemania del Sur," *Compostellanum*, vol. 37 (Santiago de Compostela: 1991), pp. 255–64. H. Jacomet, "Gotescalco, obispo de Santa María de Anís, peregrino de Santiago (950–951)," in *Rudesindus. La cultura europea del siglo X* (Santiago de Compostela: Xunta de Galicia, 2007), pp. 100–23. "*De S. Simeone monacho et eremita*," *Acta Sanctorum, Iulii*, vol. 6 (Antwerp: 1729), pp. 319–37, esp. p. 331. J. M. Lacarra, L. Vázquez de Parga and J. Uría Ríu, *Las peregrinaciones a Santiago de Compostela*, vol. 1:3 (Madrid: CSIC~Centro Superior de Investigaciones Científicas, 1948–1949; rep. fac. Pamplona: Gobierno de Navarra, 1993), pp. 44–45.

2 *Las peregrinaciones a Santiago de Compostela... op. cit.*, pp. 47–52. A. Gambra, *Alfonso VI. Cancillería, Curia e Imperio* (León: Centro de Estudios e Investigación San Isidoro, 1998), doc. 11, pp. 22–5.

3 A. Ubieto Arteta (ed.), *Crónicas anónimas de Sahagún* (Saragossa: Anubar Ediciones, 1986), pp. 20–1.

4 *Liber Sancti Iacobi Codex Calixtinus*, trans. A. Moralejo, C. Torres and J. Feo (Santiago de Compostela: Instituto Padre Sarmiento de Estudios Gallegos, 1951; rep. fac. Santiago de Compostela: CSIC~Centro Superior de Investigaciones Científicas, 1999), p. 89.

100

privileges were granted to the "*francos*" to encourage them to settle, go some way towards accounting for this development.[5] The Way attracted pilgrims of all kinds and all points of origin to the shrine of the Apostle, many of whom then returned home: some settled permanently in Santiago or other towns and cities along the Way, and others, before finally returning to their home countries, carried out their craft or trade here and there, depending on the opportunities that arose.[6] The power of attraction of the shrine throughout Europe did not decline until the second half of the sixteenth century, with pilgrims from every kingdom and principality coming to Santiago.

In 1109 or 1110 the treasurer Munio Alfonso wrote in the *Historia Compostellana* that when he succeeded to the episcopate in 1100, and in order to drag the canons of Compostela out of "*los rudimentos de la infancia*," Bishop Diego Gelmírez hired a "*maestro de retórica y de la ciencia*," probably a Frenchman, and handed over the administration of the recently created "Casa de la Moneda" to the Lombard Randulfus, who asserted his rights over two of his fellow countrymen.[7] Only a little earlier, in approximately 1075, work had begun on the construction of the new basilica, whose architects and master builders, *Bernardus* and *Rodbertus*, were in all probability foreign, perhaps Englishmen or Normans.[8] In 1118 the shrine received the visit of the Italian canonist Cardinal Deusdedit, author of a *Liber canonum* in defense of the primacy of Rome, in his role as papal legate in Spain;[9] the Frenchman Master Giraldus was at the time a teacher at the episcopal school in Santiago. The following year Bishop Gelmírez was accompanied by another Frenchman, Master Raucelinus, and a doctor from Salerno to a council held in the Auvergne. The presence of foreigners in the cathedral chapter became a habit: in 1134, the Italian Master Rainerius of Pistoia was a schoolmaster in the Basilica at Compostela, whilst twenty years later another Italian, Master Guido, was numbered amongst the canons.[10] For his part, Diego Gelmírez sent a certain number of students to France and Italy to complete their education in languages or law.[11]

There can be no doubt that the influx of foreign pilgrims and the presence of foreign artists and teachers in Compostela went hand in hand. However, to attribute the rise of culture in Compostela to foreigners, stating or supposing that it did not exist prior to their arrival, would be a mistake.[12] If so many teachers were attracted by the city of the Apostle, it was due not only to the fame of its shrine but also to the brilliance of its high level of culture and learning.

When halfway through the tenth century the bishops decided to leave Iria and establish their episcopal see in Compostela, they were undoubtedly concerned with developing a school that would satisfy the requirements of the Visigothic councils,[13]

5 J. Passini, *El Camino de Santiago. Itinerario y núcleos de población* (Madrid: Ministerio de Obras Públicas y Transportes, 1993).

6 S. Moralejo, "Artistas, patronos y público en el arte del Camino de Santiago," *Compostellanum*, vol. 30 (Santiago de Compostela: 1985), pp. 395–430.

7 *Historia Compostelana*, trans. E. Falque Rey (Madrid: Akal, 1994).

8 *Liber Sancti Iacobi...* op. cit., p. 256. S. Moralejo, "Notas para una revisión crítica de la obra de K. J. Conant," in J. K. Conant, *Arquitectura románica de la Catedral de Santiago de Compostela* (Santiago de Compostela: COAG~Colegio Oficial de Arquitectos de Galicia, 1983), pp. 221–38.

9 J. Gaudemet, *Les sources du droit canonique. VIII^e-XX^e siècle* (Paris: Cerf, 1993), pp. 90, 98.

10 *Historia Compostellana...* op. cit., p. 231. A. López Ferreiro, *Historia de la Santa A. M. Iglesia de Santiago de Compostela*, vols. 3:11 and 4:11 (Santiago de Compostela: Seminario Conciliar de Santiago, 1898–1901), pp. 256, 172, 216. *Tumbo C*, fols. 34 and 86. ACS~Archivo Catedral Santiago.

11 M. C. Díaz y Díaz, "Problemas de la cultura en los siglos XI y XIII. La escuela episcopal de Santiago," *Compostellanum*, 16 (Santiago de Compostela: 1971), pp. 187–200. A. Rucquoi, "*De gramaticorum schola*: la tradición cultrural compostelana en el siglo XI," in P. Gaucci (ed.), *Visitandum est. Sactos y Cultos en el Codex Calixtinus. Actas del VII Congreso Internacional de Estudios Jacobeos* (Santiago de Compostela: Xunta de Galicia, 2005), pp. 235–54.

12 M. Defourneaux, *Les Français en Espagne aux XI^e et XII^e siècles* (Paris: Les Presses Universitaires de France, 1949), pp. 10–6.

13 C. García Goldáraz, *El Códice lucense de la colección canónica hispana*, vol. 1:3 (Rome: CSIC~Centro Superior de Investigaciones Científicas, 1954), pp. 436–7.

and the city soon distinguished itself as a center of culture and learning. The children of kings were sent there to be brought up and educated, such as the young Bermudo II (982–999) and García, future King of Galicia (1065), as were the children of noblemen such as Guttier, entrusted by his father Count Ordoño Velasquez to the care of Bishop Hermenegild (924–951), or future bishops such as Pelagius of Leon (1065–1085) and Diego Gelmírez himself (1100–1140).[14] The declaration made by Master Giraldus at the beginning of Book II of the *Historia Compostellana*, according to which "*siendo por aquel entonces casi toda España ruda et ignorante* [...] *los anteriores prelados de la iglesia de Santiago fueron rudos e ignorantes*," does not therefore refer to their level of education, but only to the fact that before the time of Bishop Dalmatius (1094–1095), "*ningún obispo de los hispanos rendía entonces algún servicio u obediencia a nuestra madre la santa iglesia romana.*"[15]

The city shared in the cultural atmosphere that characterized the whole region at that time. Whilst churches and monasteries were being built in the Galician dioceses, Bishops Sisnandus II (952–968) and Cresconius (1037–1068) of Compostela ordered the city to be fortified with a system of strong walls, towers and gates, testimony to the skill of the architects of the time. In the field of the arts, the fondness for reusing Roman and Hispano-Visigothic monuments and for the decorative art of the caliphate of Cordoba and the East existed side by side with a curiosity for Carolingian and Byzantine iconography, or the presence of certain Viking objects.[16] The rich offerings made by the founders of churches and monasteries, and by kings and pilgrims of high birth, included chalices, sacred goblets, crosses, votive crowns, capes, censers, bells and other objects made of gold, silver and silver-gilt, sometimes encrusted with precious or semi-precious stones, of tin or of bronze, sometimes of ivory, of iron or of glass, as well as vestments, curtains or tablecloths and napkins of linen, silk and fine wool.[17] In the mid-twelfth century the Ceutan geographer al-Idrisi mentioned the size and beauty of the church, referred to "*lo crecido de sus riquezas y de los donativos que recibe,*" and added that in it "*entre grandes y pequeñas, hay sobre trescientas cruces labradas de oro y plata, incrustadas de jacintos, esmeraldas y otras piedras de diversos colores, y cerca de doscientas imágenes de estos mismos metales preciosos.*"[18]

Galician noblemen and prelates in the tenth and eleventh centuries were noted for their high level of learning and culture. The young Rudesindus (907–977) was educated in the see of Mondoñedo with his uncle, Bishop Sabaricus, mastering the arts of the *trivium* and acquiring a solid foundation in law; in February 2008 his mother Ylduara gave the monastery of Celanova a *Goticum*, in other works a copy of the *Liber Iudicum*, as well as a psalter, a work used to teach students to read.[19] His political rival, Sisnandus (c. 915–968), was also educated by an uncle, Bishop Gundesind of Iria, and held various positions in the royal court; his mother Paterna heard lawsuits in the absence of her husband and in October 952 the couple made a joint donation to the monastery of Sobrado that included eleven "ecclesiastical books," a donation to which three years later Sisnandus himself added a further fifteen volumes.[20] In 959 the Countess Mumadonna endowed the monastery of The Savior of Guimarães with a rich offering that included twenty liturgical and spiritual works;[21] ten years later Count Osorio Gutiérrez donated to the monastery of The Savior of Vilanova, in the diocese of Lugo, twenty-one books and everything necessary for worship.[22]

14 M. R. García Álvarez, "El *Chronicon Irense*. Estudio preliminar, edición crítica y notas históricas," in *Memorial Histórico Español*, 50 (Madrid: Real Academia de la Historia, 1963), p. 120. E. Portela Silva, *García II de Galicia. El rey y el reino (1065–1090)* (Burgos: Ediciones Trea, 2001). *Historia de la Santa A. M. Iglesia de Santiago de Compostela...* op. cit., vol. 2:11 and app. 75, pp. 518–9, and p. 177, resp. J. M. Ruiz Asencio, *Colección documental del archivo de la catedral de León (1032–1109)*, 4 (León: Centro de Estudios e Investigación San Isidoro, 1990), doc. 1190, pp. 439–47. "Problemas de la cultura en los siglos XI y XIII"... op. cit., p. 189.

15 *Historia Compostelana...* op. cit., II, 1.

16 D. Chao Castro, "La encrucijada de las confluencias artísticas en el noroeste peninsular del siglo X," in *Rudesindus. La cultura europea del siglo X...* op. cit., pp. 332–51.

17 E.g. the donation made to the monastery of Sobrado by Sisnandus I, Bishop of Iria-Compostela, in 955. Cf. P. Loscertales (ed.), *Tumbos del Monasterio de Sobrado de los Monjes*, vol. 1:2 (Madrid: Archivo Histórico Nacional, 1976), doc. 2.

18 J. García Mercadal, *Viajes de extranjeros por España y Portugal: desde los tiempos más remotos hasta comienzos del siglo XX*, 1 (Valladolid: Consejería de Educación y Cultura, 1999), p. 195.

19 M. C. Díaz y Díaz, "San Rosendo y Mindunieto: un episodio importante para la historia de Galicia," in *Rudesindus. La tierra y el templo* (Santiago de Compostela: Xunta de Galicia, 2007), pp. 16–29. C. Sáez and E. Sáez, *Colección diplomática del monasterio de Celanova (842–1230)*, 1 (Madrid: Universidad de Alcalá de Henares, 1996), doc. 57, pp. 130–4. C. Pérez Baliñas, "Virrey de Galicia: la vertiente política de San Rosendo," in *Rudesindus. La cultura europea del siglo X...* op. cit., pp. 36–53. M. C. Pallares, *Ilduara, una aristócrata del siglo X* (A Coruña: Edicións Do Castro, 1998), pp. 119–23.

20 C. Pérez Baliñas, *Gallegos del año Mil* (A Coruña: Fundación Pedro Barrié de la Maza, 1998), pp. 200–29. *Tumbos del Monasterio de Sobrado de los Monjes...* op. cit., docs. 1–2.

21 *Portugaliae Monumenta*, *Diplomata et Chartae*, vol. 1 (Lisbon: 1856), doc. 76, pp. 44–8.

22 "La Iglesia de Orense," in H. Flórez, *España Sagrada. Teatro Geográfico-Histórico de la Iglesia de España*, vol. 17:56 (Madrid: 1765), pp. 325–31.

One of his adversaries was forced to recognize that Bishop Arias II of Mondoñedo (977–982) had been "*adoctrinado en las letras y educado en la religión*."[23] Born into a family of servants of the parents of Bishop Sisnandus, Pedro de Mezonzo (c. 930–1003) was one of the "wise monks" of the monastery in which he was educated, and after being Abbot of Sobrado and of Antealtares ended his days as Bishop of Iria-Santiago; authorship of the hymn *Salve Regina* is attributed to him. In the year 995 or thereabouts Pedro de Mezonzo restored the monastery of Santa Eulalia, founded by his great-great-grandfather and destroyed by the Norsemen, and endowed it with liturgical objects of silver, bronze and iron as well as with vestments of silk and linen "*según nuestras posibilidades*."[24] Monasteries and churches also had their own schools, like that of the monastery of Celanova, whose students were witness to a lawsuit heard before the King in 1002, or that of San Pedro de Rocas, in the diocese of Orense, destroyed by a fire that started due to "*la negligencia de los niños que, residiendo en la escuela, leían las letras*,"[25] whilst numerous "masters" taught their pupils, male and female, to read and write. Eight "masters" are mentioned, for example, in a lawsuit in 1004 brought by the nobleman Oseredo Truitesendiz and his mother Doña Unisco against Godesteo and Rodericus Pelaiz. And Onorico Viliamondiz, whose name appears in 1072 amongst the youths – *pueruli* – brought up in the Church at Braga and later notary to Count Henry of Portugal, is also mentioned in 1103 when as a "master" he received a bequest from one of his female students.[26]

The Galician libraries were proud of the number of liturgical and spiritual works they possessed, many of them from the Hispanic tradition, whilst the Cathedral at Santiago received a richly illuminated copy of the *Beato*, and possibly also a *Diurnal*, from the monarchs Fernando I and his wife Sancha.[27] A century later, the donations made by Diego Gelmírez to his see included five volumes bound in gold and silver and sixteen books of a spiritual and liturgical nature, of which only two breviaries belonged to the Roman liturgy.[28] The works written in Compostela and its surrounding area in the eleventh century reveal a wide range of interests. They include rule books such as the *Penitencial* referred to as *Cordubense* and the records of the councils that met in 1056 and 1063, works of poetry such as the "testamento monástico" of Saint Rudesindus or the *titulus metricus* of the Compostela cleric Martín, liturgical works such as the *Kalendarium Compostellanum*, and "historical" works such as the *Chronicon perbreve*, the legendary version of the *translatio* of Saint James with the story of Queen Lupa, or the *Chronicon Iriense*, both of which were intended to favor pilgrimage and extol the see.[29] In Braga the first Bishop, Pedro, ordered an inventory of the property of his church to be drawn up at some time between 1085–1089, and commissioned a splendid sarcophagus to be sculpted in order to promote the cult of Saint Martin of Dumio.[30] And the *Beato* of 1086 preserved in the Cathedral at Osma, work of the cleric Pedro and the "sinner" Martín, may have come from Galicia, a region that enjoys a particular presence in its *mapamundi*; support for this hypothesis is a similar *mapamundi* painted at the time on the walls of the Church of San Pedro de Rocas.[31] There can thus be no doubt as to the existence in Galicia, and particularly in Compostela, of an intellectual circle capable of producing a range of different kinds of work whose central core was the episcopal school.

The presence in Compostela from the mid-eleventh century onwards of architects of Norman or French origin, of Italian moneychangers and Italian and

23 M. V. González de la Peña and C. Sáez (eds.), *A Coruña. Fondo Antiguo (788–1065)*, 2 (Madrid: Universidad de Alcalá de Henares, 2003), doc. 113.

24 M. Rubén García, "San Pedro de Mezonzo y la *Salve Regina*," in *Grial. Revista Galega de Cultura*, vol. 3, 7 (Vigo: Editorial Galaxia, 1988), pp. 67–74. *Tumbos del Monasterio de Sobrado de los Monjes...* op. cit., doc. 137.

25 J. M. Andrade Cernadas, *O tombo de Celanova*, vol. 1:2 (Santiago de Compostela: Consello da Cultura Galega, 1995), doc. 252, pp. 356–8. J. M. Fernández del Pozo, "Alfonso V, rey de León," *León y su historia*, 5 (León: Centro de Estudios e Investigación San Isidoro, 1984), pp. 173–7.

26 *Livro Preto. Cartolário da Sé de Coimbra*, eds. A. de J. da Costa and M. A. Rodrigues (Coimbra: Coimbra University Archives, 1999), doc. 212, pp. 328–30. A. de J. da Costa, *O bispo D. Pedro e a organização da diocese de Braga*, vols. 1:2 and 2:2 (Coimbra: Coimbra University, 1959), pp. 36–4, and pp. 45–6, resp.

27 M. R. García Álvarez, "Los libros en la documentación gallega de la Alta Edad Media," *Cuadernos de Estudios Gallegos*, vol. 20, 58 (Santiago de Compostela: Instituto Padre Sarmiento de Estudios Gallegos, 1965), pp. 292–3. M. C. Díaz y Díaz, "La cultura literaria en la España cristiana en torno al año 100," in *La Península Ibérica en torno al año 1000. VII Congreso de Estudios Medievales* (Ávila: Fundación Sánchez-Albornoz, 2001), pp. 193–204.

28 *Historia de la Santa A. M. Iglesia de Santiago de Compostela...* op. cit., vol. 4:11, pp. 69–71.

29 F. Bezler (ed.), *Paenitentialia Hispaniae. Corpus Christianorum Series Latina* (Turnhout: Brepols Publishers, 1998), p. 20. M. C. Díaz y Díaz, *Index scriptorum latinorum Medii Aevi Hispanorum* (Madrid: CSIC~Centro Superior de Investigaciones Científicas, 1959), pp. 774, 778, 866. Id., "El testamento monástico de San Rosendo," in *Historia, Instituciones, Documentos*, vol. 16 (Seville: 1989), pp. 418–51. Id., "La *Epistola Leonis Pape* de *Translatione Sancti Jacobi in Galleciam*," *Compostellanum*, 43 (Santiago de Compostela: 1998), pp. 517–68. "El *Chronicon Iriense*. Estudio preliminar, edición crítica y notas históricas"... op. cit., pp. 1–240.

30 *Aux confins du Moyen-Âge. Art portugais, XII⁰–XV⁰ siècles* (Brussels and Gant: Foundation Europalia International & Centrum loor Kunst en Cultuur, 1991), cat. 11: pp. 120–1 and cat. 10: pp. 114–5.

31 S. Moralejo, "El mapa de la diáspora apostólica en San Pedro de Rocas. Notas para su interpretación y filiación en la tradición cartográfica de los *Beatos*," *Compostellanum*, 31 (Santiago de Compostela: 1986), pp. 315–40.

French, is thus a further sign of the importance of the shrine and of its fame and wealth, as well as of the prestige of its school. The great contemporary centers of learning in Europe, such as Salerno, Pavia or Bologna in Italy; Laon, París and Orleáns in France; and Canterbury in England all shared the characteristic of having many foreigners amongst their leading figures.[32] These "foreigners" collaborated with local masters and students and put their talent at the service of the see that welcomed them. It should therefore come as no surprise to find them in Santiago de Compostela. It was perhaps in order to guarantee them tempting incomes that would incite them stay that Archbishop Gelmírez raised the number of members of the chapter of church to seventy-two, from seven in the time of Cresconius and twenty-four in the late eleventh century during the episcopate of Diego Peláez.[33]

This foreign presence was henceforth to provide the see at Compostela with a more cosmopolitan type of learning and culture than that of other Hispanic intellectual centers. In the cultural sphere personages or matters with of as little Hispanic nature such as the Frankish Emperor Charlemagne and his nephew Roland; saints from abroad such as Saint Faith or Saint Eutropius; foreign shrines such as Saint-Léonard de Noblat, Cluny Abbey, Rome or Saint-Gilles de Provence; and the accounts of miracles that occurred in Lyon or Toulouse, all reveal the cosmopolitan nature that would henceforth characterize culture in Compostela. It is hard not to see in the Way of Saint James one of the significant factors in the social and cultural opening-up that characterized the city of Compostela in the eleventh and twelfth centuries.

Ample recourse was had to the talents and knowledge of the foreigners then living in Compostela from the moment that the Church of the Apostle had to face a double threat: the attitude of the Popes who refused to acknowledge the apostolic nature of the see, and the constitution of Toledo as the primatial see in Spain.[34] Under the leadership of its first Archbishop, Bernardo, in the late eleventh century the see of Toledo embarked on a cultural policy based on its Visigothic past and its role as the capital of former Hispania.[35] The Church in Compostela then chose, in order to support its claims, to link the see to Western Christendom and its great figures. Various works were conceived, in different and apparently unrelated fields, but which in the end all told the same story and provided mutual authentication.

The so-called *Concordia de Antealtares*, written in 1077, in its preamble offers an account of the finding of the tomb of Saint James, relating it to King Alfonso II the Chaste (791–842) and Bishop Theodomir of Iria (c. 818–847); it is therefore no surprise that the first document included by the treasurer Bernardo in his *Tumbo A*, in approximately 1129, should effectively concern a donation made by Alfonso II to the apostle, in which mention is made of Bishop Theodomir. Written shortly after the *Concordia*, in or around 1080, the *Chronicon Iriense* also mentions the King and Bishop Theodomir in connection with the discovery, but added that this took place "*en tiempos de Carlomagno*" (768–814).[36] Two traditions were thus created before the year 1100. In the first, only the King and the Bishop intervened, proof that Saint James was the apostle of the kingdoms of Spain. The second saw the intervention of Charlemagne, Emperor of the Franks, a King appointed Emperor of the West by a Pope, thereby asserting the universal vocation of the shrine.

32 D. Jacquart and A. Paravicini Bagliani (eds.), *La Scuola medica Salernitana. Gli autori e i testi* (Florence: Sismel Edizione del Galluzzo, 2007). C. M. Radding, *The Origins of Medieval Jurisprudence. Pavia and Bologna, 850–1150* (New Haven: Yale Universtiy Press, 1988). A. Brunet, G. Paré and P. Tremblay, *La Renaissance du XIIᵉ siècle. Les écoles et l'enseignement* (Paris & Ottawa: Vrin & Institut d'études médiévales, 1933).

33 *Historia Compostellana. Corpus Christianorum Continuatio Mediaevalis*, ed. E. Falque Rey (Turnhout: Brepols Publishers, 1988), I, 20 and III, 36. M. González Vázquez, "Lugar de culto y centro de cultura," in E. Portela Silva (ed.), *Historia de la ciudad de Santiago de Compostela* (Santiago de Compostela: Consorcio de Santiago and USC~Universidad de Santiago de Compostela, 2003), p. 200.

34 J. M. Soto Rábanos, "Introducción del rito romano en los reinos de España. Argumentos del papa Gregorio VII," *Studi Gregoriani. La riforma gregoriana e l'Europa*, 14 (Rome: 1991), pp. 161–74.

35 L. Vázquez de Parga, *La División de Wamba* (Madrid: CSIC~Centro Superior de Investigaciones Científicas, Instituto Jerónimo Zurita, 1943). J. F. Rivera Recio, *El arzobispo de Toledo Don Bernardo de Cluny (1086–1124)* (Rome: Instituto Español de Historia Eclesiástica, 1962). Id., *La Iglesia de Toledo en el siglo XII (1086–1208)* (Rome: Instituto Español de Historia Eclesiástica, 1966–1976). J. M. Fernández Catón, "Documentos del archivo de la catedral de Toledo en escritura visigótica," in *Estudios sobre Alfonso VI y la reconquista de Toledo. Actas del II Congreso Internacional de Estudios Mozárabes*, vol. 1:2 (Toledo: Instituto de Estudios Visigótico-Mozárabes de San Eugénio, 1988), pp. 81–7.

36 *Historia de la Santa A. M. Iglesia de Santiago de Compostela... op. cit.*, vol. 3:11 and app. I, pp. 3–7. M. Lucas Alvarez (ed.), *Tumbo A de la Catedral de Santiago de Compostela*, 1 (A Coruña: Edicións do Castro, 1998), pp. 49–51. "El *Chronicon Irense*. Estudio preliminar, edición crítica y notas históricas"... op. cit., pp. 110–1, 115.

In the twelfth century the first of these traditions gave rise to the *Historia Compostellana*, a eulogy of the see and its Bishop, Diego Gelmírez, and to the *Tumbo A*, which contains copies of all the documents of the kings of Oviedo, and later Leon, in favor of the church. It also led to the drafting of the definitive accounts of the translation of the apostle's body from Jerusalem to Galicia, which were later collected in Book III of the so-called *Codex Calixtinus*. The authors of the first chapter of this book did not hesitate to affirm that James, brother of Saint John the Evangelist, had preached the gospel in Spain before his martyrdom in Jerusalem and eventual translation to Compostela, thus openly contradicting the Gregorian version that in 1074 had attributed this task to Saint Paul and *"los siete obispos que desde la ciudad de Roma fueron enviados por los apóstoles Pedro y Pablo para instruir los pueblos de España."*[37] An extended version of the translation of Saint James was also produced, containing the legend of Queen Lupa or Luporia, which had been widely disseminated in Europe during the previous hundred years or so.[38] Within this same tradition, very characteristic of Compostela and Spain, mention should also be made of the fragment of the poem by Master Panicha in praise of the see, and the diploma of the Offering to Saint James, written by Pedro Marcio, who took as his source a chapter of the *Chronicon Iriense*, transforming and reinterpreting it in order to uphold the claims of Compostela.[39]

At the same time, between 1090 and 1130, the "universal" version, already present in Book II of the *Codex Calixtinus*, which recalls the miracles wrought by the Apostle, took shape in two stages that when combined became the *"Historia Turpini,"* Book IV of the *Codex Calixtinus*.[40] This *Historia*, by recounting the details of the liberation of the tomb of the apostle by Charlemagne, authenticated the chronology contained in the *Chronicon Iriense*, and at the same time the presence of the apostle's body in Spain. The authors of this version of the finding of the tomb, a version in which both King Alfonso II and Bishop Theodomir have no place, had no hesitation, however, in evoking the account of the translation and even of the tradition of the evangelization of Spain by Saint James, proof of the close relationship between the various texts that make up the *Codex*.[41] The *"Historia Turpini"* thus narrated in great detail the deeds of Charlemagne, his nephew Roland and the twelve peers of France on the road from France to Galicia, the foundation and endowment of the church, and their return via the Pyrenees.

It only remained to express this itinerary in spatial terms in order to lend it greater veracity. Book V of the *Codex Calixtinus*, nowadays known as the "Pilgrim's Guide to Santiago de Compostela", served this purpose by encouraging pilgrims to travel the same roads and pass through the same places described in the *"Historia Turpini,"* from the shrines linked to the legend – Saint-Guilhem, Blaye, Belin – to the Basilica at Compostela, but not without also paying a visit to the places where the miracles narrated in Book II of the same *Codex* had taken place.[42] The foreign collaborators at the cathedral school helped to give greater verisimilitude to the itinerary, by indicating the translation of certain words – *"el pescado que la gente llama* barbo*, o el que los del Poitou llaman* alosa *y los italianos* clipia*, o la* anguila *o la* tenca*"* (V, 6), *"las enormes moscas que la gente llama* guespes *o* tavones*"* (V, 7) –, at times expressing personal opinions – *"los del Poitou son gente fuerte y guerrera, muy hábiles en la guerra con arcos, flechas y lanzas, confiados en la batalla, rapidísimos en las carreras, cuidados en su vestido, distinguidos en sus facciones, astutos en sus palabras,*

37 D. Mansilla (ed.), *La documentación pontificia hasta Inocencio III (965–1216)* (Rome: Instituto Español de Estudios Eclesiásticos, 1955), pp. 15–6.

38 "La *Epistola Leonis Pape* de *Translatione Sancti Jacobi in Galleciam"* ... op. cit., pp. 530–3, 552–4, 560–2.

39 Ibidem, pp. 562–3. *La ciudad de Santiago de Compostela en la alta Edad Media...* op. cit., pp. 181–2. A. Rucquoi, "Clavijo: Saint Jacques matamore?," *Compostelle*, 11 (Paris: 2008), pp. 48–58.

40 F. López Alsina, "La prerrogativa de Santiago en España según el 'Pseudo-Turpin': ¿tradiciones compostelanas o tradiciones carolingias?," in K. Herbers (ed.), *El "Pseudo-Turpin." Lazo entre el culto jacobeo y el culto de Carlomagno (Actas del VI Congreso Internacional de Estudios Jacobeos)* (Santiago de Compostela: Xunta de Galicia, 2003), pp. 113–29.

41 *Liber Sancti Iacobi Codex Calixtinus...* op. cit., IV, 5 and 19.

42 Ibid. See A. Rucquoi, "O caminho de Santiago: A criação de um itinerário," *Signum*, 9 (Cuibá: 2007), pp. 95–120.

muy dadivosos en sus mercedes, pródigos con sus huéspedes" (V, 7) –, and even speaking in the name of their fellow-countrymen – "*cuando nosotros, gente de las Galias, queremos entrar en la basílica apostólica*" (V, 9) –. However, the preponderance of information relating to Spain, the depth of the knowledge shown of the, as yet unfinished, cathedral, and the occasional reference to foreigners as "*bárbaros*" – "*Todos los pescados y las carnes de vaca y de cerdo de toda España y de Galicia hacen enfermar a los bárbaros*" (V, 6) –, reveal the intervention of Hispanic hands. The final attribution of the complete work to Pope Calixtus II (1119–1124), who had died several decades before the *Codex* was compiled but had been an uncle of King Alfonso VII "the Emperor," and its subsequent "legitimization" by Pope Innocence II (1130–1143), reinforced the apparent veracity of a series of texts that authenticated each other.

Literary output in Compostela was thus characterized by its great homogeneity despite the diverse nature of the works produced. They all shared a common goal, namely to promote the see of Compostela by justifying its allegations in the face of the arguments put forward by Toledo and Rome. In order to conceive an undertaking of such dimensions it was necessary to have a heterogeneous and at the same time closely linked community of intellectuals. All the members of the episcopal school, be they natives or foreigners, thus contributed to the work, placing their talents and personal knowledge at the service of the see; that same school was where the treasurer Bernardo and Pedro Elías, future Archbishop of Santiago, amongst others, received their education and training.[43]

Taking their inspiration from Isidore of Seville and Ildefonso of Toledo, the Spanish chronicles of the Early Middle Ages saw the Franks as barbaric fearsome warriors, not only uncultured in themselves but also keen to destroy Hispanic culture; this picture of the Franks is still to be seen in the opening pages of the early twelfth century chronicle commonly known as the *Historia Silense*, and explains the little interest they aroused in chroniclers.[44] Word of the fame of Emperor Charlemagne thus had to be brought to Spain by pilgrims, traveling along the French Route of the Way of Saint James. The so-called *Nota Emilianense*, which briefly recounts (in a single column) the story of Charlemagne's journey to Saragossa and the death of Roland at Roncesvalles, dates back to 1050–1070 and comes from the monastery of San Millán de la Cogolla. Visited by so many pilgrims on their way to Santiago, this foundation had moved to a new building, that "*de yuso,*" in the mid-eleventh century.[45] Thanks to the pilgrims, to the masters who came from France, to the students from sent by Diego Gelmírez from Compostela to French schools, or the journey the Archbishop himself undertook in 1119 to the Auvergne and Burgundy, the Carolingian epic tradition and a plethora of information about shrines, regions and the peoples of France and Gaul made its way to Compostela.

In Compostela itself, the mixture of elements from abroad with those concerning Spain, Galicia and the Basilica of Saint James, permitted the creation of a large part of the texts constituting the *Codex Calixtinus*, giving it universal scope. These ideas were not well received in Spain, and although the "Hispanic" tradition of a discovery by Alfonso II and Theodomir was accepted, from the anonymous author of the so-called *Historia Silense*, written in Leon in or around 1115, down to Rodrigo Jiménez de Rada, Archbishop of Toledo, a century later, the possibility of Charlemagne having intervened in the Iberiaon Peninsula was universally rejected.[46] The "*Historia Turpini,*" however,

43 *Historia Compostellana. Corpus Christianorum Continuatio Mediaevalis...* op. cit., III, 39.
44 Pérez de Urbel and A. González Ruíz-Zorrilla (eds.), *Historia Silense* (Madrid: Escuela de Estudios Medievales, 1959), pp. 113–7.
45 E. Ruiz Garcia, *Catálogo de la sección de Códices de la Real Academia de la Historia* (Madrid: Real Academia de la Historia, 1997), cod. 39, pp. 257–64, see fol. 245.
46 *Historia Silense...* op. cit., p. 130. J. Fernández Valverde (ed.), *R. Ximenii de Rada. Historia de rebus Hispanie sive Historia gothica* (Turnhout: Brepols, 1987), III, 10, pp. 126–8.

was of use to Compostela in that Rome ceased to question the presence of the relics of Saint James the Apostle in Galicia. In the rest of Western Christendom it was used as evidence in favor of the canonization of Charlemagne, proclaimed in 1165, and during the following century it was incorporated into the *Grandes Chroniques de France*.[47]

The episcopal school in Compostela, with its cosmopolitan nature, thus facilitated the creation of a series of texts in defense of the apostolic see. Its responsibilities, however, were not simply limited to the writing of chronicles, cartularies or historical fictions. In order to construct the immense basilica dreamt of by bishops Diego Peláez and Diego Gelmírez, masters Bernardo, Roberto and, later, Esteban needed not only to avail themselves of knowledge of mathematics and geometry insofar as the terrain was not particularly appropriate for the purpose, but also of the skill of master builders and masons. The concept of the new basilica was so novel that the canons of Saint-Martin de Tours, after the destruction of their church by fire, in 1096 chose it as the model for its reconstruction.[48] In 1124 the cloisters and ancillary buildings were designed *"como las iglesias de más allá de los Pirineos."*[49] The high level of theoretical and technical knowledge amongst the master builders at Compostela was also evident in the Fountain of Paradise which, thanks to the patronage of the treasurer Bernardo, in 1122 brought water to the North Door of the basilica, the one through which the pilgrims entered;[50] in the fortification of the west towers of the wall of Cresconius; and in the construction of a spacious episcopal palace next to the church, with a deep well of "admirable técnica."[51]

The "cosmopolitanism" of Compostela from the late eleventh century onwards and its opening-up to the outside world is also apparent in the decorative motifs in the basilica and the objects in its treasure-house. It was perhaps the influence of "fashions" from beyond the Pyrenees that led to the inclusion of a calendar, a motif not hitherto commonly found in the Peninsula, in the North Door, through which pilgrims entered the cathedral,[52] whilst Chapter Eight of Book V of the *Codex* contains a detailed description of the zodiac on the coffer containing the relics of Saint Giles.[53]

The theme of the Transfiguration, with the representation of Moses and Elijah at Christ's side and that of the apostles Peter, John and James at his feet, which adorned the West Door of the basilica in the mid-twelfth century, is for its part related to certain representations of the same subject in the Byzantine art of the period,[54] whilst the *Vida de San Eutropio*, translated from Greek in Book V of the *Codex*, the story of the miracle that occurred to the Greek pilgrim Esteban in 1064 in the Church at Compostela, or the giving of the name of Saint George to a castle donated by the King, are further proof of the relations between the shrine and the East.[55] The treasury at Compostela was also enriched by a cross in the Rhenish style (large numbers of merchants and pilgrims from Lorraine frequented the city at the time), by an altar frontal and a cimborio whose motifs are connected to themes also used in Gaul (at Toulouse, Moissac, Conques), in Catalonia and in Italy.[56] And it was a foreign master craftsman (*ultraportuensis*) who was commissioned by Diego Gelmírez in 1125 to make four bells, two large and two small, for the basilica.[57]

Relations between the see at Compostela and Italy were also close during the first half of the twelfth century. Several Italian masters either belonged to the cathedral chapter during this period or came to Santiago, whilst Archbishop Gelmírez maintained a close relationship with the papal chancellor Aimerico and the legates from Rome,

47 L. Vones, "La canonización de Carlomagno en 1165, la *Vita Karoli* de Aquisgrán y el '*Pseudo-Turpin*,'" in *El "Pseudo-Turpin." Lazo entre el culto jacobeo y el culto de Carlomagno...* op. cit., pp. 271–83. J. Ehlers, "El '*Pseudo-Turpin*' en las *Grandes Chroniques de France*," in ibid., pp. 285–96.

48 A. Barral Iglesias and J. Suárez Otero, *Catedral de Santiago de Compostela y museo* (León: Ediciones Leonesas, 2003), pp. 31–46.

49 *Historia Compostellana. Corpus Christianorum Continuatio Mediaevalis...* op. cit., III, 1.

50 *Liber Sancti Iacobi Codex Calixtinus...* op. cit., V, 8.

51 *Historia Compostellana. Corpus Christianorum Continuatio Mediaevalis...* op. cit., II, 13, 25, 54.

52 *Liber Sancti Iacobi Codex Calixtinus...* op. cit., p. 253. S. Moralejo, "La primitiva fachada norte de la Catedra de Santiago," *Compostellanum*, 14 (Santiago de Compostela: 1969), pp. 623–68. M. Castiñeiras, *El calendario medieval hispano: textos e imágenes (siglos X–XIV)* (Valladolid: Junta de Castilla y León, 1996), p. 73.

53 *Liber Sancti Iacobi Codex Calixtinus...* op. cit., IV, 8, p. 242.

54 *Le Mont Athos et l'Empire byzantin. Trésors de la Sainte Montagne* (Paris: Petit-Palais, 2009), no. 88: pp. 188, 192, and no. 148: pp. 262–3.

55 *Liber Sancti Iacobi Codex Calixtinus...* op. cit., V, 8 and II, 19. *Historia de la Santa A. M. Iglesia de Santiago de Compostela*, vol. 4:11, op. cit., app. V, pp. 12–5.

56 S. Moralejo, "Ars sacra et sculpture romane monumentale: Le trésor et le chentier de Compostelle," *Les Cahiers de St-Michel de Cuxa. Les origines de l'art roman. 11ème centenaire de la fondation de Cuxa*, 11 (Cuxa: 1980), pp. 189–238.

57 *Historia Compostellana. Corpus Christianorum Continuatio Mediaevalis...* op. cit., II, 77.

sending some clerics from his church to Italy. In 1136 a pilgrim from Pisa witnessed the rebellion against the Archbishop and informed the Pope of it on his return; that same year King Alfonso VII confiscated the property of one Juan Lombardo, who had joined the uprising against the Archbishop, donating them shortly afterwards to the Church in Compostela.[58] The *Polycarpus* (1104–1106) dedicated by Cardinal Gregorius to Archbishop Gelmírez, together with the works of Cardinal Deusdedit, who was the papal legate in Spain and maintained good relations with the see at Compostela, were the first milestones in the acquisition of knowledge of the new canonistic trends. This prepared the ground for the appearance in the second half of the twelfth century of great canonists such as Pedro Hispano, author of a commentary on the so-called *Compilación I Antigua*, or Bernardo Compostelano, who commented on the *Decreto de Graciano* and the *Compilación I Antigua*, and also left some *Quaestiones*.[59]

In 1173 a new Archbishop was appointed in Compostela: Pedro Suárez de Deza, the best educated of all its archbishops according to a document from Sobrado dated in 1193 – *plenus omni scientia, plus quam omnes qui in eadem sede archiepiscopi ante eum fuerunt* –, who must have studied in Italy, since he was ordained and consecrated Bishop of Salamanca in Rome in 1167.[60] The lengthy suit between the sees of Braga and Compostela during his episcopate required all the skills of specialists in Peninsular and Roman law.[61] Pedro Suárez was an active participant in the Third Lateran Council in 1179, his successor being the noted canonist Pedro Muñiz (1206–1224).[62]

The death of Archbishop Gelmírez in 1140 was perhaps the reason for compiling the contents of the *Codex Calixtinus* in a single volume, a task that appears to have taken some twenty years and even then never really completed, since new pieces continued to be added to the volume until as late as the 1180s.[63] It may also have been behind the dissemination throughout Europe of a shorter and apparently more coherent version of the *Codex*, the *Liber Sancti Jacobi*, the oldest copies of which date back to the middle of the twelfth century; the mention of a cleric who was "*amante de Santiago y peregrino*" and wanted to take the story of the Apostle back to his home country, paying for a copy to be made for him by one Fernando in Compostela, is evidence of the interest shown by pilgrims in these stories.[64]

Nevertheless, the episcopal school, although active, must have undergone certain difficulties. Under the episcopate of Pedro Gudesteiz (1168–1173), who had been brought up in the cathedral before becoming the King's chancellor and Bishop of Mondoñedo, various measures were taken in favor of poor scholars, provided they took their studies seriously, and amongst other tasks the schoolmaster of the chapter was ordered to hire a "*maestro de gramática*" for the clerics and pupils of the church, and for all those of the city and of the diocese.[65] Perhaps one of the scholars in Santiago at the time was the monk Arnaldo de Monte, author of a copy of various sections of the *Codex Calixtinus* which he gave to the monastery of Ripoll in Catalonia in 1173.[66] Under Pedro Suárez de Deza, the next Archbishop, the Church at Compostela placed itself under the direct protection of Rome. A stone chancel was built in the shrine, the work of Master Mateo, who was also responsible for the the Portico of Glory, which replaced the Door of the Transfiguration as the new West Door, and the cloister was also completed.[67] The tympanum of the door to the cathedral from the cloister contains a representation of Saint James at the Battle

58 Ibidem, III, 50, 39, and 49, 7. *Historia de la Santa A. M. Iglesia de Santiago de Compostela...* op. cit., vol. 4:11, app. X, pp. 28–30.
59 G. Martínez, "Canonística española pregraciana," in *Repertorio de Historia de las Ciencias Eclesiásticas en España*, vol. 1:7 (Salamanca: Instituto de Historia de la Teología Española, 1967), pp. 377–95. A. García y García, "La canonística ibérica medieval posterior al Decreto de Graciano," in ibid., pp. 397–434.
60 *Tumbos del Monasterio de Sobrado de los Monjes...* op. cit., doc. 175. V. Beltrán de Heredia, *Cartulario de la Universidad de Salamanca* (Salamanca: Universidad de Salamanca, 1970), p. 91.
61 A. de J. da Costa, "Geórgicas de Virgilio (Fragmentos portugueses do século XI)," *Humanitas* (Chile: 1955–1956), pp. 220–37. Id. (ed.), *Liber Fidei Sanctae Bracarensis Ecclesiae* (Braga: Junta Distrital, 1965).
62 *Cartulario de la Universidad de Salamanca...* op. cit., vol. 1, p. 45.
63 M. C. Díaz y Díaz, *El Códice Calixtino de la Catedral de Santiago. Estudio codicológico y de contenido* (Santiago de Compostela: Monografías Compostellanum, 1988).
64 Ibidem, pp. 38–42.
65 *Historia de la Santa A. M. Iglesia de Santiago de Compostela...* op. cit., vol. 4:11, pp. 292–4, and app. 40 and 42. "Problemas de la cultura en los siglos XI y XIII. La escuela episcopal de Santiago"... op. cit., note 11.
66 *El Códice Calixtino de la Catedral de Santiago. Estudio codicológico y de contenido...* op. cit., pp. 42, 77, 134.
67 *Historia de la Santa A. M. Iglesia de Santiago de Compostela...* op. cit., vol. 4:11, p. 321.

of Clavijo, with the maidens at his feet, thereby authenticating the diploma *"de los Votos de Santiago,"* fabricated some decades previously by the canon Pedro Marcio.

A few months after his arrival in Compostela, Archbishop Pedro Muñiz introduced a new constitution in which he praised science and included prebends for the canons and incumbents of the church who studied elsewhere.[68] The basilica, which received its solemn consecration in 1211, possessed at the time an extremely well endowed library that was made good use of by the first Dominican and Franciscan friars to establish themselves in Santiago. A brief glimpse at the titles of the works lent to the Mendicants reveals that the see still retained the cosmopolitan aspect that had characterized it over the previous century and a half. They include classics such as Boetius' *De consolatione philosophiae* and a *Priscianus menor*, "French" works such as the *Sentencias* of Pedro Lombardo, Pierre Riga's *Aurora* and the sermons of Maurice de Sully, numerous works of natural philosophy translated from Arabic, in some cases by the Galician doctor Johannes Hispalensis, such as the *De anima* by Avicenna, the *Metaphysica* of al-Ghazali or the *De differentia inter animam et spiritum* of Qusta ben Luca, as well as a series of works on mathematics, geometry and astronomy such as the *Scientiae astrorum et radicum motuum coelestium liber* of al-Farghani, the *De ortu scientiarum* of al-Farabi, the *Liber Alghoarsimi de practica arismetricae* attributed to Kwharismi, and Euclid's *Geometria*.[69] Archbishop Pedro Muñiz also sent nine volumes to his church, which were accepted by his successors.[70]

The libraries of the archbishops of the thirteenth century and the growing number of students at the University of Salamanca reveal that Santiago continued to maintain a high level of culture and learning. However, with the exception of the works of art donated by pilgrims as offerings to the shrine, such as the figure of Saint James given by Geoffroy Coquatrix at the beginning of the fourteenth century, that given by Jean Roucel or the alabaster retable offered by the Englishman Goodyear in 1456, and which is still preserved in the treasury of the cathedral, few foreign influences are henceforth to be noted in the field of culture and learning at Compostela. The cosmopolitanism that had characterized it in the twelfth century was by then limited to welcoming pilgrims from all parts of Europe and beyond, pilgrims who would then give an account of their journey, at times revealing their surprise at the little respect shown for the Archbishop and canons of the church. *"Un poderoso señor había acampado delante de la iglesia,"* relates Gabriel Tetzel, secretary to Baron Leon de Rosmithal of Blatna, in Bohemia, *"con él estaban todos los de Santiago y tenían la iglesia enteramente cercada, tirando tiros de pólvora y contestando los de dentro. Y el señor y la gente de la ciudad tenían prisionero en un castillo, fuera de la población, al obispo; y la madre y el hermano del obispo y un cardenal estaban encerrados en la iglesia. La gente de la ciudad y el señor mencionado, enemigo del obispo, habían atacado la iglesia el mismo día de Santiago."*[71] Compostela was no longer seen as a center of culture and learning, and only the shrine remained to attract pilgrims.

However, the creation of a university in the city in the early sixteenth century, together with the dissemination of the cult of Saint James throughout the empire of the Hapsburgs and the American continent, a militant Saint James who was the living image of the Counterreformation, restored Compostela to its role as a major center of culture and learning in the Modern Age.

68 Ibidem, vol. 5:11, pp. 47–8 and app. 7, pp. 21–3.
69 Vat. lat. 659, fl. thirteenth century. D. de Bruyne, "Une liste prêtée au XIIIᵉ siècle à des frères mineurs," *Antonianum*, 5 (Rome: 1930), pp. 229–32. M. Castro, "La biblioteca de los franciscanos de Val de Dios de Santiago (1222–1230)," *Archivo Ibero-Americano*, 53 (OFM~Franciscanos Españoles, 1973), pp. 151–62.
70 A. García y García and I. Vázquez Janeiro, "La biblioteca del arzobispo de Santiago de Compostela, Bernardo II (†1240)," *Antonianum*, 61 (Rome: 1986), pp. 540–68.
71 *Viajes de extranjeros por España y Portugal: desde los tiempos más remotos hasta comienzos del siglo XX... op. cit.,* p. 279.

John Williams

The Basilica in Compostela and the Way of Pilgrimage

Santiago Cathedral and pilgrim churches in Europe

Perhaps nothing so clearly marks the entrepreneurial spirit of Diego Gelmírez as the *Liber Sancti Jacobi*, the so-called *Codex Calixtinus*, which takes its name from the fact that it opens with a letter purportedly composed by Pope Calixtus II (1119–1124), who presents his collection of sermons to the monks of Cluny, Patriarch of Jerusalem and to Archbishop Diego Gelmírez of Santiago. The oldest and most luxurious copy of this collection is the one in Santiago and datable to the end of his life. Even so, the scholarly world has tended to detach its inspiration from Bishop Gelmírez in favor of an ultra-pyrennean origin, the Burgundian Monastery of Cluny being the favorite choice.[1] To be sure, the script and illumination are Gallic in character, but it has to have been the bishop's initiative that produced it. Its French appearance is not anomalous: the great new church that mostly rose during Gelmírez's tenure was almost as thoroughly French in artistic language.

The *Liber Sancti Jacobi*'s fifth chapter, the so-called "Pilgrim's Guide," was crucial in our own time for directing attention to the Cathedral of Santiago. Its identification of five roads as the major arteries leading to the shrine of Saint James eventually led to a perception that a church on each of the roads north of the Pyrenees, Saint-Martin de Tours, Saint-Martial de Limoges, Saint-Foi de Conques, and Saint-Sernin de Toulouse shared designs to an extraordinary degree. Inspired by the publication of a translation of the "Pilgrim's Guide" by Fidel Fita and Julien Vinson,[2] Abbé Bouillet of Conques in 1893 was the first in the modern era to connect the pilgrimage roads to Santiago with the development of Romanesque architecture and sculpture. Although he recognized the contribution of eleventh-century Auvergnate churches to the design of the group, he attributed the exceptional similarity of the buildings and décor of Conques, Toulouse and Santiago to the diffusion of the cult of Saint Faith, as well as to the stimulus that the popularity of the pilgrimage to Compostela to art and architecture.[3] While Bouillet's conclusion did not inform the comprehensive studies of French and Spanish Romanesque art that soon appeared,[4] in time Émile Mâle's and Kingsley Porter's studies granted a seminal role to the Pilgrimage to Santiago in the history of Romanesque art and architecture.[5] It was due in large part to the *Codex Calixtinus* that Cluny was granted an extraordinary, and undeserved, role in the promotion of the pilgrimage.[6]

1 It is notable, for example, that in the monograph by M. Díaz y Díaz, *El Códice Calixtino de la Catedral de Santiago. Estudio codicológico y de contenido* (Santiago de Compostela: Centro de Estudios Jacobeos, 1988), the *Codex Calixtinus* is treated as a reflection of concepts originating north of the Pyrenees, with the manuscript in Santiago merely a copy and not the archetype. In the recent study by D. Catalán, *La épica española: Nueva documentación y nueva evaluación* (Madrid: Fundación Ramón Menendez Pidal, 2001), a Galician origin is taken for granted.

2 F. Fita and J. Vinson, *Le Codex de Saint-Jacques de Compostelle. Liber de Miraculis S. Jacobi: Livre IV* (Paris: Maisonneuve, 1882).

3 "Sainte-Foy de Conques, Saint-Sernin de Toulouse, Saint-Jacques de Compostelle," in A. Bouillet (ed.), *Mémoires de la Société des Antiquaires de France*, 53 (Paris: 1983), pp. 117–28.

4 C. Enlart, "L'architecture romane," in A. Michel (ed.), *L'Histoire de l'art depuis les premiers temps chrétiens jusqu'à nos jours. Des débuts de l'art chrétien à la fin de la période romane*, vol. 1:2 (Paris: Collin Armand, 1905), pp. 454ff. V. Lampérez y Romea, *Historia de la arquitectura cristiana española en la Edad Media* (Valladolid: Ámbito Ediciones, 1999).

5 E. Mâle, *L'art religieux du XIIᵉ siècle en France. Étude sur les origines de l'iconographie du Moyen Âge* (Paris: Collin Armand, 1928), pp. 288ff. A. K. Porter, *Romanesque Sculpture of the Pilgrimage Roads*, vol. 1:10 (Boston: Marshal Jones Company, 1923), pp. 171ff.

6 J. W. Williams, "Cluny and Spain," *Gesta*, vol. 28, 1/2 special isssue (New York: 1988), pp. 93–101.

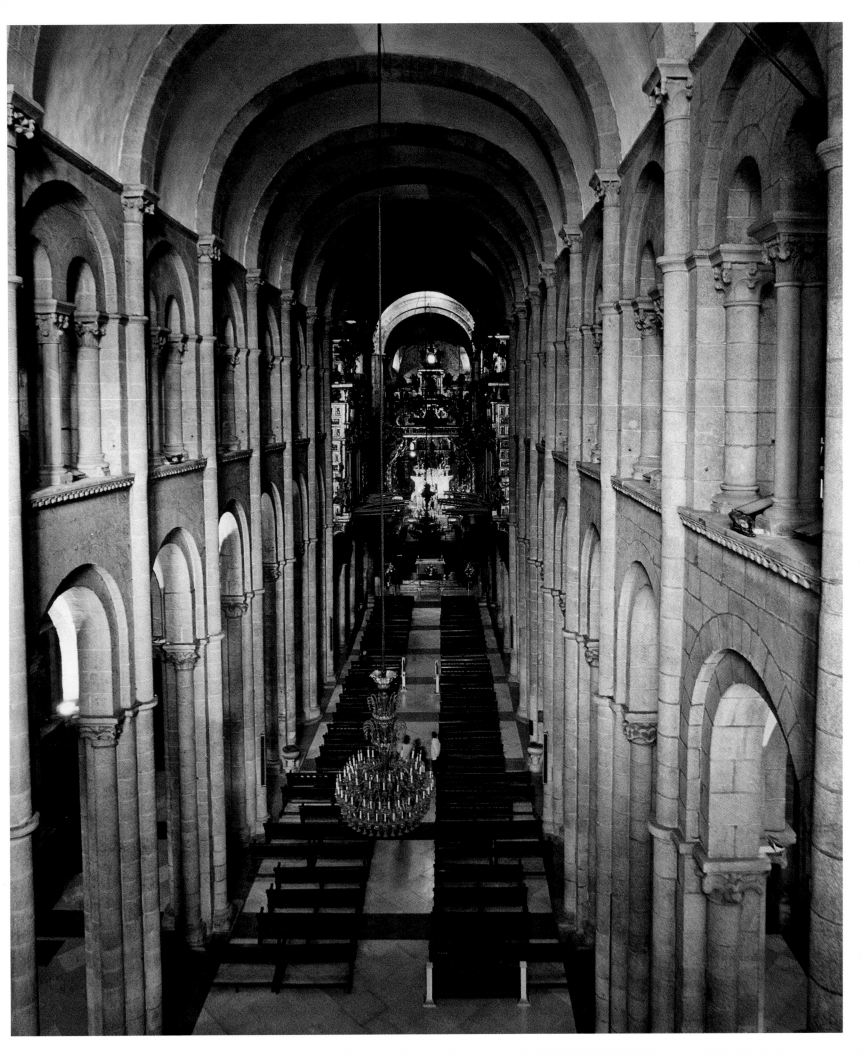

Page 111
Central nave *[interior view]*
c. 1120–1140
Cathedral of Santiago de Compostela

Church of Saint-Martin de Tours,
based on a drawing from 1620
A. Borel
1874
Bibliothèque Municipale de Tours,
Indre-et-Loire

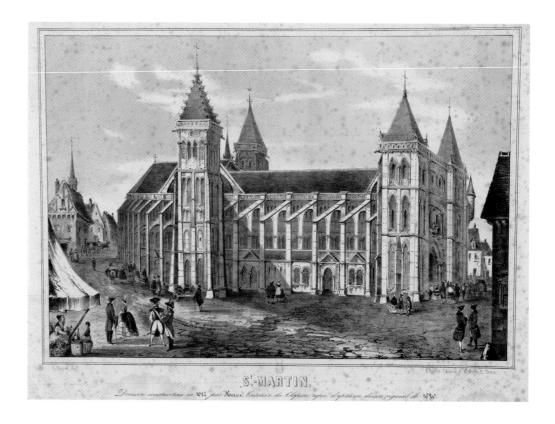

S¹-MARTIN.

7 K. J. Conant [1959], *Carolingian and Romanesque Architecture 800–1200* (New York: Penguin, 1978), p. 93.

8 E. Lambert, "La cathédrale de Saint-Jacques de Compostelle et l'école des grandes églises romanes des routes de pèlegrinage," in *Études medievales I* (Toulouse: Privat-Didier, 1956–57), p. 245.

9 M. Durliat, *La sculpture romane de la route de Saint-Jacques de Conques a Compostelle* (Mont-de-Marsan: CEHAG~Comité d'Études sur l'histoire de la Gascogne Editions, 1990), p. 38.

10 S. Moralejo, "Notas para una revisión crítica de la obra de K. J. Conant," in J. K. Conant, *Arquitectura románica de la Catedral de Santiago de Compostela* (Santiago de Compostela: COAG~Colegio Oficial de Arquitectos de Galicia, 1983), p. 222.

11 I. Bango Torviso, "El Camino de Santiago y el estilo románico en España," in *Aspectos didácticos de Geografía e Historia. Arte 8* (Saragossa: ICE~Instituto de Ciencias de la Educación, 1994), pp. 35–66.

12 "Las llamadas iglesias de peregrinación o el arquetipo de un estilo," in I. Bango Torviso (ed.), *El camino de Santiago, camino de las estrellas* (Madrid: Ediciones Alabe, 1994), pp. 11–75, esp. p. 75: "*Las llamadas iglesias de peregrinación no forman el grupo homogéneo que generalmente se le atribuye en la historiografía tradicional. [...] Son diferentes eslabones de una cadena experimental en la búsqueda de un templo apropiado a las circunstancias litúrgicas, sociológicas y estéticas de una época bajo los condicionamientos y limitaciones de los recursos técnicos.*" See also id., "Las llamadas iglesias de peregrinación

In his early monograph on the Cathedral of Santiago Conant accepted the five churches as a distinct group, and still recognized them as a "peculiar Pilgrimage type" in his comprehensive survey.[7] Elie Lambert also was unequivocal in accepting the five as a distinct *école*, that is, "*une famille de monuments issus d'une conception générale semblables dans leur plan et dans leur élevation, et présentant en outre un certain nombre de caractères particuliers communs dans leur structure et dans leur décors.*"[8] Nearer to our own time, Marcel Durliat declined to see them as forming an *école*, but nonetheless admitted they were a distinct *famille*,[9] a term Lambert had used interchangeably with *école*. Moralejo defined the relationship as constituting "*una comunidad tipológica.*"[10]

More recently the recognition of "schools" of Romanesque architecture has not been treated receptively, and the notion of a "Pilgrimage Roads" school perhaps even less so. Isidro Bango, who more than anyone in this generation has addressed the question of the problem of connecting the Camino and art,[11] has been spokesman for a more radically negative view of the idea of a Pilgrimage Roads school. He found the resemblances merely coincidental rather than substantive, concluding that the constitutive elements, ambulatory, tribune, crypt, transept, were too ubiquitous in the architecture of the eleventh century to make the particular combination that led to the recognition of a Pilgrimage School significant.[12] Still, the similarities of the basic elements of design among a group so widely dispersed geographically remains unique within Romanesque architecture. In addressing the issue Manuel Castiñeiras was right to point out that "[...] *fuera de las similitudes planimétricas, la experiencia espacial y la visión de los alzados de estos edificios resulta cuando menos decepcionante*

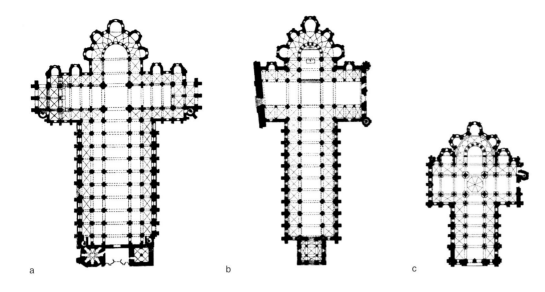

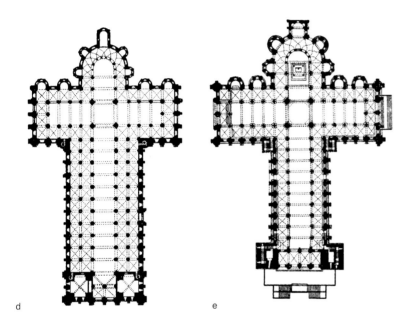

a

b

c

d

e

(a) *Saint-Martin de Tours*
(b) *Saint-Martial de Limoges*
(c) *Sainte-Foy de Conques*
(d) *Saint-Sernin de Toulouse*
(e) *Santiago de Compostela*
[Carolingian and Romanesque
Architecture, 800–1200. *New York:
The Viking Press, p. 93, fig. 113;
planimetries]*
*Kenneth John Conant
1959*

*con respecto a la pasmosa sensación de unidad que nos produce todavía hoy
la vista a Conques Santiago o Saint-Sernin, o la simple consulta de los antiguos
dibujos de [...] Saint Martial de Limoges. [...] En todo caso lo que realmente
resulta unificador para los citados cinco ejemplos clásicos del Románico hispano-
francés es el compartir, en un corto espacio de tiempo, un lenguaje artístico similar
en proyectos tan alejados."*[13]

The recognition that these churches were built in *"un corto espacio
de tiempo"* was not possible when the earlier studies cited above appeared.
Saint-Martin de Tours was customarily dated around the millennium. That
date is no longer commonly accepted, nor should it be after the excavations
analyzed by Charles Lelong.[14] His conclusion about its date made the claim
in the "Pilgrim's Guide" (V, 8) that it was modeled after that of Santiago
– *"ad similitudinem scilicet aecclesia beati Iacobi miro opere fabricatur"* –,

o el arquetipo de un estilo," in M. V.
Carballo-Calero (ed.), *Arte y ciudad:
ámbitos medieval, moderno y
contemporáneo* (Santiago de Compostela:
Fundación Caixa Galicia, 2000), pp.
233–65. M. Castiñeiras, "Tre miti
storiografici sul romanico ispanico:
Catalogna, il Cammino di Santiago e il
fascino dell'Islam," in A. C. Quintavalle
(ed.), *Medioevo: arte e storia. Atti del
Convegno Internazionale di Studi di Parma
(18–22 settembre 2007)* (Milan: Electa,
2008), pp. 86–105.

13 M. Castiñeiras, "La Meta del camino:
la Catedral de Santiago de Compostela
en tiempos de Diego Gelmírez," in
M. C. Lacarra Ducay (ed.), *Los Caminos
de Santiago: arte, historia y literatura*
(Saragossa: Institución Fernando
el Católico, 2005), pp. 217–8.

14 C. Charles Lelong, *La basilique Saint-
Martin de Tours* (Tours: Chambray-lès-
Tours, 1986).

credible.[15] With a narrower chronological bracket for the group, it is entirely possible that the similarities arose from contacts between those in charge of promoting pilgrimage shrines and their architects. Even if we know little of how knowledge of designs was transmitted in the period, it is scarcely conceivable that architects mastered their profession without working at or at least visiting notable monuments, or that ambitious prelates desiring to raise a monumental church at pilgrimage shrines and endowed with the means to do so did not try to find out what was going on. The late eleventh century was a time of enhanced travel and cultural exchange. If the pious act of pilgrimage itself cannot explain in a direct way the Pilgrimage School, the ambition and prosperity it nurtured was indispensable. As Conant concluded:

> "Although there are many French churches which resemble [the Pilgrimage churches] in more ways than one, their similarities are so great that they deserve to be treated as a group by themselves... We may say surely that the Pilgrimage type represents the ideal of a group of highly instructed, forward looking churchmen who had great means at their disposal."[16]

At Santiago the means to raise a monumental church that a pilgrim would think justified his arduous journey was supplied by a gift from Alfonso VI in 1075 from tribute exacted by him in Granada.[17] The *Concordia* of 1077, an agreement made necessary by the planned encroachment of the new basilica on an area controlled by the Monastery of Antealtares, was itself a sign of progress, but it also noted that the monks of Antealtares had already had been forced to erect a new church.[18] This time frame means that Bishop Diego Peláez's administration had chosen the plan. The difficult question is that of assigning responsibility for the decoration of the church, a question of more than casual interest given the extraordinary degree to which the newly revived medium of sculpture was exploited on the facades of the new basilica. We know from the necessity of arranging in 1077 for a relocation of the Monastery of Antealtares, the original custodian of the cult of the tomb, and the termination of the west facade only later in the twelfth century that progress was from east to west. In 1088 Diego Peláez would be deposed. How much of the elevation was achieved in a little more than the decade during which he presided?

 Not only the enormous size of the church but the irregularity of a site that was dictated by the location of the apostolic tomb could have meant an extensive period of time was dedicated to the foundations. It is not likely that the bishop's departure would have meant that contracts for materials and masons were abrogated or that masons left. Were it not recorded that Peláez left, progress on the site would probably strike us as normal. Conant did identify in the fabric of the church a change that he suggested was linked to the Bishop's departure. He saw it at the point where the westernmost bays of the ambulatory began.[19] However, Serafín Moralejo noted that these last bays, just after the chapels of Santa Fe and San Andrés, were longer than the preceding ones, and therefore required a different elevation, with taller arches, at the tribune level. He minimized as signs

15 P. Gerson, J. Krochalis, A. Shaver-Crandell and A. Stones, *The Pilgrim's Guide to Santiago de Compostela: A Critical Edition (II: The Text)* (London: Harvey Miller Publishers, 1998), p. 50.

16 K. J. Conant, *The Early Architectural History of the Cathedral of Santiago de Compostela* (Cambridge: Harvard University Press, 1926), p. 16.

17 B. F. Reilly, *The Kingdom of León-Castille under King Alfonso VI, 1065–1109* (Princeton: Princeton University Press, 1988), p. 84. F. López Alsina, *La ciudad de Santiago de Compostela en la alta Edad Media* (Santiago de Compostela: Ayuntamiento de Santiago, 1988), pp. 410–1. S. Moralejo, "The *Codex Calixtinus* as an Art-Historical Source," in A. Stones and J. Williams (eds.), *The Codex Calixtinus and the Shrine of St. James* (Tübingen: G. Narr, 1992), pp. 211–3.

18 A. López Ferreiro, *Historia de la Santa A. M. Iglesia de Santiago de Compostela*, vol. 3:11 (Santiago de Compostela: Seminario Conciliar de Santiago, 1898–1911), app. I, p. 4.

19 *The Early Architectural History of the Cathedral of Santiago de Compostela...* op. cit., p. 21.

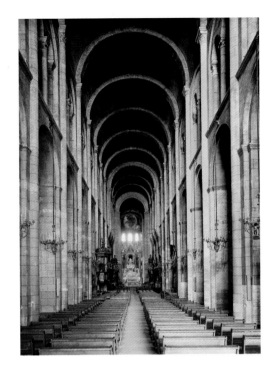
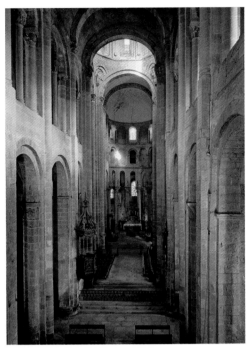

of a break in design or supervision the changes noted by Conant, finding them organically related to the progress of work.[20] To distinguish two campaigns, Moralejo attached more significance to the change in decoration. Thus the first campaign would be limited to the three easternmost chapels of the ambulatory and the immediately adjacent walls, with nothing of the upper stories implicated.[21] The capitals of the first campaign were indebted to masons connected to Auvergne, Conques and Toulouse,[22] as well as carvers identified with sites further east on the Camino, most importantly Jaca, and Frómista. Conques and Toulouse would remain important points of origin for carvers contributing to the embellishment of the cathedral, albeit with more advanced versions of their styles, a change linked perhaps to the arrival of masons freed by completion of work at their home sites. Both Diego's were partisans of the Francophile orientation embarked on by Fernando I of León and furthered by his son, Alfonso VI. But Gelmírez had been steeped from early age in a Franco-centric cultural atmosphere, having spent several years of his youth at the court of Alfonso in León when Agnes of Aquitaine was his queen.[23] Friendship with Pedro of Rodez, Bishop of Pamplona (1083–1115), also linked the two Galician Diegos, a relationship with implications for the constant reliance on workshops from Conques and Toulouse.[24]

It has been customary to separate two building campaigns with the ascent of Gelmírez as Bishop in 1100,[25] but it is not so easy to disentangle the roles of the two bishops. Definitely assigning responsibility is complicated not only by the steady progress of the works, but also by the fact that Gelmírez even before becoming Bishop was linked to the cathedral and positions of responsibility. His father was one of Peláez's lieutenants, and the son had been educated by Peláez and made a member of the cathedral chapter. Despite his youth, Gelmírez would be the chancellor and secretary of Raymond of Burgundy after Raymond became Count of Galicia in 1087, and was administrator of the dioceses by 1090.[26] Only in

20 "Notas para una revisión crítica de la obra de K. J. Conant"... op. cit., pp. 224–6.
21 Ibidem, p. 226.
22 Ibidem, pp. 227, 235, no. 22.
23 B. F. Reilly, "Santiago and Saint Denis: The French Presence in Eleventh-Century Spain," *Catholic Historical Review*, 54 (Baltimore: 1968), p. 471. Id., "Count Raimundo of Burgundy and French Influence in León-Castilla (1087–1107)," in J. A. Harris and T. Martin (eds.), *Church, State, Vellum, and Stone: Essays on Medieval Spain in Honor of John Williams* (Boston: Brill, 2005), pp. 94–8, 107–8.
24 J. Williams, "¿Arquitectura del Camino de Santiago?," *Quintana*, 7 (Santiago de Compostela: 2008), pp. 157–77.
25 "Santiago and Saint Denis: The French Presence in Eleventh-Century Spain"... op. cit., p. 481.
26 Ibidem, pp. 471–7.

1105 were the chapels of the ambulatory dedicated, that is, seventeen years after Peláez's departure. Is it reasonable to attribute this to a hiatus imposed by Peláez's exile? Or to a normal progress that saw the elevation reach the level of the capitals only after Gelmírez was in charge?

Gelmírez Cathedral as *martyrium*

If our inability to finally determine the pace at which the building rose, Gelmírez's responsibility for incorporating its most significant component, the Apostolic tomb that was the heart of the cult, is not in doubt. Their function as *martyria* galvanized the emergence in the eleventh century of a new style of monumental churches requiring a new stylistic label, "Romanesque." It is an anomalous fact, however, that as the churches of Europe sought to capitalize on their role as custodians of cults, the holy remains that justified their claims tended to be overshadowed by their monumental settings, settings that growing numbers of pilgrims made desirable and, thanks to their pious offerings, possible. Vézelay offers an example of the mentality of the era's prelates. In the middle of the eleventh century, or so a miracle assigned to the Magdalene says, abbot Geoffrey of Vézelay planned to demolish the venerable crypt that held the body of Saint Mary in order to build a more magnificent tomb. Only the descent of a terrible darkness deterred him.[27] When Diego Gelmírez decided the modest appearance of the altar and crypt of the Apostle Santiago did not measure up to the glorious role assigned to them, the saint himself did not stop him, but his canons tried to. They failed:

> "*El mencionado obispo [Gelmírez], vehementemente preocupado por aumentar la honra de su iglesia, puesto que el ara, ya engrandecida por segunda vez, no era acorde con tan gran Apóstol, consideró con piadoso reflexión que debía ampliarse el altar del Apóstol. Por ello, y fortalecido por el prudente consejo de hombres religiosos, anunció al cabildo de los canónigos, quienes en relación a este asunto oponían fuerte resistencia, que iba a destruir aquel habitáculo, construido por los dicípulos de este Apóstol tan grande como el mausoleo inferior, en donde sabemos sin ningún duda que se encierran los sagrados restos del Santo Apóstol. Muchos aseguraban que de ninguna manera debía ser destruida aquella obra edificada por las manos de tales hombres, aunque fue ruda y deforme [...] Pero él, armado como valeroso guerrero con el impenetrable escudo de su piadosa consideración [...] destruyó por completo el mencionado habitáculo y agrandó por todas partes, según convenía, el pequeño altar que había existido desde e principio, cubriéndolo con una tercera piedra admirable. Alrededor este altar, transcurrido un breve espacio de tiempo, empezó admirablemente y más admirablemente terminó un frontal de plata [...] También se encargó de reconstruir de forma lisa y perfectamente decorado el pavimento y las gradas por las que se sube al altar. Además, por deferencia ofreció a la admiración humana un baldaquino que ordenó hacer en honor del altar del Apóstol, de oro y plata con variado y conveniente artificio.*"[28]

Gelmírez's need to remodel the high altar of his cathedral as the new basilica rose over the preceding one is understandable. Gelmírez's visits to sites like Cluny in France would have made a retable imperative, as would his *ciborium* reflect

27 F. Salet, *La Madeleine de Vézelay* (Melun: Librarie d'Argences, 1948), p. 87.

28 *Historia Compostelana*, trans. E. Falque Rey (Madrid: Akal, 1994), p. 107.

29 For the ignorance of the kind and exact location of the tomb and for efforts to provide substitutes see J. Williams, "The Tomb of St. James: the View from the Other Side," in S. Barton and P. Linehan (eds.), *Cross, Crescent and Conversion: Studies on Medieval Spain and Christendom in Memory of Richard Fletcher* (Leiden: Brill, 2008), pp. 175–91. M. Taín, "Prolegómentos de una excavación en tiempos del canónigo José de Vega y Verdugo," *Goya*, 324 (Madrid, 2008), pp. 200–16.

30 *Historia de la Santa A. M. Iglesia de Santiago de Compostela... op. cit.*, vol. 1:11, p. 299.

his emulation of Rome. What strikes a modern student of the enterprise as unthinkable is the sealing off of the Apostolic tomb that this enterprise entailed. Obviously a more worthy stage for the liturgy of the cult took precedence over a humble if ancient structure. In the Bishop's mind the cathedral itself was effectively the tomb or reliquary of their apostle. In an age like ours that tends to value material evidence over mere faith, access to the presence of an ancient tomb structure would guarantee that it would be left exposed and visible as a rebuttal to the skeptical. As it was, pilgrims and the curious would for centuries be denied access to the venerable walls that had, according to tradition, sheltered the remains of Santiago.[29] Access would be possible only after the Cardinal Archbishop of Santiago Miguel Payá y Rico asked the canons Antonio López Ferreiro and José Labín Cabello in 1878 to determine the location of the tomb. The result was the crypt/tomb designed by López Ferreiro where the pilgrim can descend a short stair leading from the ambulatory to an aisle that allows a view of a neo-medieval shrine located beneath the Altar Mayor.

One of the challenging puzzles of the history of the site is the manner in which the tomb was originally exploited. The structure discovered in 1879 did not itself clarify the issue. Indeed, its actual configuration would be ignored as historians sought to solve the problem of its accommodation to the churches that were built over it. López Ferreiro's found well-cut ashlar walls making up a rectangular structure. Its granite ashlar walls measured on the outside 8.10 m north-south and 8.26 east-west. These walls varied from .64 m to .50 in thickness and rose from the bedrock as little as 1.20 m in the northeast corner to as much as 1.75 m at the southwest. "Inscribed within" this rectangle, to use López Ferreiro's description,[30] was another walled precinct attached to the center of the western wall. It measured 6.41 m east-west by 4.69 north-south on the outside, A rubble wall divided this inner precinct into eastern and western areas. The western chamber was subdivided further: at the top level, brick walls .2 m thick and .45 m high segregated to each side *loculi* some 2 m long and .75 m wide, that is, of a size consistent with human burial. Logic led to their recognition as tombs.

López Ferreiro interpreted his find as the foundation story of a first-century tomb similar to funerary monuments near Jerusalem.[31] Its single storey above ground would not have survived the passage of time. No burial vessel was encountered, but initial reports based on familiarity with the excavations indicate an initial assumption that James was buried between the disciples who occupied two brick tombs on the western side of the structure.[32] However, because of fragments of a mosaic floor in the eastern chamber indicated its greater dignity, López Ferreiro eventually placed James's interment there. Since the small size of this chamber allowed no room for both altar and a standing sarcophagus, he concluded that James would have been buried in the ground in the eastern half in a grave that was then covered with slabs of marble that in turn supported an altar above the body.

Since they lie above an earlier floor, the two brick tombs of the western half of the precinct are evidently not part of the original structure.[33] The fact that there are two graves has implications for the traditional history of the translation and

Planimetry of the tomb of the Apostle Saint James [Lecciones de arqueología sagrada. *Santiago de Compostela: Seminario Conciliar Central Compostelano, p. 33, fig. 31*] *Antonio López Ferreiro 1889*

31 Id., *Altar y cripta del Apóstol Santiago, reseña histórica desde su origen hasta nuestros días* (Santiago de Compostela: Seminario Conciliar Central, 1891). Id., *El Pórtico de la Gloria, Platerías y el primitivo altar mayor de la Catedral de Santiago* (Santiago de Compostela: Seminario Conciliar Central, 1893; II ed. Vigo: Pico Sacro, 1975), pp. 126–7.

32 J. M. Fernández and F. Freire, *Santiago Jerusalén, Roma. Diario de una peregrinación a estos y otros Santos Lugares* (Santiago de Compostela: Seminario Conciliar Central, 1880), design p. 51. A. Fernández-Guerra and F. Fita [1880], *Recuerdos de un viaje a Santiago de Galicia* (A Coruña: Librería Arenas, 1993), map p. 70. J. Guerra Campos, *Exploraciones Arqueológicas en torno al sepulcro del Apóstol Santiago* (Burgos: Ediciones Aldecoa, 1982), fig. 27. D. Bartolini, *Apuntes biográficos de Santiago Apóstol el Mayor* (Rome: Tipografia Vaticana, 1885), map. *Exploraciones Arqueológicas en torno al sepulcro del Apóstol Santiago...* op. cit., fig. 28.

33 M. Caamaño Gesto and J. Suárez, "Santiago antes de Santiago," in E. Portela (ed.), *Historia de la ciudad de Santiago de Compostela* (Santiago de Compostela: Consorcio de Santiago, 2003), pp. 31–2.

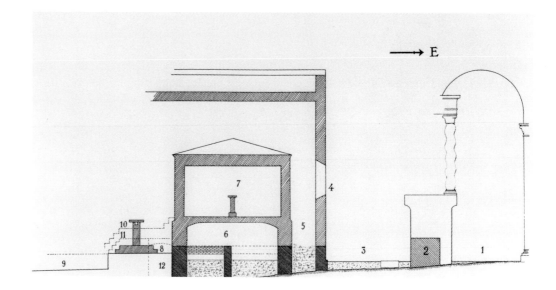

Section E-W of the Basilica of Alfonso III [Exploraciones arqueológicas en torno al sepulcro del Apóstol Santiago. Santiago de Compostela: Cabildo de la Catedral de Santiago de Compostela, p. 264, fig. 60]
José Guerra Campos
1982

burial of James. The earliest and indeed only explanation for the perplexing fact that an Apostle martyred in Jerusalem in AD 44 came to be buried in Galicia was provided by the so-called Leo Letter. It has been plausibly, if not unanimously, dated to the ninth century, that is, shortly after the discovery of the tomb itself around AD 830.[34] Since the two brick tombs, presumably the ones occupied by the disciples who remained with James after the others returned to Jerusalem to report events, were near the surface of the "tomb," it is puzzling that in the earliest redaction of the letter three, not two, disciples remained as custodians of the tomb. It implies that the tomb was not exposed.

Chamoso Lamas, the excavator of the cathedral in the campaign of 1946–1959 thought he perceived enough differences between the ashlar masonry of the outer walls and those enclosing the interior precinct to justify assigning the outer walls to a later, ninth-century, date.[35] José Guerra Campos, the master of all that touched on the Apostolic tomb and its historical and material context, seized on this interpretation of the converted outer walls into the lower part of an apsidal wall erected in the ninth century to enclose the tomb. This conclusion to design for the basilicas erected in the ninth century a sanctuary that enclosed the tomb but with outer corridors that allowed pilgrims and others to arrive by means of stairs on the east side to mount to a chapel.[36] His reconstruction ran counter to López Ferreiro's assumption that there was only one storey above ground and was justified by such literary evidence as the notice from the *Historia Compostellana* quoted above that Gelmírez removed "*el habitáculo, construido por los discipulos de este Apóstol.*" It also required Guerra Campos to revise the state of the structure reported by López Ferreiro by assuming that there were openings into the spaces between the walls that would allow them to function as a kind of ambulatory.

Guerra Campos's reconstruction seems on the face of it unlikely. The survival of the second story from the first century is problematic, but even more so the functionality of an upper chapel measuring only some 3 m by 4 m, and reached by steps over a half meter high is debatable. Most seriously, by enclosing the tomb within an apse belonging to the Church of Santiago, it ignores the fact that the

34 *La ciudad de Santiago de Compostela en la alta Edad Media...* op. cit., pp. 121–7, 187–8, 307–8. López Alsina logically rejected the usual interpretation of Leo as a pope of that name, and recognized him as the patriarch of Jerusalem in the obviously fabulous narrative of the removal of the body of James to Galicia by disciples.

35 M. Chamoso Lamas, "Excavaciones arqueológicas en la Catedral de Santiago," *Compostellanum*, 1 (Santiago de Compostela: 1956), pp. 69–70, 807–9.

36 Ibidem, pp. 193ff.

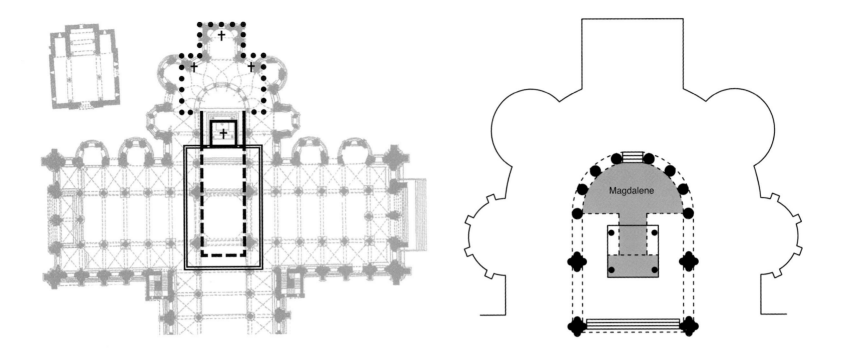

foundation of the site by Alfonso II put the service of the tomb in the hands of the monks of Antealtares whose church was on the eastern side of the tomb. Even more serious an objection is posed by the fact that the eastern outer wall of the structure discovered by López Ferreiro, that which would have supported the eastern wall of Guerra Campos's apse, seems not to have been ancient or medieval.[37] Rather than a chapel above the tomb, the space above should have allowed the Church of San Salvador de Antealtares and that of Santiago to share the tomb. The *habitaculum* would have been, in my opinion, that part of Antealtares that sheltered the tomb, a kind of counter-apse.[38] The tomb in Gelmírez's cathedral would not have been something to peer into, as it is today thanks to López Ferreiro's reformation of the structure, but the face of the western wall would in part, perhaps, have been visible to someone in the Basilica of Santiago, and, as we shall see, perhaps the eastern wall of the inner chamber, the one identified by López Ferreiro as the location of the tomb of Santiago, as well.

With the erection of the new church there was no longer a question of sharing the tomb with Antealtares, for in 1077 the monastery had yielded the area of the tomb to the new cathedral.[39] As if in compensation for enclosing the tomb, Gelmírez designed a *confessio* that, it would seem, allowed access to the inner chamber's eastern wall:

> "*Y después de construir el altar según hemos referido anteriormente, puesto que estaba abierto a los ojos humanos por todas partes, no quedaba ningún sitio oculto en el que los fieles satisficieran los deseos de orar en privado... Por lo cual empezó el obispo a insistir en este pensamiento dentro del albergue de su mente y a desear ardientemente con una solicitud infatigable hacer una confesión en el altar. Y ciertamente se ve qué grande y de que manera construyó esta confesión por debajo de las columnas del altar que sostienen el baldaquino, cuando ofrece feliz paso a los que entran.*"[40]

Church of San Salvador de Antealtares, and the basilicas of Alfonso II and Alfonso III ["¿*Arquitectura del Camino de Santiago?*," Quintana, 7. Santiago de Compostela, p. 165, fig. 4; hypothetical reconstruction] John Williams 2008

Confession of Mary Magdalene [hypothetical reconstruction] Manuel Castiñeiras 2003

37 J. Suárez Otero, "En los orígenes," in F. Rodríguez Iglesias (ed.), *La gran obra de los caminos de Santiago. Iter Stellarum*, vol. 1:8 (A Coruña: Hércules Ediciones, 2004), pp. 176–7.
38 "The Tomb of St. James: the View from the Other Side"... op. cit., pp. 175–91. The reconstruction offered in this article has since been modified by me. See fig. 4.
39 *Historia de la Santa A. M. Iglesia de Santiago de Compostela*... op. cit., vol. 3:11, app. I.
40 *Historia Compostelana*... op. cit., pp. 107–8.

We cannot know if this was in compensation for blocking access to the tomb, for we are ignorant of just how the tomb was accommodated by the pre-Romanesque churches. The change in the number of disciples buried with James in the translation narrative of the *Historia Compostellana* from three to two may mean that with the remodeling of the area the two brick graves had for the first time been exposed. Rather, the *confessio* is expressly linked to a desire to provide a relatively secluded place for prayer. Its identity as a chapel rather than a means of physical contact with the tomb seems to be confirmed by the fact that the space within the hemicycle apparently housed the altar of Saint Mary Magdalene.[41] According to the *Historia Compostellana* one entered the confessio from between the rear columns of the ciborium of the altar. That it did indeed allow access to the east wall of the tomb is indicated by the smoky surface of the wall, the result, perhaps, of candles.[42] This also confirms the fact, indicated above, that the eastern side of the inner, tomb, chamber, was not isolated by an eastern outer wall until later.

As we saw, that entrance was located, according to the *Historia Compostellana*, "*Quam equidem confessionem infra duas altaris columnas, que ciborium sustinent...*" As Conant remarked, that location is "very strange."[43] If, however, *ciborium* referred to the vault over the chancel, a usage for *ciborium* employed by Gervase of Canterbury a few years later,[44] and the two columns the central ones of the ambulatory arcade – the spot where Conant indicated steps – a logical plan would be established. This logic would be extended if the traffic of pilgrims wanting to pray at the tomb wall were organized around an entrance and an exit, portals at the north and south ends of the corridors flanking the tomb, where indeed López Ferreiro chose to locate entrances in his reconstruction.[45]

As for the tomb itself after Gelmírez's reformation, the "Pilgrim's Guide" provides this picture:

> "*En la referida y venerable catedral yace honoríficamente según se dice el venerado cuerpo de Santiago, guardado en un arca de mármol, en un excelente sepulcro abovedado, trabajado admirablemente y de conveniente amplitud, bajo el altar mayor.*"[46]

Conant marked this description as imaginary, and for good reason. Both the idea of a tomb in the form of an "*arca de mármol*" and its location within "*un sepulcro abovedado*" were based on tradition, not vision. From the first dissemination of news of the burial of James, among them the *De Ortu et Obitu Patrum* associated with Isidore of Seville, James's tomb was located in Acha Marmarica. In an effort to make sense of this enigmatic locale, Acha Marmarica was converted into the equivalent of a marble sarcophagus, or arca, or an arched tomb.[47] Both interpretations appear in the passage quoted. At about the time the *Codex Calixtinus* was written, a miniature based on this part of tradition depicted a vaulted crypt housing three sarcophagi.[48] It cannot be reconciled with the structure López Ferreiro uncovered, but it served as a model for crypt designed after the discovery.

41 *Exploraciones Arqueológicas en torno al sepulcro del Apóstol Santiago...* op. cit., pp. 113–6. M. Castiñeiras, "Topographie sacrée, liturgie pascale et reliques dans les grands centres de pèlerinage: Saint-Jacques-de-Compostelle, Saint-Isidore-de-Léon et Saint-Étienne-de-Ribas-de-Sil," *Les Cahiers de Saint-Michel de Cuxa*, 34 (Cuxa: 2003), pp. 33–4.

42 T. Hauschild, "Archeology and the Tomb of St. James," in *The Codex Calixtinus and the Shrine of St. James...* op. cit., p. 93.

43 *The Early Architectural History of the Catedral of Santiago de Compostela...* op. cit., p. 22.

44 C. Du Cange [1883], *Glossarium Mediae et Infimae Latinitatis*, vol. 2:10 (Paris: L. Favre, 1937), p. 324, col. 2. However, the vault in question was a groin vault. It is less likely to have been used for a barrel vault.

45 See point II on the plan published by Bartolini 1885, reproduced in *Exploraciones Arqueológicas en torno al sepulcro del Apóstol Santiago...* op. cit., fig. 28. López Ferreiro did not propose that they imitated the original plan of the *confessio*.

46 *Liber Sancti Iacobi Codex Calixtinus*, trans. A. Moralejo, C. Torres and J. Feo (Santiago de Compostela: Instituto Padre Sarmiento de Estudios Gallegos, 1951; reed. fac. Santiago de Compostela: CSIC~Centro Superior de Investigaciones Científicas, 1999), p. 565.

47 M. C. Díaz y Díaz, "El lugar del enterramiento de Santiago el Mayor en Isidoro de Sevilla," *Compostellanum*, vol. 1 (Santiago de Compostela: 1956), pp. 882–5.

48 M. Lucas Alvarez (ed.), *Tumbo A de la Catedral de Santiago de Compostela*, 1 (A Coruña: Edicións do Castro, 1998), p. 47. M. Díaz y Díaz, F. López Alsina and S. Moralejo, *Los Tumbos de Compostela* (Madrid: Edilan, 1985), ill. II.

As a *mecenas* Gelmírez rivaled Abbot Suger of Saint-Denis, the pantheon of the French monarchy and shrine of France's apostle. Suger's stage was a city many would have considered the heart of Europe; that of Gelmírez was a site at the remotest limit of that world, *Finis Terrae.* Suger may have presided over the invention of the Gothic style of architecture, but Gelmírez achieved a perfection of the Romanesque. With a combination of intelligence and entrepreneurial genius he saw to it that Compostela was an awesome home for a privileged Apostle, as worthy of international pilgrimage as Rome and Jerusalem. On another, symbolic, level it anchored the western reach of the ecumenical arc that, centered in Rome, reached in the east to the shrine of James's brother at Ephesus. As an Iberian of the new Spain Gelmírez naturally welcomed the cultural currents flowing from the north, but not as a passive inheritor of great experiments carried out elsewhere, but as one who perceived the possibilities they offered in his quest to make his Apostolic. If he took advantage of the talents of masons from beyond the Pyrenees, the didactic programs designed for the facades of his church exploited the possibilities of the new medium of relief sculpture to a degree scarcely imagined at contemporary sites elsewhere.[49] His was an extraordinary conception effective today.

49 J. Williams, "Framing Santiago," in *Romanesque Art and Thought in the Twelfth Century. Essays in Honor of Walter Cahn* (University Park: The Pennsylvania State Press, 2008), pp. 219–38.

Codex Calixtinus.
The Book of the Church of Compostela

Can the *Liber Sancti Jacobi* be considered a hagiographical dossier subject to the rules? Content, structure, purpose

In the times of Archbishop Diego Gelmírez pilgrimages reached their first peak. New conceptions of the cult are reflected, in the mid-twelfth century, not only in the history of the diocese – the *Historia Compostellana* – but above all, in a hagiographical dossier of a very new kind.

This book is often seen as a primary source for paths of pilgrimage, both Spanish and French. However, it is a work that summarizes and re-elaborates the most diverse traditions about the Apostle Saint James. Nowadays, following a scholarly edition, it is usually called the *Liber Sancti Jacobi*, although we find another name in the colophon: here it is simply called *Jacobus*. Due to the fact that the wording of the introductory letter and some other passages has been attributed to Pope Calixtus II (1119–1124), who legitimized the subsequent lines and recommended its reading and use, the manuscript kept in the archives of Compostela Cathedral has also been occasionally called *Codex Calixtinus*. It is likely that this ancient manuscript was written in Santiago in the mid-twelfth century, although some parts and previous sections could have been conceived at an earlier time elsewhere, such as in France. In this regard, discussions among experts in the matter continue, as the thesis supporting a Cluniac origin or that which advocates a Burgundian-Poitevin source have not been completely discarded.

The *Liber Sancti Jacobi* is clearly different from what is usually found in other hagiographical *Libelli*. It consists of five parts, or books, and each one is about a different subject. Only the *Passio* added to Book I, the *Translatio* from Book III with the history of the translation of the mortal remains from Palestine to Spain, and the list of miracles of Book II can be considered *sensu stricto* basic elements of a canonical life of a saint. But, on the whole, other passages are more extensive. Besides these two books there is a further section in which the conversion of the cult into sermon and liturgy (Book I) is very carefully detailed. Furthermore, we find in Book IV a story allegedly written by Archbishop Turpin of Reims – hence it is often known as the "*Historia Turpini*" or "Pseudo-Turpin" – who had accompanied Charlemagne on his trip to Spain and now characterizes him, among other things, as a warrior against the Moors and a pilgrim to Santiago.

The *Liber Sancti Jacobi* lacks an appendix and the compendium closes with a part that has generally been considered as one of the oldest pilgrimage guides in Europe (Book V). Thanks to the chapters devoted to liturgy, the different feast days of the Apostle have been revalued: the Day of Saint James, which the Roman Liturgy celebrated on 25 July along with the traditional octave of solemn festivities – i.e. the eight days that follow a feast day – the so-called feast of the Translation on 30 December – including liturgical proposals for an octave – and some other feasts are also recorded with their sermons, masses and offices. Books IV and V deal less with time and subdivisions of the year and more with space, as they talk about how Charlemagne came to Spain and Compostela and along which roads and how pilgrims could attain their goal. It would not seem that pilgrims to the shrine of Santiago carried this little book in their hand luggage, as can be deduced not only by its diffusion, but also by the extension of the ability to read at the time. It is true that the descriptions seem to be partially based on specific experiences; however, on the whole, they rather respond to a powerful effort to describe the pilgrimage to Santiago as it was imagined, and even how people wished it to be. Taking certain aspects of papal legitimacy as a starting point, which will allow us to place the compendium in the time of Diego Gelmírez (Book II), we should proceed to address various topics related to the pilgrimage route (Book IV), and then discuss the meaning that the compendium had in the Middle Ages according to its dissemination and reception (Book V).

Papal legitimation

A general look at the whole work shows how important papal legitimacy was for ensuring its authenticity. In an introductory letter, apparently by Pope Calixtus II, who had promoted Diego Gelmírez and his church by raising Compostela to an archbishopric, the *Codex* is given character and legitimated. We shall now cite the opening passages:

"The letter of Pope Calixtus
Calixtus II's introductory letter:
Bishop Calixtus, servant of the servants of God, to the venerable community of the Church of Cluny, see of his apostolic choice, and to the most illustrious William, Patriarch of Jerusalem, and Diego, Archbishop of Compostela, and to all the faithful, health and apostolic blessing in Christ. As men more excellent in dignity

and honor than you cannot be found anywhere in the world, I am sending you this codex of Saint James so that if you find in it something to be corrected, it can promptly be amended for love of the Apostle.

For indeed, I have suffered great distress for the sake of this codex. While I was at school, loving the Apostle since my childhood, traveling for fourteen years through foreign lands and regions, I diligently copied all that was written about him on a few rough and vile sheets, with the purpose of expressing it in a volume for devotees of Saint James to have what should be read together on feast days more at hand and all together. O wonderful fortune! I fell into the hands of thieves and deprived of everything I was left with just the manuscript. I was locked up in prisons and I lost everything I owned, and all I had was this manuscript. In deep seas I was shipwrecked many times and I almost died, and when I survived, so did the manuscript, suffering no damage [...]"[1]

The author describes the *history calamitatum* suffered by the book in the following passages and also explains the liturgy and especially the miracles of Saint James. Taking this letter as our starting point, we may assume that only the first two books formed part of the *Codex* at first, to which were added the others at a later time.

The papal legitimization is underlined by the following introductions to each book. There are prefaces by Pope Calixtus in the "Book of Miracles," the "Book of the Translation" and in the "Pilgrim's Guide." It is only lacking in the "Pseudo-Turpin," since in the latter, Archbishop Turpin himself is presented as the author of the book. The shortest introduction can be found at the beginning of the "Guide" and is simply called "*Argumentum*," while the introductions to books II and III are more extensive. I do not wish to analyze the content of these letters, but at first glance it appears very clear that books I to III above all include a decisive supplementary papal legitimacy to prove their authenticity.

This legitimacy is enhanced if we analyze the respective chapters of each book. In the 31 chapters of the first book we reckon with 22 papal authorships according to the index – in most cases alleged authorships. The same impression can be gleaned from Book II: of the 22 miracles 18 enjoy papal authorship. The third book is interesting not only for its rotund legitimation by Pope Calixtus, but also by a Pope Leo – according to some researchers as a Bishop – of the translation. If it is Pope Leo III (795–816), which is not certain, it would be an element to link books III and IV, because in *Codex Calixtinus* Pope Leo legitimized the *Translatio* of Saint James' body from Jerusalem to Santiago, but the same Leo III would have been Pope at the time of the invention of the apostolic tomb and the coronation of Charlemagne as Emperor in 800. The letter of the third book in the *Calixtinus* deals not only with Saint James' martyrdom and translation, but also with his burial in Galicia.

The papal authority is not so evident in Book V, the "Pilgrim's Guide," as only 2 of the 11 chapters contain an explicit papal authority in their titles. But one must admit that the most important chapter, in which the town of Compostela, the cathedral and the tomb are described, is explicitly attributed to Pope Calixtus and his chancellor Aymeric.

1 Translated by M. Guscin from the Spanish text, *Liber Sancti Iacobi Codex Calixtinus*, trans. A. Moralejo, C. Torres and J. Feo (Santiago de Compostela: Instituto Padre Sarmiento de Estudios Gallegos, 1951; reed. fac. Santiago de Compostela: CSIC~Centro Superior de Investigaciones Científicas, 1999), pp. 1–2.

And so to Book IV, the "Pseudo-Turpin." The subject of Charlemagne, which ensured the European dissemination of the cult to Saint James, did not at first sight enjoy a papal presence. This is why in this book, but not only here, the concept of Compostela as *sedes apostolica* is highlighted in a very significant way next to the *sedes romana*.

These trends which underscore Santiago's position as *sedes apostolica* are in close connection with Bishop, soon to be Archbishop, Diego Gelmírez's ambitions, and are more clearly highlighted in the "Pseudo-Turpin," the fourth book about Charlemagne's battles in the Peninsula. According to the "Pseudo-Turpin," Charlemagne came to Santiago de Compostela once his war effort was over. In this context the special position of the apostolic city is highlighted in a most impressive way. According to the story, the Archbishop of Reims, Turpin, consecrated the Cathedral of Santiago. A council decided the subordination of *Hispania* and Galicia in exchange for an annual census to the *sedes apostolica* of Compostela. Along with the sees of Rome and Ephesus, as the cities of Saint Peter and Saint John, Compostela enjoyed an equivalent position as the see of Saint James:

> "And on that day it was determined that the church should hereafter be called apostolic, because there lies the apostle Saint James, and it often holds councils of bishops from all over Spain; and that in honor of the Apostle of the Lord episcopal staffs and royal crowns should granted by the bishop of the city. And that if in other cities, due to the sins of the people, faith or the commandments of the Lord are not kept, they would be reconciled there under the counsel of the bishop. And it is rightly granted that faith should be reconciled and established in that venerable church, because in the same way that Saint John the Evangelist, the brother of James, brought faith in Christ to the east and established an Apostolic see in Ephesus, so the same apostolic faith and a see in Galicia, in the western part of God's kingdom, was established by Saint James. These are undoubtedly the apostolic sees: Ephesus, which is on the right in Christ's earthly kingdom and Compostela, which is on the left, sees that in the division of provinces were allotted to the two sons of Zebedee; for they had asked the Lord to sit in his kingdom, one on his right, the other on his left.
> Christianity rightly venerates three main apostolic sees in the world, namely Rome, Galicia and Ephesus, in the same way as the Lord distinguished three among all the apostles, namely Peter, James and John..."[2]

The argument is interesting because it captures the idea of giving James the responsibility of teaching the Christian West in clear parallelism with John in the East. Rome is above them, but does not play an influential role, since apostolic traditions are claimed at the same level as Rome.

This "theory of the three sees" is also explained in other parts of the *Liber Sancti Jacobi*. In addition, councils in Spain had to be convened in Compostela, and the right to ordain bishops and crown kings was also reserved for Santiago de Compostela. With these rights a program that underlined not only the struggle against the infidels in the Peninsula was deployed, but also the rights

2 Ibidem, pp. 456–7.

of Compostela within the Spanish hierarchy and in relation to kings. With the "theory of the three sees" – Rome, Ephesus and Santiago – the intention went beyond *Hispania* and thus also had an anti-Roman accent. With the help of a fictitious Carolingian tradition, as Charlemagne supposedly confirmed these traditions, the rights of the apostle and of his see were programmatically developed, but at the same time existing ideas were transformed in the see. The Carolingian tradition was also ideal for spreading the legend of Saint James in epic contexts. Jacobean traditions were disseminated especially in German speaking countries, in connection with Frederick Barbarossa's attempts to obtain canonization for Charlemagne in 1165.

For the compendium it is very striking that at the end of "*Historia Turpini*" Pope Calixtus is introduced in several chapters, perhaps added later.

In the final chapters Pope Calixtus talks specifically about the discovery of the body of Archbishop Turpin, of the events in Galicia from the days of Charlemagne to the time of Calixtus, with special mention of the battles and devastation of Al-Mansur in Galicia. But in the last chapter he relates the Jacobean and Carolingian theme with another great topic in Christianity at the time: the Crusades.

> "The Holy Pope Calixtus' epistle about the crusade in Spain, which must be disseminated by everyone everywhere.
> Bishop Calixtus, servant of the servants of God, to the bishops, his dear brothers in Christ, and to the other people in the holy church, and to all Christians both present and future, a universal greeting and apostolic blessing.
> You have often heard, beloved, how much evil, calamities and distress the Saracens have caused in Spain to our Christian brothers. No-one can count how many churches, castles and lands they have devastated, and how many Christians, monks, priests and laymen they have killed or sold as slaves in distant and barbarous lands, or had them fettered in chains or distressed with various torments. Words cannot express how many bodies of holy martyrs, that is, bishops, abbots, priests and other Christians lie buried near the city of Huesca and in the Campo Laudable, in Litera and other border territories of Christians and Saracens, where there were wars. They lie in their thousands. Therefore I beseech you, my sons, to understand how important it is to go to Spain to fight the Saracens and with how many graces shall those who voluntarily go there be paid. It is known that Charlemagne, King of the Gauls, the most illustrious of all kings, started the crusade in Spain, fighting the infidels with great effort. His blessed companion Turpin, Archbishop of Reims, according to his heroic deeds, strengthened with God's authority, in a council of bishops from all Gaul and Lorraine gathered together in Reims, city of the Gauls, granted a plenary indulgence to all who were there then and who shall hereinafter go to Spain to fight the infidels, to spread Christianity, free Christian captives and suffer martyrdom for Christ's sake. All the apostolic men who then, until our time, corroborated this and holy Pope Urban, the illustrious man, was witness that at the Council of Clermont in Gaul, which was attended by one hundred bishops, ensured this very same thing, when he ordered the crusade of Jerusalem, as recorded in the codex of Jerusalemite history. We also corroborate and confirm this: all who leave as we said before, with the sign of the cross of the Lord on their shoulders, to fight the infidels in Spain or in the Holy Land, shall be absolved of all their sins that they have

repented of and confessed to their priests, and they shall be blessed by God and the Holy Apostles Peter, Paul and James, and all the saints, and with our own apostolic blessing; and they shall deserve to be crowned in the celestial kingdom together with the holy martyrs who from the beginning of Christianity until the end of time received or will receive the crown of martyrdom. There was never such a real and desperate need to go there as there is at present. Therefore we earnestly and universally command that all bishops and prelates in their synods and councils and in church solemnities do not fail to advertise this over and above other apostolic mandates; also urging their priests to communicate this in their churches to their parishioners. And if they do this willingly they will be compensated in heaven with the same reward as those who go there. And whoever takes this epistle from one place to another or from church to church and preaches it to all publicly, will be rewarded with eternal glory. Thus, those who advertise this here and those who depart for there, will find continued peace, honor and joy, the victory of the combatants, strength, longevity, health and glory, which our Lord Jesus Christ deigns to grant, whose kingdom and dominion is for ever and ever. Amen. So be it. So be it. So be it.

Written in the Lateran. Rejoice, Jerusalem, one hundred bishops gathered in council.

To be read and displayed for the attention of the faithful after the Gospel reading each and every Sunday from Easter to the feast day of Saint John the Baptist.

May Our Lord Jesus Christ mercifully offer his hand of great mercy to the scribe and the reader of this codex, who together with the Father and the Holy Spirit lives and reigns, God for ever and ever. Amen."[3]

This letter (Jaffé-Löwenfeld 7111) was found at the end of the "*Historia Turpini*," which informs us that, apparently, Charlemagne, after his campaigns against the Moors, granted privileges to the apostolic Church of Compostela. We shall begin by paraphrasing the content: in the opening passages the writing describes in all detail all kinds of atrocities perpetrated by the Saracens in Spain against fellow Christians, both clergy and laity: murders, kidnappings and prison are mentioned. This is why, he tells us, it was impossible to go into detail about how many martyrs were lying in various places mentioned there. He continues with a general exhortation to go to Spain to fight against the Saracens and ensure a heavenly reward. He refers to the example given by Charlemagne and to a council held by Archbishop Turpin, where the forgiveness of all sins was promised to all participating in such an undertaking. All the popes up to Urban II at the Council of Clermont in the presence of a hundred bishops then echoed the same message, according to the *Historia Jerosolimitana*. The dispositive part continued: all who bear the sign of the cross, those who have confessed and accepted penance may become part of the community of martyrs and receive the crown of martyrdom. There are then instructions to make the calling in churches in exchange for the corresponding heavenly reward, and there was also an encouragement to copy, disseminate and preach the letter. In the end we find a threefold "*fiat*," a date that refers to the Lateran Council, attended by one hundred bishops, and the exhortation to read the text aloud after the Gospel from Easter until the feast day of Saint John the Baptist.

3 Ibidem, pp. 492–4.

For Jaffé-Löwenfeld, this letter was a forgery. How can the letter be interpreted? In principle it is clear that it was transmitted as a direct and exclusive link to Book IV of the *Liber Sancti Jacobi*, to the "*Historia Turpini*;" however, it only appears in certain groups of transmission. It is not found, for example, in the manuscripts that since Adalbert Hämel have been known by the name of the "Aachen group."

The letter, which is addressed to all believers, can be clearly divided into two parts. In the first, the writer tries to follow the lines laid down by the "*Historia Turpini*" concerning Charlemagne's crusade and yet, however, the facts are introduced with a *fertur*; in the "*Historia Turpini*" there is not even an allusion to a Council of Turpin in Reims, where in the eighth century the absolution of sins for all who participated in the Spanish crusade seemed to have been already decided. Furthermore, the glory of martyrdom, which as we have seen is also mentioned in the letter, is used as a general argument, more in the case of the crusades to the Holy Land than in the case of Spain, as clearly shown in comparative studies.

The other passages refer to Pope Urban II, the Council of Clermont and the *Historia Jerosolimitana* – Fulcher's work is mentioned or, more credibly, Robert the Monk's, because the latter particularly emphasized the cruelties of the Muslims. However, it is noteworthy that among the information preserved about the speech of Urban, only one reference to Spain has been verified, in the text of William of Malmesbury.

As for the subsequent dispositive part, it has been said that the reference comes from canon 10 of the first Lateran Council in 1123, mainly because the dating seems to refer to a council. The canon indeed also refers to Spain together with Jerusalem as a destination for the Crusades and points out, with a slight change in the nuance, the celebration of Easter, but there is no clear coincidence in the expression. More striking is the similarity with Olegario de Tarragona (*Pastoralis officii*): Jaffé-Löwenfeld 7116, as here the same reward was promised to the crusaders who went to Spain as for those who were traveling to the Holy Land.

Mention is then made of the call for a provincial council in Compostela by Archbishop Diego in 1125, as in this text there are some, although few, literal similarities, such as, for example, the intercession of Peter, Paul and James; above all, there is an energetic exhortation to extend the appeal.

Finally, we should focus our attention on one more point: a legate sent to Spain by Pope Innocent II, perhaps in 1138–1139, with an invitation to the second Lateran Council in Rome, to be held in Lent on the day of *Letare Ierusalem*. This was the indication of the time known in Compostela for the second Lateran Council, although the first Council was also held in this vaguely specified period of time.

These observations clarify the reasons why there has been talk of a forgery; but we are entitled to suspect the chronological order given by Jaffé, that the letter was not ordered according to a particularly exact chronology and we accept 25 March 1123 as the date of the forgery, since that day was *Laetare* Sunday in 1123 and at that time the first Lateran Council was held (from 18 to 27 March 1123),

in Rome. In this way, the temporal proximity could have come about with Jaffé-Löwenfeld 7116, which was sent on 2 April. As we can always refer to other papal documents or canons from other councils, the proximity with respect to the *Historia Compostellana* is as striking as the adaptation to the "*Historia Turpini*," as the idea of martyrdom is found here, addressing at the same time normal representations of the Crusades to the Holy Land and in a lesser form, those for the crusade of the Spanish Reconquest.

The last letter to deal with (Jaffé-Löwenfeld 8286) has been attributed to Innocent II and can be found at the end of the compendium, in the appendix on fol. 221r; on the other side of the folio is a miracle dated to 1139 and there are still more folios written in another hand. The letter is addressed to all the children of the church and mentions the *Codex*, composed ("*editum*"), as they say, by Pope Calixtus and the first copy of the *Liber*; Aymeric de Parthenay from Poitevin, also called Oliverus de Iscani, a village of the Church of Sainte-Marie-Madeleine of Vézelay, in the company of his wife Gerberga, took the *Codex* to Santiago, in Galicia, for the salvation of his soul. The Pope certifies the quality of the book and states that it should be counted among the ecclesiastical codices due to its authenticity and value, and finally threats anathema on anyone who importunes the bearers of the codex on the Pilgrims' Road to Santiago ("*in itinere sancti Jacobi*"), or whoever might steal or hide it. Next, we find the signatures of the Chancellor and seven other cardinals.

In principle, here too we should point out that the letter has been transmitted only within the framework of the *Liber Sancti Jacobi*, in much the same way as it is possible that other manuscripts, apparently independent, are ultimately based on the *Liber Sancti Jacobi*. In terms of content, it should be pointed out that the bearers of the *Codex* to Compostela play a central role. The identity of the above-mentioned Aymeric was perhaps the same as the person who on the previous folios appears as the author of *Aimericus Picaudi Presbiter de Partiniaco*. The district of Vézelay becomes important again in the context of the compendium, as on folio 221v we find a miracle whose narration has been attributed to Abbot Alberic of Vézelay, also cardinal and bishop of Ostia in 1139. It is difficult to interpret the passage that identifies Aymeric with Oliverus; according to René Louis' thesis both they are one and the same person as Aymeric had been chaplain of a Church of Saint James in Vézelay and there he had taken the name of Olivier d'Asquins. There is, however, the question of how one can explain the existence of a *sotia* when dealing with a priest: hence the change in some places of *qui* for *quem etiam*.

I shall omit here many of the considerations the name Aymeric has led to, sometimes regarded as editor, others as compiler and the majority as the mere bearer of the *Book of Saint James*. Vézelay's relations with Compostela have also been stressed on numerous occasions. And yet we must also refer to the signatures of the cardinals which in no case appear to have been invented; only in the Compostela manuscript can the attempt to reproduce individual signatures be detected, through various capital "E's" and other characterizations.

This occurs in a more striking way in the case of the last name, whose writing perhaps comes from another hand.

After chancellor Haimeric we find the following names: Gerardo de Santa Croce (1123–1144), who became Pope under the name of Lucius II, Guidus, Cardinal of Saint Cosme and Saint Damian (in Pisa) (1132–1149), Ivo, Cardinal of Saint Lorenzo in Damaso (1138–1142), Gregory of Saint Grisogono (1139?–1157), nephew of Pope Guidus, Gregory of Ihenia (?) and Alberic, Cardinal and Bishop of Ostia (1138–1148).

In a authentic papal legitimation the name Alberic would usually appear at the top of the list as he was cardinal and bishop; and so here the mention of Chancellor Haimeric in the first place implies other forms of transmission that differ from a papal letter.

If we review the whole series of headers, we find that the posts of chancellor and cardinal only cover the years 1139 to 1141, which provides a terminus *post quem* for the letter. It is not yet clear, however, where the names of the cardinals were taken from. What is certain is that the formulas differ from what is usual in a signature, because all of them, again and again and in various ways and means, praise and legitimize the *Codex*. And it is indeed curious that the cardinal who signed last, Alberic of Ostia, who was often away as a legate, and had even traveled to Antioch, was abbot of Vézelay until 1138 and then we subsequently find him again on folio 221v of the *Liber Sancti Jacobi* as the author of a miracle. It seems that there is strong evidence for his presence in the Holy Land in 1140. In any case, here lies a conscious intention to reinforce papal authority with the names of different personalities and their corresponding references, and this was not the only reason why antecedents of the *Codex* have repeatedly been searched for even in Vézelay. At the same time, the name of Alberic brings the alleged drafting closer to the second Lateran Council.

Both papal writings, therefore, provide propaganda and authenticity. Not only do they make the idea of the Reconquest clear, but with Innocent's letter papal authorship was extended to the whole *Liber Sancti Jacobi*.

The *Liber Sancti Jacobi* and the pilgrims' roads: imposition and subordination

"There are four roads to Santiago, which join together in Puente la Reina in Spain. One goes by Saint-Gilles, Montpellier, Toulouse and Somport, another passes through Saint Mary of Puy, Saint Faith of Conques and Saint Peter of Moissac, a third goes by Saint Magdalene of Vézelay, Saint Leonard of Limousin and the city of Périgueux and the last one goes by Saint Martin of Tours, Saint Hilary of Poitiers, Saint John d'Angely, Saint Eutropius of Saintes and Bordeaux. The one that goes by Saint Faith and that of Saint Leonard and Saint Martin join together in Ostabat and pass Port de Cize, and then in Puente la Reina they join the road that crosses the Somport and from there they form a single road to Santiago."[4]

4 Ibidem, pp. 497–8.

The fifth part of the *Liber Sancti Jacobi* begins with this list, after the chapter index. In this twelfth-century "Pilgrim's Guide" we find four different starting points for pilgrimages to Santiago and they all start in France: in Saint-Gilles, Le Puy, Vézelay and Tours. These few sentences set the paths for pilgrims and declare them canonical at the same time. Today it is difficult to find a book about pilgrimages to Santiago that does not include a map with these routes. The medieval versions, as a rule, did not contain maps with road markings. Today we can easily understand why the Vézelay route and especially the Le Puy road were particularly harsh: while today's pilgrims are capable of enjoying scenery through mountains and uninhabited places, for the ancients this was an enormous effort, a threat and a danger; in fact, it has already been shown that pilgrims used the Vézelay and Le Puy routes much less than those of Arles and Paris, or rather Tours. Going a bit further, we could even say that the author of these lines somehow "invented" some of these roads.

Reviewing the remaining chapters in the "Pilgrim's Guide" – in whose stages we come across a carefully drawn up list of both rivers and fords where they could be crossed, the different villages along the route and the places and relics of saints that had to be visited – it is interesting, as far as the shrines are concerned, that the author subordinates major French centers of worship, competitors of Saint James, to his tomb in Spain: thus, in chapter eight, Saint-Martin de Tours, Sainte-Foi de Conques, Saint-Léonard de Limoges and Saint-Sernin de Toulouse are primarily treated as shrines on the Road, stations on the way to another goal, and much less as independent centers. In this way the Road became an important part in the veneration of Saint James, and the distant Compostela, in the geographical periphery, became an ideal center. The daily stretches in Spain were defined in such a way that that the road seemed shorter than it actually was, as thirteen days from the Pyrenees to Santiago implied an average of over fifty kilometres a day; like this, the indications in this chapter about which stages can be done on horseback are of no use at all.

What really subordinated the competing centers of Santiago was that the fictitious map generated in the minds of potential readers and listeners seemed to take them to Saint James' tomb, far away from nearly all European regions. Santiago, thus conceived, was the center, although geographically it was in the periphery. Some of the miracles that are described in the compendium of the second part of the *Liber Sancti Jacobi* endorse this point of view, as Saint James appears to us as a greater miracle worker than even the mighty Saint Martin of Tours. We can rightly support this claim by going to the end of the third story of miracles, since there the two saints are compared:

> "It is something new and never heard before that one dead man should raise another. Saint Martin, still in life, and our Lord Jesus Christ raised three dead people; but Santiago, when he was dead, brought another dead man back to life. But someone might object: if we read that our Lord and Saint Martin did not raise anybody after death, but only three dead people before they died themselves, then one dead man cannot raise another. But the living one who says this concludes thus: If a dead man cannot raise the dead, then the blessed James, who raised a dead man, certainly lives with God."[5]

5 Ibidem, p. 343.

We still find the ninth chapter of the "Pilgrim's Guide" of the *Liber Sancti Jacobi* fascinating today, with its detailed description of the town of Compostela, the church and especially the Basilica of Saint James. Several buildings that have now lost the form they had then are described in detail. Perhaps the author of this chapter took descriptions of Rome as an example here (*Mirabilia Urbis Romae*); they were widespread in the twelfth century. Visiting the basilica is similar to visiting the heavenly Jerusalem. The measurements of the church, the number of pillars and many other detailed indications lead us to imagine the most complete harmony of the cathedral; the author ends the paragraph dedicated to the church's measurements as follows:

> "In this church, in short, no cracks or defects are to be found; it is admirably built, it is large, spacious, clear, of a convenient size, well-proportioned in width, length and height, of admirable and ineffable design, and it is doubly built as a royal palace. Whoever goes through the naves of the clerestory, even if he is sad, he will be cheered and glad to see the splendid beauty of this church."[6]

Other chapters of the "Pilgrim's Guide" and some passages from the first part of the *Liber Sancti Jacobi* represent the world of the time in a very plastic way: hence the passages that talk to us about the customs duties established, those warning against boatmen, who sometimes made their boat capsize, and against inn owners, who pestered pilgrims with the sole intention of seizing their money and their properties. In addition, we can clearly recognize the preferences and antipathies: in a chapter on the good and bad rivers of the Pilgrims' Road to Santiago it is interesting to see that the deadly waters are concentrated mostly in Navarra, within Spain, and the author also insistently discourages consumption of fish from the rivers between Estella and Logroño. Similarly, the Navarrans themselves do come out very well either: in another section dealing about the various peoples of the Road, not only are they accused of being impious and barbarians, but they are also described as capable of having dishonest contact with livestock and also, their language is similar to "dogs barking." Again and again Navarra and the Basque people are the target of similar darts, in such a way that it is inconceivable that such prejudices could come from a mere observer.

On the contrary, the work of those engaged in building bridges and roads that help make pilgrims' travel safer, as well as the merits of other groups, are here exalted. And finally, the Gospel according to Matthew is recalled once again: "whoever receives you, receives me" (Matthew 10:40); and then three divine punishments are mentioned that clearly show the importance the author gave to the obligation to provide accommodation for pilgrims on their way to Santiago: such is the meaning of the introduction at this point of the "hagiographical discourse," which is even clearer in the case of the compendium of miracles in the second part of the *Liber Sancti Jacobi*. Along with requests of the most diverse nature in connection with which the Apostle intervenes with his support or

6 Ibidem, p. 556.

punishment, pilgrims' travels and hardships and the length of the routes provide above all grounds for miracles. Thus, the stories of miracles tell us that the Apostle took a pilgrim who had met with death on the way to Compostela on his horse.

The sacredness of places seems to be important, i.e. of the populations and shrines pilgrims visited. The eighth chapter of Book II deals with this point and from its header, the text does not stop exhorting pilgrims again and again to visit the sacred tombs along the Way: *Visitandum est* or *Visitanda sunt*. We find this statement 23 times in this chapter of the book. Not only the repetition but also the grammatical structure of these passages tells us about a clear underlying intention. Precisely this part of the "Pilgrim's Guide" is more prescriptive than descriptive. Perhaps the purpose of this chapter, much like the long version – composed more or less at the same time – of the act of consecration of the Cathedral of Compostela under Alfonso III, with the list of relics and annotations on the consecration, was even to incorporate the cult of the Apostle of Compostela into a group comprising other significant saints. The outline of four roads leading from France to Santiago, as Díaz y Díaz said, contributed to "*subordinar los centros de Francia al centro de Santiago.*" This was also important, especially if the point to make was… to turn a place of pilgrimage situated in the westernmost part of the world at the time into an ideal center! But… how exactly did this happen?

The sacred places described in detail in France, 21 altogether, contrast with the three or four, if Santiago is included, described in Spain. This imbalance may be explained by the fundamental intention of subordinating the French competition centers to Compostela, destination of the pilgrimage, to honour them just as shrines laying out the route. However, we can notice major imbalance on the four French roads too. The road from Arles, which in the Latin edition occupies three printed folios, is described in as much detail as the Paris-Tours road, which, due to the insertion of the *Passio* of *Eutropius* is particularly long – five printed folios and the *Passio* occupies two and a half of them. The Le Puy and Vézelay roads are considerably shorter: Vézelay, one and a half printed folios and Le Puy, a third of a folio. This corresponds to the number of saints. On the Le Puy road there is only Saint Faith – *Fides* – of Conques, and on the Vézelay road only Mary Magdalene, Leonard and Frontus. Obviously, and this is where my theory is focused, the roads through the Macizo Central were little known and not very busy, because otherwise, other saints could have been listed without any problems. The Paris-Tours and Saint-Gilles roads have a much more sacred charge.

But… how did the author introduce these holy places? First the saint and the place are introduced, and the text almost always ends up with the date of the saint's feast day. These are almost completely absent in Spain, and from the data given we can hardly glimpse a programme. These notes are sufficient for certain saints, such as in the case of the bishop of Arles. In the case of others, we can assume that there was only basic knowledge of the hagiographical dossier. This follows from the comments regarding the *vita* or *passio* and the miracles. There are frequent mentions of foundations of convents and forms of monastic life. The description of Saint Gilles' (*Aegidius*) sarcophagus is especially thorough, almost

an artistic-historical description and, as is the case with other saints too, there is a critical mention of other centers in competition: "The Hungarians, who claim to hold his remains, should blush with shame." This comment leads the author to a fundamental statement, which tells us something about the valences of the saints presented: after describing the unsuccessful attempt to steal the relic of Saint Gilles' (*Aegidius*) arm, he says, "according to what is said and repeatedly confirmed, there are four saints whose mortal remains cannot be removed from their tombs: those of Saint James Zebedee, Saint Martin of Tours, Saint Leonard of Limoges and those of the Holy Confessor of Christ *Aegidius*. It is said that the French King Philip in his day tried to take these bodies to *Galia*, but he was not able to move them inside their sarcophagi."

The three relevant saints in France are thus mentioned in conjunction with Saint James: Saint Martin, Saint Leonard and Saint *Aegidius* (Saint-Gilles). Three of the four roads can be allocated to them. The road from Le Puy is missing here, only highlighted for the relics of Saint Faith (*Fides*). With this, the differences in the consecration of the roads are clear, because in some hidden places it also takes into account the value of the cults.

Do these holy places also structure the temporal sequencing of the pilgrimage? In no way. The places of worship have nothing to do with the stages. In chapter two, the Spanish road is divided into stages, among which France is not mentioned, but the few saints alluded to do not visibly seem to have determined the structure thereof. And therefore I think that there is another perspective that plays an important role in the sacralization of places in the eighth chapter. Given the role of the Apostle Saint James as a missionary to the Iberian Peninsula, it does not seem fortuitous that the eighth chapter of the "Pilgrim's Guide" begins with comments on Saint Trophimus in Arles in the following way:

> "Those who go to Santiago by way of Arles have to visit the mortal remains of Saint Trophimus in Arles, whom Saint Paul mentions in his letter to Timothy. Consecrated bishop by Saint Paul, he was sent as the first to preach the gospel to this city. From this clear spring all France received the source of faith, wrote Pope Zosimus. His feast day is held on 29 December."

Here we are presented with a messenger of faith, related to the Apostle Saint Paul and who allegedly carried out missionary work in *Galia*. Was he the equivalent of Saint James in *Hispania*? If we focus on the other saints who are not the object of this contribution, we discover Frontus, who Saint Peter allegedly sent to France, and also *Eutropius*, who due to confusion is located in apostolic times. The aspiration seems to crystallize here, and was claimed in a more insistent way by Rome during the ecclesiastical reform, to revalue Saint Peter and Saint Paul's primordial missionary tasks and that of their disciples. But the fact that at the beginning of the chapter, these Roman-apostolic traditions are so clearly outlined in relation to *Galia* and such important relics are named, like the head of Saint John the Baptist (Saint Jean d'Angely) and the remains of Mary Magdalene as sanctuaries along the way, indirectly contributes to highlighting the tradition

of Saint James' missionary work in the Iberian Peninsula and determining the structuring principle of the eighth chapter; which so far has not been heeded. At the beginning of the road are Trophimus and the Christianization of *Galia*, and at the end are Saint James and implicitly the Christianization of *Hispania*.

From the pilgrims' roads to the roads of research

If the roads were conceived and built on such a large scale as told in the *Liber Sancti Jacobi*, this raises the question of their relation to reality and scientific interpretation. A customs tariff from the late eleventh century (1076–1094) shows which goods were preferentially imported and exported and which were taxed with duties in the Aragonese city of Jaca: among other things, cloth from Brugges, silk from Constantinople, purple, dyes, swords, captive Moors, metals, spices, even food and gold coins of a possible Muslim origin are mentioned; as are their respective places of origin and destination. The place where the customs duties were imposed is also revealing: Jaca was a gateway to the northeast of Spain, at the foot of the pass of Somport. This road was also used by pilgrims and, although the passage through Jaca seems to have been particularly important for trade, the concluding passages of the document make it clear that pilgrims were free from any such toll. From the late twelfth century, however, Roncesvalles gained importance in the Pyrenees as a transit point for pilgrims, and one wonders whether this was solely due to feudal or economic promotion. The "Pilgrim's Guide" in the *Liber Sancti Jacobi* mentioned the two sites at the beginning; four chapters later the Hospice and Hospital of Santa Cristina de Somport are briefly featured; but if we continue reading, the eighth chapter, devoted to the holy cities along the way, distinguishes Roncesvalles in all detail, almost uniquely in the Pyrenees. What should be noted here is that, without detracting from the economic significance of the pass, an ideological argument has come to the forefront, because this was the place Charlemagne used on his journey to the Iberian Peninsula.

"In the Basque country there is on the road to Santiago a very high mountain called Port de Cize, either because there is found the doorway to Spain, or because over this mountain necessary things are transported from one land to another; it is eight miles to go up and another eight to come down. It is so high that it seems to touch the sky. For the one who scales it, it looks like he can reach out and touch the sky with his hand. The British and the Western seas and the lands of three countries, namely: Castilla, Aragón and France can be seen from its summit. On the top of this same mountain there is a place called the Cross of Charlemagne, because it was there that Charlemagne opened up a path with axes, pickaxes, hoes and other tools when he was going to Spain with his armies in other times and, finally, kneeling towards Galicia he prayed to God and to Saint James. Therefore, bending their knees there, pilgrims usually pray looking towards Santiago and they all nail crosses here – they can be found in their thousands. This is why this place is considered the first for prayer to Saint James. On this same mountain, before Christendom fully grew throughout Spanish lands, the wicked Navarran and Basque people used not only to rob pilgrims going to Santiago, but also rode them like asses and killed them.

Next to this mountain, towards the north, there is a valley called Varcarlos, where Charlemagne himself encamped with his army when the warriors were killed at Roncesvalles, and through which many pilgrims pass on their way to Santiago and do not wish to climb the mountain. After, then, the hospital and the church are located on the way down from the mountain, where lies the rock that the mighty hero Roland cleft right through with three strokes of his sword. Then comes Roncesvalles, where once the great battle was fought in which King Marsilius, Roland and Oliveros and one hundred and forty thousand more Christian and Saracen warriors were killed. Navarra comes after this valley, a land considered fortunate for its bread, wine, milk and cattle."[7]

The passage of the "Pilgrim's Guide" retakes the journey to Charlemagne's Spain that was told in more detail in Book IV of the *Liber Sancti Jacobi*, "*Historia Turpini*." In a new version of Charlemagne's Spanish crusade, a European-Carolingian tradition concerning pilgrims and Charles the Great, who fought against the Moors, leads the subject of Saint James in a new direction. Above all, this new European perspective places Roncesvalles in the foreground, naturally from the twelfth century onwards. This place, where Charlemagne suffered a heavy defeat in 778 as contemporary sources record, had now become a major transit zone for pilgrims to Santiago crossing the Pyrenees. Anyway, subsequent pilgrims' guides from the fifteenth century – like the manual written by Hermann Küunig from Vach – together with other testimonies, all mention a mountain pass at Roncesvalles.

In the "*Historia Turpini*," whose writing is attributed to a contemporary of Charlemagne (Archbishop Turpin of Reims), the beginnings of the cult to Santiago are also read in a somewhat different way than in the traditions of Compostela already outlined. This text reports on the alleged activities of Charlemagne in Spain. The discovery of the tomb by Pelagius is not mentioned and we are told that Charlemagne, during his trip to Spain, visited the tomb, which had fallen into oblivion, and that he reinitiated the campaign against the Muslims in the Iberian Peninsula. The events of 778 were thus placed in a new context, and at the same time, the initial versions of the discovery of the tomb of Saint James lose their absolute value. Perhaps it was this, another strategy from certain circles of Compostela, whose purpose was to make the tomb of Saint James, in the periphery, a European pilgrimage center. It is true that the "*Historia Turpini*" is partially linked to *La Chanson de Roland*, but it insistently links Charlemagne's journey to Spain with the traditions of Santiago. The story became popular and was copied several times from the moment when Frederick Barbarossa successfully obtained Charlemagne's canonization (1165): use was then made of these texts for the cult of Charles the Great, now a saint, and they were given diffusion (sometimes with adaptations). The reliefs on Charlemagne's tomb at Aachen, completed around 1215, clearly retake the issue of the sovereign warrior in Spain and pilgrim to Santiago. In one relief, the Apostle Saint James appears in a dream to Charlemagne and instructs him to fight against the Muslims and free his tomb so that pilgrims could go and visit him there.

7 Ibidem, pp. 517–9.

That this text could have determined the route of the passage over the Pyrenees is not only deduced from its dissemination but also, for example, from the creation of a hospital in Roncesvalles in 1127–1137 "next to the chapel of Charlemagne [...], where thousands of pilgrims died, some due to snow storms, many others devoured by wolves," as noted by the source itself.

The connection between pilgrimages to Santiago and Carolingian traditions in the history of the "Pseudo-Turpin" and other epic works continues to provide soundness to the planning of the Pilgrims' Road to Santiago, as not only did Charlemagne lead his armies – allegedly, of course – along this Jacobean route to the tomb of Santiago, but he also used the routes in his crusade against the Muslims. The significance of the comparison of Charlemagne's pilgrimage in this and other writings led philologists in the early twentieth century to assign pilgrims' roads a key role in the beginnings of epic poetry. With this – stated if you like in a somewhat exaggerated way – they created the concepts of the "Pilgrims' Road to Santiago" and "pilgrims": they used the term "Pilgrims' Road to Santiago" for their valiant attempts to explain the generation of epic poems.

Romance expert Joseph Bédier, however, hardly made concessions to potential changes in the route and his thesis looks, rather, in the opposite direction, as in his major work in four volumes, *Les légendes épiques* (1926–1929), he pointed out in an almost apodictic way, "*Au commencement était la route*" (In the beginning was the road). With this basic thesis he focused almost all his attention on the pilgrimage routes to Compostela and thereby tried to solve the already longstanding discussion about when the epic poems were written. According to Bédier, the origin of the poems should be sought in the roads traveled by pilgrims and, above all, the Crusades of the Spanish Reconquest, as they retook the topic of Charlemagne and those associated with him. Clerics from Saint-Roman de Blaye, at the outset of one of the four pilgrimage routes, would have shown the supposed tomb of Roland to pilgrims and crusaders, and in Bordeaux they would have been able to admire the legendary horn of Roland. This would have led to some crusaders in the eleventh century feeling like descendants of Charlemagne. With the help of these clerics, expert readers – the monks of these places perhaps knew other texts about Charlemagne – epic poems were bred. Bédier therefore ended up stating that the source of *La Chanson de Roland* and other epic poems should not be sought any earlier than the eleventh century.

The fascination that this attempt at explanation aroused had a prolonged effect, although meanwhile some critics proposed, rather, a development over time and previous drafting stages for the epic themes from the time of Charlemagne. Bédier's explanation is in line with French Romance philology, which aimed to free *La Chanson de Roland* from its Germanic roots. The "*Historia Turpini*" and *La Chanson de Roland* became the masterpiece of a very learned Frenchman of the eleventh century, who was on his way to Santiago at the time of the Crusades and pilgrimages. Against this backdrop, of course, the origins of the *Liber Sancti Jacobi* were also sought in France: Bédier considered it the work of a Frenchman, possibly from Cluny; but this assertion has been refuted from another angle. Anyway,

overall, Bédier stands against the stronger European position of Gaston Paris, who postulated the origin of the epic poems as early as the times of Charlemagne and in oral traditions. It is not easy to take sides on this issue, but as it is hard to accept the idea of conspiracies and propaganda planning, Bédier's thesis is "guilty," despite the fascination of much of his proof. The proposal of an oral tradition and a long prehistory of the epic from the days of Charlemagne thus rises again with force and at the same time indirect traces are classified, the alleged writings of intermediate stages; and oral traditions with deformations, which we find very difficult to follow up, are not so easy to dismiss.

Despite the detail provided by many criticisms and despite the questions that still remain about the evolution of the text of the "*Historia Turpini*" and *La Chanson de Roland*, Bédier's explanation is still suggestive, as it is almost the only one that allows us to think of a direct relationship between clerical propaganda and the epic poem. This contact creates the "Pilgrims' Road to Santiago" and since it was only in the twelfth century that it took shape, previous written versions of *La Chanson de Roland* should be excluded. But is there an underlying assumption of reality to this hypothesis? Or is the pilgrimage route an assumption created by Bédier, at least in part, to connect two given circumstances? It is quite uncertain that the different routes lie at the origins of the epic; however, epic themes could surely have been spread through pilgrimage and, indirectly, through the roads used by pilgrims, so that what we need now is to better differentiate among cause, effect and side effect.

The seed of Bédier's tentative explanations bore fruit beyond its scope of action and was especially interesting for specialists in the history of art: the theories of an influence of the pilgrimage routes on the architecture of Romanesque churches, sculpture and the dissemination of certain groups of iconographic themes are well-known. The "Pilgrim's Guide" from the twelfth century also provides us with a point of contact here: "Visit the venerable relics of the holy bishop and confessor Martin on this path along the Loire [...]. His grave with his holy relics rests in the city of Tours [...]. The venerable basilica was wonderfully built over them in his honor, just like the Bhurch of Santiago."[8] These observations point towards a phenomenon that art historians believed to have been proven in many other places along the pilgrimage road.

American research with Arthur Kingsley Porter at the head took exclusive charge of the study of the relation of the dependence of the construction of the Bhurch of Tours as compared to Compostela. Quite interestingly, Émile Mâle and French research defended the opposite influence; i.e. the French model came from the Spanish one. The truth is that, until now, every pilgrim and every art lover no doubt is and has been surprised at the large number of artistic creations – above the average – that dot the landscape along the route. This fact could be attributed, in a sense, to the exchange among various places of worship through the movement of pilgrims, especially intense at times. When observing the structure of the so-called pilgrimage churches, there is no doubt that almost all the significant places with such constructions – Tours, Conques, Toulouse, Limoges and

8 K. Herbers, *Der Jakobsweg. Ein Pilgerführer aus dem 12. Jahrhundert* (Stuttgart: Reclam Verlag, 2008), pp. 124ff.

Compostela – were at the same time places of pilgrimage, and it is also clear that with the new forms of construction pilgrims' very useful acts of worship were facilitated. The additional lateral naves and the ambulatory allowed masses of people to be led round; the second floor provided more room and better vision. However, it is still true – and younger art researchers have also made this clear – that establishing dependencies among various churches is a complicated matter and cannot always be adjusted to logic when dealing with a creation, or the idea of a definite unilateral influence, so that evidence from the world of art cannot be adduced accompanied solely by the magic words "pilgrimage architecture."

Many questions therefore still remain unanswered and diverse and distinct attempts at explaining them continue to strive with each other. Approaches of possible exchanges still crop up everywhere: thus, in Navarra, certain points of contact in the Romanesque churches of Eunate and Torres del Río seem to have been recognized, and in the view of some scholars, this could even be extended to the Holy Land. Taken together, the art of Romanesque constructions in Navarra is not so similar to "pilgrims' churches." Rather, there are testimonies to the existence of a wide variety along the pilgrimage roads, which at times – as in Sangüesa – had even directed their "points of light" in line with the cover programme, to the pilgrims' route.

Thus, not only do the observations from the twelfth-century "Pilgrim's Guide" seem to have coined the issue of the pilgrim's road, but further research promoted by the study of Carolingian epic has led philologists and art historians to draw the contours of this concept from their own perspectives.

The diffusion of the *Liber Sancti Jacobi,* a key document for the cult to Saint James

And so I find it convenient to address the dissemination of the texts of the *Liber Sancti Jacobi* as an indicator of the spread of the cult. One episode in the third part of the *Liber Sancti Jacobi* shows us how, by the time of the composition of the *Codex Calixtinus*, at least parts of these texts on the Apostle Saint James were being copied. One pilgrim paid a large sum of money for a copy of the text of the translation.

With precaution, therefore, the expansion of the cult to Saint James in Europe from the twelfth century can be highlighted, analyzing the distribution of manuscripts of the *Liber Sancti Jacobi*. However, we must take the provisional status of the collection and classification of manuscripts into account. We know of over 300 manuscripts, if we include partial copies and translations. In many cases the provenance is not indicated and there is no detailed description of the manuscript, and in these cases we can only indicate its current location.

We must say a few words about the numerous manuscripts that transmit the *Liber Sancti Jacobi* only in an abbreviated form, which we call, following Hämel, the *Libellus Sancti Jacobi*. This abbreviation usually contains the preface, the compendium of miracles, the book of the translation, the "Pseudo-Turpin," some passages from the "Pilgrim's Guide" and other small pieces.

If we try to design a geographical overview of manuscript transmission, the result is the following pattern, differentiated according to the transmission of the full compendium and the *Libellus*, and also taking into account the century when the manuscript was copied.

Without going into the problems of several manuscripts of the *Liber Sancti Jacobi*, the relatively complete manuscripts are grouped around the end of the twelfth century in Ripoll and Alcobaça, the fourteenth century in Salamanca, London and Rome and the fifteenth century in Pistoia.

The spread of the *Libellus* was paramount for the dissemination of the cult of Saint James. The *Libellus* was disseminated throughout Europe from the mid-twelfth century onwards. There was a very complex series of abbreviations of the *Libellus* in the thirteenth century, with different criteria, mixing different types in various ways. The interest is paramount as a manifestation of the spread of Jacobean legend and devotion. Above all we must bear in mind that the *Libellus* has been translated into many European languages.

Finally, we must take into account the spread of the "Pseudo-Turpin" and the *Libellus*, which evidences certain transmission centers. Many manuscripts only contain the "Pseudo-Turpin" and the *Libellus* and this version is mostly found outside Spain.

The key to explaining why the spread in Europe and more precisely in the West was more intense than in Spain lies perhaps in the "Pseudo-Turpin." Charlemagne's story in relation to the Reconquest and the discovery of Saint James' tomb somewhat contradicted the classical Spanish traditions: not only about the discovery of the tomb, which was attributed to the hermit Pelagius in the "Concordia de Antealtares" with no mention of any Carolingian participation, but also in the conception of the Reconquest, which according to Spanish writers was always a matter of the Spanish alone with no foreign aid. It should also be noted that the political aspect of Saint James as *miles Christi* and "patron saint of Spain" was widespread during the Middle Ages, especially in Spain. The image of Charlemagne within the history of Santiago was the foundation of the European aspect of the subject. With Charlemagne Saint James became much more of a European saint.

Either way, with the various abbreviations of the *Liber Sancti Jacobi*, libraries in Europe did not possess the "Pilgrim's Guide," to which so much attention is now paid, but they had information on the translation of Saint James to Galicia, on the discovery of the tomb in Compostela and on the cult then manifested in miracles. These miracles, adopted and integrated into many collections of miracles and examples, provide knowledge of the fame of the apostle and his shrine in Compostela, and spread the saint's protection over pilgrims on the harsh and hazardous roads to Compostela. The collection of miracles was above all an excellent instrument of propaganda. Although I cannot fully develop this point here, I should emphasize that miracles provided an ideal way of neutralizing and even subordinating other pilgrimage centers in competition with Santiago. A common measure for this goal was especially the miracles that occurred on the

road. The road thus became a "road of miracles" linking Europe to Santiago de Compostela. In the twelfth and thirteenth centuries Compostela was thus not only known exclusively as the site of Saint James' tomb but also the way to this place. And this knowledge was based less on the "Pilgrim's Guide," which is today usually read with so much interest, and much more on the miracles.

Diffusion therefore provides the fundamental influence of the *Liber Sancti Jacobi*, and also indicates the most striking passages in a compendium that is an essential part of the Jacobean phenomenon.

Alison Stones

Illustration in the *Codex Calixtinus*

The Santiago copy of the *Codex Calixtinus*, otherwise known as *Jacobus* according to the opening heading, contains several levels of decoration and illustration which articulate and embellish the various textual components of the manuscript and accompany the several campaigns of production in the second and third quarters of the twelfth century.[1] These embellishments are important pointers to the artistic contexts from which the *Jacobus* manuscript emerges. Here I outline the categories of decoration and illustration in the manuscript in relation to their artistic sources and influences.

The decoration in the *Jacobus* manuscript: the initials

At the lowest level in the hierarchy of the decoration are the colored capital letters in red, green, blue and yellow, sometimes only in red, but more often in combinations of colors. These accompany the work of the first scribe,[2] responsible for all of books I and III, and most of books II, IV and V. These initials mark textual divisions of paragraphs in the prose texts and subdivisions in the liturgical texts and the noted chants and songs. They are accomplished in execution and add color and articulation to the pages. The bulk of these colored initials accompany the work of the first scribe. Sometimes a simpler form of colored initial in red is used, corresponding to the rubrics, also written in red. A similar type of colored initial, in red and green, introduces the songs at the end of the manuscript; and the added half-leaf, folio 128, has still another, related, type of red and green initial. These are by other decorators working in an artistic idiom similar to that of the first decorator.

A second group of minor initials accompanies the work of the second scribe. These initials are in red or blue, with pen-flourished decoration in blue or red. Green and yellow are not used by this decorator. A further set of simple pen-flourished initials in brown with red flourishing accompanies the work of Scribe 3 in part of the "Pseudo-Turpin."

More significant textual divisions are marked by foliate initials with dragon motifs, an occasional human head, and they form the frame for the portrait of Archbishop Turpin of Reims that opens the text of Book IV, the "Pseudo-Turpin." They are drawn in light brown ink and colored in red and green in a drawing technique in which colored lines on the foliage are distinctive, forming cross-

1 ACS~Archivo de la Catedral de Santiago: *Ms 1*.
2 M. C. Díaz y Díaz, *El Códice Calixtino de la Catedral de Santiago. Estudio codicológico y de contenido* (Burgos: Ediciones Aldecoa, 1988). Díaz y Díaz has argued that the first copying campaign was the work of two closely related scribes, 1A (Book I) and 1B (books II, III, IV, V). For simplicity's sake I refer to both as Scribe 1 here. Scholars may form their own opinions from the facsimile, *Liber Sancti Iacobus: Codex Calixtinus de la Catedral de Santiago de Compostela* (Valencia: Kaydeda, 1993).

hatched "caps" on the rounded cusps of the leaf forms. These initials accompany the work of the first scribe and the first decorator, with the exception of one incomplete initial, perhaps colored at a later stage, that does not fit the pattern of the rest of the foliate initials and is the only such initial to accompany the work of Scribe; then there are two more foliate initials (fols. 24v and 31v), probably contemporary with the rest in the work of Scribe 1, but drawn by a different draughtsman. There are no corresponding foliate initials in the work of the later scribes.

The illustrations

All the illustrations in *Jacobus* accompany the work of the first scribe and decorator. As already remarked, the Turpin initial sets the figure of the Archbishop in foliage of the same type as the foliate initials accompanying the work of Scribe 1. The portrait of Pope Calixtus, claimed as author of much of the compilation, is similarly set in a "C" initial with foliage bars of the same type. The other figural illustration consists of the framed portrait of Saint James on folio 4, conceived as an initial "I" without foliage, and the three illustrations prefacing Book IV, the "Pseudo-Turpin," the *Dream of Charlemagne* on folio 162, the other two on folio 162v, depicting Charlemagne riding out of Aachen at the head of his army (fol. 162v top) and a somewhat puzzling scene of standing men, talking and pointing towards the facing text (fol. 162v middle).[3] These are most likely all the work of the same artist, the painter of the Calixtus and Turpin portraits, and accompany the work of Scribe 1.[4]

The dates

The dates of execution for the first campaign of work on *Jacobus* are, in all likelihood, those of the texts themselves. Book I's colophon is addressed to the convent of Cluny where Peter the Venerable (not mentioned by name) was abbot from 1122 to 1157; to Diego Gelmírez, Archbishop of Santiago (†6 April 1140); and William, Patriarch of Jerusalem (1130–1145). The inference is that those individuals were all alive at the time, dating the colophon therefore to between 1130 and 1140. Book I (fols. 1–129) was entirely written and decorated by Scribe 1 and decorated and illuminated in the first campaign of decoration, with the exception of the added half-leaf on folio 128. Book II (fols. 140–155v) may be

Initial C with Pope Callixtus [Liber Sancti Jacobi, Codex Calixtinus, CF 14, fol. 1r; detail]
c. 1137–1140
ACS~Archivo de la Catedral de Santiago de Compostela

3 The bottom register on folio 162v is scrollwork added to cover the titulus to Book IV when the latter was removed in the seventeenth century to form a separate book. The original inscription was copied in Ms VA, Vatican City, Arch. S. Pietro C. 128.

4 One could argue that the two registers of Turpin narrative illustration, whose precise subjects and meanings are unclear, are by a less accomplished painter than the *Dream of Charlemagne* on the preceding page.

dated between the date of the last miracle in 1135 and the 1139 date of the first of the added miracles at the end of the volume. Part of it was re-copied at a later date (fol. 155, continuing to fol. 160v, into Book III), an activity most likely in some way connected to the visit to Santiago of Arnalt de Munt, monk of Ripoll, who made the partial copy, MS R (Barcelona, Arxiu de la Corona de Aragó 99), in 1173.[5] Book III (fols. 155v–162) was composed after the institution by Diego Gelmírez of the college of 72 cardinals in 1120, and fols. 155 and 162 were recopied by Scribe 2; Book IV (fols. 163-191v) was most likely composed between 1130 and 1145.[6] Parts of it were recopied by Scribe 2 (fols. 168–169, 170–171, 178–177, 178–180, 183–184), and additions were made by two later scribes (Scribe 3, fols. 186–187; Scribe 4, fols. 181–182). Book V (fols. 192–213v) contains a synchronism including the deaths of Henry I of England (1135) and of Louis VI, King of France (1137). Part of it was recopied by Scribe 2 (fols. 196 and 203). Most of the folios recopied by Scribe 2 are outer bifolia, suggesting that the manuscript had remained unbound, resulting in damage to the outer leaves of some quires. Later additions (fols. 214–219 [there is no fol. 220], 221–225) were written by several further scribes, including several dated miracles, of which the earliest occurred in 1139.

Stylistic and iconographic sources

Sources and parallels for the minor colored initials are difficult to establish with certainty because the comparative material, whether in France or Spain, is poorly published. It is a level of decoration that has been largely ignored in art-historical and palaeographical literature. This situation is now changing thanks to the web and it is likely that more pertinent parallels will emerge from closer study in the coming years.[7] The foliate initials and the figured, historiated initials, however, find convincing similarities in France, particularly in Western and Northern France, Limoges, Vierzon, Angers, Le Mans, Normandy, Paris, and even as far to the East as Dijon. I cite here just a few of several pertinent comparisons: for the Saint James image on folio 4, the eleventh-century bibles of Limoges and Angers offer parallels, for instance particularly the frontal figures of Christ in the Angers Bible (Angers 25, fol. 85), and the Saint James the Less in Limoges (BnF lat. 8, II, fol. 228), and the Saint Matthew as angel treading on a border-dragon (looking therefore like Saint Michael) from the Bible made for William of Saint Carilef during his exile in Normandy between 1088 and 1091 (A.II.A, fol. 87v);[8] similarly the Charlemagne image from the Cartulary of Vierzon (BnF lat. 9865, fol. 3v), and the portrait of Bishop Hugues Payen preceding the Acts of the Bishops of Le Mans, in Le Mans (Méd. mun. 224, fol. 113).[9] The Turpin portrait in the opening initial of Book IV, showing the Archbishop of Reims seated frontally in foliage, bears a striking resemblance to an earlier inhabited "T" initial, in the schoolbook, either French or English (BL Royal 13.A.XI, fol. 22).[10] Whereas the later foliate initials with their distinctive "caps" may originate in England, in such manuscripts as Oxford, Bodl. Auct. E. inf., it is also the case that

5 The most recent study of the manuscript tradition is in J. Krochalis and A. Stones, *The Pilgrim's Guide. A Critical Edition*, vol. 2:2 (London: Harvey Miller Publishers, 1998), pp. 51–195.

6 The arguments, based on the inclusion of the names of Almoravid chieftains, on the mention of the idol of Cadiz (destroyed in 1145); of the mention of three clerical orders, possibly reflecting the canon on regular canons adopted at the Council of Lyon in 1130, and on mention of the building fund for Saint-Denis (between 1137 and 1140), have been advanced by P. David, "Études sur le livre de Saint-Jacques attribué au pape Calixte II, I–IV," in *Études historiques sur la Galice et le Portugal du VIᵉ au XIIᵉ siècle*) (Lisbon: Livraria Portugália, 1947), pp. 52–104.

7 The web sites Enluminures, and the sites of the Bibliothèque nationale de France, "Mandragore" and "Banque d'images," offer much material but the search mechanisms for decorative types are not yet in place.

8 This comparison was first made by S. Moralejo in "Ars sacra et sculpture romane monumentale: Le trésor et le chentier de Compostelle', *Les Cahiers de Saint-Michel de Cuxa*, 11 (Cuxa: 1980), pp. 189–238, fig. 102.

9 A fuller list of comparisons is given with reproductions in A. Stones, "The Decoration and Illumination of the Codex Calixtinus at Santiago de Compostela," in id. and J. Williams (eds.), *The Codex Calixtinus and the Shrine of St. James* (Tübingen: G. Narr, 1992), pp. 137–84.

Initials G, D and D [Liber Sancti Jacobi, Codex Calixtinus, CF 14, fol. 128v]
c. 1137–1140
ACS~Archivo de la Catedral de Santiago de Compostela

Initial P [Liber Sancti Jacobi, Codex Calixtinus, CF 14, fol. 156v]
c. 1137–1140
ACS~Archivo de la Catedral de Santiago de Compostela

Initial S [Liber Sancti Jacobi, Codex Calixtinus, CF 14, fol. 71r]
c. 1137–1140
ACS~Archivo de la Catedral de Santiago de Compostela

Human head [Liber Sancti Jacobi, Codex Calixtinus, CF 14, fol. 121r]
c. 1137–1140
ACS~Archivo de la Catedral de Santiago de Compostela

Initial P [Liber Sancti Jacobi, Codex Calixtinus, CF 14, fol. 179r]
c. 1137–1140
ACS~Archivo de la Catedral de Santiago de Compostela

Initial S [Liber Sancti Jacobi, Codex Calixtinus, CF 14, fol. 24v]
c. 1137–1140
ACS~Archivo de la Catedral de Santiago de Compostela

Initial T from the Book of Turpin
[Liber Sancti Jacobi, Codex
Calixtinus, *CF 14, fol. 163r*]
c. 1137–1140
ACS~Archivo de la Catedral
de Santiago de Compostela

the idea spread across a broad area of northern France from the west to Dijon, in tandem with the similar frontal figures referred to above. Iberian books, particularly those associated with Alcobaça and Lorvão also bear witness to the spread of such motifs across the Iberian Peninsula. It is likely that the ecclesiastical networks, whether secular or monastic, played an important part in the transmission of decorated books and the particular motifs with which they were embellished – but nothing comparable to the decoration and illustration of the first campaign of *Jacobus* is preserved in Santiago itself.

The Charlemagne scenes

The Charlemagne scenes raise particular questions. The first miniature, at the bottom of folio 162 following the end of Book III, shows (before restoration) Saint James appearing to Charlemagne in bed, pointing out the Milky Way and urging him to follow it to Compostela in order to free his

10 Cf. H. Bober, "An Illustrated Medieval School-Book of Bede's De Natura Rerum," *Journal of the Walters Art Gallery*, 19–20 (Baltimore: 1956–1957), pp. 64–97. Similar inhabited "T" initials are found in Lincoln Cathedral Library A.I.2, fol. 70v and in Le Mans BM 228, cf. *The Codex Calixtinus and the Shrine of St. James…* op. cit., fig. 51.

11 W. Voelkle (ed.), *The Stavelot Triptych, Mosan Art and the Legend of the True Cross* (New York: Oxford University Press, 1980). Other examples are on the Cross of Saint Helen's Kelloe, T. Holland, J. Holt and G. Zarnecki, *English Romanesque* (London: Arts Council of Great Britain, 1984), pp. 208–9, fig. 176. For more examples, see A. Stones "Four Illustrated *Jacobus* Manuscripts," in A. Borg, C. Hohler and A. Martindale, *The Vanishing Past: Studies in Art, Liturgy and Metrology* (Oxford: BAR~British Archeological Reports, 1981), pp. 197–222. Id., "The *Codex Calixtinus* and the Iconography of Charlemagne," in K. Pratt, *Roland and Charlemagne in Europe: Essays on the Reception and Transformation of a Legend* (London: King's College, Centre for Late Antique & Medieval Studies, 1996), pp. 169–203.

12 Examples are again to be found in Dijon manuscripts, such as the Canon Tables of the Bible of Saint-Bénigne, Dijon BM 2, fol. 402v, as suggested by W. Cahn, "Comments on the Question of Illumination," in *The Codex Calixtinus and the Shrine*... op. cit., pp. 239–43, fig. 24; or the late twelfth or early thirteenth-century wall-paintings of the Templar chapel at Cressac (Charente), cfr. "The *Codex Calixtinus* and the Iconography of Charlemagne"... op. cit., p. 189, fig. 19.

shrine from Sarracen domination. This is related to a common iconography of dreams and visions: Christ appearing to Saint Martin in the eleventh-century *Life of Saint Martin of Tours* (BM 1018, fol. 9v) is among many examples, as is the *Dream of Constantine*, as shown for instance on the approximately contemporary champlevé enamel triptych made for the Benedictine abbey of Stavelot in the Mosan region.[11] More puzzling are the two scenes on the following verso, for which obvious models come less easily to hand. Groups of advancing warriors are standard elements in scenes of warfare, whether in the context of the Old Testament or the Crusades,[12] but the second scene, showing warriors and civilians talking to each other outside a city is less readily identifiable. Their figures are clearly debating: possibly they are returning warriors relating the events of the campaign to those civilians left behind, and the one on the right points with his spear to the opposite page where the story begins. A possible parallel is the drawing of David receiving a sword and bread from Ahimelech in the Commentary of *Saint Augustine on the Psalms*, of uncertain provenance, preserved in Subiaco (Santa Scolastica, Allodi 21, Februi 22, Ms CI).[13]

Although the artist of *Jacobus* has not himself been traced in any other manuscript it is highly likely that he, together with his scribe and decorator, was

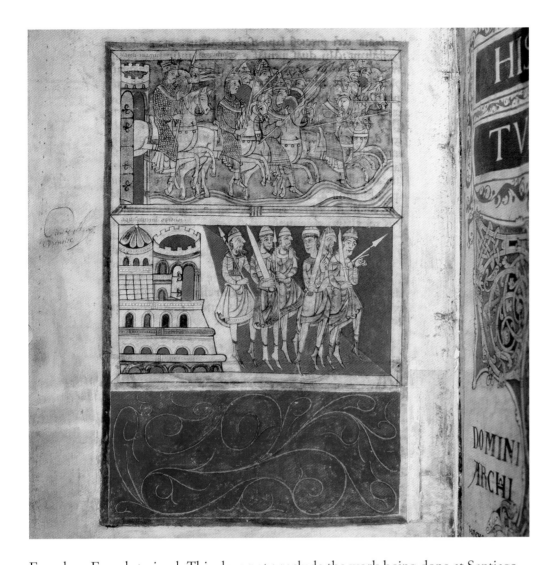

Apostle Saint James [Liber Sancti Jacobi, Codex Calixtinus, *CF 14, fol. 4r; detail*]
c. 1137–1140
ACS~Archivo de la Catedral de Santiago de Compostela

Appearance of the Apostle Saint James in Charlemagne's dream [Liber Sancti Jacobi, Codex Calixtinus, *CF 14, fol. 162r*]
c. 1137–1140
ACS~Archivo de la Catedral de Santiago de Compostela

The armies' journey from Aachen [Liber Sancti Jacobi, Codex Calixtinus, *CF 14, fol. 162v*]
c. 1137–1140
ACS~Archivo de la Catedral de Santiago de Compostela

French or French-trained. This does not preclude the work being done at Santiago. Indeed the red and blue initials accompanying the work of Scribe 2 are similar to some of the penwork in *Tumbo A*, the Santiago Cartulary and these sections of the manuscript were certainly added in Santiago. It is more than likely that the first campaign also took place there, in all probability before the death of Diego Gelmírez in 1140, as outlined above, and certainly under his (unspoken) aegis. Although Pope Calixtus is credited with the authorship of many parts of *Jacobus*, from the prefatory letter at the beginning, to parts of the "Pilgrim's Guide" in Book V, the claim is most likely a device to confer authority on the text. The other "author" to whom parts of the text are attributed is named "Aimericus," claimed with Pope Calixtus as the author of parts of the "Guide." It is tempting to assume, as many scholars have done, that this Aimericus is one and the same as the "Aimericus Picaudus (or Picandus) de Partiniaco," named as author in the *titulus* of one of the songs in the musical appendix at the end of the volume. Certainly there are elements in the text, particularly in Book V, the "Pilgrim's Guide," where the author or compiler's origins in Western France are made clear. It can be inferred that he was for a time a canon of Saint-Léonard de Noblat and was eventually associated with the Pilgrim Hospital at Santiago.[14] But other sources, notably the Pistoia manuscript, introduce another potential author

13 "The Decoration and Illumination of the Codex Calixtinus at Santiago de Compostela"... op. cit., pp. 147–8.
14 For a full account of the arguments, *The Pilgrim's Guide. A Critical Edition*... op. cit.

or compiler: Rainerius, alias Robertus, from Pistoia, a well-educated and well-traveled cleric, in Paris, perhaps at Saint-Martin-des-Champs in the time of prior Matthew of Albano, and possibly at Saint-Jacques-du-Haut-Pas; probably at Cluny; probably at Vézelay as well, if he was also responsible for the music in *Jacobus*; in England and in Italy; moving in the circle of papal legates, bishops and abbots like the authors of the songs in the musical appendix and the signatories of Innocent's Bull, and the protégé of some of the most eminent churchmen of his time. He ended up as schoolmaster at Santiago. It was Rainerius/Robertus who engineered the transfer about 1138 of the relic of Saint James's jawbone, authorized by Diego Gelmírez, from Santiago to his patron, Bishop Atto of Pistoia who in turn had done much to foster the cult of Saint James in Italy.[15] Two later Pistoia manuscripts, closely related to the Pistoia copy of *Jacobus*, Ms P, attest to Rainerius, also calling him Robertus, and the chapel of Saint James at Pistoia was granted papal privileges in 1145 (JL 8794 and 8795), so the relic transfer is unlikely to be spurious.[16] Indeed, the Pistoia relic was re-examined

15 Acta Sanctorum, Iulii VI, pp. 25–28. Pistoia, Archivio di Stato, Doc. Vari 1, discussed by Gai, R. Manno Tollu, G. Savino, *L'Apostolo San Jacopo in Documenti dell'Archivio di Stato di Pistoia* (Pistoia: Archivio di Stato di Pistoia, 1984). "Testimonianze jacobee e referimenti compostellani nella storia di Pistoia dei secoli XII–XIII," in L. Gai (ed.), *Pistoia e il Cammino di Santiago. Una dimensione europea nella Toscana medioevale* (Perugia: Centro Italiano di Studi Compostellani, 1987), pp. 192, 195. *The Pilgrim's Guide. A Critical Edition...* op. cit., pp. 153–69.

16 The letters in Pistoia, Archivio di Stato Doc. Vari 1 and in Ms P claim that Rainerius was the schoolmaster at Santiago.

17 Acta Sanctorum November I, p. 1, under the libes of James's companions, Athanasius and Theodore. For a summary, see *The Pilgrim's Guide. A Critical Edition...* op. cit., p. 158.

in 1879 when the relics of Saint James and his two companions, interred in the apse at Santiago for safety in 1589 under the threat of English invasion, were dug up; only one of the three skeletons was missing the mastoid process, which the Pistoia relic preserved.[17]

We shall probably never know exactly what the relationship between Aimericus and Rainerius/Robertus really was and which of them, if either, put together the *Jacobus* compilation; but, as we have argued, they are the kinds of individuals who must in one way or another have been responsible, and most likely they worked under the aegis of Diego Gelmírez.

Influences: the illustrated copies

The death of Diego Gelmírez in 1140 must have put a stop to any ideas he may have had about disseminating *Jacobus*, for only twelve copies of the entire compilation survive and only three of them are illustrated. Our collation of the "Pilgrim's Guide" shows that there can never have been

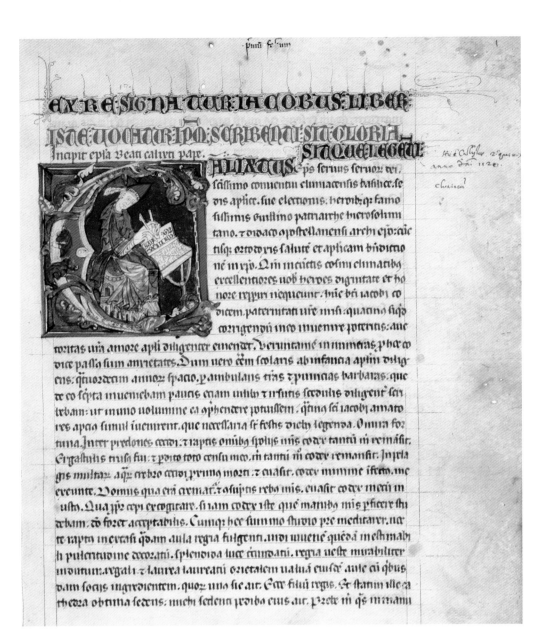

Monogram [*Tumbo A, CF 34, fol. 46r; detail*]
1129–1134
ACS~Archivo de la Catedral de Santiago de Compostela

Initial S [*Codex Calixtinus, Ms C 128, fol. 21r; detail*]
c. 1325–1350
Archivio di San Pietro, Vatican City

Initial S [*Codex Calixtinus, Ms C 128, fol. 79v*]
c. 1325–1350
Archivio di San Pietro, Vatican City

Initial C with Pope Callixtus [*Codex Calixtinus, Ms C 128, fol. 1r*]
c. 1325–1350
Archivio di San Pietro, Vatican City

more than 25 or so copies, so this was not the book that every pilgrim took on the journey to Santiago, despite the wealth of practical and useful information, comment, and invective, that the text contains.[18] As far as the illustrations are concerned, the three illustrated copies are the most direct witnesses to the influence of *Jacobus*. All three were made in the early fourteenth century, two of them, Città del Vaticano (Arch. S. Pietro C 128, Ms VA) and London (BL Add. 12213, Ms A), certainly in Santiago and each copied directly from *Jacobus*, while the third copy, Salamanca (BU 2631, Ms S) differs in significant ways. They were made in the orbit of the early fourteenth-century Cartulary of Santiago, *Tumbo B*, written around 1326, to whose illustrations Ms A is particularly close stylistically, while the miniature of Santiago Matamoros is also to be found in Ms S. It was the period of the episcopacy of Berenguel de Landoria (in office 1317–1330), former Grand Master of the Dominicans and patron of Bernard Gui, Inquisitor of Toulouse, who became Berenguel's suffragan at Tuy. This burst of interest in *Jacobus* may be linked to a desire to reassert the apostolic cult as

18 The "Pseudo-Turpin" is another matter; it enjoyed an independent circulation and most likely pre-dates *Jacobus*. The manuscripts have been extensively studied A. de Mandach [*La Geste de Charlemagne et de Roland*, 1969], *Naissance et développement de la chanson de geste en Europe*, vol. 1:6 (Geneva: Droz, 1961–1993) and C. Meredith-Jones, *Historia Karoli Magni et Rotholandi ou Chronique du "Pseudo-Turpin"* (Geneva: Slatkine Reprints, 1972), but neither reached conclusions as to which is the earliest copy and from where. See also H. M. Smyser (ed.), *The "Pseudo-Turpin"* (Paris: Bibliothèque nationale de France, 1937).

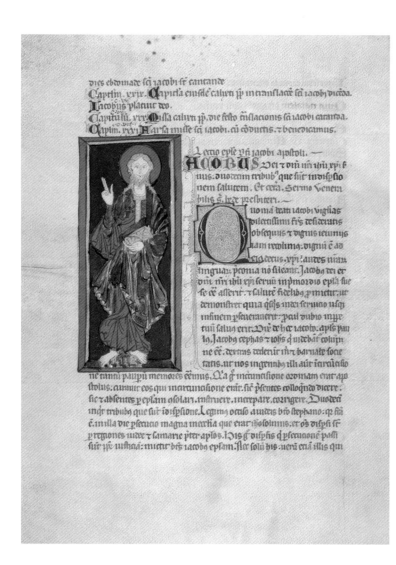

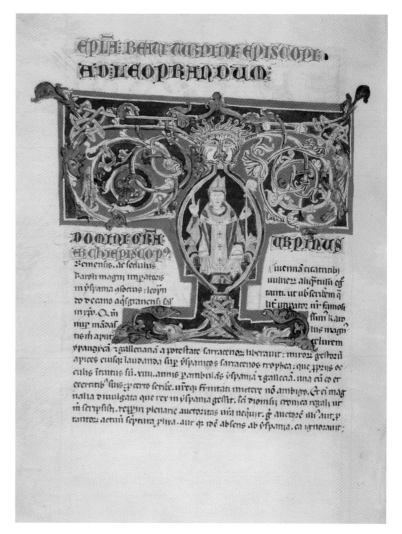

Apostle Saint James [Codex
Calixtinus, Ms C 128, fol. 3v]
c. 1325–1350
Archivio di San Pietro, Vatican City

Initial T for Turpin [Codex
Calixtinus, Ms. C 128, f. 134v]
c. 1325–1350
Archivio di San Pietro, Vatican City

a means to combat heresy in the Province, although there is no evidence of the direct ownership of any of the three manuscripts by the Archbishop or his suffragan.

Ms VA

The closest copy of the illustrations in *Jacobus* is found in the Vatican manuscript, Ms VA, where the early fourteenth-century artist has made every effort to copy the style of his original, so that the differences of artist among the foliate initials, for instance, are also reognizable in Ms VA, and the portraits of Calixtus, James, and Turpin all adopt the same format as in *Jacobus*. It is in Ms VA that the original layout of the Dream of Charlemagne miniature can be seen, and the opening inscription for Book IV obliterated in *Jacobus*, is preserved below the two-register miniature of the warriors.

Ms A

The creators of the Additional copy were less concerned to transmit exactly the format of *Jacobus,* so the opening portrait of Calixtus has become a pen-flourished initial, with the arms of León and Castile in the bottom margin – possibly a hint of royal patronage; the portrait of James lacks its frame – but is distinctive with

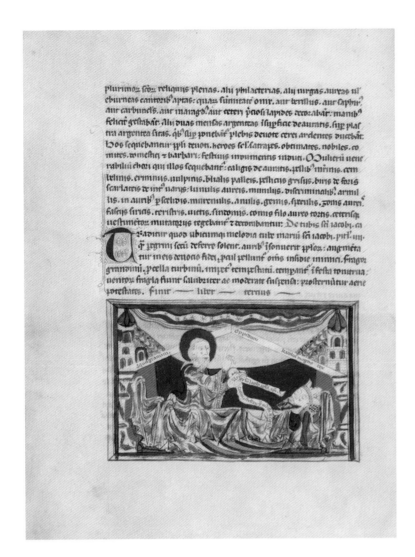

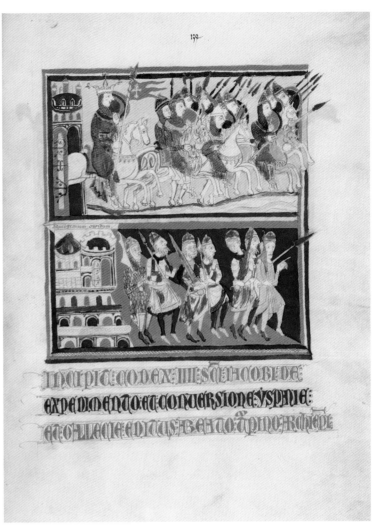

its halo embellished with cockle-shells. The Dream miniature is similar, and there too Saint James's halo is decorated with shells. The same motif is found in *Tumbo B*, folio 2v, on which see further below. The warriors page, however, is missing in Ms A.

Ms S

The Salamanca copy, though similar stylistically to the other two and to *Tumbo B*, appears to reflect another model, one where the compilation is not entitled *Jacobus* and which omits all the texts added after Book V in *Jacobus* and copied in Ms A and Ms VA. There is also textual evidence for this, as far as the "Pilgrim's Guide," Book V, is concerned, and Díaz y Díaz proposed that the significant change in the colophon of "Roma," one of the places where it was claimed the compilation was assembled, to "curia," reflects the period of papal captivity in Avignon, beginning in 1305 with the accession of Clement V.[19] The portrait of Calixtus in Ms S has been cut out, but that of James is included, showing the saint unambiguously dressed as a pilgrim with hat, Tau staff, and scrip, not as a type of Christ as in *Jacobus* and Ms VA and Ms A. The Turpin initial depicts not a portrait of Turpin in a foliate initial, but a narrative scene – Turpin's vision of the souls of the heroes of Roncevaux, their bodies lying dead, borne to heaven in a napkin as Turpin

Appearance of the Apostle Saint James in Charlemagne's dream [Codex Calixtinus, *Ms C 128, fol. 133v*] c. 1325–1350 Archivio di San Pietro, Vatican City

The armies' journey from Aachen [Codex Calixtinus, *Ms C 128, fol. 134r*] c. 1325–1350 Archivio di San Pietro, Vatican City

19 *El Códice Calixtino de la Catedral de Santiago. Estudio codicológico y de contenido...* op. cit., p. 136, no. 95. See also *The Pilgrim's Guide. A Critical Edition...* op. cit., p. 119.

20 Cf. A. Stones, "Las ilustraciones del 'Pseudo-Turpin' de Johannes y La Chronique de l'Anonyme de Béthune," in K. Herbers (ed.), El "Pseudo-Turpin," lazo entre el culto jacobeo y el culto de Carlomagno (Santiago de Compostela: Xunta de Galicia, 2003), pp. 317–30. For the Grandes chroniques, see R. Lejeune and J. Stiennon, La Légende de Roland dans l'art du Moyen Âge (Brussels: Arcade, 197) and the review by D. J. A. Ross, "The Iconography of Roland," Medium Ævum, 27 (Oxford: 1968), pp. 46–65. See also A. D. Hedeman, The Royal Image, Images of the Grandes chroniques de France, 1274–1422 (Berkeley: University of California Press, 1991).

21 La Légende de Roland dans l'art du Moyen Âge... op. cit., pp. 400, 501, fig. 296.

22 In "Four Illustrated Jacobus Manuscripts"... op. cit., I suggested that the illustrations in "S" might derive from a model other than the Santiago Jacobus, possibly one associated with Baudouin de Hainaut's now lost copy, discussed by Smyser in The "Pseudo-Turpin"... op. cit., pp. 7, 10.

celebrates mass. The subject is unusual – there is no witness to it, for instance, on the shrine of Charlemagne at Aachen, nor in the Charlemagne window at Chartres – but a similar subject occurs in the context of chronicles in French, the *Chronique de l'anonyme de Béthune* (BnF naf. 6295, fol. 25v), where the soul of Roland borne to heaven and that of Marsile wheeled off to hell,[20] and in certain copies of the *Grandes chroniques de France* (for instance, BnF fr. 2813, made for Charles V between 1375 and 1379, fol. 112v; BnF fr. 6465, fol. 104v, illustrated by Jean Fouquet c. 1460, and many others).[21] The Turpin initial is preceded in Ms S by a version of the three Charlemagne scenes, treated this time all in a single miniature, with the *Dream of Charlemagne* at the top, accompanied on the left by a detail showing Christians attacked; and the register showing Charlemagne and his army setting out gives special emphasis to Roland, shown in the center holding a banner. These details, and the arrangement of the three scenes make much better sense of the three scenes and perhaps reflect a model earlier than what is in *Jacobus*.[22]

The Salamanca copy is the only one to include a miniature, positioned on folio 120 at the end of Book V, the "Pilgrim's Guide," of Santiago Matamoro. It is closely similar to the image of the same subject in *Tumbo B*, where the miniature page faces text of the year 1326 which provides a *terminus post quem* for *Tumbo B*. Earlier versions of the subject of James Matamoro are in the sculptured relief in the south transept of the Cathedral of Santiago, dating perhaps to the late twelfth century. This subject held particular resonance for Spanish Christian audiences and enjoyed phenomenal success as the image of choice of Saint James, Apostle of Spain, but it cannot be said that its origins have anything to do with *Jacobus*.

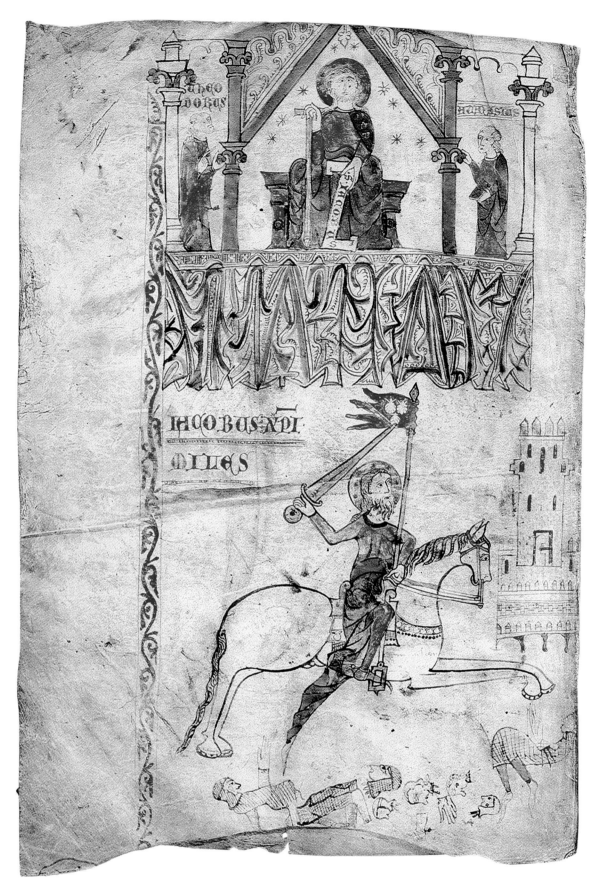

*Initial C [Codex Calixtinus,
Add. 12213, fol. 1r]
c. 1325–1350
BL~The British Library, London*

*Apostle Saint James [Codex
Calixtinus, Add. 12213, fol. 3v]
c. 1325–1350
BL~The British Library, London*

*Appearance of the Apostle Saint James
in Charlemagne's dream [Codex
Calixtinus, Add. 12213, fol. 132r]
c. 1325–1350
BL~The British Library, London*

*Saint James on horseback [Tumbo B,
CF 33, fol. 2v; detail]
c. 1326
ACS~Archivo de la Catedral
de Santiago de Compostela*

Saint James the pilgrim [Codex
Calixtinus, Ms 2631, fol. 2v; detail]
c. 1325–1350
*Biblioteca General Histórica,
Salamanca*

*Charlemagne's dream and the armies'
journey from Aachen* [Codex
Calixtinus, Ms 2631, fol. 90r]
c. 1325–1350
*Biblioteca General Histórica,
Salamanca*

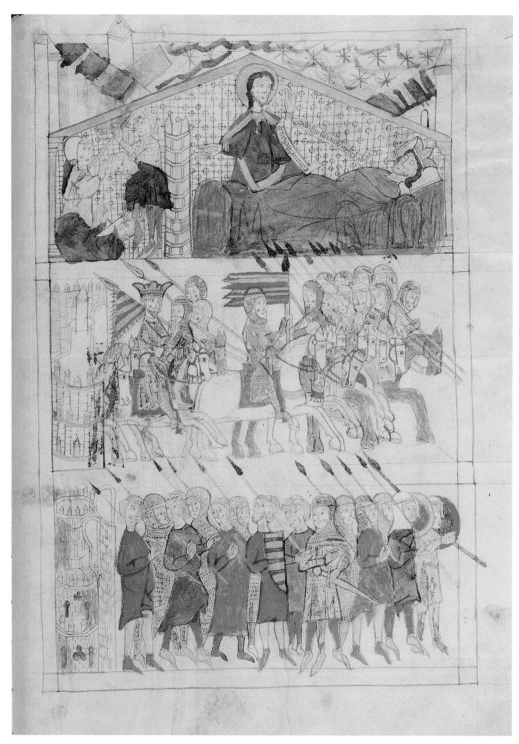

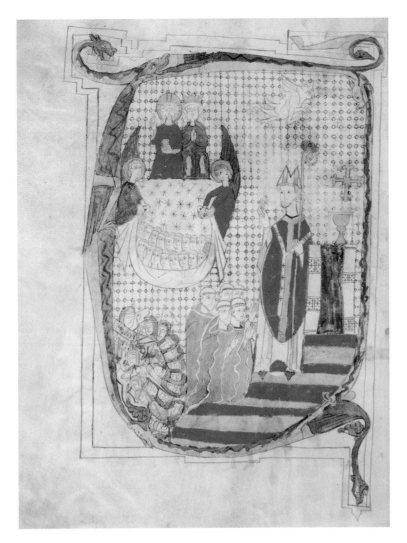

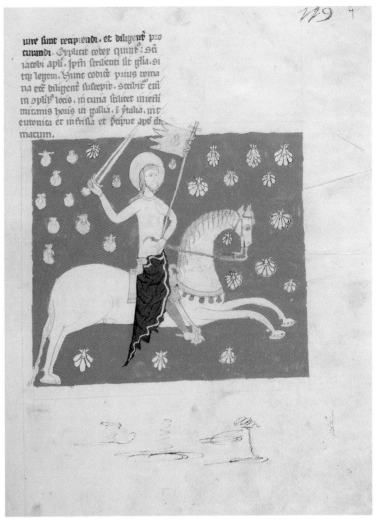

inre sunt recipiendi. et diligent pro
curandi. Explicit coder quintus: sci
iacobi apli. sprn scribenti sit glia. Si
trp legem. Vunc codice pnius roma
na ecc diligent suscepit. scribit eni
in oplib locis. incuria silicet incessi
mirimis hous in gallia. i ytalia. int
eutonica et in frisia et pcipue apud cli
macum.

Otherwise it is the Dream of Charlemagne that enjoyed the greatest
popularity, appearing on the shrine at Aachen, in the Chartres window, and taken
over into the tradition of the *Grandes chroniques de France*. This time indeed
the *Jacobus* version is the earliest surviving example. But whether the popularity
of the subject can be attributed to *Jacobus* directly is highly questionable since
there is no evidence that *Jacobus* ever left Santiago and plenty of evidence that
it remained there from its creation. More likely other Dream images gave rise
to the later traditions while the small cluster of *Jacobus* copies and the related
Salamanca version constituted no more than a small independent illustrative
tradition of its own.

*Bishop Turpin [Codex Calixtinus,
Ms 2631, fol. 90v]
c. 1325–1350
Biblioteca General Histórica,
Salamanca*

*Saint James the knight [Codex
Calixtinus, Ms 2631, fol. 120r]
c. 1325–1350
Biblioteca General Histórica,
Salamanca*

José María Díaz Fernández

Gelmírez's "Pious Robbery"

In order to obtain a suitable picture of everyday existence in such a well-traveled life as Gelmírez's, a great help is the detailed testimony of the *Historia Compostellana*,[1] focused on him and so attentive to leaving documented testimony of his unique role in building the greatness of Compostela. Perhaps the almost hagiographic intention of the authors/witnesses has not received enough attention; so well did they fulfil their role. The Gelmírez who emerges so powerfully from the pattern of events is the "bishop as pontiff" Gelmírez, accompanying his roaming with masses and processions, liturgical splendors and signs of grandiosity. His persistent access to Rome, with strategic concessions to Cluny, certainly disposed him to breathe a style of celebration with a touch of jubilant novelty into Compostela.

The liturgical Gelmírez

The theme of the liturgical Gelmírez remains quite unknown, although the *Historia Compostellana* offers abundant material to evidence him so, from the creation of a large and lofty chapter to the gifts of rich ornaments and utensils, and especially new liturgical books. When reading chapter 57 of Book II – "Concerning the clothing, books and other church ornaments which the Archbishop purchased" – we are struck by the antiphonary, the office, the Lent rite, the two benedictionaries, and, above all, the missal and breviary – "three breviaries" – which must have implied a significant contribution to the establishment of the Roman rite, an early riser when compared to, for example, what the *Missal of Mateus* represents for Braga.[2] Along with the liturgical books themselves, the presence of Saint Gregory the Great's Pastoral Rule, the *Liber Regulae Pastoralis*, would be sufficient in itself to witness the choice of a programme in which action and contemplation are combined: the "activus in contemplatione," as a rather transparent ideal in the *Historia Compostellana*. Gelmírez's book entitled *Vitae episcoporum* remains enigmatic. I am tempted to equate it with the *Vitae patrum emeritensium*, possession of which seems almost compulsory for the bishop, who, when assuming the corresponding title for the ancient metropolis of Merida, should have been considered as the continuation of the series of archbishops, especially the great Masona (†606), who might well have been a lofty example for him to follow. Of course, Gelmírez's action in Compostela corresponds quite well to that of Masona in Mérida.

1 *Historia Compostellana. Corpus Christianorum Continuatio Mediaevalis*, ed. E. Falque Rey (Turnhout: Brepols Publishers, 1988).
2 J. O. Bragança (ed.), *Missal de Mateus. Manuscrito 1000 da Biblioteca Pública e Arquivo distrital de Braga* (Lisbon: Fundação Calouste Gulbenkian, 1975).

If Gelmírez's presence implied the rise and transformation of liturgical life in the church of Compostela from the beginning of the twelfth century, one is forced to think of the special focus on the specific elements of the cult to Saint James. The *Iacobus* marks the crystallization of his programme, in which, no doubt, many new creations are joined by previous elements which were thus rescued from oblivion. The *Liber* offers at the same time colorful descriptions of the liturgy lived and, with surprising abundance, liturgical texts for the core celebrations of the Divine Office and Mass.

To the detriment of Braga

Gelmírez was not only responsible for the effective impetus to the constructive work undertaken by Diego Peláez, but also for the wise distribution of spaces and the glorious signs of the apostolic tomb under the canopy recalling his name. But there was something more... In modern times, for example, did Philip II not try to increase the pious interest of the great basilica of El Escorial by enriching it with numerous relics? This is exactly what Gelmírez had done in Santiago centuries before. It would seem, initially, that with the holy relics of the Apostle any such requirement was more than satisfied. But for him it was also true that "*quod abundant non nocet,*" wealth does no harm. Was it not a good idea to add to the remains of the Apostle other holy bodies brought from elsewhere? There were some quite eminent examples in Oviedo, taken there by Christian southerners who had sought refuge in Asturias: Saint Pelagius, Saint Eulalia of Mérida... and the numerous relics of the Cámara Santa. But it was not conceivable, nor could it have ocurred to Gelmírez to strip Oviedo, the city founded by Alfonso II, of its relics; he was the king who marked the beginnings of Compostela together with bishop Theodomirus. Braga was closer, under his special powers, and had begun its recovery from the Saracen invasion under Bishop Saint Giraldus, regularly aided by Gelmírez and made a canon of the Compostela chapter. Was the grievous status of its places of worship as presented in the *Historia Compostellana* real? There is no record of any sorrow in Saint Giraldus, as he would surely have suffered at a spoil against his will. In any case, the secretive and underhand attitude, the horses being ready to gallop off, does not match with the pontifical parsimony with which Gelmírez took the holy remains, wrapping them in rich fabrics according to the *Historia Compostellana.*

In fact, quite unintentionally – Gelmírez only sought the splendor of Santiago and, surely, the exclusion of any nearby pilgrimage center that might have meant competition – by stripping Braga of its holy bodies, which had been safeguarded there, and honourably placing them in the most privileged places in our cathedral, he assured the best presence of Braga in Compostela and the best attraction for the good people of our sister country, especially its northern lands. We are referring, of course, to the sacred bodies of San Fructuosus and the holy martyrs Susanna, Silvestre and Cucufate.[3]

Differing versions

The avatars of the "Pious Robbery" and the incidents of the translation have been told many times, always based only on the story in the *Historia Compostellana*. They arrived at the cathedral of Santiago on 16 December 1102, brought by Gelmírez, who could not have started his reign in a holier or more glorious way, bringing in the twelfth century: Gelmírez was elected on 1 July 1100. Naturally, the hagiographic version of the story has always prevailed in our circles, following the story of the reporter, Archdeacon Hugh, a witness of the translation. The original narrative seems to be taken from a calendar of saints, and could thus be included quite literally in the liturgical lessons for the divine office of the feast of the Translation of San Fructuosus – together with the other saints from Braga – which, right from the twelfth century, was held in our cathedral. Spanish historians of a universal scope – Morales,[4] Mariana, Masdeu, always affected by hypercriticism – were not such devotees of Gelmírez. And even less so, quite naturally, were Portuguese historians. The beatific Don Rodrigo da Cunha, Archbishop of Braga, is almost an exception: in his *Historia Eclesiástica dos Arcebispos de Braga, e dos Santos e Varões ilustres, que florecerão neste Arzobispado*[5] he seems to shun any bellicose word. Not so – and they are naturally within their right – historians such as Augusto Ferreira in his *Fastos Episcopaes da Igreja Primacial de Braga*,[6] who expresses his arguments to demonstrate the bad faith of the bishop from Compostela who betrayed the fraternal hospitality offered by his counterpart in Braga, nothing less than Saint Giraldus. In our own days, the wise canon Avelino de Jesus da Costa – who could be regarded as the Lopez Ferreiro[7] of the Cathedral of Braga – does not beat around the bush in his *O bispo don Pedro e a organização da diocese de Braga*:[8] each time he refers to Gelmírez and the deeds in question, he unashamedly uses the word "roubou."

Fame accomplished

The truth is that the holy bodies brought from Braga obtained a universal reputation in the Church of Compostela, at the zenith of its glory, hardly imaginable where they lay before. The specific location that Gelmírez sought for them could not have been more uplifting: San Fructuosus initially got the central chapel of The Savior, and four years later the chapel of Saint Martin, which was rechristened with the name of the saint from Braga. The two obscure martyrs Silvestre and Cucufate were respectively placed in the apsidal chapels,

3 M. Domínguez, "Gelmírez y el 'Furtum sacrum'," in C. Bosch, L. A. García, M. E. Gil and M. Vallejo (eds.), *Santos, obispos y reliquias. Actas del III Encuentro Hispania en la Antigüedad Tardía (13 a 16 de octubre de 1998)* (Madrid: Universidad de Alcalá de Henares, 2003), pp. 155–67.

4 H. Flórez, *Viage de Ambrosio de Morales por orden del Rey D. Phelipe II a los Reynos de León, y Galicia, y Principado de Asturias para reconocer las reliquias de Santos, sepulcros reales, y libros manuscritos de las Cathedrales, y Monasterios* (Madrid: Marín, 1765).

5 R. da Cunha, *História eclesiástica dos arcebispos de Braga*, 2 vols. (Braga: 1634).

6 A. Ferreira, *Fastos Episcopaes da Igreja Primacial de Braga (sec. III-sec. XX)* (Braga: Mitra Bracarense, 1928).

7 A. López Ferreiro, *Historia de la Santa A. M. Iglesia de Santiago de Compostela*, 11 vols. (Santiago de Compostela: Seminario Conciliar de Santiago, 1898–1901).

8 A. J. da Costa, *O Bispo D. Pedro e a organiçao da Arquidiocese de Braga*, 2 vols. (Braga: Irmandade de São Bento da Porta Aberta, 1959; II ed. 2000).

which are next in dignity to Saint Peter and Saint John the Evangelist. The destination of Saint Susanna's body was, if anything, even more glorious: the church of the Holy Sepulchre, which was to become the parish church of Saint Susanna, later co-patron of our city, with her own feast day on 11 August.

Needless to say, the presence of these holy bodies in Compostela helped enhance the reputation of our western Jerusalem. Surprisingly enough, in the *Hoja de las reliquias de la catedral de Santiago*, printed by Gonzalo de la Passera, probably in Monterrey, shortly after 1494, only Saint Susanna is mentioned: "*Extramuros de la Ciudad hacia la parte occidental, descansa el cuerpo de Santa Susana, virgen y mártir.*" And it was Molina, who – from Mondoñedo! – blew the trumpets of his own dodecasyllables to the winds, in imitation of Don Juan Manuel's *Laberinto*, which he must have known. We refer of course to his *Descripción del Reyno de Galicia*,[9] first printed in Mondoñedo in 1550, announcing at the beginning that "*La primera parte trata de los cuerpos santos que aquí se hallan.*" The arms and heads of the reliquary in Compostela cathedral were minutiae for the master from Mondoñedo, compared to what he now announced:

> "[...] *pero dexemos / el miembro o pedazo,*
> *digamos los cuerpos / enteros que son.*
> *Allí en Compostela, / a más del Glorioso*
> *Están otros cuerpos / de vida aprobados*
> *De muchos milagros, / bien solemnizados*
> *Que con Cucufate, / Silvestre y Fructuoso*
> *Y Sancta Susana / un cuerpo precioso*
> *Está luego junto / de aquella ciudad*
> *A este recurren / por serenidad*
> *Si el tiempo se alarga / de ser muy lluvioso.*"[10]

Molina's prose explains the content of his verses, offering us precious data: "*A San Fructuoso se le hace tal veneración que el día de su fiesta quita la misa del altar del apóstol y se dice en el suyo: lo cual en día alguno de todo el año se sufre por solemne que sea.*"[11]

As for Saint Susanna, the explanation is, if anything, even more popular and appealing: "*Hállase milagrosamente en el sufragio de esta santa, que las más de las veces que se saca con devoción su cuerpo cesan las aguas que por la mayor parte hacen gran daño en este Reyno.*"[12] Therefore it can also be deduced from Molina that the coffers of Sylvester and Cucufate went out in procession: "*Los otros dos son Cucufate y San Silvestre, cuyos cuerpos sacan a muchas necesidades con gran solemnidad e devoción.*"[13]

The final location

Well into the seventeenth century, the Compostela chapter conceived the project of bringing the existing relics together in the chapel of the Kings in the cathedral, and it became the chapel of the Relics. This determination led to artistic innovations, among which Bernardo Cabrea's altarpiece-reliquary could be highlighted, where the first Solomonic columns of

9 B. S. de Molina [1550], *Descripción del Reyno de Galicia, y de las cosas notables del, con las Armas y Blasones de los Linages de Galicia, de donde proceden señaladas Casas en Castilla* (Madrid: Roque Rico de Miranda, 1675).
10 Ibidem, p. 12.
11 Ibidem.
12 Ibidem, p. 13.
13 Ibidem, note 6.

Hispanic Baroque are recorded. As is known, it burned down last century, and all that is left are some significant remains and the testimony of some old but illustrative photographs.

Fortunately, we also have a schematic outline in the extensive "Relación de las Reliquias de la Catedral de Santiago", from which we know the exact place occupied by the Portuguese saints. Saint Susanna is no longer in her original coffer, but in the silver urn paid for by Canon Martínez of Loaisa in 1683. This urn was used as a model for the one archbishop Monroy ordered for the body of Saint Candius nine years later, obtained in Rome in 1690... Everything suggests that in Cabrera's altarpiece, which was ready in 1633, there were later changes that altered the arrangement observed in 1641, when the chapel of the Relics was officially opened.

The opening must have been quite spectacular, with the Baroque magnificence of the moment, very well described in harmonious Baroque prose by the canon Puga y Castro, who had the courage to read it in the chapter meeting held on 30 August, just a few days after the event.

The date chosen was precisely the feast day of Saint Susanna, 11 August, and the chronicler was very careful to record above all the grand procession, in which the monasteries of San Francisco, Santo Domingo and San Augustín, the Jesuit School and the Royal Abbey of San Martiño Pinario vied for the assembly of the large altars that marked out the way: five stopping points where the cathedral chapel sang as many compositions, of which only the lyrics remain; thanks, incidentally, to Puga's chronicle. It is worth transcribing some verses from the first canticle, because our "Portuguese saints" are expressly mentioned:

> *"Hoy la iglesia que a Dios enamora*
> *un festejo le quiere hacer*
> *con reseña de diestro soldados*
> *que marchan gallardos a nuevo cuartel.*
>
> *Un tronco del estandarte,*
> *del hombre Dios de Israel,*
> *quiere tremole Silvestre*
> *pues supo vencer en él*
>
> *Rosendo con Fructuoso,*
> *Arzobispo portugués,*
> *servirán de centinelas*
> *pues lo fueron de su grey.*
> *A Cucufate y Cristóbal,*
> *Januario con otros seis*
> *siguen, dos veces hermanos*
> *en el morir y nacer.*
>
> *Del ejército en el cuerpo*
> *el de Susana se ve*
> *desmintiendo valerosa*
> *los achaques de mujer."*

The list does not reflect the place assigned to each in the altarpiece, but it does provide some interesting facts concerning the relics that were in the procession. Here are the references to the "Portuguese saints:" "*En ricas andas de plata, el cuerpo de San Fructuoso, arzobispo que fue de Braga,*" "*en andas, el cuerpo de San Cucufate, mártir,*" "*en andas, el cuerpo de Santa Susana*"… Saint Silvestre, who, as we have said, had emigrated much earlier to make room for Doña Mencía de Andrade, was not included in the procession.

It must have been on this occasion when the old coffers were replaced by the wooden urns overlaid with velvet and silver ornaments. Guerra Campos dates two of them to exactly 1641. Only that of Saint Susanna had to be replaced once again with the current silver one.

Observing the outline of this list of relics, the displacement of Saints Fructuosus and Cucufate out of the altarpiece is quite surprising, oddly sheltered in the secondary place now occupied by the tomb of the Count of Traba. San Fructuosus probably remained in the chapel until it was demolished in the late seventeenth century to build the magnificent chapel of Our Lady of the Pillar. And something similar might have happened to Saint Cucufate when the structure of the parish chapel of Saint John was modified.

The fire in 1921 destroyed Cabrera's altarpiece and various relics, hardly affecting those of the "Portuguese saints," which for the first time were rightly gathered together, forming the front column to the right of the new altarpiece. This altarpiece was carved by Magarinos in cedar wood and unveiled on 30 April 1925. The urns kept therein retained many of the bones.

In the golden days of Cardinal Quiroga, aired by the conciliatory breezes of returning items – this is ecumenism – breathed with such force by Pope Montini, "*parte dos osos*" of Saint Fructuosus returned to Braga. More recently, "*parte dos osos*" of the other saints were also returned. What a pity that the Latin language is no longer used, as, lacking articles, it makes everything much simpler! By just writing the word "OSSA" on each urn, with the respective name of each saint in the genitive case, there would have been room to doubt, both in Braga and in Santiago, if all, or just some of the bones were held therein.

Identification and liturgical worship

More important than venerable materialities is the devotion and liturgical worship these saints enjoyed in Compostela. For the great saint of Visigothic Spain, Saint Fructuosus, there can be no historical doubt. But there was never a similar certainty for the identification of Saints Susanna, Cucufate and Silvestre, and there has been great confusion in the case of the first two… López Ferreiro[14] seems convinced by the data in the *Historia Eclesiástica de España* that sixteenth-century Augustinian historian Brother Jerónimo Román wrote by hand – he should not be confused with the Jesuit Jerónimo Román de la Higuera, author of the false *Cronicones*.

According to the Augustinian historian, our Saints Susanna, Cucufate and Silvestre were martyred in Braga, in the persecution in the late fifth century by the

14 *Historia de la Santa A. M. Iglesia de Santiago de Compostela…* op. cit., vol. 3:11.

Arian king of the Swabian kingdom at the time, Hermenericus III. Archbishop and historian Don Rodrigo da Cunha, in the above-mentioned *Historia Eclesiástica*, claims the sonship of these martyrs in Braga with almost the same enthusiasm as he explains in Chapter XII *"Cómo a Cidade de Braga foy a primeira de Hespanha que recibeu a Fé de Christo Senhor Nosso;"* through the preaching of the Apostle James, it is to be understood. Indeed, in chapter 43, dedicated to the martyrs, he reproduces verses alluding to Molina's *Descripción del reino de Galicia*, translated into Portuguese.

It may be said that a liturgical treatment for the "Portuguese saints," duly differentiated, was observed in Compostela from the beginning, already used in Braga. Fructuosus and Susanna had their own church devoted to them there, and this was reflected here when they received areas called after their own names. They became in addition patrons of the two parishes in the city: Saint Susanna became co-patron, as stated above, permanently guaranteeing devoted parishes which remain valid today. Cucufate and Silvestre, always celebrated together, never enjoyed such status.

Liturgically, the oldest celebration is that of their Translation, on 16 December, with historical accuracy for the exact date when the incident took place in 1102. This is recorded by the medieval church calendar in Compostela. There is no special hymn for the occasion. The liturgical lessons for Matins are incomplete in the *Breviario de Miranda* (fifteenth century), in which ten pages are unfortunately missing... But, fortunately, they are complete in the incunable *Breviario compostelano*[15] – just two copies remain, in the National Library and in the Royal Academy of History – and they reappear with absolute accuracy in the *Breviario compostelano* published in Salamanca in 1569. The narrative discourse follows the text of the Compostela literally, justifying Gelmírez's action and unfairly describing the terrible situation of the good people of Portugal. In the matter of external solemnity, on that day the body of San Fructuosus was taken out in procession through the interior of the cathedral at solemn vespers, and prayers were chanted commemorating Cucufate, Silvestre and Susanna.

Saint Fructuosus also had his own feast day in Santiago in the Middle Ages, on 16 April, the date when it is held in Braga, as is witnessed by the famous *Misal de Mateus* (twelfth century) and the *Breviario medieval bracarense*. Vives is not right, therefore, when he states that in Spain the feast day of Saint Fructuosus is only recorded in the Antiphonary of León and in the Calendar of Oña. From Santiago, the cult of Saint Fructuosus irradiated to neighboring Ourense, as can be seen in the *Misal Auriense* published in 1494 in Monterrey.

The absence of Saints Silvestre and Cucufate from the liturgical manuscripts of Braga is somewhat surprising. No mention is made of Saint Susanna in the above-mentioned *Misal de Mateus*. But I do not understand the doubt voiced by the famous Portuguese liturgist Pedro Romano Rocha, when seeking the identity of the Saint Susanna, who appears precisely on 11 August in the Braga breviary, the same day as the feast is held in Santiago. Her local cult in Braga is attested from the tenth century. Of course, in our cathedral, the feast day of Saint Susanna entailed

15 A. Cotarelo, "Un incunable compostelano," *Boletín de la Real Academia Gallega*, vol. 17, 199 (A Coruña: 1927), pp. 169–77.

great solemnity. Since her relics came to the church, she too enjoyed a glorious procession at vespers. On 14 April the same was done with the urns of Silvestre and Cucufate.

All that is left to say is that Saint Giraldus, the Archbishop of Braga who hosted Gelmírez, also has his own feast day in the Compostela breviary. It is a sign of brotherhood with the See of Braga which bases its primacy on the Apostle Saint James. There is more: Saint Giraldus, as stated, accepted the appointment as a canon of Compostela from Gelmírez, with what no doubt implied generous help from the golden prelate. We should also point out that Saint Giraldus of Braga is the only canonized saint in all the history of the chapter of Santiago.

Miguel Taín Guzmán

The Survival and Destruction of Gelmírez's Altar in the Modern Age

Between 1656 and 1657 a young member of the chapter of Santiago Cathedral, one José de Vega y Verdugo, expressed in a report his ideas for the renovation of the old basilica, particularly the chancel and the staging of the presentation of the image of Saint James the Apostle, illustrating it with thirteen drawings of which twelve have been preserved. This document, addressed to the chapter and nowadays preserved in the Cathedral Archives, is known as the *Memoria sobre Obras en la Catedral de Santiago*, its pages containing relevant information about the architectural and artistic undertakings sponsored by the well-known Archbishop Diego Gelmírez in the twelfth century,[1] the "Gelmírez Constructor" extolled by Filgueira Valverde.[2] These pages will be devoted to the study of those pertaining to the high altar.

The manuscript has its origins in the appointment of a chapter committee on 30 June 1665 that would meet weekly to analyze "*las obras que se tienen de azer en la Capilla Mayor.*"[3] We know of its existence from the minutes of the chapter meeting held on 6 February 1657, in which it is ordered to continue with its meetings, and also that it operated for at least nineteen months, although the scope and importance of its decisions are unknown.[4] Unfortunately, neither of the two sets of minutes mentions the names of the committee members – with the exception of its chairman, Juan Moreno, and that of the canon Velasco de Ibias –, it therefore being impossible to confirm whether or not Vega y Verdugo was a member. This committee was responsible for matters as important as sending the drawings of the projects for the chancel[5] and a model of the site[6] for their examination by court artists, decisions that we know of due to their being recorded in the expenses of the *Libro 2° de Fábrica*, and in the case of the latter, because it is mentioned in the manuscript. Thus, regardless of whether our prebendary was a member of the said committee or not, what is certain is that the *Memoria* is the result of the discussion aroused in its milieu. This explains the contents of the text, which begins with an initial proposal for the alterations, consisting of replacing the stone lectern by a new one ("*Del fascistol,*" fol. 6rv). It is followed by a second proposal, the one that most interests us here, namely the complete renovation of the furniture and decoration of the chancel, with particular attention being paid to its proportion ("*De la proporción de la obra,*" fols. 9r–11v), flooring ("*Del pabimento o suelo de la Capilla Mayor,*" fol. 12r) and steps inherited from Gelmírez ("*De las gradas de la Capilla Mayor,*" fol. 12r–v). Here he proposes commissioning a new frontal to replace the one dating back to the times of Gelmírez ("*De la traça del frontal,*" fols. 12v–18r) and a new altar table ("*Del muro o mesa del altar,*" fols. 18r–19r); to study how many

1 The text of the manuscript has been published twice: F. J. Sánchez Cantón, *Opúsculos Gallegos sobre Bellas Artes de los Siglos XVII y XVIII* (Santiago de Compostela: Bibliófilos Gallegos, 1956), pp. 7–52; and M. Á. Castillo (ed.), *Las catedrales españolas en la Edad Moderna. Aproximación a un nuevo concepto del espacio sagrado* (Santiago de Compostela: Fundación BBVA, 2001), pp. 207–32.

2 J. Filgueira Valverde, *Historias de Compostela* (Vigo: Xeráis, 1970), pp. 37–75.

3 ACS~Archivo de la Catedral de Santiago: *Libro 32 de Actas Capitulares* (1655), leg. 597, fol. 5r.

4 Ibidem (1657), leg. 597, fol. 140r.

5 ACS~Archivo de la Catedral de Santiago: *Libro 2° de Fábrica* (1656), leg. 534, fols. 31v–32r.

6 Ibidem (1656), leg. 534, fol. 30v.

monstrances the cathedral should have and to alter the Renaissance one, the work of Antonio de Arfe ("*De quantos géneros ay de custodias y de sus colores,*" fols. 19r–24r); make a new rayed monstrance decorated with "*perlas y piedras finas*" ("*Biril,*" fol. 25r); re-open the apostolic crypt that was believed to exist under the floor of the presbytery, remove Gelmírez's medieval altarpiece, construct a new cenotaph in jasper and not to install, as some canons would have liked, a new silver altarpiece on the high altar ("*Del retablo*" and "*Sepulcro,*" fols. 25r–32r); replace the medieval image of Saint James the Apostle with a substitute using the iconography of the Pilgrim ("Estatua del Santo," fols. 32v–34r); substitute the baldachin installed by Archbishop Alonso de Fonseca I with a new one ("*Tabernáculo,*" fols. 34v and ff); and, finally, to modify the structure of both the sacristy in the semicircular area behind the altar and the pilgrims' access to the image of the saint ("*Sacristía o camarín,*" "*Del paredón*" and "*Escalerillas nuebas,*" folio reference crossed out). The manuscript comes to a close with a third proposal, namely to alter the medieval fronts of the Obradoiro ("*Espexo y torres,*" fols. 39v and ff) and Quintana squares, the latter being mostly due to Gelmírez ("*Quintana,*" fols. 46r and ff).

The positive reaction of the chapter to Vega y Verdugo's ideas, or at least to those concerning the reorganization of the chancel, have passed down to us thanks to a letter dated 3 September 1656 and sent by the finance and property committee of the chapter to its agent in Madrid, Juan de Astorga, in which we can read:

> "*El señor Don Joseph Verdugo nos comunicó esas traças y debujos con las advertençias para su inteligencia en orden al maior acierto, aseo y grandeça del sepulcro de nuestro Grande Apóstol y complemento de algunas obras que están por acabar, y otras imperfectas. Para que careándose con las demás traças que emos remitido se es[c]oja la mejor, o tomando todas se elija la que deseamos. Hemos estimado sumamente al señor don Joseph el afecto que tiene y cuydado con que ha trabajado ese diseño, y desearemos sea allá tam bién visto como acá nos ha parecido. V. M. se sirva haçer se repare en él con atención y lo communique con el señor Don Juan Moreno, antes que venga, que, por ser su merced fabriquero, es a quien más parte le ha de caber de las advertencias.*"[7]

Imagines Altaris Maioris

In order to understand the explanations provided by our prebendary in his manuscript and projects for the renovation of the chancel, we must previously have some idea of how the site evolved from medieval times to 1656–1657, the date when the *Memoria* was written, including the elements acquired under Gelmírez's patronage.[8]

7 ACS~Archivo de la Catedral de Santiago: "Carta del cabildo a Juan de Astorga del 3 de septiembre de 1656," *Minutario de cartas y exposiciones* (1652–1663), leg. 943.

8 To A. Rosende we owe a splendid analysis of the condition of the chancel before the Baroque renovation begun by our prebendary, based on documentation and ancient stories: "A mayor gloria del Señor Santiago: el baldaquino de la catedral compostelana," *Semata, Las religiones en la historia de Galicia,* 7–8 (Santiago de Compostela, 1996), pp. 487–97.

9 We owe the first analysis of the panel to M. Stokstad, "The Sanctuary of Saint James at the End of the 15th Century," *Compostellanum*, 32 (Santiago de Compostela: 1987), pp. 527–31. According to D. M. Gitlitz the subject of the painting is the outcome of the Miracle of the Laurentians: "The Iconography of Saint James in the Indianapolis Museum's Fifteenth-Century Altarpiece," in M. Dunn and L. K. Davidson (eds.), *The Pilgrimage to Compostela in the Middle Ages* (New York: Routledge, 1996), pp. 119–21.

10 This wall would date back to the times of Gelmírez, but the image of the Apostle is thought to have presided over the cathedral only since its consecration in 1211. Cf. A. López Ferreiro, *Historia de la Santa A. M. Iglesia de Santiago de Compostela*, vol. 5:11 (Santiago de Compostela: Seminario Conciliar de Santiago, 1898–1911), p. 58. On the statue, see J. Carro García, "La imagen sedente del Apóstol en la Catedral de Santiago," *Cuadernos de Estudios Gallegos*, 15 (Santiago de Compostela: 1950), pp. 43–4.

11 This space was constructed by Gelmírez, consecrated in 1105 and dedicated to Mary Magdalene. Here pilgrims heard matins and received communion, there only being a single access from the ambulatory. Cf. M. Castiñeiras, "Topographie sacrée, liturgie pascale et reliques dans les grands centres de pèlerinage: Saint-Jacques-de-Compostelle, Saint-Isidore-de-Léon et Saint-Étienne-de-Ribas-de-Sil," *Les Cahiers de Saint-Michel de Cuxa*, 34 (Cuxa: 2003), pp. 33ff.

12 Votive lamps already existed in the presbytery before the iron Renaissance arch was installed to hang them from. Indeed, A. López Ferreiro mentions that before this intervention the lamps hung from a beam slung between pillars and fixed with ropes: *Historia de la Santa A. M. Iglesia de Santiago de Compostela…* op. cit., vol. 8:11, p. 195. In 1502 Antonio de Lalaing described them as follows: "*encima del altar hay* […] *una gran lámpara de plata que cuelga delante del cuerpo santo, dada por dicho rey [de Escocia]. Cuelgan allí otras doce lámparas, donativo del rey de Francia Luis XI, y diez más dadas por diversos señores*", see J. García Mercadal, *Viajes de extranjeros por España y Portugal*, vol. 1:3 (Salamanca: Junta de Castilla y León, 1999), pp. 419–20.

13 This representation agrees with the account given by the pilgrim Jean de Tournai in 1487, who says that in order to reach the image of the Apostle he climbed a wooden ladder located behind the high altar. Going by the date, the ladder in question could either be the one shown in the Indianapolis painting or the one we will see later in a miniature from Tournai. Cf. P. Barret and J.-N. Gurgand, *Priez pour nous à Compostelle* (Paris: Hachette Littérature, 1999), p. 231.

14 The fact that it is the pilgrim who is placing the crown on the image, and not receiving it, arguing that it would not appear that we are witnessing the rite of the *coronatio peregrinorum*, has already been put forward by R. Plötz: "Volviendo al tema: la coronatio," in V. Almazán

Fortunately we still have three extremely valuable images that show the chancel at three very different times during its history. The information they provide is complemented by that found in the abundant documentation preserved in the cathedral and in particular, by the descriptions of scholars and pilgrims who visited the Basilica of the Apostle. Amongst the latter, perhaps the most important is the *General descripción del Reino de Galicia*, by the Fernández de Boán brothers, which can be dated to 1640, not long before the time our manuscript was written, and to which we will make frequent reference.

The three images mentioned above are by anonymous foreign artists who we assume must have visited the Church of the Apostle at some time or other, and then reproduced what they saw from memory on their return home. Hence the realism with which the chancel appurtenances at the time each one was made, as well as the pilgrims' rites in relation to the image of Saint James, are portrayed. The oldest one is a well-known late fifteenth-century Flemish painting on the subject of the "Resurrection of a pilgrim at the shrine of Saint James," a work that is part of the triptych known as *The Miracles of Saint James* in the Indianapolis Museum of Art.[9] Here the artist evokes the chancel rather freely, just as he remembers it, but it is the only representation of the site as designed by Gelmírez before the construction of the baldachin by Archbishop Alonso de Fonseca I, decided in 1462 but not actually finished until 1476. Thus, we can see the current vaulted presbytery, tiled and invaded by a horde of pilgrims on their way to pay their respects to the Apostle. The scene is presided over by the high altar-table, covered by a brocade frontal cloth and a white cloth that conceal Gelmírez's silver frontal. On top of the altar there are two candlesticks and Gelmírez's altarpiece, whose iconography, with Christ in the center, flanked by his apostles, more or less coincides with that portrayed by Vega y Verdugo in two of the drawings in his manuscript, as we shall see later. The seated statue of the Apostle on a metal throne can be seen behind the altar, up against the partition wall of the *confessio*,[10] which runs from column to column, completely closing off the semicircular space at the back.[11] From the ceiling there hangs a row of thirteen glass oil lamps, all lit in honor of the Saint.[12]

As can be seen in the painting, in those days pilgrims reached the figure of the apostle by climbing up simple wooden ladders from the presbytery itself.[13] One of the pilgrims, carrying a scrip, is placing a crown on the image,[14] whilst on the other side a cleric wearing a surplice and cap is supervising the ceremony with a gesture of his hand. Several pilgrims standing close to the altar are following the ceremony attentively. In a set of *Constituciones Capitulares de la Catedral de Santiago* from 1243–1250, published by López Ferreiro, we are told that the Treasury contains a crown of the Apostle that German pilgrims come to honor, and which is occasionally transported to the chancel to be worshipped.[15] I wonder whether the painting in Indianapolis does not in fact show a *coronatio Beati Jacobi* after one of these temporary transfers.

Another character is showing us one of the two sickles used, according to legend, to behead Saint James; the other is on the altar table. According to Humbert Jacomet, one belongs to the martyrdom of Saint James and the other to that of Josiah, the two of them being put to death together after the latter's lightning conversion.[16]

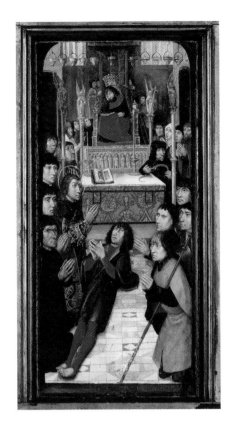

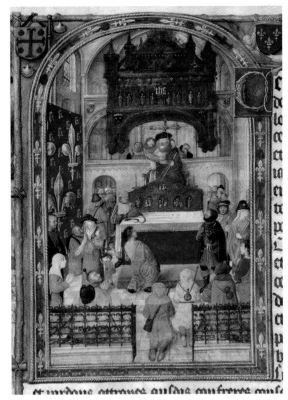

The pilgrim's resurrection in the sanctuary of Saint James [Polyptych The Miracles of Santiago, *detail]*
Master of the Legend of Saint Godelieve
c. 1500
IMA~Indianapolis Museum of Art, Indiana

Arrival of pilgrims to Santiago Cathedral presbytery [Cartulaire de l'hôpital Saint-Jacques de Tournai, Ms 27, frontispiece; detail]
1489–1512
Bibliothèque de la Ville de Tournai, Hainaut

The columns with the angels bearing the Instruments of the Passion and the splendid cloth canopy over the image of the Apostle are not documented and have been variously interpreted. In Moralejo's opinion it is not clear that the baldachin built by Gelmírez was in fact destroyed by Archbishop Fonseca, there possibly having been another Gothic baldachin between the two.[17] If he is right, these columns would be an evocation of this undocumented item. On the other hand, Stokstad suggests that the canopy may allude to a temporary baldachin installed due to the delay in the construction of the new one commissioned by Fonseca.[18] In my opinion, and given the faithful manner in which the artist has rendered the real items and figures, we cannot exclude the fact that the columns in question, with their chubby angels, are a reference to the remains of the twelfth century baldachin, the figures perhaps being an addition.

A row of high windows in the apse let in the light, although they do not correspond to the present Romanesque windows. Similarly, the cross section of the two arches on the extreme left and right of the painting, although they do not feature the gallery, enables them to be identified as the entrances to the corridor of the ambulatory, shown here as unlit and in darkness.

The second image, which is also Flemish but much more faithful to reality than the first, is a miniature from the frontispiece of the *Cartulary of the Hospital of Saint James at Tournai* on the theme of "Pilgrims arriving at the presbytery in Santiago Cathedral," dated to in or around 1489. The artist also depicts the chancel as he remembers it, but on this occasion after the modifications made by Archbishop Fonseca, the creator of the new baldachin and the modification of the existing wall of the *confessio*, which, amongst other details, appears now to have been perforated by two arches located at either end. Nevertheless, the elevation of the chapel, with its columns,

(ed.), *Padrón, Iria y las tradiciones jacobeas* (Santiago de Compostela: Xunta de Galicia, 2004), pp. 118–9.

15 *Historia de la Santa A. M. Iglesia de Santiago de Compostela...* op. cit., vol. 5:11, p. 65. On this topic see F. J. Pérez Rodríguez, *La Iglesia de Santiago de Compostela en la Edad Media: el cabildo catedralicio (1110–1400)* (Santiago de Compostela: Xunta de Galicia, 1996), pp. 147–51. The presence of this crown should come as no surprise, since in accordance with a custom of the Early Middle Ages, several members of European royal houses donated crowns to the Apostle.

16 Although this author's comment refers to the two sickles portrayed in the Tournai miniature, it can also be applied to the painting in Indianapolis. Cf. H. Jacomet, "A imaxe de Santiago a través da pregaria da Igrexa, dos seus milagres e das súas aparicións," in *Luces de Peregrinación* (Santiago de Compostela: Xunta de Galicia, 2003), p. 396. F. J. Pérez Rodríguez has documented the existence of a chest of the *cuítelo* to collect the alms given by pilgrims in the mid-fifteenth century: *La Iglesia de Santiago de Compostela en la Edad Media: el cabildo catedralicio (1110–1400)...* op. cit., p. 147. The only pilgrims to mention the sickle are León de Rosmithal in a narrative dated between 1465 and 1467, and the Englishman Andrew Boorde in 1532.

17 S. Moralejo, "Ars sacra et sculpture romane monumentale: le trésor et le chantier de Compostelle," *Les Cahiers de Saint-Michel de Cuxa*, 11 (Cuxa: 1980), pp. 189–238.

18 "The Sanctuary of Saint James at the End of the 15th Century"... op. cit., p. 531.

walls, windows and vaulting, does not in fact coincide with reality, being simply an evocation of medieval cathedral architecture. The presbytery is once again presided over by the altar-table, here also covered by a cloth frontal and a white altar cloth, with the two sickles used in the beheading of the Apostle, the two candlesticks and Gelmírez's altarpiece, the two sickles being kept by a watchful cleric. In the background there is the image of Saint James the Apostle on his throne, leaning against the partition wall of the semicircular space behind, and above it, an enigmatic cross that appears to be suspended from the baldachin.[19] The railings that close off the presbytery have been opened by the treasurers to enable pilgrims to enter.[20] These have arrived in large numbers, although this time they reach the image of Saint James from the above-mentioned openings at either end of the partition wall closing off the semi-circular space, now transformed into a treasure house for the image: they enter through the left-hand arch, climb up some steps, still simple and made of wood, to embrace the Apostle round the shoulders, and leave through the right-hand arch.[21] One of the pilgrims is performing the ritual of the embrace and according to custom has placed his hat on the statue. As can be seen in the miniature, this habit may have arisen as a result of the forced posture that pilgrims had to adopt in order to embrace the image: the traditional broad-brimmed pilgrim's hat must have got in the way when pilgrims wanted to comply with this ritual practice.

The whole scene is crowned by Archbishop Fonseca I's baldachin, built, as I have already said, between 1462 and 1476, and until now only known to us through descriptions.[22] In the miniature the artist has succeeded in producing the effect of an element suspended in the air, apparently without support, which so attracted the attention of Ambrosio de Morales in 1572.[23] Nevertheless, in this depiction it is held up by a gigantic stone diaphragm arch, although in reality only the front part rested on an arch, the rear section being supported by two large pilasters jutting out from the sacristy wall.[24] Otherwise its double-pyramid structure, with pinnacles or *castilletes* at each end, coincides with the descriptions in the accounts of ancient pilgrims' and scholars' chronicles. On the front there is a gallery of eight silver figures that cannot be identified, flanking the anagram of Christ. In fact, according to an inventory done by the cathedral silversmith Bartolomé de la Iglesia in 1649, there were only six figures, covered in sheet silver and arranged as follows: in the center the Virgin with Child, Saint James, Saint Peter and Saint John the Evangelist, flanked by two trumpeting angels, which in the Tournai miniature, as Vanwijnsberghe rightly says, may by mistake have been painted as four.[25] With regard to the anagram, the silver-gilt "JHS," it is referred to in the above-mentioned inventory in the following terms: "*...en el dicho frontispiçio, un poco más arriva, entre las ymáxines de Nuestra Señora y Santiago, ay un escudo de harmas con un Jesús, todo guarneçido de planchas de plata y el escudo del Jesús sobredorado.*"[26] And lastly, there is also a coincidence with reality in the arrangement of the two shields on the spandrels of the frontal arch, but not in the coats of arms.[27] Indeed, they are also referred to in the 1649 inventory as follows: "*más otros dos claros baxos en el frontispicio del dicho cinborio, en los quales están dos escudos de armas, el de la mano derecha son Reales y la siniestra del sr. arçovispo Fonseca,... cubierto y guarneçido de planchas de plata.*"[28]

The third representation is a French engraving bearing the legend *Le vray pourtraict de Sainct Jacques comme il est en Compostelle* and dated 1648. It is the

19 This could be the cross described by Antonio de Lalaing in 1502: "*encima del altar hay* [...] *una riquísima cruz de oro adornada con muchas perlas y piedras preciosas, conteniendo en ella un trozo de la cruz de Nuestro Salvador, dada por un rey de Escocia*". Cf. *Viajes de extranjeros por España y Portugal...* op. cit., p. 419.

20 Every day, when the bell rang for matins, pilgrims could visit the alms chest dedicated to Saint James the Lesser and leave their first offerings there. Once mass was over, the treasurers opened the presbytery railings to allow pilgrims to make their offerings to the Apostle in the high altar: *La Iglesia de Santiago de Compostela en la Edad Media: el cabildo catedralicio (1110–1400)...* op. cit., pp. 149–50.

21 We must assume that when this modification was made the former access to the *confessio* from the ambulatory was closed off to control the flow of pilgrims in the chancel.

22 For this fixture see *Historia de la Santa A. M. Iglesia de Santiago de Compostela...* op. cit., vol. 7:11, pp. 321–3. J. Filgueira Valverde and J. R. Fernández-Oxea, *Baldaquinos gallegos* (A Coruña: Fundación Pedro Barrié de la Maza, 1987), pp. 30–2. "A mayor gloria del Señor Santiago: el baldaquino de la catedral compostelana"... op. cit., pp. 493–5.

23 "*Encima de este altar está un cimborio muy grande, así que cubre al santo y al arca y al altar todo, y es alto de pica y media o más, dorado y plateado sobre la madera. Está por las tres partes en el ayre, que no toca ni afirma sino por las espaldas del vulto del santo*": H. Flórez (ed.), *Viage de Ambrosio de Morales por orden del Rey D. Phelipe II a los Reynos de León, y Galicia, y Principado de Asturias para reconocer las reliquias de Santos, sepulcros reales, y libros manuscritos de las Cathedrales, y Monasterios* (Madrid: Marín, 1765), p. 121.

24 "A mayor gloria del Señor Santiago: el baldaquino de la catedral compostelana"... op. cit., pp. 493–4.

25 The inventory states that "*...en el frontispiçio alto del dicho cinborio ay quatro ymáxines de bulto que son Nuestra Señora con su nino en los braços, Senor Santiago, San Pedro y San Juan Ebanxelista, todas las quales están cubiertas y guarneçidas de planchas de plata. Más a los lados de dichas ymáxines ay dos ánxeles con sus tronpetas y con todo de bulto, y guarneçidas de planchas de plata*": ACS~Archivo de la Catedral de Santiago: *Recuento de la plata y ornamentos de la S.I.*, leg. 382, fol. 48v.

26 Ibidem.

27 According to the documentation, the fixture displayed the coats of arms of the Royal Household and Archbishop Fonseca, whilst those in the miniature are those of the King of France and the Kingdom of Leon.

28 Op. cit., note 29. Fonseca's shield is the consequence of Celma's intervention in 1586: ACS~Archivo de la Catedral de Santiago: *Varia*, vol. 2, leg. 714, doc. 106.

simplest of the three, containing various serious errors and the least realistic reproduction of the image of the Apostle. However, from our point of view its interest lies in the fact that it shows the chancel after the sixteenth-century alteration had been completed. As in the other two cases, the presbytery presides over the high altar, once again covered by a cloth frontal and an altar cloth, with two candlesticks standing on it, although for some unexplainable reason the chest with Gelmírez's altarpiece is not shown. Nevertheless, it is significant that, just as in the Indianapolis and Tournai paintings, two candlesticks once again appear on the altar; in all three representations they hold large candles that according to an ancient tradition burn "night and day" in honor of Saint James. The image of the Apostle is seen in the background, once again seated on a metal throne,[29] although the clothing and gestures have little to do with reality. Nevertheless, there is an important novelty in this engraving: the depiction of a crown hanging from a ribbon (in reality a chain) over the saint's head. In this case it is indeed the crown used in the popular ritual of the *coronatio peregrinorum*, mentioned over several centuries in a large number of ancient accounts,[30] such as that of Arnolf von Harff in 1499, that of Jean Taccoen in 1512, that of Ambrosio de Morales in 1572, that of an anonymous writer in 1577, that of Erich Lassota of Steblovo in 1581, that of Confalonieri in 1594, that of the Boán brothers in or around 1640 or that of Magalotti in 1669. Such a crown is also mentioned in an inventory of the cathedral ornaments in 1649 with the following description: "*tiene el Santo Apóstol un collar de plata y una corona de lo mismo pendiente sobre su cabeça.*"[31] As in the previous images, the presbytery is packed with pilgrims worshipping Saint James, although here they are kneeling. Just as in the miniature at Tournai, there are two arches in the partition wall of the semicircular space, now converted into the sacristy, although the wall is now different, since it was by then a double wall with stone stairs in the middle leading up to the image on either side.[32] These stairs are only shown in the right-hand opening, their direction, curiously enough, diverging from the statue of the Apostle, this I imagine being simply a mistake made by the artist. Also, and contrary to what is shown in the Tournai miniature, a pilgrim is making his way to climb up the ladder to the image through the right-hand opening, not the left-hand one, which is now the exit door. There is no mistake in this case, since Ambrosio de Morales had already pointed out that "*súbese a esta imagen por una escalera que está al lado de la Epístola con su portecica, y desciéndese por otra del lado del Evangelio.*"[33] On top of the double wall the artist has invented a terrace that never existed, where he places a further seven pilgrims praying to the Apostle, although curiously enough without complying with the customary rituals. We know nowadays that the inner stairs going up to and down from the image converged in a kind of landing behind the saint's back on a much lower wall, cut off at the height of the statue's waist, thus enabling the pilgrims to perform the customary embrace and *coronatio* in comfort. On this point Fray Oxea writes that the image is "*arrimada a un pretil que le llega hasta casi los hombros, de modo que le quedan descubiertos parte dellos, el cuello y la cabeça, para dar lugar a la devoción de los peregrinos y gentes que viene a visitarle, a que le toquen y abracen. Y assí lo hazen ellos con gran devoción y reverencia, subiendo allí por dos escaleras que ay a los lados detrás del mismo altar mayor.*"[34] Similarly, the Boán brothers have this to say:

Le vray pourtraict de sainct Jacques, comme il est en Compostelle
[VB-135-FOL, RC-B-17289]
1648
BnF~Bibliothèque nationale de France, Paris

29 Fernando Oxea describes it as "*una silla dorada,*" in 1615: *Historia del Glorioso Apóstol Santiago patrón de España: de su venida a ella y de las grandezas de su iglesia y orden militar* (Madrid: 1615), fol. 119v. The throne in the engraving is an evocation of the one of the time, whose form we cannot determine since it no longer exists. The current throne dates from 1704 and is the work of the silversmith Juan de Figueroa, its patron being Archbishop Monroy.

30 On the obscure origin of the ritual see "Volviendo al tema: la coronatio"... op. cit., pp. 101–22.

31 *Recuento de la plata y ornamentos de la S.I....* op. cit., leg. 382, fol. 48v.

32 The double wall and its interior staircases were built in the sixteenth century, and are the result of transferring the altar of the Holy Sacrament from the *confessio*, where pilgrims had received communion since Gelmírez's day, to the chapel of The Holy Savior in the ambulatory, in 1532. It was then that the two extremely ancient altars in the semicircular space dedicated to Mary Magdalene and the Sacrament were dismantled, the area becoming a new sacristy for the Cardinal Canons, the only ones allowed to officiate at the high altar of the cathedral. Cf. *Historia de la Santa A. M. Iglesia de Santiago de Compostela...* op. cit., vol. 8:11, pp. 50–55.

33 *Viage de Ambrosio de Morales por orden del Rey D. Phelipe II a los Reynos de León, y Galicia, y Principado de Asturias...* op. cit., p. 121.

34 *Historia del Glorioso Apóstol Santiago patrón de España: de su venida a ella y de las grandezas de su iglesia y orden militar...* op. cit., fol. 119v.

"A par del altar están dos puertas de uno y otro lado, cuya pared divide otra capilla que está detrás del Santo Apóstol, en redondo, a modo de concha [...] De estas puertas dichas, así como se ponen los pies en medio de ellas por el hueco de su ancha pared, se sube de una y otra por [...] escaleras hasta el alto de su descanso a abrazar al Santo Apóstol, de manera que entran por una y bajan por otra, porque cuando hay grande concurso de gente no se aprieten sino que entren y salgan con comodidad."

Due to the dates when the three images were produced, the latest is the one that best reflects the condition of the chancel in Vega y Verdugo's day, showing the two areas that he wanted to modify, namely the presbytery and the sacristy. The cathedral chancel built by Gelmírez still existed as late as 1656, with its floor on various levels, all higher than the current one, its thick pillars, columns, arches and capitals and its barrel vaulting. However, the two medieval spans that composed the presbytery now have the addition of a third, the result of the invasion of a span of the transept in 1542.[35] The three are closed off by iron railings, mentioned in most pilgrims' accounts and described in detail by Fray Hernando Oxea in 1615: the chancel *está cerrada por los lados y la frente de riquíssimas rejas de hierro, altas y fuertes, torneados los balaustres con mucho primor, con muchas medallas y curiossísimos remates, dorados todos ellos, y las molduras, que la engrandecen mucho.*[36] The area is presided over by a large altar-table, still covered by the frontal donated by Gelmírez. On it there is, firstly, Antonio de Arfe's famous silver-gilt monstrance[37] and then a wooden chest that forms a kind of cenotaph, with Gelmírez's altarpiece inset into its front, as we shall see later. Further back we find the image of Saint James the Apostle, seated on a metal throne, just as he appears in the three depictions we have analyzed, and close up against the wall, leaving his shoulders, neck and head unprotected *para dar lugar a la deboción de los peregrinos y gentes que vienen a visitarle a que le toquen, abraçen y traten.* This wall is a double one, as shown in the French engraving. There are still two arches open in the outer wall, to the left and to the right, which allow pilgrims to circulate in comfort as they pay their visit to the saint and perform the rituals associated with their pilgrimage. Over the image and the altar, supported on a diaphragm arch constructed for the occasion, there soars the baldachin shown in the Tornai miniature, commissioned by Archbishop Fonseca I and analyzed above. Finally, in front of this fixture and at a certain height, we find the iron arch made between 1554 and 1559 by the master craftsmen Guillén and Bartolomé Ruz to accommodate the large number of votive lamps donated by royalty and nobles from all over Europe.[38] They vary in number according to the source consulted, but all of them were oil lamps and were kept permanently lit in front of the Apostle. The best description corresponds to Bartolomé Bourdelot, who in 1581 wrote:

"Ante el altar arden continuamente muchas lámparas de plata, entre las cuales hay cuatro de singular belleza y grandísimo valor: la primera la hizo hacer Don Juan, primero de este nombre y rey de Portugal, príncipe de singular religiosidad [...] La segunda la donó Carlos VIII, Rey de Francia. La tercera, Maximiliano, Rey de Hungría, por línea materna, cuando no era aún emperador y en vida de su padre Fernando. La cuarta la dio el Conde de Benavente."[39]

This reality and layout would disappear after the appointment of Vega y Verdugo as warden of the cathedral in May 1658, which is when the systematic Baroque alteration

35 J. Guerra Campos, *Exploraciones Arqueológicas en torno al sepulcro del Apóstol Santiago* (Burgos: Ediciones Aldecoa, 1982), p. 215.

36 *Historia del Glorioso Apóstol Santiago patrón de España: de su venida a ella y de las grandezas de su iglesia y orden militar...* op. cit., fol. 119v.

37 That is where it was seen, for example, by Ambrosio de Morales in 1572. Cf. *Viage de Ambrosio de Morales por orden del Rey D. Phelipe II a los Reynos de León, y Galicia, y Principado de Asturias...* op. cit., p. 120.

38 Cf. *Historia de la Santa A. M. Iglesia de Santiago de Compostela*, vol. 8:11 (Santiago de Compostela: Seminario Conciliar de Santiago, 1898–1911), pp. 58, 195–6, app. 143–8.

39 I. Tellechea Idígoras, "Un peregrino veneciano en Compostela en 1581 (Del diario inédito de B. Bourdelot)," *Compostellanum*, vol. 30, 3–4 (Santiago de Compostela: 1985), pp. 339.

40 Fortunately we still have a fourth image of the site dating from several decades after Vega y Verdugo's reformation, which also allows us to appreciate the layout of the new Baroque scenography. The work in question is an eighteenth-century oil painting of *Saint Francis praying at the altar of Saint James*, and is to be found in the sacristy of the Franciscan monastery in Santiago, and contains an extremely accurate representation of the cathedral chancel which, when added to the other three, completes the picture album of the said area.

of the largest space in the cathedral began, with most of the proposals put forward in the manuscript being put into practice. This intervention in the Modern Age has to a large extent bequeathed us the present-day appearance of the area, one of the most spectacular and successful scenographies in any Spanish cathedral, and fortunately still in a magnificent condition.[40] But the same alteration was also responsible for the irreparable loss of three great works done under Gelmírez's patronage: the frontal of the high altar, the altar-table and the altarpiece that presided over it.

The frontal

When Vega y Verdugo wrote his *Memoria* he did not have to face the dilemma of what to do with the frontal paid for by Diego Gelmírez in 1105. In fact, it is significant that he makes no reference whatsoever to it, although we know that it was in very poor condition at the time, instead devoting several pages to expounding the pros and cons of having a new one made, using different types of materials and techniques. In reality, the chapter had already come to the decision to replace the medieval fitting with a new one in 1655, in other words before the manuscript was written, fols. 13v and 17r referring to the arrival in Santiago of a new design for the frontal, sent from Madrid by the above-mentioned agent of the chapter, Juan de Astorga. This information is complemented by an entry in the *Libro 2º de Fábrica* recording a payment of 700 reales for the design, made by the said agent to its anonymous author.[41] There is no record that this project ever came to fruition.

We know what Gelmírez's antependium looked like thanks to the studies carried out by Serafín Moralejo,[42] who analyzed the information given by the *Codex Calixtinus*,[43] the *Historia Compostellana*[44] and Ambrosio de Morales;[45] to the new information provided by the inventories of cathedral ornaments in 1569,[46] 1649[47] and 1658,[48] never previously studied; and to a description in a manuscript in the Biblioteca Nacional and dated in or around 1572, a free translation of the description given in the above-mentioned *Codex Calixtinus*, with the frontal still in its original position.[49] Thanks to them we know that it consisted of a wooden core covered with embossed silver sheeting, some parts in all probability being gilded. It was of sizeable proportions, measuring approximately one meter high by two and a half meters wide. The center depicts the Vision of the Apocalypse, with Christ in Majesty, wearing a crown of lilies beset with jewels, one hand raised in blessing and the other holding the Book of Life. Around him, within a mandorla, there are the Twenty-Four Elders of the Apocalypse, distributed, according to the *Codex Calixtinus*, in twelve to the right and twelve to the left, because this is the "*orden en que San Juan, hermano de Santiago, los vió en su Apocalipsis.*"[50] The twenty-four are holding pots containing perfume and musical instruments, zithers according to Moralejo's translation of the Codex or *vihuelas* according to the manuscript in the Biblioteca Nacional, a forerunner of how they would later be once more portrayed in the Portico of Glory. In the corners, outside the mandorla, we find the four Evangelists with their respective attributes. On either side and on two superimposed levels, each consisting of a portico with three arches and their columns, stand the twelve Apostles. According to the 1658 inventory, on the Gospel side, in the first aedicule on the lower level, the apostle would appear to be

41 *Libro 2º de Fábrica...* op. cit., leg. 534, fol. 16v.

42 "Ars sacra et sculpture romane monumentale: le trésor et le chantier de Compostelle"... op. cit., pp. 170–4.

43 *Liber Sancti Iacobi Codex Calixtinus*, trans. A. Moralejo, C. Torres and J. Feo (Santiago de Compostela: Instituto Padre Sarmiento de Estudios Gallegos, 1951; reed. fac. Santiago de Compostela: CSIC~Centro Superior de Investigaciones Científicas, 1999), pp. 566–7.

44 Cf. *Historia Compostelana*, trans. E. Falque Rey (Madrid: Akal, 1994), p. 107.

45 Cf. *Viage de Ambrosio de Morales por orden del Rey D. Phelipe II a los Reynos de León, y Galicia, y Principado de Asturias...* op. cit., pp. 119–20.

46 It contains the following: "*Visítase el altar mayor cuya delantera hes de plata. En el medio [del frontal está la imagen] de la Sanctíssima Trenidad y a los lados los doze Apóstoles, seis a cada lado. Y alrededor de la Sanctíssima Trenidad quatro Evangelistas. Todo de hoja de plata*": ACS~Archivo de la Catedral de Santiago: *Tesoro. Inventario de de alhajas, ornamentos, etc., y de las Santas Reliquias* (1969), leg. 381, fol. 83r; the document was included in *Historia de la Santa A. M. Iglesia de Santiago de Compostela...* op. cit., vol. 11:11, p. 181.

47 *Tesoro. Inventario de de alhajas, ornamentos, etc., y de las Santas Reliquias...* op. cit., leg. 381. ACS~Archivo de la Catedral de Santiago: *Inventario del Tesoro de la Santa Iglesia* (1648–1649), leg. 382, fol. 48r.

48 *Tesoro. Inventario de de alhajas, ornamentos, etc., y de las Santas Reliquias...* op. cit., leg. 381. ACS~Archivo de la Catedral de Santiago: *Inventario del Tesoro de la Santa Iglesia* (1658), fols. 52r–54r, 48r.

49 It contains the following: "*En este altar de Santiago se mira una tabla de oro y plata subtilíssimamente obrada y ella está hecho de bulto el trono de la Santíssima Trinidad y los ventiquatro seniores, según lo escrive San Juan en su Apocalipsi, doçe a la mano diestra y doçe a la siniestra [y] tienen en las manos vigüelas y redomas de oro, dentro de las quales ay olores muy preçiosos. En medio dellas está Dios Padre en silla de magestad y tiene en la mano el libro de la vida y la otra levantada dando la bendiçión. A los quatro lados del trono están los quatro evangelistas. Y en el çircuito dellos están los doçe Apóstoles, seis a la diestra del trono y seis a la siniestra. Y entre los Apóstoles ay muy ricas colunas labradas sutilmente. Alderredor de la tabla, por lo alto y baxo della, están unos versos latinos cuio romance es Don Diego, Arzobispo de Santiago, hiço está tabla después de çinco años que tenía esta silla. Tiene de peso setenta libras de plata*". Cf. BNE~Biblioteca Nacional de España: *Reyno de Galicia* (c. 1572), signatura 3.329, fol. 35r.

50 *Liber Sancti Iacobi Codex Calixtinus...* op. cit., p. 566.

Saint James, since mention is made of an apostle with scallop shells, perhaps wearing a short cloak: if this is true, then it must necessarily have been the result of an intervention in the Modern Age.[51] On the other hand, on the upper level on the Epistle side, there appeared Saint Peter, the only member of the group of apostles mentioned by name. Two strips, one at the top and the other at the bottom, contain inscriptions concerning the patronage of the piece that run as follows: "HANC TABULAM DIDACUS PRAESUL JACOBITA SECUNDUS / TEMPORE QUINQUENNI FECIT EPISCOPII, / MARCAS ARGENTI DE THESAURO JACOBENSI / HIC OCTOGINTA QUINQUE MINUS NUMERA. / REX ERAT ANFONSUS, GENER EJUS DUX RAYMUNDUS, / PRAESUL PRAEFATUS, QUANDO PEREGIT OPUS."[52] Finally, in the seventeenth century and as the result of a later alteration, a gilt-bronze frame was added around the perimeter of the piece.[53] López Ferreiro published an engraving of the conjectured layout of Gelmírez's altar in the Middle Ages.[54] Moralejo has also made two splendid drawings of the antependium, taking as his reference other with a similar iconography and layout, which give us a more realistic idea of what was in all probability its original appearance.

From the contents of the chapter minutes of 1553 and 1554 regarding the alterations to Gelmírez's altarpiece, which will be dealt with in greater detail further on, it would appear that it underwent a major transformation at the hands of several silversmiths. This work would explain the presence of scallop shells around the "*pescuezo*" of the image of Saint James. Indeed, during Gelmírez's day Saint James the Apostle was depicted as an Evangelizing Apostle, with a tau-shaped walking stick, and never as a pilgrim, this iconography making its first appearance in Galicia two centuries later.

Various sixteenth century pilgrims and visitors mention the frontal in their accounts of their visits to the cathedral, amongst them Ambrosio de Morales or the anonymous author of the manuscript in the Biblioteca Nacional, whom we have already referred to. A further example is the testimony of the Venetian pilgrim Bourdelot, who wrote the following after seeing it in 1581: "*la palla no es muy grande y es plateada.*"[55] I have mentioned above that in 1655 the frontal was in very poor condition. Indeed, in the above-mentioned 1649 inventory of the ornaments in the cathedral the cathedral silversmith Bartolomé de la Iglesia describes major deficiencies:

> "*El frontispicio baxo del santo altar del Apóstol, donde se pone el frontal, ay un retablo de ymáxines de bulto, todo cubierto de planchas de plata. En que ay los doce apóstoles y, en medio, la figura del Salbador con quatro Ebanxelistas a los lados. Alláronse las faltas siguientes: en el cerco donde está el Salvador, en que avía beinte y quatro ymáxines pequeñas alrededor del Salvador, donde faltan algunos pedazos de las planchas de plata y de las ymáxenes, les faltan beinte y dos caveças, porque sólo quedaron dos. Y en el dicho frontispicio y frontal del se allaron otras muchas faltas de plata de pedazos que se an quitado. Y en español de dos figuras de dos apóstoles que están al lado del Evangelio. Todas las quales faltas de plata declaró Bartolomé de la Iglesia, platero, importarían hasta catorce marcos de plata. Tiene este altar los lados y orillas todo alrededor de bronçe labrado.*"

Mention was also made of its deterioration during the time Vega y Verdugo occupied the post of cathedral warden, in a long report written by Bartolomé, the silversmith

51 The text reads as follows: "*Y en la primera capilla de la partte de avaxo faltan unos pedaços por el arco. Y derredor del Apóstol, que está en ella, falta toda la plata del campo liso. Y de la ottra parte, en correspondençia, faltara un dedo de ancho, exsetto dende el pescueso del Apóstol arriva, donde están las beneras, está enttero. Y el cuerpo del santo tiene una plancha lisa que aún no alcança todo el cuerpo y está clavada con clavos de hierro.*"
52 *Viage de Ambrosio de Morales por orden del Rey D. Phelipe II a los Reynos de León, y Galicia, y Principado de Asturias...* op. cit., pp. 119–20.
53 This is mentioned in the 1649 and 1658 inventories.
54 Published in *Historia de la Santa A. M. Iglesia de Santiago de Compostela*, vol. 3:11 (Santiago de Compostela: Seminario Conciliar de Santiago, 1898–1911), p. 236.
55 "Un peregrino veneciano en Compostela en 1581 (Del diario inédito de B. Bourdelot)"... op. cit., p. 339.

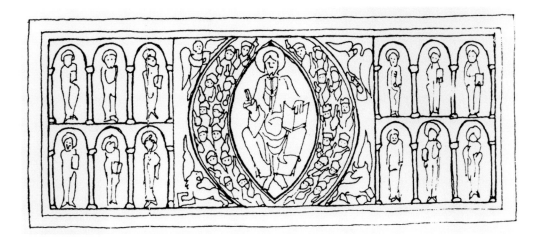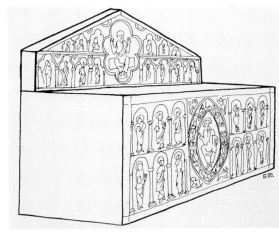

referred to above, who indicates in greater detail the many defects in the piece. Finally, the chapter minutes of 20 March 1668 say that the frontal was "*maltratado*," in this case in the lower section, where "*le avían quitado algunos pedaços de plata.*"[56]

We cannot be sure when Gelmírez's antependium disappeared. During Vega y Verdugo's time as cathedral warden there is no news of its destruction and/or replacement by a new one during those years: the only information we have is that the said Bartolomé de la Iglesia had made a "*muestra*" of a silver frontal before 1671, but it is not clear whether this was for the high altar or not. Nevertheless, it should be remembered that it is to him we owe the construction, in or about 1669, of a new marble and jasper altar-table, with frontal and lateral arcades to reveal the new cenotaph for the Apostle, which may mean that the medieval piece had already disappeared, since it would block the view of the supposed tomb of Saint James. The coincidence in date between these two events, the construction of a new altar table and the existence of test pieces for a new frontal, the work of the cathedral master craftsman, indicate that the frontal was replaced around that time. Furthermore, the new altar-table was much bigger than the medieval one, because, as López Ferreiro had occasion to discover when he dismantled it in 1879, the top of Gelmírez's table was re-used in the Baroque one, in which it was extended at both ends, the medieval frontal thus becoming too small. Another possibility, also put forward by López Ferreiro, is that the frontal continued to exist until 1695, when it would have been replaced by the present-day Baroque one, also fashioned in silver by the local silversmith Antonio de Montaos. However, as I have just pointed out, the frontal would have been too small for the Baroque table and would have needed some kind of lateral additions or supplements to match its width to that of the altar.

The altar-table

Also connected with the renovation of Gelmírez's frontal are Vega y Verdugo's ideas to build a new altar-table, contained in the *Memoria*. It is to be expected that our prebendary should have attracted the attention of this piece of furniture, the focal point of the cathedral basilica and the principal place for the celebration of holy offices. Furthermore, the location of the Apostle's body underneath the altar-table makes the latter a reliquary *sub altari* and, therefore, a point of reference

Altar frontal donated by Gelmírez ["The Artistic Patronage of Archbishop Gelmírez (1110–1140): Its reflection in the works of Santiago," in L. Gai (ed.), Atti del Convegno Internazionale di Studi. Pistoia e il Cammino di Santiago. Una dimensione europea nella Toscana medioevale. *Naples: Edizioni Scientifiche Italiane, 1984, p. 270, fig. 11; hypothetical reconstruction] Serafín Moralejo 1984*

Altar frontal and retable donated by Gelmírez ["Ars Sacra et Sculpture Romane Monumentale: le Trésor et le Chantier de Compostelle," Les Cahiers de Saint-Michel de Cuxa, *II. Cuxa, pp. 189–238, fig. 2; hypothetical reconstruction] Serafín Moralejo 1980*

56 Antonio de Saavedra and our canon were therefore ordered to repair it for the celebrations of Maundy Thursday and Good Friday. ACS~Archivo de la Catedral de Santiago: *Libro 34 de Actas Capitulares* (1668), leg. 599, fol. 253r.

for pilgrims.[57] This arrangement, baldachin included, had from time immemorial coincided with that of the altar-table of Saint Peter's in the Vatican, the model it chose to imitate.[58] This explains why our prebendary, on taking up the post of cathedral warden, decided to promote the construction of a new table, curiously re-using the granite slab of the previous one, which had apparently been done under the patronage of Diego Gelmírez. That at least is how archivist Canon Antonio López Ferreiro put it in his works *El Altar de Santiago, sus vicisitudes y transformaciones desde los tiempos primitivos hasta nuestros días*[59] and, more particularly, in his *Altar y cripta del Apóstol Santiago, reseña histórica desde su origen hasta nuestros días.*[60] Indeed, the dismantling of the Baroque altar-table by López Ferreiro in 1879 in order to excavate the foundations of the Roman mausoleum of the Apostle underneath the presbytery gave him cause to analyze the altar in detail in the two texts mentioned above. He describes it as consisting of a large slab of granite "*de una sola pieza*," which, as I have already mentioned, he roundly asserts came from Gelmírez's altar, which had been widened on both sides by Vega y Verdugo, resulting in a table that was "*extensa y dilatada*." Similarly, in his *Historia de la Santa Iglesia de Santiago* he describes Gelmírez's stone as being fine-grained granite and measuring "*doce cuartas de largo por siete de fondo y una de espesor*" (2.46 m long by 1.43 m wide and 20 cm thick). Unfortunately the author gives no indication of his reasons for stating that the piece came from the medieval altar, nor does he illustrate his descriptions with a single drawing or photograph. That said, if it does effectively correspond to the Romanesque altar-table, we are talking about the stone beneath which there was once displayed, as if it were a relic, the primitive Roman *Ara de Antealtares* before it was moved to the monastery from which it now takes its name.[61]

In all three of the depictions of the chancel analyzed above the altar-table is the one destroyed by Vega y Verdugo and, if López Ferreiro is to be believed, the one commissioned by Gelmírez, described in the *Historia Compostellana*[62] and the *Codex Calixtinus*,[63] with perhaps the occasional modification as the result of the passage of time. The fact that the medieval altar-table should have been preserved until the seventeenth century is logical enough, since its front has the same dimensions as those of the Romanesque frontal mentioned above, which also survived until the same century, and the top was broad enough to display Gelmírez's retable. The said *Codex Calixtinus* gives us the dimensions of the altar-table, "*çinco palmos en alto, doçe en largo y siete en ancho*" (1.05 m high by 2.52 m long by 1.47 m wide), and describes it as being walled off to the left, right and back, whilst the front, if the frontal is removed, remained open to provide a view of the said Ara de Antealtares, a relic which according to tradition was the work of Saint James' disciples. This description coincides with that made centuries later, in 1572, by Ambrosio de Morales, who encountered the same altar closed off by the same frontal, with a hollow interior that stood empty due to the removal of the said *ara* many years before.[64] He also points out the altar was not placed up against the wall, but was some distance from it "*como estaban antiguamente todos los de aquella tierra y de Asturias.*" This comment refers to the fact that the altar, like the present-day one, was located over the Apostle's tomb, in the first straight section of the presbytery and not, as was the custom in all other churches, to the back of the apse, an area then occupied by the sacristy in Santiago Cathedral. Furthermore, the altar had always been under a

57 Cf. M. Castiñeiras, "Los espacios arquitectónicos en función de las reliquias," in *En Olor de Santidad. Relicarios de Galicia* (Santiago de Compostela: Xunta de Galicia, 2004), pp. 65–80.

58 And also with that of other Roman basilica, such as San Paolo fuori le Mura; see S. de Blaauw, *Cultus et Decor. Liturgia e architettura nella Roma Tardoantica e Medievale*, vol. 1:2 (Vatican City: Biblioteca Apostolica Vaticana, 1994).

59 A. López Ferreiro, *El Altar de Santiago, sus vicisitudes y transformaciones desde los tiempos primitivos hasta nuestros días* (Santiago de Compostela: Seminario Conciliar Central, 1877), p. 37.

60 Idem, *Altar y cripta del Apóstol Santiago, reseña histórica desde su origen hasta nuestros días* (Santiago de Compostela: Seminario Conciliar Central, 1891), pp. 9–11, 34.

61 On this altar and its placing in Gelmírez's altar, see S. Moralejo, "Ara de Antealtares," in *Santiago, Camino de Europa. Culto y cultura en la peregrinación a Compostela* (Santiago de Compostela: Xunta de Galicia, 1993), pp. 252–3.

62 *Historia Compostelana*... op. cit., p. 107.

63 *Liber Sancti Iacobi Codex Calixtinus*... op. cit., pp. 565–6.

64 The *ara* was already in the monastery of San Paio de Antealtares by the end of the fifteenth century: "Ara de Antealtares"... op. cit., p. 252.

baldachin, in those days the one built by Fonseca, this being the typical arrangement in Roman basilicas. He also states that in the wall on the Gospel side there was a closed door "*que sólo se abre a los arzobispos quando vienen de nuevo y a los reyes,*" a door that was opened for Morales given his condition as delegate of the King, indicating that "*lo que hay dentro es dos piedras grandes llanas en el suelo, y al cabo dellas un agugero pequeño, por donde no cabrá más que una naranja, y está tapado con cal.*"[65] This hole was believed to communicate with the crypt where Saint James the Apostle was buried, as we have seen elsewhere.[66] Similarly, in his manuscript our prebendary refers with some concern to the dilapidated appearance of the walls of the old altar, pointing out that the new frontal he wanted to create should "[...] *bestir el muro o mesa del altar, donde an de yr a trabar los tornillos que le an de sustentar. Y, asimismo, de las testeras de los lados que miran a las creencias, porque es más necesario bestirlo y adornarlo que otra ninguna yglesia porque como aquello es el marco debajo de donde dicen está enterrado el Santo, todos ban a encontrar con el muro... Y [aun] quando nadie fuese a mirarlo, basta que el Jueves y el Biernes Santo queda aquel muro en carnes*" when the said frontal was removed.

One possible reason for the preservation of the medieval altar-table for so many centuries is that since Gelmírez's day, and as the result of a concession from Pope Paschal II in 1102, the only celebrants allowed to use the high altar were the Archbishop and the seven senior canons of the chapter. The French pilgrim Vanti, after his visit to the cathedral, wrote in 1717 with regard to the high altar that "*no puede allí celebrar más que el arzobispo y los canónigos cardenales, los cuales en número de siete, recíprocamente, semana a semana, cantan allí la misa. Y si falta uno de ellos o por enfermedad o por otro motivo, se hace un altar portatil fuera del peldaño [se refiere al último nivel del presbiterio] donde celebra un canónigo simple.*"[67] This statute was maintained until the Concordat of 1851, during the reign of Isabel II, when the said privilege was withdrawn, enabling all duly authorized canons and priests to say mass at the said altar from then onwards.

With regard to when exactly it was destroyed, on 31 October 1658, after Vega y Verdugo's appointment as cathedral warden, a chapter committee was set up to oversee expenditure "*en la fábrica y edificio del altar de la capilla maior y obras a éste conserníentes que están comenzadas a hazer.*" This was in all probability the starting point for the dismantling of the old medieval altar-table and its replacement by the new Baroque marble one, although the physical work may well have taken place several years later. In fact, the most likely date for its disappearance would be 1669, the year in which red and black marble and jasper from Portugal, Toledo and Cehegín were bought for the construction of the present-day flooring of the presbytery.[68] The construction of the base of the small room, the cenotaph and the tables of the high altar and the retrochoir, all done in the same materials as those mentioned above, must also date from the same year or thereabouts.

Years after the dismantling of Vega y Verdugo's table and on the occasion of the construction of the crypt in the foundations of the Roman mausoleum with the remains of the Apostle, recently discovered in 1879, López Ferreiro himself, highly aware of the symbolic value of Gelmírez's stone slab, used it again as the top of the altar in the new underground room, where it remained until 1891. In that year the altar was clad in slabs of marble, including the top, and was given a new frontal, the alleged medieval

65 *Viage de Ambrosio de Morales por orden del Rey D. Phelipe II a los Reynos de León, y Galicia, y Principado de Asturias...* op. cit., pp. 119–20.
66 M. Taín Guzmán, "Prolegómenos de una excavación en tiempos del canónigo José de Vega y Verdugo: el mito de la cripta del Apóstol Santiago y el retablo del arzobispo Gelmírez", *Goya*, 324 (Madrid: 2008), pp. 200–16.
67 G. L. Buonafede Vanti [1719], *Viaggio occidentale a S. Giacomo di Galizia, Nostra Signora della Barca e Finis Terrae (1717–18)*, ed. Guido Tamburlini (Trieste: Università di Trieste, 2004), p. 81.
68 M. Taín Guzmán, "El viaje a Lisboa del canónigo fabriquero José de Vega y Verdugo (1669)," *Quintana*, 1 (Santiago de Compostela: 2002), pp. 306–7.

stone slab being preserved inside, according to López Ferreiro.[69] After personally inspecting the place I am unable to affirm whether the said block of stone is still underneath the present one. Nevertheless, with this arrangement, namely an altar containing the aforementioned medieval stone slab and on top the new silver chest with the relics of Saint James and his disciples, a reminder of the one from Gelmírez's day and commissioned by López Ferreiro according to Vega y Verdugo's drawings, the intention was clearly to imitate the layout of the Romanesque altar in the chancel built by the great Archbishop.

The *tabula* converted into a cenotaph

Gelmírez's third intervention with regard to the high altar was to commission, in or about 1133, a small silver retable, a *tabula retro altaris* that also survived until Vega y Verdugo's day. This item, the work of an unknown craftsman, mentioned in the *Historia Compostellana*[70] and studied by Serafín Moralejo, is analyzed in the chapter that our prebendary devotes to the *Sepulcro* in his *Memoria*, with an illustration in his own hand. The retable was a five-sided object in silver, decorated with cameos and ancient stones, with a relief of Our Savior in the center and the twelve Apostles on either side of him, on two levels. The lower level features eight of the Apostles, standing in a portico of trilobate arches. The upper level, on the other hand, not only contains the four remaining Apostles, but also two other figures, who we can assume to be the Virgin Mary and Saint John the Evangelist, to the left and right of the central image, respectively. Finally, the center is occupied by Jesus Christ, seated on a throne with footstool, his outspread arms revealing the wounds of the crucifixion on his hands.

Curiously enough, in 1656 Gelmírez's *tabula* was embedded in a box of gilded wood, something like a chest, and with whose front we are familiar thanks to another drawing by our prebendary. This enables us to understand the words of Magalotti when in 1669 he wrote that on the high altar "[...] *se dice que se conserva el cuerpo del Apóstol en una caja de plata colocada sobre el altar mayor, si bien medio cubierta por adornos de madera dorada.*"[71] In the drawing the addition consists of two reclining figures "*dormidas, al modo de guardas*" along the edge of the pediment and of a frieze of shells and criss-crossed staffs supported by two Corinthian pilasters with grooved shafts. This would be the result of the work done between 1553 and 1554. Indeed in on 9 September 1553 canons Rodrigo Rodríguez and Vasco de Rebellón informed the chapter

> "[...] *del estado de la obra del retablo que se aze para el altar mayor y de la costa que avía de llebar de plata y de la forma de triángulo en que se aze el maderamiento para el dicho retablo; por ende que mandaban e mandaron quel dicho retablo se aga e acabe de la manera que está començado e se guarneza de plata. Y mandaron al [...] canónigo Pedro Maldonado dé para ello a los dichos señores canónigos, e a cada uno dellos, toda la plata que fuere menester para el dicho retablo.*"[72]

On 15 January of the following year the chapter ordered "*agan hazer e acabar las obras del retablo,*" a probable reference to the fact that the Renaissance addition had not yet been covered with sheet silver, a task that would in fact never be carried out if we are to go by Vega y Verdugo's description of the piece. The finished work was seen by

69 *Altar y cripta del Apóstol Santiago, reseña histórica desde su origen hasta nuestros días...* op. cit., pp. 11, 34.
70 *Historia Compostelana...* op. cit., pp. 573–4.
71 L. Magalotti [1669], *Viaje de Cosme de Médicis por España y Portugal (1668–1669)*, ed. A. Sánchez Rivero and A. Mariutti (Madrid: Sucesores de Rivadeneyra, 1933), p. 334.
72 ACS~Archivo de la Catedral de Santiago: *Libro 15 de Actas Capitulares* (1553), leg. 515, fol. 58r.

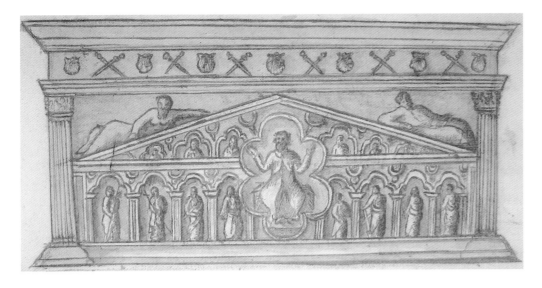

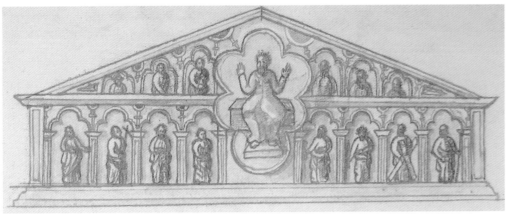

Retable donated by Archbishop Gelmírez [Memoria sobre las obras en la Catedral de Santiago]
José de Vega y Verdugo
1657
ACS~Archivo de la Catedral de Santiago de Compostela

Retable donated by Archbishop Gelmírez in 1655–1656 [Memoria sobre las obras en la Catedral de Santiago]
José de Vega y Verdugo
1657
ACS~Archivo de la Catedral de Santiago de Compostela

Ambrosio de Morales in 1572, who declared that *"el retablo del altar no es más que una como arca."*[73] Our canon also reflected on this fact, writing *"otros fabriqueros más modernos que los que mandaron acer la figura dicha de plata [se refiere a la 'tabula' medieval] que, biéndola tan delustrada y tan antigua, la procuraron ermosear, guarneciéndola con aquel cornisón de madera dorada, con aquellas dos figuras tendidas sobre el sepulcro dormidas al modo de guardas, cuydando de que no se abra. Y como digo, tanbién dispusieron el cornijón en forma de erario, siguiendo la forma de caxa u arcón, al modo de sepulcro."* García Iglesias relates the figures of the two guardians to the four allegories of time carved by Michelangelo for the tombs of the Medici.[74] In both cases the artist chose reclining figures because they are the most appropriate type for funereal sculpture due to their association with death, sleep and the loss of the living spirit.

Fortunately, a comparison of this second drawing with the first enable us to identify a large proportion of the group of apostles depicted. However, the observable differences between the figures in the two drawings, which are pointed out in notes, indicate that the author drew them from memory. Thus, on the lower level and from left to right, we have an apostle with what looks like a halberd, who could either be Saint Judas Thaddeus or Saint Matthew; Saint Philip with a long-staved cross; another apostle with what looks like a book, a common attribute of most apostles, but particularly of Saint Matthew, given his status as an evangelist; Saint Paul with his sword; Saint Peter with a key; Saint Andrew with his characteristic

73 *Viage de Ambrosio de Morales por orden del Rey D. Phelipe II a los Reynos de León, y Galicia, y Principado de Asturias...* op. cit., p. 120.
74 J. M. García Iglesias, "La visita de Cosme III de Médicis a la catedral de Santiago," in id. (ed.), *El viaje a Compostela de Cosme III de Médicis* (Santiago de Compostela: Xunta de Galicia, 2005), pp. 589–90.

X-shaped cross; an apostle with what appears to be a sharp instrument, perhaps the tanner's knife of Saint Bartholomew; and Saint Thomas with a spear. On the upper level, also from left to right, it is only possible to identify Saint James the Apostle under the first arch, the only one of the Apostles to be mentioned by name in the *Memoria*. He is portrayed with a beard, the characteristic broad-brimmed pilgrim's hat and a short cloak.

The recency of some of the apostles' attributes (e.g. Saint Andrew's X-shaped cross, Saint Jude's supposed halberd or Saint James' pilgrim attributes) indicate alterations made to the original work at a later date. The most striking case is that of Saint James, who, as we have already mentioned when dealing with his depiction on the frontal, was represented in Gelmírez's day as an Evangelizing Apostle and never as a pilgrim, which is how he appears in Vega y Verdugo's drawing, in which the iconography dates from the Modern Age. These iconographic changes must date from 1553–1554, when the retable was transformed into a chest.

Barely six years later, in 1560, the chapter decided to replace Gelmírez's retable with a Renaissance one, also in silver. Thus, in their meeting held on 4 April, the canons resolved

> "[...] *que por quanto el remate del retablo de plata que se ha de hazer para el altar mayor del señor Santiago se ha de hazer para el día de Pascoa de Resureçión deste mismo año, que cometían y cometieron e dieron poder e facultad a los señores Bartolomé Bonifaçio, cardenal mayor, e cardenal Ternero e chantre Revellón para que juntamente con el señor cardenal Mondragón, obrero, hablen con el reverendísimo y ylustrísimo señor arzobispo [Gaspar de Zúñiga], nuestro señor, y con los ofiçiales que venieren para hazer el dicho retablo e traten con ellos el modo y forma y condiçiones y lo más que a su buena providençia paresçiere conviene hazerse e trayan de todo ello relaçión al cabildo.*"[75]

Various silversmiths tendered their services for this work, Antonio de Arfe amongst them. Finally, on 10 May the project was allotted to the silversmith Juan Álvarez:

> "*En este cabildo los dichos señores dixeron que mandaban y mandaron al señor cardenal Ternero, depositario de los dineros de la Bulla de Santiago, dé y pague a Juan Álbarez, platero, vezino de Valladolid, ochenta ducados por razón del trabajo e ocupaçión que tuvo en hazer las mostras para azer el retablo de plata que se ha de azer en el Altar Mayor desta Santa Iglesia y por aver venido a tomar y fazer el dicho retablo. Y más que dé y pague [a] Antonio Darfe, platero, cinquenta ducados; a Andrés Rodríguez, platero, vecino de León, treinta e cinco ducados; a Guillermo, platero, vecino desta cibdad de Santiago, doze ducados por el bien que hizieron en la obra del dicho retablo.*"[76]

Nevertheless, the project never came to fruition and Gelmírez's retable survived until Vega y Verdugo's day.

The position of the chest on the high altar at the time when our canon did his drawing was on the altar-table, between Antonio de Arfe's monstrance and the image of the Apostle. And there it had remained since the altar was renovated in the sixteenth century, since it is the same position as that indicated in the 1569, 1649 and 1658 inventories of the cathedral silver and ornaments. It also coincides with the space

75 ACS~Archivo de la Catedral de Santiago: *Libro 16 de Actas Capitulares* (1560), leg. 516, fol. 63v.

76 Ibidem, fol. 71r. On this topic see *Historia de la Santa A. M. Iglesia de Santiago de Compostela...* op. cit., vol. 8:11, pp. 189–93.

previously occupied by Gelmírez's retable, as revealed, although without the monstrance due to their date, in the two Flemish paintings of the chancel. On the panel in the Museum of Indianapolis the iconography of the retable is accurate, although incorrectly arranged, since Christ is depicted as giving his blessing and flanked by his twelve apostles in a single frieze of Gothic arches, without the triangular pediment and the images of the Virgin and the Evangelist. On the other hand, in the Tournai miniature the pentagonal shape of the piece is depicted correctly, but the biblical scenes portrayed have no connection whatsoever with reality.

The accounts of many pilgrims wrongly identify the chest as the urn that contained the Apostle's remains. For example, one Corsini writing in 1669, close to the date of the latter's manuscript, said "*en la capilla mayor* [...] *está el altar con la caja donde dicen estar el cuerpo de Santiago*"[77] whilst Magalotti states that "*aquí dicen que se conserva el cuerpo del Apóstol en una caja de plata colocada sobre el Altar Mayor.*"[78] Several years later, in mid-November 1673, the Bolognese priest Domenico Laffi, on the occasion of the visit paid to the cathedral by Pedro Pablo Jiménez de Urrea, Count de Aranda, Captain-General of Galicia and Viceroy of Aragon in 1668, attended the opening of the alleged sepulchre, the chest drawn by Vega y Verdugo, to affix some sheet silver:

> "[...] *y la causa principal aún, que nos quedásemos, fue porque dijeron, que en tres o cuatro días, a la llegada del virrey, se debía abrir el Sepulcro de Santiago, para adornarlo de nuevo, y cubrirlo con láminas de plata decoradas con figuras, con bellísimos cincelados, como después hicieron el segundo día después de su llegada, que Dios nos hizo esta gracia, que fuésemos espectadores de una función tan hermosa, que por tantos años no se había abierto nunca, porque nunca había habido ocasión tan urgente, que se llegase a este hecho, como entonces, porque habiendo sido por los señores canónigos y fabriquero rehecha en el presente de nuevo la Capilla de este Santo Glorioso, y su Sepulcro de la misma manera restaurado, al rodearlo de bellísimas láminas de plata, como he dicho, todas diligentemente decoradas con figuras en bajo relieve, y otros magníficos trabajos; para lo cual necesitaron algunos clavos de plata, los cuales, al clavarlos, penetrando en el interior, hicieron saltar muchas piedrecillas de finísimos mármoles de varios colores, con los cuales está adornado por dentro el sepulcro con varios trabajos tipo mosaico.*"[79]

This account confirms the description given by our prebendary of an urn consisting of a box with a lid, although the latter was not sketched by the canon. Similarly, it documents a final intervention on the item in question, in this case one of embellishment, but occurring after our prebendary had left Santiago for Granada.[80] With regard to the stones that came off, as mentioned by Laffi, I wonder, as does Guerra Campos, whether they were not perhaps the stones embedded on the back of Gelmírez's medieval *tabula*, which by that time would have been inside the chest and therefore no longer visible to the public gaze.[81]

This mention of the chest in Laffi's account, as late as 1673, also indicates that despite Vega y Verdugo's declared intention in his manuscript to do away with it, and in spite of his probable efforts in this sense whilst cathedral warden, the likely opposition shown by the chapter would have prevented him from doing so, the item becoming part of the Baroque decoration designed by our canon until a time as yet unknown.

77 O. Tavoni, "La Galizia nella relazione inedita di Filippo Corsini relativa al viaggio di Cosimo III dei Medici," in P. Caucci (ed.), *I testi italiani del viaggio e pellegrinaggio a Santiago de Compostela e diorama sulla Galicia* (Perugia: Università degli Studi di Perugia, 1983), p. 68. A. Fucelli, "Il viaggio a Santiago de Compostela di Cosimo III dei Medici nella relazione inedita di Filippo Corsini. Aspetti devozionali e mondani," in *Actas del Congreso de Estudios Xacobeos* (Santiago de Compostela: Xunta de Galicia, 1995), p. 332.

78 *Viaje de Cosme de Médicis por España y Portugal (1668–1669)...* op. cit., p. 334.

79 D. Gambini, "La Galizia nel Viaggio in Ponente di Domenico Laffi," in *I testi italiani del viaggio e pellegrinaggio a Santiago de Compostela e diorama sulla Galicia...* op. cit., pp. 106–7.

80 This intervention is neither mentioned in the Chapter Minute Books nor in the Property records. Unfortunately the pages on which "*lo que ordenó el cavildo sobre la legazía hecha al señor Conde de Aranda*" in the chapter meeting held on 14 November were left blank due to an oversight on the part of the secretary. See ACS~Archivo de la Catedral de Santiago: *Libro 35 de Actas Capitulares* (1672), leg. 627, fols. 515v–516r.

81 *Exploraciones Arqueológicas en torno al sepulcro del Apóstol Santiago...* op. cit., pp. 239–48.

Francisco Singul

A Granite Shaft Possibly from a Column on the Paradise Front of the Cathedral of Santiago de Compostela

1 AHDS, *Fondo General*, 298. *Obras de la Cathedral. Cartas del Cavildo a S. S. Y. sobre reedificarse las dos fachadas de la Cathedral: la que dice a la Platería y thesoro: y la de la Azebachería*. Years 1757, 1758 and 1759, s.n. The topic was dealt with, among others by F. Singul, *La Ciudad de las Luces. Arquitectura y urbanismo en Santiago de Compostela durante la Ilustración* (Santiago de Compostela: Consorcio de Santiago, 2001), pp. 181–97. E. Beiras García, *Lucas Ferro Caaveiro e a cidade de Santiago de Compostela* (A Coruña: Fundación Caixa Galicia, 2008), pp. 63–77.

2 The whole apse of the cathedral is drawn on this plan from 1739, the transept with its fronts and three main aisles, including the chapels in the ambulatory, *La Corticela*, the Clock Tower, *La Quintana* and the *Plaza de Azabachería*. There is also a drawing of the internal elevation of *La Corticela* and the north transept. This graphic document was analyzed by M. C. Folgar, published by Alberto Fernández in 2003. M. C. Folgar de la Calle, *Arquitectura gallega del siglo XVIII. Los Sarela* (Santiago de Compostela: USC~Universidad de Santiago de Compostela, 1985), p. 30. Id., *Simón Rodríguez* (A Coruña: Everest, 1989), pp. 15, 180. A. Fernández González, "Un viejo plano olvidado en el Archivo de la Catedral de Santiago: la *Porta Francigena*, su atrio y la Corticela en 1739," in *Compostellanum*, 48 (Santiago de Compostela: 2003), pp. 701–42.

3 ACS~Archivo de la Catedral de Santiago: *Libro de Actas Capitulares*, 56 (1756–1762), 127r: *Tocante a la fachada de la Azabachería*, Chapter meeting of 30 January 1759.

4 *La Ciudad de las Luces...* op. cit., pp. 187–8.

5 "Un viejo plano olvidado en el Archivo de la Catedral de Santiago: la *Porta Francigena*, su atrio y la Corticela en 1739"... op. cit., pp. 717–20.

6 *Liber Sancti Iacobi Codex Calixtinus*, trans. A. Moralejo, C. Torres and J. Feo (Santiago de Compostela: Instituto Padre Sarmiento de Estudios Gallegos, 1951; reed. fac. Santiago de Compostela: CSIC~Centro Superior de Investigaciones Científicas, 1999), V, 9, pp. 595–6.

Seven years after unveiling the Baroque Obradoiro front (1738–1750), the chapter of the Cathedral of Santiago decided to continue the process of renovating the fronts of the Church of Santiago. In a letter addressed to Archbishop Rajoy, dated 18 December 1757, dean Policarpo de Mendoza reported the decision, claiming that the canons had opted for starting the work on the Azabachería, due to the poor state the northern front was in, apparently in need of urgent repair work.[1] We do not know if dean Mendoza was exaggerating when he described the double north arch as a ruin on a plan of the cathedral drawn in 1739 by foremen Simón Rodríguez and Francisco Sarela, on the occasion of a lawsuit between the parish priest of La Corticela and the chapter.[2] The structural soundness of the Romanesque front at this time seemed to be free from problems, in the light of what could be seen on the floor plan and elevation detailed in the drawing – neither do the architects make any comment in their respective reports – although it is possible that some reliefs and decorative details might have come loose, maybe a column was out of place. Specific pieces, in short, that could have been a threat in the mid-eighteenth century to the safety of those who entered through the *Porta Francigena*, still very busy at that time, but this would not justify the demolition of the Romanesque work.

Once they had taken their decision, the canons entrusted cathedral foreman Lucas Antonio Ferro Caaveiro with the design of a new front and the demolition of the medieval one; work started in February 1759.[3] The first section of the front was finished towards the end of 1762, and even though it evokes the triptych of the Obradoiro, its anticlassical architectural structure[4] can be seen in the plan to be the heir of medieval times, as it articulates into three different aisles separated by columns on pedestals, which hold up a broken entablature. The central aisle is lit up by the two entrances – recalling the Romanesque double arch – separated by a quadrangular pillar, retracted and holed, which works as a mullion and shows the pre-existing medieval structure, in which as we know, thanks to the 1739 plan, there was no central column to separate the two doors.[5]

We have a detailed description of the old north front in Book V of *Codex Calixtinus*,[6] as well as a significant number of reliefs embedded in the south front and others conserved in the Cathedral Museum, together with shafts and fragments of marble column shafts that flanked the two doorways. The north doorway was similar to *Platerías*, but with shorter archivolts and lower but more numerous

columns. Its design, as it was urgent to conclude the work given that it was the door pilgrims used most, was a kind of test for the south front. S. Moralejo[7] pointed out that the careful proportions of *Platerías*, organized with slender columns that elevate the lintels and the foot of the archivolts to an approximate height of 5 m, are an esthetical achievement with the previous experience of the lost north front behind them. Each of the two northern doors was decorated with six columns holding up the archivolt system. This system was significantly improved on the south front, where only eleven columns were needed, as the central one is a common element to both external archivolts. Given its nature as the doorway at the end of the Pilgrims' Road to Santiago, the north front, open to the daily hubbub of the *Plaza del Paraíso*, was the start of the iconological program for the three fronts on the building.

The program for the north front was put together from 1101–1111,[8] after Gelmírez's journeys to Rome, in 1100, to be ordained Subdeacon in Saint Peter's by Pope Paschal II,[9] and in 1105, as Bishop of Santiago, to receive the yearned after dignity of the Pallium from the hands of the same pontiff in the Basilica of San Lorenzo fuori le Mura,[10] an antecedent to the rank of metropolitan, with which he was endowed in 1120. In the trip in 1105, Gelmírez and the members of the curia that were accompanying him took good note of the public and sacred spaces that exalted the abbey of Cluny and the Holy See with their artistic decoration; it was an intellectual and representative spur that led to a kind of imitation in Santiago. It is even possible, as Castiñeiras suggests,[11] that the main author of the sculptures on the north front, the "Master of the *Porta Francigena*," formed part of Gelmírez's entourage on his trip to Rome.[12]

Granite and marble columns with a helical shaft were used in the structure of the north front, cut between 1106 and 1110, after Gelmírez's second trip to Rome.[13] Of the twelve columns that framed these doors, the Cathedral Museum conserves six marble shafts, four 185 cm high and three shaft fragments of less than 1 m – two of which were joined in the restoration, as they formed part of the same shaft – all of them with a diameter of 25 cm. The pieces, which would originally have been 2 m high (2.40 m with the base and capital),[14] were cut by masters endowed with a style inherited from the Frómista-Jaca tradition, sensitive to the archaic taste imported from Rome (other members of the workshop synthesize this Spanish tradition with the rich experience of Toulouse-Moissac and inspiration in the arts

7 S. Moralejo, "La primitiva fachada norte de la Catedra de Santiago," *Compostellanum*, 14 (Santiago de Compostela, 1969), pp. 623–68, esp. pp. 629–32.
8 M. Castiñeiras, "Roma e il programma riformatore di Gelmírez nella cattedrale di Santiago," in A. C. Quintavalle (ed.), *Medioevo: immagini e ideologie* (Milan: Mondadori Electa, 2005), pp. 211–26, esp. pp. 217–20. Id., "La meta del Camino: la catedral de Santiago de Compostela en tiempos de Diego Gelmírez," in M. C. Lacarra Ducay (ed.), *Los caminos de Santiago. Arte, historia, literatura* (Saragossa: Institución Fernando El Católico, 2005), pp. 213–52, esp. pp. 231–5.
9 *Historia Compostelana*, trans. E. Falque Rey (Madrid: Akal, 1994), I, 8, pp. 85–6.
10 Ibidem, I, 16, pp. 99–106.
11 M. Castiñeiras, "Fragmento de fuste con *putti* vendimiadores," in *Luces de Peregrinación* (Santiago de Compostela: Xunta de Galicia, 2003), p. 152.
12 According to S. Moralejo, this artist from Compostela was endowed with a style characterized by the creative synthesis of the Jaca and Toulouse tradition; the faces and arms of the figures he cut have the morbid archaic plasticity of Frómista-Jaca, while the graphics of the folds in clothes comes from Toulouse, influenced by sumptuary art's own solutions, especially work in ivory. Cf. S. Moralejo, "Fragmento de figura femenina con acios de uvas," in *Santiago, Camino de Europa. Culto y Cultura en la peregrinación a Compostela* (Santiago de Compostela: Xunta de Galicia, 1993), pp. 389–90.
13 "Roma e il programma riformatore di Gelmírez nella cattedrale di Santiago"... op. cit., p. 218.
14 "La meta del Camino: la Catedral de Santiago de Compostela en tiempos de Diego Gelmírez"... op. cit., p. 234.

15 The legend of Tristan and Isolde was very familiar to pilgrims from Brittany, France, England and Scotland in the eleventh and twelfth centuries, and was known in Compostela by oral tradition. The column thus cut speaks of the clumsy sensuality that characterizes all carnal passion and leads to worse sins such as adultery. The didactic and moralizing sense of the sculpture is evident in the meaning this story had for the faithful and pilgrims. Cf. S. Moralejo, "Fuste historiado con lenda épica (Tristán?)," in *Santiago, Camiño de Europa...* op. cit., pp. 382–3.

16 M. Mikahil Boccalato, "Tristâo e Isolda e as trovas corteses: faces do imaginário medieval," in *Actas do I Encontro Internacional de Estudos Medievais* (São Paulo: USP~Universidade de São Paulo, 1995), pp. 292–300.

17 S. Moralejo, "Fragmento de fuste decorado con *putti* vendimiadores," in *Santiago, Camiño de Europa...* op. cit., pp 380–1.

18 "Fragmento de fuste con *putti* vendimiadores"... op. cit., p. 150. Id., "Roma e il programma riformatore di Gelmírez nella cattedrale di Santiago"... op. cit., pp. 217–8. Id., "La meta del Camino: la catedral de Santiago de Compostela en tiempos de Diego Gelmírez"... op. cit., p. 233.

19 L. Martín Ruíz, *Cruceiros na provincia da Coruña*, vol. 1:3 (A Coruña: Diputación Provincial de A Coruña, 1999), p. 305.

20 A popular construction, by stonemasons known as *santeiros*, and related to popular worship, especially from the eighteenth century onwards. Cf. C. González Pérez, "Cruceiro," in *Gran Enciclopedia Galega Silverio Cañada*, vol. 12:23 (Lugo: 2003), p. 240.

of gold and silverwork). From the stylistic point of view, the columns of the *Paradisus* are the fruit of the wealth of art generated along the Pilgrims' Road to Santiago. The iconography of most comes from the Paleochristian tradition. With the exception of one, decorated with the profane story of the epic legend of Tristan and Isolde,[15] the first passionate love story in western literature that ends in death,[16] the other columns depict a topic that according to Serafín Moralejo[17] is the expression of the apostolic vine. The *putti* or grape harvesting genies that decorate the surface of the helical shafts exhibit anatomies and attitudes that recall the classical and Paleochristian tradition, a reflection of the same decorative-symbolic topic that covers the surface of the helical shafts on various columns cut by Roman marble workers at the end of the eleventh century for the churches of Santa Trinità dei Monti (Rome) and San Carlo a Cave (Palestrina), medieval interpretations of the columns of the pergola in the Constantinian basilica of Saint Peter in the Vatican.[18]

Gelmírez's trip to Rome in 1105, apart from the fortunate collection of the Pallium, was fruitful in appropriating artistic ideas. In the same way as other members of religious orders and artists from Italy had done before him, the Bishop from Compostela adopted the Roman motif of the apostolic vine for his own, and did not hesitate to use it in Santiago in the decoration of the north front of his cathedral. The memory of the apostolic seed and the first centuries of Christianity, implicit in the Gregorian Reform under papal auspices and adopted by Gelmírez, was tacitly expressed in the remains of the world that they were appealing to, and so the reliefs on the columns of the *Paraíso* contrasted the scenes of grape harvesters (the task of the good Christian) with other scenes in which the vine is trampled underfoot and covered with birds and four-footed animals that are violently biting the plant (an allegorical image of the ill-fated action of heresy). This destruction of the vine, opposed to the laborious work of the *putti*, influences the depiction of the duality of sin-redemption, the main topic of the north front, expressed through the depiction of the creation and fall of the human race and the announcement of its redemption.

The same decoration with a helical frieze of grape harvesters enframed in a torus among semicircles surrounds the granite shaft of a stone cross in the parish field of Santa María de Lamas (Boqueixón, A Coruña), just a few meters from the church atrium. This granite cross[19] has the characteristic parts of this type of popular monuments,[20] well assembled by the stonemasons who made it: a quadrangular base with three steps, on which is a cubic pedestal with our helical shaft, profusely decorated in relief – although erosion over time has made it difficult to distinguish the iconography – finished in a capital with a possible classicist inspiration. The astragalus, smooth conical tambour and prismatic abacus decorated with volutes in the corners are all present, together with a human figure on each of the four faces, very superficial – and also much eroded – but depicting a person at prayer with arms held on high; the crucifix is on this structure, a wooden cross to which the image of Christ is attached by three nails, on the obverse. The dramatic scene, the culmination of the Passion, is completed on the reverse side of the cross by the Pietà. As is common on this kind of popular monument, the lack of

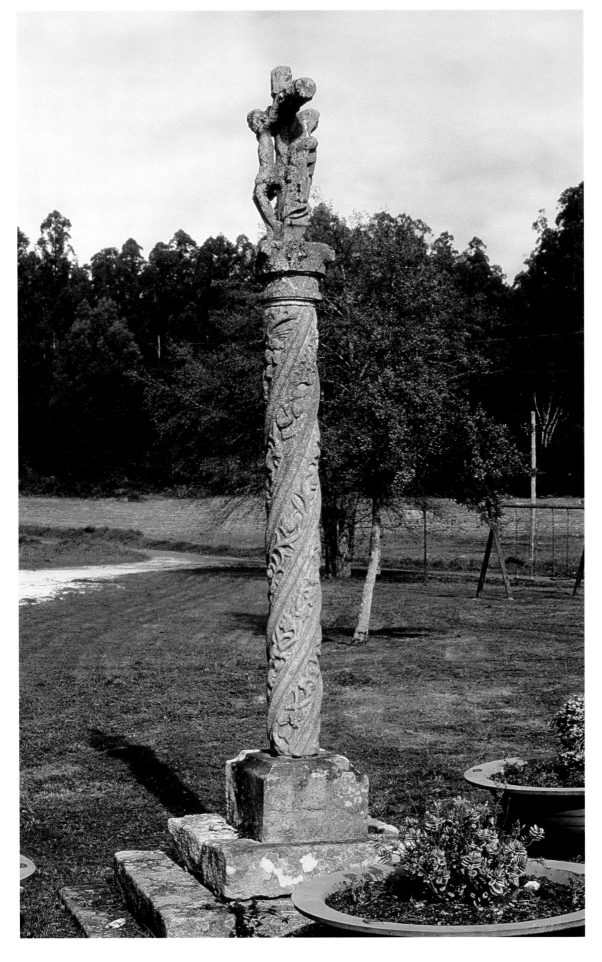

Santa María de Lamas stone cross
c. 1775–1800
Boqueixón, A Coruña

185

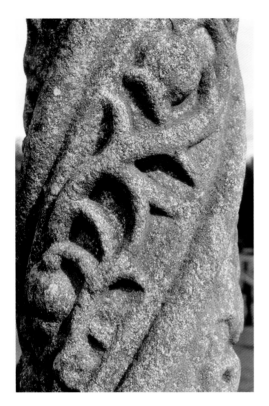

Shaft [Santa María de Lamas stone cross, *detail*]
1101-1111 (?)
Boqueixón, A Coruña

documentary sources[21] in the parish books – concerned with the church in the last quarter of the eighteenth century – would seem to denote a popular origin.[22]

The granite shaft used for the stone cross of Santa María de Lamas is 232 cm high and its diameter is 25 cm. The surface, whose helicoid turns in the opposite direction to the marble shafts in the Cathedral Museum, is basically decorated with the grape harvesters that characterize some of the marble shafts; the figuration has been heavily eroded by wind and rain and depicts the people intertwined with plant stems that seem to grow undulating upwards on the symbolic saving vine, hastening to pick bunches and other full fruits. From a stylistic point of view the piece evokes the style of the "Master of the *Porta Francigena*," with people's wide and rounded cheeks, although it is clear that the sculptor does not seem to be one of the most gifted workshop members; there is possibly better cutting in some of the best-conserved parts of the plant decoration, although it is almost imperceptible as the harsh open air has deteriorated the relief volumes considerably. As for its possible location on the Romanesque front, according to the 1739 plan,[23] we would suggest that it could have stood at the end of one of the doorways. The marble bases, much better conserved than this stone one, would have been in pairs in the internal archivolts, just next to the images of the holy guardian apostles who were blessing the faithful and pilgrims from the upper parts of the doorjambs in the City of God in Compostela – on the left door were Saint Peter (on the right jamb) and Saint Paul (the left jamb), while on the right were Saint John (right jamb) and Saint James (left jamb)[24] – leaving granite columns like the one that was reused in Boqueixón for the external archivolt of each door. This combination of materials used for the north front columns, marble and granite, made for a greater sophistication and elegance on *Platerías*.

The formal nature of the stone cross shaft of Santa María de Lamas, very different from the usual shafts on this kind of monument, leaves no doubt that it was once part of the lost Romanesque front from Gelmírez's times. We do not know for sure when the shaft was moved and placed on the stone cross – the typology could suggest, with all due caution, the end of the eighteenth or the first third of the nineteenth century – although it would not be the first time that a medieval piece from the Cathedral of Santiago, taken out of the building – more specifically from the cloister or the Matthean stone choir – found a place in a church, public fountain or stone cross in the surroundings of Santiago de Compostela. A medieval arch from the cloister ended up at the Church of Agualada (San Vicente de Amarantes, Santiago),[25] two stone figures from the medieval choir were incorporated into the fountain at San Pedro de Vilanova (Vedra)[26] – others now decorate the Holy Door[27] and the frieze at *Platerías* – and at an unknown date a singing child from the choir of Mateo and his school ended up on the stone cross shaft in the cemetery of Nemenzo (Santiago).[28]

In the twelfth century the shaft that now forms part of the stone cross of Santa María de Lamas was part of a decorated front with a rich imagination in stone and a profound religious message, lying at the end of the Pilgrims' Road to Santiago and used as the scenario for the atrium where on Ash Wednesday certain penitential

21 A common problem when studying stone crosses in Galicia, as J. J. Burgoa Fernández recalls in his works: "La catalogación y protección de los cruceros. Los ejemplares de los municipios de Sada y Oleiros," *Abrente*, 30 (A Coruña: 1998), p. 154. Id., *Los cruceros, el patrimonio etnográfico y el arte religioso popular: cruceros y petos de los municipios de Moeche, Somozas y San Sadurniño* (A Coruña: Universidad de A Coruña, 2003), p. 44.
22 When studying the history of a stone cross the researcher comes up against a clear lack of documents in the corresponding church books, and cannot find out who its authors were, "*tal vez debido a que la mayoría de las veces sus contratos se apalabraron de manera verbal o sus obras fueron la consecuencia derivada de otros trabajos considerados de mayor rango o entidad y para los que fueron contratados en principio:*" ibid., p. 82.
23 "Un viejo plano olvidado en el Archivo de la Catedral de Santiago: la *Porta Francigena*, su atrio y la Corticela en 1739"... op. cit., p. 717, figs. 1, 9.
24 *Liber Sancti Iacobi Codex Calixtinus...* op. cit., V, 9, p. 596.
25 R. Yzquierdo Perrín, "Arte Medieval (II)," in *Galicia. Arte*, vol. 11:16 (A Coruña: Hercules de Edicións, 1995), p. 186.

ceremonies were held before indulgences were obtained. In front of the *Paradisus* in Compostela Gelmírez's sculptors depicted the power of the symbolic image, a non-naturalist image that did not depend on appearance but rather formed part of an elevated spiritual message, subtle, but intelligible for medieval man, so used to the decorative and symbolic codes of his time. When the front was taken apart the message was lost, for both the ecclesiastical elite who promoted the destruction of the whole and the faithful congregation, who had forgotten the majority of the interpretative keys, obviously respecting the sense of the sacred image, intelligible to all, most of which was reused on the *Platerías* front. It is quite possible, however, that in the reuse of the granite shaft as the column of a stone cross, the Old Testament symbolism on the north front and on this piece in particular was taken into account in such a way that an evocation of Original Sin, so common on stone crosses in the province of Pontevedra and the south of A Coruña,[29] could be read on the shaft's helical reliefs, possibly identified at the time of its reuse as the Tree of Life in Eden, whose fruit was taken by Adam and Eve after they were tempted by the serpent.

26 The building of the fountain was ordered c. 1670, together with a chapel and a small hospital for pilgrims, by the canon from Compostela Don Pedro Valdés Feijóo y Noboa, which explains the reuse of the two images from the stone choir – Joel and David – in a Baroque fountain. Cf. R. Otero Túñez and R. Yzquierdo Perrín, *El Coro del Maestro Mateo* (A Coruña: Fundación Pedro Barrié de la Maza, 1990), pp. 39–41.

27 There are twenty-four images on the outside and two flanking the Holy Door inside the cathedral: ibid., p. 37.

28 A. González Millán, "Contribución a la recuperación del coro del Maestro Mateo y su taller: un original hasta ahora inédito," *Abrente*, 29 (A Coruña: 1997), pp. 81–90.

29 *Los cruceros, el patrimonio etnográfico y el arte religioso popular: cruceros y petos de los municipios de Moeche, Somozas y San Sadurniño...* op. cit., p. 89.

The Fortune of Diego Gelmírez in the Cultural Tradition of Galician Nationalism

Few figures, if indeed any, have left their mark on the history of Galicia to such an extent as that of Archbishop Diego Gelmírez. In a nation characterized by the hegemony of the communal over the individual, outstanding figures are scarcer than bishops. But in the case of Gelmírez an exception has to be made, one which with a certain degree of liberality could be extended to only very few more (the counts of Lemos and Gondomar, perhaps Martín Sarmiento or, nearer to the present day, Alfonso Daniel Rodríguez Castelao). But, as Manuel Murguía warned us in the first modern biography of this personage, if generally speaking there are very few figures who are ahead of their times, "in the history of Spain, Gelmírez was one of them. In that of Galicia, [he was] the only one." Murguía himself thought of his biography of Gelmírez as an assertion, in the manner of Carlyle, in favor of the role of great individuals or "superior men" in the history of mankind.

Gelmírez's status as Archbishop and Prince of the Christian Church, in a historical context of the establishing of the city of Santiago de Compostela as a place of pilgrimage, would on its own be enough to grant him this decisive weight in the course of Galician history. So would his organizational ability to transform the government of the cathedral and the education of its canons, just as his work in extending the urban confines of the city of Compostela and his unflagging desire to restore the goods of his church would constitute sufficient merits to guarantee him a place of honor in the history of medieval Galicia. But Diego Gelmírez was, as well as an Archbishop, an essential political figure who played a major role in two areas that have so greatly influenced the later history of Galicia, namely the appearance of the kingdom of Portugal and the definitive incorporation of the kingdom of Galicia into that of Leon, and later in that of Castile (albeit many years after Gelmírez's death). Nothing of what went on during his times was alien to him, particularly in the Christian kingdoms of western Spain.

The historical relevance of Diego Gelmírez was expressly recognized by his own contemporaries. His direct and personal dealings with great monarchs, including both Alfonso VI and his grandson Alfonso Raimúndez, whom he protected until he was able to crown him King of Galicia, whilst still a child, in the Church of Compostela in 1111; his privileged relations with Cluny Abbey and the House of Burgundy, exemplified in his dealings with Abbot Hugo and Count Raymond of Burgundy, husband to Urraca and father of the future *imperator* Alfonso VII; his direct and personal relationship with the Papacy in Rome, a city to which he traveled on two occasions, these being the opportunity to obtain many of the prebends and prerogatives that were to enrich the episcopal see of Compostela. All of these facts speak loud and clear of the personal and

institutional relevance garnered by Gelmírez in the Europe of his time. In a text that is unique for the political context in which it was read, "Curso de Alta Cultura Naval" (1963–1964), Santiago Montero Díaz provided an excellent summary of Gelmírez's significance as an emblem of Galician history:

> "*Nosotros los gallegos contamos en nuestro pasado histórico un hombre singular por su complejidad, fascinante por su energía y su agudeza, su amor a la patria y su inextinguible lealtad a los ideales de galleguidad y cristianismo. Fue este hombre Diego Gelmírez [...] El gobierno de Gelmírez, con carácter autonómico, contribuyó a reforzar la conciencia gallega de unidad política y histórica y creó un precedente más, entre tantos otros, para un futuro de autodeterminación y soberanía de Galicia.*"[1]

Gelmírez himself was extremely aware of what he was and what he signified as a man who marked a complete era. In order to put this on record, he ordered a memorable work to be written, known as the *Historia Compostellana*. The opening words of this work, in the guise of a warning, leave no room for doubt: "*Diego, arzobispo de la sede compostelana por la gracia de Dios, ordenó escribir este libro.*"[2] This was the first pillar of the *fama* or memory of Gelmírez, since the *Compostellana* itself was conceived of by its prime mover and drafted by its various authors – particularly the "Galician" Munio Alfonso and the "Frank" Giraldo – as a narrative of the epic deeds or *gesta* of its protagonist, and also as a documentary inventory or *registrum* of the Archbishop's actions and the privileges and prerogatives he obtained for the Church in Compostela.

In spite of this concern of Gelmírez to prevent his deeds from falling into oblivion, his later fame varied considerably, since many of the tensions that marked his life continued in his posterity. Suffice to say, that not only the date of the Archbishop's birth is uncertain, but also that of his death and, more particularly, the exact location of the place where his remains were buried. A lack of information that reaches down to the present day and which has something of a *damnatio memoriae* on the part of his contemporaries and even of his successors on the episcopal throne at Compostela. In reality his figure only began to form part of the general history of Spain as a result of eighteenth century scholarship, although in a highly controversial manner. Whilst Flórez published the *Historia Compostellana* itself for the first time ever, with an introduction full of praise, in his well-known work *España Sagrada* (1765)[3] the Catalan scholar Masdeu coined some of the firmest and most adverse clichés ever to have been said about the prelate from Compostela, which would later be repeated by authors such as the Galician Benito Vicetto, the Portuguese Alexandre Herculano or, more recently, the Spanish

1 S. Montero Díaz, "Diego Gelmírez: historia de una fama" [Lecture given in Santiago de Compostela on 28 February 1964], in *Universidad de Santiago de Compostela. Cátedra de Alta Cultura Naval "Arzobispo Gelmírez." Conferencias del curso 1963–1964* (Madrid: Servicio de Publicaciones del Ministerio de Marina, 1965), pp. 69, 74.
2 *Historia Compostelana*, trans. E. Falque Rey (Madrid: Akal, 1994), p. 63.
3 "*Historia Compostellana*," in H. Flórez, *España Sagrada. Teatro Geográfico-Histórico de la Iglesia de España*, vol. 20:56 (Madrid: 1765).

medievalist Claudio Sánchez Albornoz. The memory of Gelmírez changed somewhat in the nineteenth century, when Galician historiography began to concern itself with his figure, from Vicetto and Murguía to that great historian of the See of Compostela, López Ferreiro, who wrote, in the opinion of Anselm Gordon Biggs, "the first modern contribution to our knowledge of Gelmírez," an opinion shared by Richard A. Fletcher when he considered the work of this canon of the Compostela Cathedral a "monument of devout historical learning." Be that as it may, his enthusiasm for Gelmírez is less than that he had for the Church at Compostela.

Apart from the biography by Murguía and the erudite rigor of López Ferreiro, one has to wait until the twentieth century to find any particular study devoted to the figure of Diego Gelmírez. One of the first, and most relevant, was the biography that the American author Anselm Gordon Biggs (1949) dedicated to him, in which he advises the reader that although Gelmírez was "the most relevant prelate in the peninsula" of his day, "he is not a very well-known personage." This would be followed by other contributions, most of them from foreign Hispanists (Reilly, Fletcher, Vones, etc.), but there were also some from a renewed Galician and Spanish historiography, such as those on the city of Santiago[4] (López Alsina 1988) or on the most emblematic of all texts from the times of Gelmírez, namely the *Historia Compostellana*, the subject of a succession of editions and translations from that published by José Campelo and Manuel Suárez[5] (1950) down to the most recent one by Emma Falque[6] (1994), which together greatly enriched the historiography concerning Archbishop Gelmírez.

Nevertheless, for a detailed analysis of the fortune of Gelmírez at the hands of historians a different set of skills would be needed, and I thus propose to thread together some reflections on Gelmírez's political fortune in various texts by authors from the successive periods of the history of cultural and political nationalism in Galicia. I shall basically focus on four of these, who constitute two pairs of writers with largely contrasting opinions: Benito Vicetto and Manuel Murguía in the nineteenth century and Alfonso Daniel Rodríguez Castelao and Ramón Otero Pedrayo in the twentieth. The positions adopted by these authors, in spite of the historical training almost all of them received, is of no interest insofar as their discoveries and contributions to Gelmírez's biographical vicissitudes are concerned, but rather as an indication of what each of them thought about the Galicia of their time and of how they placed it in the world, whether as a Western culture that was cut off from its natural place of expansion, namely Portugal (this being the central position adopted by Vicetto or Castelao), or as a manifestation of the grandeur of Galicia and of its connection with Europe through its relations with Cluny and Rome (this being the central position adopted by Murguía, and above all by Otero Pedrayo).

A brief overview of the standpoints of each of these authors clearly reveals a fundamental idea: as had already occurred in the time of Diego Gelmírez himself, no analysis of his person and his work can be undertaken in a "naive" manner, hoping to remain untouched: it means having to take sides regarding the kind of Galicia that one wishes to see built at any given time and what its future should be. By retrieving nowadays some of the characteristics of this controversy, which never reached the category of an intellectual or political debate, we should be better able to understand one of the lines of tension that characterized the history of Galicia, this being none other than that "loving

4 F. López Alsina, *La ciudad de Santiago de Compostela en la alta Edad Media* (Santiago de Compostela: Ayuntamiento de Santiago, 1988).
5 *Historia Compostelana*, eds. J. Campelo and M. Suarez (Santiago de Compostela: Porto, 1950).
6 *Historia Compostelana... op. cit.*

indecision," in the words of Murguía, although pronounced in a different context, that Galicia maintained between Portugal and Castile during several centuries. It was a kind of Gordian knot that came to the fore during the times of Gelmírez, one which the latter clearly severed in favor of Castile and Europe in preference to Portugal and the south.

Gelmírez, traitor and despot

The view of Galicia as a medieval kingdom that was denied any possibility of expansion by the appearance of the kingdom of Portugal is almost a commonplace in Galician cultural tradition. However, authors vary in the importance they attach to this historical event that occupied pride of place in the political sphere during the transition from the eleventh to the twelfth century, precisely at the time when Gelmírez was first Bishop and then Archbishop of Compostela (from 1100 to 1140). Prompted by his coming across a "*riola de portugueses pobres*" at the customs post in Hendaye during his journey to Berlin in the spring of 1930, Vicente Risco, a writer on a wide variety of subjects born in Ourense, seized the opportunity to reflect on the relations between Galicia and Portugal, referring back to Vicetto:

> "*El* [Vicetto] *insiste de cote na ideia das duas Galizas: a Galiza Lucense e a Galiza Bracarense. Embora se non poidan sinalar os lindeiros d'unha e doutra, o certo é que tal dualidade non soamente eisistiu, senón que foi decisiva – e por certo para mal – na nosa historia. N-efeito: namentral- a Galiza Lucense entregouse inerme e esquecida, os bracarenses souperon alongar Galzia deica o Algarve, sostela independente, e crear novas Galizas na América, na Africa, na India, na China e na Malasia. Namentral- a historia da Galiza Lucense é un perpetuo fracaso políteco, a de Portugal representa o trunfo da Galiza ideal, da Galiza galega...*"[7]

Risco's musings are not only a good reflection of many of Vicetto's ideas, but also establish one of the essential characteristics for the interpretation of the process of development of the history of Galicia: the genetic explanation for what is seen as the failure of Galicia as a political project. The rift between the two ancient convents of the *Gallaecia* of the Romans and the Suevii began to make itself apparent in the eleventh century with the defeat of the King Don García, which was followed by the partition of the kingdom of Galicia (with poorly defined territorial boundaries) into two counties attributed to two daughters of Alfonso VI, Urraca and Teresa, married to two descendants of European noble families (Raymond of Burgundy and Henry of Lorraine). And here we come face to face with the figure of Archbishop Gelmírez, whose influence on the politics of that time is universally recognized, starting with the Romantic historian Benito Vicetto. This author wrote his *Historia de Galicia* in the 1860s, in obvious opposition to Murguía, who started to publish the first instalments of his own *Historia de Galicia* in 1865, through the Lugo printing firm Soto & Freire. Murguía's work did not cover, either then or in later instalments, the times of Diego Gelmírez. But both in his introductory *Discurso Preliminar* and in a youthful work about Gelmírez, Murguía had already established his favorable interpretation of this prelate, as we will see later.

Vicetto's positions are not particularly exhaustively researched and owe more to his desire to become a Galician Walter Scott than a second Augustin Thierry, since he is more fond of emphatic judgements than reasoned analysis. Nevertheless, his opinions do have a common thread, as Risco himself observed, this being none other than his insistence in

7 V. Risco (1930), "Da Alemaña, I. A viaxe," *Nós*, 79 (Santiago de Compostela: 1930), p. 141. Later included in the publication *Mitteleuropa* (Santiago de Compostela: Editorial Nós, 1934; reed. Vigo: Editorial Galaxia, 2001).

casting Diego Gelmírez in a negative role as far as the evolution of the history of Galicia is concerned, by preferring alliances with the Papacy and the monarchs of Leon and Castile instead of allying himself with Queen Teresa of Portugal and the nobility of the Braga region (other contemporary figures, such as King García or Alfonso Henriques, also come off badly in his historical narrative). Whilst recognizing that "*la influencia de Gelmírez en Galicia era ilimitada,*" that he was a "*figura soberbia,*" even "*colosal,*" he does not spare his use of critical descriptions, calling him a "*figura sombría*" and "*orgullosa,*" of a "*vaidade intolerable*" and a nature that was "*codicioso, ardidoso, artero y usurpador.*" What matters more than the prose style of Vicetto's work, which is more lively than accurate, is the essential idea he expresses: the appearance of the kingdom of Portugal is the result of the combination of Gelmírez's intrigues with the internal divisions within the Galician nobility: Gelmírez's "*traición inicua*" with regard to Queen Teresa "*fue lo que dio origen a la creación de la nacionalidad portuguesa*" and the "*altivo desmembramiento de la nobleza gallega bracarense de la nobleza gallega lucense*" was another of the reasons that led to the creation of the Kingdom of Portugal, embodied in the figure of Teresa's son Alfonso Henriques, who reigned over the kingdom until his death in 1185. Vicetto's negative vision, not only of Gelmírez but also of the appearance of Portugal itself, leads him to state that the latter is an artificially constituted kingdom:

> "*Constituyendo una nacionalidad en el día, sin razón de ser, puesto que dicho reino fue formado con dos porciones de otras tantas nacionalidades antiguas de la Iberia, constituyéndolo: – nuestra Galicia bracarense, entre el Miño y el Duero, porción de la antigua nación galaica; – y la parte de Lusitania, entre el Duero y el Guadiana, porción de la antigua nación de los lusitanos.*"[8]

If, for Vicetto, Diego Gelmírez's political judgement could be considered as treason, for Castelao it was, in addition to the action of a traitor, the primordial expression of a behavior of a "cacique," or despot, just like one of the great worthies of Galician politics during the author's youth. His work *Sempre en Galiza* makes numerous references to the figure of Gelmírez, all of them critical of the strategies adopted by the Archbishop of Compostela, to whom he refers in various sections of the text as the "gran cacique galego" of his day. Indeed, Castelao concludes that Gelmírez, with his policy of support for Castile and his opposition to Portugal, "*fanou irremisiblemente a nosa independencia.*" Sufficient support for this anti-Portuguese policy adopted by Gelmírez is provided by events such as the "Pious Robbery" of the relics from Braga, carried out in the best "James Bond" style in 1102, or the successive military actions that, as is recorded in the *Historia Compostellana*, systematically reinforced the River Miño as the border between Galician territory and that of Portugal. In spite of the respect he on many occasions expressed towards Murguía, in his interpretation of the figure of Gelmírez Castelao maintains a sustained and obvious difference of opinion throughout his *Sempre en Galiza*, in spite of it having been written in a great diversity of personal and political contexts, from his exile in Badajoz in 1935 (before the Spanish Civil War) or the time he spent in Valencia and Barcelona (during the Civil War) to his arrival and settling in Buenos Aires in 1940, where the book was finished and first published in 1944. A good example is the following text, taken from one of the articles Castelao wrote for the magazine *Nueva Galicia* (Madrid: 1937), which were later incorporated into his *Sempre en Galiza*:

8 B. Vicetto, *Historia de Galicia*, vol. 5:7 (Ferrol: Nicasio Taxonera Editor, 1872), p. 68.

"¡Que importa que nos camiños abertos por Compostela frorecese a grande arte meieval do Oucidente; que nós creásemos a insuperable poesía lírica dos Cancioeiros e que no noso idioma escribira o único Rei Sabio "que no sólio da Hespaña tivo asento"; ou que o Pórtico da Groria sexa o cume da escultura románica! O certo é que por gañar para Compostela a primacía eclesiástica da Hespaña, o Arzobispo Xelmírez – encheu co seu nome un século enteiro – consinteu a desintegración do territorio galego ao crearse o Reino Lusitano, torcendo as vereas do noso destiño e desbaratando a potencialidade do noso xenio creador, para xunguirnos a unha empresa allea, na que perdemos todo, inclusive primacía eclesiástica."[9]

This and other texts in *Sempre en Galiza* lay down some of the essential ideas of nationalist thought in the pre-Civil War years, many of them conceived by the members of Xeración Nós and the Irmandades da Fala, in narrative literature as well as in theoretical writings. The purpose was to establish, as Justo Beramendi[10] has remarked, a reference point for negation (Castile) and a reference point for reintegration (Portugal). In Castelao's opinion, this reference point for negation takes as its starting point the period during which the Archbishop of Compostela chose to make "*Galiza o afluente más caudaloso de Castela, sen proveito nen honra para o seu país,*" since Castile was a "*monarquía soxuzgadora*" (despite having at its head a protegé of Gelmírez such as Alfonso Raimúndez, who would later become Alfonso VII "the Emperor"), whilst the monarchy ruled over by the latter's relative Alfonso Henriques was the expression of "*o noso xenio creador,*" precisely for having been a dynasty founded "*sobor d-un anaco de terra galega.*" This did not prevent Castelao himself, in his *Alba de Groria*, from placing Gelmírez – together with Alfonso VII and the Count of Traba – in the rear of a procession of souls of "*inmortaes galegos*" that his Rianxo-born writer, in the year 1947, imagined traversing the skies of Galicia just before sunrise on 25 July, the national day of Galicia.

Vicetto and Castelao's interpretations share a series of common ideas, despite having been written at different times in history and adopting very different approaches with regard to the definition of Galicia as a nation. For Vicetto, his criticism of Gelmírez's actions to separate Galicia from Portugal was a way of reinforcing the position of the "provincia" of Galicia within Spanish history and vindicating its relevance in the "historia nacional" of Spain, since he openly confesses that "*nos hallamos en un periodo en que la historia de España es propiamente historia de Galicia,*" but one with which the national histories of Spain have never concerned themselves, "*desde Sandoval hasta Ghebartd y Romey mismo.*" As was the case in so many Romantic texts of the period, the aim was to reinforce the historical narrative of the Spanish nation through the incorporation of local or regional diversity. For Castelao, on the other hand, what mattered was to emphasize the block placed on the creative force of Galicia by Castile, so that in the end it had to be Portugal that performed the work that Galicia had been unable to carry out. Put another way, it was Gelmírez who put paid to the national ambitions of Galicia "*creando un emperador para Toledo en vez de formar un Rei para Compostela,*" a city that was unable to become the "*cabeza d-unha nación.*" This pessimistic viewpoint adopted by Castelao, particularly with regard to the great "varóns" or leading figures in the history of Galicia, finds it best expression in that of Gelmírez, leading him to differ on this point from the standpoint taken by the patriarch Murguía.

9 A. D. R. Castelao, *Sempre en Galiza* (Buenos Aires: Editorial As Burgas, 1961), pp. 36–7.
10 J. Beramendi, *De provincia a nación. Historia do galeguismo político* (Vigo: Edicións Xerais, 2007).

Gelmírez, Prince of Christendom

The exceptional dimension of the figure of Diego Gelmírez was never called into doubt by any of the foregoing authors, nor by many other chroniclers and historians, all of whom pay tribute to the central role played by the Archbishop of Compostela in what would be the future history of Galicia. The difference lies in the interpretation constructed around his figure. And in this regard there are two outstanding writers on Galician culture, namely Manuel Murguía and Ramón Otero Pedrayo, who pay particular attention to Gelmírez (to whom each devote a biography) and, above all, single out from his historical trajectory those aspects that most clearly strengthened the idea that Galicia was a "*cultura de Occidente*," connected to a Christian Europe with Carolingian roots. In this regard, Gelmírez would not be a traitor but rather a great prince of medieval European Christendom who whilst battling to extend the limits of the city and apostolic see of Saint James also managed to extend those of all Christendom, and who, in his role as protector of culture and the arts, was the driving force behind the splendor of Romanesque art, the style which together with the Baroque best defines the spirit of Galicia, as Otero Pedrayo always affirmed.

Let us begin, however, with Murguía, who showed great devotion to the figure of Diego Gelmírez throughout his whole life. Even as a young man in bohemian Madrid he had written a serialized story in the newspaper *Las Novedades* (1859), called "Don Diego Gelmírez (novela original)." He then concerned himself with this personage in his school textbook *La primera luz*, declared a "*texto en las escuelas del reino*" in 1860, in which he devotes an entire lesson to the figure of the prelate from Compostela, whom he refers to as "*uno de los hombres políticos de más talento que produjo Galicia en todos tiempos,*" a great worthy who "*salvó a la monarquía castellana*" by acting as protector to Alfonso VII, "*el que elevó al más alto grado de esplendor la iglesia compostelana y el que más hizo por la gloria y el esplendor de Galicia.*" As can be seen, Murguía's admiration for the figure of Gelmírez dates from very early on, and was maintained systematically throughout his whole life, proof of this being the references he makes to Gelmírez in the *Discurso Preliminar* of his *Historia de Galicia*[11] (1865–1866) or in the great book *Galicia*[12] (1888).

His most systematic contribution to the historiography concerning Gelmírez, however, was his biographical work *Don Diego Gelmírez*,[13] published in 1898. Written as a result of the invitation extended to him by the Ateneo de Madrid to take part in the lecture programme of its Historical Sciences section during the academic year 1895–1896, the text retains the style appropriate to a "*conferencia leída en público,*" even though the lecture was never actually given. Nevertheless, it was not to be long before it appeared in the form of a booklet, because Murguía was greatly concerned with combatting the "*abominable olvido*" into which the figure of Diego Gelmírez had fallen, the result of what the patriarch called a "*posteridad adversa.*" And he blames this oblivion not only on non-Galician historians (from Masdeu or Herculano to Vicente La Fuente) but also on some "paisanos" born in the city of Compostela itself, such as Manuel Colmeiro or even A. López Ferreiro, "*de quien debía esperarse otra cosa*" – later, in his *Historia de la Catedral*,[14] this canon of Compostela Cathedral would devote many of its pages to Gelmírez's episcopate, although in a prose much less dithyrambic than that of Murguía –.

11 M. Murguía, *Historia de Galicia*, vol. 1:2 (Lugo: Imprenta de Soto Freire, 1965–1966).

12 Id., *Galicia. España: sus monumentos y artes, su naturaleza e historia* (Barcelona: Cortezo y Cía., 1988; reed. Valladolid: Editorial Maxtor Librería, 2009).

13 Ibid., *Don Diego Gelmírez* (A Coruña: Librería Eugenio Carré, 1898; reed. Buenos Aires: Editorial Nova, 1943).

14 A. López Ferreiro, *Historia de la Santa A. M. Iglesia de Santiago de Compostela*, vols. 3:11 and 4:11 (Santiago de Compostela: Seminario Conciliar de Santiago, 1898–1901).

The image that Murguía constructs of the figure of Gelmírez is therefore a clearly favorable one, to the extent that it borders on the panegyrical. But it is also the result of theoretical reflection that gives greater weight to "*individualidades*" than to "*la inteligencia política de las masas.*" At a time when Western culture was beginning to debate the role played by the masses or the "multitude" in the onward march of history, Murguía invoked the tradition of the historian Thomas Carlyle to establish the idea that not every leading player in history is simply a product of the times in which he or she lives: "*nada más intolerable que dar toda importancia a los elementos impersonales de la historia, negándosela a las individualidades.*"

The strictly biographic profile of Diego Gelmírez sketched by Murguía is based on an ethnical consideration that is consistent with the author's ideas. The first explanation for the prelate's genius lies in the racial origin of his parents: "*por su padre pertenecía a la raza invasora* [los suevos] *y no creemos engañarnos al pensar que la madre debió ser celta.*" This statement, scantily documented, was one of the reasons why the academic critics of his day launched scathing criticisms at Murguía and his biography of Gelmírez. But this is not the essential point of the patriarch's argument, which, in the style of Voltaire's *Louis XIV*, is to assess the most prosperous period in the history of Galicia through the figure of Gelmírez: "*el verdadero periodo de nuestras grandezas se abre bajo su impulso y bajo su imperio,*" in the words of Murguía. This great patriarch of Galician letters is of the opinion that Gelmírez may have been mistaken in some of the political and military actions he undertook. But where there can be no reservations about his greatness is in the field of the arts, the sciences and culture in general, although there may be some reluctance to see in him the emblem of a whole era, once again implicitly evoking Voltaire's idea that it is great persons who define eras, not the opposite:

> "*De otros más afortunados, recibe el nombre su siglo; no sucedió eso a Gelmírez, por más que el siglo XII en Santiago y en Galicia es completamente obra suya y obra gloriosa. En la arquitectura, la orfebrería, las artes sumptuarias todas, influyó por modo decisivo, amándolas, protegiéndolas con la mayor esplendidez y cuidado, haciendo que tomasen en la ciudad arraigo poderoso y duradero [...]. Lo que con el arte, hizo con la ciencia [...]. En su alma, sólo la cátedra compostelana, sólo Galicia importaba; lo demás, nada. Puede por lo mismo decirse de él, para concluir, que no sólo amaba a su país, sino que le amaba sobre todas las cosas. Que no sólo fue un grande hombre de Estado, tal como hoy se entiende, sino uno verdadero jefe de Estado [...]. Levantó edificios, edificó palacios y fortalezas, equipó soldados, construyó naves, organizó escuelas, dio vida al arte, guió su tiempo, socorrió largamente a los que lo necesitaban y lo merecían, protegió el comercio, organizó la sociedad, dispensó mercedes, en fin, hizo un pueblo, actos todos propios tan sólo de la soberanía.*"[15]

It is clear that not only does Murguía seek to construct a positive, even rather hagiographic, image of the figure of Diego Gelmírez, but that he is also moved by the desire to combat the oblivion into which the Bishop of Compostela was condemned by an adverse posterity, something which began at the very moment of his death, the dating of which has been anything but peaceful. López Ferreiro himself observes with a certain slyness that "*probablemente no para todos los compostelanos fue motivo de duelo la muerte del insigne Prelado; en cierto modo lo guardó la Historia, suspendiendo, por no corto tiempo, su narración.*"[16] Needless to say, Murguía took this oblivion as an offence to one who

15 *Don Diego Gelmírez...* op. cit., pp. 151–62.
16 *Historia de la Santa A. M. Iglesia de Santiago de Compostela...* op. cit., p. 219.

showed so much love for his country. But what is strange about Murguía are his silences, both regarding Gelmírez's contribution to the consolidation of the Castilian monarchy and his responsibility in the appearance of the kingdom of Portugal. The greatest concern of this regionalist historian was to reinforce the narrative of a Gelmírez who laid the foundations of Galicia as a "*nacionalidade*" and endowed it with a certain degree of cultural and political unity, rather than emphasizing, as Vicetto did, his decisive influence over the division of the old *Gallaecia*. Gelmírez's decision to back the House of Burgundy and to pursue what could be called a "pro-French" policy, which lent so much weight to the constitution of the kingdom of Portugal, are strategies that Murguía omits from his narrative or considers to be of little relevance. Essentially, the Gelmírez envisioned and constructed by Murguía is nothing other than a national hero in Galicia ("un jefe de Estado") who strove to recover its national (although many texts speak of it as "regional") identity within the framework of Restorations Spain, but who never even considered the possible alternative of a reintegration with Portugal, in spite of the threat of the "*indecisión amorosa*" invoked on certain occasions. It is no wonder that Castelao disagreed with, and even disowned, some of Murguía's views.

In a more exhaustive fashion, Murguía's vision of Gelmírez found an excellent continuation in the work of Otero Pedrayo. This continuity can be seen at the very outset in a definition of their protagonist using a concept with a markedly French flavor. Murguía had stated that Gelmírez was a "*verdadero clerc a la manera francesa, intermedio entre el hombre de Estado y el eclesiástico.*" Years later, in his first approach to the figure of Gelmírez, in 1929, Otero Pedrayo repeats the same profile, although quoting a highly appropriate authority for those times: "*Xulian Benda diría de que xeito foi D. Diego un bó 'clerc.'*" A definition that Otero refines a little further in a later work, when he sees Gelmírez as a clerc who "*no es un monje, ni significa un clérigo,*" continuing in the vein that Benda had established in 1927 in his famous book *Le trahison des clercs*.[17] The idea of the *clerc* as an intellectual or man of the spirit, rather than as an active politician who had acted like "*unha especie de cacique de outura,*" a reputation that Otero admitted had been attributed to Gelmírez, is the leitmotif of the writer's vision of the prelate, which links directly to the approach taken by Murguía.

This brings us to the extensive work that Otero devoted to the figure of Diego Gelmírez, widely distributed over his texts on history, articles or lectures, or concentrated in two books of a very different nature but which both reflect the great interest shown by the author in the Archbishop of Compostela. The first of these books is the historical novel *A Romeiria de Gelmírez* (1934),[18] whilst the second is a historical biography of the Archbishop that Otero wrote in 1951 as his entry in a competition organized by the publisher Barcelona Aedos. His text did not win the prize – obtaining only a single vote from the five members of the jury –, and therefore remained unpublished until 1991, when it first saw the light of day in its original Spanish version, the Galician translation appearing later.[19]

Throughout all of Otero Pedrayo's works concerning Gelmírez there is evidence that he had read, at length and with great satisfaction, the *Historia Compostellana* in its original version published by Father Flórez in his *España Sagrada*.[20] He recalled that work, which he first read whilst still a schoolteacher in Ourense, in the opening lines

17 J. Benda [1927], *La trahison des clercs* (Paris: Éditions Grasset, 1990).

18 R. Otero Pedrayo, *A Romeiria de Xelmírez* (Santiago de Compostela: Editorial Nós, 1934; reed. Vigo: Editorial Galaxia, 1991).

19 Id., *Gelmírez o el genio afectuoso, creador y humorista del tiempo románico. Vida y glosas a su vida* [1951] (Santiago de Compostela: Xunta de Galicia, Santiago de Compostela, 1991).

20 Op. cit. note 3.

of this 1929 essay on Gelmírez's oratory (the magazine *Nós*, 66). Other works in which fragments of the *Compostellana* appear are the historical novel and the biography that are dedicated to the figure of Gelmírez.[21] The image that the author constructs of the figure of Gelmírez rests upon two basic pillars: i) his great qualities as a political manager and as an educated and well-traveled person possessing a seductive way with words, in short, as an expression of his status as a *clerc*, as an intellectual who formed part of an enlightened minority in European Christendom, and ii) his "pro-French" stance, exemplified in his relations with the secular policies of Burgundy and the ecclesiastical policies of Cluny, which converted Gelmírez into an early expression in Galicia (as in their own way Priscillian or Paulus Orosius had also been) of the Europeanizing trend that found so much favor with the members of Xeración Nós. A "*galo da Galiza*," as a monk from Toulouse defines Gelmírez in Otero's historical novel.

The historical novel that Otero wrote about Diego Gelmírez's journey to Rome with the intention of obtaining the dignity of the Pallium for the see in Compostela is an attempt to construct the "*grande novela histórica galega de asunto medieval.*"[22] It is something of a surprise that Otero should have chosen this particular protagonist, since, as he was later to admit in his biography of the prelate, the figure of Gelmírez is lacking in a legendary aura, "*ni piadosa ni moralizante, y así el romanticismo no ha podido escogerle como tema.*"[23] Nevertheless, Otero, as Rodriguez del Padrón would later do in *Las palmas del convento*,[24] made use of a historical figure and a contemporary text such as the *Compostellana* to create a story that would be more of an authentic national narrative than a biography of its main character. In all the novels Otero wrote before the Spanish Civil War, from *Os camiños da vida*[25] or *Arredor de sí*[26] to *Devalar*[27] or the very *Romeiria de Xelmírez*, the same "*idea esencial*" appears time and time again: that of the discovery and affirmation of the national status of Galicia, inasmuch as a European culture, by its leaders, whether they be called Paio Soutelo, Adrián Solovio, Martiño Dumbría or Diego Gelmírez. All these literary or historical figures pursue the same goal: to make Galicia a cultural nation of Western Europe. This is something that Diego Gelmírez dreams of when he makes a stop at Cluny Abbey and receives the advice of the old abbot, Hugo, "*ledo de rexer había máis de medio século o mundo e familia cluniacens*e:"

> "*Xelmírez pensaba en Compostela [...] E dentro do grave orbe da Catolicidade sentía o decorrer do futuro por novos vieiros. ¡Metropolitano de Occidente! Ista frase, chama inmorrente, rubía acesa na cinza milagrosa da cova apostólica, queimaba e exaltaba a enerxía da terra e da xente galega, a chamada a gobernar nos lindeiros do mundo, a franqueada cara o infindo alén do mar e da alma.*"[28]

The essential idea that takes Diego Gelmírez to Rome, as evoked by Otero, is, in addition to extending the see of Compostela, that of affirming the European dimension of Galicia, taking its inspiration from France, or more specifically, from Burgundy and Cluny. In Otero's historical novel a Galician monk, a devout follower of Cluny, affirms that "*Galiza élle unha pequena Francia, unha Galia,*" an idea that is also expressed, in different ways, by other characters in the novel. Thus, Lucio Arias, musing on the universal resonance that the name of Galicia is achieving as a result of the pilgrimages to Santiago, ends up with a political reflection: "*por xustiza*

21 R. Otero Pedrayo, "Xelmírez, orador," *Nós*, 66 (Santiago de Compostela: 1929).

22 R. Carballo Calero, *Historia da Literatura Galega Contemporánea* (Vigo: Editorial Galaxia, 1981).

23 *Gelmírez o el genio afectuoso, creador y humorista del tiempo románico. Vida y glosas a su vida...* op. cit.

24 R. Otero Pedrayo, *Las palmas del convento* (Buenos Aires: Emecé, 1941).

25 Id., *Os camiños da vida* (A Coruña: Editorial Nós, 1928; 13th ed. Vigo: Editorial Galaxia, 2003).

26 Id., *Arredor de sí* (A Coruña: Editorial Nós, 1930; 12th ed. Vigo: Editorial Galaxia, 2003).

27 Id., *Devalar* (A Coruña: Editorial Nós, 1935; ed. M. C. Ríos Panisse, Vigo: Editorial Galaxia, 1992).

28 *Gelmírez o el genio afectuoso, creador y humorista del tiempo románico. Vida y glosas a su vida...* op. cit., p. 260.

debiamos ser membros do Imperio mellor que de León e Castela." There is a continuous outpouring of passion for the lands of Galia, the need to link the destiny of Galicia to that of contemporary European history.

This is a kind of spiritual ecumenism that encloses a certain contempt for political alliances within the Iberian Peninsula, particularly with the lands of the south, amongst which Otero's historical novel also includes the Portuguese territories. In one of the many conversations in the novel, Gelmírez reflects on the "*moitos camiños da Galiza para o mundo,*" confessing that "*de todos [los caminos], eu especialmente amo os que van na procura da Francia,*" to which his companion Munio Alfonso replies that they should not forget Portugal. Gelmírez's response is a good metaphor for what many members of Xeración Nós thought about the future of Galicia: "*¿E logo Braga non é Galiza?,*" says the Bishop, thinking of the adventure of the theft of the relics and the importance of possessing the tomb of Saint James: "*Mais o Apóstolo, escolmando a terra da cova, fixo da nosa cidade o centro soberano.*" Here we find an echo of some of the ideas of the apologetic literature of the period of the Hapsburg dynasty (in particular *El búho gallego*, by the Count of Lemos[29]), but on the other hand, they are far from the position defended by an author like Castelao, for whom Portugal was a decisive element in the future construction of Iberia or what he called "Hespanha" (with an H). Otero was by no means unaware of the influence of Gelmírez and the policies that took their inspiration from Burgundy on the division of *Gallaecia* – "*a fidalga e católica casa de Borgoña faría a división de Galicia*" –, but this is a matter that does not occupy a prominent position in his narrative. Pride of place is granted to Compostela, Cluny and Rome, as opposed to Braga and, naturally, also as opposed to Toledo, a city that had by then already become the reference point for the monarchy of Alfonso VI, as Otero Pedrayo's historical novel itself stresses.

These ideas held by Otero with regard to Gelmírez reappear in the biography that he wrote in 1951 of a figure that he defines in the sub-title of the work as "*el genio afectuoso, creador y humorista del tiempo románico.*" Although written in a political and ideological era very different to that of the *Romeiría*, its interpretative approach is virtually unchanged, as is generally the case in all of Otero Pedrayo's works. The biography draws directly on medieval sources, above all that of the *Compostellana*, but does not conceal a series of political reflections that suddenly appear in the text like scattered pearls. In reality it is a new version of the historical novel of 1934, written in elegant prose in Spanish in which the historian's narrative style fails to conceal a tendency towards creative writing. Otero repeats his definition of Gelmírez as a *clerc*, well trained intellectually in the top cathedral schools, "*en las que no falta el grano de aticismo o la resonancia del carmen latino.*" Contrary to the image of Gelmírez as an astute and even artful politician, which runs from Masdeu and Vicetto down to Sánchez Albornoz, Otero's vision precisely emphasizes his personal qualities from a cultural rather than a political standpoint. For it his work in the cultural sphere, performed directly with the very members of the cathedral chapter in Compostela, and his passion for "restoring" churches and monasteries as well as rules and regulations, which Otero sees as Gelmírez's great contribution to the history of Galicia.

An idea pervades this biography that links it with the historical vision of Gelmírez that we are highlighting here: the privileged relationship that Gelmírez enjoyed with

29 P. Fernández de Castro, "VII Conde de Lemos" [1602], *El Buho gallego* (Santiago de Compostela: Editorial Compostela, 1992).

the politics and culture from the other side of the Pyrenees, or "*alén-portos*." This strategy contrasts with his relationship with the political project represented by the old *Gallaecia* and in all probability also by the figures of the King Don García and the Bishop of Iria, Diego Peláez. Once again the age of Gelmírez appears as a true turning point in the history of Galicia, like a dividing line between the paths to be taken in the future. Otero Pedrayo frequently places the figure of Gelmírez at a crossroads, where he is obliged to take one of these paths. For example, he remarks that Gelmírez "*nace a la existencia política en la aureola de dos grandes figuras,*" Diego Peláez and Raymond of Burgundy, two figures who represent opposing directions.

The figure of the ancient Bishop of Iria signifies the "*resistencia de una tradición gallega,*" political and even liturgical, that led him to defend the King Don García against the attack on him by Alfonso VI for the veiled accusation of having committed the crime or treason of wanting to deliver Galicia into the hands of the English and the Normans. An unproven accusation, but one that clearly reveals that in the transition from the eleventh to the twelfth century the kingdom of Galicia was faced with a choice of paths to follow. One of these, that of reinforcing the political identity of the ancient *Gallaecia*, represented by Don García. In the words of a modern historian, "*la alianza de don García con la nobleza media del entre Miño y Duero y su impulso decidido a la restauración de la sede de Braga, presenta indudables parecidos con la convergencia de fuerzas que impulsaron luego la acción política de Alfonso Enríquez.*"[30] Put another way, the experience of Don García's reign would have its continuity in the work of Henry, rather than that of Gelmírez.

On the other hand, the figure of Raymond of Burgundy, with whom Gelmírez had so many dealings on a personal and political level, represents the relationship with continental Europe, especially that of the Carolingian tradition now represented by the strength of the House of Burgundy and that of the Abbey of Cluny. The Bishop who succeeded Peláez in the see of Iria, the Cluniac monk Dalmatius, in Otero's opinion represents "*el espíritu de la Europa romana y alpina.*" The best continuator of the work of Dalmatius was Gelmírez himself, scorning Braga and southern *Gallaecia*, allying himself with the monarchs Alfonso VI and Alfonso VII, and promoting a direct relationship between Compostela and Rome and Cluny whose main consequence was the splendor attained by the see of Compostela and, by extension, the whole of northern Galicia. In the opinion of Otero, who classified Gelmírez's management as a "*programa revolucionario,*" the outcome was the application of a "pro-French" and even "Europeanizing" policy, the latter being an expression that produced a certain reluctance in the author:

> "*Es el programa de la casa de Borgoña, de Cluny, del papado renacido, de Fernando I y de Alfonso VI. No puede, tal vez, hablarse de europeización, pero sí someternos al ritmo nuevo entonces en la Cristiandad. Lo contrario de Peláez. Gelmírez amó, sin duda, en su juventud al gran desterrado. Como tantos otros gallegos rompió con un pasado entrañable, se olvidó del rey García, su rey de nación.*"[31]

The "French" and even "European" profile that Otero Pedrayo sketched of Archbishop Gelmírez is a recurrent theme in the author's novels, essays and historical works. Amongst the great range of political possibilities of that turbulent period

30 E. Portela Silva, *García II de Galicia. El Rey y el Reino* (Burgos: Editorial Olmeda, 2001).
31 *A Romeiría de Xelmírez...* op. cit., p. 165.

which, in the opinion of Otero, "*é un deses tempos expostos de mala gana polos historiadores*," Gelmírez's actions eventually bore their fruit, because he was able to "*extraer as puras esencias do galeguismo e do occidente europeo*," as the author points out in his *Ensaio histórico*,[32] written shortly before the *Romeiria*. Galicia and Europe: this alliance forged by Gelmírez perfectly summarizes not only the thinking of Otero but also that of a whole sector of Xeración Nós, the sector that based the identity of Galicia on culture rather than on ethnicity, on religiosity rather than politics, on Europe rather than the Iberian Peninsula. This explains the existence of certain silences or excuses on the subject of Portugal which, on the other hand, featured so relevantly in the philosophy of Castelao. It is essentially a question of the opposition between a political nation and a cultural nation, two aspects that cannot always be separated, but are never easy to combine, which coexisted like two souls in the heart of pre-Civil War Galician nationalism.

Coda

It is evident that neither the person nor the religious, cultural and political actions of Archbishop Gelmírez were a matter of indifference for his contemporaries or a subject on which historians and politicians have been able to reach a consensus in more recent times. Although the important role he played has never been a subject for discussion, his decisions are seen as positive or negative according to the times in which they are analyzed. When placed in the context of the cultural tradition of Galician nationalism, the figure of Gelmírez facilitates the appearance of two interpretations that represent two souls (not necessarily mutually incompatible) in the understanding of the history of Galicia: i) a nation that was politically amputated by the appearance of the kingdom of Portugal, or ii) a nation that obtained its identity thanks to its connection with the European from the other side of the Pyrenees. As a result, both the concepts of "traitor" or "despot," like those of a "superior man" of his times, can only be understood in the political context of the construction of an idea of Galicia, whether as "province" or "nation," in which an analysis of the present is dependent on the right or wrong decisions made by those in the past.

The dependence of Galicia, first on Leon and later on Castile (and, by extension, on the Spanish monarchy) is a line of force that for authors such as Vicetto or Castelao – amongst many others, past and present – has its roots in the policies of Archbishop Gelmírez. And something similar can also be said of the appearance of the kingdom of Portugal, in which the leading role played by Gelmírez was clear even to his contemporaries, and would obviously be hard to play down in the light of current historiography of the utmost reliability. As an example let me refer to a recent biography of Alfonso Henriques written by the Portuguese medievalist José Mattoso, for whom the political sauce in which the rebellion of the son of Queen Teresa against his mother, the Trava family and many Galician nobles – branded as "indignos" in the Portuguese chronicles – simmered and came to the boil was his radical opposition to the "pro-French" policy represented by the Cluniacs, and Archbishop Gelmírez in particular, with the result that "*a luta entre Braga e Compostela vai cavando o fosso entre portugueses e galegos.*"[33]

32 R. Otero Pedrayo, *Ensayo histórico sobre la cultura gallega* (Santiago de Compostela: Editorial Nós, 1933; reed. Arteixo: La Voz de Galicia, 2004).
33 J. Mattoso, *D. Afonso Henriques* (Lisbon: Temas e Debates, 2007), p. 39.

The alternative image of Gelmírez as a great Prince of Christendom who was able to strengthen the links between Compostela and European culture, thanks to the expansion of the cult of James the Apostle and the pilgrimages to his tomb, but also to that of an intensive territorial colonization led by the secular and monastic church, is part of the best cultural tradition of Galicia, nationalist or otherwise. For if for Murguía or Otero Pedrayo Gelmírez's grandeur lies in his condition as an "home de Estado" of Galicia or as a coordinator of its identity as a cultural nation in the European context, but without political independence, for an author as changeable in his ideology as Montero Díaz the Archbishop of Compostela ended up being a forerunner of the "self-determination" of Galicia. The fact that this cultural brilliance of Galicia, achieved in the times of Gelmírez, was inspired and even governed by monks and laymen educated in France, and particularly in Cluny Abbey, is, like the appearance of the kingdom of Portugal itself, a two-sided historical outcome, but one that is impossible to weigh on the scales of history, however much one may think that what is won on the one hand is lost on the other.

Going beyond this diversity of approaches and even of the inevitable reflections on the counterfactual vision, as attractive as it is impossible – What would current-day Galicia be like if Portugal had never been brought into existence? What would it be like without the "invention" of the body of James the Apostle in Compostela? or How would it have evolved had it been a kingdom of its own formed from the ancient *Gallaecia*?, and *sic de ceteris...* – what is true is that Diego Gelmírez's "programa revolucionario" was much more the expression of the strength of twelfth century Galician society than the personal work of a single individual, however much of a "superior man," in the sense intended by Murguía, he might have been. The social and political forces of the time made a choice of which we should consider ourselves neither prisoners nor proud heirs, but which in any event cannot be lightly dismissed. For it seems clear that current-day Galicia, the Galicia constructed in our days, owes much more to the work of Gelmírez than we can imagine. And one of its principal emblems is undoubtedly being able to count on a high culture, expressed in the poetry of the *Cancioneiros* and in the art of churches and monasteries, in a language that was even then spoken by Gelmírez himself and in a spiritual center that is one of the beacons of the West, such as the city of Santiago de Compostela, all of this being the heritage of that golden age of the twelfth century.

Gelmírez's memory, as well as being controversial, is also tinged with brotherly hatred. Not only is the exact location of his tomb unknown, but neither was he "reinvented" in contemporary times when that was the common practice amongst national cultures in construction. The first great figure in the history of Galicia did not even inspire the setting up of a large statue nor the construction of a pantheon worthy of him. How is it possible to explain that in the "Panteón Real" located in the Compostela Cathedral we find the tomb of the Count of Traba, as well as those of the so-called "Galician Kings," but not that of Diego Gelmírez? It is just as well that many of his works are still standing, and that much of his programme still remains, not least the alliance, which has resisted the passage of time, that he forged between Compostela and Europe. Because from that spring, extant now for more than eight hundred years, there continue to flow the waters that assuage our thirst.

EUROPE

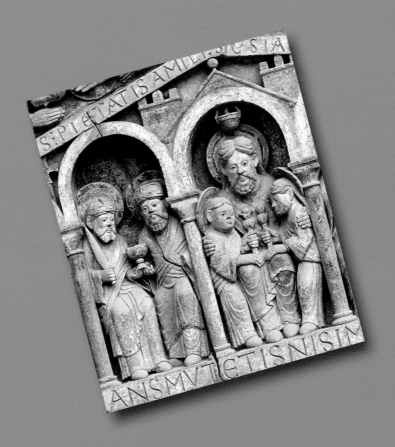

Arturo Carlo Quintavalle

The Gregorian Reform and the Origins of Romanesque

1 G. T. Rivoira, *Lombardic Architecture: Its Origin, Development and Derivatives* (London: W. Heinemann, 1910).

2 J. Puig i Cadafalch, A. Falguera and J. Goday i Casals, *L'arquitectura romànica a Catalunya*, 4 vols. (Barcelona: IEC~Institut d'Estudis Catalans 1909–1918; reed. 2001).

3 K. J. Conant, "Les fouilles de Cluny (Saône-et-Loire)," *Bulletin Monumental*, 88 (Paris: 1929), pp. 109–23.

4 The debate on the problem of dating Cluny, the building and its capitals, is vast. The French archaeological school tends to date the capitals of the ambulatory to around the first or second decade of the twelfth century, while other critics relate them to the construction of the major apse and peribolos. The debate also reflects the modes of construction of the transept-apse system, in horizontal rows or vertical sections. Previously, defenders of the late dating had suggested that the capitals might have been carved *aprés la pose*, but hard data show that it is certainly the opposite. The problems of Cluny and its capitals is related to the history of sculpture from the eleventh century in France, which we cannot discuss here.

5 A. K. Porter, *Romanesque Sculpture of the Pilgrimage Roads*, 10 vols. (Boston: McGrath-Sherrill Press, 1923).

6 C. Enlard, *Manuel d'archéologie français depuis les temps mérovingiens jusqu'à la renaissance*, 2 vols. (Paris: Alphonse Picard et Fills, 1916).

7 É. Mâle, *L'art religieux du XIIᵉ siècle en France* (Paris: A. Colin, 1922).

8 P. Deschamps, "Notes sur la sculpture romane en Bourgogne," *Gazette des Beaux-Arts*, 6 (Paris: 1922), pp. 61–80.

9 M. Aubert, *Cathédrales, abbatiales, collégiales, prieurés romans de France* (Paris: Arthaud, 1965).

10 M. Durliat, *La sculpture romane de la route de Saint-Jacques de Conques a Compostelle* (Paris: Comité d'études sur l'histoire et l'art de la Gascogne Mont-de-Marsan, 1990).

11 M. Castiñeiras, "Arte del pellegrinaggio e primo romanico: le scelte artistiche nella Galizia dell'XI secolo," in A. C. Quintavalle (ed.), *Medioevo: arte lombarda* (Milan: Mondadori Electa, 2004).

12 J. Wirth, *La datation de la sculpture médiévale* (Geneva: Droz, 2004).

A ghost flits over Europe, the evolution of the barrel vault into the transept vault, and thence to the groin vault. Entire generations of researchers and manuals spread all over the world have always established the difference between Romanesque and Gothic based on this evolution, considered fundamental. But behind this transformation that everyone considers decisive, there is another, taken into consideration much less but equally, if not more significant: the exclusion of the entire Italian peninsula from the origins of the "true" Romanesque panorama. Throughout the eleventh century, if not earlier, *Lombard art*, a "Romanesque" art characterized by the early use of the barrel vault, followed later by the transept vault, was defined in Italy, but while Rivoira's thesis,[1] which we could say focuses on the Lombard, placed the matrix of Romanesque civilization in the West, in the tradition from Ravenna to Saint Ambrose in Milan, Puig i Cadafalch's studies[2] saw the origins of the "premier art roman" as a Western phenomenon, with clear examples not only in Italy but also in Catalonia and the Pyrenees, and also present in many other places in the West. However, the main historiographical research, especially in France, has identified true Romanesque, not so much in Lombard art, as in the introduction, also Cluniac, of the segmented barrel vault, another phase of the so-called "technical" evolution of the pilgrimage road to Compostela, in two main areas, France and Spain. Conant,[3] retaken later by all scholars, defines thus a particular art, characteristic of pilgrimage roads, identifying five buildings, three of which are still standing – Saint Sernin de Toulouse, Sainte-Foy de Conques and the Cathedral of Santiago de Compostela, while two are lost, Saint-Martin de Tours and Saint-Martial de Limoges. The typology includes churches of three or five naves, churches with or without a transept, but all covered with segmented barrel vaults or traces of groin vaults in the areas of the peribolos. Another feature of the buildings is the radiating chapels that enable the worship of various relics. While main chapels are usually placed in the crypt, they are also visible from the nave thanks to the annular passageway giving access to them without disrupting religious functions held at the main altar.

The great similarity between these five that we have named is obvious, but surprisingly the Abbey of Cluny has been excluded from this analysis. It was built in third place, and is the key, for chronological reasons too, to an entire system of structures that depend on this model: it was founded in 1088 and consecrated, in its final phase, and therefore probably up to the second transept, in 1095.[4] There is

of course Porter's research,[5] linking Jaca and Compostela, Leon, Bari and Modena as contemporary events, but this research, although well founded, had little impact, especially on French archaeological historiography, from Enlart[6] to Mâle,[7] from Deschamps[8] to Aubert.[9] In this complex issue, recent research has pointed above all towards the analysis and dating of the main stages of sculpture, with less attention in general to architecture. I am referring specifically to the comparative and often conflicting chronology of Toulouse and Compostela, which has led to a lengthy series of confrontations among critics, and which has recently been changed by the research of Durliat,[10] Castiñeiras[11] and Wirth,[12] as Marie-Madeleine Gauthier's research[13] on "*les routes de la foy*" has also managed to achieve.

Such is, therefore, the status of the debate – summarized, I admit, and a little too schematic, and so the problem is how to place architecture and sculpture, mosaics and painting in Italy from the eleventh to the twelfth century in the context of the so-called culture in the West. To answer this question it is a good idea to reflect on certain facts; the first, from where we started, is the evolution of the barrel vault to the groin vault, which therefore excludes roofs with trusses from "true Romanesque." A statement considered incontrovertible, though one wonders if things can be truly expressed in these terms. If we consider the word commonly used in Latin texts to indicate church roofs in the West in a general sense, and the terms used in encyclopaedias to examine the symbolic values of buildings, e.g. from Bede[14] to Rabanus Maurus,[15] Honorius of Autun,[16] Hugh of Saint Victor,[17] Sicard the Bishop of Cremona,[18] we find that, in addition to specific terms for tiles and beams, the word indicating the top part of the church is *coelum*. There is no specific distinction between the buildings covered with domes and buildings covered with trusses. The term *coelum* indicates the complex system of beams and roof, whether the beams are exposed or if they have a *velarium* below, or a system of painted wooden planks, or even when there are vaults under the beams that hold up the roof.

If we consider the problem in historical terms, that is, if we take it back to the eleventh and twelfth centuries, we see that the issue was not raised at that time; however, from the nineteenth century onwards there have been contradictory theories by art historians, from Viollet-le-Duc on.[19] In fact, in the eleventh and twelfth centuries the *coelum* was the upper area of buildings that were undoubtedly laden with precise symbolism in the church system, and collectively represented the

Interior of the chevet of the Church of Cluny III [Cluny. Les églises et la maison du chef d'ordre. Mâcon: Protat Frères, pl. XLV, fig. 83; hypothetical reconstruction] Kenneth John Conant 1968

13 M.-M. Gauthier, *Les routes de la foi. Reliques et reliquaires de Jérusalem à Compostelle* (Freiburg: Office du livre, 1983).
14 Beda, "*De natura rerum*," in J. P. Migne (ed.), *Patrologia latina cursus completus*, L–XC, col. 187ff (Paris: Apud Garnier, 1844).
15 "*Beati Rabani Mauri fuldensis abbatis et moguntii archiepiscopi de universo libri viginti duo*," ibid., CX, col. 9ff.
16 Honorius Augustodunensis, "*Gemma animae*," ibid., CLXXII, col. 541ff.
17 Hugh of Saint Victor, "*De sacramentis legis naturalis et scriptae*," ibid., CLXXVI, col. 17ff.
18 "*Sicardi Cremonensis episcopi mitrale seu de officiis ecclesiasticis summa*," ibid., CCXIII, col. 13ff.

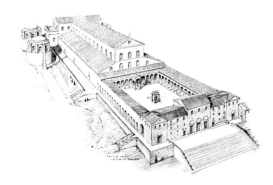

Romanesque Basilica of Saint Peter's, Rome [Carolingian and Romanesque Architecture, 800–1200. *New York: Penguin, fig. 3; hypothetical reconstruction*]
T. C. Bannister and Kenneth John Conant
1959

Christianized world, where for example the pavement is land, the columns and capitals are saints with *pedes* and *capita*, and the *coelum* is precisely the space that dominates the land. Let us therefore dwell on this point only to say that, based on the way principals and *fideles* in the eleventh and twelfth centuries conceived the space, archaeologists' distinction between roofs covered with trusses and vaulted roofs does not exist. Of this we have documented proof, to which I intend to return later. Conant's research[20] has shown that the third Abbey of Cluny is a copy of Constantine's Saint Peter's, a copy measured in Roman feet, of similar length, but a copy nevertheless, which appears to our eyes, following the traditional guidelines of archaeology, like a very different building. And yet, for the designers of the abbey founded in 1088, things were not so. Saint Peter's in Rome has five naves and so has Cluny III, Saint Peter's in Rome has one transept while Cluny has two, Saint Peter's in Rome is covered with trusses but the naves at Cluny have segmented barrel vaulted naves; Saint Peter's in Rome has a four-porticoed structure in front while Cluny has a complex system, a large atrium whose entrance is defended by towers, Saint Peter's has large Roman columns and Cluny composed pilasters, Saint Peter's has undecorated Roman capitals but Cluny's are partially Corinthian and partially figurative, Saint Peter's has no figurative sculptural compounds and architraved doors, Cluny has richly carved and figured tympanums. One could continue, but this is enough to help us understand what "copy" meant in the Middle Ages; it would be appropriate to refer those who have doubts to literary production, where our modern idea of authenticity and authorship comes up against a very different conception: quoting, and therefore copying, in the Middle Ages actually means highlighting, exalting the text used as a model and endowing one's own with dignity, as is clearly shown by the entire tradition of the medieval encyclopaedia or the lives of the saints, copied in part, changing names and places, where miracles, almost always recalling the miracles of Christ, are repeated with variations in all circumstances and contexts.

Let us therefore return to the problem of architecture and sculpture in the eleventh and early twelfth centuries in Italy and try to understand if the idea of Western artistic historiography reflects the truth, in which case Italy would be behind European Romanesque. The critical point lies therefore in the Reform. What do we know about the so-called Gregorian Reform, a reform that began before this pontiff, in fact under Alexander II, previously Bishop of Lucca with the name of Anselmo da Baggio? I would like to propose a reflection on some facts that part of the recent critical debate has opened up. First of all, the Roman pontiffs' demand to unify the word, to unify the texts of the Old and New Testaments; this operation, primarily focusing on Rome, but not only there, led to the production of large illuminated manuscripts, the so-called "Atlantic Bibles,"[21] of which eighty remain, although it is estimated that there were more than 400. Unifying the word, therefore, unifying the texts and eliminating local differences; such was the program initiated by the Church of Rome. But this was not enough, the Roman Church wanted to unify rituals and therefore to impose the Roman Rite, something decided by Pope Gregory VII, as shown in his *Registrum*.[22] The Church of Rome

19 E. Viollet-le-Duc, *Dictionnaire raisonné du mobilier français de l'époque carlovingienne à la Renaissance*, vol. 2:6 (Paris: A. Morel, 1873).

20 "Les fouilles de Cluny (Saône-et-Loire)"... op. cit.

21 M. Maniaci and G. Orofino (eds.), *Le Bibbie atlantiche. Il libro delle Scritture tra monumentalità e rappresentazione* (Milan: Centro Tibaldi, Ministero per i Beni Culturali e Ambientali, 2000).

22 "*Sancti Gregorii VII pontificis romani, Registrum*," in *Patrologia latina cursus completus*... op. cit., CXLVIII, col. 283ff. See also E. Caspar (ed.), "Das Register Gregors 7," in *Monumenta Germaniae Historica* (Munich: 1990).

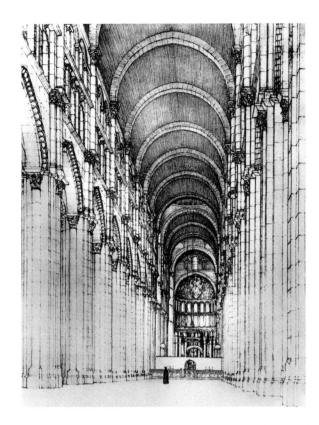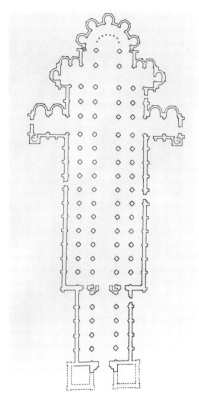

Interior of the central nave of the church of Cluny III [Cluny. Les églises et la maison du chef d'ordre. Mâcon: Protat Frères, pl. XLIV, fig. 82; hypothetical reconstruction]
T. C. Bannister and Kenneth John Conant
1968

Church of Cluny III [Cluny. Les églises et la maison du chef d'ordre. Mâcon: Protat Frères, pl. XXXVII, fig. 67; planimetry]
T. C. Bannister and Kenneth John Conant
1968

was opposed to the schismatic Church, that of the pontiffs appointed by the Emperor or by the Bishops united to him, Pontiffs such as Cadalus or Guibertus, and this opposition is manifested in a very well-known text, the *Dictatus Papae*,[23] completed by the letters of the *Registrum* and the councils:[24] concerning Pope Gregory VII I am only going to mention Miccoli's research,[25] which in recent decades has given rise to the problem, and I will not go beyond reflecting on the importance of the *Dictatus* itself. This not only concerns the confrontation between the two churches, and therefore between Pope and Emperor, but also the common life of priests which involved, as is not often noted, the construction of complex cloister structures attached to cathedrals. The rejection of Simoniac and concubinary members of a religious order imposed on them a common life, and therefore not the secular life according to the Cluniac model. Almost all of these cloisters have disappeared, but some survive, and in many other cases there is documentation. All this implies a complete change in the buildings attached to cathedrals, where the cloister for common life becomes a necessary structure, as are the buildings for the collective presence of dozens of members of the order. The internal organization of these complexes has been subject to very little research, as the most serious research is limited to monastic complexes.

Pope Gregory VII and his successors' policy is very well-known, promoting the use of the order of Cluny as a place of training for the new reformed Church. In northern Italy, monasteries belonging to the order of Cluny were numerous and some significant, such as San Benedetto al Polirone, which was decisive in sending out reformed clergy through the Mechtildian lands to the north and south of the Apennines. Art historians have been investigating the presence of Cluny in the West[26] for some time now, but what matters here is the dialog between the Abbey of Cluny

23 *"Sancti Gregorii VII pontificis romani, Concilia"*... op. cit., vol. CXLVIII, col. 407.
24 Ibidem, vol. CXLVIII, col. 749ff.
25 G. Miccoli, *Chiesa gregoriana. Ricerche sulla Riforma del secolo XI* (Florence: Nuova Italia, 1966).
26 J. Evans, *The Romanesque architecture of the order of Cluny* (Cambridge: Cambridge University Press, 1938).

27 *"Leonis marsicani et petri diaconi chronica monasterii casinensis"*... op. cit., vol. CLXXIII, col. 439.

28 A partial edition of the *Chronica di Montecassino* of Leo Marsicanus was published in 2001: F. Aceto and V. Lucherini (eds.), *Cronaca di Montecassino* (Milan: Jaca Book, 2001).

29 *"Leonis marsicani et petri diaconi chronica monasterii casinensis"*... op. cit., vol. CLXXIII, col. 748: *"Legatos interea Constantinopolim ad locandos artifices destinat, peritos utique in arte musiaria et quatrataria, ex quibus videlicet alii absidam et arcum atque vestibulum majoris basilicae musivo comerent, alii vero totius ecclesiae pavimentum diversorum lapidum varietate consternerent. Quarum artium tunc ei destinati magistri cujus perfectionis extiterint, in eorum est operibus estimari, cum et in musivo animatas fere autumet se quisque figuras et quaeque virentia cernere, et in marmoribus omnigenum colorum flores pulchra putet diversitate vernare. Et quoniam artium istarum ingenium a quingentis et ultra jam annis magistra Latinitas intermiserat, et studio hujus inspirante et cooperante Deo, nostro hoc tempore recuperare promeruit, ne sane id ultra Italiae deperiret studuit vir totius prudentiae plerosque de monasterii pueris diligenter eisdem artibus erudiri. Non tamen de his tantum, sed et de omnibus artificiis quaecumque ex auro vel argento, aere, ferro, vitro, ebore, ligno, gipso, vel lapide patrari possunt, studiosissimos prorsus artifices de suis sibi paravit. Sed haec alias. Nunc vero constructam basilicam qualiter decoraverit, demumque sacraverit, designemus."*

30 For a complete dissertation on this issue, see *Enciclopedia dell'Arte Medievale*, under the term "Montecassino," vol. 8:12 (Rome: Instituto della Enciclopedia Italiana, 1991), pp. 534–43.

31 S. Romano, *Riforma e tradizione, 1050–1198* (Turnhout: Brepols, 2006). J. E. Julliard and S. Romano (eds.), *Roma e la Riforma gregoriana, tradizioni e innovazioni artistiche, XI–XII secolo* (Rome: Viella, 2007). A. C. Quintavalle, "I Cristi viventi e la Riforma gregoriana in occidente," in *La pittura su tavola nel secolo XII in Europa. Riconsiderazioni e nuove acquisizioni a seguito del restauro della Croce di Rosano* (Florence: Kunsthistorisches Institut in Florenz, 2009).

(the third building), and other monasteries founded after the mother abbey by sending out reformed monks, monks who were also sent to cathedrals to reform the clergy. These monks went from belonging to a monastic order to the secular clergy, becoming priests or even bishops. We should note that this specific revolution swept over the West in the late eleventh and early twelfth centuries, but it would seem that its origin, on which we should reflect, is much earlier. Desiderius, abbot of Montecassino, was undoubtedly a man of a great humanistic culture based on the Latin classics, and also on the Greek, and it was precisely he who planned and organized the rebuilding of the Abbey of Montecassino in 1066. For this purpose he proposed a model which became the basis for the churches of the Reform. The Abbot, as stated in the *Chronica casinensis* by Leo Marsicanus,[27] carried out a series of operations of great importance: he prepared levelled ground to make room for the building, although in my opinion he did so mainly to build a four-porticoed structure in front of the church itself. He went to Rome to obtain columns, bases and capitals and other ancient Roman pieces to use them in the building that was based on Constantinian churches.[28] The vicissitudes involved in bringing these marbles by river and sea from Rome and then taking them up to the top of the hill on which the abbey stands are well-known, but the simple fact that it was told in such detail gives us an idea of the importance contemporaries attributed to the operation.

Another significant aspect highlighted by historiography on more than one occasion is Desiderius' programed decision to call in builders from abroad to work on the church, many of them from Byzantium.[29] Leo Marsicanus revealed that the mosaics, metalwork, glasswork and probably the building skills themselves were characteristic of non-local technicians who were invited to transmit these techniques to *operarii in situ*, probably not only monks; furthermore, Desiderius imported bronze doors from Byzantium, following a tradition that we see reflected in many other similar doors in southern buildings.[30] The figure of Desiderius – very aware of the problems in early Christian architecture, conscious that techniques had been lost in the West but were preserved in Byzantium – cannot simply be regarded as a significant character who drew up an image system of a local nature; here we have an abbot who was very close to Gregory VII, and therefore to the Reform, who co-ordinated and a modeled a program, which was simultaneously proposed in Pisa. But let us return to the Abbey of Montecassino, which is considered a copy of early Roman Christian basilicas, and also of buildings that were specifically built, such as the lower (today) basilica of San Clemente or the underground Church of Quattro Santi Coronati, also in Rome, in relation to which recent studies which have also analyzed the frescos have suggested new interpretative models for the coming of the Reform.[31] Therefore, the Montecassino School set a trend.

A notable example is the Church of Sant'Angelo in Formis, with cycles of frescos in the nave showing images of the Old and New Testament, probably inspired by the Montecassino cycles that had been lost. I would also like to mention two significant churches, the Cathedral of Salerno and the Cathedral of Capua. The Cathedral of Salerno was consecrated in 1084 by Pope Gregory VII, who had just

been saved by the Normans; they moved him to Salerno from Castel Sant'Angelo, where he had taken refuge to avoid being captured by the imperial troops. It is a large building, covered with trusses with a four-porticoed structure in front, like the Cathedral of Capua just afterwards, and therefore a replica of the Roman basilicas. It is not possible to follow the spread of church naves divided by Roman columns, which was very widespread in the south, so I will confine myself to mentioning one more example, this time in Tuscany, a building after the model of Saint Peter's in Rome. I am referring to the Cathedral of Pisa,[32] whose construction was started in 1063 by Buscheto, a highly-praised architect in epigraphs and chronicles for his great technical skills. The building represents the continuity between early Christian basilicas and the new architecture of the Reform, which in Tuscany was expressed in such significant buildings as the Church of Sant'Alessandro in Lucca[33] and, also in Lucca, the Cathedral of San Martino,[34] which was significantly rebuilt in the fourteenth century. The Church of San Frediano is later, with colonnades made from re-used materials dividing the three naves.[35] Thus, the Cathedral of Pisa, finished by Rainald, is a building inspired by Saint Peter's in Rome. If we observe it today, we see the apses at the end of the transept that did not exist in the Roman basilica, but in this case what I said about the meaning and value of copies in medieval times is also applicable. In the case of Pisa and its Cathedral, and the buildings of Lucca, and various others, we need to reflect on the precocity of this program and the complexity of the decisions it entails. Focusing only on the Cathedral of Pisa, we should not forget that Buscheto was praised for his technical abilities, such as recovering columns submerged in the sea, or using winches that could be handled even by young girls so effortlessly, etc. All this helps us to understand how decisions in relation to the Church in Pisa were cautious, but it also leads us to the conclusion that the principals desired a clear symbolic model, and this cannot be understood without reference to Anselmo da Baggio, at the time Pope under the name of Alexander II (1061–1073), closely linked to the Reformed Church, nay, one of its greatest adherents. If we take into account that the recovery of a unified text of the Old and New Testaments in the West with the Atlantic Bibles took place under his pontificate, we can perfectly understand the decision to build the Cathedral in Pisa, whose design must be interpreted in the same light as that of Desiderius at Montecassino.

In the Church of the Reform, in its origins, church architecture became an essential reference point and a model prevailed that did not include the presence of figurative images on the outside of buildings, except in the case of bronze doors. Re-used Corinthian and Ionic capitals from old buildings also excluded narrative capitals. In these buildings of the first Reform there are no figurative architraves, although sometimes parts of architraves or Roman cornices of re-used materials can be seen, and all this is related to an aniconic program of interior decoration, for example in the case of presbytery enclosures.

If we now analyze these buildings and compare them to those in the north, we find that, while in the center and south of the peninsula figurative images are rare, a wealth of carved heritage is evident in the north, and hence the invention

Porta dei Leoni
c. 1080–1085
Cathedral of Salerno

32 A. Peroni (ed.), *Il Duomo di Pisa* (Modena: F. C. Panini, 1995).
33 C. Taddei, "Lucca tra XI e XII secolo. Territorio, architetture, città," *Quaderni di Storia dell'Arte*, 23 (Parma: 2005), pp. 117–56.
34 C. Baracchini and A. Caleca, *Il Duomo di Lucca* (Lucca: Libreria editrice Baroni, 1973).
35 R. Silva, *La Basilica di San Frediano in Lucca. Urbanistica, architettura, arredo* (Lucca: M. Pacini Fazzi, 1985).

Scenes from Genesis [Bibbia del
Pantheon, *Vat. lat. 12958, fol. 4v*]
1125–1130
*BAV~Biblioteca Apostolica
Vaticana, Vatican City*

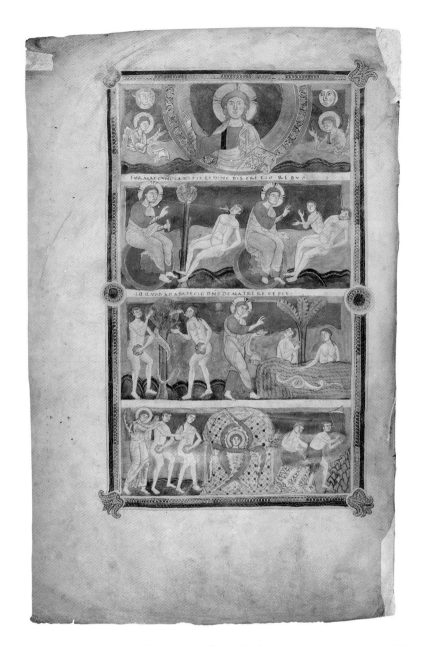

36 In Parma, a first construction phase is
 dated to the end of the eleventh century.
37 A. C. Quintavalle, "Niccolò architetto,"
 in A. M. Romanini (ed.), *Nicholaus
 e l'arte del suo tempo. In memoria
 di Cesare Gnudi*, vol. 1:3 (Ferrara:
 Corbo, 1985), pp. 167–256.

of a narrated story, the reason for which we must investigate. We could cite the
Cathedral of Modena with Wiligelmus' imposing narrative solutions (1099–1106,
collusion around 1110); Nonantola Abbey with its carved door and a pinnacle on
lions in the narthex (c. 1090–1095), the frieze and other sculptures (1107–1115) in
the Cathedral of Cremona. We should also mention Nicholaus' archaeological and
artistic interventions in Parma on the nave capitals and the presbytery enclosure
(c. 1106–1115),[36] the Cathedral of Piacenza (from 1122 to approximately 1130),
the Cathedral of Verona and San Zeno, finished around the end of the 1130s,
and the Cathedral of Ferrara (1135).[37]

 Before providing an answer to this problem, it is convenient to analyze at
least some of the larger churches in the north that we have just mentioned, almost
all of them cathedrals. Some of them, like the Cathedral of Parma, the Cathedral
of Cremona and the Cathedral of Piacenza, have transepts stemming from the north
and south wings of the buildings, while others, like Modena, Nonantola, Ferrara
Cathedral, San Zeno in Verona and the cathedral in the same city, do not have

Right-hand nave [*interior view*]
c. 1150–1200
Cathedral of Pisa

transepts. Having reached this point, it is a good idea to return to the buildings located on the pilgrimage routes mentioned earlier, leaving aside the topic of the vaults that in northern Italy were added later, such as in Parma, Piacenza, Modena and Cremona; these buildings were in fact originally put up with truss roofs. If we reflect on the architectural approach of these buildings in northern Italy, we should grasp their symbolic value and role in relation to the readings that the faithful of the eleventh or twelfth century could make of their structures. I do not think it is difficult to admit that the Romanesque cathedrals and monastic buildings we have mentioned in the north, although there were many others, like the Church of Santa Maria Maggiore in Bergamo and the Cathedral of San Lorenzo in Genoa in its first phase, have to be considered as imitations of the Roman basilicas; of Saint Peter's when they have a transept, and other churches without a transept when this structure is not used. At this point it seems we can conclude that the churches studied as basilicas on pilgrimage routes are simply a restatement of the forms of Roman basilicas, as indeed we have seen at Cluny III.

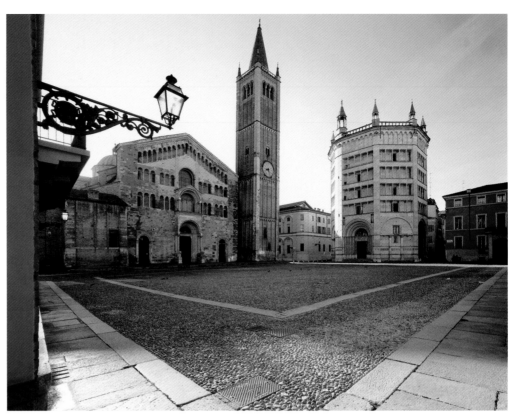

Apse *[exterior view]*
1107–1117
Cathedral of Cremona

Piazza del Duomo
Parma

Therefore, the problem we have to pose is the presence of complex systems of narrative sculpture in the north. How can we explain, apart from the mosaic pavements, which also had evident narrative functions, doors with finely sculptured stipes and archivolts, fronts with narrative friezes, presbytery and pulpit enclosures, and also outside and inside capitals always bearing the mark of an allegorical program? How can we explain all this, if furthermore we compare it to the differences in the decoration of churches in central and southern Italy? We will try to formulate a working hypothesis: emperors, from Henry IV onwards, went through Italy and reached Rome, but their most violent struggles were waged against Matilda of Canossa in the time of Gregory VII and his successors, and with the nascent municipalities in northern Italy. The internal split in the clergy, and among the bishops and monasteries in and outside of cities, was extremely harsh: entire bishoprics, such as Piacenza and Bologna, Modena before 1099 and Parma before 1106, and many other monasteries, had joined the imperial party, and so the influence, for example, of Matilda of Canossa, joined to the Church of Rome, had considerable influence in Reggio Emilia, Pisa and Lucca. In the north, however, it often became apparent after the recapture of different cities, sometimes even *manu militari*, like Parma, Piacenza and Mantova. The conquest also meant the return of the Reform, as in Bologna, where the confrontation between the two parties continued into the second decade.[38] Therefore, from the late eleventh to the second decade of the twelfth century, when various religious buildings in the north were being enriched with a complex narrative system could only be compared to France and Spain in the West, we have to think that this new iconography may be related to an anti-imperial program desired by the Church

38 "Il medioevo delle cattedrali," in id. (ed.), *Il medioevo delle cattedrali. Chiesa e Impero: la lotta delle immagini* (Milan: Skira, 2006), pp. 23–290.

of Rome and directed through mosaics, paintings and sculptures understood as a grandiose educational system programed against heresy.

Let us now reflect on the sculpture, painting and mosaics: it seems clear to critics that for a long time the attempts to find artistic, pictorial and mosaic texts in the West have failed. They have not found a style, to use a traditional term, that is similar everywhere, for example from Bari to Modena, from Toulouse to Cluny, from León to Compostela; in fact it is unthinkable that one or more workshops should move from one end of Italy, Spain, France and parts of Germany to another – I am of course referring to the regions with their current names, not their historical ones – and that these workshops had the habit of using the same sculptors. We should seek for the explanations of the many similarities elsewhere. Moreover, critics have acknowledged that, on a regional level, the transfer of the same workshop from site to site can often be verified, and therefore a problem arises; what did that particular workshop take with it in order to reproduce the same patterns? How did it fix not only a thematic but also a graphic and therefore stylistic memory of the images produced? What did the various different pieces have in common? It also seems that any election by the principals of any particular *magister* for being endowed with a particular style should be rejected; we could

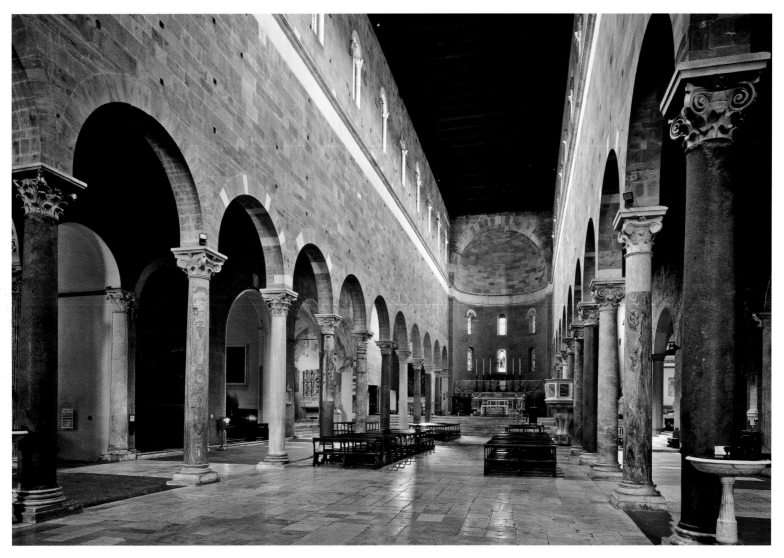

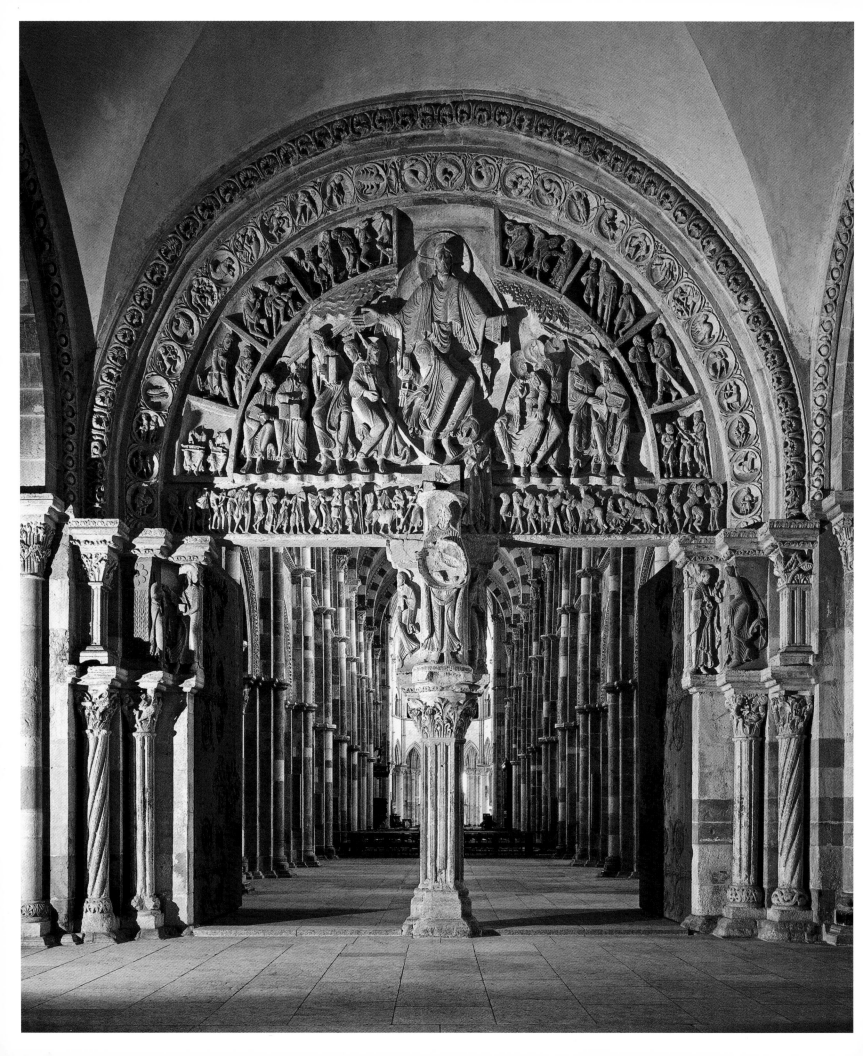

think of the choice of a particular workshop motivated by a complex global competition among different techniques, from construction techniques to stone, brick, wood, metal and glasswork. If this is true, we could identify examples of the transmission of writings, graphics, style, as well as the iconography from one piece to another in the hands of the same workshop. It certainly seems impossible to me, on this occasion, to accurately account for all the vicissitudes in different places; but in any case an indication, albeit sketchy, of these complex exchanges and transfers of masterwork, will allow us to provide a further indication about the chronologies that, as we will see below, are concentrated within a very short period of time, from the last decade of the eleventh century to the second or third decade of the twelfth. A more articulated reflection on time and methods of the Reform in the West is the argument of a forthcoming publication of mine, which I refer readers to.[39]

We will therefore try to list the periods of some works and the temporary relocation of workshops from site to site. We will begin with a work associated to the dominant figure of Wiligelmus. As I have said on other occasions,[40] we must place Wiligelmus' beginnings in Nonantola (in the 1090s), and therefore in Modena (c. 1099–1101), then in Cremona (1107–1117), and finally in Piacenza (from 1122). Wiligelmus' workshop was followed by Nicholaus in the Sagra di San Michele in Val di Susa (1117); around 1106–1115 the sculptor and architect was active in the Cathedral of Parma, in 1122 in Cadeo (Piacenza), from approximately 1122 to 1130 in the Cathedral of Piacenza, in 1135 at the Cathedral of Ferrara, in the 1130s in San Zeno and the Cathedral of Verona, without taking into account the presence of Nicholaus' workshop elsewhere, from San Ciriaco de Ancona to Fano. As is also apparent from this schematic listing, the amount of building carried out the two workshops, also related by coinciding iconographic decisions, suggests programming on a higher level, which depended on the decisions of the principals. We could say the same about one type of production that characterizes northern Italy: complex mosaics in cathedrals or major buildings. Their remains, still impressive despite the losses, in the Museo Civico di Pavia or the Reggio Emilia, where among other items we can see the remains of the pavements of these cathedrals, pose the problem that workshops were active at different locations in the north, but they often worked with the same "cardboard," and in any case, with similar iconographic decisions, from Pavia to Piacenza, from Cremona to Reggio Emilia and to San Benedetto al Polirone (inlaid marble floors) and in many other places. The periods are the same; in fact, they all date from the 1090s or the first decade of the next century.

I will not go into detail about other European carved cycles, and so I will limit myself to underlining, from my point of view, possible datings, important also in relation to the iconography chosen by the principals, with the intention of linking the different workshops. The archaic chronology of Cluny, from 1088 to 1095 for the final zone with two transepts, means we have to date Vézelay long before the 1119 fire that supposedly destroyed the building, rebuilt after that date; the sculptors working in Vézelay did a similar job to the authors of several capitals

Central portal
c. 1104–1110
Basilica of Sainte-Marie-Madeleine de Vézelay, Yonne

39 Id., *Il Romanico e la Riforma gregoriana* (Milan: Electa, 2010).
40 Id. (ed.), *Romanico mediopadano: strada, città, ecclesia* (Parma: Università di Parma, Centro di studi medioevali, 1978). Id., *Wiligelmo e Matilde. L'officina romanica* (Milan: Electa, 1991). Id., *ad vocem* "Wiligelmo," *Enciclopedia dell'Arte Medievale...* op. cit., pp. 775–86. Id., *Il medioevo delle cattedrali. Chiesa e Impero: la lotta delle immagini...* op. cit.

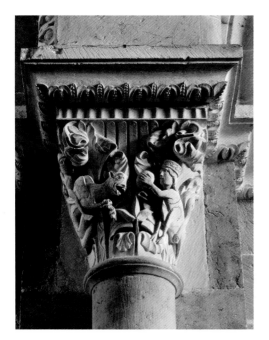

Capital *[Central nave]*
c. 1104–1110
Basilica of Sainte-Marie-Madeleine
de Vézelay, Yonne

Southern door *[Narthex]*
1110–1130
Church of Saint-Pierre de Moissac,
Tarn-et-Garonne

within the mother abbey and the remains of the doors and the tympanum of the front reconstructed by Conant.[41] In my opinion, therefore, Vézelay is a complex to be dated to the first decade of the twelfth century, including the three great carved doors of the narthex, and therefore no earlier than 1104, when the choir was rebuilt and consecrated, after which the nave was built. Another *vexata quaestio*, on which Wirth's significant contribution[42] shed some light, is the one of Conques and the chronology of the major sculpted complexes of Alvernia. I believe Wirth's dating is acceptable, regardless of the evolutionary patterns of archaeological tradition, and I think the *terminus ante quem* for Conques should be 1107, the date of the cloister, unthinkable if the church was not complete. I am not going to spend any longer on the reconstruction of the facade at Conques, part of which is set at the top of the north transept of the church; its typology should be compared to Moissac. While on the topic of the tympanum and door at Moissac, it is difficult to agree with the traditional dating of around 1130; in fact, the cloister can be dated to 1100. The capitals of the atrium, heavily decorated, and even the tympanum itself are related to a complex tradition – the sculpture of Cluny in Burgundy and of Conques in Alvernia, as well as, of course, as Mâle pointed out, precise sources of painted miniatures.[43] The hypothesis of dating the Moissac door to about 1130 is born of evolutionary schemes. I think, therefore, that we can state that the tympanum and front can be dated to within the first decade or early in the second. The dating of Souillac should also be brought back to the first decade of the twelfth century.

There are evident difficulties in accepting the evolutionary archaeological model in Toulouse, for whose chronography there has been so much uncertainty, apart from the unquestionable date of the altar and, therefore, of the related sculptures in Guilduin Bernard's presbytery area, 1096, and the nexus between Gilduin himself and the *Porte des Comtes*. The whole set of tiles from the

41 "Les fouilles de Cluny (Saône-et-Loire)"...
 op. cit.
42 J. Wirth, *L'image à l'époque romane*
 (Paris: Cerf, 1999). Id., *La datation*
 de la sculpture médiévale... op. cit.
43 *L'art religieux du XIIᵉ siècle en France...*
 op. cit.

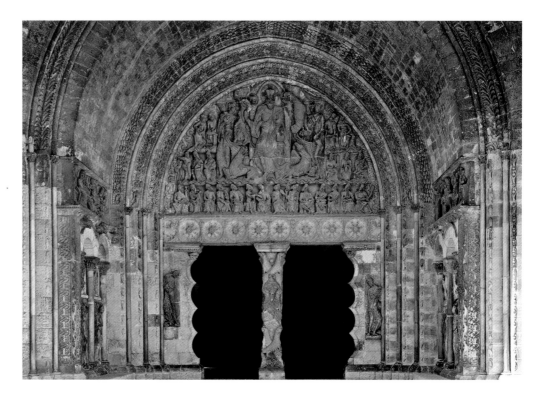

Tympanum and Annunciation
group [*Abbey Church of Sainte-Foy
de Conques, c. 1103–1110;
hypothetical reconstruction*]
1939–1941
*Cité de l'architecture et du patrimoine–
musée des Monuments français, Paris*

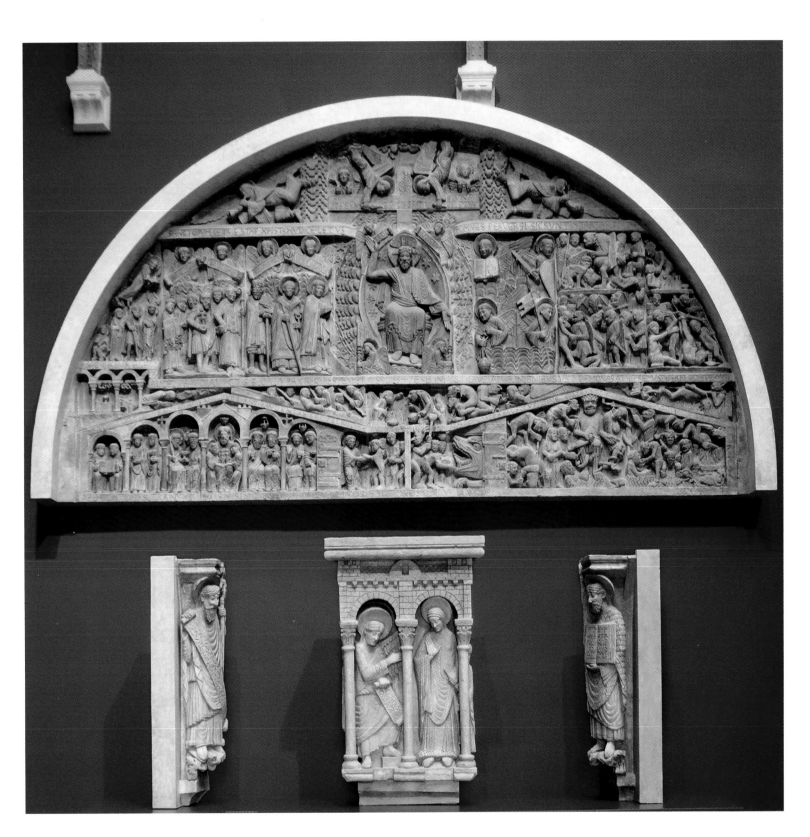

ambulatory should be dated, I think, to the last decade in the eleventh century. The tiles must have been part of the angular pillars of a cloister. The most difficult problem in Toulouse is the dating of the *Porte Miègeville*, which the pattern of evolutionary criticism has generally placed at around 1118, probably because the use of artistic forms more directly related to the age imposed, in evolutionary terms, a date later than the *Porte des Comtes*, dated to the late eleventh century. I do not think that things fit in these periods and I think a timeline within the first decade, and perhaps even within the first five years of the twelfth century, is possible, taking into account the relations with the *Platerías* Door sculptures in Compostela.

We shall now analyze other cycles whose chronology is sometimes well proven, and others where it is controversial. The dating of the Jaca sculptures is unquestionable, where dialog with Antiquity appears clearly and whose chronology with the church capitals, the half-destroyed cloister and the tympanum seems to be set in the early 1090s. The dating of the two tympanums of San Isidoro de León to around 1100 does not seem to have been opposed by critics, while the dating of the double-tympanum in the Cathedral of Santiago de Compostela, as is well-known, reconstructed with sculptures coming from the destroyed northern gate and also with pieces from the late twelfth century,[44] and the dating of the double portico of the cathedral to between 1101–1103 and 1111, seems perfectly plausible today, at least in its original layout before destruction and reconstruction.

I have attempted to indicate the chronology I find most plausible for the major narrative cycles of the Christian West in the Reform, because I think the problem of dating the sculptures is very important. What do all the cycles I have enumerated have in common? and many others that, for obvious reasons, it would make no sense to take into consideration? We will soon see their iconography, but I think that the choice of models common to all should be recognized; it has a specific value. Let us start precisely with this aspect; what do these cycles have in common? With regards to style, the sculptures in different areas, whether regional or subregional, are different, except when we are dealing with the same workshops active along the Pilgrims' Road to Santiago, like in Languedoc, Burgundy and northern Italy. And yet there is a profound relationship present in all these sculpture systems, and hundreds of others throughout the West: the relationship with Antiquity. It is true that Antiquity, and I mean by this Roman provinces, has taken on different forms in different places, hence the relationship with Antiquity that we see in Jaca, with capitals reminding us of second-century Roman art, or the figures on the tympanums in San Isidoro de León, which also evoke early Christian sarcophagi, does not match the Antiquity evident in the cloister of Moissac, also influenced by Islamic models, or the complex tympanum of the church. Antiquity is also evident in Cluny and Vézelay, but while in the capitals of the ambulatory dialog is also established with the great cycles of the eleventh century, Saint-Benoît-sur-Loire[45] and Saint-Germain-des-Prés,[46] in the capitals of the nave from Cluny III and perhaps of Vézelay, the dialog is established with Roman sculptures in Burgundy, not to mention Gilabertus in Autun. In Toulouse, dialog with Roman art is evident on the *Porte Miègeville*, while a dialog with Antiquity has been proposed

44 The literature on the problem of Compostela is vast, from the earlier discussion of Toulouse against Compostela and vice versa, and therefore of a national confrontation between art historians with very different ideas in recent decades; I refer to Durliat's above-mentioned volume and to Manuel Castiñeiras Gonzalez's studies on Compostela, to which I refer for an articulated historiographical debate. See M. Castiñeiras, "*Introitus pulcre refulget*: algunas reflexiones sobre el programa iconográfico de las portadas románicas del transepto de la catedral," in *La meta del Camino de Santiago. La transformación de la catedral a través de los tiempos* (Santiago de Compostela: Xunta de Galicia, 1995), pp. 85–103. Id., "Arte románico y reforma eclesiástica, Las Religiones en la Historia de Galicia," *Semata*, 7–8 (Santiago de Compostela, 1996), pp. 307–32. Id. "La catedral románica: tipología arquitectónica y narración visual," in M. Núñez (ed.), *Santiago, la Catedral y la memoria del arte* (Santiago de Compostela: Consorcio de Santiago, 2000), pp. 39–96. Id., "Roma e il programma riformatore di Gelmírez nella cattedrale di Santiago," in A. C. Quintavalle (ed.), *Medioevo: immagini e ideologie* (Milan: Mondadori Electa, 2005), pp. 211–26. Id., "La meta del Camino: la catedral de Santiago de Compostela en tiempos de Diego Gelmírez," in M. C. Lacarra Ducay (ed.), *Los caminos de Santiago. Arte, historia, literatura* (Saragossa: Institución Fernando El Católico, 2005), pp. 213–52. Id., "Tre miti storiografici sul romanico ispanico: Catalogna, il Cammino di Santiago e il fascino dell'Islam," in A. C. Quintavalle (ed.), *Medioevo: arte e storia. Atti del Convegno Internazionale di Studi di Parma (18–22 settembre 2007)* (Milan: Electa, 2008), pp. 86–105. V. Nodar, *Los inicios de la catedral romànica de Santiago* (Santiago de Compostela: Xunta de Galicia, 2004).

45 E. Vergnolle, *Saint-Benoît-sur-Loire et la sculpture du XIᵉ siècle* (Paris: Picard, 1985).

46 I refer to the pieces surviving in the Musée National du Moyen Âge, Thermes & Hôtel de Cluny in Paris, while the capitals preserved in the church are often copies: cf. D. Johnson, "The architecture and sculpture of the eleventh-century abbey church of St Germain-des-Prés: their place in the millennial period," in N. Hiscock (ed.), *The White Mantle of Churches: Architecture, Liturgy, and Art around the Millennium* (Turnhout: Brepols, 2003).

Genesis [*Western facade*]
Master Wiligelmus
c. 1099–1110
Cathedral of Modena

many times by critics in relation to Wiligelmus[47] and also Nicholaus.[48] Naturally, for Wiligelmus the relationship with Antiquity refers to sculpture from the second and third centuries, especially sarcophagi, partly preserved in the courtyard of Pinacoteca Estense in Modena, while for Nicholaus dialog is also established with the sculpture of Byzantine and Islamic ivories from the eleventh and twelfth centuries.

After this series of rapid chronological indications that should be studied in more detail on another occasion, if we now consider the dialog with Antiquity in key buildings of the Reform, which were programmatically inspired by early Christian Roman basilicas, from Montecassino to the Cathedral of Pisa, from the Cathedral of Salerno to the buildings of Apulia, from the eleventh to the twelfth century, together with San Frediano in Lucca and other places, we will understand that, apart from the above-mentioned aniconism, a decoration that clearly evokes Antiquity was chosen, as is evidenced by the hundreds of re-used columns and capitals. They were also imitated, as in the case of the capitals and columns in the Cathedral of Modena. The intention to build the cathedral as a memory and symbol of early Christian buildings is reinforced through the re-use of Roman pieces or, as in the Cathedral of Pisa, settling in the outer wall fragments of inscriptions and sculptures from the Roman era of the Middle Ages, along the perimeter wall of the Cathedral of Buscheto and Rainaldo.[49]

But how is it that in the entire West, reference to Antiquity is expressed with a common language, which, as is well known, differs across the cultural divergences of the various provinces of the Roman Empire? Obviously there had to be a top-level program that required the establishment of this dialog, this reference to Antiquity, that identified with early Christianity to show through architecture,

47 R. Salvini, *Wiligelmo e le origini della scultura romanica* (Milan: Martello, 1956). *Il medioevo delle cattedrali. Chiesa e Impero: la lotta delle immagini…* op. cit.
48 "Niccolò architetto"… op. cit.
49 *Il Duomo di Pisa…* op. cit.

Capital [*Central nave*]
Master Nicholaus
1106–1115
Cathedral of Parma

Apse and transept [*exterior view*]
Master Buscheto
1063–1118
Cathedral of Pisa

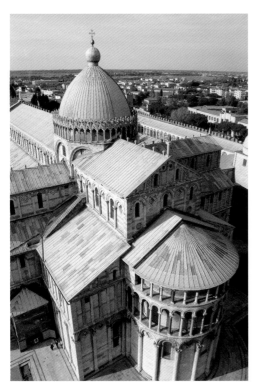

sculpture, marble cladding and internal decoration that the Church of the Gregorian Reform was like that of the origins. This is therefore what all "Romanesque" has in common in the West; not the style of some *magistri* from different workshops, but a dialog with Antiquity that was undoubtedly suggested by the Curia in Rome – the Orthodox Curia, not the schismatic one. But there is another thing that is common to the different Middle Age workshops in the West: the choice of a certain iconography that had not been used previously, or at least had not been used so often. This iconography assumes a specific meaning in the context of a West divided by the de facto existence of two churches brought into conflict, the Roman Orthodox and the one supporting the Empire, which resulted in the appearance of a series of anti-Popes and schismatic Bishops largely in the West, and in particular in the Italian peninsula.

It therefore seems likely that the Church of Rome launched the mission, aimed at all local churches and abbeys attached to the Reform, of using architectural remains from ancient times as far as possible and returning to Antiquity in the sculpture of the times. An obvious element in this decision was the recovery of an artistic form unknown in Otthonian times, through the direct use of imagery often inspired by the sarcophagi which are, ultimately, the most widespread kind of artistic texts in the West after the destruction of statues of deities, or more explicitly, pagan statues. Copying Corinthian capitals when they are not *in loco* original, copying compositional schemes on sarcophagi, perhaps moving them to capitals or tympanums, is a widespread fact throughout the West during the late eleventh and early twelfth centuries.

We now need to analyze, once the stylistic difference of Roman matrices is established and, therefore, the different trends of medieval workshops too, if there

is a common iconography that may imply the existence of a narrative program previously set by the Roman curia. In fact, as regards style it is impossible to find a unity – what the historiography of art has called "Romanesque" – but for iconography it is plausible to consider the hypothesis of the existence of a common project, a generalized instruction from the Church of Rome, which tried to propose certain politically significant arguments to the faithful.

A first observation is necessary: the topics depicted with particular evidence and repeatedly disseminated in the late eleventh and early twelfth centuries were generally present in the past as well, and so in most cases we are not dealing with new iconographic inventions. And yet, what does seem significant is the number of images of a certain type, including, even outside the Italian peninsula, significant depictions of Saint Peter on cathedral fronts, on tympanums, on doors – a sign of membership, as we shall see below, of the Orthodox Church of Rome.

Let us now briefly examine some of the issues, politically significant, that quickly united the West. The murder of Abel by Cain, preceded by an offering to God by the two brothers, is certainly an image that goes back to early Christian times, but the fact that it now appears again, e.g. in Wiligelmus' bas-relief on the front of the Cathedral of Modena, means something else. The Church of Modena, which had been ruled by schismatic bishops until 1099, now came back to the Roman Orthodox Church, and so depicting the sacrifices of the two brothers, one who pleased God and one who did not, represents the contrast between two religious systems, the reformed and the Empire, and, finally, it symbolically means killing the repudiated, as the blind Lamech does in Wiligelmus' bas-relief.

In the mosaics of Santa Maria del Popolo in Pavia and in the church next to the Cathedral of Cremona we see *Fides*, depicted with a long dress and contained gestures, fighting victoriously against Strife. Once again we are witnessing a metaphor for internal conflict in the church. Let us take into account that the theme of Cain and Abel's sacrifice is also found in San Michele in Pavia and this diffusion of the issue is an indirect testimony to the diocese of Pavia's fidelity to the Church of Rome. Another unique case as regards iconographic decisions is the spread of the living Christ, eyes wide open, watching people, which we see on the Holy Face of Lucca and Borgo San Sepolcro to the Batlló Christ in Barcelona and the Catalonian Christs that can be related to this. The image of the living Christ talking to the faithful has to be explained from its origin through a wide range of texts that clarify the reasons for this depiction. The Christs have a similar iconography, but they are from a very different culture, in fact, there is nothing in stylistic terms to associate most *colobium* Christs in Spain with the Christs of Lucca and Borgo San Sepolcro. I have already proposed this issue[50] and I will not spend more time on it here, but it is interesting to underline that the unique spread of robed Christs in Catalonia is testimony to a fact that, as in the case of *prèmier art roman*, spread out along the Mediterranean basin. Christs with a *colobium* triumph over death and talk directly to the faithful. Choosing this iconography, where the *colobium* refers to the early Christian model, means proposing a direct dialog with the faithful, who can only be saved through this dialog.

50 "I Cristi viventi e la Riforma gregoriana in occidente"... op. cit.

Volto Santo *(Holy face)*
twelfth century
Cathedral of San Martino, Lucca

Rosano Cross
Master of Rosano
c. 1120–1130
Abbey of Santa Maria Assunta
di Rosano, Florence

The same symbolic value includes the image of a series of Christs from the early twelfth century, such as Rosano and others that are similar, such as Uffizi Cross 432. The iconographic choice of the scenes on the piece is important in these images: in the scenes that accompany the painted figure of Christ we often find significant iconography, for example, Saint Peter and the cock predicting that before dawn he will betray Christ three times, and also the image of the kiss of Judas. For us perhaps, the symbolic meaning of these images is less clear but, for a person of the time, the allusion to undecided priests and, at first, followers of the Empire in the scene with Peter must have been clear, while Judas' Kiss must have meant the betrayal of the members of a religious order of the Empire. I have interpreted the image of Noah's Ark carved on the front of Modena by Wiligelmus as a manifestation of the clergy's common life; we find the same iconography again in the frescos from the other pole of the Reform, Saint Savin sur Gartempe, which are dated to around 1100, and so contemporary of Wiligelmus' sculptures. Both in Modena and in Saint Savin sur Gartempe we can see Noah's ark, depicted as a system of arcades at different levels, two in Modena and three in Saint Savin: this is the ark understood as a cloister and we know that the Reformed Church imposed common life on the members of religious orders.

I cannot analyze here in detail the iconographic invention of the great tympanums in churches along the Pilgrims' Road to Compostela; in any case it only depicted half the journey, as the tombs of Peter and Paul in Rome were very important for the faithful in the West. Thus, pilgrimages could go both to Rome and to Compostela, even starting from Italy:[51] there are different routes and then different poles, even regarding the so-called "Pilgrim's Guide."[52] Coming back to sculpture and specifically to tympanums, I could say that, in general, apart from the old Roman sculpture and many sarcophagi that have survived in the West, tympanums carved in the late eleventh and early twelfth centuries developed different and complex experiences, Otthonian and Byzantine ivories and sometimes Islamic chests for the friezes or *textures* of the non-decorated parts. But there is an image that is repeated in churches along the pilgrimage route, and this is the image of Saint Peter, who is always depicted in a conspicuous position; there is a Saint Peter at Cluny, on the tympanum that is now destroyed, at Vézelay, together with the other apostles, at Conques on the tympanum of the front, and another one on the frontispiece of the *Porte Miègeville* in Toulouse, where we also see Simon Magus. And we also see Saint Peter at San Isidoro de León and in Santiago de Compostela. Peter appears next to Saint James many times along the pilgrimage

Vault *[Central nave, detail]*
c. 1100
Abbey Church of Saint-Savin-sur-Gartempe, Vienne

51 A. C. Quintavalle, *La strada romea* (Milan: Silvana, 1975).
52 J. Vielliard (ed.), *Le Guide du pèlerin de Saint-Jacques de Compostelle* (Mâcon: Protat frères, 1938). B. Gicquel, *La légende de Compostelle. Le livre de saint Jacques* (Paris: Tallandier, 2003).

Tympanum [*Western door*]
c. 1090–1100
Church of San Pedro de Jaca, Huesca

route to Compostela, but the only thing this does is to reinforce the symbolic value of his image; on the one hand this is the message to be conveyed – orthodoxy, dependence on the Church of Rome – while on the other hand, he is the saint that watches over the pilgrimage together with Saint James. The latter, as we know, was later transformed into Saint James the Moor-slayer, not a metaphor but the metonymy of the Christian crusade against Islam in Spain and after in the Holy Land.

We should certainly reflect on the whole iconography of the tympanum in the most important buildings along the pilgrimage route, but this would take us too far afield from the topic proposed, which is the centrality of the Church of Rome and the Reform Programs in the West. The novelty therefore of these great images lies in the proposal to the faithful entering the church, which is, symbolically, the *janua coeli*, the Final Judgement, as at Cluny but also in Conques and Moissac. There may be other topics, like the double lion at Jaca, the Ascension in Toulouse, Pentecost at Vézelay and in the same church the Adoration of the Magi and the Appearance of Christ to his disciples, while on the two tympanums of San Isidoro de León we see the Sacrifice of Isaac and the Passion of Christ. If we wish to reflect on the iconography of the later tympanums, for example, Gilabertus in Autun, we see that the Final Judgement is back, while in Italy Nicholaus' workshop proposed another, the patron saint of the center, such as Saint Zeno in Verona and Saint George in Ferrara, or the Virgin in the Cathedral of Verona. While on the tympanums of the Western reformed Churches the Day of Judgement seems to be the dominant theme, on the tympanums carved by Nicholaus the dialog with municipalities and with the people who managed them seems evident, as shown by the graven images of the *cives*, defenders of the saint, on foot or horseback. Here, then, in northern Italy, in San Zeno, there is also a political novelty that we cannot forget. In Italy the birth of free municipalities that also became principals provided architects with different themes, the depiction of Roman orthodoxy, no doubt, but also the dialog among the new powers of the bourgeoisie.[53]

Let us now approach the problem that we cannot neglect, of how the memory of these images was conveyed, given that in the Western buildings, apart from the tympanums and the sculpted capitals, always painted, always colorful,

53 C. V. Bornstein, *Portals and Politics in the Early Italian City-State. The Sculpture of Nicholaus in Context* (Parma: Università di Parma, Centro di studi medioevali, 1988).

we cannot forget the cloths, large-scale embroideries hanging on the wall, and of course the frescos, and less frequently mosaic floor pavements, a heritage of images which was therefore very complex and for which careful planning was needed. How did workshops move? How did principals establish the iconography to depict and execute? It seems logical to think that the architecture and sculpture workshops had codex, picture books, most of which have been lost[54] precisely because they were used as a workshop instrument and therefore lacked the sacred aspect that has allowed religious manuscripts to reach our days. Workshops had to travel with parchment sheets on which the shapes of the sculptures were traced, and they probably brought with them patterns, profiles of the images, both painted and sculptured, patterns that can clearly explain the compositional similarities between *ad unguem* sculptures in different places.

The dialog between workshops and principals was the result of a schedule that we could not explain without a central will, the will of the Church of Rome. Let us return then to the problem of the reason for this programming, to the complexity of these imaging systems and the wealth of the models for worship to which these images referred. The idea that the Church aligned with the Empire is depicted as heretical makes us think about what Pope Alexander II considered heretical, sending Hildebrand of Soana to Milan; in this particular case, the Patarins. But while in relation to the latter, Hildebrand, later Pope Gregory VII, accepted some of their requests and expelled Simonist clergy and those with concubines, in the case of the struggle against the Empire the only thing the Roman Church could do was to impose a much clearer line of action and had to resort to images to teach the unlearned its own theses. The Church of Rome related its own identity to early Christian origins, and this explains the architectural, artistic and pictorial image decisions which it co-ordinated in the West against the Empire and religious schismatics.

Tympanum *[Porte Miègeville]*
c. 1105
Basilica of Saint-Sernin de Toulouse,
Haute-Garonne

54 "I Cristi viventi e la Riforma gregoriana in Occidente"... op. cit.

But how could this opposition take place, if not, as in the case of the Atlantic Bibles, through a specific iconographic program? From Pope Gregory the Great's time, the Church of Rome had a specific project in relation to images: it was the Bible of the Unlearned, as it was known later on – the instrument of theological knowledge for those who could not read or write. The educational function of the images is part of the global iconographic project within churches, that today we can only reconstruct with difficulty because there are no fully preserved buildings with architecture, sculpture, painting or decoration, and so we have to recompose the parts preserved in different places and often from quite different times. In any case, the educational function of the church building is clearly documented in encyclopaedias, from Bede[55] to Rabanus Maurus,[56] from Honorius of Autun[57] to Hugh of Saint Victor,[58] to Sicard of Cremona[59] who, as we know, wrote in the late twelfth century. Thus, the texts bear out our thesis, the thesis that has always existed, from at least the late sixth century onwards, a precise policy of the Church of Rome in relation to images. This thesis is based not only on the two letters from Gregory the Great to Serenus Bishop of Marseilles, but also on commentaries on the biblical text about the Temple of King Solomon, precisely describing its wealth of images.[60]

But then, even though the text of a hypothetical *Dictatus Papae* of the images seems to be lost, based on the great tier system that suddenly emerged in the West, from our peninsula to France and Spain – and perhaps not by chance, much less significant in imperial Germany – and based on encyclopaedias and the symbolic analysis of the various parts of the church they developed, we can distinguish two major lines: the so-called Lombard sculpture on the one hand and the sculpture of the Reform on the other. Lombard sculpture, and I think I have proved this beyond Lombardy,[61] responded to a tradition of images that illustrated most of the buildings associated with the Empire and located predominantly in Germany, and it remained in these lands until the late twelfth century. Our peninsula and the territories from France to the Spain free from Islam were nevertheless characterized by sculpture related to the Reform.

We can finally ask, and it is obviously only an approach to focusing more didactically on the problem of images in the West – we can ask how they might have configured a *Dictatus Papae* for images. Its existence is proven by the facts and, therefore, by a unified program, the relation to Antiquity and the multitude of matching icons. In this regard I would list a number of possible points providing an idea of common lines laid down by Rome for images in the West, but first I would like to point out that I have not included anything related to goldsmiths, wall faces or miniatures, although this would also have been possible, given the transformations in the decoration system in these areas too. I hereby propose a scheme that refers to a possible text written by the Roman curia concerning images in the time of Pope Gregory VII, and even though it has not yet been possible to find any evidence, it reflects the historical reality of the events concerned with carved figures, paintings, mosaics and architectural manifestations from the last third of the eleventh century to the first third of the twelfth.

55 *"De natura rerum"*... op. cit.
56 *"Beati Rabani Mauri fuldensis abbatis"*... op. cit.
57 *"Gemma animae"*... op. cit.
58 *"De sacramentis legis naturalis et scriptae"*... op. cit.
59 *"Sicardi Cremonensis episcopi mitrale seu de officiis ecclesiasticis summa"* ... op. cit.
60 Gregorius I, "Epistola CV ad Serenum Massiliensem episcopum," *Patrologia latina cursus completus*... op. cit., LXXVII, col. 1027 C.
61 *Il medioevo delle cattedrali. Chiesa e Impero: la lotta delle immagini*... op. cit.

Central portal *[Western door]*
Master Gislebertus
c. 1130–1135
Church of Saint-Lazare d'Autun,
Burgundy

227

i) The Orthodox Church of Rome is the Church of Constantine, and as such, the images in Roman basilicas had to be reproduced and copied.

ii) The re-use of ancient monuments, for example, the foundations of temples, their columns and cornices had to be thorough and the reconsecration of pagan places seemed to be essential for convincing the faithful, as Pope Gregory the Great had already declared.

iii) The destruction of images of pagan gods, especially feminine ones, was always a goal to pursue. Models for new narrations were to be taken from Paleochristian sarcophagi.

iv) The re-use of ancient fragments in architectural buildings, renovated or built *ex novo*, endowed them with historical dignity, and therefore, these fragments acquired a symbolic value. All churches should re-use many Roman fragments and place them in significant locations.

v) Painted, sculpted or mosaic iconography must always be coherent. Images of the crucified Christ, carved or painted, should be created, but always showing a living Christ, with eyes wide open, speaking to the faithful as shown by tradition from the Fathers of the Church until today.

vi) Above all, an image of Christ representing Christ the judge should be proposed, whether carved on the tympanum or painted or depicted in mosaics in church apses. The iconography of the Final Judgement should analytically illustrate the punishments of hell as opposed to the beatitudes of Paradise. Other iconographies are also desirable, such as the foreshadowing of Christ's sacrifice and that of Isaac, but in the Judgement there should be a clear distinction between the reprobate and the chosen.

vii) There will always have to be specific iconographies for topics alluding to the schism within the church determined by the philoimperial clergy and by the anti-Popes, depicting a clear distinction between the orthodox and the heretical in these images. I shall list some of the topics: Cain and Abel's Sacrifice, Abel's murder and Cain's punishment, Sin and Expulsion from Paradise, Peter denying Christ three times, the Kiss of Judas, the Struggle between Virtue and Vice, with special emphasis on the triumph of *fides*, depicting the common life of the clergy through the symbolic image of Noah's Ark as a system of overlapping arches representing the cloister.

viii) The image system of the church should be contemporaneously and comprehensively analyzed, so that outdoor sculptures, mosaic pavements, and later on, capitals, the enclosures of the presbytery, pulpits and altars, all propose a narrative unity to enable the ignorant to understand the Old and New Testaments, the lives of the saints, but also the grave sin of simony and concubinage in the imperial church.

ix) When a diocese, city or cathedral returns to the bosom of the church, there should be a rapid construction of a new religious building, or the complete modification of the carved or painted iconography on the old building. Contributions should be requested from the nobility outside the city and the richest citizens to quickly build a cathedral where dialog with the tradition linked to images from the origins of Christianity was evident, both inside and out.

228

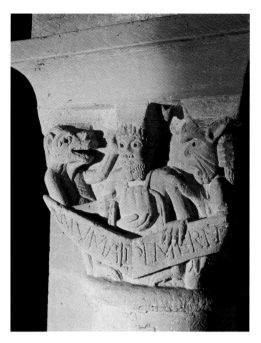

Crucifixion
1073–1087
Sant'Angelo in Formis, Capua

The Chosen *[Tympanum
on the western door, detail]*
c. 1103–1107
*Abbey Church of Sainte-Foy
de Conques, Aveyron*

Capital *[Gallery]*
c. 1070
*Abbey Church of Sainte-Foy
de Conques, Aveyron*

x) Graphic sources should be provided to architects' and sculptors' workshops, based on which it should be possible to unify images in religious buildings, whether they are abbeys or cathedrals, and each diocese or group of dioceses should choose which part of these sources they wish to use. The images were transmitted in codices or folios in which many iconographies were proposed; the clergy, apart from the prescribed depictions, should also add others depicting the saints whose relics were preserved in the church or the patron saints of the city. The images of saints were eventually repeated on the nave or cloister capitals or in the frescos and sculptures in the presbytery enclosure.

I doubt very much that the terms of the *Dictatus Papae* for images were exactly these that I have tried, in a slightly ironic way, to draw up, but it seems clear that the reasons which induce me to produce this working hypothesis are twofold, one *ante* and the other *post factum*. Firstly, the production of the Atlantic Bibles, after the incredible unity of the references to Antiquity, although with different graphics, and Western iconography over the last decades of the eleventh century and approximately the first three decades of the next. The iconography of the most significant sculptural complexes from the eleventh century was initially far sketchier and substantially less articulate. Then, one or two decades after the concordat of Worms of 1122, iconography inside and outside churches was confronted with heresy, not the anti-Popes and the Emperor, but the Cathars. These heresies obliged the Church to profoundly change its images, as we can see half-way through the century and also in Tuscany, with Gruamonte and Biduino, and in the north, especially in the last quarter of the twelfth century, with the masters known as "*campioneses*," or rather, Antelami masters, a term which was synonymous with architects in Genoa.

One last point: except for the popes from Alexander II, Gregory VII and Victor III to Urban II, Paschal II, Calixtus II and, consequently, down to the concordat of Worms, that is to say from 1061 to about 1122 and even beyond, the Church of Rome proposed a unitary model; indeed, it imposed it, and this model was identified with a style in the romantic age, and defined as "Romanesque." Romanesque, thought of as the Renaissance of a supposedly popular art form as opposed to learned art. Well, Romanesque, if we still want to call it so, is a an extremely learned art; it would be unthinkable as a unitary Western phenomenon without a unitary program, that of the Church of Rome; it is unthinkable without a constant monitoring of images, their functions and their meaning. Only then can this system of meanings and matching iconography be explained, the texts related to Antiquity and even renewed, the constant reinvention of narrative schemes, which obviously depict imperial "heretics" in a negative light, deduced from our analysis.

The term "Romanesque," as we have already mentioned, comes from a linguistic loan and therefore from the definition of Romance languages, but whereas these languages were divided by nations, Romanesque is a unitary culture; the former were thus popular languages, spoken by the people, whereas

Romanesque is a culture of images addressed to the people, but elaborated by the educated *elite*. A language that would never have been born were it not for the will of many Popes. It was not by chance that the origins of Romanesque coincide with the Gregorian Reform; that is, so-called Romanesque is nothing but art in relation to the image, the main instrument for the persuasion of the ignorant, adopted by the Gregorian Reform. An image that persuades – something that in most cases, the historiography of European art has never held – from the neo-basilical architecture of Pisa, Montecassino, Capua and Lucca and from the united Churches of the Roman Reform, starting with San Clemente. So please, let us not talk any more about the "evolution" of style and Romanesque as characterized by the barrel vault and transept; contemporary texts do not allow it. In conclusion, the style of the Reform is "Romanesque," as I hope I have demonstrated.

The Basilica of Saint-Sernin at Toulouse and the Question of the Carved Tympani

The Basilica of Saint-Sernin at Toulouse enjoys unanimous recognition and fame as one of the masterpieces of Romanesque architecture and sculpture. The studies it has given rise to are numerous, and are the perfect expression of what caught the attention of their authors at the time they were written. Thus, in the seventeenth century, Raymond Daydé penned *L'histoire de St-Sernin ou l'incomparable trésor de son église abbatiale de Tolose*,[1] this being a church history of the period of the Counter-Reformation to which he added historical fragments and legends, descriptions of carved reliefs and of miracles, incitements to visit and worship the numerous relics that the church took enormous pride in possessing. The *Monographie de l'insigne basilique de Saint-Saturnin*, published in 1854 by Auguste d'Aldéguier and Alexandre Du Mège,[2] is at one and the same time a reflection of the working methods that characterized learned studies in the mid-nineteenth century (such as the use of epigraphy and literary analysis to date the reliefs of Christ, the Cherub and the Seraph, nowadays attributed to Bernard Gilduin, to the Carolingian period) and a description that was intended to be analytical, comparative and chronological. Eugène Viollet-le-Duc's intervention on the building, which commenced in the 1860s, contributed to the blossoming of points of view marked by the rationalism preached by the great architect,[3] whilst at the same time the discoveries produced by the enormous amount of restoration work led to publications of an archaeological nature such as those by Jacques-Jean Esquié.[4] During the first quarter of the twentieth century there was a significant change of directions, with art historians engaging in a dispute tinged with nationalism about the question of the chronological pre-eminence of French and Spanish works. Well-known is the enormous task of inventorying and analysis of Romanesque buildings undertaken and directed by Manuel Gómez Moreno,[5] and, prior to its publication, the standpoints adopted by Arthur Kingsley Porter against "French orthodoxy," which led him to state that the great works of the Cathedral at Santiago de Compostela or the Basilica of Saint Isidore in Leon predate that of the Basilica of Saint-Sernin in Toulouse, which is the descendent of a Burgundy tradition whose crowning masterpiece was Cluny Abbey.

It was the job of the post-World War Two generation to reformulate the terms of the debate. A critical review of the historical documents upon which the chronology of a building is based, attention paid to the amount of time needed for any building work carried out, a much deeper stylistic analysis of sculpture: these

1 R. Daydé, *L'histoire de St-Sernin ou l'incomparable trésor de son église abbatiale de Tolose* (Toulouse: Arnaud Colomiez, 1661), p. 427.

2 *Monographie de l'insigne basilique de Saint-Saturnin* (Paris: Société Impériale d'Archéologie du Midi de la France, 1854); the book does not contain the author's name, but the archives of the Société archéologique du Midi de la France enable it to be identified as a joint work by Auguste d'Aldéguier and Alexandre Du Mège.

3 E. Viollet-le-Duc, "Proportion," in *Dictionnaire raisonné de l'architecture française du XIᵉ au XVIᵉ siècle* (Paris: AM, 1875), vols. 7–9, pp. 532–61.

4 J.-J. Esquié, "Note sur une peinture récemment découverte à l'église Saint-Sernin de Toulouse," in *Mémoires de l'Académie des Sciences. Inscriptions et Belles-Lettres de Toulouse*, 6ᵗʰ series, vol. 3 (Paris: Douladoure-Privat, 1865), pp. 361–71. Id., "Note sur les travaux de restauration récemment exécutés à l'église Saint-Saturnin de Toulouse," in *Mémoires de l'Académie des Sciences, Inscriptions et Belles-Lettres de Toulouse*, 8ᵗʰ series, vol. 3 (Paris: Douladoure-Privat, 1881), pp. 283–300. And on the archaeological side, see also A. Saint-Paul, "Note archéologique sur Saint-Sernin de Toulouse," *Bulletin archéologique du Comité des Travaux Historiques et Scientifiques* (Paris: Ernest Leroux, 1899), pp. 396–413.

5 M. Gómez Moreno, *Provincia de León. Catálogo monumental de España* (Madrid: Ministero de Instrucción Pública y Bellas Artes, 1925). Id., *El arte románico español. Esquema de un libro* (Madrid: Centro de Estudios Históricos, 1934). A. K. Porter, *Romanesque Sculpture of the Pilgrimage Roads*, vol. 1:10 (Boston: Marshal Jones Company, 1923).

were the footings that provided the foundations for the works of art historians such as Serafín Moralejo or Marcel Durliat, whose thought reached its maturity in the period 1970–1990. 1990 was the year of publication of Marcel Durliat's masterpiece *La sculpture romane de la route de Saint-Jacques. De Conques à Compostelle*,[6] signalling the outcome of a system of reasoning which has brought forth its fruits. We will take from it several essential points that fundamentally concern the years 1070–1120. The author affirms the coherence of an art free from political, ecclesiastical and geographical restrictions in the particular case of the route leading from Conques to Compostela. The "renaissance" of the Romanesque period, which basically concerns architecture and sculpture (although he takes great care to clearly separate architectural from sculptural style), depends on the free interpretation of the Corinthian capital and the rise of the palmette, whose variations follow the rules of ornamental stylistics, as defined by Jurgis Baltrusaitis.[7] The insertion of animal forms in this decoration shares something of abstract mental representation, symbolic thought and a stylization that owes much to the sculpture/monument dialectics articulated by Henri Focillon.[8] References have to be sought in manuscripts in the cases of Moissac and Toulouse, in ancient art in that of Jaca, from which latter there comes "*le risque d'un retard à rattraper.*"[9] Historiated capitals, which make their appearance from the beginning of the period in question, proceed from religious compositions totally unattached to any specific time or place, and when a profane subject intervenes it is usually on the edge, as in the abaci from the first series of capitals from La Daurade in Toulouse or in the cloisters at Moissac. Marcel Durliat insists on the creative freedom given to sculptors during this period, which led to the appearance of totally unexpected works such as the Solomonic columns in Santiago de Compostela Cathedral. The development of the large-scale representation of the human figure at Toulouse and Moissac stems not from ancient statues but from the enlargement of Carolingian ivories. Always forming part of a whole, this almost life-size representation finds its natural place in the large historiated porticoes to whose proliferation it greatly contributed. The construction of the latter, once again according to Marcel Durliat, was only made possible by the finding of a solution to the technical difficulties presented by the fitting together of stone blocks and themes, unresolved at Santiago de Compostela, better dealt with in the *Puerta del Cordero* at Leon and totally mastered at Toulouse. Now, at the beginning of the twentieth century, Marcel Durliat's work continues to be the indispensable foundation for any

6 M. Durliat, *La sculpture romane de la route de Saint-Jacques de Conques a Compostelle* (Paris: Comité d'études sur l'histoire et l'art de la Gascogne Mont-de-Marsan, 1990).
7 J. Baltrusaitis, *La stylistique ornementale dans la sculpture romane* (Paris: Ernest Leroux, 1931). Id., *Formations, déformations. La stylistique ornementale dans la sculpture romane* (Paris: Flammarion, 1986).
8 H. Focillon, *L'art des sculpteurs romans* (Paris: Ernest Leroux, 1931).
9 *La sculpture romane de la route de Saint-Jacques de Conques a Compostelle...* op. cit., p. 499.

study on meridional art. Nevertheless, a new approach to the study of monuments has brought about a slight change in perspective. The practice of building archaeology, which leads to an in-depth analysis of construction processes; a sensitivity to the notion of space, of the monument in the city as well as the monument itself; the numerous studies made of works commissioned and those who commissioned them, which tend to rehabilitate the latter's actions: it is the very nature of our reflections that has changed, and these necessarily induce perceptions of a different kind. Our analysis of Saint-Sernin de Toulouse[10] is obviously situated within these trends, and leads us to reconsider some of the lines of research initially opened up by Marcel Durliat.

Construction

The present-day Basilica of Saint-Sernin owes its origins to the burial of Saturnin, first bishop of Toulouse, martyred in the year AD 250 and whose story has come down to us thanks to the contents of his *Passio*, written in the early fifth century. An extremely important necropolis developed as from the fourth century, whilst a *memoria* and then a large basilica consecrated around the year AD 400 allowed his cult to develop. Some time shortly before 1070, the canons undertake the reconstruction of the monument housing "the body of the very holy Saturnin" (which is how the church is designated in contemporary texts).[11]

The architecture of Saint-Sernin immediately places the building amongst the most important projects of its day, because of its dimensions (109 m long and a 64 m transept), the design of its chevet, with ambulatory and radial chapels, the most monumental formula of the eleventh century, the materials from which it was built and the way in which they were used, which represented a radical break from earlier practices, and because of the consummate art of the balance of the vaults that cover the ceiling of the entire building, an indication of the presence of an extremely great architect. The presence of five aisles also marks the desire to follow in the footsteps of Saint Peter's in the Vatican, which is at one and the same time the model *par excellence* of a martyr's basilica and the seat of Roman, a subject to which we will later return.

Nevertheless, construction did not proceed at an even pace, and even remained unfinished. A methodical analysis of the vertical sections, based on the distribution of the materials (stones and bricks) and the way they were laid, gives us a better understanding of the main stages of building work, which began in or shortly before 1070 with the construction of the peripheral walls of the chevet and of the transept. Work continued with the apse of the chancel (with the particularity that its floor was raised to preserve the base of the fifth century apse, whose foundations still contained the body of the saint[12]), the columns of the transept and of the first two bays of the north aisle, the vaulting of the radial chapels and the apsidal chapels off the transept, and that of the ambulatory. This allowed the lateral aisles of the two eastern bays of the central nave, both to the north and to the south, as well as those of the transept, to be vaulted, whilst construction of the second storey of the apse was being prepared. After covering the corridor above the ambulatory with a quadrant vault,

10 D. Cazes and Q. Cazes, *Saint-Sernin de Toulouse. De Saturnin au chef-d'œuvre de l'art roman* (Graulhet: Odyssée, 2008).

11 We can see that in all the eleventh- and twelfth-centry texts relating to Saint-Sernin, no relation whatsoever is established with the pilgrimage to Compostela; the latter is never even mentioned. However, frequent use is made, when referring to the Abbey at Toulouse, of the formula of the "*lieu où repose le corps saint*," a formula that both justifies the importance of the work and reveals something of the ambition of its patrons, which was probably to create a shrine equivalent to that at Compostela.

12 This reconstruction implies the presence of a large staircase, facing west, giving access to the apse where the altar was located. Furthermore, the arrangement of the columns that commence where the apse and first section of the chancel meet proves the existence of lateral passageways, on either side of the great staircase, leading to the crypt. In this way the canons had sole control of access to the crypt. Thomas W. Lyman had imagined a different reconstruction, although it did not take into account the archaeological elements. See T. W. Lyman, "La table d'autel de Bernard Gilduin et son ambiance originelle," *Les Cahiers de Saint-Michel de Cuxa*, 13 (Cuxa: 1982), pp. 53–67.

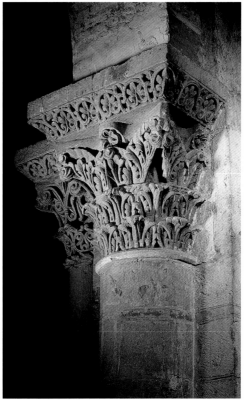

work then commenced on the high windows of the apse at the same time as the bays of the galleries started to be put into place. The galleries themselves were then constructed before the full vaulting of the arms of the transept was carried out and the base and the first floor of the bell-tower built.

With that, the chevet and the transept were entirely finished and what had been built could function as a church in itself, public access being through the double *Porte des Comtes* on the southern end of the transept. Only then, and not before, did work begin on the peripheral wall of the nave, with its three doors: that leading to the cloisters, the *Porte Miègeville* and the West Door.

Work now slowed down considerably: the vaulted ceiling above the nave was not completed until 1280–1300 (but still according to the initial project, a truly amazing occurrence), whilst the western end was never actually finished: the front was only finally "put in order" during the years 1926–1929.

The earliest sculptures

This analysis, however summary, of the basilica's construction enables the abundant sculptures in the building to be classified in exact chronological order. Thus, amongst the very earliest capitals to be put in place we find two similar works, located at the top of the columns that mark the point where the ambulatory and the arms of the transept meet. They are fairly exact copies of Corinthian capitals of a style that spread to Gaul and to Toulouse itself as early as the second half of the second century AD; the extremely precise form of the foliage and the sense of volume make it impossible to think that they were taken from a book of models. This choice is highly significant: it places the sculpture of Saint-Sernin under

Porte des Comtes
1080–1090
Basilica of Saint-Sernin de Toulouse,
Haute-Garonne

Capital [Transept]
c. 1080
Basilica of Saint-Sernin, Toulouse,
Haute-Garonne

235

the sign of Classical Antiquity, admired for the perfection of its work, but above all it anchors the building in history, in the times of Saint Saturnin, in the origins of Christianity, which, at a time of Gregorian Reform, was an extremely topical question. Why, therefore, should we not think of a deliberate wish on the part of those who commissioned these works? This is essential, because all the sculpture in Saint-Sernin springs from this initial choice.

The *Porte des Comtes* also dates from the earliest period of construction. A complete iconographic programme is represented in it, both above the archivolts with the figures that nowadays support the arcade of the saint to whom the basilica is dedicated – between the two lions guarding the door – and his two deacons, and in the eight capitals on the splays of the portal. These capitals, illustrating the parable of Dives and Lazarus, of sinners in the clutches of demons and what is in all probability Moses praying during the battle between Israelites and Amalekites,[13] express the vulnerability of mankind to sin and encourage the faithful to follow the teachings of the Church and consider prayer as the means of attaining Salvation. Although all adopt common canons in their scabbling and principal stylistic lines, it is however possible to discern the presence of two sculptors, with four capitals being attributable to each. One is distinguished by the difficulty of their composition – in the scene of Dives, for example – and for the fullness of their faces, the other by the greater ease with which he worked, especially in his portrayal of the naked figure, by the slenderness of his bodies. Nevertheless, they worked together and obeyed the same rules. The same two sculptors reappear inside the building, on the ground floor of the transept, in the ambulatory and in the galleries of the chancel.

The activity of Bernard Gilduin

The name of Bernard Gilduin is linked with some of the most important evolutionary changes in the sculpture of Saint-Sernin: the use of marble, the multiplication of sources, the modifications of a stylistic nature and, above all, the expansion of iconographic programmes. It would probably be wrong to attribute absolutely all of them to him, but there can be no doubt that he was one of the principal contributors to the work. The fact that his name is engraved into the table-altar consecrated by Pope Urban II in 1096 immortalizes him, to a certain extent, at the end of the great inscription that records the services held for the salvation of the souls of the faithful and explains the role of Saint Saturnin as intercessor. This table-altar is indeed exceptional, starting with the material used, marble, and with the dished carving and the presence of a lobed border that place it firmly in a series that had its origins in Classical Antiquity but was still current in the ecclesiastical province of Narbonne in the ninth and tenth centuries. Novelty is also appreciable in the decoration of the abacus-style bevelled sides,[14] a decoration that reveals the intensity of the culture and programmatic intentions associated with it.

On an iconographic level, the complex ideas are expressed quite clearly. The front face shows the Christ of the Second Coming in a triple frame heavily

13 This interpretation provided by Thomas W. Lyman seems likely. Id., "The Sculpture Programme of the Porte des Comtes Master at Saint-Sernin in Toulouse," *Journal of the Warburg and Courtauld Institutes*, 39 (London: 1971), pp. 12–39.

14 Nevertheless, decoration of the vertical sections of the table is well certified in Provence in the final years of Antiquity, at Saint-Victor de Marseille, Vaugines (Vaucluse) or Auriol (Bouches-du-Rhône). Cf. J. Guyon and M. Heijmans (eds.), *D'un monde à l'autre. Naissance d'une Chrétienté en Provence, IVᵉ–VIᵉ siècles* (Arles: Musée départemental Arles antique, 2001), pp. 167–70.

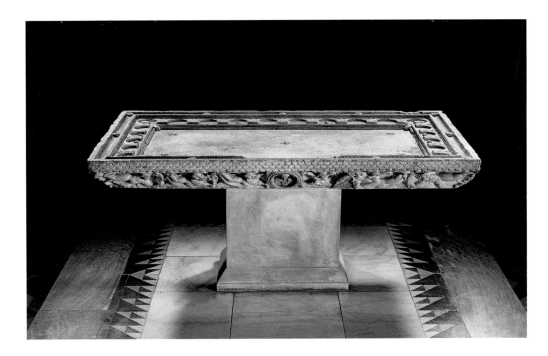

Altar
Master Bernard Gilduin
1096
Basilica of Saint-Sernin de Toulouse,
Haute-Garonne

ornamented with pearls and gemstones that reflect his dazzling light; he is giving his blessing and presenting the open book of his Word. This representation is carried by two angels who are averting their gaze, followed by a further two, identical to the former, carrying a cross, whilst at the ends two angels unfurl a veil that represents the vault of the heavens, as the mythical *Caelus* would have done. On one of the end faces we have Christ at Calvary, flanked by the Virgin Mary and Saints John, Peter and Paul – the founders of the Church of Rome – and two other apostles, in clear allusion to the reiteration of his sacrifice on the altar for the salvation of the souls of canons and the faithful alike. This is the illustration of the first part of the inscription, whilst the second part is given a similar treatment on the other end face, where the intercessor Saturnin and his two deacons are placed between two symmetrical representations of a griffin carrying a figure up to heaven, an astonishing allegorical image of the migration of the soul. The rear face, with its seven pairs of doves, is perhaps an allusion to the souls of the faithful.

Gilduin is also the author of three reliefs that undoubtedly once formed a retable associated with the altar,[15] but nowadays set in the walls of the ambulatory. They affirm the all-powerful nature of the divinity, the cherub and seraph intoning the chant of the triple *Sanctus* that will be taken up by the other angels, the apostles, the evangelists, the saints, the canons and the people of God as a whole. This art is impregnated with models from the time of Theodosius,[16] certainly a deliberate choice, because in order to reform the Church it would be necessary to return in some way or another to a glorious moment in its history, the last decades of the 4th century, when Christianity had triumphed over paganism to become the religion of the State. This message is then taken up by four truly monumental reliefs, also set into the wall of the ambulatory at some time in the nineteenth century: two angels with majestic robes that appear to be stepping forth from the niches in which they are situated, and two figures wrapped in togas, like orators in the Forum, each holding a book and giving his blessing.

15 These three slabs are too high to have been used as an *antependium* (they would have raised the level of the top of the altar table to 1.3 m). They are inscribed with the year 1467, indicating the year when they were set into the external wall of the ambulatory. It is clear that when the floor of the apse was removed in the thirteenth century in order to install a monumental stone baldachin in the lower level of the crypt, destined to highlight the sarcophagus containing the remains of Saint Saturnin, the liturgical layout of the apse was modified and the three reliefs moved.

16 In order to ascertain this, one only has to compare the head of the seraph with those of the Germanic guards appearing in Theodosius' *missorium*. See J. Meischer, in M. Almagro-Gorbea (ed.), *El disco de Teodosio* (Madrid: Real Academia de la Historia, 2000), p. 247.

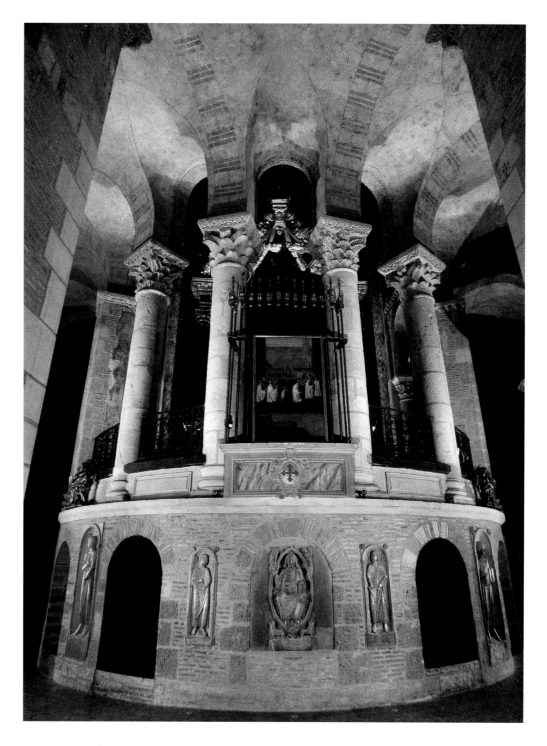

Ambulatory
1070–1080
Basilica of Saint-Sernin de Toulouse,
Haute-Garonne

Even if we cannot be absolutely sure whether these last four reliefs really
formed part of the decoration of the sanctuary, the table-altar itself and the three
reliefs that make up the retable, in all probability arranged in the apse vertical to the
tomb of the saint – repeating the same arrangement as in the Vatican –, are evidence
of the greater importance attached to sculpture, which here attempts to represent
the ineffable, the presence of God, and the order of the world, with the heavenly
hierarchy, the intercessor and the faithful. Similarly, the sources of Gilduin's art
are also multiple and explicitly anchored in the art of Classical Antiquity. The
composition of each of the faces of the altar is perfectly balanced: the front face
derives its inspiration exactly from the frontal compositions of the lids of Roman

sarcophagi, whilst the models for the figure of Christ in his medallion are to be found in paleo-Christian sarcophagi and Byzantine marbles.[17] The recurring motif of the scalelike imbrications – which we also find in the great circular keystone of the crossing vault – also harks back to the numerous tombs found in the original necropolis. And we could mention many more references besides. These works thus come from the thought of a truly cultivated man or environment, placing an elevated knowledge of art and theology at the service of carved expression, undoubtedly surpassing the mere role of sculptor.

The four large reliefs are the work of a different sculptor (perhaps two), to whom we can also attribute a modillion from the cornice of the ambulatory, certain cornice elements from a micro-architecture that was scattered throughout the building as from the beginning of the twelfth century – and which was never actually put in place – and perhaps also two capitals from the galleries in the transept and three of the capitals of the *Porte Miègeville*. They differ from Gilduin in their sense of volume, the different morphology of their faces and the imbricated treatment given to the hair, but follow Gilduin in one of his greatest contributions, the way in which he deals with the folds of the tunics. These are no longer superimposed from bottom to top, but created by a small fold between two incisions, this perhaps being the result of the study of classical models or the desire to imitate the result of the technique used for embossing metal – which, for the panels of a retable, would not be surprising –, the greatest consequence of this being to highlight the body underneath.

We will probably never know who Bernard Gilduin really was. He is the author of at least another capital, decorated with foliage, and of the abacus associated with him in the galleries of the south arm of the transept, and perhaps also of one or two capitals at the spring of the vaults of the transept – the *Sacrifice of Abraham* and the *Battle between Angels and Dragons* –. In these more "habitual" works, he closely follows the earliest sculptures of Saint-Sernin, thus leading one to think that he learnt his craft there. On the other hand, however, his extremely personal style is no longer evident at the time when the *Porte Miègeville* was built.

The *Porte Miègeville*

With the *Porte Miègeville*, the absolute clarity with which its discourse is organized is served by peerless sculptors. It follows the same principles as that of the *Porte des Comtes* – a projecting westwork, the insertion of reliefs in the upper section –, but this time the similarities in the composition of the whole to ancient portals such as the *Porta Boiano*, built at the change of the era at Saepinum (Molise, Italy[18]), but especially with regard to its sculpted tympanum, are extremely close indeed.

The iconographic programme brings together the story of the Salvation and the affirmation of the Roman Apostolic Church. In the stone capitals, the Expulsion from Eden is symmetrical to the Annunciation: Mary the Mother of God is the new Eve, and the angel praising her at the moment of the Annunciation by Gabriel is witness to the Divine Conception. On the right-hand console bracket the young shepherds wearing Phrygian caps are taming lions; with one foot bare and the other shod they are

17 See in particular the plinth of the sarcophagus preserved in Aix-en-Provence for the composition. Cf. B. Christern-Briesenick (ed.) [1967], *Repertorium der christlich-antiken Sarkophage*, vol. 3 (Wiesbaden: F. Steiner, 2003), 25, p. 11, pl. 25–1. The sarcophagus of the Anastasis at Arles can also be studied in ibid., no. 49, pp. 35–6 and pl. 17. For the ivory preserved in the Museo Nazionale di Ravenna, see A. Carile, *Storia di Ravenna. Dall'età bizantina all'età ottoniana*, vol. 2:5 (Venice: Marsilio Editori, 1992), p. 354, fig. 10.

18 Image in P. Zanker, *Augusto y el poder de las imágenes* (Madrid: Alianza Editorial, 1992), p. 378. In this city gate, which repeats the model of the triumphal arch, the most striking feature is the position of the lateral reliefs, under the strip that marks the top of the jambs: a pedestal decorated with mouldings supports a statue. They are the same mouldings as those found on the reliefs located beneath the figures of Peter and James.

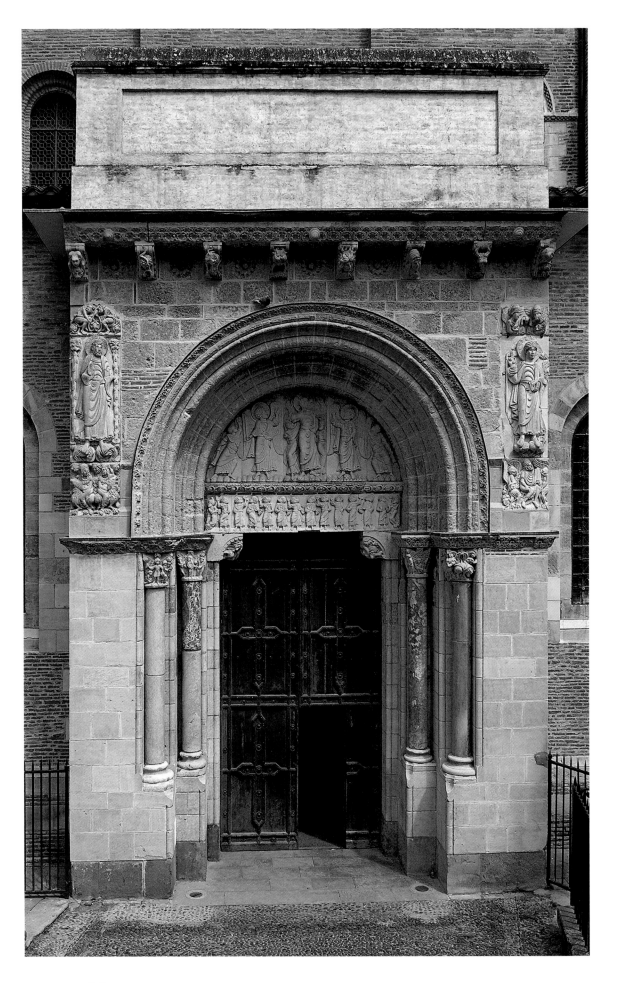

Porte Miègeville
c. 1105
Basilica of Saint-Sernin de Toulouse,
Haute-Garonne

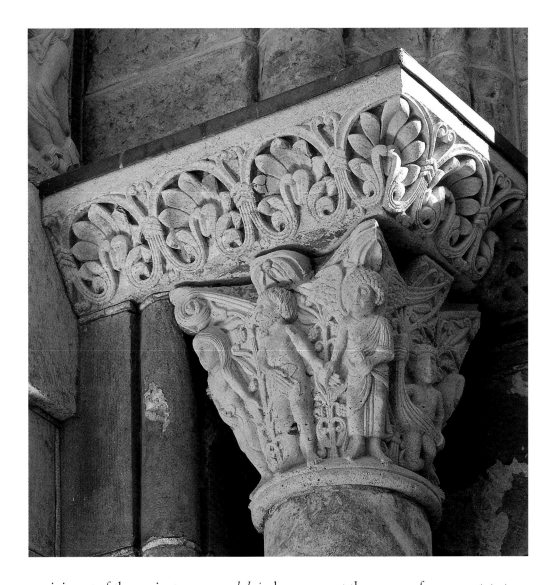

Capital *[Porte Miègeville]*
c. 1105
Basilica of Saint-Sernin de Toulouse,
Haute-Garonne

reminiscent of the ancient *monosandaloi* who represent the passage from one state to another, in this case perhaps from peril to victory. They are answered by King David, on the symmetrical console bracket, playing a rebec at the entrance to the church, just as he had praised God when he brought the Ark of the Covenant to Jerusalem. The tympanum represents the Ascension of Christ in the midst of four angels. The central group is formed by Christ, looking heavenwards with raised hands, his impressively volumetric body being lifted up above the clouds by two angels: this is indeed the material body of a man rejoining God, his Father, and who will return at the end of days, as the inscriptions carved on his halo clearly indicate. On the lintel, the twelve apostles gesticulate as the two men dressed in white from the *Acts of the Apostles* announce the glorious return of He who is ascending into heaven before their very eyes. The foliated scroll of grapes and vine leaves, which marks the boundary between earth, where the apostles are standing, and heaven, is the Vine of the Lord, another allegory of the Church, represented also by Peter and Paul in the center of the lintel.

The two reliefs placed on either side of the archivolt feature Peter and James the Elder. These two apostles, chosen by Christ at the outset of his public life, two of those who were the first to receive the revelation of his divine nature during the Transfiguration, are also the evangelizers of the West and are worshipped in two

Saint Peter [Porte Miègeville]
c. 1105
Basilica of Saint-Sernin de Toulouse,
Haute-Garonne

Saint James [Porte Miègeville]
c. 1105
Basilica of Saint-Sernin de Toulouse,
Haute-Garonne

major Western shrines, those of Rome and Compostela. Peter, the first pope, eternally young, is holding a set of keys, his other hand raised in blessing, and flanked by the standard of the Church and the Eucharistic vine. Underneath, Simon the Sorcerer, the first gnostic according to Ireneus of Lyon and a leading heresiarch according to Eusebius of Caesarea, is defeated in his duel with Peter, whilst the vine developing above him starts to grow. The exact moment being depicted is that when demons pick him up after his failed ascension, in clear contrast to the only Ascension admissible, that of Christ depicted on the tympanum. Santiago appears between the trunks of two trees that are beginning to sprout, holding the Gospel in one hand whilst the other displays a gesture of prayer. He is topped by a hard to interpret relief in which two naked men, one young and the other old, are trapped by a vine. Beneath the feet of James there is a relief with an absolutely extraordinary theme, which matches the symmetrical one on the east side. A bearded man brings together the heads of two women who are seated astride lions, riding in opposite directions. The fact that the two women are really riding the lions – as witnessed by their stirrups –, as the goddess Cybele would have done, and the importance of antique sources in the general conception of the sculpted work as a whole, give reasonable grounds for identifying these figures with Prisca and and Maximilla, who had been devotees of the Mother of the Gods. The man is Montanus, a former priest of Cybele who had converted to Christianity, the false prophet who considered himself to be the voice of the Holy Spirit and announced the imminent Second Coming of Christ. Although his relationship with James is unclear, the two apostles responsible for spreading the Good Tidings in the west are corresponded to by two famous sectarians. These heresiarchs are rejected and defeated by the Church, incarnated in Peter, James and the Apostles, and whose successors are the canons of Saint-Sernin – which, in those times of Gregorian Reforms, is also a strong "political" message from the canons not only to Rome, but also to the society of Toulouse, where the fight against heresy had been dealt with in two councils, in 1059 and 1119 –. Displaying them so as to better condemn them was, in those early years of the twelfth century, a topical question for a Church that wished to be universal, as further evidenced by two modillions from the upper cornice, *Sol* and *Luna*, cosmic witnesses to the Ascension.

Masterly in its conception from the standpoint of thought, this portico is equally so from a technical point of view: the five marble slabs of the tympanum are sufficient to contain Christ and the four angels; the lintel is fashioned from a sarcophagus that has been re-used – hence the very flat relief – and completed with two new blocks. During the recent restoration of the portico, particular care was taken to look for possible vestiges of paint, but none were forthcoming. But that was without taking into consideration the value placed on marble. A symbol of wealth and power in Antiquity, it acquired, in the earliest Christian churches, a series of religious virtues: was it not the material used for the temple of Solomon, associated with the Holy Sepulchre, used for columns of the Basilica of the Nativity in Bethlehem...? And Paul the Silentiary, extolling Hagia Sophia in Constantinople, compares its extraordinary appearance with the divine nature and sanctity: in itself, marble is a "*marqueur visuel du sacré.*"[19] It is therefore by no means anodyne that it was first used for the table-altar

19 E. Grabiner, "L'iconographie du faux marbre, le cas de l'église franque à Abou Gosh," *Les Cahiers de Saint-Michel de Cuxa*, 38 (Cuxa: 2007), pp. 137–42, esp. p. 139.

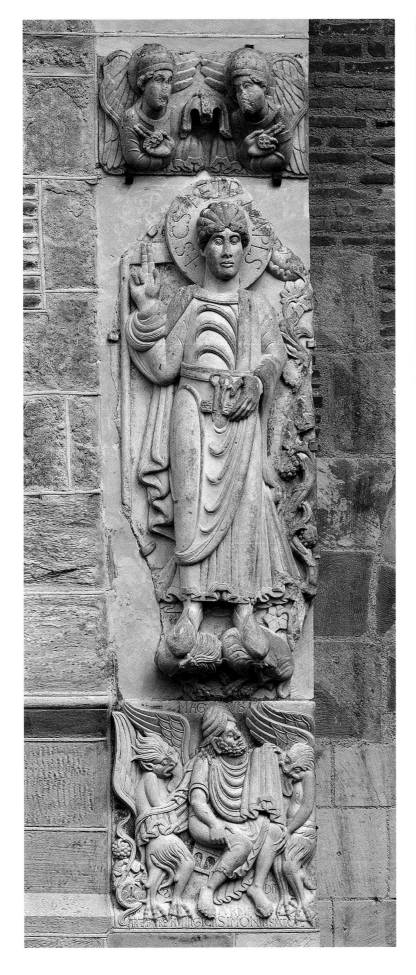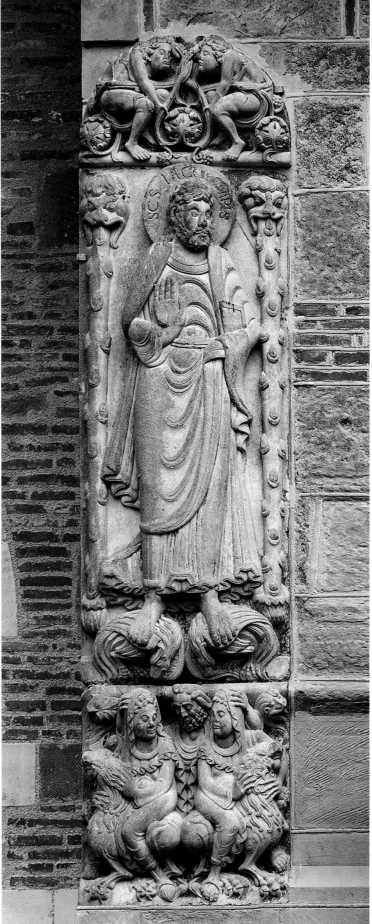

and, more generally, for the decoration of the apse. Nor that it was also chosen for the large reliefs on the *Porte Miègeville*, whose aim was to represent that most transcendent of all possible themes, the omnipresence of God.

Several different sculptors worked on this programme. The one who carved Saint James – and perhaps the same one who created Montanus and Simon – owes much to the modalities used in the reliefs of the cloister at Moissac. The one who produced Saint Peter worked in a wholly classical vein and strives to achieve high-relief, as in the extraordinary angels on the tympanum. These latter figures, particularly those at either end, bear a close relationship to the characters on the lintel, which reveals that the sculptor was able to adapt his art to whether or not it was possible to execute a relief. The author of the *Sol* and *Luna* modillions, and perhaps also of *King David*, is probably the same to whom we owe the extraordinary reliefs of the *Sign of the Lion* and the *Sign of the Ram*, nowadays in the Musée des Augustins, and whose original location and exact meaning remain unknown. However, they are all within the mainstream of what had been done until then, with no sudden break of any kind whatsoever: they mark the zenith of an evolution fashioned by those who created the sculptures but driven by those who commissioned them.

The West Door

A close connection in style, for example in the figuration of lions and birds, and a similarity of conception allow us to venture that the ornamentation of the West Door should be placed immediately after the *Porte Miègeville*: the dogmatic programme is followed by the hagiographic programme.

Texts from the sixteenth and seventeenth centuries describe part of the iconography of the West Door.[20] Above the archivolts, two reliefs on the left depict King Anthony judging Saturnin, whilst the other two, on the right, show Saturnin healing Austris, aided by Saint Martial; in the latter, a centaur with bow and arrow and a "harpy crushing a crocodile."[21] To these there must be added a relief representing the martyrdom of Saturnin, a further unidentified carving, the two mentioned by Du Mège[22] and, in all certainty, another large relief depicting a naked body in a mandorla, set in one of the columns of the church in the seventeenth century. This latter sculpture undoubtedly represented the apotheosis of Saturnin's soul, and one can suppose that it was crowned by the two angels placed above Saint Peter on the *Porte Miègeville* some time in the 1860s. They disappeared or were moved without doubt during the eighteenth century.[23] In fact, only the capitals remain today, much appreciated for the exuberant, almost Baroque, touch, without really attaching any meaning to them. In fact, under the reliefs that tell of the positive action taken by the saint, following a form of composition and educational explanation comparable to that of the *Porte Miègeville*, these capitals evoke the hostile world against which Saturnin fought. They portray inextricably entangled vegetation, a kind of disturbing forest plunged into half-light, a forerunner of the "*selva oscura*" in Dante's *Divina Commedia*. It is inhabited by lions ready to spring on their prey, dog-faced baboons that are the antithesis of intelligent man, and even by

20 Essentially A. Noguier, *Histoire tolosaine* (Toulouse: G. Boudeville, 1556), pp. 58–63. G. de Catel, *Mémoires de l'histoire du Languedoc* (Toulouse: Pierre Bosc, 1633), p. 818. *L'histoire de St-Sernin ou l'incomparable trésor de son église abbatiale de Tolose...* op. cit., pp. 277–9.

21 Only a fragment of the *King Anthony* and the *Harpy Crushing a Crocodile* are preserved in the Musée des Augustins de Toulouse; the small reliefs of a centaur with bow and arrow and a siren/bird-woman, which have often been attributed to the West Door, appear to be antique and having at one time formed part of the plinth of a sarcophagus.

22 A. Du Mège, *Monumens religieux des Volces-Tectosages, des Garumni et des Convenae ou fragmens de l'archéologie pyrénéenne. Et recherches sur les Antiquités du Département de la Haute-Garonne* (Toulouse: Benichet Cadet, 1814), pp. 146–7. Id., *Description du Musée des Antiques de Toulouse* (Toulouse: Jean-Matthieu Douladoure, 1835), cat. 448.

23 We should remember, however, that the door was unfinished in the twelfth century. On the *Porte Miègeville* it has been proved that the reliefs were put into place as it was being built, and the same method must have been used on the West Door. Thus it is by no means impossible that, as was the case in Compostela, some reliefs fashioned to be placed on this latter door were finally reused elsewhere.

Capital *[West Door]*
c. 1105
Basilica of Saint-Sernin de Toulouse,
Haute-Garonne

Capital *[West Door]*
c. 1105
Basilica of Saint-Sernin de Toulouse,
Haute-Garonne

hybrid pagan deities, a bald young satyr or and astonishing sphinx of Egyptian ancestry. This is precisely the *"fallacieuse foule des démons"* reduced to silence by the word of Saturnin and mentioned in the *Passio*: the style, the models and the culture of those who commissioned the work are once more placed at the service of thought.

The question of dating

There is still a significant amount of debate regarding the exact dating of the commencement of construction work, as well as that of the *Porte Miègeville*.[24] As far as the commencement of construction work is concerned, there is no exact documentary evidence available: only a record of 1096[25] tells us that Bishop Pierre-Roger, in the 1030s, had *"jadis [...] réuni toutes les oblations en vue d'édifier une nouvelle basilique."* Memory of the consecration of the high altar, on 24 May 1096, has been handed down by copies of what was undoubtedly the authentic relic, but we can only imagine in what state the building might have been at that time. We therefore have to look at monuments that are more or less contemporary with the basilica, and better dated, in order to put forward any proposal.

The architectural project of Saint-Sernin has to be placed between the commencement of the construction of Conques (the chevet with ambulatory and radial chapels had already been built at the time it was consecrated, between 1041 and 1052[26]) and that of Santiago de Compostela Cathedral in 1075. The architect of Saint-Sernin was undoubtedly familiar with Conques, because the dimensions of the columns of both transepts are identical, down to the last centimeter, but we cannot be totally sure of the chronology of Conques, at least as far as the columns are concerned. Furthermore, Saint-Sernin displays a series of spectacular improvements (the layout of the apsidal chapels, the extension of the galleries, the invention of the vaulted corridor above the smaller side aisles) that make it hard to think that it was built at the same time as Conques. Let us then stay with the date of 1070, proposed by Marcel Durliat, or perhaps a little earlier.

From the point of view of the sculpture, there is no precedent in the region that has been dated, and probably for a very good reason, since we have already seen that the creation of the capitals, derived from the Corinthian model, was done specifically for Saint-Sernin. We can be fairly sure about the cloister at Moissac, that has been dated with some certainty to 1100:[27] several of the sculptors who worked there evidently came from Saint-Sernin and reproduced in the cloister some well-known motifs from the earliest period of the basilica and certain stylistic features or new images that appeared with Bernard Gilduin. The roof of the transept must therefore have been completed in or around 1100.

The *Porte Miègeville* also reveals a certain relationship with Moissac, but in this case in the opposite direction: the Saint James in Toulouse is subordinate, from a stylistic point of view, to the relief in the cloister featuring the same apostle. What is more, if we go by the analysis done by Chantal Fräisse,[28] the cloister at Moissac represents a major turning point in the use of sculpture as a means of expression of thought. For her, the apostles on the columns are the authority for the discourse expressed in the capitals, the whole being conceived as a veritable exegesis,

24 For example, for standpoints that differ from our own, see H. Pradalier, *Saint-Sernin de Toulouse au Moyen Âge, Congrès Archéologique de France, 154e session. 1996: Toulouse et Comminges* (Paris: Société française d'archéologie, 2002), pp. 254–301.

25 *Cartulaire de Saint-Sernin*, ed. P. and T. Gérard (Toulouse: Association des Amis des Archives, 1999), no. 281. Studies in P. Cabau, "Les données historiques relatives à la reconstruction de Saint-Sernin de Toulouse (XIe–XIIe siècles). Réévaluation critique," *Mémoires de la Société archéologique du Midi de la France*, 58 (Toulouse: 1998), p. 103.

26 Q. Cazes, "L'abbatiale de Conques: genèse d'un modèle architectural roman," *Les Cahiers de Saint-Michel de Cuxa*, 37 (Cuxa: 2006), pp. 103–16.

27 We have been able to demonstrate, and this is of great importance for the proof, that six to eight sculptors were working in the cloister at the same time, which leaves time for the work to have been done in the year 1100. See Cazes and M. Scellès, *Le cloître de Moissac* (Bordeaux: Sud Ouest, 2001).

28 C. Fraïsse, "Le cloître de Moissac a-t-il un programme?," *Cahiers de Civilisation Médiévale*, 50 (Poitiers: 2007), pp. 245–70.

a commentary on the Scriptures: it is therefore Abbot Ansquitil who must be credited with having transposed in stone and marble what was habitually a task for the *scriptorium*, and the monumental inscription constitutes the finishing touches to his work. The very idea of a programme of such density, which can be read at different levels and is perfectly controlled, would in all probability never have seen the light of day in Toulouse had it not been for the precedent of Moissac. And this relationship must in all certainty have been very close in time, as revealed by the stylistic links established with the *Platerías* Door in Santiago de Compostela.

The fact, for example, that the abaci of the *Platerías* Door take up almost exactly the main motif of those of the West Door – which we have already said was built immediately after the *Porte Miègeville* – is a clear indication of this. This specific motif belongs completely to Saint-Sernin, where it is to be found in the galleries of the transept,[29] and is also present at Moissac. But above all, the reliefs at Compostela that Serafín Moralejo considers were originally part of the *Porta Francigena* – a woman with a lion cub, King David the musician, etc. – are evidence of a deep knowledge of the work done at Toulouse. And in Compostela, where the earliest sculpture work owes much to that in the Abbey at Conques, it can by no means be purely a matter of chance that on the ground floor of the transept we find plant motifs of lobed leaves, at times reworked, like those at Saint-Sernin. The references are multiplied in the columns of the transept – which were undoubtedly erected after the periphery walls –: one of the capitals is remarkably similar to that of the dog-faced baboons on the West Door at Toulouse; there is also a woman riding a lion and an apostle with a book, amongst others.[30] If we admit that the transept at Compostela had mainly been built by 1111, we will then have to assign an earlier date to the construction of the *Porte Miègeville* and the West Door.

Conclusion: Saint-Sernin, a center of creation

Three are the features that distinguish Saint-Sernin as a center of creation: the unrelenting momentum of work between 1070 and 1110 – we are talking here in terms of a chronological bracket, not absolute dating –; the absolute coherence, which does not exclude, in fact quite the opposite, a certain evolution, which allows us to mark the progress of time; and the evidence that art, whether it be in terms of architecture or sculpture, is placed at the service of a theological and dogmatic thought.

The speed with which building took place leads us to think that the work was remarkably well prepared and perfectly managed, with different stages that reveal a concern for organization, and even rationalization, in the supply of materials.[31] The architecture is in itself a manifesto which has as its aim the glorification of the "saint martyr Saturnin." Furthermore, the three major donations received by Saint-Sernin between 1080 and 1120[32] reflect the success of the work undertaken by the canons, which reaches as far as Périgord and, above all, to Navarre: there can be no doubt that an even greater expansion was considered, but, for reasons which still have to be discovered, there was practically no continuation after the 1120s, a decade in which donations diminished and building work slowed down.

29 At Saint-Sernin, capital no. 182: *Saint-Sernin de Toulouse. De Saturnin au chef-d'œuvre de l'art roman...* op. cit., p. 177. In Moissac, capitals nos. 43, 49 and 71: *Le cloître de Moissac...* op. cit., pp. 152–3, 166–7, 221.

30 Nos. 247, 229 and 103 from *La sculpture romane de la route de Saint-Jacques. De Conques à Compostelle...* op. cit., pp. 321–2.

31 The masons' marks on the walls built during stages three and four of the six in which the chevet was built (i.e. from the roofing over of the side aisles of the transept to the beginning of the construction of the galleries) are there as evidence of the need to rationalize the supply of stone to the site at a time when work was progressing apace.

32 These donations are confirmed in *Cartulaire de Saint-Sernin...* op. cit.

If the architecture represents the continuation and perfecting of the concepts of the day, the sculpture introduces a certain number of novelties destined to enjoy a great future. Its coherence is due to it seeking its inspiration in ancient sources and the way in which it then exploits them. In the beginning it draws on the resources offered by the Corinthian capital, making it part of a more ancient and general movement, but one which here is very precise in the use it makes of copy. Both the structure and the very particular form of the leaves and the lobes, followed by all the variations imaginable, from those in the ambulatory to those on the West Door, become as many prototypes for a number of works in the same region (from Saint-Salvy d'Albi to the collegiate Church of Saint-Gaudens) and in northern Spain (from Loarre to Compostela). The same cannot be said of the representation of the human figure: we have to wait until Gilduin completes the table-altar, that is to say 1095–1096, for the models of Late Antiquity or the Byzantine period to be taken into account. They are used for their iconography (*Caelus* or the ascension led by gryphons), they make reference to a system of composition derived from the ornamental fronts of sarcophagi and induce stylistic features. However, we have to wait for the four reliefs (angels and "apostles"), which are contemporary with the work of Gilduin but done by a different hand, for ancient statues with their recourse to the *togatus* to become a real reference at the same time as the human figures take on an almost lifelike size. These works, like those by Gilduin, are carved in marble, which is thus reaccredited: this represents the emergence of a new craft, with progress moreover being noticeable in the polishing between Gilduin's reliefs and the rest, it being brought to total perfection in the *Porte Miègeville*.

The models from Antiquity are as obvious in the *Porte Miègeville* as they are in the West Door, and are evidence of a wide variety of sources. The style of the young shepherds on the console bracket of the lintel is somewhat reminiscent of an ancient style of figuration,[33] whilst their feet, one shod and the other bare, are a reference to the ancient *monosandaloi*. It is indeed a river god, with its characteristic posture, although here represented vertically, that appears in the Garden of Eden. *Sol*, with its flaming hair and visible teeth that express the biting nature of the midday heat; the sphinx or the satyr on the West Door... But more than all this, underlying these iconographic programmes there is a culture of the patriarchs of the church that draws from the best sources: Augustine, Jerome, Ireneus of de Lyon, Eusebius of Caesarea or the pseudo-Chrysostom.

The idea of placing a tympanum above the door was current at the time: until proved to the contrary, that of the West Door at Jaca or that of Charlieu are attributed to the 1100s. If, as we believe we can prove, the two doors of the nave at Saint-Sernin were built before those of the transept at Compostela, it will be necessary to cease seeing in the former a kind of perfecting of the more or less clumsy attempts made in *Platerías*. The coherence of the ensemble of the *Porte Miègeville* is due, as well as to the extraordinary sculptures done *in situ*, to a carefully considered thought with a lofty flight of intellect, a far-reaching educational aim and, consequently, expressed with great clarity. The role of those who commissioned the work is thus of great importance in how these programmes were defined. The names

33 E.g. the portrait of a young man discovered in Palmyre, in J. Charles-Gaffiot, H. Lavagne and J.-M. Hofman, *Moi, Zénobie, reine de Palmyre* (Milan: Skira, 2001), p. 217, cat. 70.

of some of the canons of Saint-Sernin at that time have come down to us in the *Cartulaire*, but with no specific intellectual activity being attributed to them (there is no mention, for example, of a *scriptorium*). Nevertheless, the epitaph of Munio, provost from 1100–1102, reveals, through the inflated nature of its style, the form of its verses (four rich elegiac Leonine distychs) and the graphic play of the letters, a concettism and a quest for effect that are unique in the Toulouse of those years: we have to see in it one of the extremely rare indications of the cultural level of that ecclesiastical circle.[34] Those clerics place themselves firmly in the mainstream of the Gregorian Reform, of which they not only approve but also actively promote, as evidenced by the affirmation of the Church on the *Porte Miègeville*, amongst other examples. This return to the spirit and the rules of the early Church is to a large extent based on the recovery of paleo-Christian iconographic programmes and schemata, as Hélène Toubert has clearly shown[35] and, in this sense, the art of Saint-Sernin is truly a "planned art." Finally, it should be noted that the direction taken by sculpture at Saint-Sernin did not enjoy a true continuation in Toulouse itself: the capitals of the cloister, done at a later date, abandoned the preceding iconographic paths in favor of a more "severe" kind of art that practically renounced human figuration altogether. The trend provided, during the years after the construction of the *Porte Miègeville*, by Gilabertus at Saint-Étienne deliberately turns its back on the ancient models and renounces sculpture done in marble in favor of a more humanist nature, more in tune with the development of the courtly society of the time.

34 Engraved on a marble slab, this epitaph, preserved in the Musée des Augustins at Toulouse, was published by R. Favreau, B. Leplant and J. Michaud, *Corpus des inscriptions de la France médiévale*, vol. 7:23 (Paris: CNRS~Centre d'Études Supérieures de Civilisation Médiévale, 1982), cat. 47. The inscription reads: "*Munio homme illustre par ses mœurs, estimé en son rang / à bon droit plut à Dieu, lui qui n'eut pour lui-même aucune complaisance. / Il ne fut pas impur; tant qu'il vécut, il vécut dans la probité. / Et parce qu'il fut pour lui-même sans complaisance, il occupa le premier rang.: Prodigue envers tous, il possédait un ardent amour de la divinité. /Il gît en ce tombeau, connu par cette épitaphe. / Il quitta ce monde au mois d'octobre, le quinzième jour: Des calendes [17 septembre] selon ce que je crois.*"
35 H. Toubert, *Un art dirigé. Réforme grégorienne et iconographie* (Paris: Cerf, 1990).

José Luis Senra Gabriel y Galán

The Art of the Pilgrims' Road to Santiago and Cluny

Throughout the last century the idea that the Burgundian Abbey of Cluny exercised a very active sponsorship of pilgrimages to Santiago de Compostela was very common, and by extension the active responsibility that Romanesque style would have extended along the route. Most studies concerning the so-called Romanesque art on the Pilgrims' Road to Santiago and attributing to Cluny the responsibility for this style are based on this idea. Cluny was deeply involved in the development of pilgrimage through its network of priories, which at its height, under the rule of Abbot Hugh (1049–1109), had almost twelve hundred establishments submitted to its jurisdiction. Through these franchises the abbey collected much of the economic resources that nourished its coffers and thereby exerted a self-interested guardianship and the consequent publicity of the profitability of spiritual pilgrimage. The influence of this idea in the Iberian Peninsula was very successful with the recovery of the nineteenth-century ideas of German historian Ernst Sackur (1862–1901), concerning the patronage exercised by Cluny in the high medieval phenomenon of pilgrimage. And together with this is the opinion of influential philologist Joseph Bédier (1864–1938), according to which the *Liber Sancti Jacobi* was a work of Cluny propaganda. Half-way through last century such ideas were repeated and applied to Spain by the German art historian Werner Weisbach (1873–1953) and the Spanish philologist Américo Castro (1885–1972). The translation of Weisbach's detailed research on Romanesque art – he was a specialist in Baroque art – based on Cluny's influence on Western art, contributed to this idea, obviously somewhat unrealistic, but it was hammered in with sufficient force to penetrate deeply and become a handbook stereotype.

There are many elements that allow us to downplay this claim somewhat: Cluny only had two large priories on the Pilgrims' Way to Santiago – San Zoilo de Carrión (Palencia) and Santa María de Nájera (La Rioja) – and neither of them are mentioned in the *Liber Sancti Jacobi*.[1] Neither is one of the great institutions in the south of France that was subject to Cluny: the Abbey of Saint-Martial de Limoges, located on one of the main roads to Compostela, the *via lemovicensis*. Together with devotional reasons, the two Spanish institutions had been based on significant geopolitical principles since their foundation in the first half of the eleventh century. And as we shall see, they remained attached to the *Ecclesia cluniacensis*. For some time now it has been emphasized that Cluny's interests in the Iberian Peninsula were based on

1 This was already noted by specialists like J. Evans, *The Romanesque Architecture of the Order of Cluny* (Cambridge: Cambridge University Press, 1938), p. 14, no. 2.

making the monarchy of Castile and Leon dependent on their diplomatic capacities. The proximity to a papal curia, which was nurtured by Cluniac monks, endowed the mediation regarding Rome's demanding needs on the Peninsula with special importance. Since the pontificate of Gregory VII, the universalistic aspirations on the Spanish kingdoms forced Alfonso VI (1072–1109) to abolish the Visigothic rite and adopt the Roman liturgy. We know from documentation that there were peaks of tension in this process due to the monarch's vacillations when implementing the reform. And it was in the renewal of dialogue between the two parties where Abbot Hugh of Cluny played a significant role.

This comfortable mediating capacity is what on a spiritual level led to the metaphor that compared the monks of Cluny to angels. The success of the Cluniac order was founded on its self-proclaimed excellence as an effective intermediary between heaven and earth. In the mid-eleventh century the Cluniac monk Jotsald narrated in his hagiography of Abbot Odilon (*Vita Sancti Odilonis*) the existence of an indefinite place – a precedent of the idea of Purgatory – in which souls suffered for their sins while Cluniac prayers made release and access to Paradise possible.[2] It was precisely during the rule of Odilon in the Abbey (994–1049) when Cluniac spirituality attained its most refined expression through the commemoration of All Souls' Day (2 November). Such a guarantee of effectiveness turned Cluny into a model of prestige supported more and more enthusiastically by the European aristocracy and some monarchies during the eleventh and the first half of the twelfth century, the peak of its evolution. With regards to the case of Spain, various later Cluniac texts and narratives strived to highlight the monks' capacity for prayer to either free Alfonso VI from prison, where he had been sent by his brother Sancho (*Vita Sancti Hugonis*, by Gilus, c. 1120), or to free him from the torments he underwent after his death because of his many sins (*De Miraculis Libri Duo*, by Peter the Venerable, c. 1142).

The period when King Ferdinand I of Castile-Leon (1037–1065) established links with Cluny based on the annual delivery of 1,000 pieces of gold is usually put somewhere between 1055 and 1065. There is no agreement about whether this fraternity was hereditary: this is, if his successors were subject to this same bond. The truth is that his son Alfonso VI doubled the amount in 1077 and it was only the invasion of al-Andalus by the Almoravids and the subsequent elimination of the parias tax on the Taifas kingdoms – an essential source of Alfonso's income – that led

2 D. Iogna-Prat, "Les morts dans la compatibilité céleste des clunisiens de l'an Mil," in id. and J.-Ch. Picard, *Religion et culture autour de l'an mil* (Paris: Picard, 1990), pp. 55–6.

to the payment ceasing to be made. It is well known that much of this generous offering was used by Abbot Hugh of Semur (1049–1109) to finance the large new church known as Cluny III, a project that took up the revenues of the institution for nearly half a century (c. 1088–1130). The continuity of this tax burden by his daughter and heiress Urraca and his grandson Alfonso VII was circumstantial and not materialized in cash but rather with the donation of monasteries and properties.

Beyond Alfonso VI's cash donations, what Cluny obtained from the kingdom of Castile-Leon was a significant network of priories with their consequent territorial lordships, some located in areas with such a sensitive past for the *status quo* of the kingdoms of Leon, Castile and Navarre as Tierra de Campos and La Rioja. King Sancho II of Castile, Alfonso VI's brother, was assassinated in 1072 in front of the walls of Zamora and, just a year after, the latter gave Cluny the first great monastery of royal ownership: San Isidoro de Dueñas. Its location on the border of Leon with Castile, a traditional area of conflict between the two kingdoms, made it an important strategic stronghold. This process reached its fullness with the involvement of the high nobility in the royal plans: in 1076 the powerful Beni-Gomez family donated the monastery of San Zoilo de Carrión, also on the border with Castile. This same scenario occurred again some years later when after taking La Rioja, a traditional territory in the conflict between Castile and Pamplona, making the most of the lack of a ruler in the kingdom of Navarre after the regicide (1076), they handed over the powerful royal monastery of Santa Maria de Nájera (1079). In this case there was mutual benefit as Alfonso involved abbot Hugh of Cluny in the Castilian-Leonese integrity of the newly absorbed territory. These three monasteries, redefined as priories, were until the late Middle Ages the three main units of the Burgundian abbey in the Iberian Peninsula.

Cluniac architecture?

For various decades, in the wake of studies focused on the architecture of Cistercian monasteries prone to consider this order's manifestations as subject to a very specific design and aesthetical guidelines, it was considered that being generated by a reaction against the Cluniac model, this model in turn could have had specific coordinates. But the architecture of Cluny, of complex structures, sumptuous in its decoration and kaleidoscopic iconography, was clearly not the exclusive property of Cluniac heritage. It is true that the abbey contributed with unparalleled efficiency to the dissemination of a model of monastic sensibility which laid a special emphasis on the liturgy and the divine office, but while the architecture of the establishments subject to the order was governed by a common order of the various units, this pattern was not exclusive to the monks of Cluny. Neither were church designs subject to strict regulation. Localisms, i.e. ornamental and architectural lines that were popular in a certain region, were used in the structure of the priory renewing its buildings. And so, rather than Cluniac architecture we should speak of a Cluniac sensibility based on liturgical emphasis which is evident to a greater or lesser extent in the various different priories, regardless of where they might be.

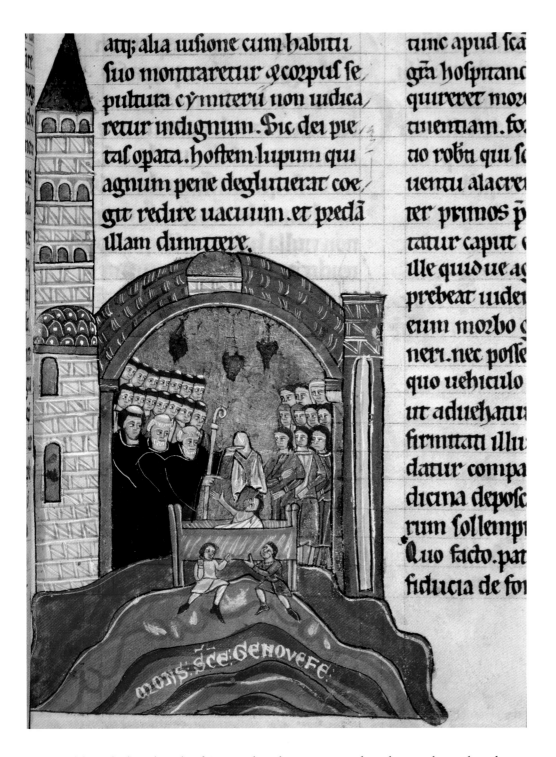

atq; alia uisione cum habitu
suo monstraretur qcorptis se,
pultura cymiterii non iudica,
retur indignum. Sic dei pie,
tas opata. hostem lupum qui
agnum pene deglutierat coe,
git redire uacuum. et predã
illam dimittere.

tunc apud sca
gra hospitand
quireret moze
tinentiam. fo,
tio robti qui s
uentu alacre
ter primos p
tatur caput
ille quid ue a
prebeat uide
eum morbo
neri. nec posse
quo uehiculo
ut aduehatu
firmitati illu
datur compa
dicina depose
rum sollempi
Quo facto. par
fiducia de for

Saint Hugh of Cluny (1024–1109), Abbot of Cluny, brings a dead man back to life in Paris [Chroniques de Cluny, *Ms Latin 17716, fol. 35; detail*]
1189
BnF~Bibliothèque nationale de France, Paris

Although the Church of San Pedro el Viejo is now lost, known by archaeology as Cluny II (c. 980–1035), we know that the fundamental aspects of the final configuration of this building date from the early 1030s. At that time, a previous structure characterized by the great development of its apse with a proliferation of apses was equipped with a second liturgical pole – the inclusion of a large block attached to its western front. Defined by the monks under the term of "*galilea*," it was an evocative space that laid a singular emphasis on the commemoration of the death and resurrection of Christ. As a symbolic space for the transition from Death to Eternal Life it was called by the same name as the place Christ had identified as where he would meet his apostles after the Resurrection: the land of Galilee by

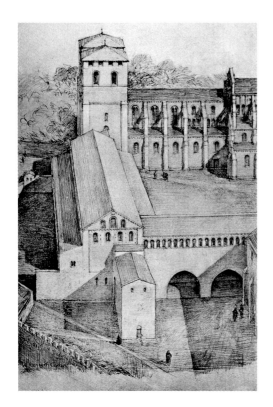

Galilee, Cluny III [Cluny. Les églises et la maison du chef d'ordre. Mâcon: Protat Frères, pl. XXXIII, fig. 59; hypothetical reconstruction] Kenneth John Conant 1968

extension, the Mount of Olives in particular, from where he ascended into heaven (Matt 26:32, 28:7–16). The architectural configuration of one ground floor and another higher up, intermediate in spiritual elevation and overcoming death, accessed by stairs, became a metaphor for the essence of the Christian message. As a further exercise of the application of the *Vita Apostolica* this area was used by monks for liturgical processions in an elevated itinerary focused on the western area of the church. We should not forget that this area was traditionally associated with the eschatological: in the sacred notion of space it was the twilight area. The celebration of the mystery of Christ's Resurrection resulted in this specific architectural space. In turn, the presence of towers and the special attraction of the Cluniac world for the commemoration of the archangel Michael led to some of these structures incorporating small elevated chapels dedicated to the chief of the celestial militia in the Apocalypse. Of Carolingian origin, the presence of a cult to archangels with a preference for Saint Michael was deeply rooted in the Cluniac liturgy: both in the office for the dead, in which he played a leading role, and on Holy Saturday, or especially in the litany of the vigil for Pentecost.[3] Through the liturgical documents we still have, we know that 29 September, the feast day of Saint Michael, was one of the most important celebrations.[4] Building altars, preferably on high, was therefore an invariable, which was to be found particularly on the upper floors of these western spaces called *galileas*. In the second church of Cluny, regrettably lost, the *galilea* was almost certainly still operative in the course of the building work for the third great abbey church (c. 1088–1130). From the demolition of the nave of Cluny II for the construction of the cloister of the new church (c. 1120), the *galilea* was connected to the large building via a corridor, but we do not know if it maintained its liturgical function or was reconfigured with a new content. We know that when the great church opened in 1130 it had three altars in high places devoted to the archangels Michael (over the western front), Gabriel (in the south tower of the great transept) and Raphael (probably in the north tower of the great transept).[5]

The impact of the second church of Cluny

From its opening until its partial demolition, the second church of Cluny had a life span of a century and a half (c. 980–1120). For the last thirty years it coexisted with the building process of the great church that was to replace it. The building had become obsolete in relation to the large increase in the number of monks who lived in the abbey: from approximately seventy in 1000 there were three hundred at the time of the death of Abbot Hugh of Semur in 1109. There was also the high number of ordained monks who were therefore involved in liturgical celebrations: as a result of this and taking into account the requirement that it was prohibited to say more than one mass on the same altar on the same day, together with the celebration of private masses, the number of altars was entirely inadequate. But beyond this inadequacy that came with abbot Hugh, there is an indisputable fact: Cluny II had much more influence than the immeasurable and protracted number of altars in Cluny III. The second church was the first major building of Cluniac monks and its liturgical activity coincided with the order's period of

3 S. Cassagnes-Brouquet, "Cluny et les anges. Les créatures célestes dans la spiritualité et l'art clunisien," *Les Cahiers de Saint-Michel de Cuxa*, 28 (Cuxa: 1997), p. 23.
4 *Liber Tramitis aevi Odilonis abbatis*, ed. P. Dinter (Siegburg: Schmitt, 1980), pp. 173–5.
5 K. J. Conant, *Cluny. Les églises et la maison du chef d'ordre* (Mâcon: Protat Frères, 1968), pp. 93–4.

Cluny II monastery and church [Cluny. Les églises et la maison du chef d'ordre. *Mâcon: Protat Frères, pl. XXVIII, fig. 46; hypothetical reconstruction*] *Kenneth John Conant 1968*

maximum expansion. It could be said that it was a model to follow because of its complex apse, which for the purposes of the liturgical requirements consisted of a pronounced transept over which a battery of apses was built, especially on the west side. This element could almost have been considered key to Cluny's essence. Apses could be complex and subject to Cluny guidelines to a greater or lesser degree, but there are also others, much simpler; three apses with no transept marked on the ground level. However, the presence of elaborate western fronts is seen in most of the churches subject to the order.

The beginning of institutional relations with Cluny by the Spanish monarchy in the mid-eleventh century led some specialists to seek early echoes of Cluny II in Spanish Romanesque of the period. The result was negative. And not only because of the erroneous dating of many buildings, placed much too early and untenable today. The great monasteries which could have included architecture from the Burgundian church after its reform, not subordination to Cluny, do not evidence any reflection whatsoever, either because they are based on local parameters (San Juan de la Peña, renovated in 1028) or because they have been profoundly changed by subsequent interventions (San Salvador de Oña, renovated in 1033). But the reformist intervention was most probably limited to the imposition of specific patterns of Cluniac interpretation of the rule of Saint Benedict, i.e. specifically emphasizing the monastic office and the liturgy. Even though it is a dim reflection that probably did not last long beyond its inception, some celebrations at Oña were strictly Cluniac amidst all the Spanish rites: the obituary of Abbot Maieul (992) and the translation of the relics of Saint Marcellus the Pope to Cluny – one of the apses of the second church at Cluny was devoted to him –, among others.[6] It is unlikely that this brought about an architectural response in the light of the remains that have survived – the simple and conventional apse at the Church of Leire, for example – and the solid inertia of the regional constructions throughout the majority of the eleventh century.

With the information we have today it is possible to state that the architectural impact of Cluny on other churches took place over several decades. In fact we have no evidence to date it before the last quarter of that century. Only when the subordination of Spanish monasteries to Cluny was confirmed during the reign of Alfonso VI can we really speak of a *terminus post quem* for Cluniac influence on

6 B. de Gaiffier, "Un calendrier franco-hispanique de la fin du XIIᵉ siècle. Le calendrier d'Oña du ms. Ambrosien F.105 Sup.," *Analecta Bollandiana*, 69 (Brussels: 1951), pp. 282–323.

Church of San Martín de Frómista
c. 1118
Palencia

specific spaces: mostly western fronts. And the most interesting solutions crystallized in the three above-mentioned great priories – Dueñas, Najera and San Zoilo – once the new monks were able to replace the inherited buildings, around the year 1100. In relation to this, the planning of cloisters according to the Benedictine code, a phenomenon which as told in the *Historia Compostellana*, did not occur before the early decades of the twelfth century.[7]

From the medieval remains which have been preserved at the churches of Dueñas and San Zoilo, whose Romanesque structures were reused to a very large extent by modern reforms, we can say that the churches of the great Cluniac dependencies in the Iberian Peninsula were subject to these coordinates, imposed from the mother church that laid emphasis on the development of western enclosures. The Cluniac reflection of the interaction of liturgy and space can be clearly seen from the clear design of fronts with a portico and elevated spaces accessed from the lateral towers. This same concern with a similar morphology can be seen in the Church of San Martín de Frómista, a monastic institution incorporated into Cluny in 1118. As mentioned before, in all three cases the reforms in modern times (Dueñas and San Zoilo) or the nineteenth-century restorations (Frómista) wiped out many of the archaeological remains but through comparative analysis it becomes possible to trace the guidelines which united the three projects. Guidelines, it should be stressed, that we do not find in other monastic ensembles of the same period that have come down to us from outside the Cluniac institution. It is this contrast that enables us to consider the hypothesis that the institutions subject to Cluny in Castile-Leon adopted a church plan which specifically indicated, with great emphasis, the special way in which western fronts should be defined for their full exploitation of the liturgy. With larger faces than the rest of the building, inside the wall were corridors, accessed through the lateral towers. There were also altars in high places devoted to Saint Michael, clearly visible in the northwest tower of San Zoilo, in which a small canonically oriented chapel still survives.

Cluny and Compostela

The links between Compostela and Cluny became particularly relevant when the Cluniac monk Dalmatius became bishop of the see from 1094 to 1096. Halfway through his short legislature he took part in the consecration of the altar devoted to the apostle Saint James in the apse of the third church of Cluny, and must have contributed to the ceremony with the donation of a relic of the Apostle. The brief transit of Dalmatius coincided with the arrival in Galicia of Count Raymond of Burgundy (†1107), the king's son-in-law and protector of the one who would succeed him to the apostolic see, Diego Gelmírez.[8] During these years Gelmírez probably became aware of Cluny, convinced that the abbey could be a significant ally for the impending political expansion policy to which he submitted the bishopric.[9] The bishop of Compostela's political genius extended the dominion of his see, gave him a European scope and made the cathedral, like the abbey of Cluny itself, an ecumenical space in which relics of a local and supranational dimension were gathered.[10] With the collaboration of one of the most prominent priors in Spain,

7 "Illa tamen ecclesia nullum adhuc claustrum, nullam competentem officinam habebat nec erat edifitiis ornate aut decorate sicut Vltraportuenses ecclesie," in *Historia Compostellana. Corpus Christianorum Continuatio Mediaevalis*, ed. E. Falque Rey (Turnhout: Brepols Publishers, 1988), III, 1, p. 420.

8 B. F. Reilly, "Count Raimundo of Burgundy and French Influence in León-Castilla (1087–1107)," in J. A. Harris and T. Martin (eds.), *Church, State, Vellum, and Stone: Essays on Medieval Spain in Honor of John Williams* (Boston: Brill, 2005), pp. 95–8.

9 P. Henriet, "Capitale de toute vie monastique," "Élevée entre toutes les églises d'Espagne," "Cluny et Saint-Jacques au XIIᵉ siècle," in A. Rucquoi (ed.), *Saint Jacques et la France* (Paris: Cerf, 2003), pp. 434–9. E. Portela Silva, "Diego Gelmírez. Los años de preparación (1065–1100)," *Studia Historica. Historia Medieval*, 25 (Salamanca: 2007), pp. 121–41.

10 O. K. Werckmeister, "Cluny III and the Pilgrimage to Santiago," *Gesta*, 27 (New York: 1988), pp. 103–12.

Gallery *[Ambulatory]*
c. 1106
Cathedral of Santiago de Compostela

Esteban de San Zoilo de Carrión, an efficient link in the years of unrest that followed the death of Alfonso VI, it was through the mediation of abbot Pons (1109–1122) that he obtained the granting of the Archbishopric (1120) from another Cluniac Pope, Calixtus II.[11]

To illustrate the importance of Cluniac liturgy on the architectural plan of the Cathedral in Compostela, different examples could be reviewed but just one is sufficient in the context we are interested in. During his stay at Cluny in the fall of 1105, on his way to Rome, Gelmírez received the privilege of saying high mass for the archangel Michael, probably in the church of Cluny II.[12] Perhaps aware of this, only a few months later and before the west front of the Cathedral of Santiago was built (as we have seen, the traditional location of altars devoted to the archangel), the bishop of Compostela devoted an elevated altar to Saint Michael, in an alternative location: certainly not without symbolic intention, on the eastern edge of the tribune, over the access to the chapel of The Savior.[13]

The state the western enclosure of the Cathedral in Compostela before Gelmírez's death (1140) is still under debate, because if we are to believe Book V of the *Liber Sancti Jacobi*, very short in its descriptive story in relation to the two lateral fronts, we would have to think that it had not got beyond the planning stage in the 1130s. In addition, an adjacent paragraph of the same work states, "*Sed ex his dicimus that iam sunt omnino alia adimpleta, aliaque adimplenda* [But of all this, part is completely finished and another part remains to finish]."[14] Apparently it had double access and stood out above the other two due to its higher size and superior quality of sculpture. Decorated with the *Transfiguration*, perhaps within a large tympanum with a mullion, an exotic topic in the monumental iconography, it was present in the Spanish liturgy but deeply rooted in Cluny under abbot Peter the Venerable – the *De Transfiguratione Domini* sermon –, who instituted the festivity in 1132.[15]

11 C. Reglero de la Fuente, *Cluny en España. Los prioratos de la provincia y sus redes sociales (1973–ca. 1270)* (León: Centro de Estudios e Investigación San Isidoro, 2008), pp. 208–10, 352–5.

12 *Historia Compostellana. Corpus Christianorum Continuatio Mediaevalis...* op. cit., I, 16, p. 39.

13 Ibidem, I, 19, p. 45. "*sursum in palacio aeclesiae tria altaria solent esse, magister quorum est altare Sancti Michaelis arcangeli,*" in A. Stones, P. Gerson and J. Krochalis (eds.), *The Pilgrim's Guide: A Critical Edition*, vol. 2:2 (Turnhout: Harvey Miller, 1998), pp. 78, 210, no. 107.

14 Ibidem, pp. 78–9. On this subject, see S. Moralejo, "Notas para una revisión crítica de la obra de K. J. Conant," in J. K. Conant, *Arquitectura románica de la Catedral de Santiago de Compostela* (Santiago de Compostela: COAG~Colegio Oficial de Arquitectos de Galicia, 1983), p. 231.

15 M.-L. Thérel, "Pierre le Vénérable et la création iconographique au VIIᵉ siècle," *Pierre Abélard-Pierre le Vénérable* (Paris: CNRS~Centre national de la recherche scientifique, 1975), pp. 734–8.

The significant priory of La Charité-sur-Loire, ruled by one of the disciples of the Venerable, composed one of its three western fronts with this foreshadowing of Christ's divinity and harbinger of future glory (c. 1135).[16] The front of Compostela probably corresponded to a design different from the one built later under the auspices of Maestro Mateo (*post.* 1168) as far as the towers are concerned. We should keep in mind that most buildings in the first half of the twelfth century planned the western towers as quadrangular on the same level as the walls enclosing the naves, and not protruding upwards as in the Matthean reform. The collapse of the entrances to the lateral naves by the towers generated a deficit of spatial integration with regards to the body of the building, which in no way appears in the solution adopted in the new project.[17] A medium sized building whose construction progressed in parallel to the Cathedral in Compostela was the Cathedral of Pamplona. Completed in 1127, apart from adopting the polygonal shape of the smaller Compostela apses in its central apse – Saint Faith and Saint Andrew –, it has a single western dual front framed by towers aligned with the lateral naves, a more conservative solution that could absorb, perhaps partially, the unfinished project of Gelmírez for the western enclosure. Both buildings, with the common denominator of the western fronts with towers, were completely alien to local tradition and together with the smaller Spanish priory churches subject to Cluny, dominated the monumental landscape of the Christian northwest of the peninsula in the first half of the twelfth century.

The expansion of Burgundian sculpture

After decades largely dominated by a sculptural style emanating from Aragon, Gascony and Languedoc, in the last years of Archbishop Gelmírez the presence of sculptors from Burgundy is attested to in the northwest of the Iberian Peninsula. This exodus of workers from Cluniac lands should be understood in the setting of the completion of most of the larger buildings, or a halt in the work due to lack of financial liquidity. The latter is what is found in the Church of Cluny III, the large lavish building solemnly opened in 1130 after dedication by pope Innocent II. Work continued for a few years on the great narthex until abbot Peter the Venerable (1122–1156), faced with an exhausted financial situation, decided to put a stop to it. Some of the artisans went in search of new labour markets and moved to the Iberian Peninsula. So far we have not found any traces of them along the pilgrimage route, although they are evident in the periphery: as shown on occasions, another example of the fact that pilgrimage routes were just as important as monks' routes.[18] More specifically, their work is registered in some of the most thriving monastic institutions: not long after 1138, in the apse of the Church of Santa María de Estíbaliz (Álava), an independent institution and thereafter subject to the Cluniac priory of Santa María de Nájera (La Rioja). In 1141, we can see the presence of Burgundian trained sculptors, particularly close to the Cluny narthex workshop, working in the refectory of the monastery of Oña (Burgos), renovated a century earlier by the Cluniac Benedictines: an arcade found on the eastern front of the building enables us to trace this stylistic affiliation. Finally, in 1142, King Alfonso VII was in Salamanca with abbot Peter the Venerable, travelling around the peninsula in

16 This iconography is also present in the Cluniac priory of Saint-Fortunat de Charlieu (Loire), although reduced to an archivolt on the north front of the church (c. 1140).

17 An exception is the western block of the Abbey Church of Saint-Denis (c. 1135), whose towers were made hollow by moving their respective helical accesses to the thickness of the side walls, thereby making possible the triple access to the inside of the building.

18 S. Moralejo, "Cluny et les debuts de la sculpture romane en Espagne," in *Le gouvernement d'Hugues de Semur à Cluny* (Mâcon: Protat Frères, 1990), p. 407.

search of financial support, and gave him the monastery of San Pedro de Cardeña (Burgos). Given the opposition of the native Spanish community to accepting the subjection to Cluny, the Cluniac monks' stay was short-lived but the conservation of part of the Romanesque cloister of this monastery is a clear witness to Burgundian affiliation: the capitals of the arcade and those at the access to the chapter house are very similar to the models from the workshop, which with a remarkable figurative restraint, worked on the eastern part of the Cluniac priory Church of Paray-le-Monial (Saône-et-Loire), also present in some Romanesque houses in the town of Cluny.[19]

A little over two decades later, in the late 1260s and under the above-mentioned management of Mateo, the Cathedral of Santiago itself admitted sculptors from the same place. The sculptural ornamentation in the western crypt, which holds up the Portico of Glory (called the old cathedral), is clearly dependent on Burgundian parameters, evident in the artistic speculation with acanthus leaves. This last phase of the Cathedral in Compostela coincided with the decline of the Cluniac order, whose status in the Iberian Peninsula was in great measure subject to the variable managing talent of the priors of its three main dependencies. But by then the days of Gelmírez were already an echo lost in time, a time that eventually dissolved even the memory of an archbishop, who seemed to sense it in his infinite wisdom, and wrote his lengthy epitaph in the legacy of the *Historia Compostellana*.

19 J. L. Senra, "L'influence clunisienne sur la sculpture castillane du milieu du XII^e siècle: San Salvador de Oña et San Pedro de Cardeña," *Bulletin Monumental*, 153 (Paris: 1995), pp. 267–92.

Francisco Prado-Vilar

Nostos: Ulysses, Compostela and the Ineluctable Modality of the Visible

Not tenderness for a son, nor filial duty / toward my aged father, nor the love I owed / Penelope that would have made her glad, / could overcome the fervour that was mine / to gain experience of the world / and learn about man's vices, and his worth. / And so I set forth upon the open deep / with but a single ship and that small band / of shipmates who had not deserted me. / One shore and the other I saw as far as Spain, / Morocco, the island of Sardegna, / and other islands set into that sea. / I and my shipmates had grown old and slow / before we reached the narrow strait / where Hercules marked off the limits, / warning all men to go no farther. / On the right-hand side I left Seville behind, / on the other I had left Ceuta. / "O brothers," I said, "who, in the course / of a hundred thousand perils, at last / have reached the West, to such brief wakefulness / of our senses as remains to us, / do not deny yourselves the chance to know – / following the sun – the world where no one lives. / Consider how your souls were sown: / you were not made to live like brutes or beasts, / but to pursue virtue and knowledge." / With this brief speech I had my companions / so ardent for the journey / I could scarce have held them back. / And, having set our stern to sunrise, / in our mad flight we turned our oars to wings...

Dante, *Inferno*, XXVI, 94–125

1 For Dante's Ulysses, see E. Bloch, "Odysseus did not Die in Ithaca," in G. Steiner and H. Fagles (eds.), *Homer* (Englewood Cliffs: Prentice Hall, 1962), pp. 81–5. P. H. Damon, "Dante's Ulysses and the Mythic Tradition," in W. Matthews (ed.), *Medieval Secular Literature. Four Essays* (Berkeley: University of California Press, 1965), pp. 25–45. J. Freccero, "Dante's Ulysses: From Epic to Novel," in *Dante: The Poetics of Conversion* (Cambridge: Harvard University Press, 1986), pp. 136–51. P. Boitani, *La sombra de Ulises. Imágenes de un mito en la literatura occidental* (Barcelona: Ediciones Península, 2001). A. Deyermond, "El Alejandro medieval, el Ulises de Dante y la búsqueda de las Antípodas," in R. Beltrán (ed.), *Maravillas, peregrinaciones y utopías: literatura de viajes en el mundo románico* (Valencia: Universitat de València, 2002), pp. 15–32.

A mongst the shades that come to meet Dante and Virgil in their journey through the deepest regions of the Inferno, particular relevance is acquired by the celebrated Ulysses who, wrapped in a trembling horn of fire, eternally purge their sins in the circle reserved for fraudulent advisors. When he meets the visitors, the hero narrates the tragic circumstances of his last voyage, in which, sailing beyond the Pillars of Hercules towards the western bounds of the known world, he perished along with all his crew as "the sea closed over us."[1] If the famous wiles that Ulysses used to propitiate the victory of the Greeks in the Trojan War determined his sentence in Dante's universe, the unfortunate outcome of his post-Homeric voyage invites us to suppose that his death could be understood as a divine punishment for the *hubris* of an unbridled curiosity. By putting into Ulysses' mouth so ardent an exhortation to pursue knowledge, going beyond the limits set by the Creator, and through his use of the metaphor of turning oars to wings in order to set off on such a reckless quest, Dante traces an ill-fated moral genealogy for his exploits, linking them with those of Adam and Icarus. Although the prominent position occupied by Ulysses in the *Divine Comedy* is a faithful testimony of his continuing presence in the

medieval imaginary, his characterization *in malo* contrasts with that which can be perceived in most of the literary corpus of the Middle Ages, in which, returning to an allegorical tradition that has its roots in antiquity, he is presented as a paradigmatic example of virtue and wisdom.

As far back as in the times of classical Greece authors from different schools of philosophy, but particularly those relating to stoicism and gnosticism, had already extolled Ulysses as an ascetic model of perseverance against the cruel misfortunes of life, interpreting his seaborne odyssey as a metaphor for the tortuous exile of the soul in the material world, where it was assaulted by all manner of vices and temptations that had to be overcome before one could finally return to the celestial homeland.[2] Hellenistic Christian writers such as Clement of Alexandria took up these ideas, seeing in the itinerary followed by Ulysses from the dark land of the Cimmerians and then to the isle of the Sirens with all its perils before finally arriving in his sun-drenched native land an image of the Christian's epic journey through the trials and tribulations of this world before reaching the eternal light of the *Logos* that illuminates everything. Neither did the symbolic potentiality of the events and characters of the *Odyssey* go unnoticed by contemporary Latin writers, such as Hippolytus of Rome, who at the beginning of the third century AD developed a Christological interpretation of the episode of the isle of the Sirens within the framework of his attacks on heresy:

"The pupils of these men, when they perceive the doctrines of the heretics to be like unto the ocean when tossed into waves by violence of the winds, ought to sail past in quest of the tranquil haven. For a sea of this description is both infested with wild beasts and difficult of navigation, like, as we may say, the Sicilian Sea, in which the legend reports were Cyclops, and Charybdis, and Scylla, and the rock of the Sirens. Now, the poets of the Greeks allege that Ulysses sailed through (this channel), adroitly using (to his own purpose) the terribleness of these strange monsters. For the savage cruelty (in the aspect) of these towards those who were sailing through was remarkable. The Sirens, however, singing sweetly and harmoniously, beguiled the voyagers, luring, by reason of their melodious voice, those who heard it, to steer their vessels towards (the promontory). The (poets) report that Ulysses, on ascertaining this, smeared with wax the ears of his companions, and, lashing himself to the mast, sailed, free of danger, past the Sirens, hearing their chant distinctly. And my advice to my readers is to adopt a similar expedient, viz., either on account of their infirmity to smear their ears with wax, and sail (straight on)

2 For the allegorical tradition of Ulysses in the Neoplatonic schools and the Christian milieu, see R. Lamberton, *Homer the Theologian. Neoplatonist Allegorical Reading and the Growth of the Epic Tradition* (Berkeley: University of California Press, 1986). H. Rahner, *Mitos griegos en interpretación cristiana* (Barcelona: Herder, 2003).

3 Hippolytus of Rome, *The Refutation of All Heresies*, trans. J. H. MacMahon (Edinburgh: T&T Clark, 1870), pp. 266–7. For the portrayal of the episode of Ulysses and the Sirens on pagan and Christian sarcophagi of the time of Hippolytus of Rome, see J. Wilpert, *I sarcofagi cristiani antichi*, 3 vols. (Rome: Pontificio Istituto di Archeologia Cristiana, 1929–1936). P. Courcelle, "Quelques symboles funéraires du néo-platonisme latin. Le vol de Dédale, Ulysse et les Sirènes," *Revue des études anciennes*, vol. 46,1 (Pessac: 1944), pp. 65–93.

De Consolatione Philosophiae
[Ms Hunter 279 (u.5.19), fol. 45v]
Boethius
c. 1120–1140
University of Glasgow

Divina Commedia *[Ms Holkham
misc. 48, p. 40]*
Dante Alighieri
c. 1350–1375
Bodleian Library, Oxford University

through the tenets of the heretics, not even listening to (doctrines) that are easily capable of enticing them into pleasure, like the luscious lay of the Sirens, or, by binding one's self to the Cross of Christ, (and) hearkening with fidelity (to His words), not to be distracted, inasmuch as he has reposed his trust in Him to whom ere this he has been firmly knit, and (I admonish that man) to continue steadfastly (in this faith)."[3]

The routes by which the characters of the *Odyssey* became an integral part of the literary and visual imaginary of Romanesque art was via the sermons of other key Fathers of the Church such as Saint Jerome and Saint Ambrosius, as well as through the work of mythographers such as Fulgentius, who traces the etymology of the name of Ulysses in Greek to *"olonxenos"* for *omnium peregrinus* (the eternal pilgrim),[4] or that of philosophers as important as Boethius, who in *De Consolatione Philosophia* devotes two poems to Ulysses that would be the object of many commentaries in the centuries to come. Thus, in a manuscript from the first third of the twelfth century there is an illustrated gloss of the poem in which the allegory of Philosophy gives an educational commentary on the story of Circe's spell, which turned Ulysses' men into animals, to explain that those who abandon virtue reduce themselves to the level of wild beasts.[5] In the same century, the Greek hero's adventures would be moralistically interpreted in a wide variety of exhortations against all manner of follies – heresies or worldly temptations alike – or would be used as a metaphorical medium for expounding evangelical dogmas such as the mystery of the Incarnation of Christ or the role of the Church in the salvation of the faithful. Honorius Augustodunensis, in his *Speculum Ecclesiae*, a popular collection of sermons that was avidly read and used as a guide for the creation of figurative motifs in some the major iconographic programmes of that century, gives the following summary:

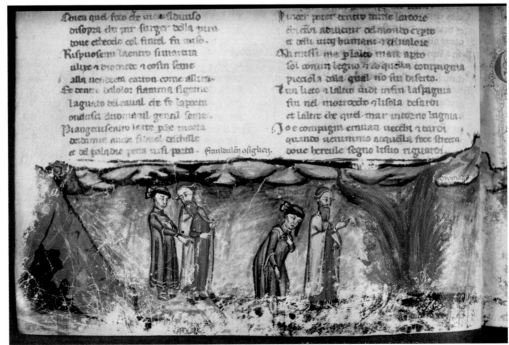

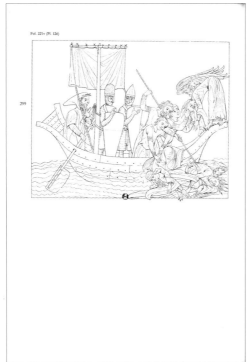

Hortus Deliciarum [Herrad de Landsberg, 1159–1175. London: The Warburg Institute, pp. 365–6] Christian Maurice Engelhardt 1979

"Ulysses is said to be the exemplary wiseman. He sails past [the Sirens] unscathed, because a Christian people that is truly wise floats in the ship of the Church over the sea of this world. He binds himself with the fear of God to the mast of the ship, that is, to the cross of Christ; he seals up the hearing of his companions with wax, that is, the Incarnation of Christ, so that they may turn their heart from vices and sensual desires and strive only after the things of heaven."[6]

One example of the ongoing popularity of the moralizations of the episode of Ulysses' victory over the Sirens throughout the century in question is its inclusion in Herrad of Landsberg's *Hortus Deliciarum*, an illustrated guide to doctrine that quotes the commentary by Honorius Augustodunensis, together with those by Fulgentius and other authors, accompanied by three illustrations in which Ulysses and his men are portrayed as medieval soldiers fighting against bird-legged Sirens in a moral battle for the soul.[7]

It was at the dawn of the twelfth century that Ulysses, the *omnium peregrinus*, following these winding paths of allegory and religious imagination, arrived at the most important center of pilgrimage in the West, namely Santiago de Compostela. Whilst in the *Divine Comedy* this Greek hero ended up having to tell the story of his failed expedition from a spiral of fire located in the Inferno, his place in the "Divine Compostela," however, was to be in Paradise, the name given to the square in which there rose up a marble column around which there twisted the chronicle in stone of this triumphal *nostos* [homecoming] to the celestial Ithaca of the West.[8] Currently preserved in the Cathedral Museum, this masterpiece of Romanesque art comes from the North Door of the Cathedral in Compostela, known as the *Porta Francigena* – the entrance used by the countless pilgrims who, after having traveled long distances along a route strewn with temptations and dangers, entered the church

4 L. G. Whitbread (ed. and trans.), *Fulgentius the Mythographer: On the Ages of the World and of Man; The Exposition of the Content of Virgil; The Mythologies; Super Thebaiden* (Columbus: Ohio State University, 1971), p. 31 (*Mythologies* 2.8).

5 For this manuscript, see D. Bolton, "Illustrations in manuscripts of Boethius' Works," in M. Gibson (ed.), *Boethius: his life, thought and influence* (Oxford: Blackwell, 1981), p. 429.

6 H. Vredeveld, "Deaf as Ulysses to the Siren's Song: The Story of a Forgotten Topos," *Renaissance Quarterly*, 54.3 (Chicago: 2001), pp. 846–82, esp. p. 858.

7 See the facsimile edition of Herrad de Landsberg, *Hortus Deliciarum*, vol. 2:2 (London: The Warburg Institute, 1979).

8 For this square see S. Moralejo, "La imagen arquitectónica de la Catedral de Santiago," in *Il Pellegrinaggio a Santiago de Compostela e la letteratura jacopea (Atti del Convegno Internazionale di Studi, Perugia, 1983)* (Perugia: Università degli Studi di Perugia, 1985), pp. 37–61.

9 For the reconstruction of the iconographic programme of this portal, which was destroyed in the eighteenth century, see S. Moralejo, "La primitiva fachada norte de la catedral de Santiago," *Compostellanum*, vol. 14, 4 (Santiago de Compostela: 1969), pp. 623–68.

Akragas Tetradrachm [Agrigento]
414–3 BC
RHA~Real Academia de la Historia,
Madrid

Shaft [detail]
Master of the Twisted Columns
1101–1111
Museo de la Catedral de Santiago
de Compostela

to approach the tomb of Saint James, the apostle whose body, like that of Ulysses, had passed between the Pillars of Hercules on its way to its eternal resting place in the westernmost bourne of the known world –.[9]

The four spiral carvings along the shaft display a sermon in images whose core section consists of Christianized episodes from the epic of Ulysses. They combine a moralizing discourse that presents Ulysses as the model pilgrim who, overcoming all temptations on his way, finally reaches his spiritual goal with a doctrinal exposition from a typological perspective on the Incarnation of Christ and the role of the Church in the Christian odyssey of salvation. Although the column presents a combination of motifs and characters that undoubtedly refer to the imaginary of a Christianized *Odyssey*, its iconography has remained inscrutable for so long because it depicts not so much the descriptive narration of each episode of the famous Greek literary adventure as its visual Christian exegesis.[10] Ulysses is characterized as a medieval soldier whose adventures take place in a marine environment defined by a fluid and constantly changing current, that in the first carving undulates to form the curved prow of his ship, and in the second rises up to trace the outline of the cross-shaped mast that stands between the two figures. This threatening aquatic infra-world is inhabited by a Siren with a woman's torso and a fish's tail who, from the far right-hand side of the second carving, attempts to draw Ulysses and his companions towards perdition, whilst they are simultaneously being hounded on the other side by a sea monster called Scylla, who is escorted by another monstrous Siren with bird's legs. The ferocious Scylla is portrayed both here and in a further appearance in the carving above, with the attitude and attributes that had characterized her since classical times, as can be seen in the Agrigentum tetradrachms and a host of later works throughout the Middle Ages, holding her tail like a rudder and surrounded by voracious creatures emerging from her waist.[11] The combination of Scylla and a Siren in the same scene, in spite of appearing in two different episodes in the *Odyssey*, is due to their common moral meaning as incarnations of lust and the temptations of the flesh. As Fulgentius points out:

> "Her loins were filled with wolves and wild sea dogs. For Scylla in Greek is said to be for *exquina*, which in Latin we call violence. And what is violence but lust? [...] Scylla is explained as the symbol of the harlot [...] she is then truly filled with dogs and wolves, because she cannot satisfy her private parts with inroads of any other kind. [...] Ulysses also sailed harmlessly past her, for wisdom scorns lust."[12]

This text, taken together with the previous quotations, provide us with the guidelines for understanding the figurative visual exegesis in this central carving, in which there is a summing up of the main lines of the Christological interpretation of the episode of Ulysses facing Scylla and the Sirens, stressing the metaphor of the life-saving act of sealing his followers' ears with wax – a metaphor which was echoed, to give a further example from the time when this column was designed, by the anonymous author known as the Third Vatican Mythographer –:

Development of epic motifs on the helical shaft of the Porta Francigena ["Artistas, patronos y público en el arte del camino de Santiago," Compostellanum, *XXX. Santiago de Compostela, p. 429, fig. 11; hypothetical reconstruction*] *Serafín Moralejo 1985*

"When Ulysses was about to sail past [the Sirens], he sealed his companions' ears with wax, fastened himself to the mast, and safely passed by them [...] The Sirens, therefore, are manifestly the bodily allurements [...] But the wiseman seals up the ears of his followers, lest they hear their songs, that is, he instructs them with salutary precepts, lest they be enmeshed in mundane delights. He himself, however, sails past them while bound to the mast, that is, while supporting himself by virtue. Though he discerns the allurements in all their worldly varieties, he despises them nevertheless and steers toward the fatherland of everlasting bliss."[13]

And it is a Christ-like Ulysses that we must recognize in the figure leaning firmly against a support that bends around his head to form a halo, in a kind of visual "stream of consciousness" – a process of uninterrupted figurative metamorphosis through which the cross-shaped mast also comes into being –.[14] The hero protectively extends his left arm around his follower's head, ostensibly covering the latter's ear with his hand and thereby separating him from the threatening presence of the seductive Siren who is coming towards his lance, the image of death. Indifferent to the temptations of the flesh, the man kneels before his savior, his gaze seeking visual communion. The tenderness of the body language employed by the artist to express the affective link between the Christ-like Ulysses and his devoted follower has led some specialists to interpret the two figures as participants in a love scene similar to those described in epics of chivalry.[15] The sensorial empathy with which he represents the act of salvation, however, is the defining characteristic of the personal style of the sculptor of genius, as can be seen in another of his unmistakable creations, the healing of the blind man on the right-hand tympanum of the *Platerías* Door. Leaning back with a smile that is identical to that shown on Ulysses' face, Christ lays his miraculous hand on the blind man's eyes whilst at the same time reaching out his left arm towards the latter's chest, gently bringing him closer. The blind man responds by stroking the arm with which Christ is holding him and turning his head towards that of The Savior, so as to be able, at the exact moment when the miracle takes place, to make himself one with Him in an intimate visual communion. The subtlety and tenderness of the body language that joins Christ to the blind man makes this scene,

10 Serafín Moralejo, always stressing the provisional nature of his hypothesis, proposed that some of the scenes on this column should be understood in the framework of the epic cycle of Tristan, the first written testimonies of which date from half a century after this work was created. Although, as I make clear in this study, I do not share Moralejo's interpretation, whether concerning the identification of motifs and specific figures or the overall iconographic theme, I do coincide with his opinion that each scene should not be seen through the "*craso positivismo de la documentación libresca*" but rather that it constitutes a "*tema de encuadre* [...] *un sucinto nucleo argumental susceptible de variados desarrollos o comentarios orales en cuanto su cicunstancialidad*": S. Moralejo, "Artes figurativas y artes literarias en la España medieval: Románico, Romance y Roman," *Boletín de la Asociación Europea de Profesores de Español*, vol. 17, 32–33 (Santander: 1985), pp. 61–70, esp. p. 69. For a summary of the main points of Moralejo's hypothesis with a prior bibliography, see S. Moralejo (ed.), *Santiago, Camino de Europa. Culto y cultura en la peregrinación a Compostela* (Santiago de Compostela: Xunta de Galicia, 1993), pp. 382–4.

11 See e.g. G. M. A. Hanfmann, "The Scylla of Corvey and Her Ancestors," *Dumbarton Oaks Papers*, 41 (Washington D.C.: 1987), pp. 249–60. P. Cabrera Bonet, "Del mar y sus criaturas. Seres híbridos marinos en la iconografía suritálica," in I. Izquierdo and H. Le Meaux (eds.), *Seres híbridos: apropiación de motivos míticos mediterráneos* (Madrid: Ministerio de Educación, Política Social y Deporte, 2003), pp. 111–42.

12 *Fulgentius the Mythographer: On the Ages of the World and of Man; The Exposition of the Content of Virgil; The Mythologies; Super Thebaiden...* op. cit., p. 74 (*Mythologies* 2.9).

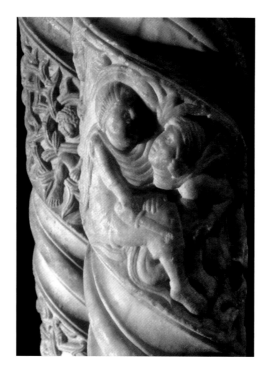
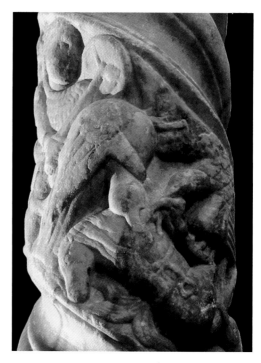

out of the whole of this sculptor's output, a true *pendant* with the scene of Ulysses on the column, revealing his extraordinary sensitivity when it comes to expressing the somatic and affective dimension of the act of salvation and mystical union.

If this scene is a masterly condensation of the allegorical interpretations of the myth of Ulysses in a Christological sense, by showing the hero sealing his faithful companions' ears with wax as a foreshadowing of the mystery of the Incarnation of Christ and of His role in the Redemption of man, the scene portrayed in the lower carving emphasizes the ecclesiological dimension of the Christian exegesis of Ulysses' *nostos*, also referred to in the gloss by Honorius Augustodunensis quoted above. The hero is sailing in the ship of the Church, once again identified by its cross-like mast, over the stormy waters of this world, infested by all manner of vermin, an idea emphasized by the presence of an ibis which, with its eagle's body, powerful claws and curved beak, is portrayed in the act of catching a snake. According to the Medieval Bestiary, the Ibis lives close to the water's edge and feeds on reptiles, carrion and dead animals because, unable to swim, it cannot get to the fresh fish that live in deeper waters. For this reason, in the moral significance attributed to it by the Bestiary, the Ibis symbolizes the person who succumbs to the superficial vices of this world and is incapable of undertaking the long voyage needed to reach the pure waters of Christian doctrine. The same motif is repeated, with the same allegorical content, in the third carving, where an ibis is feeding on a dead horse next to its two chicks, a frequent combination in the bestiaries, as shown in a beautiful twelfth century manuscript illustrating the carrion-eating activity of the ibis next to the sea, home to other dangerous creatures such as the Sirens. Although it is no easy task to provide an accurate reconstruction of the narrative sequence of this carving, in which the warrior appears between the scene of the carrion-eating birds feeding on their prey and the threatening presence of Scylla, from whose breast there springs forth a voracious four-legged beast, its moralistic content is perfectly clear, once again illustration the idea of

13 "Deaf as Ulysses to the Siren's Song: The Story of a Forgotten Topos"... op. cit., p. 857. On the Third Vatican Mythographer, whose work is preserved in a considerable number of manuscripts dating from the twelfth to fifteenth centuries, see C. S. F. Burnett, "A Note on the Origins of the Third Vatican Mythographer," *Journal of the Warburg and Courtauld Institutes*, 44 (London: 1981), pp. 160–6.

14 It is still possible to make out, at the height of the figure's waist, a series of bands that crossed his cape in a backwards direction.

15 This is how it was seen by Moralejo, who within the thematic framework of the story of Tristan identified the kneeling character as a woman, Isolde, more on the basis of attitude than iconographic characteristics. In fact, the type of cap the figure is wearing, slightly pointed and divided into broad horizontal strips, is always used by male characters, for example the young man riding a bird on the right-hand jamb of the *Platerías* Door.

the dangers and temptations of this world that lie in wait for the unwary traveler. Finally, in the upper carving, which is badly mutilated, it is only possible to make out a large reclining figure with unruly locks who should be identified with another of the monsters, in this case perhaps Polyphemus, that Ulysses had to face; the latter's victory over the famous Cyclops is also moralized in Christian texts, being interpreted as the triumph of prudence over arrogance, immaturity and the random nature of fortune.[16]

It can therefore be said that, in its pastoral dimension, the column of Ulysses from the *Porta Francigena* presents the Greek hero's *nostos* as a parallel of the physical and spiritual journey undertaken by a pilgrim, a kind of moral mirror to warn travelers of the dangers they will encounter on their way – the temptations of the flesh, heresies, weakness – and at the same time to offer the certainty of a happy end. Nothing could have been more appropriate than having the most striking representation of the myth of Ulysses in the whole of medieval art in the shrine dedicated to the martyr who, like the Greek hero, had passed between the Pillars of Hercules on his way to his eternal resting place in the West. The artists who designed the programme consciously underscored these parallels, as is particularly revealed by the iconic image located at the base of the column that shows the sleeping hero sailing in the ship of salvation towards his celestial homeland – and image that performs a dual purpose, acting as a visual exegesis both in the context of the mythology of Ulysses, who was to arrive sleeping on the shores of Ithaca, and in that of the hagiography of Saint James, whose body was carried in a ship from the port of Jaffa to Galicia. Any pilgrim purchasing something in the market located opposite the *Porta Francigena* could have held one of the coins produced in the mint at Santiago, and looking at it seen a representation of the translation of the apostle that would have been very similar to the scene shown on the marble column.[17] Water was also the dominant feature of this urban environment, for, as the pilgrims' guide known as the *Liber Sancti Jacobi* tells us, the square of

Etymologiae, Synonyma, Bestiary
[Ms 22, fols. 167v–168r]
Isidoro de Sevilla
twelfth century
Parker Library, Corpus Christi
College, Cambridge

16 *Fulgentius the Mythographer: On the Ages of the World and of Man; The Exposition of the Content of Virgil; The Mythologies; Super Thebaiden...* op. cit., p. 127 (*Exposition of the Content of Virgil*, 15). J. Chance, *Medieval Mythography, vol. 1: From Roman North Africa to the School of Chartres, AD 433 to 1177* (Miami: University Press of Florida, 1994), p. 408.

17 The coin from the mint at Compostela found in Adro Vello, which shows on its reverse the oldest known image of the translation of the Apostle, dates from the reign of Fernando II of Leon (1157–1188), although it is reasonable to suppose that the same iconography was used on the coins from the mint that had been active since the end of the eleventh century.

Nós, 32 (Ourense) *[Cover]*
Alfonso Daniel Rodríguez Castelao
1926

18 *Liber Sancti Iacobi Codex Calixtinus*, trans. A. Moralejo, C. Torres and J. Feo (Santiago de Compostela: Instituto Padre Sarmiento de Estudios Gallegos, 1951; reed. fac. Santiago de Compostela: CSIC~Centro Superior de Investigaciones Científicas, 1999), p. 558.

19 *Santiago, Camino de Europa. Culto y cultura en la peregrinación a Compostela...* op. cit. p. 387.

20 One of the fundamental sources in the artistic genealogy of the Hispano-Languedocian style, of which the sculptures of the *Porta Francigena* are outstanding examples, is the sarcophagus with scenes from the *Oresteia* found in the Church of Santa María de Husillos, in Palencia, whose reliefs, imbued with the *pathos* of classical art, were copied and studied by successive generations of sculptors who worked on churches of the Way of Saint James such as San Martín de Frómista, the Cathedral at Jaca, San Isidoro de León, Saint-Sernin de Toulouse and the Cathedral at Compostela. Characters from the sarcophagus came back to life in these monuments, undertaking a kind of trans-historical *nostos* by means of which they were transformed into Biblical personages such as Cain, Abel, Abraham, Isaac and so many of the figures on the *Porta Francigena* the *Platerías* Door, whose bodies vibrate with the *pathos* of classical tragedy. It is significant that this *nostos* of forms had as its starting point a work of art whose underlying theme is the *nostos* of another Greek soldier, Agamemnon, who, like Ulysses, returned to his homeland after the Trojan War. After

Paradisus was presided over by the wonderful fountain built by the treasurer Bernardo, in the center of which "*se elevaba una columna de bronce [...] de cuyo remate surgen cuatro leones por cuyas bocas salen cuatro chorros de agua [...] dulce, nutritiva, sana, clara, caliente en invierno y fresca en verano.*"[18]

The multi-purpose nature of the image of the ship located on the base of the column that "springs forth" from the square whose central motif was water, evoking at one and the same time the moralizing odyssey of the Greek hero, the miraculous translation of the apostle and the journey made by the soul of a Christian on its way to salvation, is particularly representative of the role played by the images on the column in the context of the general programme of this door and its typological relationship to that of the South Door. Showing Ulysses as the mythical antecedent and moral model of the pilgrim who in his journey to the West entered the cathedral by this front, and of whom the Apostle himself, portrayed on the *Platerías* Door, constituted the Christian paradigm, this column exemplifies the typological function expressed by the other figurative iconographic cycles of the *Porta Francigena*, such as those devoted to the Book of Genesis, the months of the year and the groups of moral and ecclesiological allegories. Together they constituted a vision of the Creation of the world, the antecedents and promise of Redemption that would be portrayed on the *Platerías* Door through the cycles devoted to the Incarnation (of which, as we have seen, the story of Ulysses provided a typological antecedent), the Passion of Christ and the apostolic and evangelical work of the Church. The figure of Ulysses, as a forerunner of the pilgrim, joined that of Adam, the protagonist of the Genesis cycle, since as Moralejo had already pointed out, "*En su parte doctrinal, el* Liber Sancti Jacobi *menciona a Adán como el primero de los peregrinos – en el sentido original de 'expatriado' – y 'figura' por tanto de toda una humanidad peregrina en la tierra.*"[19]

When, on arriving in Santiago, pilgrims like Aymerico Picaud halted before the *Porta Francigena* to contemplate the decoration of its marble columns and the multitude of "*imágenes de santos, de bestias, de hombres, de ángeles, de mujeres, de flores y de otras criaturas, [...] los meses del año y otras muchas hermosas alegorías*" that enlivened its walls, they were undoubtedly looking at the culmination of Romanesque art of their day, a veritable *Timeo* in stone in which, through the medium of figures imbued with the *pathos* of the art of antiquity, the cosmogony of the Christian world and its mythical antecedents were depicted.[20]

Immersing our gaze in the protean current of entwined forms and bodies that in an unbroken succession of metamorphoses run upwards along the spiral carvings on the column, we cannot but murmur the famous words used to describe Stephen Dedalus' inner mediation as he walked along the beach in that other masterly reworking of the Odyssey done by James Joyce on the shores of the Atlantic Ocean exactly eight hundred years after the creation of the Romanesque work of art:

"Ineluctable modality of the visible: at least that if no more, thought through my eyes. Signatures of all things I am here to read, seaspawn and seawrack, the nearing tide, that rusty boot. Snotgreen, bluesilver, rust: colored signs. Limits of the diaphane. But he adds: in bodies. Then he was aware of them bodies before of them colored."

268

The ineluctable modality of the visible that imbues the artistic spirit of the column from Compostela also infuses the graphic forms of Castelao's design for the front cover of the magazine *Nós*, in whose August 1926 issue the characters of Joyce's novel would first see the light of day in the Iberian Peninsula, speaking in the Galician of Otero Pedrayo's translation.[21] Just as at the dawn of the twelfth century, when thanks to the skilful and artistically talented hands of the artists working on the construction of the cathedral Galicia became the Ithaca where the most beautiful of all transfigurations of Ulysses as Christ took shape, in the early twentieth century this land once again stood proud as being the first privileged stopping-point of the odyssey of the Irish Ulysses, thanks to the members of the *Xeración Nós*; it is to the imagination of one of its leading writers, Vicente Risco, that we owe the pilgrimage made by Stephen Dedalus from the beaches of Ireland to the streets of Compostela:

> "*O que vou referir aconteceu coma vo-lo conto n-unha mañá de seca-fría, quinta-feira, día da Ascensión do Noso Señor do ano de 1926 da Era Cristiáa, cento e vinte anos despois da invención do Corpo do Santo Apóstolo Sant'Iago Zebedeu, e sendo o autor d'iste escrito de corenta e un anos. Día nebracento e fresqueiro, con moito gando en Santa Susana e rapazas de trenza c'unha lazada no cabo andando pol-as rúas de tenda en tenda. Foi a segunda vegada qu'atopei a Stephen Dedalus.*"[22]

Such are the opening words of "*Dedalus en Compostela*," the extraordinary tale in which Risco imagines a walk through the streets of the city in the company of the main character of *Ulysses*, who confesses his desire to be "the last pilgrim to come to Santiago" for his "corpse to rest beside that of the Apostle." In a literary setting that evokes Dante's and Virgil's journey in the *Divina Commedia*, the Galician writer and the fictional character stroll the streets of Compostela in lively conversation about life and death, homeland and identity, God and Satan, hell and transcendence. Thus they reach the square in Acibechería, the former *Paradisus* where once, and totally unknown to them, there had once stood the column of water from which Ulysses bore witness of the happy outcome of his westward odyssey and his homecoming to a celestial Ithaca. They entered the cathedral through that door to visit the tomb of the Apostle, where the hero of the Irish *Ulysses* was to discover that, just as in the case of his mythical predecessor, his Galician *Nós-tos* would end not in hell, but in Eternity.

> "*Diante da y-arca de prata, as luces ardendo quedas e inmóbeles, que aluman sen que se sintan arder, semellan lámpadas perpétuas.*
> *Stephen enmudeceu á entrada, e púxose branco coma papel. Co-a voce tremente e baixa, dixo aigiña:*
> *–Non. Imos, imos d'eiquí. Pronto.*
> *Surtimos, e cando se repuxo dixo:*
> *–Non podo estar embaixo. Alí hai algo; d'alí sai unha forza que non podo aturar. Alí síntese a eternidade.*"[23]

arriving at Mycenae, the hero was murdered by his wife Clytemnestra and her lover Aegisthus, a crime that would unleash the cycle of vengeance and expiation wreaked by his son Orestes, the subject of the carvings on the sarcophagus from Husillos. See F. Prado-Vilar, "*Saevum facinus*: estilo, genealogía y sacrificio en el arte románico español," *Goya*, 324 (Madrid: 2008), pp. 173–99. Id., "*Lacrimae rerum*: San Isidoro de León y la memoria del padre," *Goya*, 328 (Madrid: 2009), pp. 195–221.

21 R. Otero Pedrayo, "Ulises (Anacos da soadisema novela de James Joyce, postos en galego do texto inglés, por Ramón Otero Pedrayo)," *Nós*, 32 (Santiago de Compostela: 1926), pp. 3–11.

22 V. Risco, "Dedalus en Compostela," *Nós*, 67 (Santiago de Compostela: 1929), p. 123 ["The events which I am about to relate happened exactly as follows, one cold, misty Thursday morning, Ascension Day 1926, one hundred and twenty years after the discovery of the Holy Apostle Saint James Zebedee. I was forty years of age at the time. It was a chilly, foggy morning. The market of Santa Susana was full of cattle, and girls with ribbons in their plaited pigtails walked down the streets, going from shop to shop. This was the second time that I had met Stephen Dedalus," trans. David M. Clark and M. Jesús Lorenzo Modia, *Galician Review*, 1 (Birminghan: 1997)].

23 Ibidem, pp. 127–8 ["In front of the silver chest the lights burned, silent and still, noiselessly giving off light as if they were everlasting lamps. Stephen went quiet when we got inside, and turned as white as a sheet of paper. With a low, trembling voice, he said: / –No. Let's go. Let's get out of here. Quick. / We went out, and when he had recovered, he said: / –I can't stand it down there. There's something there which gives off a power which I can't bear. You can feel Eternity in there."]

Rosa Vázquez

Gelmírez and the Cult of Saint James in Italy

1 M. Salvi, *Delle historie di Pistoia e fazioni d'Italia*, vol. 1:3 (Rome: Ignatio de' Lazari, 1656), pp. 36–7.

2 Hypotheses put forward by Lucia Gai and the principle researchers of the codices concerning Saint James preserved in the Archivio di Stato at Pistoia: L. Gai, *L'altare argenteo di San Iacopo nel duomo di Pistoia* (Turin: Allemandi, 1984), pp. 37–8. "Testimonianze jacobee e riferimenti compostellani nella storia di Pistoia dei secoli XII–XIII," in id. (ed.), *Pistoia e il Cammino di Santiago. Una dimensione europea nella Toscana medioevale* (Perugia: Centro Italiano di Studi Compostellani, 1987), no. 24, p. 131.

3 The existence of this place of worship was documented in 1131 "Testimonianze jacobee e riferimenti compostellani nella storia di Pistoia dei secoli XII–XIII"... op. cit., p. 135. Q. Santoli, "Libro Croce," *Regesta chartarum Italiae*, 27 (Rome: 1939), doc. 166, pp. 302–4.

4 "Testimonianze jacobee e riferimenti compostellani nella storia di Pistoia dei secoli XII–XIII"... op. cit., p. 137. L. Mascanzoni, *San Giacomo: Il guerriero e il pellegrino. Il culto iacobeo tra la Spagna e l'Esarcato (secc. XI–XV)* (Spoleto: Centro italiano di studi sull'alto medioevo, 2000), p. 90.

5 From the tenth century we have the names of the first foreign pilgrims, such as Godescalc, Bishop of Le Puy, Raymond II or Hugo de Vermandois. In the eleventh century the list of foreigners is a lengthy one, with numerous pilgrims coming from Catalonia, France and Flanders, as well as the first news of those from England: Ansgot de Burwell and his companions.

6 J. Pérez de Urbel, "El culto de Santiago en el siglo X," *Compostellanum*, 16 (Santiago de Compostela: 1971), p. 35.

7 Studies by Coturri and other authors date the foundation of the hospital to the middle years of the century: P. Caucci, "La asistencia hospitalaria en la *via francigena*. Órdenes y confreternidades," in S. Moralejo (ed.), *Santiago Camino de Europa. Culto y cultura de peregrinación a Compostela* (Santiago de Compostela: Xunta de Galicia, 1993), pp. 83–97. E. Coturri, "L'ospedale di San Jacopo di Altopascio in Toscana lungo la Via Francigena," in *Pistoia e il Cammino di Santiago.*

The eleventh century and the origins of the cult of Saint James in Italy. Altopascio, Pistoia and Rome

In the mid-seventeenth century Michelangelo Salvi indicated the year 849 as the date when the cult of Saint James first commenced in Pistoia. According to his account, the threat of Saracen invasions had led the inhabitants of Pistoia to build the *chiesetta* of San Jacopo in Castellare, with the aim of obtaining for their city the same protection that the Apostle had given King Ramiro (842–c. 850).[1] This item of news can be taken to be an invention of the period, since at that time the city was immersed in the process of beatification of Bishop Atto (1133–1153) and had strengthened its links with Compostela, or may even be connected with the legend that had been created in the twelfth century to provide hagiographic support for the new cult of Saint James, transmitted through the codices dedicated to his figure in Pistoia.[2]

The small Church of San Jacopo in Castellare was in fact founded at a much later date than that given by Salvi, although in any event prior to the arrival of the relic of Saint James in Pistoia, some time during the years 1140–1145.[3] Nevertheless, specialists such as Lucia Gai and Leardo Mascanzoni coincide in denying the existence of a cult "to Saint James" in Italy prior to the final years of Diego Gelmírez's archiepiscopate in Compostela (1100–1140), referring to the pre-existing devotion as belonging to a stage they call *apostólica*.[4] For our part we think it necessary to revise the cause-effect relationship between Gelmírez's promotion of pilgrimage and the implantation of the cult of Saint James in Italy, since although the Archbishop's labours were decisive in enabling the saint to attain a privileged position amongst Italian devotions between the twelfth and fifteenth century, there are many indications enabling us to believe that the "Compostelan" cult was already present in eleventh-century Italy.

We should first consider the evident internationalization that pilgrimages to Compostela had already achieved by the eleventh century. Well known are the lists of illustrious pilgrims arriving from various corners of Europe from the tenth century onwards,[5] as is the Arabic verse panegyric that in or around 997 extolled the triumph of Almanzor over a city in which "*son innumerables las turbas de peregrinos que acuden de todas partes.*"[6]

As far as Italy is concerned, the clearest proof of the pilgrimage to Compostela's fame before the times of Archbishop Gelmírez is given by San Jacopo d'Altopascio,

founded in the mid-eleventh century.[7] Altopascio was a major hospital for pilgrims on the *via francigena*, the main pilgrim route to Rome, and therefore its choice of Saint James as patron saint should be interpreted as an unequivocal indication of the relationship between the devotion to the saint and the act of pilgrimage. This relationship becomes even clearer if we take into account the fact that the apostle originally shared the dedication of the hospital with two other saints linked with pilgrimage and the protection of pilgrims: Saint Giles and Saint Christopher.[8]

We also know that manuscripts containing the legend of Saint James were circulating in Italy before the *Codex Calixtinus* was compiled, amongst these the copy used by Bishop Atto of Pistoia himself, which contained the texts of the "*Passio*" and the "*Liber miracolorum.*"[9] The "*Liber miracolorum*" in fact includes four miracles whose beneficiaries were Italian,[10] all dated prior to 1110, which once again provides proof of the importance of the pilgrimage to Compostela before Gelmírez introduced his policy of its promotion.[11]

In the city of Rome itself, the cult of Saint James the Greater developed during the eleventh century. The first news we have of it strongly links the introduction of this devotion to the Basilica of Saint Peter. Eleventh-century calendars and lists of saints' feast days introduced the feast day of the apostle and its corresponding vigil in the offices of the basilica in the Vatican, although they enjoyed a much lesser presence in those of the Lateran basilica.[12] Furthermore, a census of Saint Peter's Basilica dated in the mid-eleventh century contains the earliest references to churches dedicated to Saint James: San Giacomo alla Lungara and San Giacomo Scossacavalli, both belonging to the Vatican basilica.[13]

It is clear that the introduction of the cult of Saint James in the papal see was that of an "apostolic" cult, but it is hard to refuse to believe that the coincidence of the saint's feast day with that of Saint Christopher, patron saint of travelers and pilgrims, must have been a decisive factor. The feasts of the two saints were held on the same day from the eleventh century onwards in the Basilica of Saint Peter, and from the twelfth century onwards in that of San Giovanni in Laterano,[14] a fact that must have influenced and reinforced the nature of the son of Zebedee as a patron saint of pilgrims.

It would therefore appear to be evident that in the final decades of the eleventh century there was already a "Compostelan" devotion in Italy, at least along pilgrim routes and at places where pilgrims stayed.

Una dimensione europea nella Toscana medioevale... op. cit., pp. 331–42. Id., "Le origine dello spedale di Altopascio e il suo probabile fondatore," in A. Cenci (ed.), *L'ospitalità in Altopascio* (Altopascio: Cassa di Risparmio di Lucca, 1996), pp. 16–21. M. Sensi, "Pellegrinaggi votivi e vicari alla fine del Medioevo. L'esempio umbro," in *Santuari, Pellegrini, Eremiti nell'Italia Centrale*, vol. 1:3 (Spoleto: Centro italiano di studi sull'alto medioevo, 2003), p. 70. For his part Andreucci has dated the construction of the hospital to some time during the period 1070–80: S. Andreucci, "San Giacomo di Altopascio (Lucca)," in *Dizionario degli istituti di perfezione*, vol. 8:10 (Rome: Edizioni Paoline, 1974), coll. 462–5.

8 "La asistencia hospitalaria en la *Via Francigena*. Órdenes y confraternidades"... op. cit., p. 84. *San Giacomo: Il guerriero e il pellegrino. Il culto iacobeo tra la Spagna e l'Esarcato (secc. XI–XV)...* op. cit., p. 92.

9 M. C. Díaz y Díaz, *El Códice Calixtino de la Catedral de Santiago. Estudio codicológico y de contenido*, 36 (Santiago de Compostela: Monografías Compostellanum, 1988), p. 41. *Pistoia e il Cammino di Santiago. Una dimensione europea nella Toscana medioevale...* op. cit., no. 84, pp. 146–7.

10 Italians are the beneficiaries of miracles 2, 11, 12 and 15: K. Herbers, "The Miracles of Saint James," in A. Stones and J. Williams (eds.), *The Codex Calixtinus and the Shrine of Saint James* (Tübingen: G. Narr, 1992), app. 2, p. 34.

11 "De los 22 milagros que contiene, 21 pueden situarse, por datos cronológicos expresos o por criterios internos, en torno a los años 1080–1110, algunos incluso antes": in *El Códice Calixtino de la Catedral de Santiago. Estudio codicológico y de contenido...* op. cit., p. 53. Klaus Herbers dates miracle 2 to the eighth or ninth century: "The Miracles of Saint James"... op. cit., app. 2, p. 34.

12 In his study of the basilicas of Saint John Lateran and Saint Peter, Pierre Jounel notes the presence of the feast of Saint James in two eleventh century saints' day calendars from Saint Peter's: the *Evangeliaire-Sacramentaire du Vatican* and the *Lectionnaire-Collectaire de Saint-Anastase*. P. Jounel, *Le culte des saints dans les basiliques du Letran et du*

Vatican au douzième siècle (Rome: École Française de Rome, 1977), p. 139. According to the author the celebration of the feast day of the apostle was introduced in Rome during the tenth century: "*Au XIᵉ siècle le sacramentaire de Saint-Pierre reproduit le formulaire des Gélasiens du VIIIᵉ siècle,*" p. 261.

13 F. Erhle, *Ricerche su alcune antiche chiese del Borgo di San Pietro* (Rome: Tipografia Vaticana, 1907), p. 40. C. Hülsen, *Le chiese di Roma nel Medio Evo: cataloghi ed appunti* (Firenze: Olschki, 1927), pp. 267–8.

14 *Le culte des saints dans les basiliques du Letran et du Vatican au douzième siècle...* op. cit., pp. 139, 150, 193–9.

15 *Documenti vari* 1, from the mid-thirteenth century; *Documenti vari* 27, from the late fifteenth century; and document C. 59, from the early seventeenth century. L. Gai, R. Manno Tolu and G. Savino (eds.), *L'Apostolo San Jacopo in documenti dell'Archivio di Stato di Pistoia* (Pistoia: Archivio di Stato di Pistoia, 1984). L. Gai, "Testimonianze jacobee e riferimenti compostellani nella storia di Pistoia dei secoli XII–XIII"... op. cit., pp. 153–9.

16 *L'altare argenteo di San Iacopo nel duomo di Pistoia...* op. cit., p. 34. "Testimonianze jacobee e riferimenti compostellani nella storia di Pistoia dei secoli XII–XIII"... op. cit., pp. 151–3.

17 *El Códice Calixtino de la Catedral de Santiago. Estudio codicológico y de contenido...* op. cit., pp. 137–8. *L'altare argenteo di San Iacopo nel duomo di Pistoia...* op. cit., pp. 137–8. "Testimonianze jacobee e riferimenti compostellani nella storia di Pistoia dei secoli XII–XIII"... op. cit., pp. 152–8

18 *L'altare argenteo di San Iacopo nel duomo di Pistoia...* op. cit., p. 35. "Testimonianze jacobee e riferimenti compostellani nella storia di Pistoia dei secoli XII–XIII"... op. cit., p. 143.

19 Principally beginning with Honorius II (1126) and then steadily continuing throughout the whole century with Anastasius IV (1154), Alexander III (1169) and Innocence III (1198): *San Giacomo: Il guerriero e il pellegrino. Il culto iacobeo tra la Spagna e l'Esarcato (secc. XI–XV)...* op. cit., p. 95. A. Spicciani, "Il patrimonio fondiario dell'ospedale di Altopascio tra l'XI e la fine del XII secolo," in *L'ospitalità in Altopascio...* op. cit., pp. 22–31.

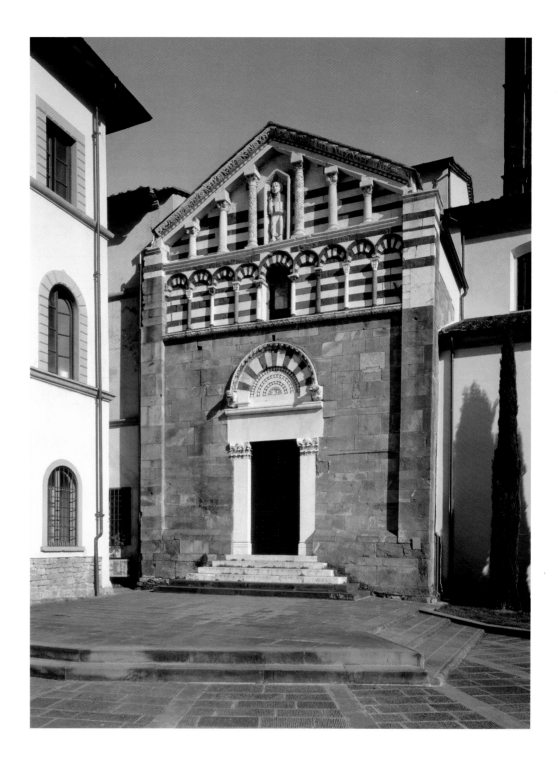

Donation of the relic of Saint James to Pistoia and his cult in Tuscany in the twelfth century

The importance of the Altopascio hospital and the city of Rome in the dissemination of the cult of Saint James has been overshadowed by the privileged role granted to Pistoia. This Tuscan city is considered, even today, as the main center of the cult of Compostela in Italy on the basis of the relic of Saint James the Apostle, supposedly donated by Gelmírez, which it treasures in the Cathedral of San Zeno.

The donation of the relic is based on the texts preserved in the *Achivio di Stato* at Pistoia, fundamentally in three codices, from different periods, containing fragments

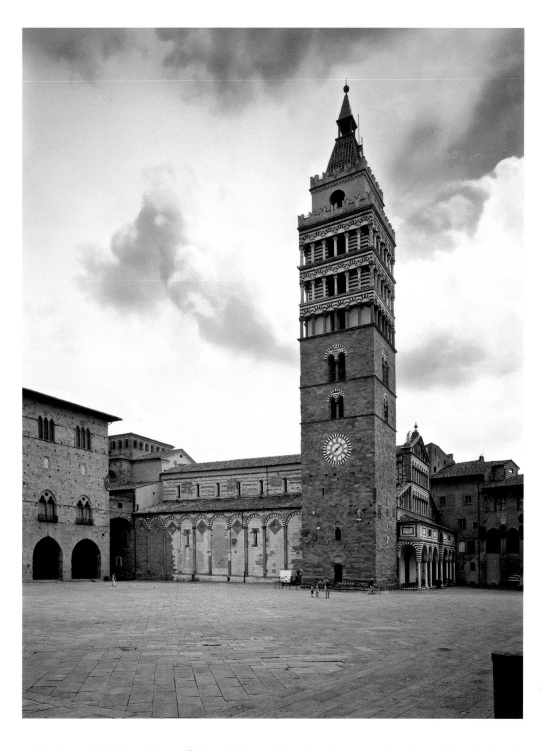

Cathedral of San Zeno
twelfth-thirteenth century
Pistoia

20 O. Brattö, *Studi di antroponimia
 fiorentina. Il Libro di Montaperti (1260)*
 (Göteborg: Elanders, 1953), pp. 141–2.
21 Ibidem, p. 142.
22 Ibidem.
23 *Liber Extimationum (II Libro degli
 Estimi, 1269)*, ed. O. Brattö (Göteborg:
 Elanders, 1956), pp. 119–20.
24 "Il braccio di San Iacopo maggiore,"
 in P. Ugonio, *Historia delle Stationi di
 Roma* (Rome: Bartolomeo Bonfadino,
 1588), p. 282. "*vi sono molte reliquie,
 come parte d'un braccio di San Giacomo
 Maggiore,*" in P. M. Felini, *Trattato
 nuovo delle cose maravigliose dell'alma
 Città di Roma, 1610* (Berlin: Verlag
 Bruno Hessling, 1969), p. 46.
25 G. Mancini, *Considerazioni sulla pittura.*
 Ed. A. Marucchi (Rome: Accademia
 nazionale dei Lincei, 1956).
26 M. Mesnard, *La Basilique de Saint-
 Chrisogone à Rome* (Rome: Pontificio
 Istituto di Archeologia Cristiana, 1935),
 p. 141.
27 C. Piccolini, *S. Crisogono in Roma.
 Chiesa primitiva sotterranea e basilica
 medioevale* (Rome: Tipografia delle
 Mantellate, 1953), p. 107.
28 M. Castiñeiras, "Calixto II, Giovanni da
 Crema y Gelmírez," in *Compostellanum*,
 47 (Santiago de Compostela: 2002),
 pp. 403–4. Id., "Roma e il programa
 riformatore di Gelmírez nella
 cattedrale di Santiago di Compostella,"
 in A. Quintavalle (ed.), *Medioevo:
 immagini e ideologie* (Milan: Mondadori
 Electa, 2005), pp. 220–3.
29 Serena Romano uses the chronological
 references in Mancini's text to date the
 missing frescoes to between 1128 and
 1129: S. Romano, *Riforma e tradizione,
 1050–1198* (Turnhout: Brepols, 2006),
 p. 181, n. 50.
30 "*Queste furon fatte al tempo d'Onorio II
 nel 1128, come si vede dalla seguente
 scrittura: In nomine Domini Amen,
 Anno Incarnationis Dominicae 1128 /
 Indictione VII Anno Honorij PP. II
 Johannes Crema [...] Perché è ben vero
 che sotto Callisto II del 23 fu fatta la
 chiesa, ma l'ampliatione, gl'ornati et
 i doni furono fatti sotto Honorio II,*"
 in *Considerazioni sulla pittura...* op. cit.,
 pp. 62–3.

of the legend of Saint James.[15] The oldest codex, dated in 1244, has been identified with one of the "*duos libros de legenda sancti Iacobi*" referred to in an inventory of the *Opera di San Iacopo* as far back as 1261.[16] The manuscript is badly mutilated but its content has been identified as the "*Passio maior*" from Compostela and the extraordinary narration of the donation by Archbishop Gelmírez of a relic of Saint James the Apostle to Bishop Atto. The story has been attributed to a certain "*clericus Cantarinus, pisanae urbis cancellarius,*" and consists of a presentation and several letters supposedly exchanged between Atto and Gelmírez in connection with the donation.[17]

Ever since Fletcher's documentary research proved beyond doubt that Diego Gelmírez did in fact die in 1140, the hypothesis that the *carteggio compostelano* was

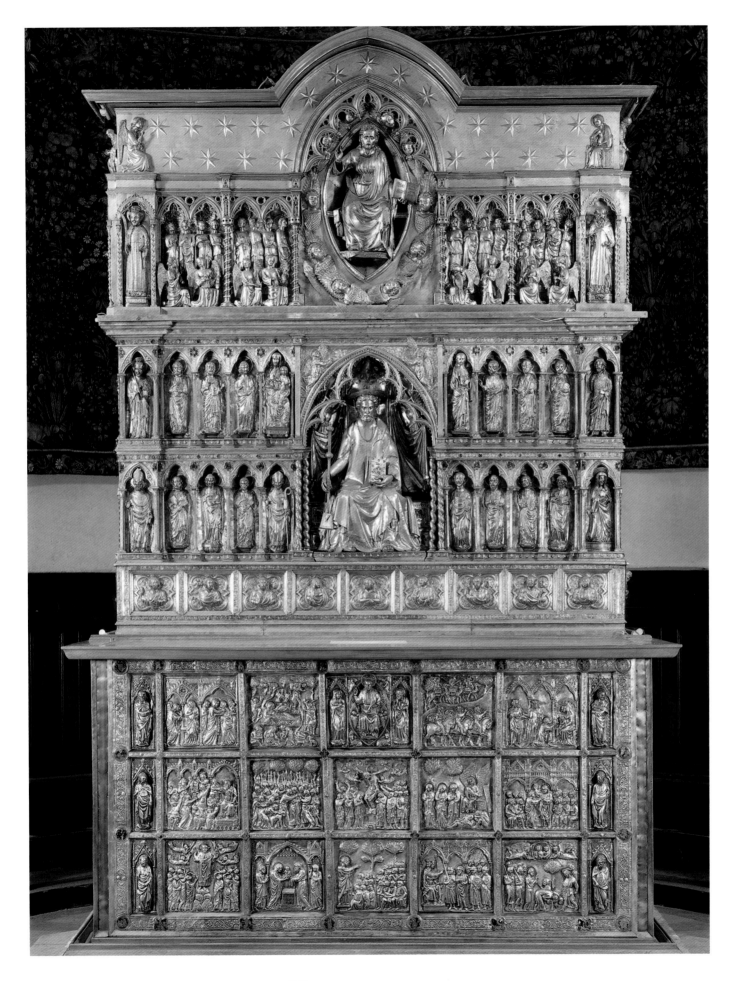

274

apocryphal, or at least a skilful forgery, has gradually gathered weight. The reason for this is that the donation of the relic of Saint James would have had to have occurred at the beginning of 1140, but there is no record of its presence in the city until the consecration of the San Iacopo altar, almost five years later. Whatever the reality, the historical facts enable both hypothesis, namely the donation by Gelmírez or the 'invention' of the relic, to be upheld. Either of the two scenarios would have been equally useful to Bishop Atto in his attempt to resolve the profound crisis that since 1138 had brought his episcopacy into conflict with the city authorities – *comune* – a conflict that was finally resolved in or around 1145 thanks to the prestige, donations and offerings that the relic and its new chapel assured the city.[18]

Donation or invention, the legend was complemented by enormous festivities to celebrate the consecration of the altar and a complete machinery of hagiography, set in motion by Bishop Atto and worthy of Gelmírez himself, that would result in a collection of miracles wrought by the relic during its journey from Compostela, reproduced in the above-mentioned *Cantarinus*. Nevertheless, we still believe that the importance of the "effect" of the relic at Pistoia should be reduced , or at the very least that the reason for the expansion of the cult of Saint James should be shared with the hospital of San Jacopo di Altopascio and the *via francigena*. In this regard it is important not to forget that the arrival of the relic from Compostela occurred at the same time as the tremendous expansion of the hospital, an expansion that can readily be confirmed from the abundant number of papal documents relating to concessions and confirmations of its assets in the twelfth century.[19]

A source from outside the world of studies dedicated to Saint James that may help throw some light on the cult of the saint in Tuscany are the works of anthroponomy, a branch of onomastics, undertaken by Olof Brattö, a useful mirror that reflects the geographical and chronological development of twelfth century devotions. According to this author, there is a clear division in Tuscan documents between the dates in which the name of James first appears and the time when it becomes a common occurrence, the latter corresponding to the first half or middle decades of the twelfth century, namely the period during which Gelmírez was Archbishop in Compostela and the cult of the city's patron saint experienced a massive expansion throughout Europe. In Florence the name "Jacobus" appears for the first time, used by a notary, in the year 893; in 1031 we find it in a Bishop of Fiesole; and it begins to become very popular from the middle decades of the twelfth century onwards. Similarly, in Lucca we find the first mention in 786, but only in 1131 does it begin to appear with any frequency.[20] As far as Pistoia is concerned, the author cites only a single isolated example in 1118, with a certain popularity of the name only being confirmed in the *Liber Censuum* of 1179.[21] On the other hand, in Florence there are indications of the cult of Saint James as early as 1131, in the *Libro Croce*.[22]

Personal names thus also blur the image of Pistoia as a unique focal point, confirming the decentralization of the phenomenon of Saint James and the enormous importance attained by the cult of the saint in the second half of the twelfth century. The expansion of the devotion to Saint James was so great that in the thirteenth

Altar [Chapel of Saint James]
1287–1486
Cathedral of San Zeno, Pistoia

31 "*Né voglio lasciar quelle che erano in S. Crisogono nella parete verso il monasterio, dove era depenta la traslation del braccio di S. Jacomo, dove era la navigation con la quale fu trasportato detto braccio, con molti prelati con habiti di quei tempi che, ancorché fussero goffamente fatte, nondimeno davan cognitione degl'habiti dei sacerdoti che usavano in quei tempi dai quali pendon, a mio giuditio, alcuni atti nel celebrare, come quello d'alzar la pianeta al sacerdote nell'elevation del Ss.mo Sacramento, perché la pianeta era serrata in modo verso le braccia che non si potevan elevar per tal atto, se non s'alzava nel modo che si usa,*" ibid., p. 62.

32 "*E quando s'arricchisce qualche chiesa di qualche tesoro notabile di reliquie, sogliono esser depinte queste historie nella chiesa o luogo vicino dove sono ricevute, come nel Duomo di Siena si vede la reception del braccio di S. Gio. Battista fatta al tempo di Pio II, et la translatione del corpo di S. Gregorio Nazianzeno dato a S. Pietro da Gregorio XIII, che la fece dipingere nelle Logge. Così questo pio cardinale, donando questo tesoro, e, come venisse a Roma, lo fece dipinger in questa chiesa,*" ibid., p. 63.

33 A. Acconci, "Un perduto affresco a San Lorenzo fuori le Mura," in J. E. Julliard and S. Romano (eds.), *Roma e la Riforma gregoriana, tradizioni e innovazioni artistiche, XI–XII secolo* (Rome: Viella, 2007), pp. 98–101, 110–1, figs. 12, 13.

34 "*In que' medesimi tempi [di Giovanni da Crema] visse un tal Giovanni che dipinse in S. Crisogono la navigatione di un braccio di S. Giacomo Apostolo. Visse sotto Callisto II° intorno agli anni del Signore 1119; fu huomo goffo e di poc'harte, et adesso questa pittura nell'abbellimento di detta Chiesa per cristiana liberalità dell'Ill.mo Borghese è andata a male, che dalla memoria di questa navigatione et antichità in fuore non era degna di memoria,*" in *Considerazioni sulla pittura… op. cit.*, p. 166.

35 K. G. Saur, *Allgemeines Lexikon der bildenden Künstler*, vol. 4 (Munich & Leipzig: 2000), p. 189. A. Bolaffi and U. Allemandi (eds.), *Dizionario enciclopedico Bolaffi dei pittori e degli incisori italiani*, 6 (Turin: 1972–1976), p. 16. E. T. Prehn, "Le opere di Giovanni, Stefano e Niccolò, pittori dell'undicesimo secolo," *Rivista dell'Istituto Nazionale d'Archeologia e Storia dell'Arte*, 8 (1969), pp. 19–25.

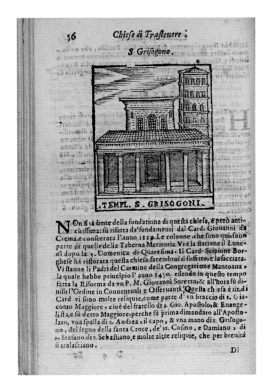

Basilica of San Crisogono [Roma antica e moderna. Rome: Domenico Franzini, Giacomo Fei, 1660. Dg 450 - 2600 Coll. Rom., p. 56]
Giovanni Domenico Franzini
1660
Bibliotheca Hertziana, Rome

36 "*La basilica di San Crisogono fu officiata dai Benedettini fino al secolo* XII, *epoca in cuifurono sustituiti dal clero secolare per volontà di Innocenzo III (1198–1216)*": R. Luciani and S. Settecasi, *San Crisogono* (Rome: Fratelli Palombi, 1996), p. 37. Cf. M. Mesnard, *La Basilique de Saint-Chrisogone à Rome...* op. cit., p. 116. *San Crisogono in Roma. Chiesa primitiva sotterranea e basilica medioevale...* op. cit., p. 49.

37 Fundamentally beginning with the work of G. Matthiae, "Gli affreschi di Castel Sant'Elia," *Rivista dell'Istituto Nazionale d'Archeologia e Storia dell'Arte*, 10 (Rome: 1961), pp. 181–226. Amongst recent publications having a bearing on the relationship of the frescoes with San Clemente we can single out P. Carmassi, "Die hochmittelalterlichen Fresken der Unterkirche von San Clemente in Rom als programmatische Selbstdarstellung des Reformpapsttums. Neue Einsichten zur Bestimmung des Entstehungskontexts," *Quellen und Forschungen aus italienischen Archiven und Bibliotheken*, 81 (Tübingen: 2001), pp. 1–66.

century *Jacubus* was the most common name in Tuscany, overtaking that of John, which had enjoyed that privilege during the preceding centuries. This fact is exemplified in the *Liber Extimationum* of 1269, a document that narrates an episode in the struggle between Guelfi and Ghibellini, in which "Iacobus" is by far the most frequent name amongst the 1550 persons mentioned, including people of different social classes: clerics and laymen, cobblers and nobles alike.[23]

Rome and the cult of Saint James in the time of Diego Gelmírez: the relic of Saint James the Greater in the Basilica of Saint Chrysogonus

Roman art history provides us with the necessary clues to attribute a decisive event for the cult of Saint James in Italy to Diego Gelmírez: the donation of a relic of the saint that was for centuries kept in the Basilica of Saint Chrysogonus.

The existence of a relic of James the Apostle in the Basilica of Saint Chrysogonus is no novelty. From the sixteenth century onwards it is mentioned in *mirabilia* and religious guides to the city, which often specify that it was an arm or part of one.[24] The most interesting source is undoubtedly the Roman guidebook written by Francesco Mancini in the seventeenth century,[25] whose comments on Saint Chrysogonus and the relic have been partially reproduced by the historians Maurice Mesnard[26] and Celestino Piccolini,[27] as well as by the art historians Manuel Castiñeiras[28] and Serena Romano.[29]

Mancini wrote his work in 1623, dedicating it to the powerful cardinal Scipione Borghese, patron of the restoration of the Church of Saint Chrysogonus. The text describes a no longer extant iconographic cycle dealing with the receipt of the relic, which he dates to 1128,[30] permitting the event to be related to the period when Gelmírez was Archbishop and instituted his policy of relations with the papacy. The author also managed to decipher the content of the frescoes, by then badly damaged but still visible, as portraying the "traslation" of the arm from distant lands and the procession of the clergy to receive it in the Basilica of Saint Chrysogonus.[31]

Mancini's work also offers a reflection on the tradition of giving a solemn reception to new relics, citing other examples of paintings that depict ceremonies similar to the one portrayed in Saint Chrysogonus.[32] Although the examples he mentions come from much later periods, we know of the existence in the Rome of those days of other similar paintings, such as those in the Church of San Lorenzo fuori le Mura, a series done towards the end of the eleventh century and now also no longer extant, although various watercolours have come down to us that reproduce its iconographic program: the arrival of the relics of Saint Stephen at the basilica, otherwise known as the *Traslatio Sancti Stephani.*[33]

Mancini devoted one chapter of his guide to the painters who had worked in the city of Rome, amongst whom he mentions the author of the frescoes of Saint Chrysogonus, a certain Giovanni, who was active during the times of Pope Calixtus II (1119–1124); he also tells of the destruction of the frescoes during the restoration financed by Scipione Borghese (1576–1633).[34] This reference to the artist is of enormous interest, since it could well refer to the same Giovanni who together with

Stefano and Nicolò painted the famous frescoes at Castel Sant'Elia.[35] The attribution seems appropriate since both churches were at the time connected with the Benedictine Order.[36] Furthermore, if we accept this hypothesis the exact chronology of the Saint Chrysogonus cycle could help to solve the problem of the dating of the frescoes at Castel Sant'Elia. These latter paintings have traditionally been dated to the late eleventh century on the basis of stylistic similarities with the frescoes of the Basilica of San Clemente in Rome,[37] although new findings resulting from a study of the church's architecture have led art critics to defend a later date, namely during the first quarter of the twelfth century,[38] or even after the reconstruction of the Church of Saint Chrysogonus in 1127.[39]

If Mancini's text has gone almost unnoticed by the majority of critics, the provenance of the relic has attracted even less attention. The problem has only been dealt with in any detail by Mesnard and Piccolini, who, taking as their starting point Ulysse Robert's biography of Calixtus II,[40] state that the relic would have been a gift from Gelmírez to Calixtus II in gratitude for the concession of the status of metropolitan see, the Pope then giving it to his favorite Giovanni da Crema (1116–1137).[41] In our opinion this hypothesis is perfectly plausible and consistent with the history of its three main players: Gelmírez, Calixtus II and Giovanni da Crema.

The relationship between Gelmírez and Rome had continued, according to Fletcher, the policy of relationships with the papacy begun by Bishop Dalmatius (1094–1095): "Protection, then, in the sense of special, privileged arrangements, was what the churchmen of Compostela sought from the popes in the first instance."[42] As is well known, amongst all possible privileges the one that Gelmírez most desired was that of metropolitan rank for the see of Compostela. To this end he twice visited the papal see and repeatedly sent envoys bearing not only messages but also gold and anything else he deemed necessary to achieve his ends. From his meeting with Abbot Hugh of Cluny (1049–1109) in 1104 he had learnt the importance of working on the cardinals at the papal court, immediately initiating a lengthy series of contacts with Deusdedit and Boso.[43] In this regard, the *Historia Compostellana* reveals to us the long list of coins, reliquaries and crosses carried by Gelmírez's envoys to the popes Gelasius II (1118–1119) and Calixtus II between 1118 and 1120,[44] which led Fletcher to conclude: "Thus, by a prodigious expenditure of effort and treasure, Diego became an Archbishop."[45]

To the list of cardinals and prelates cited so far in this study we must add the name of Giovanni da Crema, who proved to be of particular importance in the years immediately following the gaining of metropolitan rank in 1120. The incumbent Cardinal of Saint Chrysogonus was the most faithful ally of Paschal II (1099–1118) and Gelasius II in the crisis of the "investitures" and, together with Calixtus II, the person mainly responsible for the fall of Maurice of Braga (1109–1118), whom he finally defeated at Sutri in 1121, and for the subsequent peace of Worms.[46] After the victory at Sutri Giovanni da Crema devoted himself to restoring the basilica of which he was the incumbent, it finally being consecrated 1127, receiving the relic from Compostela shortly afterwards.[47]

38 P. Hoegger, *Die Fresken in der ehemaligen Abteikirche S. Elia bei Nepi: ein Beitrag zur romanischen Wandmalerei Roms und seiner Umgebung* (Stuttgart: Huber, 1975), pp. 152–4. D. Kottmann, "Le cycle apocalyptique de Castel Sant'Elia," in S. Romano and J. Enckell Julliard (coord.), *Roma e la riforma gregoriana: tradizioni e innovazioni artistiche (XI–XII secolo)*... op. cit., pp. 411–31.

39 Poeschke and Kottmann have linked the architecture of the restored basilica to that of Castel Sant'Elia: "Le cycle apocalyptique de Castel Sant'Elia"... op. cit., p. 416. J. Poeschke, "Der römische Kirchenbau des 12. Jahrhunderts und das Datum der Fresken von Castel S. Elia," *Römisches Jahrbuch für Kunstgeschichte*, 23–24 (Vienna: 1988), p. 25.

40 U. Robert, *Histoire du Pape Calixte II* (Paris: Picard, 1891).

41 "*Callixte II faisant alors élever l'église de Saint Jacques de Compostelle au rang de primatiale. Dans une lettre du 27 avril 1120, il exhortait l'archevêque à se montrer reconnaissant envers l'Église romaine pour tous ces bienfaits. Diego répondit en envoyant au Pape un bras de l'apôtre Saint Jacques. On sait la gratitude de Calixte II envers Jean de Créma, pour avoir fait prisonnier l'antipape Burdin. C'est à lui qu'il donna la relique de Saint Jacques, qui fut placée dans la nouvelle basilique de Saint Chrysogone*": *La Basilique de Saint-Chrisogone à Rome*... op. cit., p. 141. Piccolini simply repeats the same hypothesis: *S. Crisogono in Roma. Chiesa primitiva sotterranea e basilica medioevale*... op. cit., p. 107.

42 R. A. Fletcher, *Saint James's Catapult. The Life and Times of Diego Gelmírez of Santiago de Compostela* (Oxford: Clarendon Press, 1984), p. 195.

43 Ibidem, pp. 200–1.

44 The information is included in Book II, which deals with how the church at Compostela was made metropolitan: *Historia Compostelana*, trans. E. Falque Rey (Madrid: Akal, 1994), pp. 293–490. Amongst all the gifts, of particular interest for our discourse is the reference to a gold reliquary that Gerald took with him in 1119, together with a large amount of money, on his eventful journey to France as a legate before the newly appointed Pope Calixtus II: ibid., pp. 315–8; as well as the numerous gems taken by the "*dos pedros*" immediately after the see was granted the rank of a metropolitanate: ibid., pp. 330–2.

45 *Saint James's Catapult. The Life and Times of Diego Gelmírez of Santiago de Compostela*... op. cit., p. 206.

46 L. Cardella, *Memorie Storiche de' Cardinali della Santa Romana Chiesa* (Rome: Stamperia Pagliarini, 1792), pp. 229–31. *La Basilique de Saint-Chrisogone à Rome*... op. cit., pp. 125–6. G. Moroni Romano, *Dizionario di erudizione storico-ecclesiastica. Da S. Pietro sino ai nostri giorni*, vols. 38–92 (Venice: Tipografia Emiliana, 1843), pp. 176–7. *Histoire du Pape Calixte II*... op. cit., p. 119.

47 *La Basilique de Saint-Chrisogone à Rome*... op. cit., p. 130.

The importance of Giovanni da Crema for the papacy of Calixtus II is made very clear by Robert, who states that "*La prise de Sutri fut un des évéments les plus considérables du pontificatde Calixte II*," concluding with Duchesne that "*le basilique de Saint-Chrysogone restaurée par le cardinal Jean de Creme, peut être considérée comme un monument de cette victoire.*"[48] Would it not therefore be logical for Calixtus II to donate the relic to the cardinal and the church that were to celebrate the most important triumph of his papacy?

We know that the Pope rewarded his favorite with the issuing of a bull on 17 April 1122, the anniversary of the victory at Sutri, confirming the basilica's title, privileges and possessions. A relic, however, was in those days the greatest reward that could be given to a churchman, since it was a means of enhancing the status of his church and re-launching or promoting his own career. As we have seen in the case of Pistoia, the arrival of a new relic implied the consecration of a chapel or altar

48 *Histoire du Pape Calixte II... op. cit.*,
 p. 121.

278

to the saint in question, enabling donations and offerings to be renewed and increased.[49] Another example from the same period is the arrival in 1141 of the body of Saint Petronius at the Monastery of Saint Stephen in Bologna, which gave rise to the construction of a new altar and the creation of an annual procession that assured greater offerings to the church, and thus enormous popularity for its patron, Bishop Enrico.[50]

With regard to its chronology, the donation of the relic must be established as having taken place during the papacy of Calixtus II, whilst that of its arrival at Saint Chrysogonus would have been prior to the painting of the frescoes in 1128.[51] The fact that several years must have passed between the time of the donation and the presentation of the relic in the basilica does not in itself constitute a problem, since the delay would be justified by the work being done on the church, the latter not in fact being consecrated until 1127.[52]

The most immediate consequence of the arrival of the relic was the beginning of the cult of Saint James in the basilica. This cult must have reached sizeable proportions and been maintained over several centuries, leaving important iconographic traces such as the famous mosaic with the *Vergin and Child between Saint James and Saint Chrysogonus*,[53] attributed to Pietro Cavallini (c. 1250–c. 1330),[54] a mosaic that has lately been related to the Stefaneschis, the most powerful family in the Trastevere of those days. One of its members was Bertoldo di Pietro Stefaneschi, Cavallini's patron in the nearby Basilica of Sancta Maria, another being his famous brother Cardinal Jacopo Stefaneschi (1295–1343), considered by some authors to have been the driving force behind the cycle at Sancta Maria,[55] and according to Giovanna Ragionieri possibly the patron of the mosaic at Saint Chrysogonus.[56]

To conclude, we would briefly like to assess the consequences that Gelmírez's promotional policy and the cult of the new relic from Compostela brought with them with regard to the city of Rome. First, we must remember that the city of the popes based all its grandeur on the cult of its own relics of apostles, martyrs and saints, and it would therefore be no easy matter for the cult of Saint James to develop to such a spectacular extent as it did in Tuscany. Nevertheless, it is clear that from the time when Gelmírez became an Archbishop the devotion to Saint James took root in the city, growing steadily throughout the second half of the twelfth century and the whole of the thirteenth. Furthermore, the cult took on a nature that was manifestly "*jacobeo*" or "*compostelano*," based on the consideration of Saint James as the patron saint of pilgrims and pilgrim routes, as can be seen in the churches that were dedicated to him: churches whose purpose was clearly to provide care and assistance, linked to hospitals or brotherhoods that devoted themselves to taking in and looking after pilgrims.[57]

49 Cf. note 18.
50 M. Ronzani, "La 'Chiesa del Comune' nelle città dell'Italia centro-settentrionale (secoli XII–XIV)," *Società e storia*, 21 (Milan: 1983), p. 499.
51 Cf. note 30.
52 "*La consécration eut lieu solennellement le 7 août 1127, comme en fait foi une autre inscription, actuellement conservée dans le choeur. Elle fut célébrée par le même Pierre, cardinal de Porto, qui avait consacré l'oratoire. L'inscription donne la liste des reliques placées sous l'autel,*" in *La Basilique de Saint-Chrisogone à Rome...* op. cit., p. 130.
53 Currently in the presbytery of the church. Mesnard considers that it was originally part of a Gothic tomb: ibid., pp. 162–3.
54 We owe the first attribution of the mosaic to Cavallini to Vasari: G. Vasari, *Le vite de' più eccellenti pittori scultori e architettori nelle redazioni del 1550 e 1568*, eds. R. Bettarini and P. Barocchi (Florence: 1967), II, p. 186. Modern criticism upholds this attribution: P. Hetherington, *Pietro Cavallini. A Study in the Art of Late medieval Rome* (London: The Sagitarius Press, 1979), p. 160. G. Matthiae, *Pietro Cavallini* (Rome: De Luca, 1972), p. 128. A. Parronchi, *Cavallini "discepolo di Giotto"* (Florence: Edizioni Polistampa, 1994), pp. 18–9.
55 P. Hetherington, "The mosaics of Pietro Cavallini in Sancta Maria in Trastevere," *The Journal of the Warburg and Courtauld Institutes*, 33 (London: 1970), p. 84. V. Tiberia, *I mosaici del XII secolo e di Pietro Cavallini in Santa Maria in Trastevere. Restauri e nuove ipotesi* (Todi: Ediart, 1996), pp. 123, 130.
56 G. Ragionieri, "Cronologia e committenza: Pietro Cavallini e gli Stefaneschi di Trastevere," *Annali della Scuola Normale Superiore di Pisa*, vol. 11, 2 (Pisa: 1981), pp. 463–4.
57 I refer the reader to my article "Primeras conclusiones sobre el culto y la iconografía de Santiago el Mayor en la ciudad de Roma", *Archivo Español de Arte* (Madrid: 2010). See also R. Vázquez, "Saint James in Rome: the vanished churches," *La Corónica*, vol. 36, 2 (Madrid: 2008), pp. 75–98.

Jean-Marc Hofman
Annaig Chatain

Diego Gelmírez's Journey through the Collections of the musée des Monuments français, Paris

1 Concerning the work of Diego Gelmírez and the historical context, cf. R. A. Fletcher, *Saint James's Catapult. The Life and Times of Diego Gelmírez of Santiago de Compostela* (Oxford: Clarendon Press, 1984).

2 A band of white wool with six black crosses. The Pallium is one of the insignias denoting the rank of archbishops and patriarchs.

3 *Historia Compostellana. Corpus Christianorum Continuatio Mediaevalis*, ed. E. Falque Rey (Turnhout: Brepols Publishers, 1988). *Historia Compostelana*, trans. E. Falque Rey (Madrid: Akal, 1994).

4 A.-L. Barbanès, "Écrire l'histoire d'un évêque et de son Église au XIIᵉ siècle: le cas de Diego Gelmírez (1100–1140) et de l'*Historia Compostellana*," *Rives nord-méditerranéennes. Révolution et minorités religieuses*, vol. 14 (Aix-en-Provence, 2003), pp. 77–93. Chapters 1 to 45 in Book I of the *Historia Compostellana* have been attributed to canon Munio Alfonso. They are thought to have been written between 1107 and 1113. Anne-Lise Barbanès underlines the fact that some of the events are contemporary with the writing of the *Historia Compostellana* and are based on eye-witness accounts. In the case in question, Munio Alfonso formed part of the entourage on the journey *ad limina apostolorum*, to use the consecrated formula for designating a Bishop's visit to the Holy See. He abandoned the entourage after Toulouse and went to Rome by the most direct route.

5 Ibidem, p. 90, note 49: M. C. Díaz y Díaz dates the "Guide" to between 1130 and 1150. About the Compostela Cathedral School, see A. Rucquoi, "Compostelle: un centre culturel aux Xᵉ–XIIᵉ siècles," in J. D'Emilio (ed.), *Culture and Society in Medieval Galicia: A Cultural Crossroad at the Edge of Europe* (Leiden: Brill, 2010).

6 J. Vielliard (ed.), *Le Guide du pèlerin de Saint-Jacques de Compostelle* (Mâcon: Protat frères, 1938), p. 3: "*l'une passe par Saint-Gilles [du Gard], Montpellier, Toulouse et le Somport; une autre par Notre-Dame du Puy, Sainte-Foy de Conques et Saint-Pierre de Moissac; une autre traverse Sainte-Marie-Madeleine de Vézelay, Saint-Léonard en Limousin et la ville de Périgueux; une autre encore passe par Saint-Martin de Tours, Saint-Hilaire*

In autumn 1105, the Bishop of Santiago de Compostela, Diego Gelmírez,[1] undertook a long journey to Rome in order to request the privilege of the Pallium[2] from Paschal II (1099–1118), successor to Urban II (1042–1099) in the papal see of Rome. The Eternal City had already received him five years before on the occasion of his ordination as subdeacon. This second journey to the city of popes marks a turning point in the ascent of the illustrious prelate, an influential and ambitious man who devoted his life to enhancing the prestige of the Church of Santiago and to spreading the pilgrimage to Compostela throughout Europe. His ecclesiastical ambitions took form in 1120 with the rise of the Galician see to archiepiscopal dignity and as a corollary, the rise of its Bishop to the rank of first Archbishop of Compostela.

The story of the Bishop's journey is compiled in a chronicle known by the name of the *Historia Compostellana*, sponsored by Diego Gelmírez in order to transmit to posterity the memory of his great deeds.[3] It is not exactly a model of travel literature, although the sixteenth chapter, entitled "Journey to Rome to request the pallium" is particularly valuable, since this expedition is not related in any other source.[4]

In order to arrive in Rome, the Bishop apparently followed the pathways described in the final Book V of the *Liber Sancti Jacobi*, also known as the *Codex Calixtinus*. This fifth book, popularized in 1938 under the mistaken title of the "Pilgrim's Guide to Santiago de Compostela," was probably written within the bosom of the Compostela Cathedral School under the archiepric of Diego Gelmírez.[5] Four main pilgrimage routes through France are quoted, which "leading to Santiago, join together in Puente la Reina, in Spain."[6]

However, at the time of Diego Gelmírez's journey, the pilgrimage to Santiago had not gained the fame it would do several decades later. His journey through France can therefore also be interpreted as a succession of steps that took him from one Cluniac shrine to another, all the way to the mother Abbey of Cluny. Serafín Morajelo said "*il est presque impossible de faire la distinction entre les routes des pèlerins et celle des moines.*"[7] Beyond the artistic and cultural exchanges triggered by the pilgrimage to Compostela, we should not ignore the historical factors related to the significant network of European monasteries in the twelfth century.

In light of the textual sources, the collections of reproductions in the musée des Monuments français help us to evoke the main stages of the journey made by

Old Basilica of Saint-Martin
de Tours, late eighteenth century
A. Bourgerie
1841
Bibliothèque Municipale de Tours,
Indre-et-Loire

Diego Gelmírez's delegation, such as Toulouse, Moissac and Cluny. The musée des Monuments français, christened so in 1937 by Paul Deschamps (1888–1974), is heir to the Musée de Sculpture Comparée, created in 1879 by Eugène Viollet-le-Duc (1814–1879). Herein is expressed over a century of activity by the Historical Monuments Commission. Its collections of reproductions and life-size murals, created for educational and scientific purposes, have been enriched and diversified according to museum restructuring that has accompanied the evolution of doctrines of heritage and schools of thought.[8] The intrinsic nature of the museum's collection thus reflects the major historiographical controversies that defined the study of Compostela in the first half of the twentieth century.

A stop on the way to Toulouse

After Auch, the first stage beyond the Pyrenees, the city of Toulouse hosted Diego Gelmírez. Although the *Historia Compostellana* echoes the care with which the prelate was surrounded, it focuses primarily on the presence of King Alfonso VI's adversaries in the city in Languedoc, as well as the consequences of this threat for continuing the journey to Rome. There is complete silence regarding the conditions of the stay. We do not therefore know whether the Archbishop of Compostela visited the Basilica of Saint-Sernin, or the relics of Saturninus, the first Bishop of Toulouse, which were the subject of a major local pilgrimage, like those of Saint Faith in Conques or Saint Gil in Saint-Gilles du Gard. The veneration of "Saturninus' blessed body" became more favored thanks to the expansion of the pilgrimage to Santiago, since Toulouse signalled the end of the French route to which the city gave its name: the *via tolosana*, the southernmost of the four routes outlined in the "Pilgrim's Guide."[9]

de Poitiers, Saint-Jean d'Angély, Saint-Eutrope de Saintes et la ville de Bordeaux. La route qui passe par Sainte-Foy, celle qui traverse Saint-Léonard et celle qui passe par Saint-Martin se réunissent à Ostabat et, après avoir franchi le col de Cize, elles rejoignent à Puente la Reina celle qui traverse le Somport; de là, un seul chemin conduit à Saint-Jacques." These four *viae francigenae* are called *via tolosana, via podiensis, via lemovinencis* and *via turonencis* respectively.

7 S. Moralejo, "Cluny et les debuts de la sculpture romane en Espagne," in *Le gouvernement Hugues de Semur à Cluny* (Mâcon: Buguet-Comptour, 1990), pp. 405–35, esp. p. 407.

8 L. Pressouyre (ed.), *Le musée des monuments français. Cité de l'architecture et du patrimoine* (Paris: Editions Nicolas Chaudun, 2007). H. Lemoine, "Le musée des Monuments français et la Cité de l'architecture et du patrimoine: une possible anthologie de l'architecture *à la française*?," *Patrimoines*, 5 (Paris: 2009).

9 *Le Guide du pèlerin de Saint-Jacques de Compostelle...* op. cit., p. 49. As Marisa Melero-Moneo showed, the cult of Saint Saturninus grew significantly in Spain towards the end of the eleventh century. The author attributes the implementation of the cult to people or social groups of French origin who had settled in Navarra, and holds that it was possibly favored by the development of the pilgrimage to Compostela: M. Melero-Moneo, "Saint-Saturnin en Espagne: culte et iconographie en Navarre," in A. Rucquoi (ed.), *Saint-Jacques et la France* (Paris: Cerf, 2003), pp. 287–320.

The beginning of reconstruction work on Saint-Sernin could have coincided with the reform of the cathedral chapter and the adoption of the Rule of Saint Agustine in 1073–1076, under Abbot Isarn (1071–1105).[10] The consecration of the church and the main altar by Pope Urban II in 1096 seems to imply that in the year of Diego Gelmírez's journey, the chancel and the transept, i.e. the liturgical heart of the building, were probably finished, and the construction work on the nave walls was underway.[11]

The Basilica of Saint-Sernin and the Cathedral of Santiago de Compostela come from the same architectural decision, which was probably modelled on Saint-Martial de Limoges.[12] The plan includes a broad nave and a projected transept flanked by lateral naves crowned by galleries. The choir is surrounded by an ambulatory which leads to more radiating chapels. This layout favors the welcome and movement of pilgrims, while at the same time enabling religious ceremonies to be held in the choir. According to a configuration common to both buildings, each end of the transept had a geminated door. In both Toulouse and Compostela, only the south door survives. A comparison of the sculpted decoration of the two monuments reveals remarkable iconographic and stylistic affinities.

The relationship between the architecture and sculpture of the two buildings, as well as the delicate question of dating the respective works, clearly contemporary, have generated and still generate abundant literature. In the early decades of the twentieth century, these issues were the subject of strenuous historiographical debates, which found an echo in the Musée de Sculpture Comparée, and even more at the musée des Monuments français. Reproductions of the architectural elements of the Basilica of Toulouse preserved in the museum's collection are the result of two acquisition campaigns carried out in 1925 and 1938. Previously, the sculpture of the building was hardly represented at all in the Musée de Sculpture Comparée collection. This extension of the collection coincides with the theories advocated in the 1920s by Émile Mâle, regarding the origin of Romanesque sculpture in the Iberian Peninsula. For this art historian, the city of Toulouse was the true center of creation, the original melting pot from which Romanesque art in northern Spain had spread out:

> "*On retrouve [l'art de la France] enfin à l'extrémité de la route, à Saint-Jacques de Compostelle. Les artistes qui couvrirent de bas-reliefs les portails latéraux de la basilique venaient tous de France, et la plupart d'entre eux avaient fait leur apprentissage dans les ateliers de Toulouse ou de Moissac. La route de Saint-Jacques fut pour l'Espagne la route de la civilisation. C'est par là que lui arrivait ce que la France produisait de plus raffiné : la poésie, l'art, l'orfèvrerie, les émaux de Limoges.*"[13]

This expansionist concept of French art found an ardent supporter in the person of Paul Deschamps, curator of the Musée de Sculpture Comparée from 1924 and refounder of the Museum of French Monuments.[14] His sympathy for Émile Mâle's thesis came to light at the Musée du Trocadéro in 1932, when he introduced

10 The date when building work started is unknown. Proposals go from 1060 to 1090. Recent work suggests 1077, in relation to the reform of the monks' chapter. See H. Pradalier, "Saint-Sernin médiéval," in *Saint-Sernin de Toulouse. Trésors et Métamorphoses* (Toulouse: Musée Saint-Raymond,1989), pp. 25–34, esp. p. 25.

11 Id., "Saint-Sernin de Toulouse au Moyen Âge," in *Congrès archéologique de France. Monuments en Toulousain et en Comminges. 54e session, 1996* (Paris: Société française d'archéologie, 2002), pp. 256–301. For a summary on the state of the work on the basilica at the end of the eleventh century, see id. "Saint-Sernin Gothique," in *Mémoires de la Société archéologique du Midi de la France*, 63 (Toulouse: 2003), pp. 89–108, esp. p. 90. In the opinion of this author, the ritual of consecration implies the conclusion of the chancel and the transept, and the construction of the nave walls to a height in consonance.

12 A. Prache, "Les sources françaises de l'architecture de Saint-Jacques de Compostelle," in *Saint-Jacques et la France*... op. cit., pp. 263–70, esp. p. 269. The author has analyzed the situation of "pilgrimage" churches based on Émile Mâle's work. She proposes rechristening them as the "Santiago Group," as the Cathedral of Santiago de Compostela is the most complete.

13 É. Mâle [1922], *L'art religieux du XIIe siècle en France* (Paris: Libraire Armand Colin, 1966), p. 301.

14 P. Deschamps, "Notes sur la sculpture romane en Languedoc et dans le nord de l'Espagne," *Bulletin Monumental*, 32 (Paris: 1923), pp. 305–51. In this article, the author defends Émile Mâle's theories, which were severely criticized at the time by American scholar Arthur Kingsley Porter: "*Les archéologues [français] sont, d'après lui [i.e. A. Kingsley Porter], tendancieux et c'est l'amour de leur pays qui leur a fait voir en France la renaissance de l'art roman et par suite l'influence exercée par l'art français sur les monuments de l'Espagne du nord. Pour lui, cette influence n'existe pas; bien mieux, il parait considérer que notre art roman du Sud-ouest serait plutôt tributaire de l'Espagne*" (p. 305). For the exchanges between Mâle and Porter, see J. Mann, "Romantic Identity, Nationalism, and the Understanding of the Advent of Romanesque Art in Christian Spain," *Gesta*, 36, 2 (New York: 1997), pp. 156–64.

recreations of the Cathedral in Compostela,[15] in 1937, when he installed a map of the pilgrimage routes in the facility and then, the following year, when he had a monumental reproduction of *Porte Miégeville* made.[16] Studies since then have demonstrated beyond any doubt that the buildings of Compostela and Toulouse absorbed reciprocal influences. Marcel Durliat underlined the common features of the two artistic centers, but also between Compostela and Conques, whose museum displays the well-known replica of the polychrome tympanum's Day of Judgement.[17] With this purpose, Manuel Castiñeiras has recently shown that, beyond stylistic and morphological relationships, the sculpture in the portico of the Abbey Church of Sainte-Foy de Conques and the Obradoiro portico in Compostela was due to an equivalent plan and culturally linked to the pilgrimage to Santiago.[18]

The best-known sculptures from Toulouse are on display in the Museum's permanent collection; four reproductions from the campaign of 1925 by Louis Bot, moulding master of the Maison Gache, in Toulouse. The sculpture from the ambulatory is represented by three of the seven bas-reliefs embedded in the skirting board from the nineteenth century.[19] The differences in size and style lead us to recognize two distinct groups, several years distant from each other. The first is exemplified by the moulding of the bas-relief of *Christ in Majesty Surrounded by the Tetramorph and the Cherubim*.[20] The iconographic motifs, the shallow sculpture and the graphic treatment of the drapery, have led to their being attributed to Bernard Gilduin, sculptor of the altar table at Saint-Sernin,[21] consecrated by Pope Urban II in 1096. Representative of the second group, the moulding of an apostle has a sharper relief.[22] The movement outlined by the apostle breaks the hieratism of Bernard Gilduin's sculpture. These characteristics date the execution of the second group to soon after 1100. Attributed to the decoration on the western front, the bas-relief which depicts the signs of Leo and Aries,[23] decorated a pillar on the *Porte des Comtes* before the Revolution, in the south arm of the transept. It depicts two women, each of them with their legs crossed, one foot shod, the other bare, one of them carrying a lion, the other a ram. The Latin inscription engraved on the bottom says "Lion sign / ram sign / Made in the time of Julius Caesar." Both the iconography and meaning of the inscription exemplify the embodiment of the zodiacal signs.[24] The style of this bas-relief reminds us of another, representing a woman seated in a chair decorated with lion heads, embedded in the far right of the tympanum in the Obradoiro portico, in the south arm of the Cathedral of Compostela.

The completion of the *Porte Miégeville* cast,[25] located on the southern flank of the basilica, was carried out by Camille Garnier. Furthermore, the analysis reveals the alterations made by Viollet-le-Duc when the basilica was restored from 1860 to 1879, but now lost due to erosion of the original. The portico of Miégeville is exemplary in terms of the close bonds between the two artistic centers. It is the oldest preserved example of a portico that associates a decorated tympanum and lintel. The Apostles, present on the lintel, attend the Ascension depicted on the tympanum. Affinities with Compostela are especially evident in

15 Nine casts were obtained with great difficulty (Mou. 06904 to Mou. 06912) from the Cathedral of Santiago de Compostela in 1932. Only three of them, two of voussoirs of an arch (Mou. 05969 and Mou. 05868), the other of a statue of Saint Paul in the *Pórtico de la Gloria* (Mou. 05867), formed part of the collections in 1906.

16 P. Vitry, "Le nouveau musée des Monuments français," *La revue de France*, 24 (París: 1937), p. 705: "*M. Deschamps se propose de conserver [au musée], malgré l'exclusion des sculptures étrangères, quelques monuments non français, lorsque ceux-ci marqueront un caractère évident d'influences ou de parallélisme absolu avec les créations plastiques de notre pays [...] Il serait fâcheux que l'on ne pût étudier aussi, à proximité des œuvres françaises qui les ont inspirés, les reliefs de Saint-Jacques de Compostelle...*"

17 Mou. 07133. M. Durliat, *La Sculpture romane de la route de Saint Jacques de Conques à Compostelle* (Mont-de-Marsan: Comité d'études sur l'histoire et l'art de la Gascogne, 1990).

18 M. Castiñeiras, "Da Conques a Compostella: retorica e performance nell'era dei portali parlanti," in A. C. Quintavalle (ed.), *Medioevo: Immagine e Memoria* (Milan: Electa, 2010), pp. 65–81, esp. pp. 65, 72: "*Oltre alle più che evidenti somiglianze formali e morfologiche che emergono fra le sculture di Conques e quelle di Plaserías, vi sono anche altri elementi di riscontro attinenti alle cosiddetta cultura del pellegrinaggio, in cui i soggetti e il loro linguaggio, calcolatamente distribuiti nello spazio compositivo, instaurano una relazione diretta con lo spettatore.*" The author suggests that at the end of his stay in Cahors, Diego Gelmírez visited Conques: Diego Gelmírez, "*secondo la Historia Compostellana, fece il tratto della via podiensis da Moissac a Cahors, da dove era molto facile continuare fino a Conques.*"

19 For the status of the question about the original location of the bas-reliefs cf. J. Cabanot, "Le décor sculpté de Saint-Sernin de Toulouse," *Bulletin monumental*, vol. 132, 2 (Paris: 1974), pp. 99–147, esp. pp. 132–4.

20 The casts are Mou. 06746 and Mou. 06747 respectively.

21 There is a replica of the altar table in the museum collections (Mou. 07080).

22 Mou. 06748.

23 The original bas-relief has been in the Musée des Augustins, Toulouse (RA502), since 1800.

24 B. Mora, "Signum Leonis, signum Arietis: Signes zodiacaux? A propos du bas-relief toulousain des "deux vierges," *Annales du Midi*, 103/196 (Toulouse: 1991), pp. 483–9. *La Sculpture romane de la route de Saint Jacques de Conques a Compostelle...* op. cit., pp. 412–5.

25 Mou. 07133.

Signum Leonis, Signum Arietis
*[Saint-Sernin de Toulouse,
plaster cast]*
1925
*Cité de l'architecture et du patrimoine–
musée des Monuments français, Paris*

the two figures of the apostle, placed at either side of the tympanum, recalling Saint Andrew on the Obradoiro portico. To the left of the tympanum, Saint Peter; on the right, Saint James, surely the Elder, according to Émile Mâle.[26] Three of the four capitals from foreign workshops illustrate a cycle devoted to the childhood of Christ, which Marcel Durliat relates stylistically to Bernard Gilduin's workshop. In contrast, he attributes the fourth capital, decorated with lions entangled in lianas, to "*autre atelier* [...] *ouvert à l'extérieur, en l'occurrence à des influences venues de Saint-Jacques de Compostelle.*"[27]

In the shadow of Moissac

According to the *Historia Compostellana*, after leaving Toulouse, Diego Gelmírez came to the Benedictine Abbey of Saint-Pierre de Moissac. The short fragment devoted to this stage is limited to the honors received by the Bishop of Compostela, on the one hand, and the tranquility of the stay on the other. The Abbey of Saint-Pierre de Moissac is therefore described as a peaceful asylum, "*quasi ad tranquillitatis portum.*"[28]

This stay corresponds to the height of the abbey under Abbot Ansquitil (1085–1115), the third abbot since Moissac became a member of the *Ecclesia cluniacensis* in 1053.[29] It can be guaranteed that Diego Gelmírez walked, and perhaps even meditated in the galleries of the cloister adjoining the new church built under Abbot Durand de Bredons (1048–1071). The dedicatory inscription, under the central pillar of the western gallery, indicates, in fact, that the cloister building was completed in 1100, under the authority of its host.[30] Nevertheless it would be implausible to say that he could see the famous porch on the bell tower. Its construction, attributed to Abbot Ansquitil according to the chronicle written by Aymeric de Peyrac in the fourth century, is dated to between 1115 and 1130.[31]

The sculpture of the cloister, together with that of the portico of the abbey church, is well represented in the collections of reproductions at the musée des Monuments français. In his second report on the creation of the Musée de Sculpture Comparée, dated 12 July 1879, Eugène Viollet-le-Duc projected "casts from some figures on the south door of the Church of Moissac" for the first room devoted to *Hieratic Times*. "Examples brought from Moissac" were also proposed for the sixteenth room, devoted to *Sculpted ornamentation*. Monuments from the abbey are therefore among the *specimens* selected by the architect to participate in the rehabilitation of national medieval art that was to be materialized in the Musée du Trocadéro at the time of its opening in 1882.[32]

The execution of the casts of the capitals in the cloister at Moissac, the oldest and most complete decorated cloister conserved in France, took place in 1881.[33] In 1906 and 1907, the museum purchased seventeen more capitals from the reproduction workshops of the Musée des Beaux-Arts in Paris. The reproductions, currently displayed in the *Elements of Architecture* room, come from this last campaign of acquisitions. The scenography set up on the occasion of the reopening of the museum in 2007 seeks to recover the layout of an angular

26 O. Testard, "La porte de Miégeville de Saint-Sernin de Toulouse: analyse iconographique," *Mémoires de la Société archéologique du Midi de la France*, vol. 64 (Toulouse: 2004), pp. 25–62. Émile Mâle bases his hypothesis on the similarity with the relief on the *Platerías* Door. In Olivier Testard's opinion, this attribution should be reconsidered in favor of a synthetic representation of the Apostle Saint James: "*Nous ne pouvons donc écarter qu'à Toulouse Jacques soit une image synthétique, qu'il ne faut pas choisir entre Majeur et Mineur, et qu'il faut s'en tenir à Jacques tout simplement.*"

27 *La Sculpture romane de la route de Saint Jacques de Conques a Compostelle...* op. cit., pp. 399–402.

28 *Historia Compostelana...* op. cit., I, 16, p. 101.

29 P. Racinet, "L'expansion de Cluny sous Hughes Ier de Semur," in *Le gouvernement d'Hugues de Semur à Cluny...* op. cit., pp. 93–131, esp. p. 117.

30 "L'an de l'incarnation du prince éternel 1100 a été fait ce cloître, au temps du seigneur Ansquitil, abbé. Amen. VVV. MDM. RRR. FFF." A reproduction of the inscription made by the Musée des Beaux-Arts de Paris workshop has been in the museum collection since 1996 (Mou. 05871).

31 J. Wirth, *La datation de la sculpture médiévale* (Geneva: Droz, 2004), pp. 26–38. The author proposes dating the portico to before 1115.

32 At the request of Ludovic Vitet, inspector general of Historical Monuments, Viollet-le-Duc carried out a significant restoration campaign in Moissac from 1845 to 1853. The cloister and the abbey church were declared historical monuments in 1840 and 1846 respectively.

33 Musée de Sculpture Comparée sub-committee minutes dated 11 December 1880. The casts of three capitals were entrusted to sculptor Barrion. National Museum Archives (5HH3): contract deeds dated 1 February and 8 April 1880. A fourth capital was cast in 1888.

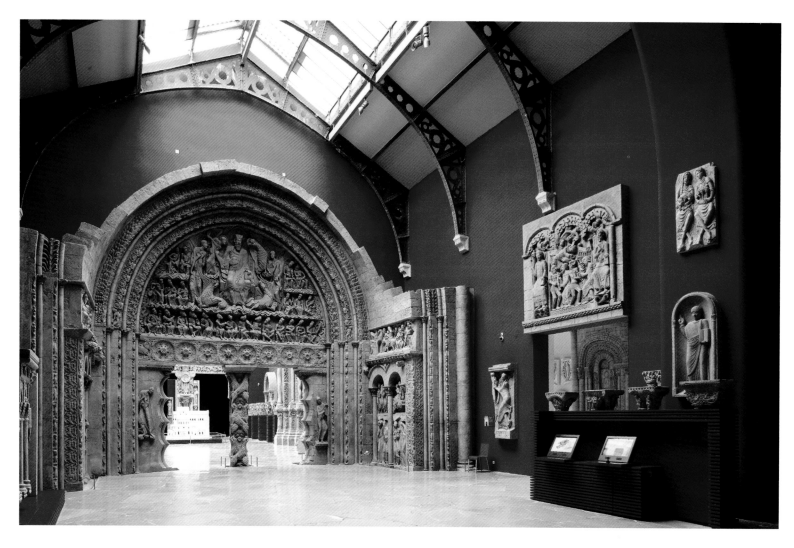

Davioud Gallery
*Cité de l'architecture et du patrimoine–
musée des Monuments français, Paris*

34 Mou. 05873 and Mou. 05872 respectively.
35 For an exhaustive analysis of the cloister
 sculpture: Q. Cazes and M. Scellès,
 *Le cloître de Moissac. Chef d'œuvre
 de la sculpture romane* (Burdeos:
 Editions Sud-ouest, 2001).
36 Mou. 05874.
37 M.-C. Correia Leandro, "Le lieu et les
 images: les sculptures de la galerie du
 cloître de Moissac," in A. Von Hülsen-
 Esch and J.-C. Schmitt (eds.), *Methodik
 der Bildinterpretation / Les méthode de
 l'interprétation de l'image. Deutsch-
 Französische Kolloquien 1998–2000*
 (Göttingen: Wallstein Verlag, 2002),
 p. 460, note 64.

pillar in the cloister galleries, with its large reliefs of apostles, and on its extension, the capitals on smaller columns, alternatively single and geminate. Thus, the casts of the reliefs with the effigies of Saint Peter and Saint Paul[34] are grouped together in such a way that they recall the original situation, against the pillar of the southeast corner of the cloister. From this location, monks could see the two patron saints of the monastery as soon as they came through the cloister door. The originals of these two great reliefs, among the most notable of the cloister sculpture, were carved on marble plates from ancient sarcophagi. The shallow relief, inspired by Carolingian ivories, and its graphic character links them to the slightly earlier sculpture (1096) by Bernard Gilduin. This stylistic similarity speaks in favor of the presence in Moissac of sculptors trained in the construction of the Basilica of Toulouse.[35]

The casts of the three capitals in the cloister that have been discussed come from two different galleries. The capital on the smaller geminate pillar, adorned with plant decoration, belongs to the north gallery.[36] In the cantilever a regular pattern of coiled plants is visible, doubtless inspired by Islamic art, as it tends to confirm the pseudo-Arabic inscription that imitates the Kufic script running along the cast. The decorated capitals which illustrate the Washing of the feet and the martyrdom of Bishop Fructuosus and deacons Augurius and Eulogius come from

the east gallery. The scenes depicted successively show the three martyrs of Tarragona, their condemnation by governor Emilianus, their torture and, finally, their glorification. The relationship between Moissac Abbey and the region of Tarragona, especially the diocese of Gerona, could explain the depiction of the imploration of the three Spanish saints in the cloister iconography.[37]

According to the museum program outlined by Viollet-le-Duc, only the tympanum of the portico and several other elements were cast in 1881 by the sculptor Barrion. The execution of the cast of the jambs and the wall of the portico front was carried out Jean Pouzadoux, master caster of the museum, eight years later.[38] These different parts were assembled in order to compose the monumental replica that has marked the magnificent entrance to the *Galerie des moulages* since 1937.[39] The portico marks the height of Romanesque architecture in Languedoc. The bas-reliefs of the side walls – *Christ's Infancy* and the *Parable of the Rich Fool* – complete the vision of the Apocalypse on the tympanum. The sculptor has respected the text of the Apocalypse: Christ is surrounded by the symbols of the Evangelists and the twenty-four elders. The lintel, decorated with rosettes, is supported by a column ornamented with lionesses. The two doors, framed on one side by the prophets Isaiah and Jeremiah, and on the other by the apostles Peter and Paul, symbolize the continuity between the Old and New Testaments.

Cluny, *Caput totius monastice religionis*

Having stopping in Toulouse and Moissac, Diego Gelmírez reached the Abbey of Cluny, undoubtedly the main goal and ultimate purpose of his trip to France: "*Diego Gelmirez savait that le chemin le plus court pour atteindre Rome passait par le long de Cluny caput totius monastice religionis.*"[40] The Bishop of Compostela could not miss the powerful abbey, elevated to the rank of "second Rome" and which, under Abbot Hugh of Semur (1049–1109) knew its height.[41]

The monastery, founded in 910 by William II, Duke of Aquitaine and Count of Mâcon, was home to over 200 monks in the early twelfth century and exerted its authority over hundreds of priories within a strictly hierarchical Church system: the *Ecclesia cluniacensis*.[42] Its abbots had managed to gain favor with the great; emperors, kings and nobles, and maintained close and constant relations with the papacy. Since the early eleventh century, the Iberian Peninsula was also a potential ally.[43] The growing prestige of the abbey had taken the kings of Navarra, León and Castilla to adopt it as a model for reforming their monasteries.[44] In 1063, Ferdinand I, who wished to enjoy the intercession of the holy abbey, offered to deliver an annual census in return for the prayers of the monks.[45] His donations helped Hugh of Semur undertake the reconstruction of the monastic buildings.[46] The son of Ferdinand I, Alfonso VI, King of León and Castilla, had made the Cluniac expansion in Spain one of the main pillars of his policies.[47] At the same time, he had become one of the abbey's most generous *partners*, providing a substantial contribution for the building of the new abbey church.[48]

38 Jean Pouzadoux (1829–1893), the first master caster of the Musée de Sculpture Comparée reproduction workshop, collaborated with Adolphe-Victor Geoffroy-Dechaume in the restoration by Viollet-le-Duc, Lassus and Boeswillwald. He was also in charge of casting work at the Opera Theatre under Charles Garnier. When he died in 1893, Charles-Édouard, his son and collaborator, took over the licence and title of the museum's master caster.

39 Mou. 00027. The traces of the jambs and the portico mullion were inspected regularly, as is shown in the Musée de Sculpture Comparée sub-committee minutes from 1882 on. The effective realization of these complements is part of the extension of the Musée de Sculpture Comparée in the west wing of the Trocadero Palace.

40 "Cluny et les debuts de la sculpture romane en Espagne"… op. cit., p. 405.

41 The expression *ad limina sanctorum apostolorum Petri et Pauli*, which appears in Cluniac cartularies, suggests that the abbey that held the relics of Saint Peter and Saint Paul wished to play the role of substitute in Roman pilgrimage. D. Iogna-Prat, *Ordonner et exclure, Cluny et la société chrétienne face à l'hérésie, au judaisme et à l'islam, 1000–1050* (Paris: Aubier, 1998), pp. 85–6.

42 D. W. Poeck, "Cluniacensis Ecclesia. Der cluniacensische Klosterverband (10.–12. Jahrhundert)," *Münstersche Mittelalter-Schriften*, 71 (Munich: LMU~Ludwig-Maximilians-Universität, 1998). Based on the works of the Münster school, the term *Ecclesia cluniacensis* is to be preferred to that if the Cluniac Order for the period before 1200.

43 In line with the work of Joseph Bédier in the field of literature, a fundamental role in the cultural program in Spain was attributed to the Burgundian abbey, and more specifically, a decisive action in the development of the pilgrimage to Santiago, which it allegedly turned into an instrument at the service of the Reconquest and a financial manna. The colophon of the fifth book – the "Pilgrim's Guide" – which states that it was written at Cluny, was one of the reasons for this theory, which was ardently defended by Marcelin Defourneaux, Émile Magnien and Émile Mâle. In Spanish historiography, the pen of Américo Castro led to a genuine demonization of the black monks, accused of imperialism; Hugh of Semur was compared to Napoleon. Nowadays, historians' points of view are more nuanced. It is admitted that the abbey was favorable towards the pilgrimage to Santiago, although it made no direct effort to spread it, and Cluniac imperialism is overstated. See P. Henriet, "Moines envahisseurs ou moines civilisateurs? Cluny dans l'historiographie espagnole (XIIᵉ–XXᵉ siècles)," *Revue Mabillon*, vol. 11, 72 (Paris: 2000), pp. 135–59. Id. "Capitale de toute vie monastique," "Élevée entre toutes les églises d'Espagne," "Cluny et Saint-Jacques au XIIᵉ siècle," in A. Rucquoi (ed.), *Saint-Jacques et la France*… op. cit., pp. 407–50.

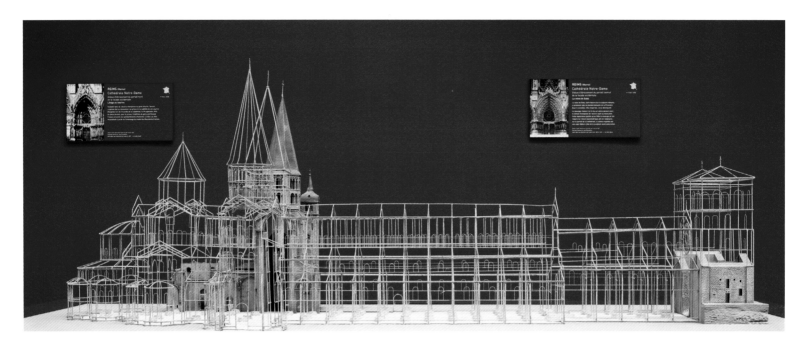

Model of the Abbey Church
of Cluny III
1938–1940
*Cité de l'architecture et du patrimoine–
musée des Monuments français, Paris*

44 *"J'appris (Sanche III de Navarre) que
personne ne pouvait témoigner plus
parfaitement de la perfection de cette
sainte profession [...] dans un parfait
mode de vie régulier avec plus de prestige
que tout autre monastère bénédictin."*
A. Bernard and A. Bruel (eds.),
*Collection de documents inédits sur
l'histoire de France. Première série
Histoire politique*, vol. 4:6 (Paris: Firmin
Didot frères, 1876–1903), no. 2891.

45 From its very founding, Cluny
maintained a privileged link to the
cult of the departed and life after death.
Under abbot Hugh of Semur, the
"funeral policy" of Cluny developed
with an emphasis on the Great.
Monastery benefactors, in exchange
for their donations, became part of the
societas or *fraternitas* of the monastery
and reaped the benefits of monk's
prayers. For Cluny's funeral policies, see
D. Iogna-Prat, "Des morts très spéciaux
aux morts ordinaires: la pastorale
funéraire clunisienne (XIᵉ–XIIᵉ siècles),"
Médiévales, 31 (Paris: 1996), pp. 79–91.
For Spanish sovereigns and Cluny, see
C. J. Bishko, "Liturgical Intercession at
Cluny for the King Emperors of Leon,"
Studia Monastica, 3 (Montserrat: 1961),
pp. 53–76. J. W. Williams, "Cluny and
Spain," *Gesta*, vol. 27, 1/2 (New York:
1988), pp. 93–103.

46 Kenneth John Conant dates these works
to 1077: K. J. Conant, "L'abside et le
chœur de Cluny III," *Gazette des Beaux-
Arts*, 79 (Paris: 1972), pp. 5–12.

Peter the Venerable said that "*son zèle lui avait acquis, après son royaume temporel un autre royaume – éternel on peut le croire.*"[49]

In the context of this network of alliances, both political and spiritual, Compostela also sought to occupy a privileged position. In 1095, Dalmatius, a former Cluniac monk who became Bishop of Compostela, obtained the transfer of the see of Iria to Compostela, and the privilege of exemption which placed the church exclusively under Roman authority.[50] From this moment on the links between the Church of Compostela and the Burgundian abbey never ceased consolidating. The Abbey of Cluny preserved relics of Saint James and a chapel consecrated to the Holy Apostle.[51] A seventeenth-century source tells us that the altar had been consecrated by Dalmatius during Pope Urban II's journey to France for the Council of Clermont.[52] In fact, Cluny "*jouait un rôle non négligeable dans la diffusion des miracles jacobéens*" and probably relied on its friendship with the see of Compostela to expand its network of influence in the Iberian Peninsula.[53] For its part, the Church of Compostela recognized Cluny's preeminent position and its role as capital of monastic life.[54] Its friendship, constantly reaffirmed, with the great abbey, a recognized center of holiness and legitimacy, was an endorsement of prestige. The Cluniac model was considered a source of direct inspiration. Beyond mutual recognition, Cluny was also a key mediator. In its struggle for metropolitan dignity, the mainstay of the *Ecclesia cluniacensis* and its influence in Rome were essential for Diego Gelmírez.

The *Historia Compostellana* devotes long passages to Diego Gelmírez's visit to Cluny.[55] It says that he was welcomed like a brother and that he was received with great processions. It then continues with the nature of the agreement between the two characters. Hugh of Semur, after evoking the difficulties that still beset Diego Gelmírez on the road and reason for the previous pontifical denials, guaranteed his support for the Archbishop. The joint intercession of the Prince of Apostles, Peter, and James enabled him to overcome the last obstacles. Several

days later, the Bishop of Compostela, invited to say mass on the occasion of the feast day of Saint Michael, became part of Cluniac *memory*. With the assurance of the monks' prayers, he left Burgundy full of hope and continued his journey towards Rome, from one Cluniac possession to another. Once again, the *Historia Compostellana* later recorded the decisive action of abbot Ponce de Melgueil in favor of Diego Gelmírez. In 1120 Pope Calixtus II, recently elected at Cluny, consented, thanks to the abbot's advice, to grant the Pallium to the Bishop of Compostela.[56] This historical source of primary importance tells us nothing, however, about the project that focused the energy of the whole Cluniac community at the time: the construction of Cluny III.

The works of Cluny III, a "vast net stretched out to fish souls" according to Hugh of Semur, the largest building in medieval Christianity, had in fact started in 1088. In 1105, when the Bishop of Compostela arrived at the prestigious Abbey in Burgundy, the *Maior Ecclesia* was still a huge building site. The state of progress on this date is not known precisely, but numerous studies devoted to the building of Cluny III give us some clues.

On 25 October 25 1095, Pope Urban II, during a stay in Cluny, where he had been a monk and Grand Prior, consecrated the high altar and the morning mass altar. In turn, the prelates who formed his entourage consecrated three secondary altars "*in tribus primis cancellis* [in the first three shrines]."[57] The question of the conclusion of the chancel on this date, addressed from the unique interpretation of texts that are often difficult to understand, and very few remains, was the subject of controversy for a long time. Excavations by Kenneth John Conant had led archaeologists to think of a progression of works from east to west by vertical profiles, and to propose two great phases of work: the first, in stages from 1088 to 1107, corresponding to the construction of the eastern parts of the abbey church.[58] In 1968, Francis Salet reconsidered these assumptions and stated that the works of the abbey church could not have advanced in such a linear way.[59] Doubts and changed decisions evident in both the preserved buildings and the layout of the ambulatory, seem to indicate that the works had initially started at the level of the great transept and spoke in favor of a late completion of the choir of the abbey church, around 1118–1120. The date of the demolition of the old church, Cluny II, securely established around 1120, confirmed this theory.[60] No matter what, the consecration in 1095 could not be regarded, in his view, as evidence of the completion of the eastern sections of the sanctuary. The three chapels mentioned in the sources could also designate the chapels orientated from one of the other transepts. The relics of Saints Peter and Paul had not been formally transferred up to then, which clearly indicates that the building had not progressed sufficiently as to be able to move them to the choir. The research work undertaken in 1993 by Anne Baud on the Cluny site has shown that the master builders had from the outset used a predetermined and perfectly conceived plan. The quality of the techniques used, the mastery of the challenges posed by the structure and the balance show a high level of reflection that had already been achieved by some innovative architects whose skills anticipated

Cluny capital of Gregorian Chant tones *[plaster cast]*
1929
Cité de l'architecture et du patrimoine–musée des Monuments français, Paris

47 Donations to Cluny's monastic establishments started under Alfonso VI. Patrick Henriet points out that from 1072 to 1143, almost 25 Spanish establishments came under the control of Cluny. We could also point out that many of them were in Tierra de Campos, a delicate border area between Castilla and León, which Alfonso VI had just reunited. "Capitale de toute vie monastique," "Élevée entre toutes les églises d'Espagne," "Cluny et saint Jacques au XIIᵉ siècle"... op. cit., pp. 407–51, esp. pp. 412–4.

48 E.g. in one letter from a Cluny cartulary there is a donation from Alfonso VI of 10,000 talents "*ecclesiae quam edificatis.*" Collection of papers of Cluny Abbey, *Collection de documents inédits sur l'histoire de France. Première série Histoire politique...* op. cit., no. 3562.

49 Pierre le Vénérable, *De Miraculis*, ed. D. Bouthillier and J.-P. Torrell (Paris: Cerf, 1992), p. 184.

50 "De Dalmachio Cialmachio Clvniacensi Monacho in Episcopvm Compostelle Promoto," in *Historia Compostellana. Corpus Christianorum Continuatio Mediaevalis*, ed. E. Falque Rey (Turnhout: Brepols, 1988), I, 5.

51 There is a mention of the relics of Saint James in the *Liber Tramitis* when describing the content of a valuable reliquary with the image of Saint Peter, containing, among other saintly bodies: "*Portio cruce domini et de veste sancte Marie matris domini et de proprio corpore sancti Petri apostoli et de carne sancti Iacobi apostoli...*": *Liber Tramitis aevi Odilonis Abbatis*, ed. P. Dinter (Siegburg: Schimitt, 1980), 1980, p. 260.

52 A. de Yepes, *Crónica general de la Orden de san Benito*, ed. Pérez De Urbel (Madrid: Ediciones Atlas, 1959–1960), p. 262.

53 "Capitale de toute vie monastique," "Élevée entre toutes les églises d'Espagne," "Cluny et saint Jacques au XIIᵉ siècle"... op. cit., pp. 407–51, esp. pp. 425–32, 443–9.

54 The expression "*caput totius monastice religionis*" is at the start of the chapter in the *Historia Compostellana* which tells of Diego Gelmírez's stay at Cluny in 1105. "Qvando romam adiit pro pallio," in *Historia Compostellana. Corpus Christianorum Continuatio Mediaevalis...* op. cit., I, 16 p. 38.

55 Ibidem, pp. 38–40.

56 Ibidem, "De Scismate Et De Recontiliatione Calixti Pape et Clvniacensis Abbatis" II, 14, p. 247.

57 A. Duchesne [1614], *Bibliotheca Cluniacensis* (Matiscone: svmptibvs typisqve fratrvm Protat, 1915), col. 518–519. "Cronología."

58 The solemn consecration in 1130 by Pope Innocence II provides us with a *terminus ante quem*. In accordance with Urban II's indications – who wished it to be organized *tempore opportuno* – the day of the anniversary of the first consecration was 25 October.

59 F. Salet, "Cluny III," *Bulletin Monumental*, 126 (Paris: 1968), pp. 235–92.

60 In 1120–1121, monk Hugh glorifies his abbot for demolishing the old church and enlarging the cloister after finishing the new sanctuary: "*novo mirabili opere constructo monasterio illud antiquum destrui et claustra dilatari mandasti.*"

61 A. Baud, "Le chantier de la troisième abbatiale de Cluny," *Revue Mabillon*, vol. 11, 72 (Paris: 2000), pp. 278–80: "*Le réseau de chaînage qui court sous l'ensemble de l'édifice conforte l'idée d'une rigoureuse organisation du projet. Les décalages repérés entre piliers et murs, loin d'être des repentirs, sont au contraire la preuve d'une réflexion déjà très aboutie sur les notions de structure et d'équilibre qui autorise l'élévation exceptionnelle des voûtes, à 30 m, grâce au report des charges sur l'ossature du bâtiment et un usage novateur du porte-à-faux.*" The author speaks of a "révolution architecturale." See also id., *Cluny, un grand chantier médiéval au cœur de l'Europe* (Paris: Éditions A. & J. Picard, 2003).

62 O. K. Werckmeister, "Cluny III and the pilgrimage to Santiago de Compostela," *Gesta*, 27 (New York: 1988), pp. 103–12.

the inquiries of the Gothic period. The scholarly nature of the references and quotations, the firm will of reconciliation with the old architecture and of inscription in the tradition of Saint Peter's in Rome, the innovative use of the large apparatus accurately reflect the ambitions of the *Ecclesia cluniacensis*.[61] Thus, when he stopped at Cluny, Bishop Diego Gelmírez discovered works of an extraordinary magnitude, designed by experienced men who had already reached the summit of their art. Whatever stage they were in, it is not hard for us to imagine the extraordinary impression they must have made on the prelate, himself a great builder.

The solutions used in Cluny are to an extent comparable with those of the architecture of "pilgrimage" churches, with which the Cluniac Abbey Church shares certain similarities: a plan that integrates a transept provided with absidioles and an ambulatory with radiating chapels. Otto Karl Werckmeister interpreted them as evidence of the hegemonic policy of Cluny over sanctuaries on the roads to Santiago de Compostela.[62] Carol Heizt also noted that five of the ten altars at Santiago de Compostela had, according to "Pilgrim's Guide," identical dedications to those of Cluny III, and that the altar of Saint Nicholas was located in the same place in both buildings.[63] While we believe today that Cluny sought to be defined as a potential pilgrimage center and a "monastic Rome," Cluniac liturgical requirements, so compelling in the sources relating to the abbey, seem more critical. Furthermore, the duplication of the transepts, the large number of chapels and the multiplication of bell towers make the chancel of Cluny III a unique example in the history of architecture. Having made such a decision, a reflection of a symbolism of a specifically Cluniac space, testifies above all the Burgundian abbey's wish to appear as the "beacon of Christianity."[64]

Nowadays nothing remains from Cluny but a few vestiges of the narthex and the south arm of the great transept of the *Maior Ecclesia*. However, the layout of the abbey church has been well known since the pioneering work of archaeologist Kenneth John Conant. Between 1928 and 1950, archaeological excavations by the Medieval Academy of America, conducted under his direction, came up with key results for this comprehension. Graphic recreations, particularly evocative, proposed by the Harvard professor, provided for the first time a suggestive image of the immense building.[65] His fundamental discoveries quickly materialized in the form of a model in the musée des Monuments français. Ten years after the beginning of the archaeological exploration, the painted wood and metal wire model of the *Maior Ecclesia* recreated, in its correct proportions, the parts of the abbey destroyed after the Revolution and the vestiges that were still preserved *in situ*.[66] Like the great Roman basilicas on which the abbey was directly modeled, the building had a floor of five naves. The huge chancel, used for holding processions and as a monumental framework for Cluniac liturgy, consisted of a double transept and an ambulatory with five radial chapels. Four towers, dominating the whole, underlined the symbolic importance of this sacred space. The basilica, an earthly foretaste of the Heavenly Jerusalem, had exceptional

dimensions: a total inside length of 172 m, 38.5 m wide and a height that is still rarely reached – 29.5 m. It was preceded by a spacious Galilea, or narthex, which doubtless played a central role in the cult of the dead. In the musée des Monuments français, two models complete the presentation of Cluniac architecture. The southern arm of the abbey transept, commissioned by Paul Deschamps in 1943, depicts the emblematic construction of the building on three levels,[67] still visible in one of the sections: large arches, blind arches and high overlapping windows in a grand and monumental order which includes fluted pilasters and molded columns in order to disguise the subtle projecting cantilever of the three levels of construction. The model of Paray-le-Monial Church is an image of the architecture of the great abbey church, of which it is, in part, an echo.[68]

The question of the alleged influence of Cluny Abbey should also include the study of preserved decorations.[69] The musée des Monuments français exhibits copies of the famous capitals of the *Maior Ecclesia* choir, whose originals are preserved in the Musée du Farinier, in Cluny.[70] At the time of the campaign for the execution of the casts, undertaken by Paul Deschamps in 1929, the Trocadero moulding workshop made two sets, the first for the Musée de Sculpture Comparée and the second for the Cambridge Harvard Art Museum. That same year, Paul Deschamps had to dispatch a critique on Arthur Kingsley Porter and Kenneth John Conant's theories about their dating in the *Bulletin Monumental*. In agreement with the great French art historians, he said in a controversial tone that the two American scholars' point of view did not enjoy the support of the entire scientific community and that he personally refused to endorse a dating far from the whole:

> "*Pour qui a étudié l'art roman à la suite de Lasteyrie, d'André Michel, de Lefèvre-Pontalis, d'Enlart, de Brutails et de M. Émile Mâle, ces magnifiques images de pierre, réalisées dès 1095, semblent aussi surprenantes que seraient dans un jardin des rosiers ne produisant que des fleurs largement épanouies sans jamais avoir de boutons. J'attends sans inquiétude les preuves indiscutables que nous promet M. Conant.*"[71]

The following year he reaffirmed his statement.[72] The remarkable quality of the capitals seemed to him hardly compatible with the suggested dating. Miracles do not exist in the field of art; a sculptor, no matter how great he might have been, could not work outside his historical period. Comparisons with Burgundian Romanesque buildings suggested even more points in common with the achievements of Autun and Vézelay than with previous sculptures, considered more "vulgar."[73] By placing the building of the capitals under Abbot Peter the Venerable, around 1125–1130, during the repair campaign that followed the collapse of the central nave of the abbey church, he thought he was placing them in their proper place in the chronology of Burgundian sculpture.[74] The capitals, which survived the destruction of the church in 1823, are nowadays seen deprived of their architectural context, and several resist attempts at interpretation.[75] But four of them have clearly identified, corresponding to the capitals of the four

63 C. Heitz, "Réflexions sur l'architecture clunisienne," *Revue de l'Art*, 15 (Paris: 1972), pp. 81–94, esp. p. 90.

64 "Le chantier de la troisième abbatiale de Cluny"... op. cit., p. 280.

65 K. J. Conant, *Cluny. Les églises et la maison du chef d'ordre* (Mâcon: Protat Frères, 1968): esp. the excavation plan, plate II, fig. 2 and the illustration of the rehabilitated sanctuary, plate XLV, fig. 83.

66 The wire and painted wood model of Cluny III (Maq. 00022. Deposit MAP/CRMH) was made between 1938 and 1940 by Perfecta.

67 The plaster model of the south arm of the transept (Maq. 00035. Deposit MAP/CRMH) was entrusted to Georges Latapie in 1943.

68 The model of the chancel of the Church in Paray-le-Monial (Maq. 00031. Deposit MAP/CRMH) was made by Georges Latapie from 1947 to 1956.

69 Concerning the artistic role of Cluny in Spain, Serafín Moralejo speaks of an irradiation through the privileged network of monastery relations rather than a direct or immediate influence. Only the murals in the Church of San Juan de la Peña are stylistically related to the paintings at Berzé-la-Ville. Cf. "Cluny et les debuts de la sculpture romane en Espagne"... op. cit., pp. 405–34.

70 The ten capitals are exhibited in the *Galerie des moulages* (Mou. 06790 to Mou. 06799).

71 P. Deschamps, "À propos des chapiteaux du chœur de Cluny," *Bulletin Monumental*, 88 (Paris: 1929), pp. 514–6.

72 P. Deschamps, *La sculpture française à l'époque romane, XIᵉ–XIIᵉ siècles* (Paris: Éditions du Chêne, 1930), pp. 30–4. Id., "L'âge des chapiteaux de Cluny," *Revue de l'Art*, 58 (Paris: 1930), pp. 157–76, 205–18.

73 Thanks to the museum replicas, Paul Deschamps was able to directly compare these different sculptures. In 1929, the collections held the casts of the tympani at Vézelay (Mou. 00125) and Autun (Mou. 00436), together with the portico of the Cluniac priory of Charlieu (Mou. 00982), dated to 1094, the only point of agreement between Paul Deschamps and A. K. Porter.

74 An intermediate dating solution of 1118–20, doing justice to the exceptional quality of the capitals and the revolutionary nature of the work, was proposed by Francis Salet. Cf. "Cluny III"... op. cit., pp. 235–92. Id., *Cluny et Vézelay, l'œuvre des sculpteurs* (Paris: Société française d'archéologie, 1995).

75 The demolition of the abbey church, started in 1798, when the building was sold to a wealthy trader from Mâcon who transformed the church into an immense quarry, only led to the destruction of the apse in 1823. Despite the local council's attempts to preserve it, Doctor Ochier – a local scholar with a passion for the monument – only managed to conserve a few fragments of the sculpted decoration – they were deposited in the old abbey building.

76 E. Vergnolle, "Les chapiteaux du déambulatoire de Cluny," *Revue de l'Art*, 15 (Paris: 1972), pp. 95–101.

77 A. Pougnet, "Théorie et symbolisme des tons de la musique grégorienne," *Annales archéologiques*, 26 (Paris: 1869), pp. 380–7. W. M. Whitehill, "Gregorian Capitals from Cluny," *Speculum*, 2 (Cambridge: 1927), pp. 385–95. K. Meyer, "The eight Gregorian Modes of the Cluny Capitals," *Art Bulletin*, 34 (Paris: 1952), pp. 75–94. C. E. Scillia, "Meaning and the Cluny Capitals: Music as Metaphor," *Gesta*, 27 (New York: 1988), pp. 133–48.

78 P. Diemer, "Femmes savantes dans le chœur des moines, le programme sculptural du déambulatoire de Cluny," in *Le Gouvernement Hugues de Semur à Cluny...* op. cit., pp. 385–403.

79 F. Mercier, *Les primitifs français, la peinture clunisienne en Bourgogne à l'époque romane, son histoire et sa technique* (Paris: Picard, 1931). P. Deschamps and M. Thibout, *La peinture murale en France. Le Haut Moyen Âge et l'époque romane* (Paris: Plon, 1951). E. Palazzo, "L'iconographie des fresques de Berzé-la-Ville dans le contexte de la réforme clunisienne et de la liturgie clunisienne," *Les Cahiers de Saint-Michel de Cuxa*, 19 (Cuxa: 1988), pp. 169–82. Y. Christe, "À propos des peintures de Berzé-la-Ville," *Cahiers archéologiques*, 44 (Paris: 1996), pp. 77–84. N. Stratford, "Visite de Berzé-la-Ville," in *Le Gouvernement Hugues de Semur à Cluny...* op. cit., pp. 33–52. D. Russo, "Espace peint, espace symbolique, construction ecclésiologique. Les peintures de Berzé-la-Ville," *Revue Mabillon*, 11 (Paris: 2000), pp. 57–87.

80 Copy of mural (Pem. 00015) made in 1939 by fresco painter Albert Moras. In 1938, Paul Deschamps created a new gallery for murals and stained glass windows in the musée des Monuments français. There are currently almost 350 items in the collection.

81 Juliette Rollier-Hanselmmann's work, carried out during a preventive study in 2000, led to a detailed analysis of the diverse pigments employed and their application. It also revealed that the figure of Christ had undergone a significant touching up in the Gothic period. J. Rollier-Hanselmann, "Berzé-la-Ville, la Chapelle-des-Moines: découverte d'un christ caché sous les repeints," *Bulletin Monumental*, 163 (Paris: 2005), pp. 243–9.

elements, the four rivers of Paradise and the eight tones of music.[76] The two capitals devoted to the evocation of the eight plainsong tones were identified thanks to the poetic texts accompanying the depictions of dancers and musicians, harmoniously spread on their faces, and that probably reflect the musical manuscripts preserved yesteryear at Cluny.[77] The quality of the sculpture is admirable from every point of view: the musicians are comfortably separated from the mandorlas which frame them and the calligraphic nature of the drapery accentuates the vividness of the powerfully modeled figures. Furthermore, the rivers of Paradise force their way through the tangled plants, loosely based on the ancient Corinthian. The choice of an allegorical program of powerful cosmological and ethical dimensions for the decoration of the choir is a sigificant development. However, the lack of overall coherence could indicate that this decoration located at a high altitude was still secondary in comparison with the great fresco of the apse, depicting Christ in Majesty.[78]

From the frescoes of the great abbey church, only some scarce archaeological remains survive today. On the contrary, and in general, it is considered that the Berzé-la-Ville frescoes, rediscovered under plaster in 1887, are a faithful reflection of the great Cluniac painting.[79] After the reopening of the musée des Monuments français in 2007, a copy of these paintings, made on the initiative of Paul Deschamps in 1939 for the Musée de la Fresque, is exhibited together with the capitals and models of Cluny III.[80] The decoration of the chapel, undertaken while Hugh of Semur was abbot, in the course of the numerous periods he spent at Berzé between 1100 and 1109, was probably taken up or continued under his successor Abbot Ponce de Melgueil (1109–1122). The choice of the iconographic theme, the "Traditio legis," that here is enriched by the unusual presence of Saint Paul, symbolically affirms the commitment of the Burgundian abbey to the Holy See and its direct dependence on the papacy. References to Rome are again noted on certain ornamental principles that recall mosaics or paintings from Latium. The vividness of the narrative scenes devoted to the martyrdom of Saints Blas and Lorenzo are opposed to the majesty of Christ, who reigns immense and immobile in the mandorla. The painting, of a remarkable perfection, was executed with great care in every detail. The symmetrical plaits in the garments suggest loans from the Byzantine tradition, also evoked by warm dyes, gently variated, and the greenish shadows that stand out on the deep blue of the background. The richness of the palette used, the likely use of additional features embedded in the coating, the exceptional refinement and technical mastery displayed by the painters make it an exceptional work.[81]

The decisive stages of the formation of the collections of the musée des Monuments français are confused with the evolution of the doctrines on heritage, which in the nineteenth and twentieth centuries contributed to forging medieval archeology as a scientific discipline. The creation of the Musée de Sculpture Comparée in 1879 and then the musée des Monuments français in 1937 reveal the identitary concerns of the era after the 1870 war, in the case of the former, and the interwar period in the case of the latter. With the recent reform of its

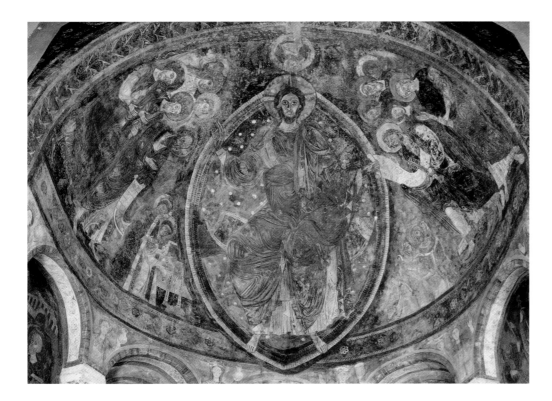

Paintings in the apse of the chancel
at Berzé-la-Ville [copy]
1939
Cité de l'architecture et du patrimoine–
musée des Monuments français, Paris

historic collections, the museum is today a privileged place to discover French architecture from the eleventh century to the present. Although the collections of its reproductions are suitable for evoking Diego Gelmírez's journey *ad limina apostolorum*, they are to an equal degree useful to illustrate the main stages for pilgrims along the roads to Compostela. There is still no better place than the musée des Monuments français, which includes the finest examples of French heritage, to discover its richness and diversity.

Catalog of Works

SANTIAGO AND
OF THE WAY OF

THE ADVENTURE
PILGRIMAGE

Founding Capitals of the Cathedral of Santiago de Compostela

1

Capital of Diego Peláez
1075–1088
[Cathedral of Santiago de Compostela, ambulatory, proscenium arch of the chapel of The Savior]
Master Bernard of Conques
Plaster cast (granite)
71 × 70 × 45 cm
Metropolitan Chapter of Santiago de Compostela, Museo de la Catedral, Santiago de Compostela
TEMPORE PRESULIS DIDACI INCEPTVM HOC OPVS FUIT [This work was started at the time of the prelate Diego]

2

Capital of Alfonso VI
1075–1088
[Cathedral of Santiago de Compostela, proscenium arch of the chapel of The Savior]
Master Bernard of Conques
Plaster cast (granite)
71 × 70 × 45 cm
Metropolitan Chapter of Santiago de Compostela, Museo de la Catedral, Santiago de Compostela
REGNANTE PRINCIPE ADEFONSO CUNSTRVCTVUM OPVS [This was made under the reign of Prince Alfonso]

We do not know the date and circumstances of when the plaster casts of these two capitals were made. However, the existence of two copies in the musée des Monuments français in Paris, made in 1932 under the auspices of Paul Deschamps, curator of the Musée de Sculpture Comparée at the time, means it is possible that both couples were made at the same time for the sake of enriching the institution's Spanish collection.

The two capitals were made to commemorate the beginning of construction work on the new Basilica of Santiago and are located in the axial chapel of the ambulatory devoted to Christ The Savior: the Alfonso VI capital in the transverse arch, and the Diego Peláez capital in the right buttress, facing the ambulatory. In both cases both characters are depicted surrounded by angels holding placards with inscriptions, in which the beginning of the work is recorded and the King and the Bishop are celebrated as builders of the same. This event is related to the celebration of a grand council in Compostela in the same year of 1075, which, even though there is no document to corroborate it, saw the presence of King Alfonso VI (1072–1109) and was the main point of discussion for the new rite in the Galician Church.[1] The other reason for the King's visit was no doubt to offer to Santiago part of the previous year's booty collected from the payment of the paria tribute in Granada.[2] This would certainly be the final push Bishop Diego Peláez (1070–1088) needed to implement the project of a new Romanesque basilica to replace the old and inadequate church of Alfonso III, consecrated in 899.

Serafín Moralejo showed that the iconography of these capitals includes the theme of the donors or founders who were so popular in the contemporary sculpture of Auvergne. In his dissertation, Moralejo takes Volvic as an example, on whose capitals the same elements as in Compostela could be found, such as the commemorative inscription, located on the cyma, the lay and the religious donor, and an angelic entourage, now bearing thuribles.[3] More recently, Manuel Castiñeiras fixed his attention on these winged bodies by placing them in direct relation to the pattern of depiction in the dedication ceremonies that were so widespread on the pilgrimage routes to Santiago.[4]

It is precisely on one of these, known as the *via podiensis*, that we can find the most satisfactory model for the Compostela capitals, more specifically in the Church of Saint-Pierre de Bessuéjouls (Aveyron), located on the early route to Conques.[5] An interesting tower-porch with an upper chapel devoted to the Archangel Michael still survives from its early construction in the eleventh century, decorated by a workshop that shows knowledge of the sculptural models of the first construction campaigns at the Abbey Church of Sainte-Foy de Conques. On one of the capitals,

two full-length angels with outspread wings, holding a placard, occupy the angles of the piece, while in the middle are the remains of a nimbus from what could have been another figure. Its location in a high chapel devoted to Saint Michael, the psychopomp archangel *par excellence*, gives us the clue to the interpretation of the composition. Undoubtedly, the missing effigy would be the soul of a deceased person taken to heaven with the Chosen – or at least the surviving nimbus so suggests. The placard, which must have had some kind of polychrome inscription that is now lost, could have told us something about the identity of this character, possibly a promoter of the construction.[6] After recognizing this model the disembodied representation of Bishop Diego Peláez on the Compostela capital is better understood, where, surely, the intention was to depict the prelate in a state of beatitude consistent with the Gregorian Reform idea of sanctifying the clergy in search of dignity for the ecclesiastical ministry. The depiction of a relief on the funerary monument of Abbot Bégon III of Conques is similar; by 1107 he is also depicted in a state of beatitude, surrounded by angels as a plastic translation of the Reform texts. A clear indication for what is now our concern would be that of Urban II from the Council of Nimes in 1096, in which priests were compared to angels because just like them, they announced the precepts of God.

With respect to the design of the Compostela capitals, the sculptor who made them evidences a style from the first construction campaign of Sainte-Foy de Conques Abbey in the mid-eleventh century. In fact, it is striking that the name of the architect who directed the building of the cathedral, Bernard, coincides with that of one of the masters of the transept of Sainte-Foy de Conques, active under Abbot Étienne in the 1070s. He made a capital in one of the high windows with an angel bearing a phylactery, where he signed, in the same style as on the founding capitals of the chapel of The Savior: "BERNARDUS ME FE[CIT]."[7] Although his stay at the abbey workshop must have been fleeting – only this capital and another in the same window with a two-tailed mermaid can be attributed to him without doubt – the activity of his workshop can be traced in the churches built in the last quarter of the eleventh century in the same region of Aveyron, like Bozouls and the above-mentioned Bessuéjouls.

Victoriano Nodar (V. N.)

[1] F. López Alsina, "Fragmento izquierdo de la carta de coto concedida por Alfonso VI al monasterio de San Isidro de Montes, con ocasión de un 'Concilio Magno' celebrado en Santiago," in *Santiago, Camino de Europa. Culto y Cultura en la peregrinación a Compostela* (Santiago de Compostela: Xunta de Galicia, 1993), p. 287, cat. 25 and 26.

[2] B. F. Reilly, *The Kingdom of León-Castille under King Alfonso VI, 1065–1109* (Princeton: Princeton University Press, 1988), p. 85. F. López Alsina, "Le concordat de Antealtares," in *Santiago de Compostela, 1000 ans de pèlerinage européen* (Brussels: Credit Communal, 1985), p. 203.

[3] S. Moralejo, "Capitel conmemorativo del comienzo de las obras de la Catedral de Santiago: el rey Alfonso VI, el obispo Diego Peláez," in *Santiago, Camino de Europa. Culto y Cultura en la peregrinación a Compostela...* op. cit., pp. 288–9, cat. 27 and 28.

[4] M. Castiñeiras, "La meta del Camino: la Catedral de Santiago de Compostela en tiempos de Diego Gelmírez," in M. C. Lacarra Ducay (ed.), *Los caminos de Santiago: arte, historia y literatura* (Saragossa: Institución Fernando el Católico, 2005), pp. 220–1. Id. "La Catedral de Santiago de Compostela (1075–1122): obra maestra del románico europeo," in *Siete Maravillas del Románico Español, Aguilar de Campoo* (Palencia: Fundación Santa María la Real, 2009), pp. 237–9.

[5] G. Gaillard, "'Saint-Pierre de Bessuéjouls," in *Rouergue Roman* (La-Pierre-qui-Vire: Zodiaque, 1963), pp. 188–92.

[6] P. Deschamps, "L'autel et les chapiteaux romans du clocher de Saint-Pierre de Bessuéjouls (Aveyron)," *Bulletin Monumental*, 99 (Paris: 1940), pp. 69–80.

[7] V. Nodar, *Los inicios de la catedral románica de Santiago. El ambicioso programa iconográfico de Diego Peláez* (Santiago de Compostela: Xunta de Galicia, 2005), pp. 105–9. Id., "Alejando, Alfonso VI y Diego Peláez: una nueva lectura del programa iconográfico de la Capilla de El Salvador de la Catedral de Santiago," *Compostellanum*, vol. 45, 3–4 (Santiago de Compostela: 2000), pp. 617–48. Id., "Su cabelleras brillaban como plumas de pavo real: los guerreros de Alejandro y las sirenas en un capitel de la Catedral de Santiago de Compostela," *Troinalexandrina*, 5 (Turnhout: 2005), pp. 29–61.

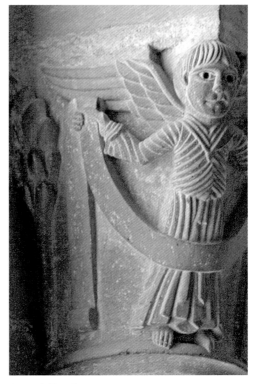

Capital *[Southern wing of the transept]*
Master Bernardo
c. 1070
Abbey Church of Sainte-Foy de Conques, Aveyron

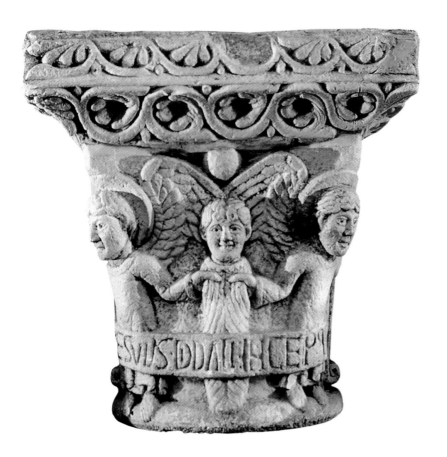

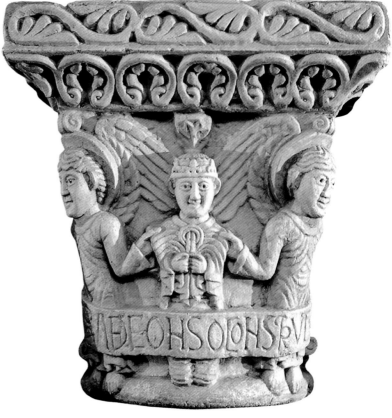

Capital of the Church of Santiago de Jaca

3
Capital of the Church of Santiago de Jaca
c. 1105
[Cathedral of Jaca, cloister]
Cloister of Jaca workshop
Limestone
41 × 48 × 48 cm
Church of Santiago y Santo Domingo de Jaca, Huesca

Below: *View of Mercury (?), view of Venus (?)*
Pages 302, 303: *View of Saturn and Diana-Luna (?), view of the Sun (?)*

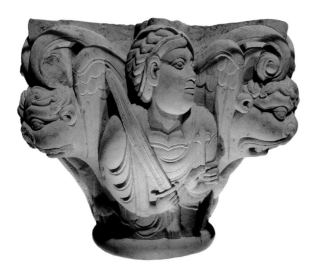

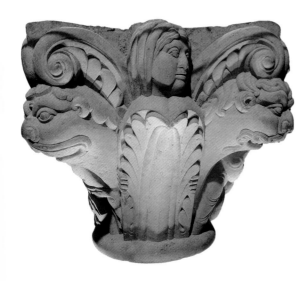

This extraordinary capital is almost certainly one of the sixty the Romanesque cloister in the Cathedral of Jaca was endowed with.[1] The cloister was built no earlier than 1105, coinciding with the improvement of the relationship between the Bishop of Huesca-Jaca, Esteban (1099–1130), and the King of Aragón and Pamplona, Alfonso I the Battler (1104–1134).[2] Dismantled in the seventeenth century, most of its pieces were scattered, to be reused for various purposes both in the cathedral and in religious and civic buildings in the city.[3] And it must have been at that time when the capital came to its present accommodation in the Church of Santiago y Santo Domingo and where it remained until recently as a support for the baptismal font. Restored in 2000, it is currently on display in a glass case.[4]

Its four sides host five busts of an unmistakably archaic nature. The rhetoric monumentality of the figures shows the influence of ancient statue models, including the characteristic lateral head rotation. One of them, a winged figure carrying a sword and a sceptre topped with a fleur de lys, has been identified as one of the testimonies that, together with the similarity of the dimensions of this capital with those of the original cloister cymas which remained *in situ*, would seem to indicate that the piece belongs to this series, understanding that the "pillar of the sword or *signum ensis*" mentioned in the books of the anniversaries in the fifteenth and sixteenth centuries was thereby identified.[5] The remaining faces of the capital are taken up by a woman with her head wrapped in a cloak covering her body with two large leaves, a half-naked man with his torso covered by a chlamys, carrying a rectangular object with a curved top edge and a fringed recess[6] – perhaps a small harp-psalterium, a musical instrument from the zither family that was very widespread in western Europe from the tenth to the twelfth century – and two male figures also with a chlamys: one with a coiled serpent with a bird's head and wings, responding to the iconography of the *Ouroborus* dragon and another holding a snake in both hands. The latter is wearing a curious chlamys in whose folds are shown some spherical shapes that could well be fruits – like those of the grape harvesters on the Compostela pillars – or an echo of the breasts or bull's testicles of the Artemis of Ephesus.[7] In the angles of the capital four impressive lion heads, one of them incomplete, reveal the skill of this great sculptor in the depiction of volume, a quality that is especially evident in the modeling of the bony protuberances over the beasts' eyes. Interpreted for a long time as scenes referring to the biblical passage of the Expulsion from Paradise,[8] now we tend to see these figures in the light of the survival of ancient themes in Christian culture in the Middle Ages. Sonia Simon has seen therein a reinterpretation of the personalization of the seasons from pagan sarcophagi and the

planetary deities of the Roman calendar – like the calendar from 354 – and the astronomical treatises of antiquity that were transcribed in medieval scientific manuscripts.[9] Based on these figurations she suggests a double or triple reading for each of the busts. Thus, in the one with the *Ouroborus* she sees an image of Saturn, of the concept of time and/or Winter, and in the character which accompanies him an image of Autumn with fruits of the folds of his robe. In the veiled woman, the image of Venus and/or the Moon or the Spring and in the young man with the chlamys, Apollo and/or the Summer; for the winged youth she suggests a possible identification with Jupiter, king of all seasons or the symbol thereof.[10] Bearing in mind how usual the depiction of the planetary deities in the ancient style was in astronomical manuscripts of the Middle Ages – like those produced in Saint-Martial de Limoges[11] and Santa María de Ripoll[12] – Manuel Castiñeiras is more inclined to assume that the Jaca capital busts form a planetary series shaped by Saturn, the Moon, Venus, the Sun and Mercury; the figure accompanying Saturn is a Diana-Artemis of Ephesus and the winged figure a reinterpretation of Mercury.[13]

The master's training in Toulouse has not gone unnoticed.[14] His formal language shows great affinity with that developed on the *Porte Miègeville* by Bernard Gilduin's disciples. The treatment of the relief shows the characteristic work of the master responsible for the altar table with his dramatic contrast between the taut, polished surfaces of the fabrics and the ribs marking the folds. We can see thereon the same evolution of Gilduin's *pliegues pincées* that can be found in the works of his successors; he also shares with them a taste for morbid anatomies and for round and bloated faces, a low forehead, fleshy chin and small mouth. Hairstyles and headdresses repeat the recipes of the Toulouse workshop, combining their style according to the principle of *variatio*; thus, for example, the female figure in Jaca hidden behind the leaves – Venus or the Moon – is wearing a very similar headdress to the lunar personification of one of the corbels at Saint-Sernin, while her hair reproduces the formula of Christ's locks in the tympanum;[15] some details of clothing show the same resources – the folds of Simon Magus' chlamys in *Miègeville* and those of the likely Apollo *Kitheraios* in Jaca. The contacts between Jaca and Toulouse workers cannot have been at all unique. In the previous phase there had already been exchanges of craftsmen; a capital of the western gallery of the southern transept at Saint-Sernin is witness to this, as a certain sculptor who knew the archaic repertoire in Jaca left his mark on the Toulouse workshop with a new vision of nude figures that would later be exploited on the capitals of the *Porte Miègeville*;[16] a counterpart, as noted by Moralejo,[17] of a modillion in the apse at Jaca shows the hand of a sculptor – perhaps the same

one who traveled to Toulouse[18] – who had mastered Bernard Gilduin's peculiar style. Stylistically, the capital at Jaca has been related to other Spanish-Toulouse pieces like the bas-relief with women, a young lion and the lamb from the Musée des Agustins, or those with the woman and a small cat and the woman with the skull, on the *Platerías* Door in Compostela.[19] Two capitals currently kept in the arcades of the chapter house of Jaca Cathedral and another reused as a support for the altar table in the southern apse – the Pillar chapel – that David L. Simon believes come from the cloister, seem to emanate from the same workshop. The exceptional nude of an erotic ephebos in retrospective attitude carved into one of the fronts of the capitals in the Pillar chapel, which seems to have been taken from a Dionysian procession, reveals the use of archaic models by this workshop.

The model behind the Santiago y Santo Domingo capital must also be ancient. The corporeal clarity of these figures points towards a sculptural pattern that could well have been one of the many Roman monuments that contained reliefs with busts of the gods. The splendid series of eleven medallions with the Greco-Roman gods from the village of Chiragan (Martres-Tolosane) – in use up to AD 408 – is a notable example of this type of sculpture, which dates back to the late second century. The medallions are preserved in the Musée Saint-Raymond de Toulouse.[20] More than specimens of this type, the figures in Jaca seem to derive from work of a more provincial style, like an octagonal altar discovered in 1837 in the garden of the Golat Castle (Isère-Vienne), devoted to Septimius Severus and Marcus Aurelius (no earlier than AD 198). Its eight faces are taken up by busts of the bearded Emperor with armor, a cloak and a spear, and by the seven planetary gods on acanthus-leaves – according to the inscription, the gods of the week, Diana, Mars, Mercury, Jupiter, Venus, Saturn and Apollo.[21] The rigid appearance of the figures and even the faceted typology of the piece show a certain affinity of the Jaca capital with the design of this altar. Proximity to this type of work indicates that, although the Jaca workshop for the cloister perpetuated the archaic trend of the previous phase, the models had changed. According to the distinction made by Friedrich Gerke,[22] it could be said that the "Jaca classicism" of the late eleventh-century workshops, primarily informed by the visual morphology of a sarcophagus from Hadrian's times like that of Husillos, in the Museo Arqueológico Nacional de Madrid,[23] had taken a step towards "Toulouse classicism," based on the late Roman provincial repertoire that was defined by Gerke as an "*echte gallisches Renaissance*," that is to say authentic Gallic renaissance.[24]

The relationship of this capital with Toulouse and Compostela makes it possible to estimate completion dates around the second decade of the twelfth century, dates consistent with the estimated timeframe for work in the cloister.[25] Recourse to the mythopoetic power of the ancient models and to the allegorical imagery in the new phase undertaken by Bishop Esteban in Jaca enables us to imagine the classical knowledge that presided over this cathedral center in the early twelfth century and the culture of its promoters.[26] From another point of view, it is conceivable that classical forms, which had become the hallmark of the church's decoration in the previous phase, still retained their ability to make the policy of the kingdom of Aragón, its alliance with the papacy and its commitment to the Reform visible.[27] The good relationship with Rome, however, faltered in 1118 with the election of Esteban as Bishop of Saragossa, against the opinion of Paschal II.[28]

Dulce Ocón (D. O.)

1 J. Camón Aznar, "Restos del siglo XI en la iglesia de Santo Domingo de Jaca," *Archivo Español de Arte*, 15 (Madrid: 1942), pp. 112–3. F. Aznárez López, "El claustro de la catedral de Jaca," *Zaragoza*, 14 (Saragossa: 1961), pp. 171–9, esp. 178. D. L. Simon, *The Doña Sancha Sarcophagus and Romanesque Sculpture in Aragon* (London: Courtauld Institute of Art, 1977), pp. 67–93. S. C. Simon, "Capital," in J. D. Dodds (ed.), *The Art of Medieval Spain 500–1200 A.D.* (New York: MET~Metropolitan Museum of Art, 1993), p. 207. Id. "Iconografía de un capitel del claustro de la Catedral de Jaca," in I. Falcón (ed.), *Relaciones de la Corona de Aragón con los estados cristianos peninsulares. Actas del Congreso de Historia de la Corona de Aragón (Jaca, 1993)*, vol. 3:3 (Saragossa: Gobierno de Aragón, 1997), p. 423.

2 A. Durán Gudiol, *Arte altoaragonés de los siglos X y XI* (Saragossa: Caja de Ahorros y Monte de Piedad de Zaragoza, 1973), p. 213. D. L Simon, "Le sarcophage de Doña Sancha à Jaca," *Les Cahiers de Saint Michel de Cuxa*, 10 (Cuxa: 1979), p. 118.

3 These pieces were identified and studied by D. L. Simon, *The Doña Sancha Sarcophagus and Romanesque Sculpture in Aragon... op. cit.*, pp. 67–93.

4 For a summary of the restoration report, see *La Estela, Revista de la Asociación Sancho Ramírez*, 5 (Jaca: 2000), pp. 19–20.

5 ACJ~Archivo de la Catedral de Jaca: *Libros de Gestis y Sacristía* (1615–20). "El claustro de la Catedral de Jaca"... op. cit., p. 177.

6 Not circular as interpreted by S. C. Simon: "Iconografía de un capitel del claustro de la Catedral de Jaca"... op. cit., pp. 426, 435.

7 "Le sarcophage de Doña Sancha à Jaca"... op. cit., pp. 117, 120–1.

8 "El claustro de la Catedral de Jaca"... op. cit., p. 177.

9 "Capital"... op. cit., pp. 208–9. "Iconografía de un capitel del claustro de la Catedral de Jaca"... op. cit., pp. 427–37.

10 "Iconografía de un capitel del claustro de la Catedral de Jaca"... op. cit., pp. 433–4.

11 BnF~Bibliothèque nationale de France: *Lat. 5239* (c. 950), fol. 38.

12 Biblioteca Apostolica Vaticana: *Lat. 123* (1055).

13 M. Castiñeiras, "Tra Jaca e Compostela: i cantieri lungo il Cammino di Santiago (1075–1112)," in A. C. Quintavalle (ed.), *La Riforma e l'immagine dei cantieri in Occidente* (Milan: Electa, 2010).

14 "Le sarcophage de Doña Sancha à Jaca"... op. cit., pp. 119–20, n. 40 and 41.

15 D. Cazes y Q. Cazes, *Saint-Sernin de Toulouse. De Saturnin au chef-d'œuvre de l'art roman* (Graulhet: Odyssée, 2008), figs. 284, 327.

16 Ibidem, pp. 165–7, capital 250, fig. 215.

17 S. Moralejo, "Une sculpture du style de Bernard Gilduin à Jaca," *Bulletin Monumental*, 131 (Paris: 1973), pp. 7–10.

18 *Saint-Sernin de Toulouse. De Saturnin au chef-d'œuvre de l'art roman... op. cit.*, p. 165.

19 "Le sarcophage de Doña Sancha à Jaca"... op. cit., note 12.

20 E. Espérandieu, *Récueil Général des bas-reliefs, statues et bustes de la Gaule romaine*, vol. 2:16 (Paris: Presses universitaires de France, 1908), n. 892, pp. 30–3.

21 Ibidem, vol. 1:16, n. 412, pp. 281–2. It collects the inscription dated by Allmer: "*Iovi optimo maximo et caeteris dis deabusque unmortalibus, pro salute imperator [um] L. Septimi Severi et M. Aureli Anton[ius]...*"

22 F. Gerke, "Der Tishaltar des Bernard Gilduin in Saint-Sernin in Toulouse," in *Akademie der Wissenschafte und der Literatur in Mainz. Abhandlungen der Geistes und sozialwissenschaftlichen Klasse*, 8 (Mainz: 1958), pp. 453ff. S. Moralejo, "La sculpture romane de la cathédrale de Jaca," *Les Cahiers de Saint-Michel de Cuxa*, 10 (Cuxa: 1979), p. 90, n. 42.

23 S. Moralejo, "Sobre la formación del estilo escultórico de Fromista y Jaca," in *Actas del XXIII Congreso Internacional de Historia del Arte. España entre el Mediterráneo y el Atlántico. Granada, 1973*, vol. 1:2 (Granada: Universidad de Granada, 1976), pp. 427–34. Id., "La sculpture romane de la cathédrale de Jaca"... op. cit., pp. 85–93.

24 "Der Tishaltar des Bernard Gilduin in Saint-Sernin in Toulouse"... op. cit.

25 "Le sarcophage de Doña Sancha à Jaca"... op. cit., pp. 122–3.

26 "Iconografía de un capitel del claustro de la Catedral de Jaca"... op. cit., pp. 435–6.

27 D. Ocón, "El tímpano de Jaca: nuevas perspectivas," in A. Franco Mata (ed.), *Patrimonio artístico de Galicia y otros estudios. Homenaje al Prof. Dr. Serafín Moralejo Alvárez*, vol. 3:3 (Santiago de Compostela: Xunta de Galicia, 2004), pp. 217–26.

28 A. Ubieto Arteta, "Nota sobre el obispo Esteban," *Argensola*, 29 (Huesca: 1957), pp. 59–64.

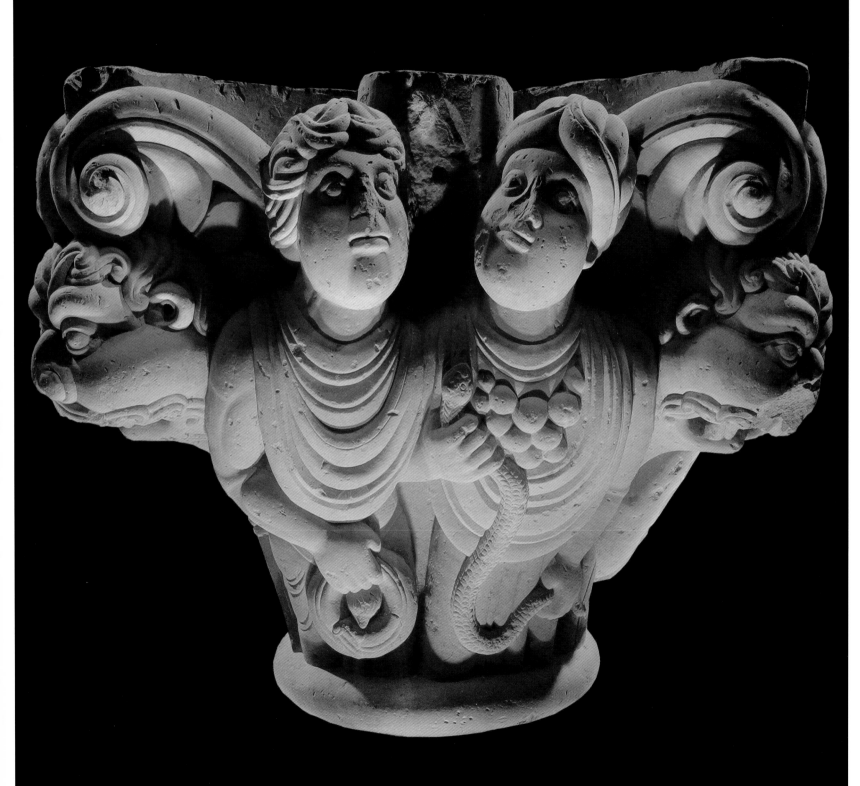

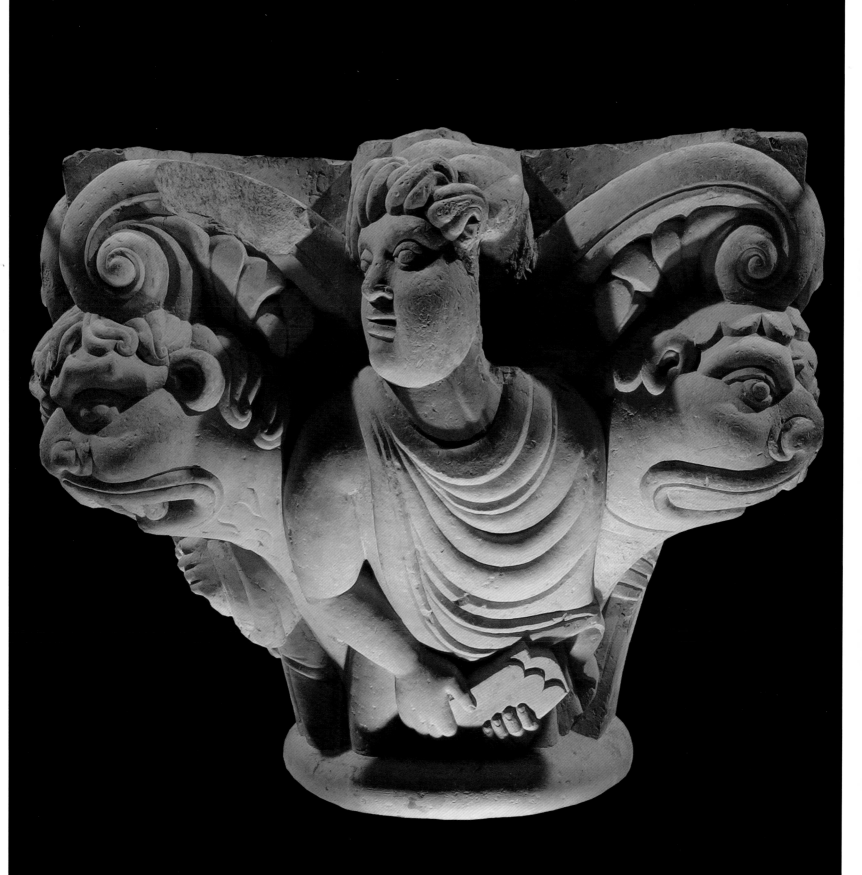

Capital with Birds in the Cathedral of Pamplona

4
Capital with Birds in the Cathedral of Pamplona
c. 1120
[Cathedral of Santa María de Pamplona, western door]
Workshop of Master Esteban
Sandstone
55 × 47.5 × 40 cm
Museo de Navarra, Pamplona

Like other sculptural pieces which must have come from the Romanesque door of Pamplona Cathedral,[1] this capital remained at the cathedral premises until 1957, when it was taken to the Museo de Navarra.[2] These are the only ornamental remains of the Romanesque church, which, as was revealed by the excavations conducted between 1992 and 1993, must have been very large (EW: 70 m × NS: 50 m) and had three naves and a large transept.[3] Part of it collapsed in the late fourteenth century, and it was gradually replaced by the current Gothic building.[4] Its western entrance lasted until 1782, when Ángel de Ochadategui built the new access, based on plans by Ventura Rodríguez.[5] One of these plans, in which the new design is superimposed on the existing floor plan, makes it possible to envision the planimetry of the Romanesque door.[6] Flanked by two towers, it reached a height, from buttress to buttress, of almost 13 m. It had two doors, with a width of just over 2 m, framed by three archivolts on their respective bases; similarly to the Platerías, the separation pillar in both openings was made up of five shafts, with the central one being shared by both doors. There is no doubt that the two corbels at the Museo de Navarra, one with a lion's head with huge open jaws – from inside of which we can glimpse the legs of an animal with long and powerful claws – and the other, also showing a lion's head, although this time it holds in its mouth the unconscious body of a man,[7] formed part of the lost access, as proven by the fact that the first one displays an inscription which reads "EX INCARNATI DE VIRGINE

TE[M]P[O]RE XP[IST]I," which refers to the final part of a legend that was transcribed in its entirety before the entrance's destruction.[8] It describes the Bishop Pedro de Roda (1083–1115) – the reforming prelate of the diocese – as promoter of the new church, as well as the date when the building works began, 1100. This data coincides with that provided by the cathedral's documents, according to which, in 1101 someone called Esteban —"Stephanus"— was appointed as *"magister operis sancti Iacobi."*[9] Both corbels share their design with those at San Isidoro de León; in this way, the one containing the inscription mimics the triangular design of those at the *Puerta del Cordero* – with a more intense Baroque style, exemplified by a zig-zagging moulding plane framing it –, while the man-eating lion one copies the arched profile of those at the *Puerta del Perdón*. The fact that both corbels have a different shape suggests that, like the Platerías, each access had its own decoration.[10] The motif on the corbel with the lion devouring another animal can be traced back to the emblematic capital used in the galleries of Saint-Sernin de Toulouse,[11] which were repeated in one of the modillons of the *Porte Miègeville*.[12]

The same can be said of the capitals, which seem to have stemmed from the entrance, particularly in the case of the one describe here, which features four birds – two at the front and one on each of the sides – against a background of acanthus leaves and shoots with Tolosa roots. Like the other capital, adorned with lattices, also at the Museo de Navarra, it must have occupied one of the edges of the entrance before it was

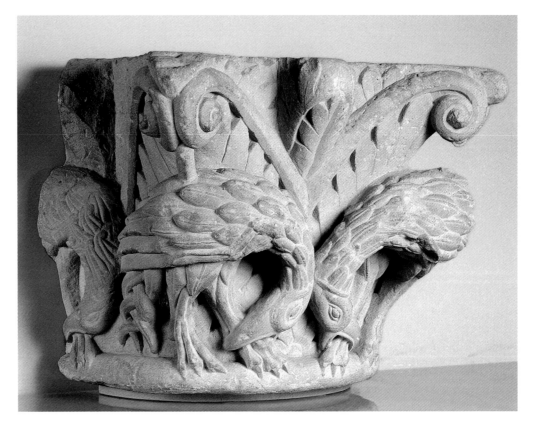

destroyed.[13] The elegant design of the birds, which curve over themselves, can be linked to the two figures – one with the head of a quadruped – placed under the feet of Saint James at the *Porte Miègeville*. The vigorousness of their form, the level of detail and the vitality of their anatomies link these animals with those from the Tolosan workshops and with some from the *Platerías*, particularly with regards to the claws and legs of the animals.[14] The use of shared methods and repertoires, with Occitanian roots, by the craftsmen of both Santiago de Compostela and Pamplona can also be observed in the representation of the motif of the birds nibbling on their legs, below the relief of Abraham on the *Platerías* Door, which had originally been designed for the western door. We find the precedents of this motif in Languedoc miniatures[15] and in the sculptures of Saint-Sernin, whose *Porte Miègeville* offers two examples: the quadruped, a lion or a wolf, on one of the modillons, which is biting its own leg,[16] and the fierce bird which grips with his beak and claws the lateral moulding plane of the corbel of the two "Orientals."[17] In Navarra and Aragón the motif from the Pamplona capital became somewhat popular, and was repeated as a result of the influence of the Irun church in Leire and in Sos del Rey Católico.[18] The representation of these birds was interpreted in a moralistic way, seeing them as desperate souls trying to escape from earthly ties;[19] nowadays, they are seen as purely decorative.

Traditional historiography has attempted to link the craftsman behind these works – the "opifex" mentioned in the 1101 document – with the sculptor who produced the door in Pamplona. Modern criticism has ruled out the idea of Esteban as an architect-sculptor who produced a great many works throughout the Way of Saint James,[20] seeing him instead as the architect who designed the polygonal lines of the axial chapel of Pamplona and the chapels at the entrance of the apse in Santiago de Compostela, Santa Fe – whose consecration in 1105 was witnessed by the prelate of Pamplona Pedro de Roda –, and San Andrés, which no longer exists.[21]

It has been debated whether Esteban's arrival in Pamplona took place as a result of the exile of the Bishop Diego Peláez,[22] or whether it was the result of the friendship between Pedro de Roda and Diego Gelmírez, who endorsed this craftsman in the document from 1101, a theory which has gained popularity in the last few years.[23] Pedro had a good relationship with both Peláez and Gelmírez, even in the context of the difficult circumstances which arose as a result of Peláez's warm welcome in Pamplona, confirming his well-deserved reputation as an expert mediator.[24]

Although it could be thought that Esteban might have designed the entrance in Pamplona, it is unlikely that he would have directed its decoration works. The inscription in which Pedro de Roda is mentioned suggests that the entrance was produced after his dramatic death during the events which took place in Toulouse in 1115.[25] It would therefore seem appropriate to date the building of this access between that date and the consecration of 1127. Keeping in mind the fact that the motif which boasts the most solid internal proof with regards to its belonging to the entrance, the lion from whose jaws dangle the legs of an animal, was circulated, from 1120 onwards, throughout the Languedoc area and the cloisters of Rousillon,[26] it would seem fitting to consider a chronology closer to 1127 than to 1115 as the time when the workshops carried out their work.[27] This approach takes us further from the last reports of Esteban in Pamplona, dating from 1107.[28] Without a doubt, the turbulent events which took place in Santiago in 1117 would have brought about a situation favorable to craftsmen moving from this city to carry out the work on the entrance,[29] although it cannot be firmly stated that this migration took place. The sculptural similarities between Santiago de Compostela, León and Pamplona only reveal the use of a shared repertoire and the awareness of a series of methods learnt in the Tolosa workshops where all of these masters had trained.[30]

Born in Rodez to a family from the local aristocracy, Pedro de Roda – or Andouque –, enjoyed privileged relations with Sainte-Foy de Conques, the abbey where he had been sent by his father, and with Saint-Sernin de Toulouse, with whose canons he collaborated closely in the reform of the Irun diocese. In 1096 he attended in Saint-Sernin the consecration conducted by Urban II.[31] It would not be surprising if, as John Williams has suggested, Peláez and Gelmírez benefitted from his friendship, rather than the other way round, when attracting craftsmen who had trained at Sain-Sernin to produce their works.[32] This prelate was in an excellent position when procuring craftsmen from the southwest of France; he might, therefore, have given rise to his own current of communication between these workshops and Pamplona, which would have made it possible to continue attracting craftsmen to the Irun church even after his death. The craftsmen who made the pieces for the entrance in Pamplona reveal a sense of familiarity with the style and repertoire of *Porte Miègeville*; they also share some elements with the western door, such as a number of characteristics from the "Baroque phase" of Saint-Sernin, e.g. the exaltation of the volumetric values of prior works and a taste for a motley combination of motifs.[33] The probable chronology of the *Porte Miègeville*, in the first decade of the twelfth century, and that of the western door of Saint-Sernin, whose works must have taken place after it,[34] constitutes, therefore, an essential reference point when dating the pieces from the entrance in Pamplona.

D. O.

[1] I am referring to two corbels, four more capitals, a relief showing a seated figure, another with the heads of the ox and the mule eating from the manger and a third showing a cobbler at work. J. Martínez de Aguirre, *La Edad de un Reyno. Las encrucijadas de la corona y la diócesis de Pamplona: Sancho el Mayor y sus herederos*, vol. 1:2 (Pamplona: TF Editores, 2006), pp. 875–93.

[2] P. Madoz, *Diccionario Geográfico-Estadístico-Histórico de España y sus posesiones de Ultramar*, vol. 12:16 (Madrid: Sebastián Miñano, 1849), p. 649.
P. de Madrazo, *España sus Monumentos y Artes. Su Naturaleza e Historia. Navarra y Logroño*, vol. 2:3 (Barcelona: Daniel Cortezo, 1886), pp. 214–5.
J. Iturralde y Suit, "Capiteles de la catedral románica de Pamplona," *Boletín de la Comisión de Monumentos Históricos y Artísticos de Navarra*, vol. 1, 2 (Pamplona: 1895), pp. 7–11.

[3] Without a full report of the excavations, the data we have been provided by the catalog of an exhibition which took place at the Museo de Navarra when the prospect work had been finished: M. A. Mezquiriz Irujo and M. I. Tabar Sarrías, *Los niveles del tiempo. Arqueología de la Catedral de Pamplona* (Pamplona: Gobierno de Navarra, 1993).

[4] C. Fernández-Ladreda and J. Lorda, "La Catedral Gótica. Arquitectura," in *La Catedral de Pamplona*, vol. 1:2 (Pamplona: Caja de Ahorros de Navarra, 1994), pp. 246–63.

[5] J. Goñi Gaztambide, "La fachada neoclásica de la catedral de Pamplona," *Príncipe de Viana*, year 31, no. 1118–1119 (Pamplona: 1970), pp. 5–64.
M. Larrumbe Martín, "Neoclasicismo," in *La catedral de Pamplona 1394–1994*, vol. 2:2 (Pamplona: Gobierno de Navarra 1994), pp. 72–89.

[6] The other traditionally invoked testimony, that of the image of a seal of La Navarrería from the mid-thirteenth century, has been ruled out by J. Martínez de Aguirre, as it is believed to represent a wall: C. Fernández-Ladreda, J. Martínez de Aguirre and C. J. Martínez Álava, *El arte románico en Navarra* (Pamplona: Gobierno de Navarra, 2002), p. 113, n. 25.

[7] This element, which takes us back to some old sources in the style of the gladiator and the lion at Chalon-sur-Saône (Musée Denon), was repeated in a simpler way in several corbels from churches which were dependent on the Cathedral of Pamplona: Sangüesa, Gazolaz, San Miguel de Estella en Navarra, Ejea de los Caballeros, Luesia, San Felices de Uncastillo, Santiago de Agüero, San Miguel de Biota and San Nicolás de El Frago in the Cinco Villas de Aragón.

[8] ACP~Archivo de la Catedral de Pamplona: *Catalogus Episcoporum Eccesiae Pampinolensis* (Francisco Creuzat, c. 1575), fol. 73v. It was included in the *Catalogus episcoporum* by Francisco Creuzat, and interpreted by Fray Prudencio de Sandoval in 1614: "*Virginis Ecclesiam Praesul sanctissimus olim / Hanc rexit, Sedem Petrus in ista fecit, et aedem / Ex quo sancta piae domus est incepta Mariae / Tempus protentum fert annos milique centum, / EX INCARANATI DE VIRGINE TEMPORE CHRISTI.*" According to the translation by J. Goñi Gaztambide: "in another time this church was ruled by a holy Bishop, Pedro, who created this see and this building. From the start of the holy house of the pious Mary 1100 years passed from the incarnation of Christ in a Virgin," in "La fecha de construcción y de consagración de la Catedral románica de Pamplona (1100–1127)," *Príncipe de Viana*, year 10, no. 37 (Pamplona, 1949), pp. 385–95, espec. p. 388.

[9] As stated in two documents dating from 11 June 1001, one of which, in which Estaban is linked to the work in Santiago, seems to be a copy of the other one. On that date Esteban received from Pedro de Roda a number of houses and vineyards and an oven in Pamplona in payment for the works carried out on the cathedral. J. M. Lacarra, "La catedral románica de Pamplona. Nuevos documentos," *Archivo Español de Arte y Arqueología*, 7 (Madrid: 1931), docs. 2, 3.

[10] L. M. Lojendio, *Navarre romane* (La-Pierre-qui-Vire: Zodiaque, 1967), p. 229.

[11] D. Cazes and Q. Cazes, *Saint-Sernin de Toulouse. De Saturnin au chef-d'œuvre de l'art roman* (Graulhet: Odyssée, 2008), pp. 189–90, capital 159, fig. 247.

[12] Ibidem, modillon 4, figs. 323–4.

[13] *La Edad de un Reyno. Las encrucijadas de la corona y la diócesis de Pamplona: Sancho el Mayor y sus herederos*... op. cit., vol. 1:2, p. 877.

[14] Flagstone showing the cockerel, the throne legs and the diabolic figure from the relief by David. M. Castiñeiras, "Capitel con aves," in *Santiago, Camino e Europa. Culto y Cultura en la peregrinación a Compostela* (Santiago de Compostela: Xunta de Galicia, 1993), pp. 391–2.

[15] C. Fraïsse, *L'enluminure à Moissac aux XI^e et XII^e siècles* (Auch: Edi-Service, 1992).

[16] *Saint-Sernin de Toulouse. De Saturnin au chef-d'œuvre de l'art roman*... op. cit., p. 264, modillon 8, fig. 326.

[17] Ibidem, pp. 244–6, figs. 302–3.

[18] F. J. Ocaña, "La controvertida personalidad del Maestro Esteban en las catedrales románicas de Pamplona y Santiago," *Príncipe de Viana*, year 64, no. 228, (Pamplona: 2003), pp. 42–6.

[19] F. Iñiguez, "La escatología musulmana en los capiteles románicos," *Príncipe de Viana*, year 28, no. 108–9 (Pamplona, 1967), p. 271.

[20] M. Gómez Moreno, *El arte románico español. Esquema de un libro* (Madrid: Centro de Estudios Históricos, 1934), pp. 117, 129. F. Íñiguez, "El monasterio de San Salvador de Leyre," *Príncipe de Viana*, year 27, no. 104–5 (Pamplona: 1966), pp. 216–8. Id. and J. E. Uranga, *Arte Medieval Navarro*, vol. 2:5 (Pamplona: Aranzadi, 1971), pp. 84ff. The historiographic production by Gómez Moreno, which was received with scepticism by Gaillard in 1938, has been described by Serafín Moralejo as an example of "the temerity of the biographical method in the interpretation of an art with no biographies:" G. Gaillard, *Les débuts de la sculpture romane espagnole, Leon-Jaca-Compostelle* (Paris: P. Hartmann, 1938), pp. 220–3, n. 29, 35. S. Moralejo, "Notas para una revisión crítica de la obra de K. J. Conant," in J. K. Conant, *Arquitectura románica de la Catedral de Santiago de Compostela* (Santiago de Compostela: COAG~Colegio Oficial de Arquitectos de Galicia, 1983), pp. 221–36, esp. p. 227.

[21] Ibidem, pp. 221–32, esp. p. 228. Id., "Santiago de Compostela: la instauración de un taller románico," in R. Cassanelli (ed.), *Talleres de arquitectura en la Edad Media* (Barcelona: Moleiro, 1995), pp. 127–44.

[22] Hypothesis by Íñiguez which has been adopted by J. Williams: "El monasterio de San Salvador de Leyre"... op. cit., pp. 216–8. J. Williams, "La arquitectura del camino de Santiago," *Compostellanum*, vol. 29, 3–4 (Santiago de Compostela: 1984), p. 282. Id., "¿Arquitectura del camino de Santiago?," *Quintana*, 7 (Santiago de Compostela, 2008), pp. 157–77, esp. pp. 160–1.

[23] On the current situation see C. Valle, "Maestro Esteban," in *Gran Enciclopedia Gallega*, vol. 20:54 (A Coruña: Silverio Cañada, 2000), pp. 34–7. F. J. Ocaña, "La controvertida personalidad del Maestro Esteban en las catedrales románicas de Pamplona y Santiago," *Príncipe de Viana*, year 64, no. 228 (Pamplona: 2003), pp. 7–58.

[24] M. Soria, "'Tolosae moritur, Pampilonae sepelitur' Pierre d'Adouque un évêque malmené," in M. Aurell and A. García de la Borbolla (eds.), *La imagen del obispo hispano en la Edad Media* (Pamplona: UNAV~Universidad de Navarra, 2004), pp. 167–83.

[25] On the circumstances of his death, see ibid., pp. 179–83.

[26] *Saint-Sernin de Toulouse. De Saturnin au chef-d'œuvre de l'art roman*... op. cit., pp. 189–90.

[27] Chronology which was also set out by S. Moralejo with regard to the unlikelihood that this entrance was built by Esteban: "Notas para una revisión crítica de la obra de K. J. Conant"... op. cit., p. 227.

[28] Donation of some mills in Maurumilio: J. Goñi Gaztambide, *Colección diplomática de la catedral de Pamplona. Años 829–1243*, 1 (Pamplona: Gobierno de Navarra, 1997), doc. 114.

[29] "Capitel con aves"... op. cit., p. 391.

[30] P. Deschamps, "Études sur les sculptures de Sainte-Foy de Conques et de Saint-Sernin de Toulouse et leur relation avec celles de Saint Isidore de Léon et Saint Jacques de Comportelle," *Bulletin Monumental*, 100 (Paris: 1941), pp. 234–69.

[31] *Colección diplomática de la Catedral de Pamplona. Años 829–1243*... op. cit., pp. 254–316. "'Tolosae moritur, Pampilonae sepelitur' Pierre d'Adouque, un évêque malmené"... op. cit., pp. 175–9.

[32] "¿Arquitectura del camino de Santiago?"... op. cit., p. 161.

[33] The capital decorated with lattices reveals that it can be linked to nos. 18 and 19 of the western door of Saint-Sernin: *Saint-Sernin de Toulouse. De Saturnin au chef-d'œuvre de l'art roman*... op. cit., pp. 303–4, figs. 364, 365.

[34] Ibidem, p. 285.

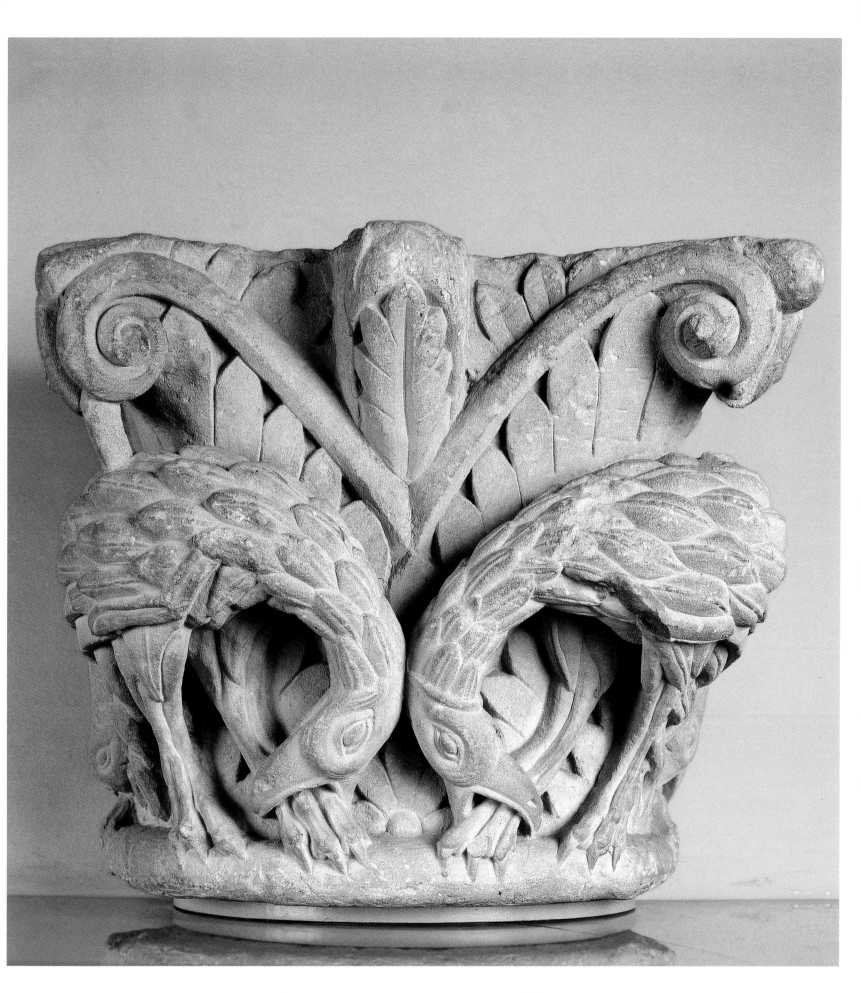

Scallop Shell

5
Scallop Shell, the Pilgrim's Emblem
c. 1120
[Cathedral of Santiago de Compostela,
necropolis]
Natural seashell
9.5 × 2.5 × 10 cm
Museo das Peregrinacións e de Santiago,
Santiago de Compostela

The shell was unearthed during the excavations conducted between 1945 and 1965 by Manuel Chamoso Lamas in the subsoil of the Cathedral of Santiago, inside a tomb set along the sixth section of the northern lateral nave, very close to the foundations of the defensive tower of the Bishop Cresconius (1037–1066).[1] In the same way as much of the western side of the *Locus Sancti Jacobi*, the area was used as a necropolis until it was taken over by the *magnum opus* that is the cathedral, which helps us date the scallop shell to sometime before 1120, the year when Cresconius's tower[2] was torn down to allow construction works on the cathedral to continue.[3] The piece's interest lies in the fact that it is the oldest archaeological proof of the use of the shell as a symbol of the pilgrimage to Compostela. Originally, the scallop shell with which the pilgrims returned from their "journey" was no more than a simple souvenir, a way of remembering their arrival at the *Finis Terrae* where the apostolic sepulchre was set. The "official" definition of this shell as an emblem of Saint James's Way must have begun during the first few years of Diego Gelmírez's time as Bishop; more specifically, Díaz y Díaz suggests the years between 1099 and 1106.[4] Firstly, in 1099, the crusaders' siege of Jerusalem took place, with the subsequent reactivation of the pilgrimage to the Holy Places causing Santiago to seek a way of standing out by means of a new and distinctive symbol; secondly, the year 1106 framed the miracle described in the *Codex Calixtinus* (II, 12) in which the knight of Apulia was healed by touching a shell brought from Santiago. This narrative is not only the first written testimony of its use as an emblem of the pilgrimage, but also hints at the wide use of the shell in the early twelfth century.
In addition to the miraculous properties of the shells brought from Santiago by pilgrims, as revealed in the narrative of the *Codex Calixtinus*, this same codex offers two other interesting facts about them. In Book I, the sermon "*Veneranda Dies*" offers a description of the emblem and explains its meaning as symbol of Christian charity and the good deeds forged by the pilgrimage.[5] In Book V, in the description of the city of Santiago, it describes the way pilgrims could purchase these shells at the market stalls in the *Paradisus* or atrium of the cathedral's *Porta Francigena*, the final portico of their path.
V. N.

[1] J. Guerra Campos, "Exploraciones Arqueológicas en torno al sepulcro del Apóstol Santiago" (Burgos: Ediciones Aldecoa, 1982), p. 454. F. de la Fuernte Andrés and J. Gallego, "Coquille de Pèlerin ou coquille Saint-Jacques," in *Santiago de Compostela, 1000 ans de pèlerinage européen* (Brussels: Credit Communal, 1985), n. 170, p. 291.
[2] "Construyó un nuevo palacio," in *Historia Compostelana*, trad. E. Falque Rey (Madrid: Akal, 1994), II, 25, pp. 345–6.
[3] S. Moralejo, "Concha de peregrino," in *Santiago, Camino de Europa. Culto y Cultura en la peregrinación a Compostela* (Santiago de Compostela: Xunta de Galicia, 1993), pp. 356–7, cat. 75.
[4] M. C. Díaz y Díaz, "Las tres grandes peregrinaciones vistas desde Santiago," in *Santiago, Roma, Jerusalén. Actas del III Congreso de Estudios Jacobeos* (Santiago de Compostela: Xunta de Galicia, 1995), pp. 111–25.
[5] M. Castiñeiras, *A vieira en Compostela: a insignia da peregrinación xacobea* (Santiago de Compostela: Xunta de Galicia, 2007), pp. 19–23.

GELMÍREZ IN FRA

NCE

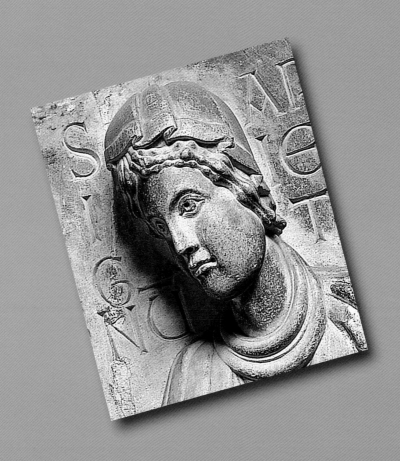

Woman with Bunches of Grapes at the *Porta Francigena*

6

Woman with Bunches of Grapes
1101–1111
[Cathedral of Santiago de Compostela,
Porta Francigena]
Master of the *Porta Francigena*
Marble
32 × 21.5 × 14 cm
Metropolitan Chapter of Santiago de Compostela,
Museo de la Catedral, Santiago de Compostela

All that remains of what must have been a complete figure is this fragment from the top half, which almost certainly formed part of the primitive *Porta Francigena* of the Cathedral of Santiago: in the description which appears in the "Pilgrim's Guide" of the *Codex Calixtinus* some "*immagines feminarum*" are mentioned, which, however, do not appear in the description of the *Platerías* Door.[1] The figure is a woman dressed in a tunic with numerous folds on the chest, with her hair loose and messy, tumbling onto her shoulders; in her hands she holds two bunches of grapes, with her bust facing forward and her face turned slightly to the right, in what seems to be a gesture hinting at visual communication with another figure.

It was Serafín Moralejo who included the piece in the programmatical context of the *Porta Francigena*. In his theoretical development, the figure would be accompanied by the woman with a lion cub which currently stands at the right-hand access to the *Platerías* Door. Both figures are personifications of The Savior in his "suffering" stance – the woman with the grapes – and his triumphant attitude – the woman with the lion cub –,[2] in what is a very appropriate interpretation of the iconographical structure of the facade, which revolved around the idea of man's Fall into Sin, its consequences and the promises of Redemption.

From a stylistic point of view, the piece displays strong connections with the *Porte Miègeville* of Saint-Sernin de Toulouse (1100–1105), and, more specifically, with the sculptor who carved the characters wearing frigian helmets.[3] The faces with swollen cheeks, small mouths and noses, the messy hair and the tight and draped tunics, forming a "U" on the chest, are some of the characteristics which this master shares with the sculptor of Santiago, who has become known as the "Master of the *Porta Francigena*." As well as displaying a commitment to the taste for Antiquity seen in the sculpture of Frómista-Jaca, he also seems to have been familiar with the monumental experience of the Toulouse school, which suggests he might have arrived in Santiago from the French city, having visited it on the occasion of one of his trips to Rome.[4]

V. N.

[1] S. Moralejo, "Fragment of female figure with grape clusters," in *The Art of Medieval Spain, A.D. 500–1200* (New York: MET~The Metropolitan Museum of Art, 1994), p. 211. M. Durliat, *La sculpture romane de la route de Saint-Jacques de Conques a Compostelle* (Paris: Comité d'études sur l'histoire et l'art de la Gascogne Mont-de-Marsan, 1990), p. 350.

[2] S. Moralejo, "La primitiva fachada norte de la Catedral de Santiago," *Compostellanum*, vol. 14, 4 (Santiago de Compostela: 1969), pp. 623–68.

[3] D. Cazes and Q. Cazes, *Saint-Sernin de Toulouse. De Saturnin au chef-d'œuvre de l'art roman* (Graulhet: Odyssée, 2008), pp. 278–85, capitel 159, fig. 247.

[4] M. Castiñeiras, "La Catedral de Santiago de Compostela (1075–1122): obra maestra del románico europeo," in *Siete Maravillas del Románico Español, Aguilar de Campoo* (Palencia: Fundación Santa María la Real, 2009), pp. 237–9.

Reliefs in the Basilica of Saint-Sernin, Toulouse

7

Signum Leonis, Signum Arietis
c. 1105
[Basilica of Saint-Sernin de Toulouse]
Grey marble from Saint-Béat
134 × 69 × 14.5 cm
Musée des Augustins, Toulouse
Inv. # Ra 502/Me 206
SI/G/NV[M]/ L/E/O/NIS/
S/I/G/NV[M]/ ARI/E/T/IS/
H/OC/ FV/IT/ FA/CT/VM/ T/ TEMPO/RE/
IVLII/ CE/SA/RI/S [This was undertaken
at the time of Julius Caesar]

8

Sagittarius Centaurus
c. 350 (?)
[Basilica of Saint-Sernin de Toulouse]
Marble
33.5 × 43.5 × 16.5 cm
Musée des Augustins, Toulouse

9

Harpy
c. 350 (?)
[Basilica of Saint-Sernin de Toulouse]
Marble
33 × 40 × 6.8 cm
Musée des Augustins, Toulouse

We will focus here solely on the material aspect of this famous work and on the different hypotheses that have been mooted concerning its origin. Although the carving known as *Signum Leonis, Signum Arietis* undoubtedly comes from the Basilica of Saint-Sernin, it has not been possible to pinpoint its original location, which may have been the west door, the *Porte Miègeville*, or indeed anywhere else in the abbey.

At the time of writing, the work is still undergoing a process of restoration. During the first stage of this undertaking, the samples taken by Annie Blanc, geological engineer emerita with the Laboratoire de Recherches des Monuments Historiques, confirmed that the marble came from the Pyrenean quarries of Saint-Béat.[1] Next, a pre-restoration analysis performed by Anne Courcelle and Laurence Labbé enabled certain technical elements to be determined:[2] the *Signs* are carved from a single block of marble some 15 cm thick with a three to four and a half centimetre moulding on the back, at the level of each of its vertical edges, a sign that we are dealing with a piece of marble that has been reused. The slab had at some time been broken into fourteen fragments that were stuck together again during a previous intervention, in which some of the small areas of missing marble were filled with plaster.[3] Undoubtedly at the same time two parallel rectangular pieces of marble were placed transversely on the back in order to reinforce the damaged piece.[4]

The restorers' observations have revealed the presence, on the back of the *Signs*, of a bonding mortar which must have been placed there prior to the previous restoration mentioned above, since it lies under the transverse marble reinforcements. However, it is unfortunately impossible to use this mortar as a chronological indicator: its composition varies very little over the ages, since the formulae used by different workshops are handed down without any significant modifications being made to them; at the most, they may help us to define the number of different interventions the piece has undergone and the order in which they were carried out, and this would only be of interest at a latter stage, when we are able to compare our results with the observations from the restoration of the *Porte Miègeville* sculptures, which took place in 2005. The same can be said of the tool marks recorded by Hugues de Bazelaire during that campaign, since it would be a good idea to compare them with those found on the *Signs*.[5] And, finally, it would also be useful to examine the back of the two fragments preserved in the museum whose origin leaves no room for doubt: the reliefs of *King Anthony* and of the *Siren/bird-woman trampling on a crocodile* (?) from the west front of Saint-Sernin.

To date no traces of polychromy have been detected on the *Signs* in the museum. This is not necessarily proof that work on the sculptures was interrupted before they were completely finished, since there is nothing to tell us that they were originally intended to be decorated in this fashion. It is quite possible that the sponsors of the work wished to highlight the Antiquity and the nobleness of the marble. Only the restoration itself will enable any traces of localized polychromy to be detected, for example on the rims or edges. If the work was never painted, then the extremely dirty brown layer covering the surface of the bas-relief may well be the result of residues from a casting process, which have altered our perception of its volumes. It will be necessary to reduce the thickness of this layer during the restoration process in order to give the sculpture its extraordinary plastic qualities back.

The *Signs* were discovered in the Basilica of Saint-Sernin in 1556, on the column of the south arm of the transept, close to the baptismal fonts, by one of the pioneers of the history of Toulouse, Antoine Noguier.[6] This location was confirmed by Raymond Daydé in 1661.[7] Nevertheless, this relief was one of the earliest pieces to form part of the collection in the Musée des Augustins (in fact, since 1800), where it was taken at the request of Jean-Paul Lucas, who was at the time acting as the "preparer" of the museum. The role of this painter, son and brother of sculptors and a collector of antiquities, was decisive in the creation of the Museum du Midi de la République, on 19 December 1793. Once the museum had actually opened in the former Augustinian monastery in 1795, we owe it to him that many works of the first order were saved from destruction.[8] Jean-Paul Lucas himself is the author of the earliest notes referring to the *Signs*, which appear in the first catalogs of the museum, and he also provided the reference to the relief in Noguier's *Histoire Tolosaine*, proof that the work was not only known to exist, but that it was also famous, thus justifying its arrival in the museum at such an early date.[9]

From 1814 onwards Alexandre Dumège devoted himself to deciphering the meaning of the work and its inscription with a view to providing it with an esoteric interpretation, in line with his views as a freemason. Dating it to the Carolingian period, he decided that its original location had been in a contemporary basilica that predated the Romanesque building. He stated that the bas-relief had been located in a chapel of Saint-Sernin, without citing any sources, adding that "[*il*] *était placé jadis au-dessus de la principale porte de l'église de Saint-Saturnin.*"[10] In 1854, with the help of d'Aldéguier, he unambiguously wrote that he thought that the relief of the *Signs* had once been a feature of the west front,[11] an opinion that was for a long time generally accepted with no real discussion. However, David Scott has clearly shown with what suspicion these writings must be treated.[12]

If we take into consideration this hypothesis regarding the west front, we must remember that

SIGNV... L S AR...
6 EO NIS... TIS
NV...

...b
...o
...FV
...it FA
...ct ct
...tempo
re
ciuli

ce ri
sm s

315

Centaurus [Platerías *Door, detail*]
Master of the Porta Francigena
1101–1111
Cathedral of Santiago de Compostela

various historians of Toulouse, such as Bertrand, Noguier and later Catel and Daydé, have given more or less exact descriptions of the west front of the Basilica of Saint-Sernin and the marble slabs dedicated to the story of Saint Sernin/Saturnin that once adorned it.[13] They referred to the presence of several bas-reliefs in which the figures could be identified from the Latin inscriptions in verse that accompanied them. On the north side of the door, they noted the presence of King Anthony seated on his throne and Saint Saturnin with a bull under his feet, whilst on the south side there appeared the scene of Saint Saturnin baptizing Austris, below which there was a plaque decorated with the figure of a centaur with bow and arrow; these were accompanied by an effigy of Saint Martial placed over a siren/bird-woman trampling on a crocodile (?).[14] This ornamentation on the west front apparently disappeared before the end of the eighteenth century.[15] Only two plaques, in very poor condition, managed to reach the Musée des Augustins, where they first appear in the 1818 catalog: those of *King Anthony* and the *Siren/bird-woman*.[16] A further relief depicting a naked man, undoubtedly representing Saturnin's soul, was located on the nearest column to the *Porte Miègeville* until 1651, when it was taken down because of its immodesty.[17] This latter work must undoubtedly have completed the program dedicated to the life and martyrdom of Saturnin on the west front. Would it be possible to consider a similar solution for the *Signs*? However seductive this hypothesis may seem, there is nothing that truly supports it. The presence of these two reliefs on columns may be an indication that the decoration of the west front was incomplete when work on it stopped, in or around 1118. Some of the reliefs that had already been finished, but not yet attached to the front, might then have been placed on the columns. However, the very fact that work was interrupted and numerous sculptures were either lost or put in place before their intended time prevents us from being able to provide an exact reconstruction of the whole of the planned iconographic programme. It is also extremely difficult for us to connect the *Signs* with the program dedicated to Saint Saturnin, and it is clear that the complex iconography of the *Sign of the Lion* and the *Sign of the Ram* leaves room for a large degree of uncertainty.
After previously having linked the *Signs* to the work done on the west front, in 1990 Denis Milhau ventured, more prudently, that nothing had as yet been found to prove this connection.[18] Professor Durliat was equally circumspect in the same year when he spoke of a relief that was "perhaps" destined to form part of the decoration of the west portal.[19] Similarly, in 1982 the authors of the *Corpus des Inscriptions de la France médiévale* expressed their doubts, basing their view on the inscription that appears on the relief,

which unlike those noted by our historians of Toulouse on the reliefs from the west front is not in verse.[20] Should we therefore be looking at the *Porte Miègeville*, in whose decoration a large number of ancient pieces of marble have been re-used, as reflecting stylistic concerns very close to those of the relief in the Musée des Augustins? Or will a third solution have to be found? The forthcoming analyses may perhaps allow us to narrow down the possibilities. We must however acknowledge that simple realism dictates the utmost prudence with regard to nature and interest of the results that may be found. The *Signs* will undoubtedly continue to preserve a large part of its mystery for many years to come, thereby inviting art historians and archaeologists to salutary dose of humility...
Charlotte Riou (C. R.)

The relief known as *Signum Leonis, Signum Arietis* is, without any doubt, one of the masterpieces of Romanesque art, as well at the same time being one of the most enigmatic. It shows two women with their legs crossed; one with a lamb on her lap, the other with a lion cub. A number of mysteries arise, not only as a result of its peculiar iconography but also due to the inscriptions that accompany the image, which, far from shedding light on the relief's meaning and function, have instead led to the most diverse interpretations possible. The inscription along the base of the relief consists of two very different parts. The first identifies the two figures – "the sign of the lion" and "the sign of the ram" – whilst the second establishes the time that the work was created – "This was undertaken at the time of Julius Caesar."[21] In other words, the sculpture itself is giving viewer both iconographic and chronological information – information which dates back to Roman times. Evidently, this is not a Roman work but instead is Romanesque, giving credence to Jean Adhémar's claim that what we have before us is an attempt to create a fake antique in the Middle Ages.[22] With this "falsification" the magnificent sculpture workshop at Saint-Sernin went from creating a conscious imitation of one of the many models of Roman statuary conserved in the city to sculpting a piece such as this, whose prestige would reside not only in its craftsmanship but also its supposed antiquity. It was therefore not enough to merely imitate the ancient style: an inscription also had to be added that certified its authenticity and which, by extension, also further dignified the building which housed the piece with the prestige of "Roman-ness."
From the earliest times the relief became the subject of a growing legend, one which identified the piece as a representation of a miracle which had taken place in the times of Julius Caesar, and retold by Saint Jerome. According to his account, two virgins had given birth to a lion cub and a lamb which respectively prefigured the meekness

of Christ with respect to the chosen and his severity with the condemned at the Final Judgement. To this legend, already documented in 1388,[23] and taken up in 1515 by Nicolas Bertrand and again in 1661 by Raymond Daydé[24] a complementary reading by Noguier can be added, who in 1556 interpreted the image as two zodiac signs relating to the virtues of Caesar. Du Mège took up this astrological interpretation anew in 1814 in an analysis which would be further espoused in contemporary historiography.[25] The main problem with this zodiacal reading is that both ancient and medieval calendars focused figuration on the astrological signs whilst the relief in Toulouse centers its attention on the two women. So much so that the association of the two signs, Leo and Aries, which are not consecutive in the Zodiac, lead one to think about the very careful choice of iconography which demonstrates an intentional and much deeper symbolism. Thus, in 1990, Marcel Durliat accepted the astrological interpretation, adding that the strength, traditionally attributed to the lion and the ram, should also be symbolically applied to the nature of Christ.[26] Bernardette Mora, quoting the writings of the Venerable Bede (c. 673–735) and Honorius Augustodunensis (c. 1080–c. 1157) suggested that the summer sign of the lion (23 July to 25 August) and the spring sign of the ram (21 March to 20 April) represent first a warm, then a cool cycle which, added to the fact that they are in the laps of two allegorical women who each have one foot bare and one covered could allude to the death and resurrection of Christ. As allegories of Christ, and as a result of the Christianization of the Zodiac undertaken by Saint Zeno of Verona in the fourth century, the lion would represent the tribe of Judah, from which Christ descended, whilst the small ram symbolized the sacrificed Lamb of God.[27] The relief therefore represents an allegory of the dual nature of Christ, triumphant yet suffering. This is the same interpretation that Serafín Moralejo gave to the reliefs of two women in the Cathedral of Santiago which had belonged to the long disappeared *Porta Francigena*.[28] Both these pieces reflect the Toulouse style of a woman sitting with her legs crossed, holding something in their lap. The woman, who, as in Toulouse, is holding a lion cub, was reused in the eighteenth century in a jamb in Santiago Cathedral's *Platerías* Door, whilst the woman holding the bunch of grapes is kept in the Cathedral Museum. Its inclusion in the programme of the old *Porta Francigena* can be explained by its dedication to the fall of man into sin, to its consequences and to the promise of redemption, as these are two personifications of The Savior in his role as sufferer – the woman with the grapes, and triumphant – the woman with lion. The zodiacal interpretation of the Toulouse relief is further supported by a relief discovered in 1954 in Nogaro (Gers) in south-

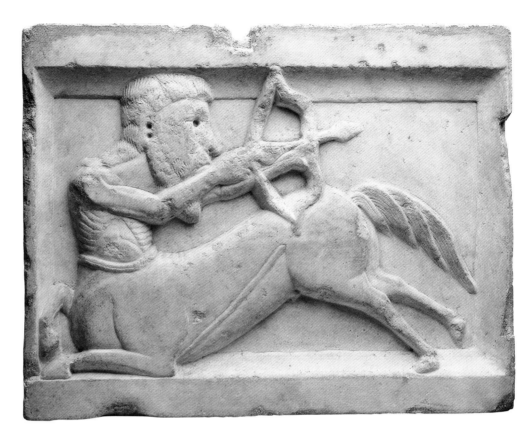

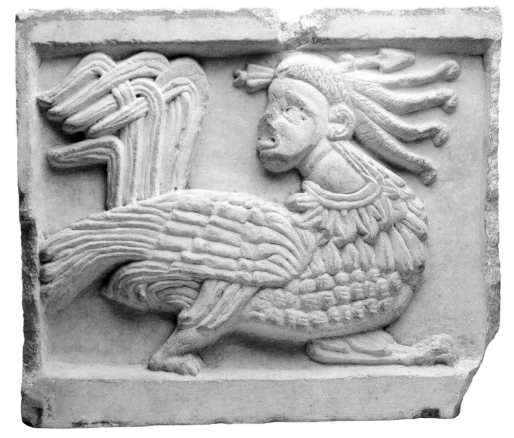

west France which must have been a part of the decoration of the Romanesque collegiate Church of Saint-Nicolas. This piece represents a woman who is sitting with her legs crossed, with a mutilated lion in her lap. The Christianization of the zodiac sign is evident in this relief due to the inscription "SIGNVUM LEONIS" which on this occasion does not appear on the base but on the halo around the figure's head.[29]

If the allegorical content of this relief is, as we have seen, exceptional, no less so is the craftsmanship employed, which can be attributed to a highly-renowned sculptor from the *Porte Miègeville* workshop. Here we can also see reliefs such as the Montan relief where the accompanying women, Priscilla and Maximilla, are clearly heralding zodiacal signs. Nevertheless, the closest relationship is with the sculptor who produced the extraordinary modillion cornices which represent the Sun and the Moon, with their long faces, bony hands, the folds in their veils, their expressive eyes.[30] This was the work of an artist who had garnered the experience of provincial Roman sculpture yet with a tendency to simplify volume and stylize the figures, creating forms that had strayed from naturalism whilst gaining in monumentality.[31] This relief is undoubtedly a truly unique piece of work which represents the zenith of sculpture in the Saint-Sernin de Toulouse workshop.

The other two marble plaques which show a centaur and a harpy undeniably complete this group of Saint-Sernin reliefs, not only due to the identical way in which they have been produced but also as a result of the clear links that exist between the pieces. One depicts a centaur bending its front legs in a clear gesture which shows the effort being made in firing an arrow from the bow it is holding. Both the centaur's hair and beard fall in thick plaits and the anatomy of the torso shows an attempt to outline the bones and muscles below the skin. The harpy has the body of a bird and the head of a woman, with separate flowing locks which end in ringlets. The two figures are connected by their respective lines of sight, turning the scene into a chase in which the centaur aims its arrows at the harpy, one of which we can see has not hit its target and passes by the harpy's head.

Both respond to the same sculptural style, with the emphasis on low relief which seeks to depict a real anatomy and faithfully capture a sense of movement. The considerable differences which can be seen with respect to the various workshop which operated in Saint-Sernin brings into doubt the chronology of the pieces and their place within the decoration of the basilica. Quiterie Cazes has actually stated his preference for the notion that these are in fact Roman pieces and that in the event that they prove to be medieval, they would lead to serious doubts being raised with regard to ancient statuary.[32]

What we do know for sure about them is that they were sold to a private art collector around 1812 along with other sculptures which had been saved from the demolition of the basilica's Romanesque cloister, and in 1960 were acquired by the Musée des Augustins. If they are medieval sculptures, we do not have any other similar pieces, at least in Toulouse, and if they prove to be older, they could have been reused in another part of the basilica or at least used as the models for other pieces – not only another centaur or another harpy, which we can be certain decorated the western facade of Saint-Sernin,[33] but also for two other marble reliefs which can today be seen on the *Platerías* Door of the Cathedral of Santiago and which must have come from the old *Porta Francigena.* One of these later pieces shows a centaur shooting a mermaid-fish which initially must have been part of the adjoining piece, following an iconographic association which was habitual in the illustrations which featured in the medieval bestiaries in which both of these hybrid creatures were included within the same chapter.[34] The points of contact between the Santiago and the Toulouse centaurs are many. Not only is the position of the creature identical, turning on itself and folding its front legs, but there is also the repetition of other very specific details from the Toulouse relief, such as the hair falling in thick plaits and the arrow that has missed the mermaid's head.

The sculptor of the two Santiago reliefs is also the craftsman known as the "Master of the *Porta Francigena*" who, among all those who worked on the cathedral during the time of Diego Gelmírez, the craftsman who most took on board the knowledge he had gained from Jaquesian, Toulousian and Roman sculpture. Greater credence is therefore being given to the idea that one of the artists who had worked on the cathedral had also been a part of Gelmírez's entourage during his trips to Rome in 1100 and 1105, as Manuel Castiñeiras has suggested recently.[35] On both journeys the Bishop would have had to pass through Toulouse, a city which was positively bubbling with artistic vivacity during the early years of the twelfth century, where the accompanying artists would have not only become aware of the work being produced by the Saint-Sernin studio but also the significant amount of "plundered" Roman art that could be found in the city at that time which would serve as models for later pieces.

V. N.

[1] A. Blanc and P. Blanc, *Les minéraux accessoires des marbres blancs des Pyrénées utilisés dans la sculpture du Languedoc*, oral communication given during the seminar on marble held at Bagnères-de-Bigorre on 2–4 May 2007. Unpublished.
[2] A. Courcelle and L. Labbé, *Dossier d'étude du bas-relief Me 206. Le Signe du Lion et du Bélier* (December 2008). Deposited in the documentary archives of the Musée des Augustins.

[3] This intervention appears to date from before the end of the nineteenth century, since it is perfectly visible in the glass plate negatives in the museum that show works displayed in the 1890s.

[4] These features were already mentioned by D. Milhau, but with some erroneous details, in *Saint-Sernin de Toulouse. Trésors et métamorphoses* (Toulouse: Du Non Verbal, 1990), pp. 89–90.

[5] H. Bazelaire, *Reliefs sculptés de la Porte Miègeville. Étude de traces d'outils et de grattage. Rapport à la documentation du C2RMF* (Paris: C2RMF~Centre de Recherche et de Restauration de musées de France, 2005).

[6] A. Noguier, *Histoire Tolosaine* (Toulouse: Guyon Boudeville, 1556), I, pp. 52–3: the "*effigie est au tiers pillier de la grande porte de la dite église du côté de l'hôpital, & vis-à-vis les Fons d'icelle...*"

[7] R. Daydé, *L'histoire de Saint-Sernin ou l'incomparable trésor de son église abbatiale de Tolose* (Toulouse: Arnaud Colomiez, 1661), pp. 280–3.

[8] On the origins of the Musée des Augustins, see *Les origines du musée de Toulouse* (Toulouse: Archives départementales, 1956).

[9] J.-P. Lucas, *Catalogue des tableaux et autres monumens des Arts formant le Museum provisoire établi à Toulouse*, (Toulouse: P. B. A. Robert, 1800), p. 3, cat. 131.

[10] A. du Mège, *Monumens religieux des Volces-Tectosages, des Garumni et des Convenae, ou fragments d'archaeologie pyrénéenne, et recherches sur les Antiquités de la Haute-Garonne* (Toulouse: Benichet Cadet, 1814), pp. 242–50. The information was taken up again with some changes in the catalogs of the Musée des Augustins for 1818, 1828 and 1835.

[11] L. Cluzon and V. Dieron, *Monographie de l'insigne basilique Saint-Sernin* (Toulouse: Bayret, Pradel et ce., 1854), p. 32, for the *Signs* in particular, see pp. 45–9.

[12] D. W. Scott, "A Restoration of the West Portal Relief Decoration of Saint-Sernin of Toulouse," *The Art Bulletin*, vol. 46, 3 (New York: 1964), appendix, pp. 279–82.

[13] N. Bertrand, *Les gestes des Tolosains et autres nations de l'environ* (Toulouse: Jacques Colomies, 1517), p. 30; there is a first edition in Latin: *Opus de Tholosanorum Gestis* (Toulouse: Jean Grandjean, 1515). *Histoire Tolosaine...* op. cit., p. 53. G. de Catel, *Mémoires de l'histoire du Languedoc* (Toulouse: Pierre Bosc, 1633), p. 818. *Histoire de Saint-Sernin...* op. cit., pp. 276–9.

[14] For further details, see *Saint-Sernin de Toulouse. De Saturnin au chef-d'œuvre de l'art roman* (Graulhet: Odyssée, 2008).

[15] Scott cites the various descriptions of the west door before "its defacement during the French Revolution," but there is no proof that any such vandalism took place. "A Restoration of the West Portal Relief Decoration of Saint-Sernin of Toulouse"... op. cit., p. 275.

[16] The two small marble bas-reliefs portraying a centaur shooting an arrow at a siren/bird-woman, acquired in 1960 by the Musée des Augustins, undoubtedly never formed part of the west front of Saint-Sernin. On this subject, see ibid., pp. 271–82.

[17] *Histoire de Saint-Sernin...* op. cit., p. 280.

[18] D. Milhau, *Les grandes étapes de la sculpture romane toulousaine. Des Monuments aux collections* (Toulouse: Musée des Augustins, 1971) p. 65, cat. 19. *Saint-Sernin de Toulouse. Trésors et métamorphoses...* op. cit., p. 89.

[19] M. Durliat, *La sculpture romane de la route de Saint-Jacques. De Conques à Compostelle* (Mont-de-Marsan: Comité d'études sur l'histoire et l'art de la Gascogne, 1990), p. 212.

[20] *Corpus des inscriptions de la France médiévale*, eds. M. Favreau, B. Leplant and J. Michaud, vol. 7:23 (Paris: CNRS~Centre d'Études Supérieures de Civilisation Médiévale, 1982), pp. 62ff.

[21] Ibidem, p. 62.

[22] J. Adhémar, *Influences antiques dans l'art du Moyen Âge Français* (London: The Warburg Institute, 1939), pp. 252–3.

[23] D. de Mély, "Les deux 'vierges' de Toulouse et leur legende," *Gazette des Beaux-Arts*, 5th series, 6 (Paris: 1922), pp. 88–96.

[24] *L'histoire de Saint-Sernin ou l'incomparable trésor de son église abbatiale de Tolose...* op. cit., pp. 280–94.

[25] *Monumens religieux des Volces-Tectosages, des Garumni et des Convenae, ou fragments d'archéologie pyrénéenne, et recherches sur les Antiquités de la Haute-Garonne...* op. cit., pp. 242–50.

[26] *La sculpture romane de la route de Saint-Jacques. De Conques a Compostelle...* op. cit., p. 414. D. Milhau, "El Signo del León y el Signo del Cordero," in *Santiago, Camino de Europa. Culto y Cultura en la peregrinación a Compostela* (Santiago de Compostela: Xunta de Galicia, 1993), p. 390. P. Mesplé, *Toulouse. Musée des Augustins. Les sculptures romanes. Inventaire des collections publiques françaises* (Paris: Editions des Musées Nationaux, 1961). E. Valdez del Alamo, "Relief of two women with a lion and a ram," *The Art of Medieval Spain, AD 500–1200* (New York: MET~Metropolitan Museum of Art, 1994), pp. 205–6. M. Castiñeiras, "La catedral románica: tipología arquitectónica y narración visual," in M. Núñez (ed.), *Santiago, la Catedral y la memoria del arte* (Santiago de Compostela: Consorcio de Santiago, 2000), pp. 39–96.

[27] B. Mora, "Signum Leonis, Signum Arietis: Signes Zodiacaux? A propos du bas-relief toulousain des deux vierges," *Annales du Midi*, 103 (Toulouse: 1991), pp. 487–8.

[28] S. Moralejo, "La primitiva fachada norte de la Catedral de Santiago," *Compostellanum*, vol. 14, 4 (Santiago de Compostela: 1969), pp. 623–68.

[29] M. Durliat, "Église de Nogaro," in *Congrès archéologique de France* (Paris: Société française d'archéologue, 1970), pp. 91–110.

[30] *Saint-Sernin de Toulouse. De Saturnin au chef-d'œuvre de l'art roman...* op. cit., p. 288.

[31] T. Lyman, "Le style comme symbole chez les sculpteurs romans: essai d'interprétation de quelques inventions thématiques a la Porte Miègeville de Saint-Sernin," *Les Cahiers de Saint-Michel de Cuxa*, 12 (Cuxa: 1981), pp. 161–78.

[32] *Saint-Sernin de Toulouse. De Saturnin au chef-d'œuvre de l'art roman...* op. cit., p. 293.

[33] "A Restoration of the West Portal Relief Decoration of Saint-Sernin of Toulouse"... op. cit., pp. 271–82.

[34] *El Fisiólogo. Bestiario Medieval*, trans. M. Ayerra Redin and N. Guglielmi (Buenos Aires: Eudeba, 1971), XV.

[35] M. Castiñeiras, "La Catedral de Santiago de Compostela (1075–1122): Obra Maestra del Románico Europeo," in *Siete Maravillas del Románico Español, Aguilar de Campoo* (Palencia: Fundación Santa María la Real, 2009), pp. 237–9.

Capital with Sphinxes from the Cloister of Sainte-Foy de Conques

10
Capital with Sphinxes
c. 1110
[Abbey of Sainte-Foy de Conques, cloister]
Stone
24 × 24 × 27 cm
Stone deposit of the Abbey of Sainte-Foy
de Conques, Aveyron

One of the few capitals of the largely destroyed cloister of Sainte-Foy de Conques Abbey that is still preserved. The top is decorated with two hybrid figures, virtually identical and symmetrically arranged, and two large overturned palm-leaves finishing the top corners on the sides. The design and the style of the winged creatures depicted respond perfectly to the style known as "Abbot Bégon III's workshop" (1087–1107), active in both the nave and the cloister and also responsible for the completion of his tomb. The shortness of the figures, their exaggerated heads and other details, such as the hair like a cap, quadrangular faces, pierced pupils to be filled with lead and the fact that the animal's feet are perfectly placed in the space available on a shelf, are signs of this workshop, whose characteristics, as noted on more than one occasion, can also be found in large numbers on the reliefs of the magnificent west door.

As for the iconography, the double depiction is partly human and partly animal. A female head and torso are inserted into the body of a large quadruped, whose back legs end as the claws of a bird of prey; they are joined to the trunk by an arm on one side and a large unfurled wing on the other. The result is a strange figure that produces a misleading impression. The frontal view of the capital – which is only carved on three sides – provides a mirror composition of two similar mermaid-like bird figures, with large eyes in their heads that are settled on a trunk that could well be taken for a wide neck inserted into the animal's body, and surrounded by a kind of pearly belt that looks like a necklace. The unfurled wings are attached to the bodies or necks, taking up the center of the capital in a symmetric layout. The side view of the capital changes the nature of the figures, which seem to suffer a metamorphosis into a kind of female centaur, with their hair tied back in a bun and extending their arm backwards to grab the long tail that ends in a kind of decorated cone that could be perceived as a plant.

Their attitude, the centaur shape and the long tails decorated with tassels recall the characteristic figures of Centaurs and Minotaur-centaurs in the varied bestiary carved at Auvergne workshops.[1] However, the piece from Conques is an iconographic rarity, because the fabulous being depicted has no exact parallels in contemporary sculptural production, either in appearance or in composition, although it has been interpreted as a sphinx,[2] the mythical winged lion with a human head that was female in its Greek version.[3]

The original status of the sphinx as an oriental monster partially conditioned its iconographic transmission,[4] but in the texts, the medieval idea of its nature is a direct heir of the Greek version, the female interlocutor of Oedipus. The texts by Pliny and Solinus,[5] recorded by Isidore, transformed the Theban monster into a kind of ape "with long hair and prominent breasts, docile and tamable."[6] This brief comment, contained in *The Latin Physiologist*,[7] determines the presence of the sphinx in the Bestiaries, removed from the list of fabulous hybrids and deprived of the transmission of a figured image.[8] Possibly conditioned by this absence, the incidence of the hybrid image in Romanesque sculpture is scarce and fluctuating in its conception. As representatives of the Hellenic heritage of the area, sphinxes became a motif per se for Apulian Romanesque in the eleventh and twelfth centuries, on capitals and acroteria.[9] Surprisingly, and exceptionally, an echo of these Apulian sphinxes of classical roots can be found on an acroterium in the ambulatory in the Cathedral of Santiago de Compostela (the chapel of Saint John), which we have dated around 1122–1124 in relation to the Compostela canons' journeys to the lands of Apulia.[10] However, we cannot talk about a clear or canonical example of the sphinx in French Romanesque. Quadrupeds with human heads appear in the sculptural decoration of the twelfth century, but it is difficult to ascribe them a clear identification with the mythical figure and they do not seem to fit a single model. Among the few examples, the image of the sphinx has been seen in female figures with a winged lion's body, like those forming four pairs on the faces of a capital at Saint-Pierre de Chauvigny,[11] the pair of winged lions with human faces and clothes at Saint-Loup de Naud[12] and the pair of winged bull lions with human faces on a capital from Montmajour Abbey, preserved in Arles.[13] The appearance of the Chauvigny figures, which are wearing a grooved Phrygian cap, a headdress of the bird-sirens, cannot strictly be deemed canonical judging from the long strange neck, a tight coat of mail made of scales, interpreted as an assertion of the component of the hybrid bird; the presence of the headdress, however, reinforces some oriental reminiscences that connect them with the Islamic world, in which the sphinx had found a new formulation.[14] The pair of sphinxes at Saint-Loup de Naud depict the personalization of the mythical figure, with clothing and male and female versions, like the Montmajour hybrids, which are also crowned and have lost the essential leonine element. The instability of the appearance and the absence of a model can be appreciated, firstly in the variety of mixed beings who have at one time or another formed part of the catalog of alleged sphinxes: quadruped-women with no wings – like those flanking a mermaid-fish on a capital at Saint-Germain of Mouliherne[15] – quadrupeds with female face and serpentine tail – like the figure on the upper archivolt of the south front at Saint-Pierre de Aulnay[16] – and the lion with a human face, Phrygian cap and tail

ending as a snake on the archivolt of the ancient Church of Saint-Côme de Narbonne;[17] and secondly, in those figures which were not considered as such but, however, could be part of the cast, like the winged lions with a human face on a geminate capital from the former cloister of Nôtre-Dame de la Daurade in Toulouse[18] and on an archivolt on the western doorway at Saint-Ours de Loches.[19]

The reality of the figures considered sphinxes in French Romanesque sculpture is marked by the random combination of human elements, of different sexes, with animal elements including lions, bulls and eagles, resulting in a being that is distant and dramatically close to both to a mermaid-bird and the centaur in its female version. Although in the written transmission the sphinx is not part of the same field as the mermaid or the centaur, with which it is strongly bound by its being a human hybrid, in the iconographic programs, however, its possible figurative version does share the same space with the mythological creatures of the Bestiaries they resemble and with which they are sometimes confused and interchanged. The hybrids of Conques, with evident eagle's claws embedded in a powerful four-legged body, are partly like the griffon, although it is clear that it is the human component and more specifically the female condition – conspicuously highlighted by the pearl necklace-belt and the careful hairstyle – that takes priority in these figures, which in their composition suggest the overlapping hybridization of a mermaid-bird and a centaur-woman. Like the latter, the transition between human body and animal part is marked or veiled with a decorated band and, like the mermaids, the Conques figures, seen from the front, give the impression that they lack a trunk and are menacingly spreading their wings.

The centaur and the mermaid, which are dealt with together in the Bestiaries, are associated in their meaning to sins of the flesh, and thus they frequently appear in the same figurative space

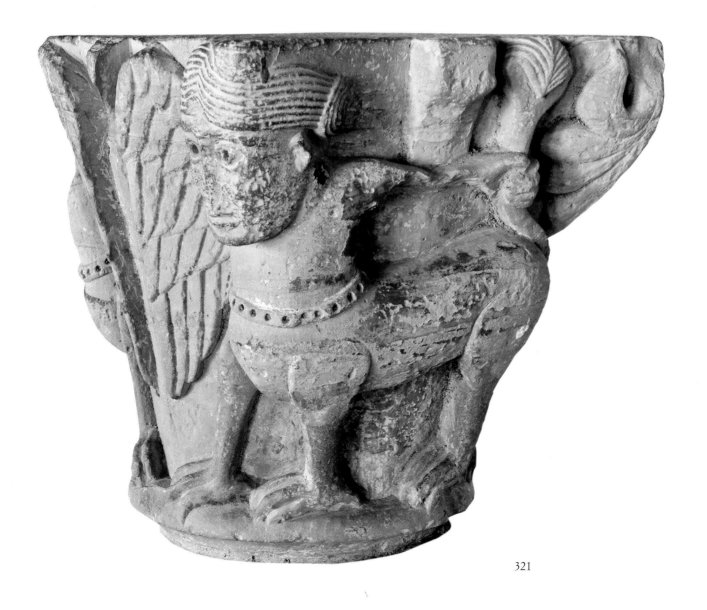

321

as on another capital of the Abbey of Conques itself,[20] within an iconographic program that recovers figures from the classical imaginarium by incorporating the presence of mythological beings that were already dangerous and lascivious in antiquity. The experiment of the figures on the capital of this cloister can be added to this, showing a creative freedom that is evident in the creation of fantastic beings in Romanesque sculpture, although the composition of the figures is possibly due in part to the technical needs of organizing a coherent decoration to cover the capital and provide a certain impression. The result is a quintessential figure of the symbol and the warning of lust, embodied in various female figures of a mixed nature. The menacing air that is sensed in the gaze of their large eyes and the unfurled wing makes them look more like harpies and lamias, concomitant beings with mermaids, with which they are often confused and sometimes take on the form of a quadruped.[21] All of them are in their own right the warning of sin, which at this time and in these iconographic programs, encloses hybrid creatures combining human features with animal traits; especially the females, which become a way of making women's underlying animal nature more obvious.

Manuel Castiñeiras (M. C.)
and Fátima Díez (F. D.)

[1] Z. Swiechowsky, *Sculpture romane d'Auvergne* (Clermont-Ferrand: G. de Bussac, 1973), pp. 289–90, figs. 370, 372, 376–9.
[2] Jean-Claude Fau defines them as "*deux magnifiques figures de sphinx ailés*," although he finds the fact they have a wing on one side and an arm on the other an anomaly due to the composition: J.-C. Fau, *Les Chapiteaux de Conques* (Toulouse: É. Privat, 1956), p. 96. Durliat simply says the hybrids are not so strange: M. Durliat, *La sculpture romane de la route de Saint-Jacques de Conques a Compostelle* (Paris: Comité d'études sur l'histoire et l'art de la Gascogne Mont-de-Marsan, 1990), p. 422.

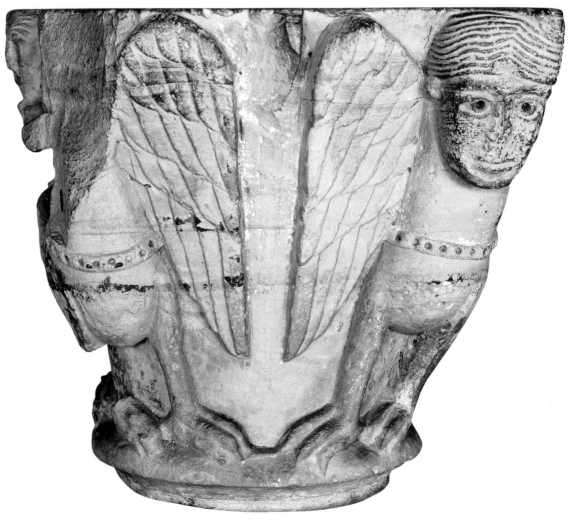

[3] The sphinx is a hybrid of eastern origin, initially masculine, which came into the Greek imaginarium in the oriental period (the seventh century BC). The figure became feminine in Greece and was thus transmitted through Rome and Byzantium down to our own days. On the sphinx in the ancient world cf. "Sphinx" in the *Lexicon Iconograficum Mythologiae Classicae (LIMC)*, vol. 8:16 (Zurich: Artemis, 1994).

[4] Islamic art adopted the image of the sphinx as a feminine hybrid and it was thus transmitted again to the West through Sassanid Persia. For sphinxes in the Islamic world cf. Baer, *Sphinxes and Harpies in Medieval Islamic Art: An Iconographical Study. Oriental Notes and Studies*, 9 (Jerusalem: Israel Oriental Society, 1965).

[5] Gaius Plinius Secundus, *Historia Natural*, M. J. Cantó, Spanish trans. I. Gómez Santamaría and S. González Marín (Madrid: Ediciones Cátedra, 2002), 8:21. Towards the middle of the third century the geographical parts were summarized by Solinus: ibid., 27:59.

[6] Saint Isidore of Seville, "Ethym," in *Etymologiae*, ed. M. C. Díaz y Díaz, vol. 2:2 (Madrid: Biblioteca de Autores Cristianos, 1982), XII, 2:32.

[7] *El Fisiólogo. Bestiario Medieval*, trans. M. Ayerra Redin and N. Guglielmi (Buenos Aires: Eudeba, 1971), XXII. *The Physiologist* is the first known bestiary; the original text was written in Greek but is lost, and the translation referred to is from a fifth-century Latin source. This text is representative of the medieval spirit and dates to the second or third century. Attributed among others to Saint Jerome, Origen and Athanasius, it was the source of numerous similar books throughout the Middle Ages.

[8] In the section devoted to apes in some Bestiaries from the second family, like *Ms. 764* at the Bodleian Library, the sphinx can be seen in the company of a satyr with a similar consideration. The mention is accompanied in this manuscript by a curious illumination which might be an unusual image of a hybrid converted into a primate: Richard H. Barber (ed.), *Bestiary: Being an English Version of the Bodleian Library, Oxford MS Bodley 764* (London: Folio Society, 1992), pp. 49–50.

[9] An acroterium in the ambulatory of the Cathedral of Santiago de Compostela (the chapel of Saint John) is shaped like a sphinx that could be related to the Apulian repertoire: M. Castiñeiras, "La catedral románica: tipología arquitectónica y narración visual," in M. Núñez (ed.), *Santiago, la Catedral y la Memoria del arte* (Santiago de Compostela: Consorcio de Santiago, 2000), p. 77.

[10] Especially some like those in the Cathedral of Bitonto: F. Moretti, *Specchio del mondo. I "bestiari fantastici" delle Cattedrali: la cattedrale di Bitonto* (Fasano di Brindisi: Schena, 1995), p. 216.

[11] Y. Labande-Mailfert, *Poitou romane* (Yonne: Zodiaque, 1961), fig. 41.

[12] A pair of bird and quadruped hybrids with human heads; the masculine figure looks like a monk, with an obvious hood, and the feminine one has a headdress like a nun or mistress. They are seated in a space over the heads of the doorway's jambs. Leclercq thinks they are sphinxes sharing space with mermaids: J. Leclercq-Marx, *La Sirène dans la pensée et dans l'art de l'Antiquité et du Moyen Âge: du mythe païen au symbole chrétien* (Brussels: Academie Royale de Belgique, 1997), p. 158.

[13] The cloister at Saint-Trophime de Arles: *Poitou romane*... op. cit., p. 358.

[14] Fatimi art is responsible for the transmission of a type of crowned sphinx, in an active, rampant attitude or in sinuous movement, found in illustrations like those in manuscript IV F 3 at the National Library in Naples, which holds the *Metamorphosis* of Ovid copied in Bari: G. Orofino, "L'illustrazione delle *Metamorfosi* di Ovidio nel Ms. IV F 3 della Biblioteca Nazionale di Napoli," *Ricerche di Storia dell'Arte*, 49 (Rome: 1993), p. 13.

[15] Two seated quadrupeds with a female torso, whose femininity is underlined in their large breasts, careful hairstyle and the necklace one of them is wearing; Debidour thinks they are sphinxes and Leclercq-Marx centaurs: V.-H. Debidour, *Le bestiaire sculpté du Moyen Âge en France* (Paris: Arthaud, 1961), fig. 329. *La Sirène dans la pensée et dans l'art de l'Antiquité et du Moyen Âge: du mythe païen au symbole chrétien...* op. cit., p. 184.

[16] *Le bestiaire sculpté du Moyen Âge en France...* op. cit., fig. 277.

[17] Ibidem, fig. 1. The figure is more like the illustration of the manticore, the fabulous animal of eastern origin with a human face, lion's body and a tail ending in a scorpion's sting, described in the Bestiaries. As a hybrid of a lion with a human head it is often assimilated to the sphinx.

[18] *La Sirène dans la pensée et dans l'art de l'Antiquité et du Moyen Âge: du mythe païen au symbole chrétien...* op. cit., p. 145, fig. 84: described as a centaur, despite its lion's mane and wings.

[19] A winged lion with a mane on its neck, a woman's head, hair like the devil and a long tail placed like on the figures at Conques, ending in a large bun like a pine cone. Ibidem, p. 249, fig. 23: it is not explicitly considered as a sphinx.

[20] *La sculpture romane de la route de Saint-Jacques. De Conques à Compostelle...* op. cit., p. 57, fig. 74. The topic of centaurs and mermaids, and their figuration and meaning is exhaustively analyzed in *La Sirène dans la pensée et dans l'art de l'Antiquité et du Moyen Âge: du mythe païen au symbole chrétien...* op. cit. pp. 149–54.

[21] See the interesting comment in ibidem, pp. 99–102.

Capital with David and his Musicians at Sainte-Foy de Conques

11
Capital with David and his Musicians: Moulding
c. 1100
[Abbey of Sainte-Foy de Conques, cloister]
Limestone from the Causse Comtal
23 × 33 × 21 cm
Musée Joseph Fau, Conques

12
Capital with David and his Musicians: Cornice
c. 1100
[Abbey of Sainte-Foy de Conques, cloister]
Limestone from the Causse Comtal
13 × 53 × 32 cm
Musée Joseph Fau, Conques
DAVID + IDITHVN [David and Jeduthun]
EMAN + ASAPH [Heman and Asaph]

Capital from the cloister of Sainte-Foy de Conques Abbey. The cloister, located to the south of the abbey church, largely disappeared in the early nineteenth century; only two small arcades were left standing in the east, providing access to the former Chapter house, together with six geminate openings communicating the western gallery with the monks' old refectory. However, thirty capitals were preserved from the destroyed arcades, shared out between the old refectory and the lapidary room in the basement of the Musée Joseph Fau, where the pieces we are currently analyzing are kept.

On the capital moulding two lively scenes of music and dance are depicted, each consisting of three characters: two musicians in the corners, identified by an inscription on the cornice, and a funny jester in the middle. On the back, the musician on the left, David, is playing a fiddle with a bow, while on the right, Jeduthun plays a crwth; on the back side, Heman plays a pear-shaped fiddle, while Asaph plays a horn topped by an animal head. This is the well-known theme of David and the musicians responsible for the cult of the Ark of the Covenant, once it was transferred to the new capital, Jerusalem: "David told the heads of the Levites to appoint their kinsmen as singers with the accompaniment of musical instruments, harps, lyres and cymbals to play joyfully. The Levites appointed Heman son of Joel, Asaph son of Berechiah, one of his brothers, Ethan son of Kushaiah, one of their Merarite kinsmen [...]" (1 Chronicles 15:16–17). The Bible then tells how when the Ark was placed in the Tabernacle and sacrifices were offered, Jeduthun is also mentioned: "Heman and Jeduthun were with them, and the trumpets and cymbals for those who played them, and the instruments for chants in honor of God." Although it has been repeatedly compared with the capital of the same theme in the southern gallery of the cloister of Moissac (1085–1110),[1] whose immediate echo was a copy of the destroyed cloister of the Priory of La Daurade (c. 1100–1110)[2] – conserved at the Musée des Augustins in Toulouse – the Conques piece shows a series of thematic, compositional and stylistic peculiarities, which grant it an undeniable

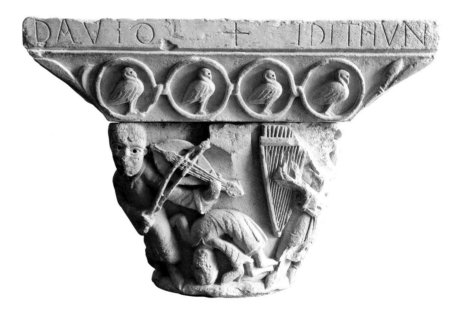

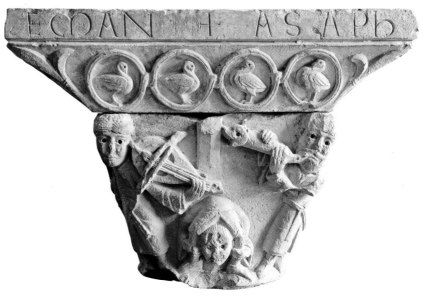

personality. At Moissac, David is seated and canonically flanked by his four musicians – Asaph, Heman, Ethan and Jeduthun; the inscriptions are *tituli* of a narrative type, accompanying the characters on the moulding. The group is divided, loosely, over the four faces of the capital. By contrast, in Conques the narrative focuses on the front and back sides, as if they were reliefs on a frieze; the number of accompanying musicians is reduced to three; and the nature of the scene, with David standing, and the addition of two acrobats doing somersaults, seems more like a minstrel event. This worldly nature is not surprising, as it is justified by the Bible passage that explains how David leapt and danced before the Ark on its arrival in Jerusalem (1 Chronicles 15:29). Moreover, this free and festive spirit characterized the iconography of liturgical-musical manuscripts in the first half of the eleventh century, like the well-known *Tropario-tonario de Auch*,[3] where the modes or tones of Gregorian Chant – required for the proper practice of the Benedictine chanting – were illustrated through figures such as David strumming a stringed instrument or horn players with jugglers, while the response for the Alleluia was assisted by the image of a swirling dancer.[4] We should not forget, however, that this casual nature, so close to the viewer, with recourse to issues of everyday life, is characteristic of the so-called "Abbot Bégon III's workshop" (1087–1107), as can be seen on other capitals from the cloister, where warriors and builder monks are also depicted. In this case, the Davidic mention of the Ark of the Covenant and the imminent construction of the Temple of Jerusalem become a striking musical and festive scene, no stranger to certain contemporary rites of the abbey. According to the *Liber Miraculorum Sancte Fidis*, novices at Conques played olifaunt horns to remind the faithful of the sacred nature of the procession of the saint's relics both on her feast day and during the processions of the "Treasure" through the lands of Saint Faith in Auvergne: "*Parmi les jeunes novices, les uns portent les livres des Evangiles et l'eau bénite, les autres frappent sur les cymbales ou sonnent des olifants, sorte de cors d'ivoire que les nobles pèlerins ont offerts au monastère en guis de décoration.*"[5] In fact, Asaph is playing a horn or cornamuse, topped with an animal head, which may well recall the role played by these instruments in such ceremonies, so characteristic of pilgrimage centers.

For the dating of Conques cloister we have a series of privileged texts indicating its completion before Bégon III's death in 1107. So says the chronicle of the abbey itself – *Bego venerabilis qui claustrum construxit*,"[6] the Leonine hexameters of his epitaph – "HOC PERAGENS CLAUSTR/VM: QVOD VERVUS/TENDIT AD AVSTRUM,"[7] as well as the pentagonal lintel found in a house in Molinols, near Conques, which

feasibly comes from the monastic dependencies. A cross stands out on this piece, together with the Alpha and Omega, which probably allude to a consecration in the year 1100: "[ANNO AB IN]CARNATIONE DOMINI: MILLESIMO: C: TE[RTIO] [The year of the Incarnation of the Lord 1100, the third day before...]."[8] If the cloister was finished at such an early date, this reopens the controversial dating of the west front of the abbey church,[9] whose grammar and formal repertoire – such as the use of a squat canon, hair like a cap, faces and pierced pupils filled with lead, the layout of the three-quarter bodies on a shelf and the structure in a narrative frieze – repeat many of the formulas of the Bégon III workshop and in particular, of this capital. Thus, on the front, a devil removes a musician's tongue while snatching a psalterium from his hands, very similar to Asaph's, in order to stop him from singing the praises of God.[10] In the same way, in Hell, the feminine figure who rides on the shoulders of a man, recalls in some ways the contortionist scheme of the capital, which places its own head between its legs.

M. C.

[1] Q. Cazes and M. Scellès, *Le cloître de Moissac* (Burdeos: 2001), no. 28, pp. 110–1.

[2] K. Horste, *Cloister Design and Monastic Reform in Toulouse. The Romanesque Sculpture of La Daurade* (Oxford: 1992), p. 90, fig. 22.

[3] BnF~Bibliothèque nationale de France: *Tropario-tonario de Auch* (Ms. Lat. 1118).

[4] M. Castiñeiras, "El concierto del Apocalipsis en el arte de los Caminos de Peregrinación," in C. Villanueva (ed.), *El sonido de la piedra. Actas del Encuentro sobre instrumentos en el Camino de Santiago* (Santiago de Compostela: Xunta de Galicia, 2005), pp. 119–64, esp. p. 123.

[5] "*Liber Miraculorum Sancte Fidis*," in L. Servières and A. Bouillet, *Saint-Foy. Vierge et martyre d'Agen* (Agen: Impr. moderne, 1901), II, 4, p. 508.

[6] "*Chronicon monasterii Conchensis*," in E. Martène-Durand (ed.), *Thesaurus novus anecdotorum* (Paris: Lutetiae Parisiorum, 1717), II, col. 1390. M. Aubert, "Conques-en-Rouergue," in *Congrès Archéologique de France* (Paris: A. et J. Picard, 1938), pp. 459–523, esp. p. 464, no. 1.

[7] *Corpus des inscriptions de la France médiévale*, eds. M. Favreau, B. Leplant and J. Michaud, 23 vols. (Paris: CNRS~Centre d'Études Supérieures de Civilisation Médiévale, 1974–2008), pp. 34–6.

[8] F. de Gournay, P. Lançon, "Une inscription romane inédite à Conques," *Revue de Rouergue*, 31 (Rodez: 1992), pp. 367–70, esp. p. 369.

[9] J. Wirth, *La datation de la sculpture médiévale* (Geneva: 2004), pp. 201–42. M. Castiñeiras, "Da Conques a Compostella: retorica e performance nell'era dei portali parlanti," in A. C. Quintavalle (ed.), *Medioevo: Immagine e Memoria* (Milan: Electa, 2009), pp. 233–51.

[10] C. Frugoni, "La rappresentazione dei giullari nelle chiese fino al XII secolo," in *Il contributo dei giullari alla drammaturgia italiana delle origini, Atti del II Convegno di Studio, Viterbo, 1977* (Rome: Bulzoni, 1978), pp. 113–34, esp. p. 114.

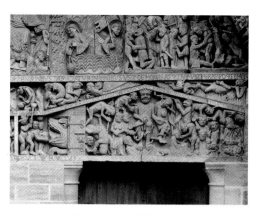

Tympanum *[Western door, detail]*
c. 1103–1107
Abbey Church of Sainte-Foy de Conques, Aveyron

Dintel *[Cloisters, Abbey of Sainte-Foy de Conques]*
1100
Molinols-Conques, Aveyron

Liber Miraculorum Sanctae Fidis

13
Liber Miraculorum Sanctae Fidis
c. 1095
[Sainte-Foy de Sélestat, priory]
Parchment (Carolingian minuscule)
32.5 × 21.5 cm
Bibliothèque Humaniste Sélestat, Lower Rhine

Page 327: *Folio 5v, detail*

Towards the end of the first millennium, Rouergue, a wooded region in the center of France, was proud of its significant historical presence on the European stage, thanks above all to the lords of Rodez and an abbey that soon became exceedingly popular: Conques. The links with Compostela and the roads of pilgrims on their way to Galicia were already sound and had become even tighter over time. Around 955–960, according to the *Liber Miraculorum Sanctae Fidis*, the Count of Rouergue made the pilgrimage to Santiago. Almost thirty years later, his son Raymond gave the monks of Conques a marvelous silver saddle in gratitude for the victory obtained over the Saracens near Barcelona. The saddle was later made into a cross. Towards 1077, Peter of Andouque, a monk from Conques, became Bishop of Pamplona in Navarre, while in 1100 Pontius, a colleague of his, obtained the same rank in Barbastro,[1] Aragon; both regions are among those that took an active part in the Reconquest of the country from the Arabs. The name of the young virgin of Conques,[2] used as a war cry, became a song of victory; a new cult that was destined to last spread out over the lands conquered from the Arabs;[3] the first priories were built while the mother abbey grew with territorial donations and a spectacular, grandiose[4] and unique treasure of reliquaries; from inside arose all of a sudden the *Majestas Sancte Fidis*[5] as the piece that more than any other drew the attention and amazement of the crowds. It was a magnificent statue, like an ancient idol in appearance, but containing a powerful relic[6] capable of protecting, helping and fighting to defend their world. The *Liber Miraculorum Sanctae Fidis* is, to all effects and purposes, the irreplaceable and surprising key to the reading of this relic and what tells us its whole story. The beginning of the *Liber* was written with the intention of recording the deeds of one specific virgin, whose head is locked up in an extraordinarily beautiful golden statue, ready to "take the arena" for her devotees. The book was written preferably for those people who intended or were thinking of setting out on the direct experience of pilgrimage. Parchment codex Ms. 22 at the Bibliothèque Humaniste de Sélestat,[7] dating from the late eleventh century, contains an excellent example of the *Liber Miraculorum Sanctae Fidis*.[8] The structure and particular care it was copied with immediately identify it as the "official" text, due to the wealthy liturgy it includes. The manuscript contains a series of Latin texts written from the eleventh to the fourteenth century in honor of Saint Faith, the young virgin venerated at Conques, together with hymns to Saint Nicholas and Saint James the Elder,[9] and official documents from the priory of Sélestat. In fact, the emerging cult of Saint Faith is directly mentioned in the opening hymns,

reproduced with musical notes (fols. 2r–4r), the text of the *Passio sancte Fidis virginis et martiris...* (fols. 5v–7v),[10] the translation of the relics, in prose (fols. 8r–12r) and in verse (fols. 12r–12v); followed by the office of Saint Faith (fol. 12v); the *Liber Miraculorum*, the story of the miracles, making up the largest section (fols. 15r–104v), and two sermons for the feast day of Saint Faith (fols. 105r–106v and 107r–108v). In the text of the bull (false) by Pope Paschal II (1106), copied at the beginning of the manuscript (fol. 1r), an important reference for the history of the tradition of the *Liber Miraculorum Sancte Fidis* is the ecclesiastical authorization that explicitly contemplates its reading within the rites. There is also a note (fol. 13r–13v) related to the dissemination of the description of the miracle for the founding of the priory of Sélestat.[11]

The *Liber Miraculorum* of Sélesat consists of four parts written by two different authors; according to the note on fol. 64v, the first two were written between 1013 and 1020 by Bernard of Angers, and the others by an anonymous monk, most probably from Conques. There are clear differences between the two sections, despite an evident will in the monk who compiled the definitive books to extend and consolidate, at least partially, the hagiography that was already written. Among the most obvious differences we could cite the diverse positions taken by the two authors about the spectacular statue or *Majestas Sancte Fidis*;[12] the powerful "symbol" that pilgrims discovered on their first visit to Conques with such force that it remained etched into their memories. In fact, the statue is mentioned numerous times as a main *lietmotiv* in the part of the text attributed to Bernard of Angers, while it almost completely "disappears" in the continuation. Mention is made in I:13 of the precise description of the processions through Aveyron and Rouergue, all the miracles that occurred as it passed by, the enthusiastic applause of the multitudes when they saw it, the waits while it was taken to synods, and the restitution of goods and the criticisms by its opponents.

It should be pointed out that the first book begins with descriptions of the three types of interventions characteristic of Saint Faith: curing the blind, resurrecting dead animals and the defense and guardianship of monks.

In the following section of *Liber* I, from the "Sermon" to the "Epistle," there are three further particular reasons to complete the essence of the cult to the Virgin of Conques: punishing unworthy sinners, freeing prisoners and protecting pilgrims.

And yet, as for the evident difference between the first two books and what follows – significant from the point of view of the history of the text, because it is characteristic of a different time of composition – it is not so evident for the

ancta
suum ciuita
clarissimis. s
lumna loc
inpassionis
& generosa
munere nob
candida inc
xpo odorem

namq; prima incuitate agenno. decus
cunctis fidelibus xpi fuit. Yrram namq;
ut possidet etiam. quia abipsis insacie
dilexit & suum sep dixit ee auctorū. Inuenī

reader of the *Liber* due to the uniform figurative language, used after the second round of miracles, completing the reading. Without going into the problems involved in the miniature workshop, it is important, nevertheless, to at least allude to the most interesting iconographic problem, i.e. the typology of the depictions of the saint they are devoted to. In fact, in the codex, Saint Faith is described in the text of different episodes in books I, II, III and IV, but the type of illustration accompanying some of them seems to proceed from an interpretation that is clearly different and unique. The image of the young maiden, elegant, wearing wide-sleeved clothes, a long veil, jewels and matching head-dress, that we find so often repeated in the corpus of the *Liber Miraculorum*, was taken up by the artist, who depicted this type in e.g. the illustration on folio 5v: where the author of the text holds up the *Liber Miraculorum*, offering it towards the stand of a medieval theater on which stand Saint Faith (dressed as described above), Saint Caprasius, her companion in martyrdom, and the pagan Dacian.[13]

The texts of the *Liber*, however, describe many different models of the saint's garments when she appears in the events narrated, including the most typical for her figure; these were not noticed by the illustrator.[14]

One of the most curious images, and in my opinion one of the most significant, is the one accompanying the miracle at I:30. The illustration shows a young girl with a long flowing dress, with wide sleeves, holding a sharp-pointed pilgrim's staff in her hand. She is wearing a broad hat on her head and a broad and elegant belt round her waist. This image is significant, as it is the first, after a lengthy series of characteristics and fantastic fitomorphic depictions, to show a human figure illustrating a miracle. The event described here effectively

required a special depiction, as it is clearly a variation on one of the most typical miracles of Saint James the Elder: the hanged person escaping from the noose. In the illustration, the pilgrim's staff has a sharp point like a soldier's lance, ensuring readers of both the force of her protection and the defense of a "road." The same sense of struggle is expressed again in the two illustrations which are not fitomorphic and complete the reading of the miracles in books III and IV. In these two examples, the image is not linked to any specific moment of the appearance of Saint Faith in the stories. In both drawings, the saint is portrayed with an elegant figure, a long dress tied at the waist, with wide sleeves, and long hair falling down over her back; she is holding the tail of a fallen dragon, in the former; the same pilgrim's staff as mentioned above, piercing the belly of the monster, in the latter. The victory over the dragon was, in the language of imagination, the sublime sign of angels' great power.

And so, in truth, the illustrations taken as a whole seem to show only the latest moment in the evolution of the cult, which gradually transformed a sweet little girl, in love with her "games," into a soldier capable not only of fighting, but also of leading anyone who wished to follow her to victory. When the *Liber Miraculorum Sancte Fidis* of Sélestat was illuminated, the prayers and hope of those who prayed to the young Faith had deteriorated into a controversy over territorial defense along the roads leading to Santiago de Compostela, affecting not only Roncesvalles, but also Catalonia and Navarre. Faith's walking staff, which she had grown used to leaning on during her weary journeys, had become a sword; the images in the *Liber* brought on all the immediate consequences and tensions of these last epic gestures.

Marco Piccat (M. P.)

1 J. M. Lacarra, J. Uría Ríu and L. Vázquez de Parga, *Las peregrinaciones a Santiago de Compostela*, 3 vols. (Madrid: CSIC~Consejo Superior de Investigaciones Científicas, 1948–1949; reed. fac. Pamplona: Gobierno de Navarra, 1992), p. 466.

2 M. D. Dauzet, *Petite vie de sainte Foi* (Paris: Desclée de Brouwer, 2002).

3 For the text of the poems inspired by the saint, see A. Thomas (ed.), *La chanson de sante Foi d'Agen, poème provençal du XI^e siècle, édité d'après le manuscrit de Leide* (Paris: É. Champion, 1925). J. de Cantalausa (ed.), *La chanson de sainte Foi. Un miracle de sainte Foi* (Conques: Annales du Midi, 1985). R. Lafont (ed.), *La Chanson de Sainte Foi, texte occitan du XI^e siècle* (Geneva: Droz, 1998). M. Piccat, "Une autre chanson occitane? La Légende de sainte Foy représentée en peinture murale dans l'abbatiale de Conques," *Revue du Rouergue*, 87 (Rodez: 2006), pp. 311–26.

4 A. Darcel (ed.), *Trésor de l'église de Conques* (Paris: Musée du Louvre, 1861).

5 J. Hubert, "La majesté de Sainte-Foy de Conques," in *Bulletin de la Société nationale des antiquaires de France* (Paris: 1943–1944), pp. 391–3. R. Rey, "La sainte Foy du trésor de Conques et la statuaire sacrée avant l'an mille," *Pallas IV,* year 5, 3 (Toulouse: 1956), pp. 99–116. J. Taralon, "La majesté d'or de Sainte-Foy du trésor de Conques," *Revue de l'Art*, 40–41 (Paris: 1978), pp. 9–22.

6 J. Hubert and M. C. Hubert, "Piété chrétienne ou paganisme? Les statues-reliquiaires dans l'Europe carolingienne," in *Cristianizzazione ed organizzazione ecclesiatica delle campagne nell'alto medioevo: espansione e resistenze* (Spoleto: Centro italiano di studi sull'alto medioevo, 1982), pp. 237–75.

7 Facsimile version in *Liber Miraculorum Sanctae Fidis* (Sélestat: Amis de la Bibliothèque Humaniste de Sélestat, 1994). For the French translation, see *Livre de Miracles de Sainte Foy 1094–1994*, trans. R. Walter (Sélestat: Amis de la Bibliothèque Humaniste de Sélestat, 1994).

8 For an edited text, see L. Robertini (ed.), *Liber Miraculorum Sancte Fidis* (Spoleto: Centro italiano di studi sull'alto medioevo, 1994).

9 For Saint James, apart from the part of the hymn on folio 1v, also "*Gratulemur detemur summa cum leticia et iocunda gaudeat Ispania*" (fol. 5r), and for Saint Nicholas, "*Congaudentes exultemus vocali concordia…*" (fol. 4v).

10 For a debate about the possible sources and variants of the Passion, it is still useful to see P. Alfaric and E. Hoepffner (eds.), *La Chanson de Sainte Foy* (Paris: Société d'édition Les Belles Lettres, 1926), pp. 179, 355–7.

11 J. Gény, *Geschichte der Stadtbibliothek zu Schlettstatt* (Strasbourg: Schlettstadt, 1889). Id., *St. Fidis-Büchlein* (Strasbourg: Schlettstadt, 1894).

12 A. Bouillet, *L'église et le trésor de Conques (Aveyron). Notice descriptive* (Rodez: P. Carrère, 1905). M. M. Gauthier, "Le trésor de Conques," in *Rouergue roman* (La Pierre-qui-Vire: Zodiaque, 1963), pp. 98–187. E. Gaborit-Chopin, "Majesté de sainte Foy," in id. and D. Taburet-Delahaye (eds.), *Le trésor de Conques* (Paris: Musée du Louvre, 2001), pp. 18–24.

13 A. Mandach, "La Chanson de Sainte Foi en occitan: chanson de geste, mystère ou théâtre de danse?," in *La vie théâtrale dans la provinces du Midi. Actes du II^e Colloque de Grasse* (Tübingen: Gunter Narr, 1980), pp. 33–45.

14 M. Piccat, "Santa Fe de Conques y la tradición épica," in P. Gaucci (ed.), *Visitandum est. Sactos y Cultos en el Codex Calixtinus. Actas del VII Congreso Internacional de Estudios Jacobeos* (Santiago de Compostela: Xunta de Galicia, 2005), pp. 213–34.

Abbot Bégon III's Portable Altar

14
Abbot Bégon III's Portable Altar
1100
[Abbey of Sainte-Foy de Conques]
Porphyry, silver, filigrees
25 × 16 × 4.3 cm
Treasure of the Abbey of Sainte-Foy de Conques,
Aveyron

ANNO AB INCARNATIONE DOMINI MILLESIMO
C[ENTESIMO] /SEXTO KALENDAS IULII DOM[I]NUS
PONCIUS BARBASTRENSIS / EPISCOPUS ET SANCTE
FIDIS VIRGINIS MONACHUS / HOC ALTARE BEGONIS
ABBATIS DEDICAVIT / ET DE + [CRUCE] CHR[IST]I ET
SEPULCRO EIUS MULTASQUE / ALIAS SANCTAS
RELIQUIAS HIC REPOSUIT [In the year 1100 since
the Incarnation of our Lord, on the sixth day
before the calends of July (26 June), Ebontius,
Lord Bishop of Barbastro and monk of the virgin
Saint Faith, dedicated this altar belonging to
Abbot Bégon and placed in it relics from the
Cross of Christ and his Sepulchre as well as many
other holy relics]
S[ANCTUS] PAULUS; S[ANCTA] CECILIA; S[ANCTA]
MARIA; IHESUS; S[ANCTA]FIDES; S[ANCTUS]
VICENTIUS; S[ANCTUS] PETRUS / S[ANCTUS]
ANDREAS; S[ANCTUS] IACOBUS; S[ANCTUS]
IHOHANNES; S[ANCTUS] THOMAS / S[ANCTUS]
MATIAS; S[ANCTUS] LUCAS; S[ANCTUS] MARCUS;
S[ANCTUS] CAPRASIUS; S[ANCTUS] STEPHANUS;
S[ANCTUS] TADDEUS; S[ANCTUS] SIMON /
S[ANCTUS] MATHEUS; S[ANCTUS] BARTOLOMEUS;
S[ANCTUS]PHILIPUS; S[ANCTUS] IACOBUS

Below: *Side view*
Page 333: *Top view*

Bégon's altar is a small solid object consisting, on the top, of a slab of red porphyry set in silver bands. The greatest part of its figurative decoration is to be found on its sides, embellished with two strips of gilded, engraved and nielloed silver, each measuring 41 cm long by 43 mm high, and each covering a long and a short side. The first is bent at the bottom right corner, the second at the top left corner. Each of these two strips features eleven half-length figures placed under archways: four on the short sides and seven on the long. These figures are: Jesus and Mary; the twelve Apostles named in the Gospels according Saint Matthew and Saint Mark, and as completed in the Acts of the Apostles; the two non-apostolic evangelists, Luke and Mark; Paul; the martyrs of Agen, Saint Faith and Saint Caprasius; and finally three saints, two male and one female, who were the object of particular veneration at Conques: Saint Cecilia, Saint Vincent and Saint Stephen.

The layout of these figures was very carefully planned, especially on the two long sides: both of them are organized in the same symmetrical manner in relationship with a principal character located in a prominent position in the center of the composition. Thus, on the first of these sides, the central figure is Christ blessing, surrounded by Mary and the saints Faith, Cecilia and Vincent, and finally by Peter and Paul, the twin pillars of the church. On the opposite side it is Caprasius, the Bishop-Saint from Agen who suffered martyrdom just after Faith, who is in the center, surrounded by Mark and Stephen, Luke and Thaddeus and finally Matthew and Simon.

Out of all these figures, only one is portrayed in a strictly frontal manner, namely Christ, and there is also only a single figure in strict profile, this time that of Bishop Caprasius. All the other figures are shown in three-quarter view. Mary and Faith, each symmetrically placed on one side of Christ, share the same attributes: they are both wearing wrought gold crowns on their heads and holding, under a veil, another crown of a different texture. Cecilia is uncrowned. This is a deliberate choice made by the person who commissioned the work, who wished to elevate Faith to the same rank as Mary.

It can be observed that the two nielloed strips, although of equally fine and delicate design, were done by two different craftsmen, both experts, the one responsible for the side on which Christ is surrounded by Mary and Faith being more skilful than the other.

The style cannot be compared to that of any of the other works that once belonged to Abbot Bégon; here a deliberate effort has been made to individualize the main figures, contrasting strongly with the stereotyped nature of the secondary characters. In vain can we attempt to find any similarity between this and all the other works in Conques. On the other hand, both the style and certain elements of the decorative syntax evoke the work of goldsmiths from Germany or northern Italy, evidence of the cultural exchanges between the leading centers of Christianity of the time. The Novara gospel book binding[1] or the Hildesheim portable altar[2] immediately spring to mind.

However, when it comes to comparing the iconography of Bégon's altar with that of other contemporary portable altars, we have to say

that the central theme chosen for the former is in many respects unique and original. Instead of making reference to the sacrifice of Christ or extolling his glory, it emphasizes the spreading of the Good Tidings by the Apostles and Evangelists and lays stress on the martyrs of Agen. In so doing, it reveals the eminence of Saint Faith and her place in the liturgy of Conques: Abbot Bégon had in fact obtained the permission of the Pope to mention the saint in the Canon of the Mass.

The top of the altar consists of a slab of porphyry framed to the left and right by two identical slim embossed silver bands, whilst at top and bottom it bears an engraved and nielloed inscription and above and below these, respectively, two partially gilded bands of filigree silver.

The dedicatory inscription reveals, not without some subtlety, Bégon III's care to affirm his autonomy as well as the territorial claims of Bishop Ebontius, who we learn from the inscription had been a monk at Conques and was made Bishop of the diocese of Ribagorza-Barbastro, with its see in Roda de Isábena, Upper Aragon, in 1097. Although nothing is known of Ebontius' life before he became a Bishop, it is feasible to think that Bégon III was not totally alien to the former's appointment, since two decades previously one his predecessors had placed Pierre d'Andouque, another monk at Conques, on the episcopal throne of Pamplona. The Rouergian abbey was then at the height of its power and enjoyed numerous links with the north of Spain: was not one of the chapels of the ambulatory of Santiago de Compostela Cathedral indeed consecrated to Saint Faith?

Seen within its context, the inscription on Bégon's altar is particularly instructive. First, the fact that Bégon III had chosen a Bishop from outside his own ecclesiastical region to consecrate a portable altar for him is clear evidence of his desire for emancipation from the local ecclesiastical hierarchy. Furthermore, we know from other sources that in April 1100 Ebontius was in Rome with Pope Paschal II and that the latter ordered a fragment of the True Cross to be sent to Conques. Two months later Ebontius was in Conques (without having had time to visit his diocese) and a fragment of this relic had been placed in the portable altar, as its inscription reveals: this leads us to think that it was Ebontius himself who brought the precious relic to Conques. Finally, at the time when Ebontius was in Conques, Barbastro was still in the hands of the Moors. By proclaiming himself as Bishop of the Diocese of Barbastro, or, to be more precise, of the inhabitants of the region of Barbastro (*barbastrensis*), Ebontius was affirming his wish to retake possession of that area of territory once it had been regained, much to the prejudice of the Bishops of Urgell, Huesca and Jaca, who also coveted it. This is exactly the reason why Ebontius had gone to Rome: to obtain confirmation of his rights over Barbastro. And in this way a simple dedicatory inscription reveals itself to be a political manifesto.

Apart from the unusual thickness of Bégon's altar (half-way between that of slab altars, such as the Hildesheim portable altar, in which only the upper and lower surfaces are decorated, and that of block altars, such as the Stavelot portable altar,[3] in which the decoration of the sides is

given its full importance, as is the case here), its bottom is made of base metal, with no decoration whatsoever: an exceptional detail for a portable altar, but one that it shares with other objects in the treasury at Conques. There is a further detail: the silver strips that edge the slab of porphyry are dissimilar, and the altar itself is not homothetic with the stone. Now, almost all known portable altars are decorated in a more coherent and homogeneous fashion, with the notable exception of the other portable altar in the Conques treasury, that of Saint Faith, which all authors from Auguste Bouillet onwards agree was assembled at a later date, combining elements from several different periods.

The condition of the various elements that constitute the portable altar varies considerably: the nielloed inscription is in excellent surface condition, as are the two strips decorating the sides of the altar slab. The same cannot be said, however, of the bands to left and right on the top, and even less so of the filigree silver bands, which are badly damaged: almost none of the cabochons remain in place (the settings in which they were fixed have all disappeared), and a large proportion of the filigree work itself has become detached. This gives the impression that

Bégon's altar, as it appears to us today, is in all probability a reasonably faithful reflection of the original appearance of its main components (the porphyry slab, the dedicatory inscription and the two filigree bands along the sides), whilst its secondary elements would be the result of a later modification (which we suggest occurred in the mid-fourteenth century[4]). On that occasion – or indeed on a different one – it may have lost its bottom facing, and even its feet, if it ever had any.

It is therefore no easy matter to reconstruct with certainty the original condition of Bégon's altar (which is also true of many other objects in the Conques treasury). However, what does seem sure is that the rather unconventional nature of its current appearance goes back, at least in part, to its origins.

Emmanuel Garland (E. G.)

[1] Musée National du Moyen Âge, Paris.
[2] V&A~Victoria & Albert Museum, London.
[3] Musée Royaux d'Art et d'Histoire, Brussels.
[4] E. Garland, "L'art des orfèvres à Conques," *Mémoires de la Société archéologique du Midi de la France*, 60 (Paris: 2000), pp. 83–114.

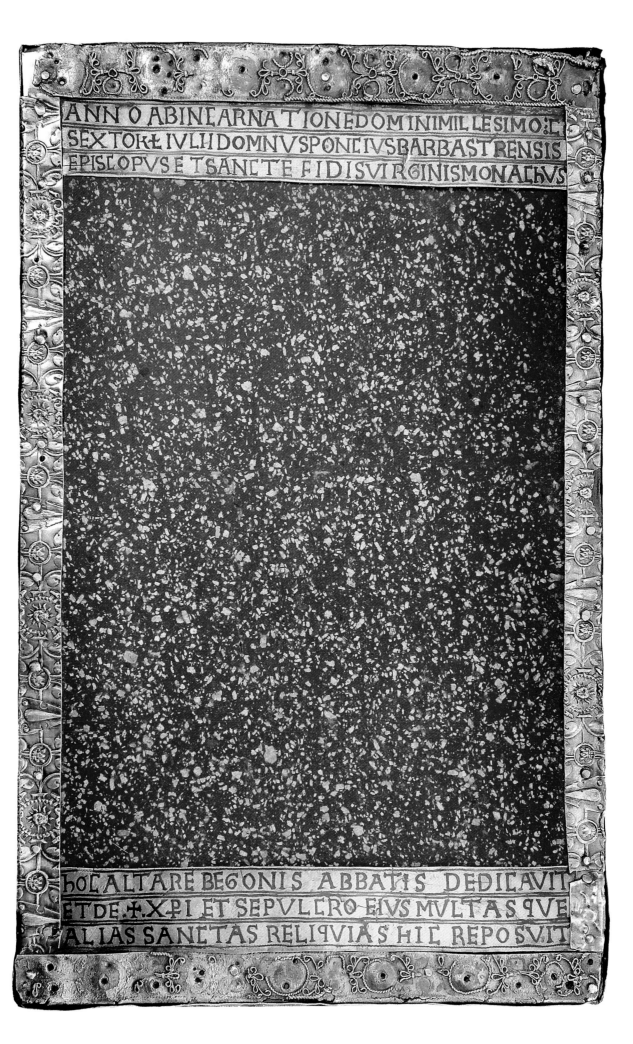

ANNO AB INCARNATIONE DOMINI MILLESIMO : C :
SEXTO KL IVLII DOMNVS PONCIVS BARBASTRENSIS
EPISCOPVS ET SANCTE FIDIS VIRGINIS MONACHVS

hOC ALTARE BEGONIS ABBATIS DEDICAVIT
ET DE + XPI ET SEPVLCRO EIVS MVLTAS QVE
ALIAS SANCTAS RELIQVIAS HIC REPOSVIT

Portable Altar of Saint Rosendo

15

Portable Altar of Saint Rosendo
1100–1105
[Monastery of San Salvador de Celanova, treasury]
Green porphyry, gilded nielloed silver
26 × 18 × 4 cm
Museo Catedral-Basílica de San Martiño de Ourense, Ourense
OB HONOREM SANCTI SALVATORIS CELLENOVENSIS RUDESINDUS AEPISCOPUS PETRUS ABBA ME IUSSI FIERI [Bishop Rudesind in honour of Saint Savior of Celanova. Aboot Peter ordered to be made]
ESSE DECET CLARAM VITAM VENIENTES AD ARAM. OFFERAT UT MITEM POPULI PRO CRIMINE VITE
[The life of he who approaches this altar should be virtuous, so that it may be offered up as a propitiary sacrifice for the remission of the sins of mankind]

Page 335: *Top view and bottom view*

A portable altar is a sumptuary object that used to be part of bishops' and abbots' furnishings, because as it contained relics and was canonically consecrated, it enabled the celebration of the Eucharist during their journeys. In this case we find ourselves face to face with an altar made of a piece of green porphyry garrisoned by a wooden frame and lined with sheets of gilded silver. On these sheets is set a rich nielloed decoration that extends to both sides. On the front, the framework revealing the stone is surrounded by bands of plant volutes inhabited by birds on the short sides. On the back, all the central space is devoted to a depiction of Christ surrounded by an angelic entourage.

The altar belongs to the so-called "Treasure of Saint Rosendo," kept today in the Cathedral Museum of Ourense.[1] The cult to Saint Rosendo (907–977) was enhanced during the twelfth century at the behest of the monastery that he himself had founded in Celanova (Ourense) in the tenth century. This process reached its culmination in the second half of the twelfth century with the writing of his life and miracles and his official canonization in 1172. The promotion of his cult had already started under Abbot Pedro I (1091–1119), in order to attract the flow of pilgrims to the monastery which held his relics.

At the time of Pedro I, the Monastery of Celanova consolidated its presence in Santiago de Compostela through the purchase of plots of land and houses near the *Locus Sanctus* where monks could reside during their stays in the city.[2] This presence in Compostela would have enabled a first contact for Abbot Pedro and his monks with the nascent art of the Pilgrims' Road to Santiago, which started to flourish around 1100. As witnessed by the inscription on the front of the altar, the work was commissioned by Pedro I, and as suggested by Serafín Moralejo,[3] surely from one of the flourishing workshops in Compostela working in the shade of the cathedral and Bishop Diego Gelmírez (1070–1140). The other possible way of contact with Languedoc was pointed out by Castiñeiras,[4] who suggests that in Celanova they may have known a sumptuous piece from Languedoc in a direct way through a visit by Giraldus of Braga (1096–1108) to the monastery after staying at the see of Ourense, its suffragan. The Archbishop had a portable altar that he took with him on his travels, as is shown by a miracle narrated in his *Vita* which occurred precisely during this visit to the see of Ourense.

In the style of the altar of Saint Rosendo we notice a close relationship with the artistic currents of southern France which started to flourish in the northwest of the peninsula within the nascent art of the pilgrimage road. Thus, the Muslim decoration of vegetal volutes inhabited by animals on the front of the altar comes from Moissac.[5] The type of Christ with full frontal face, almond-shaped eyes and abundant hair falling on his back is a link to the art of Bernard Gilduin in Saint-Sernin de Toulouse. The niello technique on silver which is an attempt to suggest the volume of the figures through parallel incisions of color and the search for variation and movement in the faces of the angels on the back of the piece have a suggestive parallel in the portable altar of Abbot Bégon III in the treasury of the Abbey of Sainte-Foy de Conques.[6]

All this data suggests, therefore, a timeline for the piece that could range between 1100 and 1105, at which time a greater presence of the artistic trends of Moissac, Toulouse and Conques can be detected in Compostela. This presence was undoubtedly favored by the two journeys Gelmírez and his entourage made to Rome precisely in these two years, and for which they had to use roads as busy as the *via tolosana* and the *via podiensis*, where these three centers of creation were located.

V. N.

[1] M. Castiñeiras, "Un enxoval para un corpo santo," in *Rosendo: o esplendor do século X* (Santiago de Compostela: Xunta de Galicia, 2007). M. A. González García, "El culto a San Rosendo y la creación del 'tesoro de Celanova' en la Edad Media," in *Rudesindus. El legado del santo* (Santiago de Compostela: Xunta de Galicia, 2007), pp. 156–73.
[2] J. M. Andrade Cernadas, "El abad Pedro I de Celanova (1091–1119): una primera aproximación," *Plenitudo Veritatis. Homenaje a Mons. Romero Pose* (Santiago de Compostela: Instituto Teológico Compostelano, 2008), pp. 653–64.
[3] S. Moralejo, "'Ars Sacra' et sculpture romane monumentale: le trésor et le chantier de Compostelle," *Les Cahiers de Saint-Michel de Cuxa*, 2 (Cuxa: 1980), pp. 189–238. Id., "Les arts somptuaires hispaniques aux environ de 1100," *Les Cahiers de Saint-Michel de Cuxa*, 13 (Cuxa: 1982), pp. 285–310. C. Bango García, "Ara de Celanova (Ourense)," in *Maravillas de la España Medieval. Tesoro sagrado y monarquía* (León: Junta de Castilla y León, 2001), p. 354, cat. 127.
[4] M. Castiñeiras, "La cultura figurativa Románica en el Noroeste peninsular y sus conexiones europeas (1050–1110). El caso de Braga," in *II Congreso Internacional Portugal: encruzilhada de culturas, artes e sensibilidades* (Coímbra: Associação portuguesa de Historiadores da Arte, 2005), pp. 582–3.
[5] C. Fraisse, *L'enluminure à Moissac aux XIᵉ et XIIᵉ siècle* (Auch: Edi-Service, 1992).
[6] D. Gaborit-Chopin and E. Taburet-Delahaye, "Autel portatif de l'abbé Bégon," in *Le trésor de Conques* (Paris: Musée du Louvre, 2001), pp. 56–61.

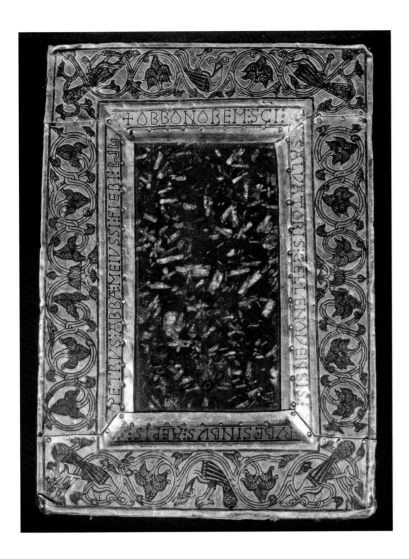

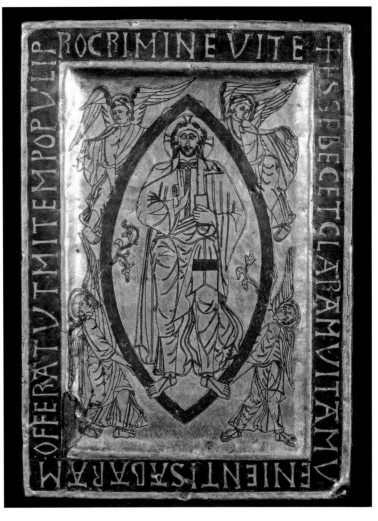

Capital with the Four Seasons, Abbey of Cluny

16
Capital with the Four Seasons
c. 1113–1120
[Abbey Church of Cluny III, choir]
Plaster cast (granite)
85 × 85 × 85 cm
Musée du Farinier, Cluny
[Cité de l'architecture et du patrimoine–
musée des Monuments français, Paris]
VER PRIMOS FLORES PRIMOS PRODUCIT ODORES
[Spring makes the flowers bloom and provides
the first scent]
FALX RESECAT SPICAS [FER]VENS [QVA]S
DECOQ[V]IT AESTAS [The sickle cuts the first ears
of corn that the hot summer has dried]
DAT COGN[OSCE]NDV[M] PRVUDENTIA Q[V]ID SIT
AGENDV[M] [Prudence knows what to look for]
DAT NOS MONENDV[M] PRVUDENTIA Q[V]ID SIT
AGENDVM [Prudence advises us how on we
should proceed]

This is a plaster cast of one of the best-known of the choir capitals in the Abbey Church of Cluny III, made in 1929 at the behest of Paul Deschamps, the curator of the then Musée de Sculpture Comparée de Paris. The original forms a part of the remains which were saved from the almost total destruction that the Monastery of Cluny – considered a monument to the *Ancien Régime* – suffered after the French Revolution. The Musée du Farinier de Cluny currently has eight capitals from the first ambulatory of the abbey church, decorated with the following subject matter: Foliate-Corinthian, the Rivers of Paradise, the Tones of Gregorian Chant, the Four Elements, the Four Humors, the disciplines of the *Quadrivium* and the two under consideration here, dedicated to *Prudentia* and the Four Seasons. Here, on a foliate background of acanthus leaves of the Corinthian, there are four mandorlas with inscriptions around their edges which helped K. J. Conant to identify the feminine figures which appear inside.[1] One of these, who appears to be cracking a kind of whip against another figure, now long disappeared, according to Conant is *Prudentia* who is imposing herself in fear of punishment. At her side, the effigy dressed in a coat of mail represents the virtue that prevails through use of intelligence. The other two figures represent two seasons: spring as a woman holding a book and dressed in a tunic and cloak, and summer, carrying a bundle of wheat.[2] This capital formed a part of the complex iconographic program of the abbey's ambulatory, the central thread of which, according to Ch. Scillia, is music in all its dimensions, in compliance with the theory put forward by Boethius (480–524) in his *De Institutione Musica.* As far as Scillia is concerned, worldly music is shown in representations of the four rivers of Paradise, the four seasons of the year, the elements; *musica instrumentalis* by the two capitals representing the tones or modes of Gregorian chant, and human music through the representation of the *Quadrivium*, of the four humors and the cardinal virtues, such as *Prudentia*, who appears in this capital, not by mere chance, but due to a *titulus* taken from the work by Boethius, cited earlier. This is, therefore, a program which is perfectly adapted to its location, as the columns of the ambulatory enclosed the most important space in the Clunian worship: the massive choir where monks chanted the Liturgy of the Hours, echoing the celestial choirs. With good reason, in works such as *Musica Disciplina* by Aurelianus Reomensis in the ninth century[3] – a text which, as in the case of Boethius, would have been found at the time in the monastery's library – or *The Life of Saint Hugh of Cluny*, compared the Divine Office in the church with *deambulatorium angelorum*.[4] The representation was undertaken in a spirit of great vivaciousness in which the figures possess enormous freedom of movement, having rejected the limitations that the architectural framework imposed upon them and having been realized in a very high relief which, in certain areas leaves parts of the figures completely isolated, a fact which has been related to the possible influence of the art of fine metalwork

and sculpture in ivory.[5] Worthy of special mention when considering the style of this workshop is the way that movement in clothing is depicted – perfectly exemplified in the tunic worn by the figure representing spring, with its characteristic *plis soufflés* – an element which would become a constant in Burgundian sculpture in the twelfth century. Although Conant,[6] basing himself in the consecration of the high altar in 1095 by Pope Urban II (1088–1099), proposed this date as the *terminus ante quem* for the sculpting of the capitals, this suggestion was criticized by French historiographers led by Deschamps,[7] as being too early bearing in mind the quality of the work. Painstaking archaeological research into the abbey enabled Salet, in 1968, to propose that the choir was finished between 1118 and 1120, dates which have once again been revised due to certain information of an epigraphic nature that has been discovered.[8] Testimonies regarding the calligraphy of some of the inscriptions of the mandorlas of the capitals, as well as the painting in the high chapel of the south transept, dedicated to Saint Gabriel, which mention the Spanish Archbishop Pedro de Pamplona, who died in 1115 and who consecrated the chapel, make this latter date the most likely for the finishing of the easternmost parts of the enormous abbey church and its decoration.[9]
V. N.

[1] K. J. Conant, *Cluny. Les églises et la maison du chef d'ordre* (Mâcon: Protat Frères, 1968), pp. 88–9.
[2] As far as Scillia is concerned, on the other hand, the figure holding a book represents Prudence, the man in chainmail is *Fortitudo*, the women punishing the other figure is *Temperantia*, with the remaining figure representing Justice, making this capital a joint representation of the cardinal virtues: Ch. E. Scillia, "Meaning and Cluny Capitals: Music as Metaphor," *Gesta*, vol. 27, 1–2 (New York: 1988), pp. 139–40. Diemer, supposing a possible error in the location of the inscriptions and concentrating on the iconography of the figures, claims that this capital represents *Trivium* and Prudence: P. Diemer, "What does *Prudentia* Advise? On the subject of the Cluny Choir Capitals," ibid., pp. 153–5. E. Vergnolle, "Les Chapiteaux du Déambulatoire de Cluny," *Revue de l'Art*, 15 (Paris: 1972), pp. 95–101.
[3] Aurelianus Reomensis, *Musica Disciplina*: "*Hinc ergo colligendum est, quam gratum sit deo officium cantandi, si intenta mente peregatur; quando in hoc angelorum choros imitator, quos sine intermissione Domini laudes concinere traditur,*" cf. "Meaning and Cluny Capitals: Music as Metaphor"... op. cit.
[4] Ibidem, p. 133. M. Angheben, *Les chapiteaux romans de Bourgogne. Thèmes et Programmes* (Turnhout: Brepols, 2003), pp. 36–8.
[5] M. F. Hearn, *Romanesque Sculpture. The Revival of Monumental Stone Sculpture in the Eleventh and Twelfth Centuries* (Oxford: Phaidon, 1981), p. 115–6.
[6] K. J. Conant, "The iconography and the sequence of the ambulatory capitals of Cluny," *Speculum*, 5 (Cambridge: 1930), p. 287.
[7] P. Deschamps, "À propos des chapiteaux du chœur de Cluny," *Bulletin Monumental*, 88 (Paris: 1929), pp. 514–6.
[8] F. Salet, "Cluny III," *Bulletin Monumental*, 126 (Paris: 1968), p. 235–92.
[9] N. Stratford, *Studies in Burgundian Romanesque Sculpture*, 2 vols. (London: 1998). *Les chapiteaux romans de Bourgogne. Thèmes et Programmes*... op. cit., pp. 42–59. J. Wirth, *La datation de la Sculpture médiévale* (Geneva: Librairie Droz, 2004), pp. 50–2.

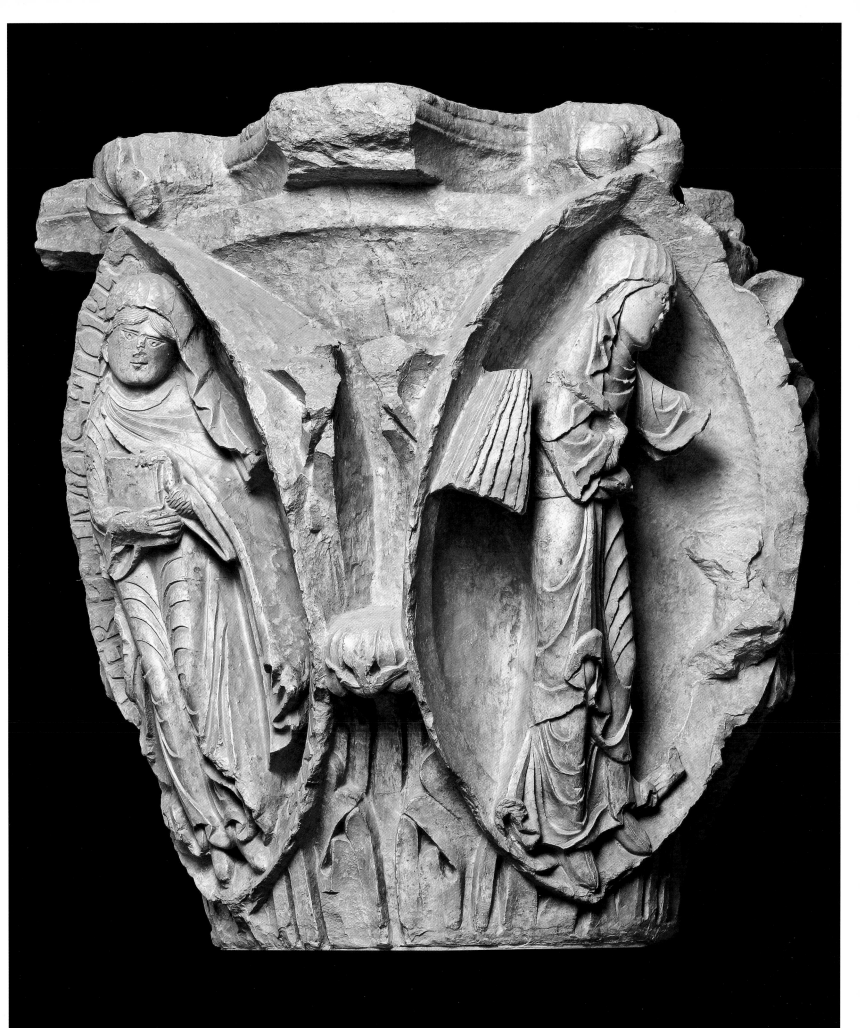

GELMÍREZ IN ITA